ARCHITECTURAL DIGEST

at 100
A CENTURY OF STYLE

ABRAMS, NEW YORK

Foreword
by *Anna Wintour*

Simply put, *Architectural Digest* is a legend, a publication one pores over and holds on to. But times change and so do legends—and recently *AD* has been changing in ways that have been thrilling to see. Under the editorship of *Amy Astley*, whose vision I am constantly impressed by, *AD* has modernized. Where one might have once called the magazine elegant and formal—possibly a little conservative—it now feels youthful and stylish and full of personality. The homes that Amy chooses reflect not just the idealized visions of their designers and architects, but also the lives of the owners. She's brought warmth and energy to her pages—and a great new logo—and she's updated *AD* for the 21st century with its digital brands Clever and ADPro. One might say she's done a lovely renovation. She's let the light in.

How exciting to celebrate *AD* past and present with this wonderful book. The pages that follow combine unforgettable images and unforgettable homes—one after another. From *Frank Gehry's* new residence in Santa Monica to a fascinating look at the *Obama* White House, to the Brooklyn loft of the artist *KAWS*, to *Tory Burch's* Southampton estate, to *Kylie Jenner's* private getaway in Los Angeles, *AD at 100* is quite the house tour. Here's to the next 100 years.

Introduction
by *Amy Astley*

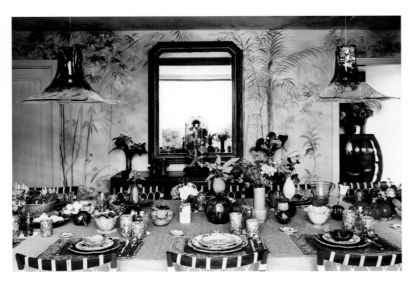

The colorfully-set table in the dining room of Margherita Missoni Amos in Varese, Italy (*AD* September 2018; see page 371).

100 YEARS! It's a big deal. So, to celebrate this major milestone, how could we resist throwing *Architectural Digest* a big birthday bash and inviting all our friends? Well, you are now holding that party in your hands, and, indeed, all of our crowd, past and present, are here for the occasion.

And what an A-list celebration it is! So many stars of pop culture have welcomed *AD* into their private realms to examine their version of the well-lived life. We've got *Fred Astaire* at home in Beverly Hills; *Kate Moss* lounging around her London dressing room; *Frank Gehry* revealing the Santa Monica dream house he designed for himself and his wife; *David Bowie* in his Mustique hideaway; *Anderson Cooper* poolside at his Brazilian beach house; *Georgia O'Keeffe* in her adobe home in New Mexico. There's a slew of ageless scene-stealing divas—

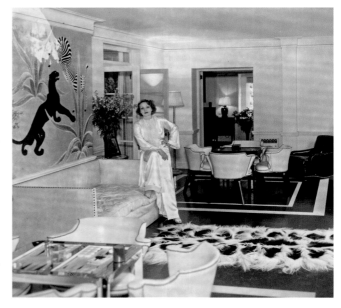

Marlene Dietrich in the lounge of her Beverly Hills residence, circa 1930s (*AD* April 1990; see page 100).

Bette Davis, Marlene Dietrich, Carole Lombard, Elizabeth Taylor, Liza Minnelli, Barbra Streisand, Mariah Carey—at ease in their luxe lairs. And house-proud, design-savvy tastemakers like *Jennifer Aniston, Julianne Moore, Valentino Garavani, Ricky Martin, Mandy Moore, Robert Downey Jr., Kris Jenner, Margherita Missoni Amos, Marc Jacobs,* and buzzy artist *KAWS* (a.k.a. *Brian Donnelly*) have all opened their doors.

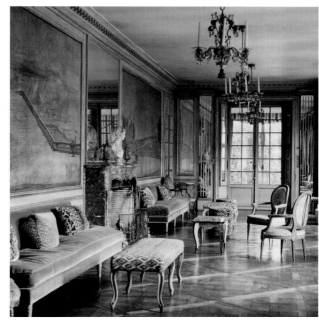

The long gallery of the Villa Trianon, Elsie de Wolfe's beloved home, in Versailles, France (*AD* September 1996; see page 142).

It's no surprise that celebrities of every realm—entertainment, art, fashion—have long played a role in our story; *AD* was, after all, founded in Los Angeles. They humanize our glossy vision, lending charisma, personality, and context to our photography and providing an irresistible way to chart the shifting tides of taste.

But, fun though they most certainly are, stars are only one piece of our mosaic. It really is the interior designers, architects, and landscape designers who guarantee that our pictures exude what I call the "wow factor" month after month. It takes a professional to beguile our cameras in the manner our readers expect. The grandees of decorating are all here, too, of course: *Elsie de Wolfe, Madeleine Castaing, Henri Samuel, William Haines, Billy Baldwin, Renzo Mongiardino, Nancy Lancaster, Albert Hadley, Michael Taylor,* and so many others. The photos we've selected prove that their work stands the test of time. These classic interiors remain as worthy of study

now as when they were first published, and their influence on new generations of talent—as evidenced throughout these pages—is readily apparent.

In the early years *The Architectural Digest* (the "The" thankfully dropped in the 1960s), true to its name, documented mostly façades and exteriors, all largely confined to its birthplace. California architects such as *Wallace Neff, Cliff May*, and *Paul Williams* were championed, and later the Case Study crowd *(Richard Neutra, Pierre Koenig, Craig Ellwood)* and the daring visionaries *(John Lautner, Frank Gehry)* all got star treatment. But once *AD*'s cameras moved inside, there was no going back. Over the decades, the publication has built a vast archive of interiors that tell a fascinating story of the evolution of manners and mores. In fact, after sifting through a century of photos, it strikes me that our lifestyles may have changed even more profoundly than our tastes.

Whereas *AD* had been known—and celebrated—for capturing grand residences with stately (and, to our modern eyes, a bit stiff) rooms for formal dining and entertaining, the prevailing spirit loosened up with each passing decade. Today's trophy room might be a spacious, chef-grade kitchen, a spa-like bathroom, a high-tech screening room, a fully loaded Pilates studio,

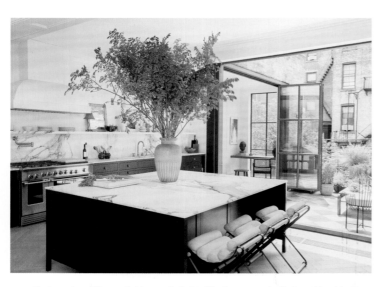

Tastemaker Athena Calderone's light-filled, custom-built Brooklyn kitchen, created in collaboration with designer Elizabeth Roberts (*AD* November 2018).

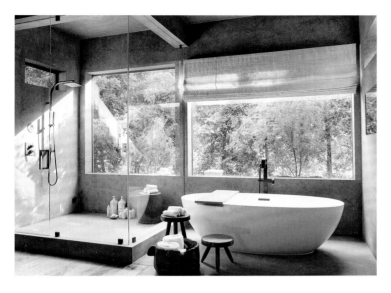

Kris Jenner's serene, spa-like bath at her Hidden Hills, California residence (*AD* March 2019; see page 117).

or even a children's climbing wall. Such spaces speak volumes about modern people and our predilections. In the 21st century, dream houses are now likely to be family-centric and casual, with a decided desire for indoor/outdoor living, and finely calibrated to suit their owners' interests rather than to impress the dinner guests.

AD is constantly exploring digital frontiers, seeking inspiring and interactive new ways to share our passion for innovative design with our audiences. What challenges and opportunities will the next 100 years bring as the climate changes, technology continues its rapid progression into all corners of our lives, and the need to encourage sustainable development looms ever larger? While I cannot predict the future, I can confidently guess that the age-old desire to see how others live will persist—and that *AD* will be there.

Willow Romanek climbs the rock wall in the playroom of her family's Hollywood Hills home, which was designed by her mother, Brigette (*AD* October 2016).

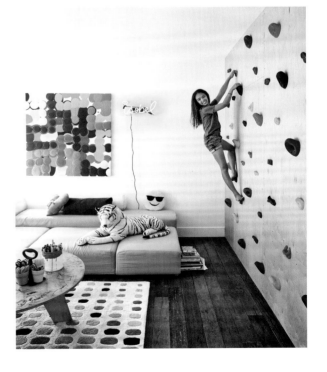

Amy Astley
Editor-in-Chief

Nate Berkus & Jeremiah Brent
Frank Gehry
Cliff May
Michael Taylor
Nikolai Haas & Djuna Bel
Robert Graham
Mary Pickford & Douglas Fairbanks
Wallace Neff
Jeffrey Deitch
Reginald D. Johnson
Atelier AM
Barron Hilton
Paul R. Williams
Edythe & Eli Broad
Commune
Bart Prince
Richard Neutra
Lawrence Lapham
Arthur Elrod
Frank Wynkoop

California

Jamie Bush
Marmol Radziner
Charles de Lisle
John Lautner
Kelly Wearstler
Richard Shapiro
Tony Duquette
Paul László
Perry Farrell
Steven Ehrlich
Waldo Fernandez
Matthias Vriens-McGrath
William Haines
David Geffen
Charles Moore
Michael Bay

BEFORE THE Manhattan penthouses and the Parisian pieds-à-terre, and before the superyachts and Balinese pleasure domes came to its attention, *Architectural Digest* was singularly focused on the glories of the Golden State, the magazine's birthplace in 1920.

The young publication elucidated a vision of America's western frontier as a place of 20th-century innovation and promise, replete with stately Mediterranean-style manses, sun-kissed Italianate gardens, and picturesque reflecting pools. As California became a crucible for the nascent modernist movement, *AD* began to revel in the heterogeneity of the California landscape, where New World interpretations of Cotswolds cottages, Spanish palaces, and French châteaux mingled amicably with spruce, streamlined houses of glass and steel.

The greatest California-based architects of the past century were all championed in *AD*'s pages. *Wallace Neff*, who built romantic houses of every stripe for merchant kings and Hollywood stars, was a staple of the magazine's editorial mix. His remodeling of Pickfair, the storied house that belonged to the legendary actors *Douglas Fairbanks* and *Mary Pickford*, made no fewer than six appearances in *AD* over several decades. *Paul R. Williams*, the first African American member of the American Institute of Architects, was another of the magazine's mainstays. Beloved by celebrities on the order of *Frank Sinatra*, *Barbara Stanwyck*, and *Lucille Ball*, Williams helped establish an

image of California glamour that captivated the world.

From *Irving Gill* to *Cliff May* to the stars of the Case Study crowd—*Richard Neutra, Pierre Koenig, Craig Ellwood*, et al—*AD* tracked the advent and blossoming of California modernism. *Julius Shulman* and other master photographers chronicled their work in elegant images that helped sell the progressive style to a skeptical public weaned on European-inflected traditionalism. In later decades, the progeny of the early modernists, from *John Lautner* to *Frank Gehry*, became the new standard-bearers heralded in the magazine's pages.

Just as California incubated a particular strain of modernist architecture, the state produced a roster of enormously influential interior designers who riffed on the colors and light of Los Angeles, Palm Springs, Santa Barbara, San Diego, San Francisco, and all points in between. *William Haines*, the silent-film heartthrob turned decorator, was one of the first design stars in the *AD* constellation. That groundbreaking society would grow to include *Rose Tarlow, Kalef Alaton, Steve Chase, Michael Taylor, Anthony Hail*, and *Sally Sirkin Lewis*. In more recent years, *Michael S. Smith, Steven Volpe, Kelly Wearstler*, and a new generation of talents have picked up the torch of sublime, homegrown California design. ◢◗

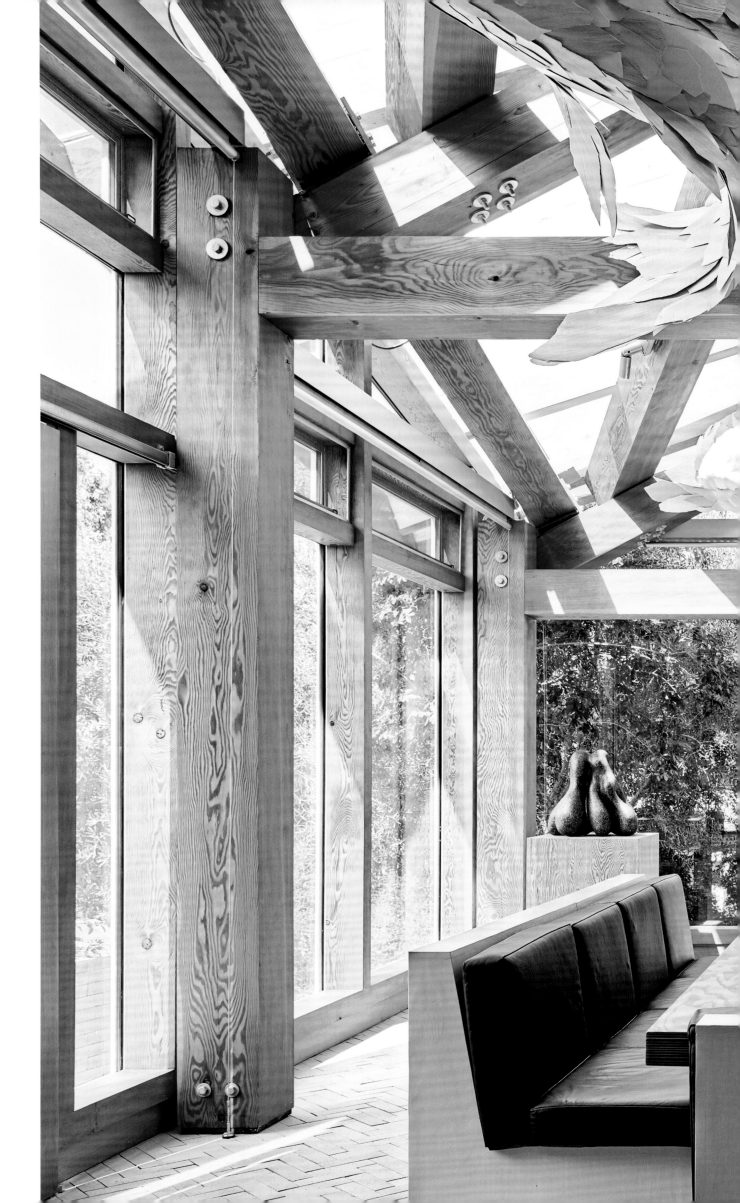

April 2019
Santa Monica

HOMEOWNER
Frank Gehry
ARCHITECT
Gehry Partners

With their sons grown, Gehry and his wife, Berta, began to wonder about the practicality of remaining in their longtime Santa Monica home. The architect, whose international practice has left him little opportunity for designing houses, was intrigued at the prospect of being his own client again, this time working with his son Sam. With gabled roofs, broad expanses of glass, and heavy diagonal timbers of Douglas fir, this new house is like a modern take on an Adirondack lodge, unconventional yet enthusiastically welcoming.

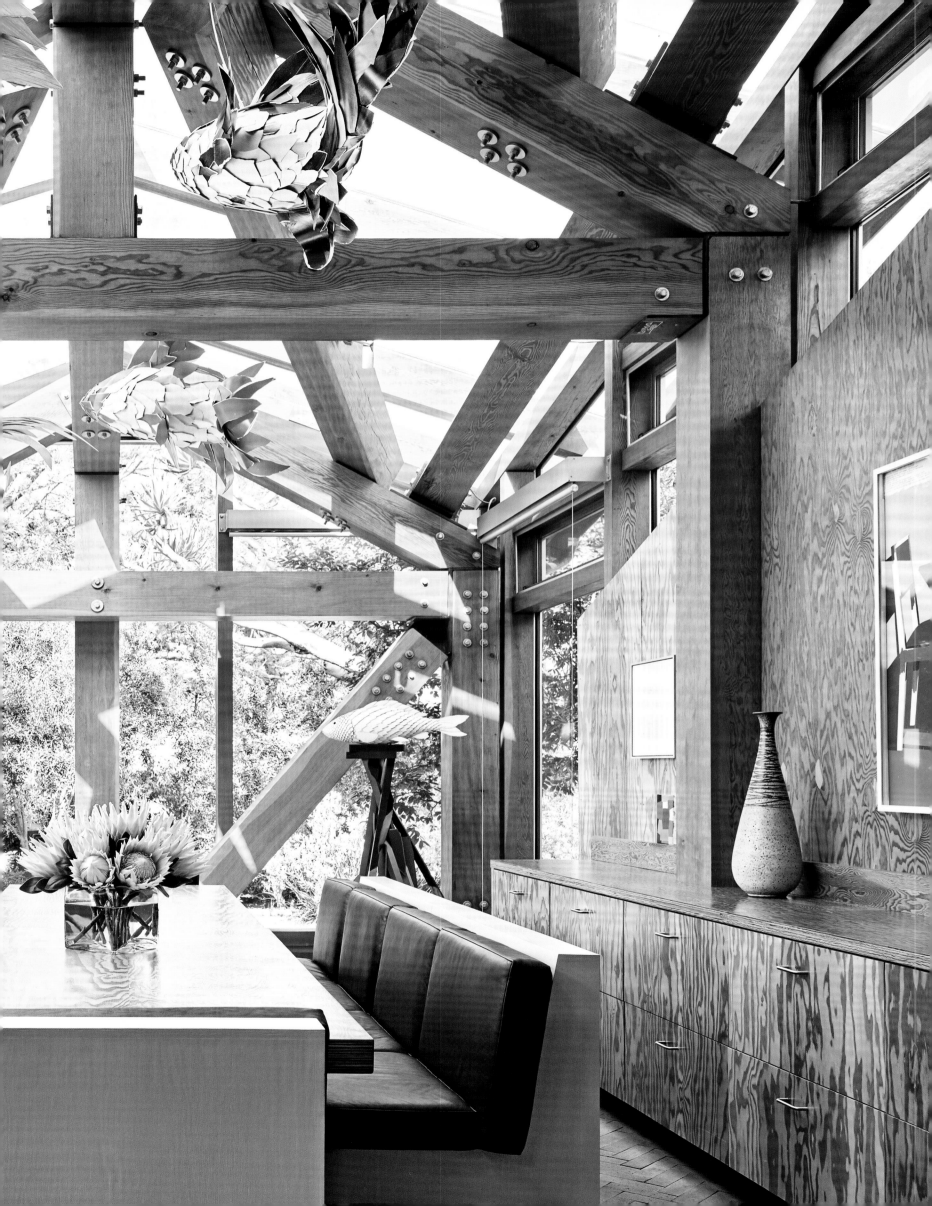

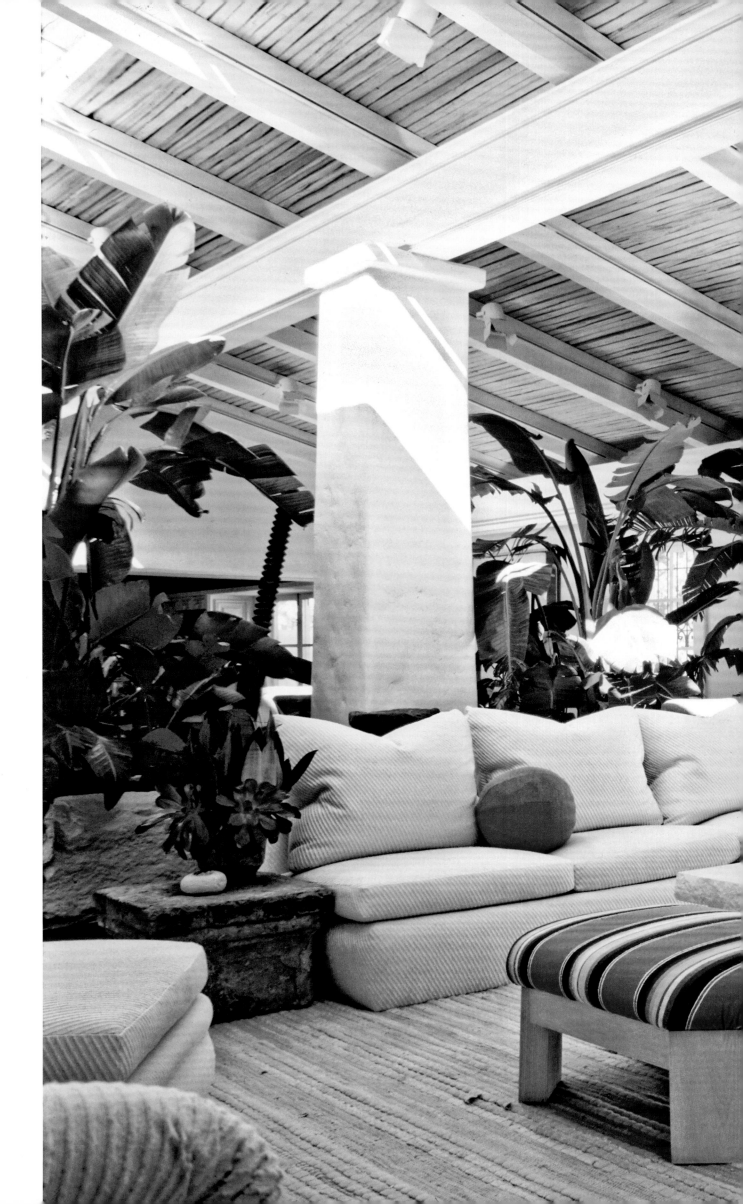

July 1986
San Diego

ARCHITECT
Cliff May

DESIGNER
Michael
Taylor

For an East Coast
couple moving to the
hills north of San Diego,
Taylor breathed fresh
life into a turn-of-the-
century ranch house
by May. Bleaching the
beams and introducing
an overall white palette
accented with bold
Mexican fabrics, Taylor
provided a "happy,
strong, up feeling" for
clients accustomed
to darker color schemes.
"We were concerned
about respecting [May's]
original intention," said
Taylor, but the home-
owners were eager to
try something different.
"Their openness and
enthusiasm were an
inspiration to me."

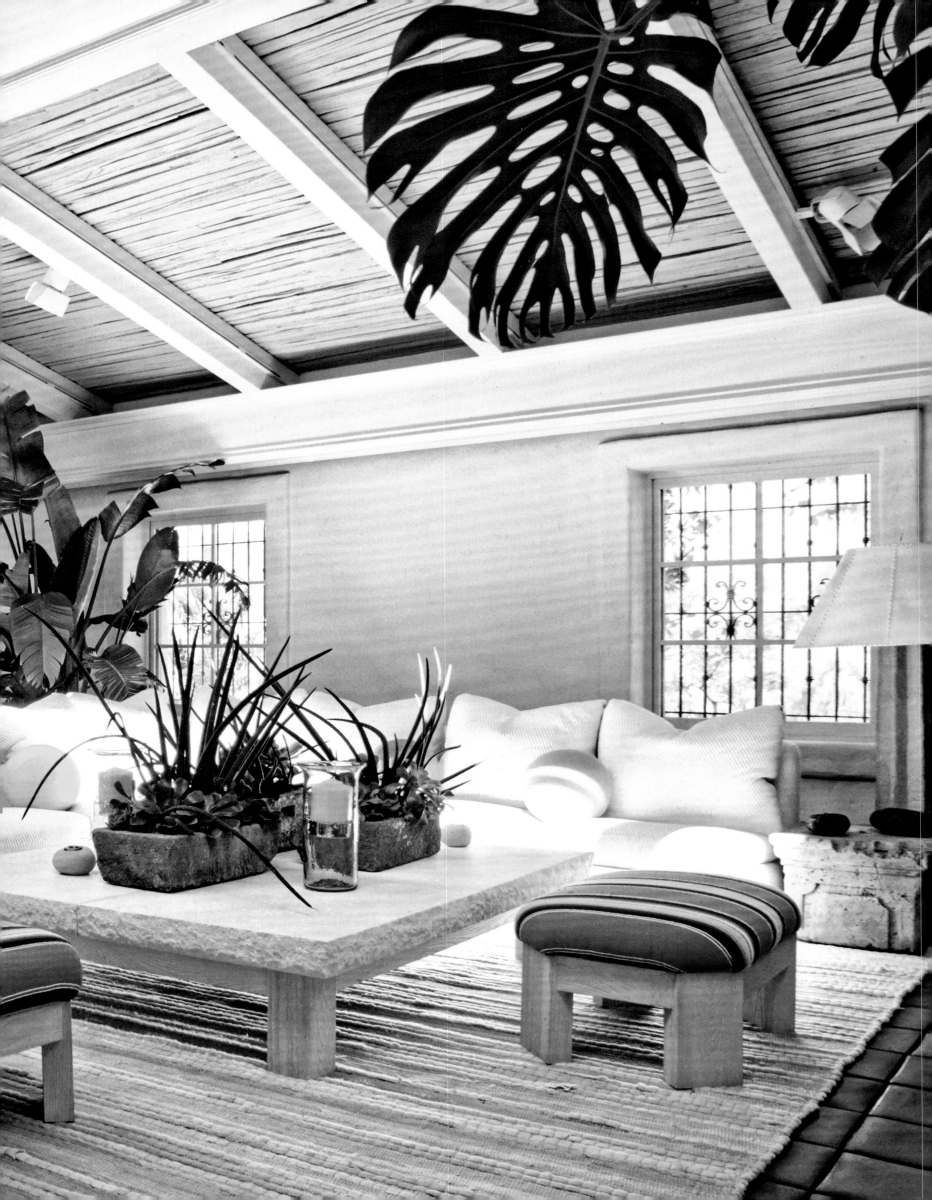

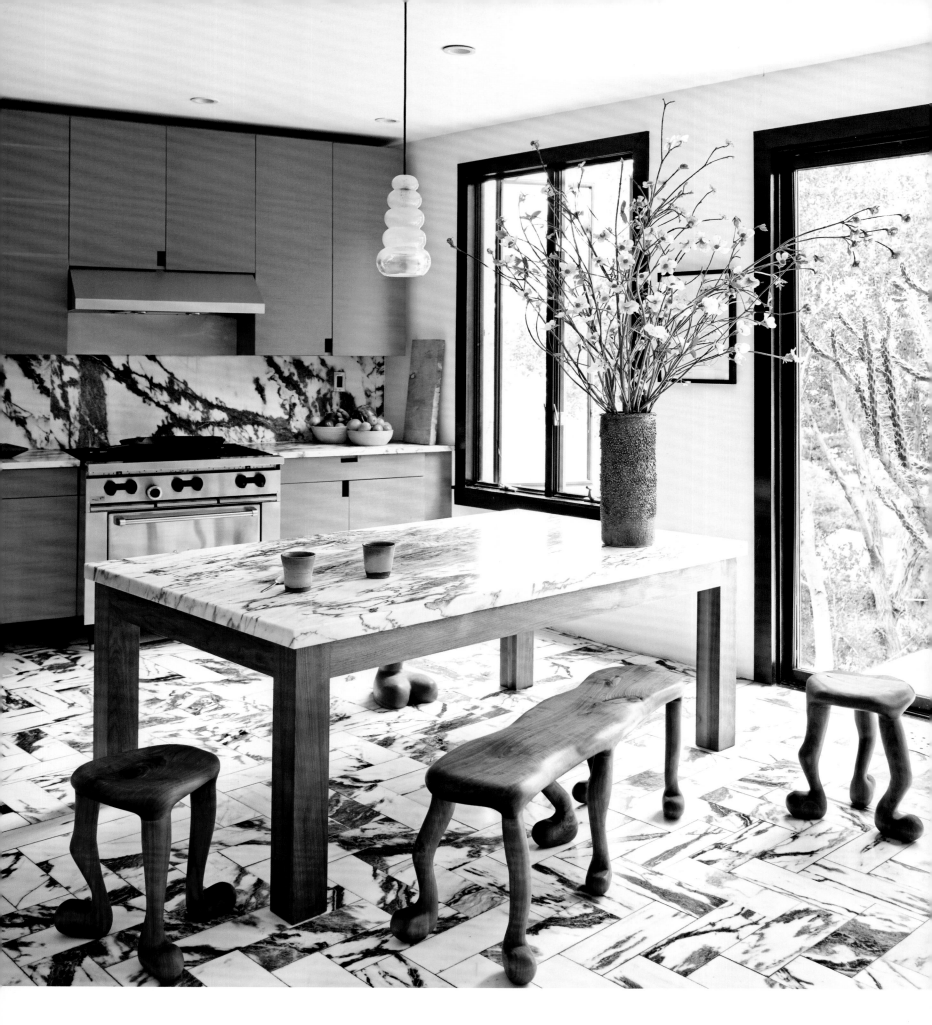

December 2018 | Highland Park

HOMEOWNERS Nikolai Haas & Djuna Bel

A magical mash-up of hippie hut and high design, the stylish couple's Los Angeles home is almost unrecognizable from the dated 1985 structure they purchased in 2015. Haas's handicraft is everywhere: The stonework in the kitchen is made with the same marble he and his twin brother, Simon, utilize to fabricate the pieces that have made them superstars in the contemporary-design world; much of the walnut furniture is hand-carved. In the master bedroom, a custom cashmere quilt by The Elder Statesman covers a walnut bed by Haas.

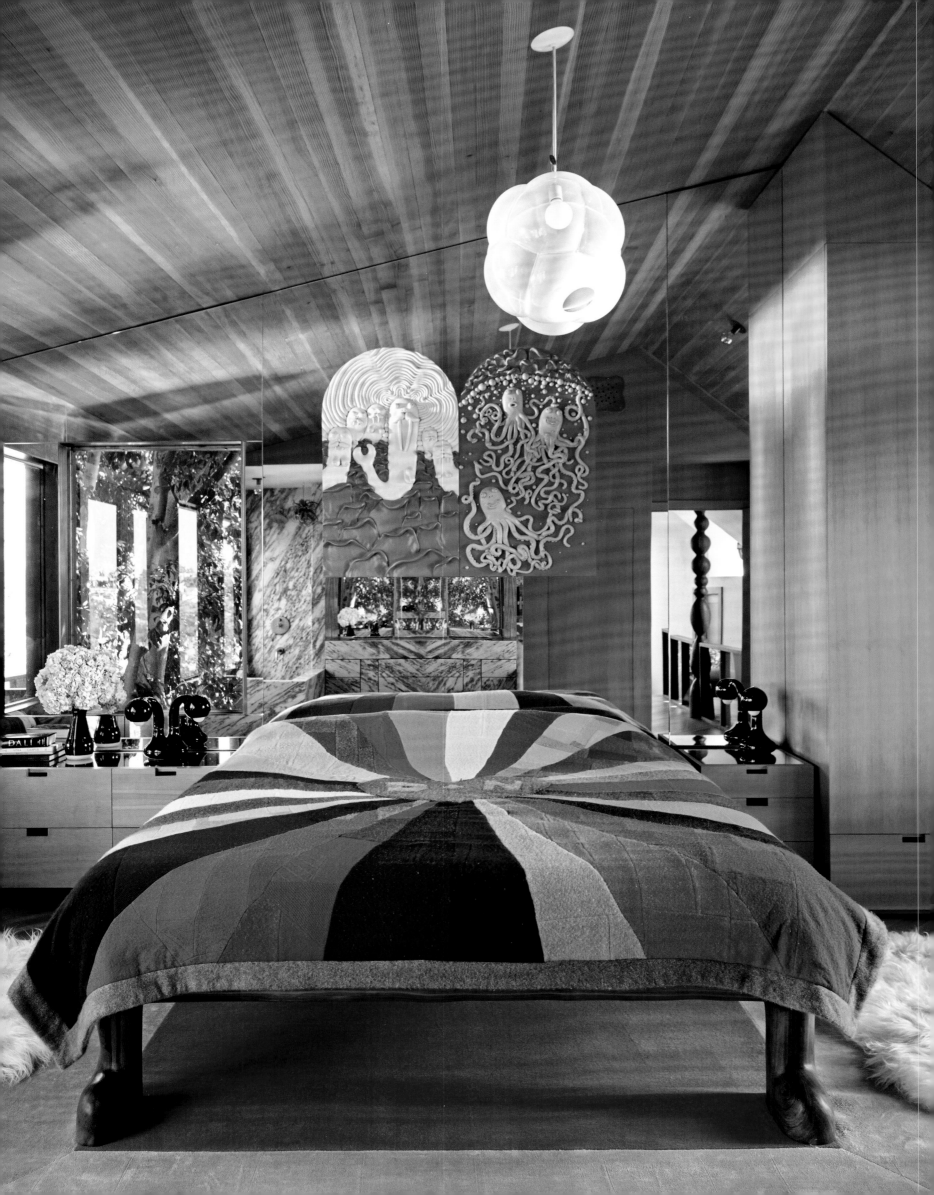

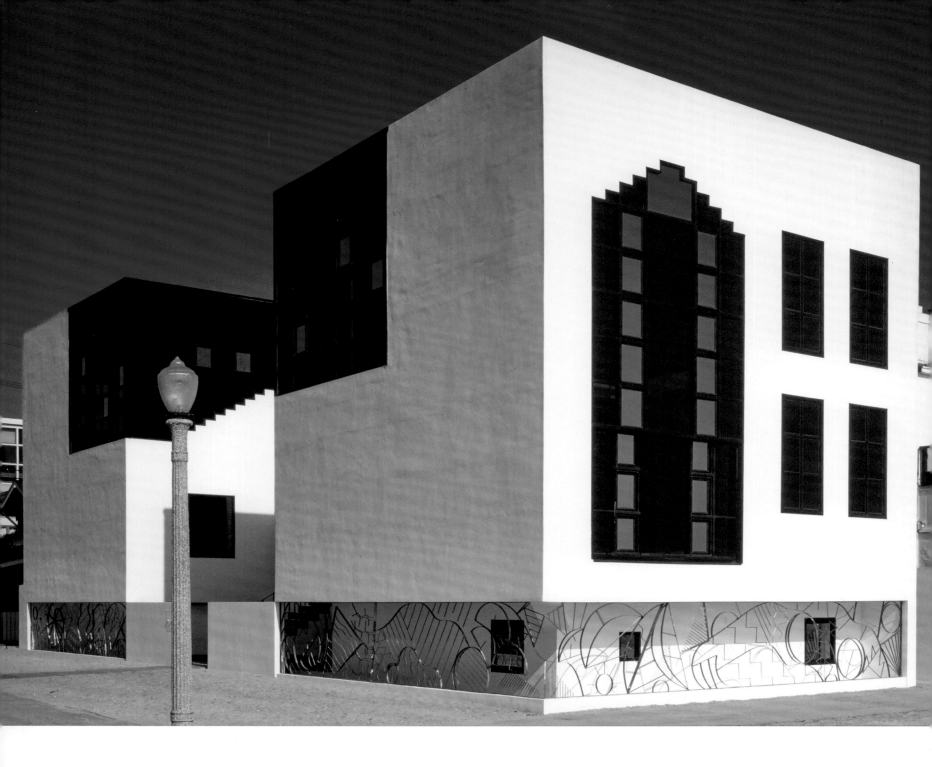

March 1983 | Venice

ARCHITECTURAL DESIGNER Robert Graham

In 1978, commissioned by collectors Roy and Carol Doumani, Graham melded art and architecture to realize his first built structure—a postmodern beach house with high ceilings, voluminous spaces, skylights, and broad walls designed specifically to accommodate artworks by David Novros, Joanna Pousette-Dart, Billy Al Bengston, and others.

Fall 1966 | Beverly Hills

Pickfair HOMEOWNERS Mary Pickford & Douglas Fairbanks

Pickford and Fairbanks, Hollywood's top stars of their era, bought the Beverly Hills hunting lodge they dubbed Pickfair in 1919, shortly before they married, and commissioned Wallace Neff, the film colony's favorite architect, to renovate it in mock-Tudor style. Royals and celebrities were entertained in the mansion's 25 gracious rooms and stately formal gardens. "Of famous American homes, Pickfair is probably as well known as any—second only to the White House," mused AD.

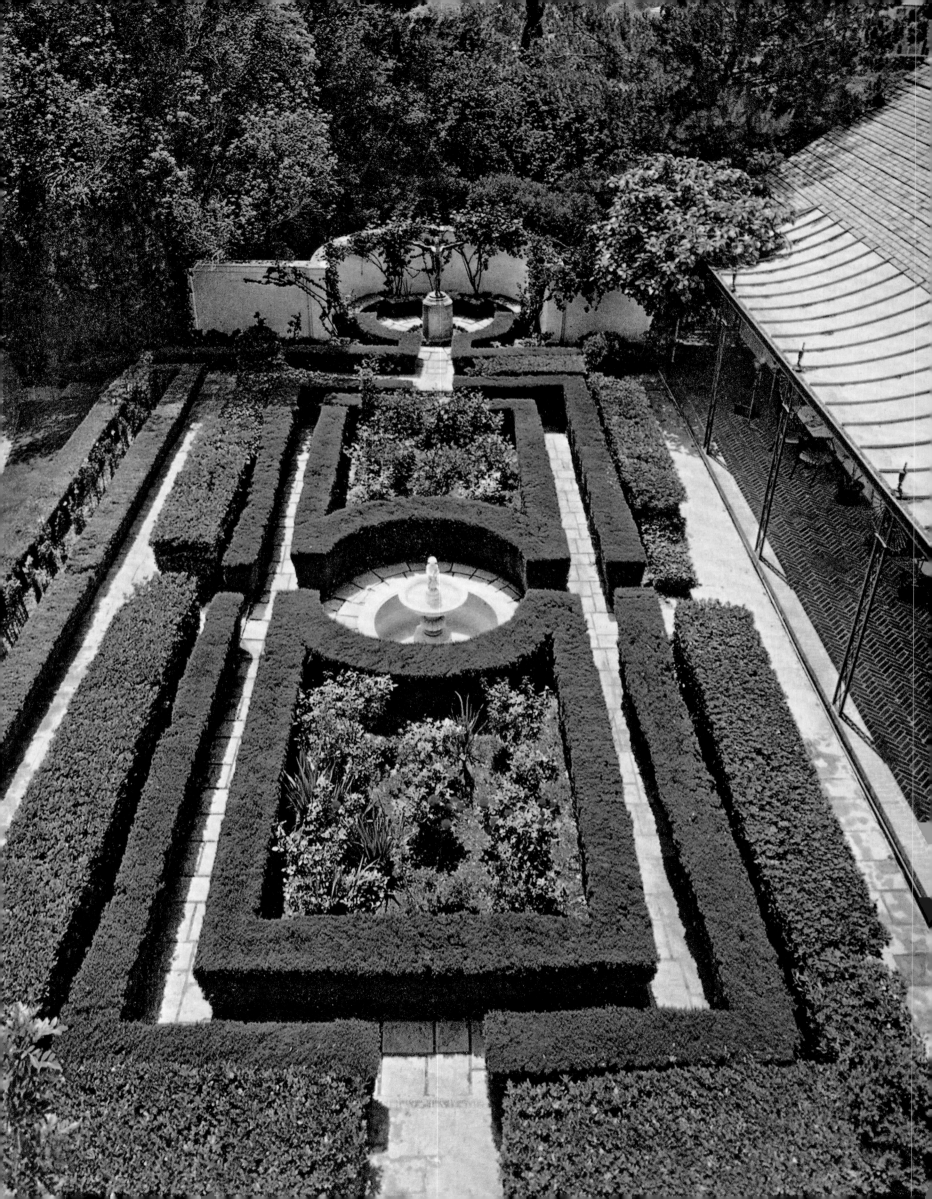

December 2017
Los Feliz

HOMEOWNER
Jeffrey Deitch

After the art dealer
and curator moved into
a 1929 Wesley Eager
house that had been the
onetime bachelor pad
of actors Cary Grant and
Randolph Scott, Deitch
invited artists and design-
ers to create site-specific
installations. In the party
room, Richard Woods's
blue faux-hardwood panels
provide a bold backdrop
for a light sculpture by Tim
Noble and Sue Webster as
well as an extravagant sofa
by Gaetano Pesce. "I did
not want the house to be
just a house," Deitch wrote.
"I hope that it will become
my Hollywood version of a
total work of art."

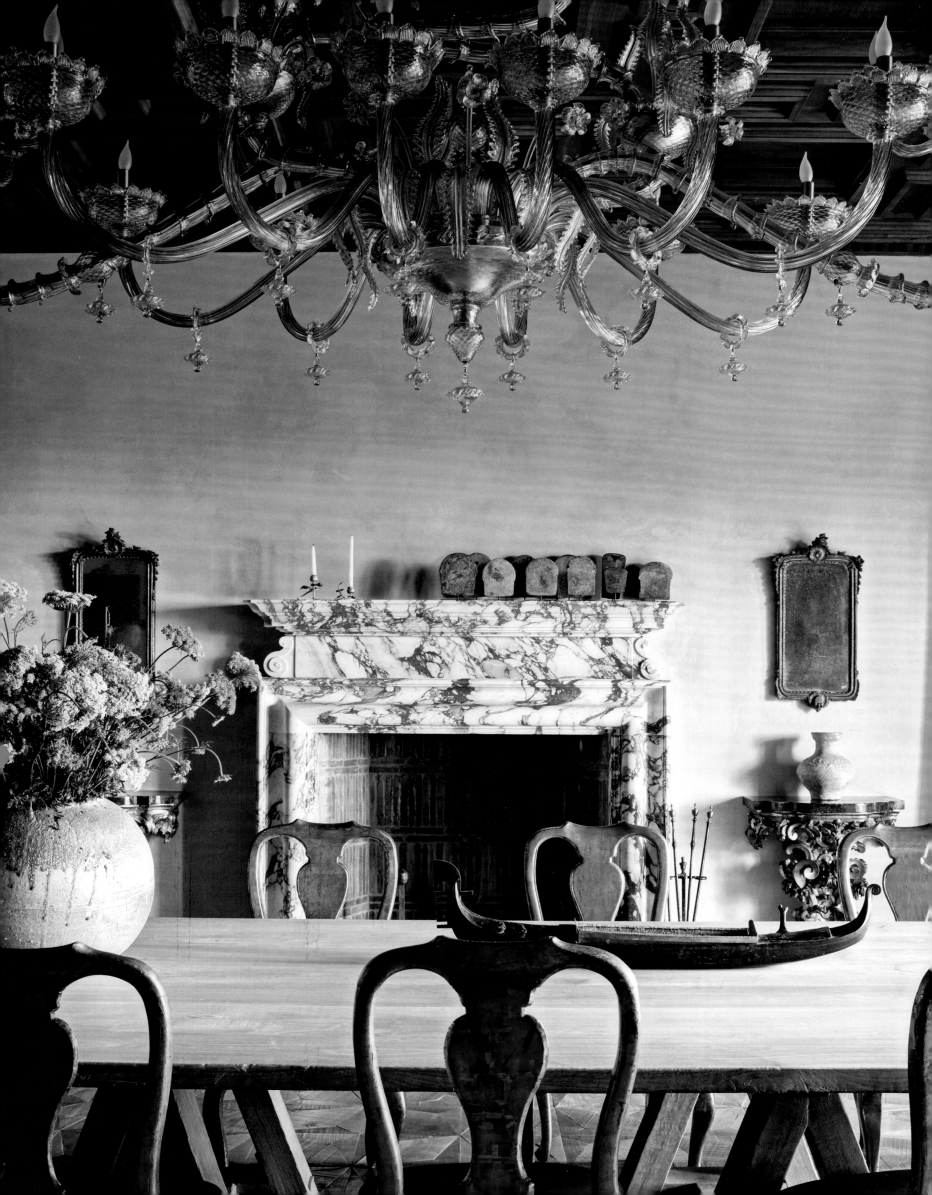

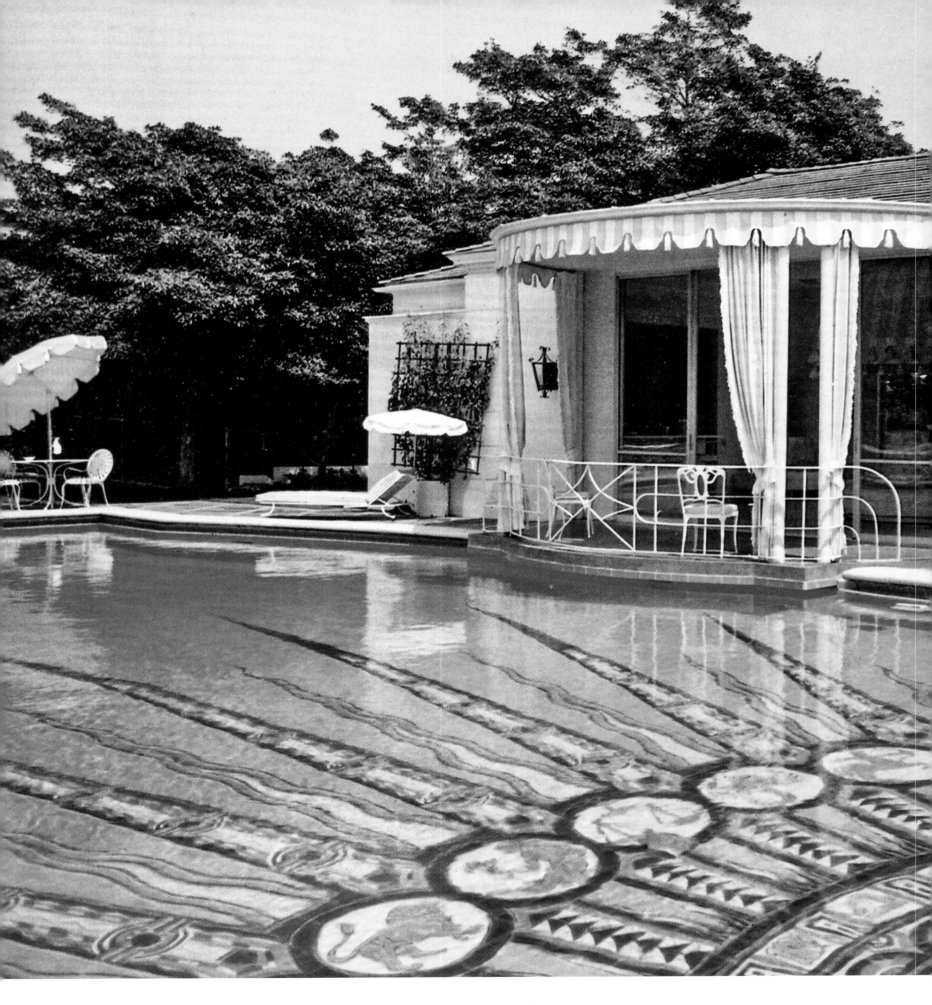

March 2018 | Montecito

ARCHITECT Reginald D. Johnson DESIGNER Atelier AM

For a multigenerational family, Michael and Alexandra Misczynski (the husband-and-wife duo behind the Los Angeles–based design firm Atelier AM) reinvented a 1930 estate designed by Johnson, a renowned Pasadena architect. With reverence for the building's history, they deployed timeworn materials (vintage terra-cotta tile flooring, reclaimed wood, Italian marble) and objects that span centuries. Said Michael: "We simply believe the past and the present do not exist in opposition."

Fall 1968 | Beverly Hills

HOMEOWNER Barron Hilton ARCHITECT Paul R. Williams

Mosaics depicting the zodiac decorate the pool at a 1930s neo-Georgian residence by Williams, the first African American member of the American Institute of Architects. The house was updated in the 1960s by designer Kathryn Crawford for the hotel heir and his wife.

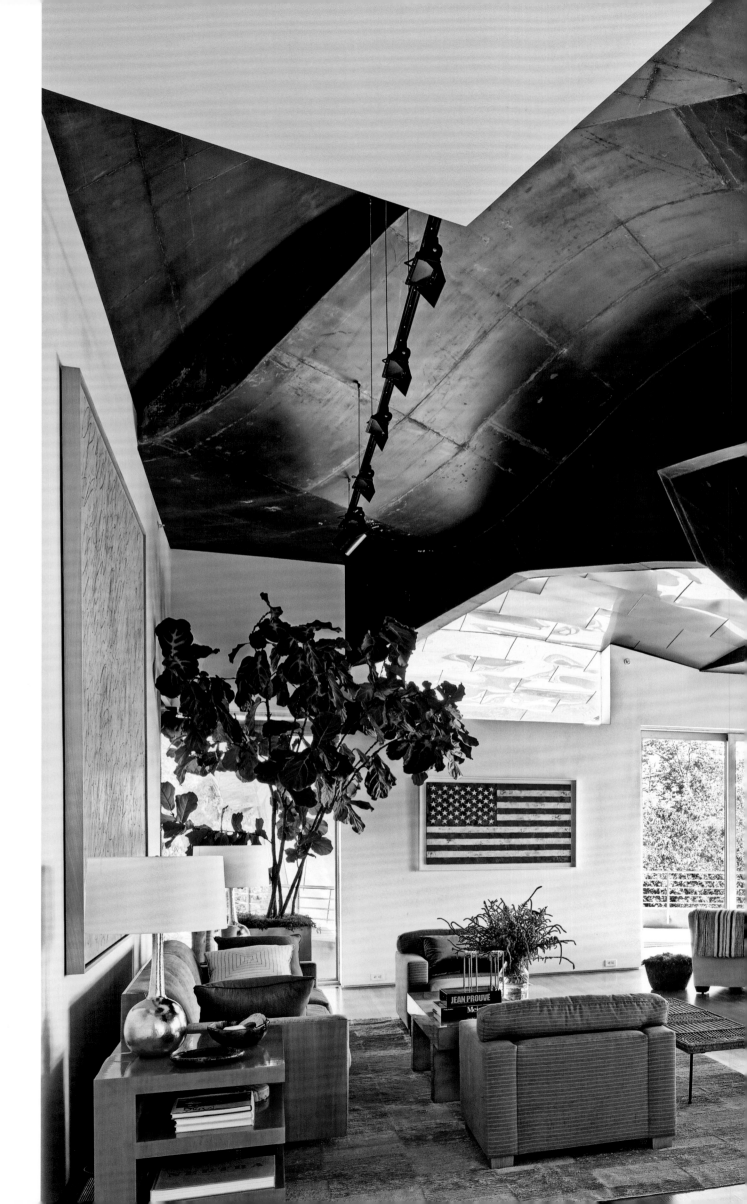

August 2015
Brentwood

HOMEOWNERS
Edythe &
Eli Broad
DESIGNER
Rose Tarlow

A stainless-steel ceiling
crowns the living room
of the philanthropists'
house, built by Langdon
Wilson according to
Frank Gehry's designs.
Tarlow chose furnish-
ings to complement
the couple's legendary
art collection, which
includes works by Jasper
Johns and Alexander
Calder. (Much of it is
now displayed at L.A.'s
Broad museum.) "My
task was to soften the
architectural edges and
keep the house from
feeling like a museum,"
explained Tarlow.

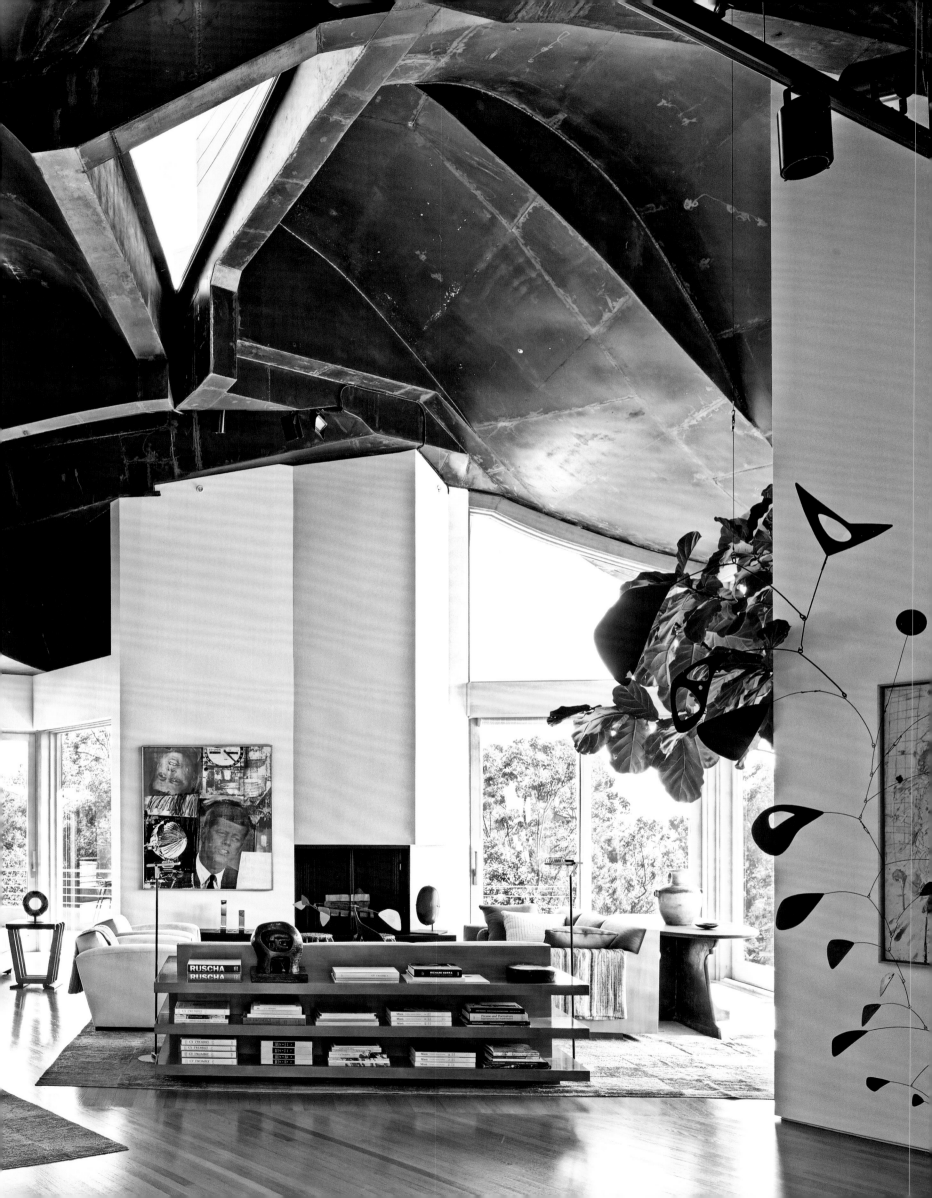

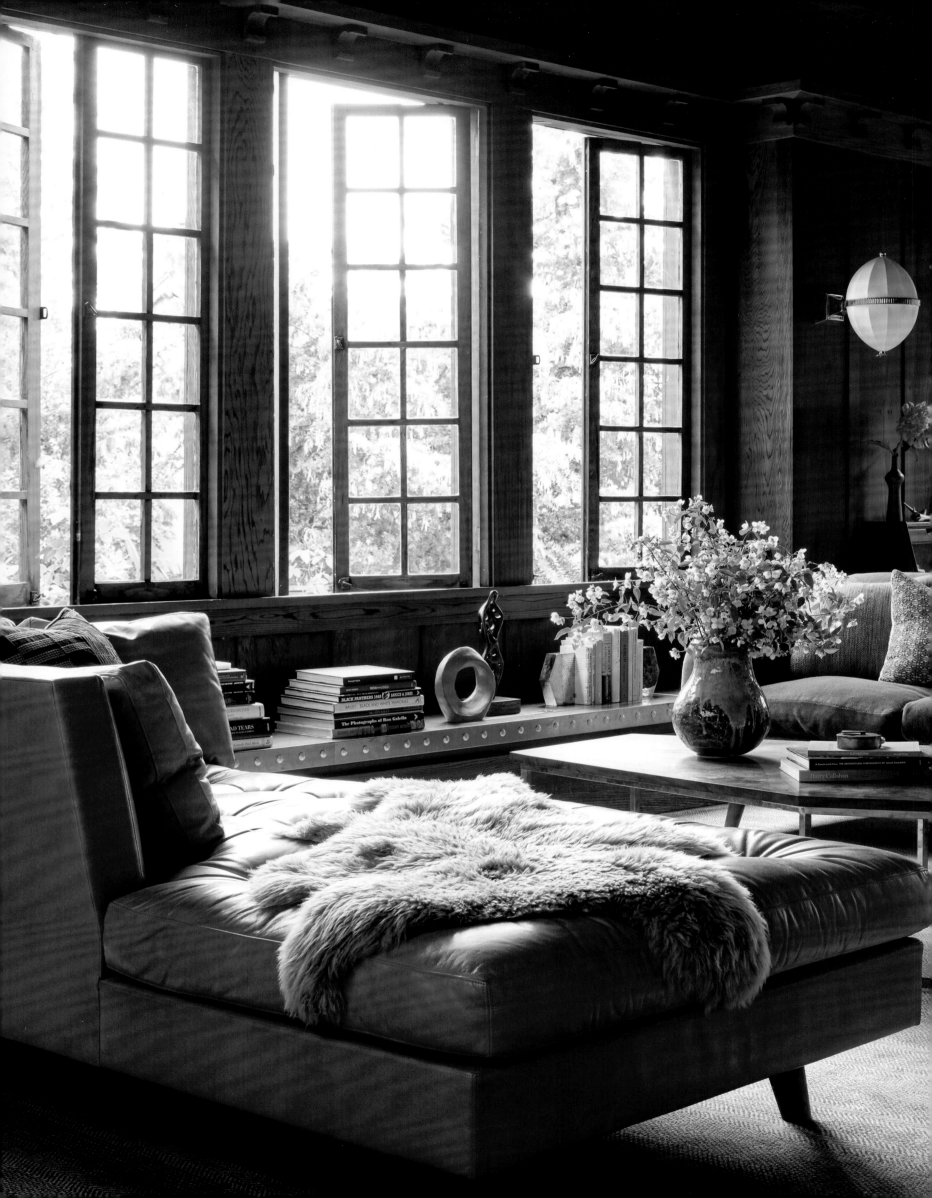

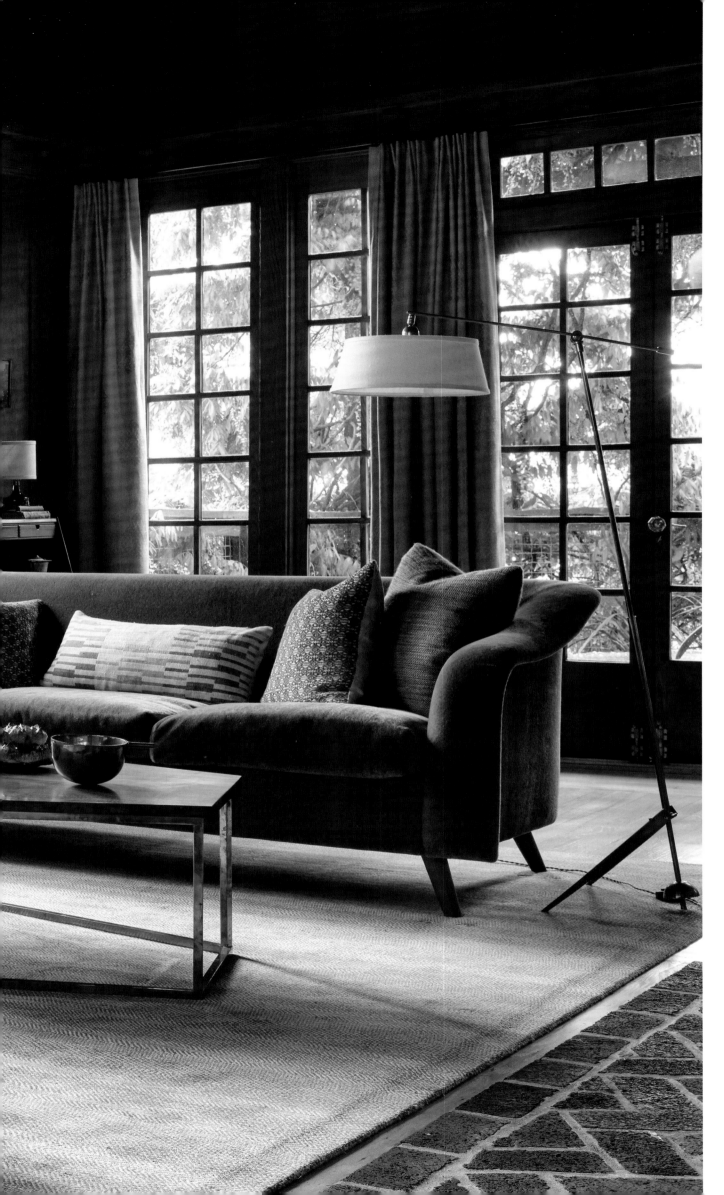

October 2017
Berkeley

DESIGNER
Commune

For a young Manhattan family recently transplanted to Northern California, Commune's Roman Alonso reimagined a 1915 redwood home in Berkeley. Despite the often brooding feel of houses designed in the First Bay Tradition style, Alonso brought light into its rooms and created livable spaces with custom, contemporary, and vintage decor. His touchstones ranged from Wiener Werkstätte to Scandinavian design. "We weren't looking to do an exact reproduction of an Arts and Crafts home, but we still wanted to honor that spirit," said homeowner Pat Kelly.

Volume 7, Number 4 1930 | Calabasas

ARCHITECT Wallace Neff

In the first half of the 20th century, there was no Southern California architect with a client list grander than Neff's. His popular houses for film stars and members of the Hollywood elite were so plentiful that his work became known simply as "California style" architecture. As he once modestly described his fertile oeuvre: "I just build California houses for California people." Set in the Santa Monica Mountains, the 1928 Spanish Colonial Revival ranch he designed for King C. Gillette (of safety-razor renown) remains an emblem of the state's golden age.

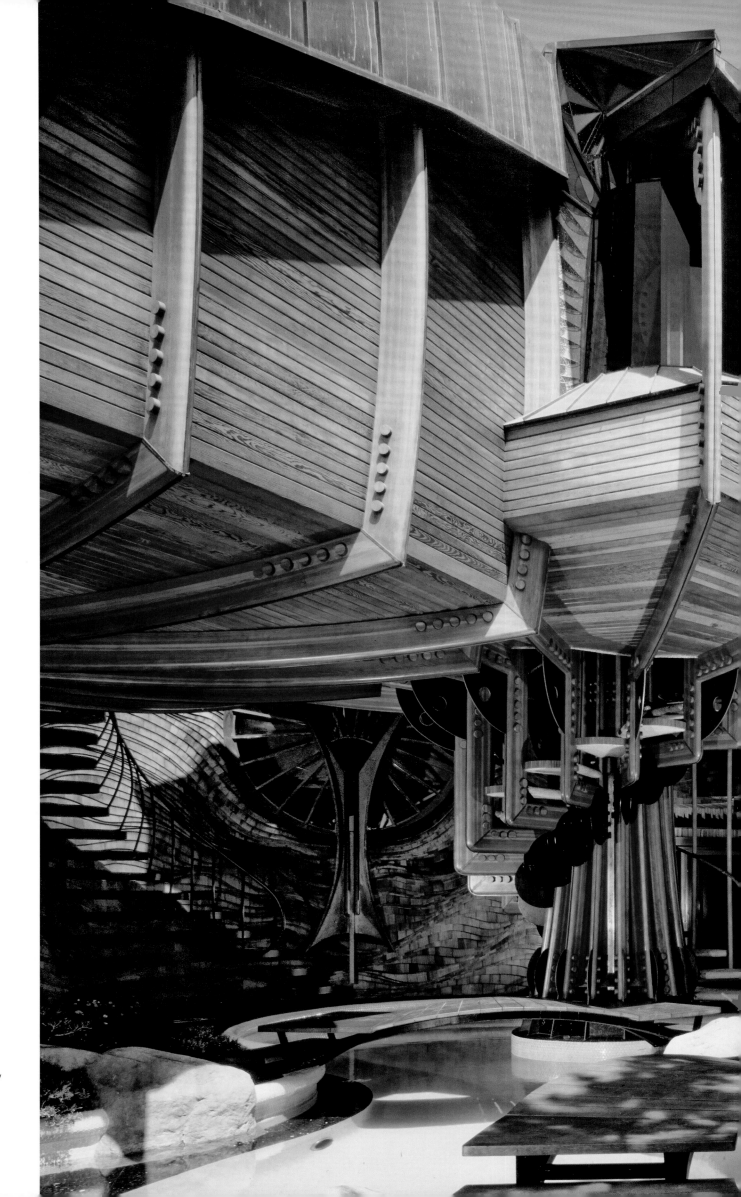

December 1990
Malibu

ARCHITECT
Bart Prince

"My goal was to create an unusual and beautiful solution to the client's requirement, which was actually to create a work of art itself," said the architect of the sculptural beachfront home he designed for collectors Etsuko and Joe Price. Taking cues from modernist architecture and traditional Japanese floor plans, three copper-roofed "pods" surrounded by free-form cedar-shingled walls create indoor-outdoor spaces that are surprisingly private. A courtyard and swimming pool mark the formal entrance.

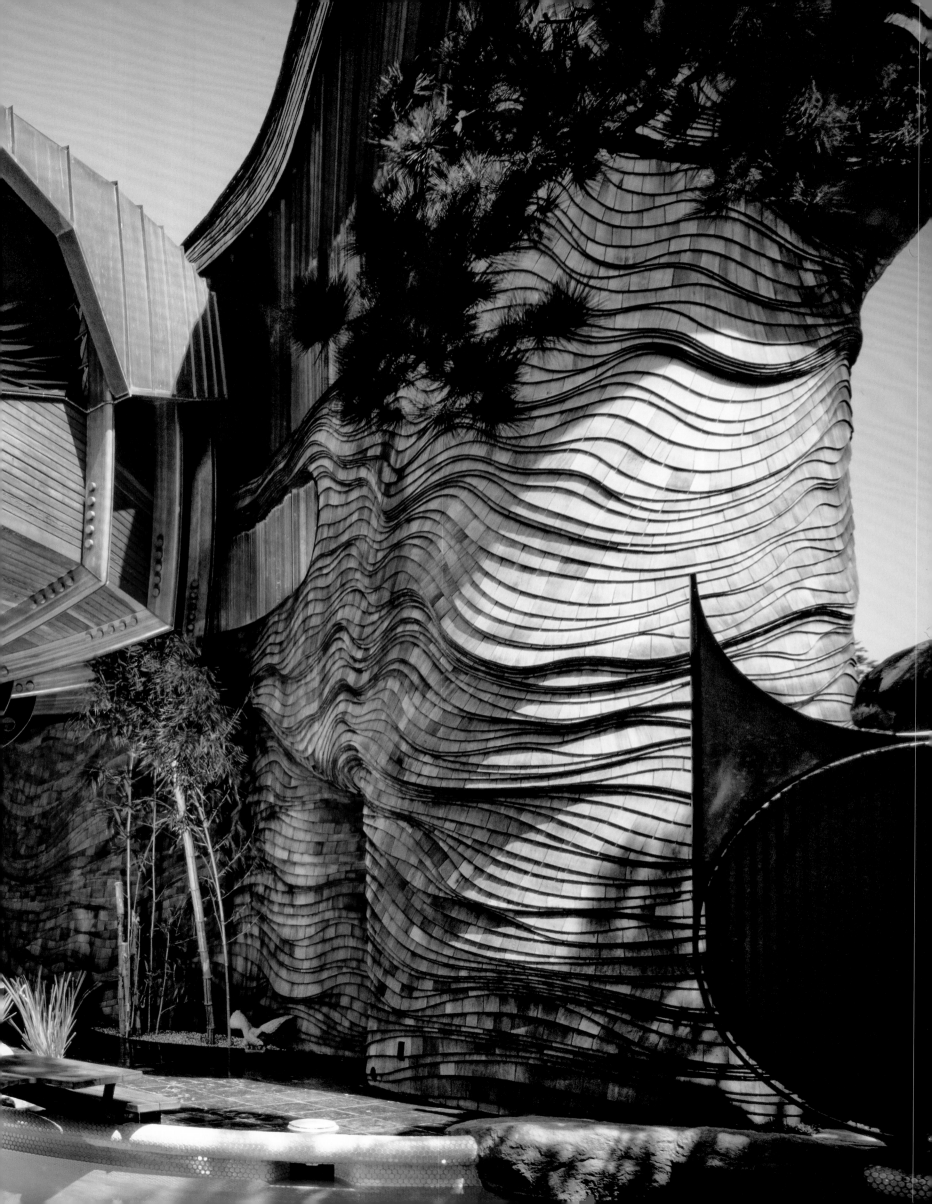

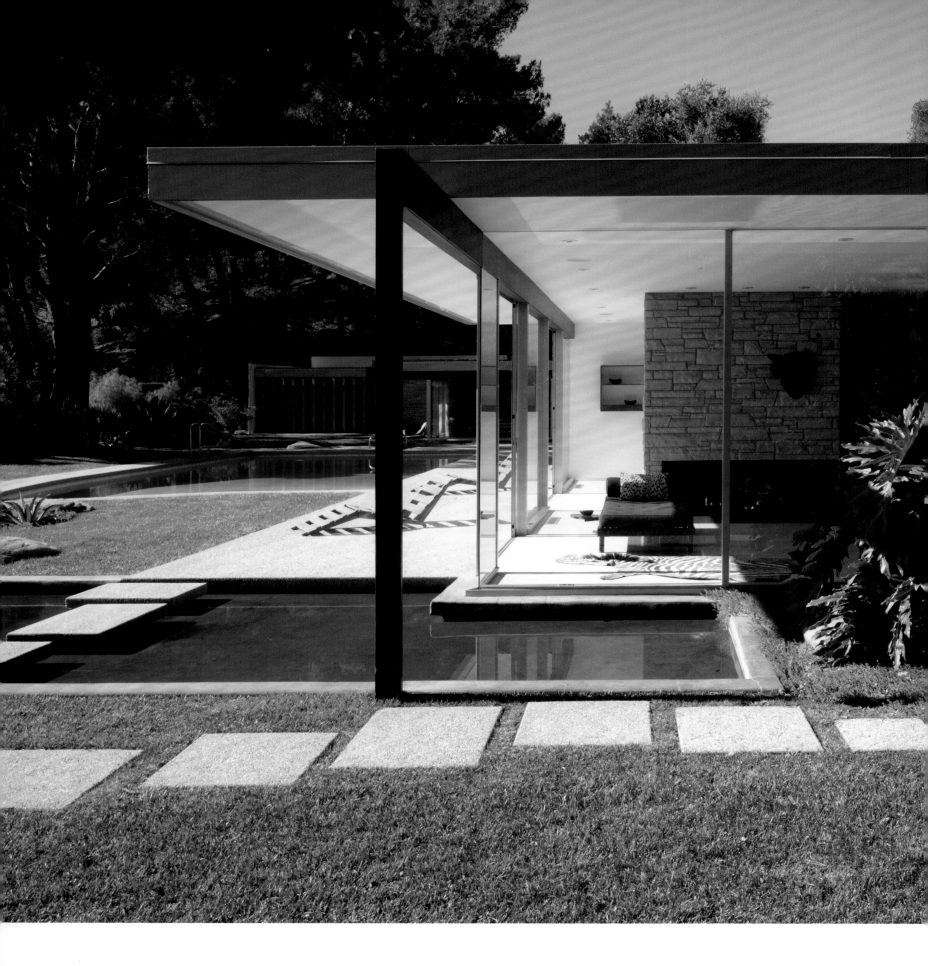

April 2011 | Bel Air

Singleton House
ARCHITECT Richard Neutra

Vidal Sassoon and his wife, Ronnie, knew that renovating Neutra's 1959 icon would be an adventure. But two weeks after the sale, part of the roof collapsed and a chunk of the house slid into a neighbor's yard. Carefully studying the architect's work and poring over period photographs by Julius Shulman led the couple to embark on a complete renovation (and some contemporary reinvention). Designer Martyn Lawrence Bullard consulted on the interiors. "Architects have always been my heroes," declared the legendary hairstylist. "It was total euphoria."

September/October 1972 | Palm Springs

ARCHITECT Lawrence Lapham
DESIGNER Arthur Elrod Associates

For a desert home that felt attuned to its surroundings, a California couple called on Lapham to create a Frank Lloyd Wright–inspired structure in poured concrete with colored marble aggregate. The homeowners wanted the house to "match the mountains," said Lapham, and the interiors were no exception. Stephen Chase of Arthur Elrod Associates evoked Mayan style with bold patterns, colors, and a hint of fantasy—the master bedroom's tree-form four-poster is reflected in a "floating" mirrored ceiling.

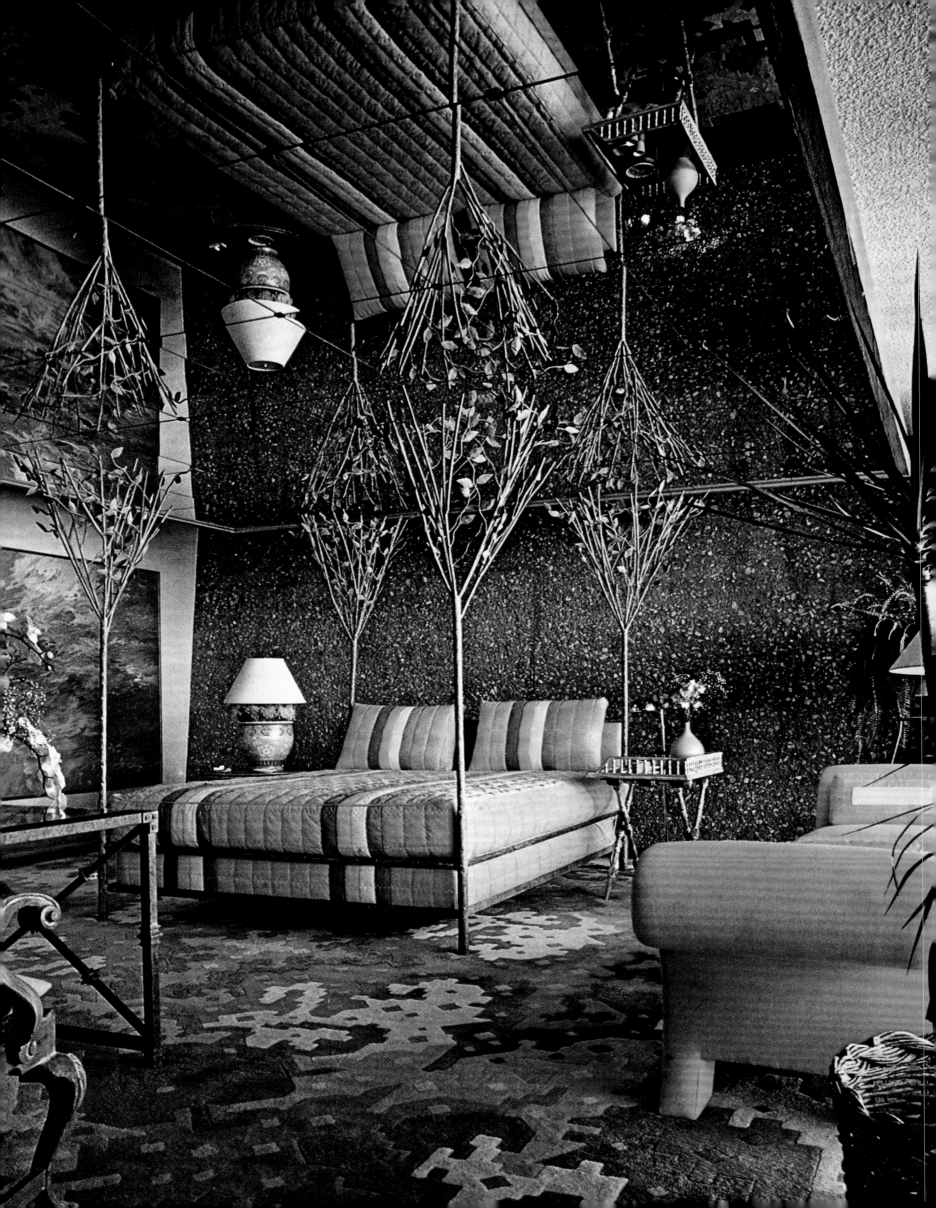

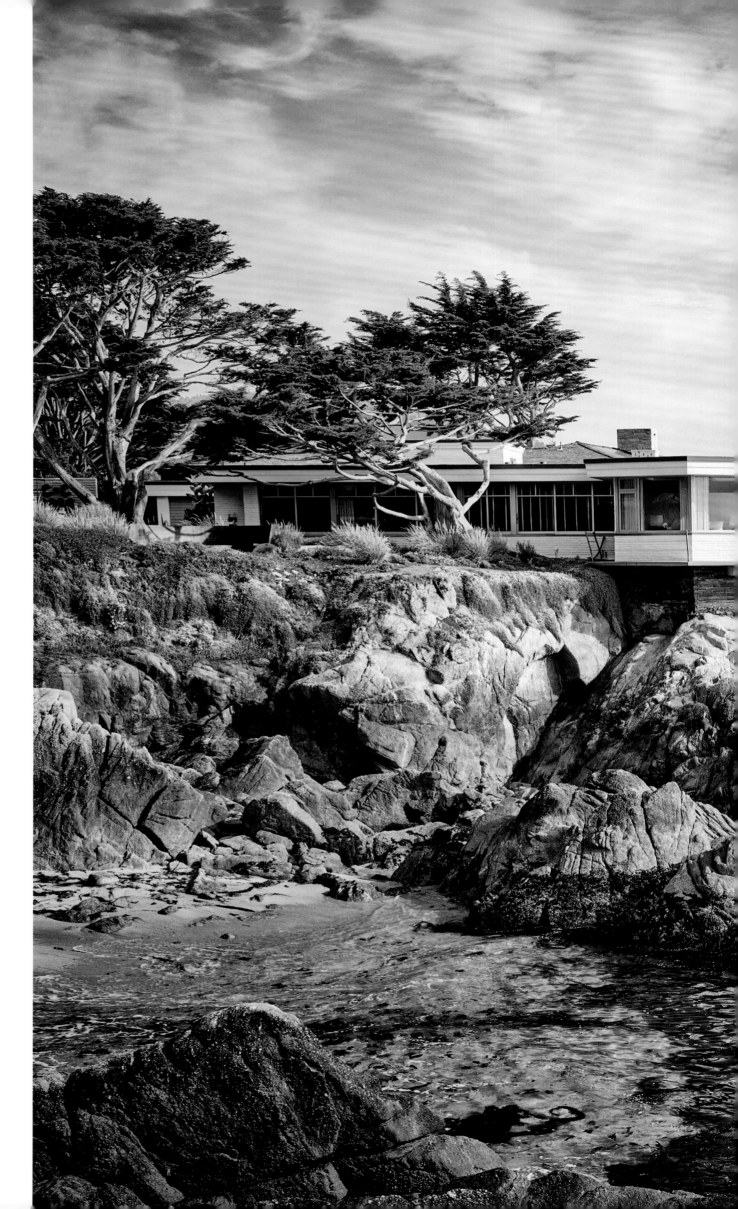

June 2018
Carmel-by-the-Sea

Butterfly House
ARCHITECT
Frank Wynkoop
DESIGNER
Jamie Bush + Co.

Bush updated Wynkoop's 1951 project—set on a dramatic coastal outcropping—into a dazzling home for a young family. "I wanted the interiors to celebrate the irregularities of pattern and texture in nature," said Bush, who deployed materials able to withstand indoor-outdoor use, handcrafted finishes and hardware, and vintage furnishings. "It's a magical house in a magical spot."

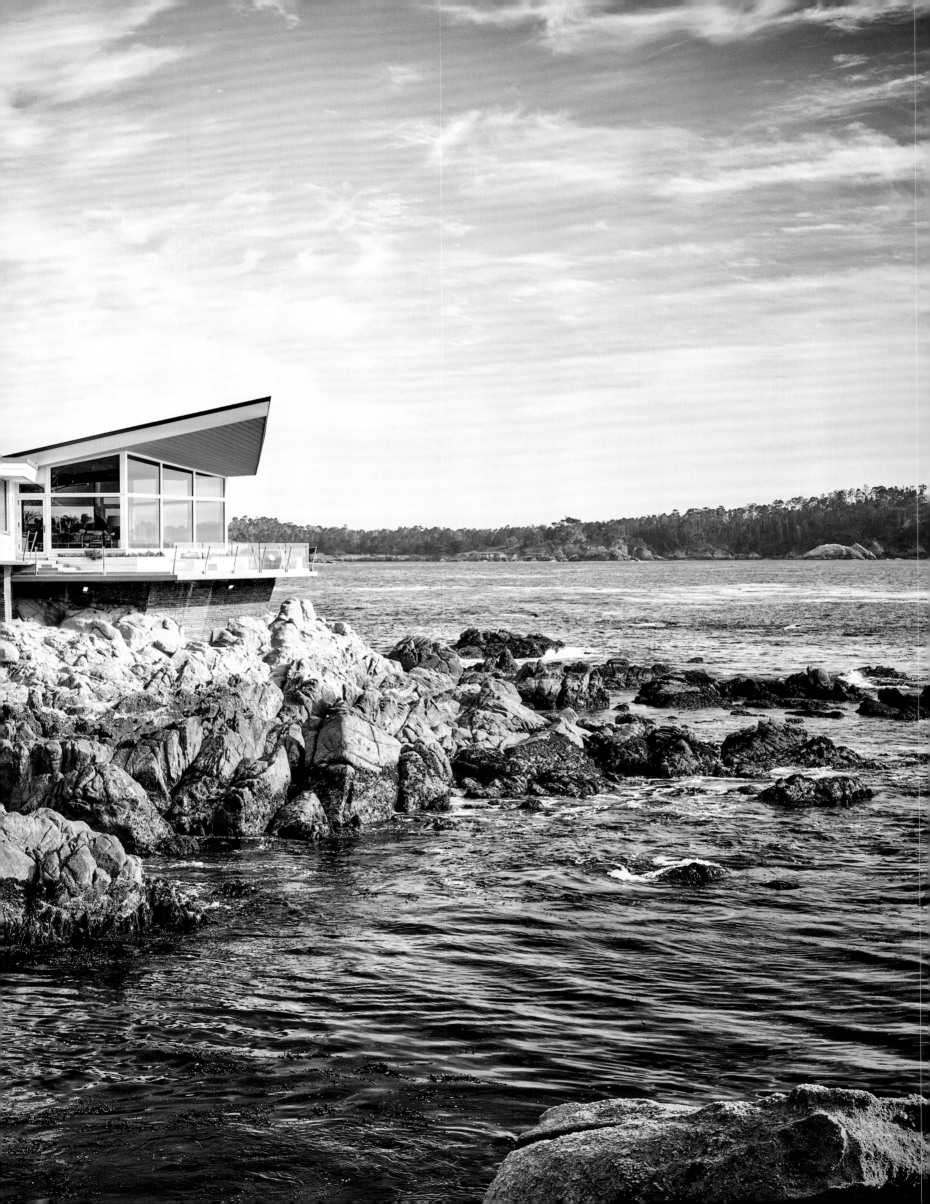

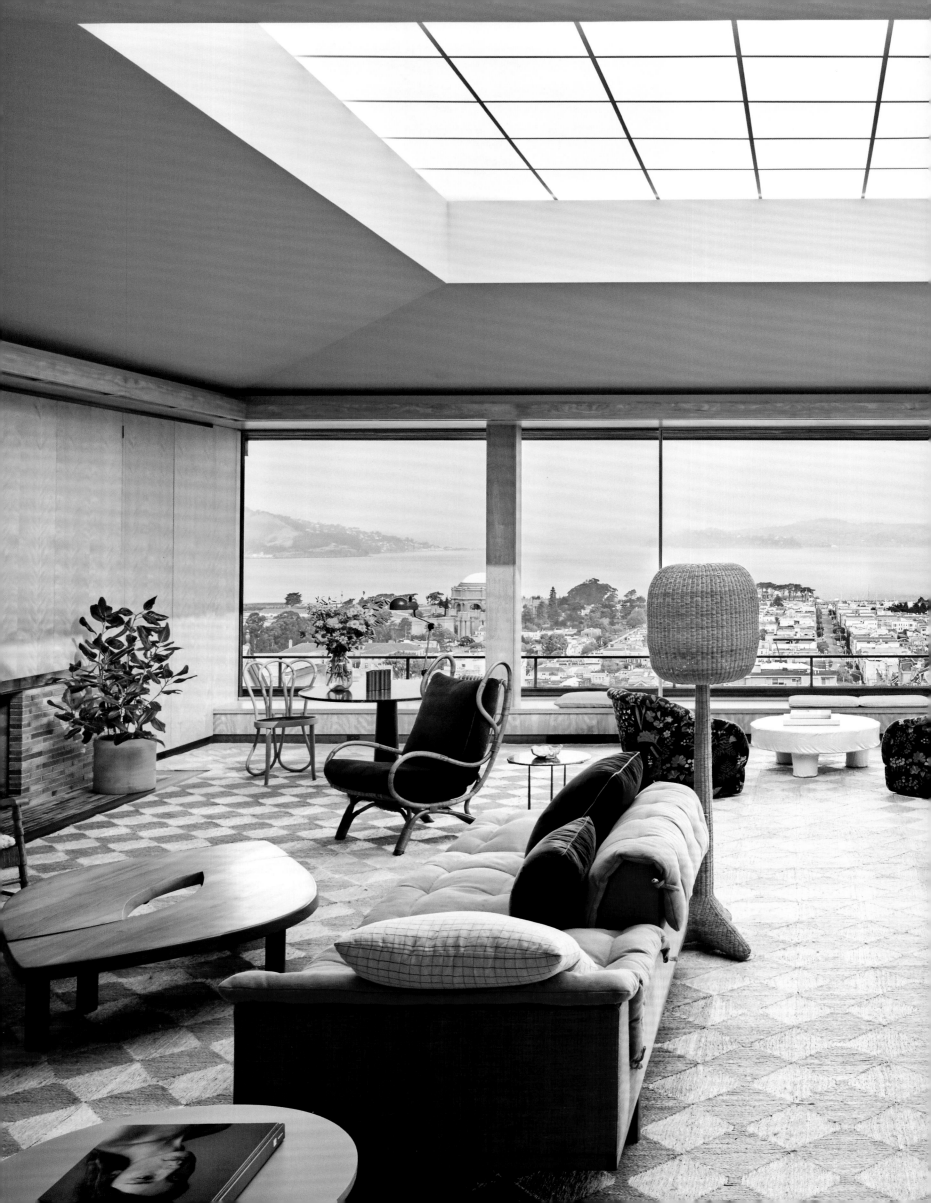

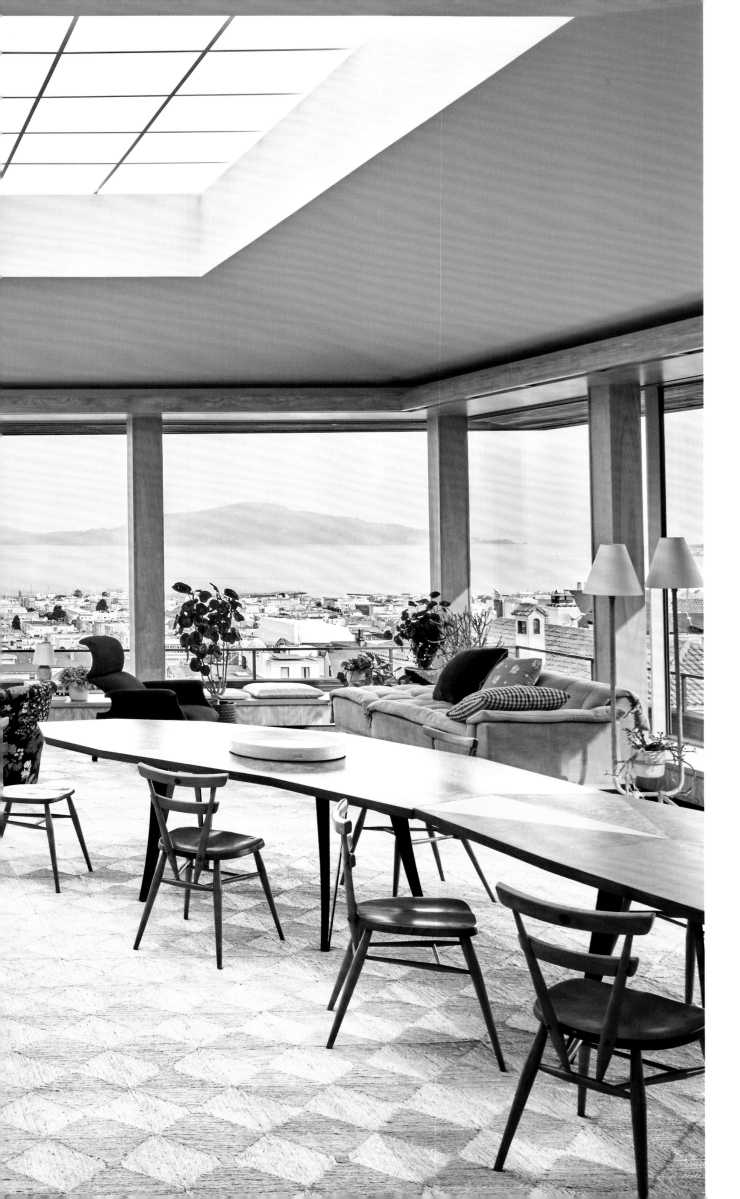

October 2018
San Francisco

ARCHITECT
Marmol Radziner

DESIGNER
Charles de Lisle

Aaron and Jessica Sittig, a young tech couple, set out to renovate a mid-century home overlooking San Francisco Bay and declared that no detail was too small to consider. So they hired Marmol Radziner and de Lisle and got involved in every step of the process. Together the team created rooms full of character that revel in the tension between meticulous restoration and wild decoration. Vintage pieces mix with bespoke furnishings and artisan works. "They approached the design process with a kind of intellectual curiosity beyond compare," said de Lisle of the Sittigs. "They wanted to question everything."

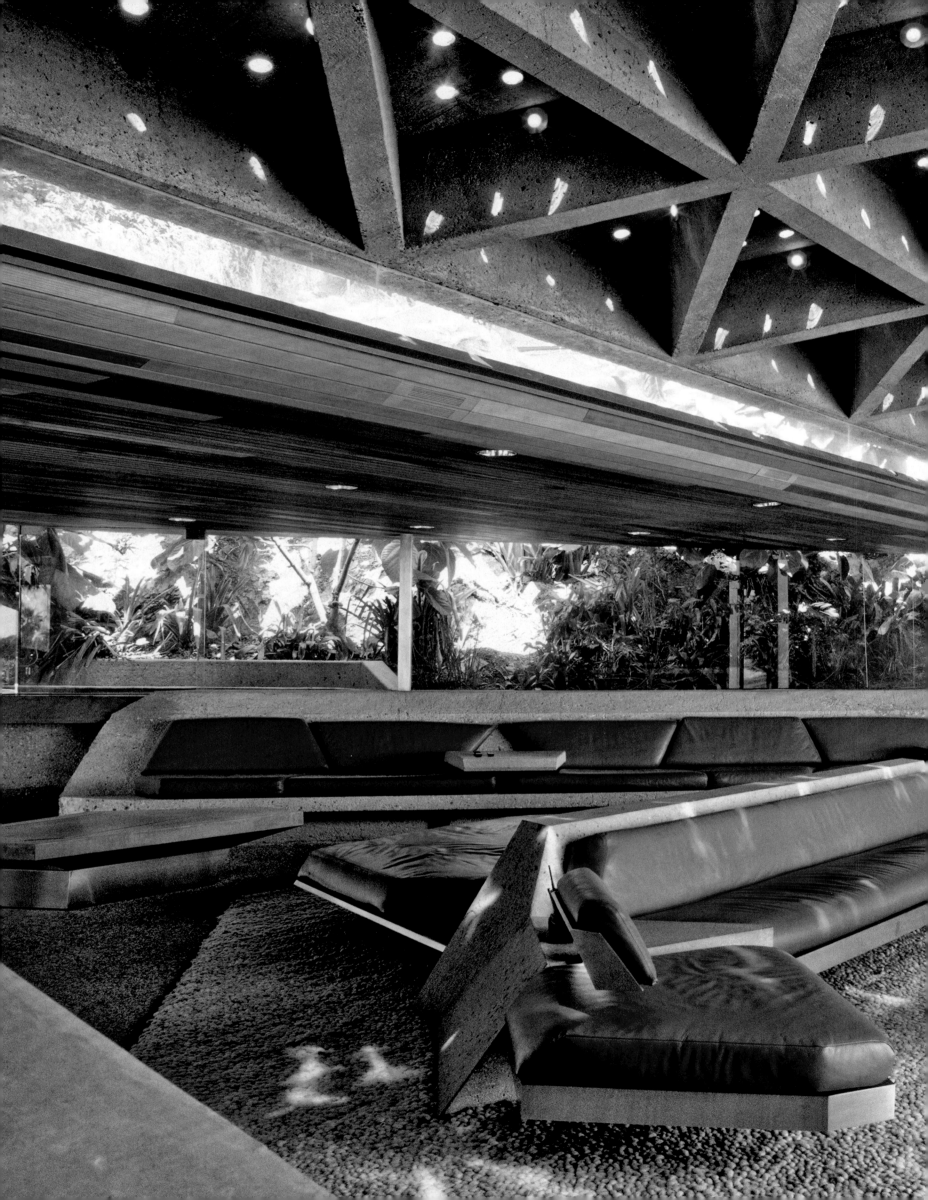

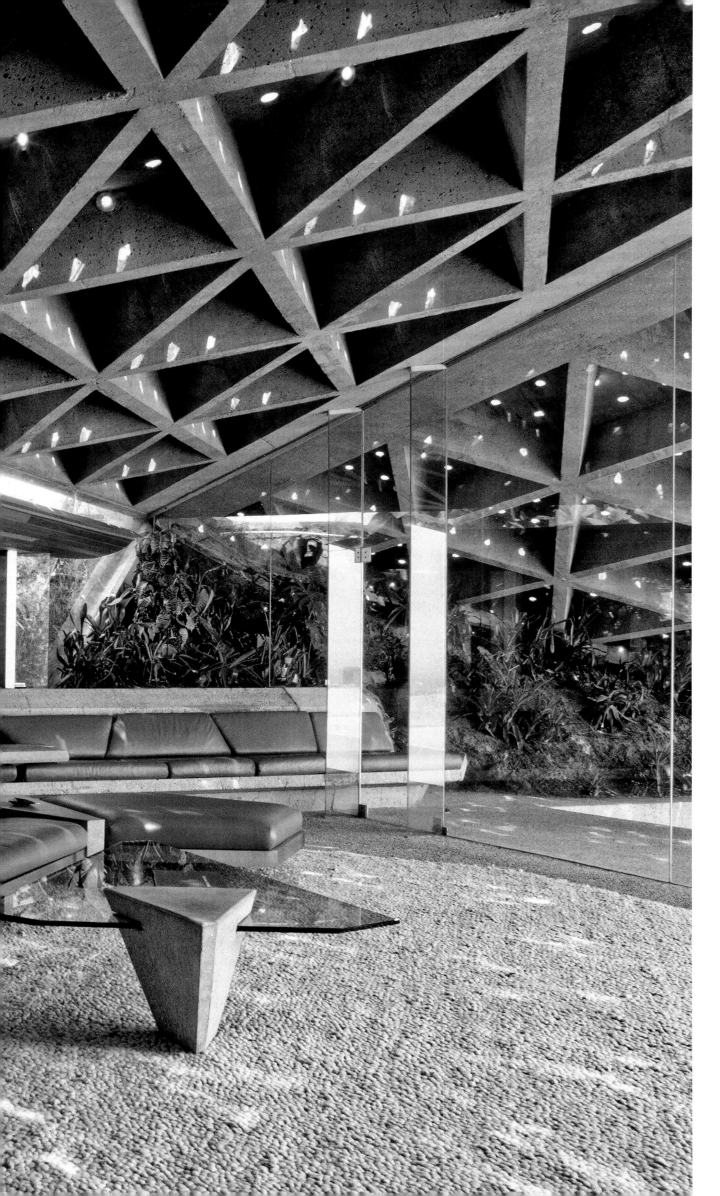

October 1995
Beverly Hills

Sheats—Goldstein Residence

ARCHITECT
John Lautner

"Sensitively conceived and executed, a finely designed and crafted space can be magical," said Lautner, who died in 1994. One of his last projects was an extensive upgrade of the iconic house he had originally designed for Helen and Paul Sheats in 1963. Lautner worked for many years with subsequent owner James Goldstein to implement materials and techniques that had previously been unavailable. In the living room, lighting enhances the form of the sweeping coffered ceiling, a large wool rug is woven to blend in with the concrete-aggregate floor, and Lautner-designed tables and seating extend the theme of angularity.

January 2018
Los Angeles

DESIGNER
Kelly
Wearstler

It was a pairing ripe for
experimentation when a
color-loving couple turned
to Wearstler to decorate
their home. Comedian
Sebastian Maniscalco and
artist Lana Gomez (who
had previously worked for
Wearstler as a painter)
called for a warm, family-
friendly retreat with
a bit of pizzazz. "This
is definitely one of my
most playful projects,"
admitted the designer,
who set modern and
postmodern collectibles
in conversation with
one-of-a-kind commis-
sions by emerging talents,
and a hypnotic dining
table of her own creation.

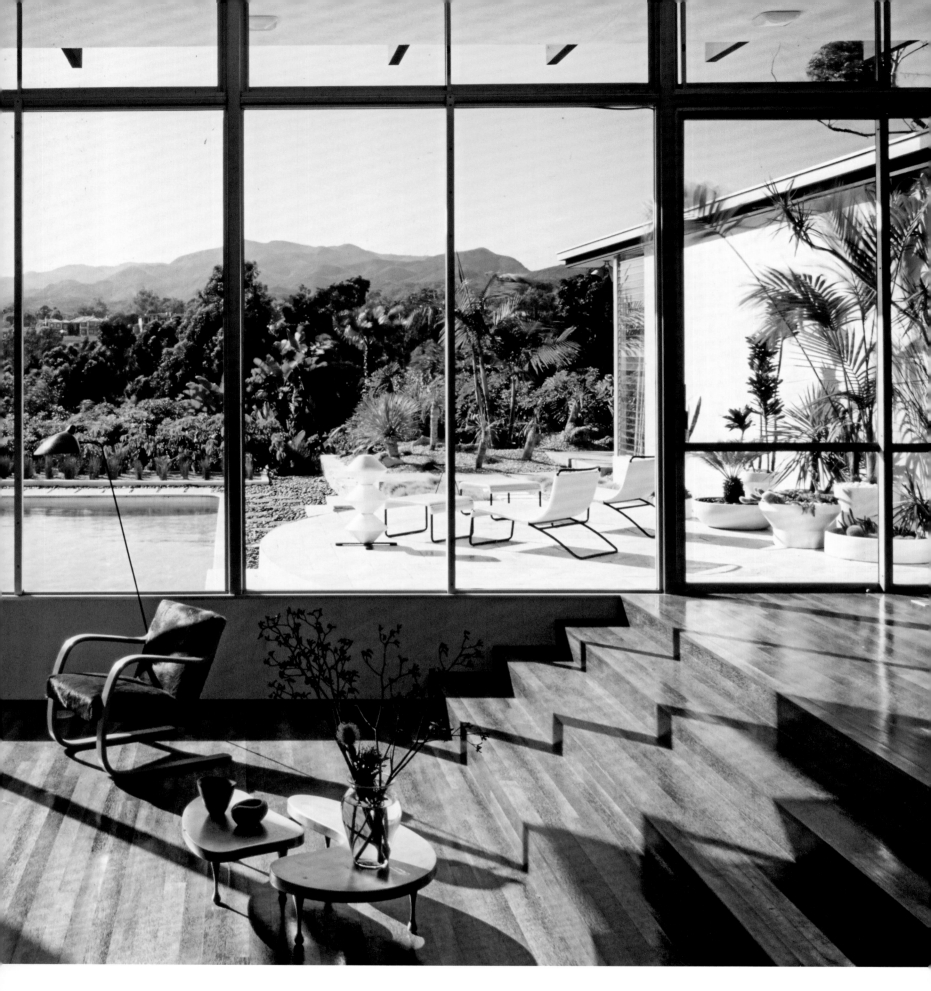

May 2005 | Santa Monica

Strick House ARCHITECT Oscar Niemeyer

Once midcentury modern–furniture collectors Gabrielle and Michael Boyd caught wind of a plan to raze Strick House, Brazilian modernist Niemeyer's only residential structure in the United States, they raced to buy it, restore it, and make the 1963 indoor-outdoor structure their own. "Essentially, we've been on a quest," said Gabrielle. "We've wanted to live in an environment that's a comprehensive, avant-garde whole, from the furniture to the house. It's all art to us."

April 2011 | Malibu

HOMEOWNER/DESIGNER Richard Shapiro

Designer and antiques dealer Shapiro stumbled upon an abandoned surf shack on Malibu's Broad Beach and found "love at first sight." Envisioning a home like a "windswept structure from the Mediterranean," he called upon architect Douglas Burdge to help construct what he lovingly calls a "folly," with a feeling that straddles the line between ancient refectory, Renaissance chapel, and modern loft. Frescoed plaster covers the walls, a sculptural steel staircase leads to the second floor, and double-height windows evoke classic California modernism.

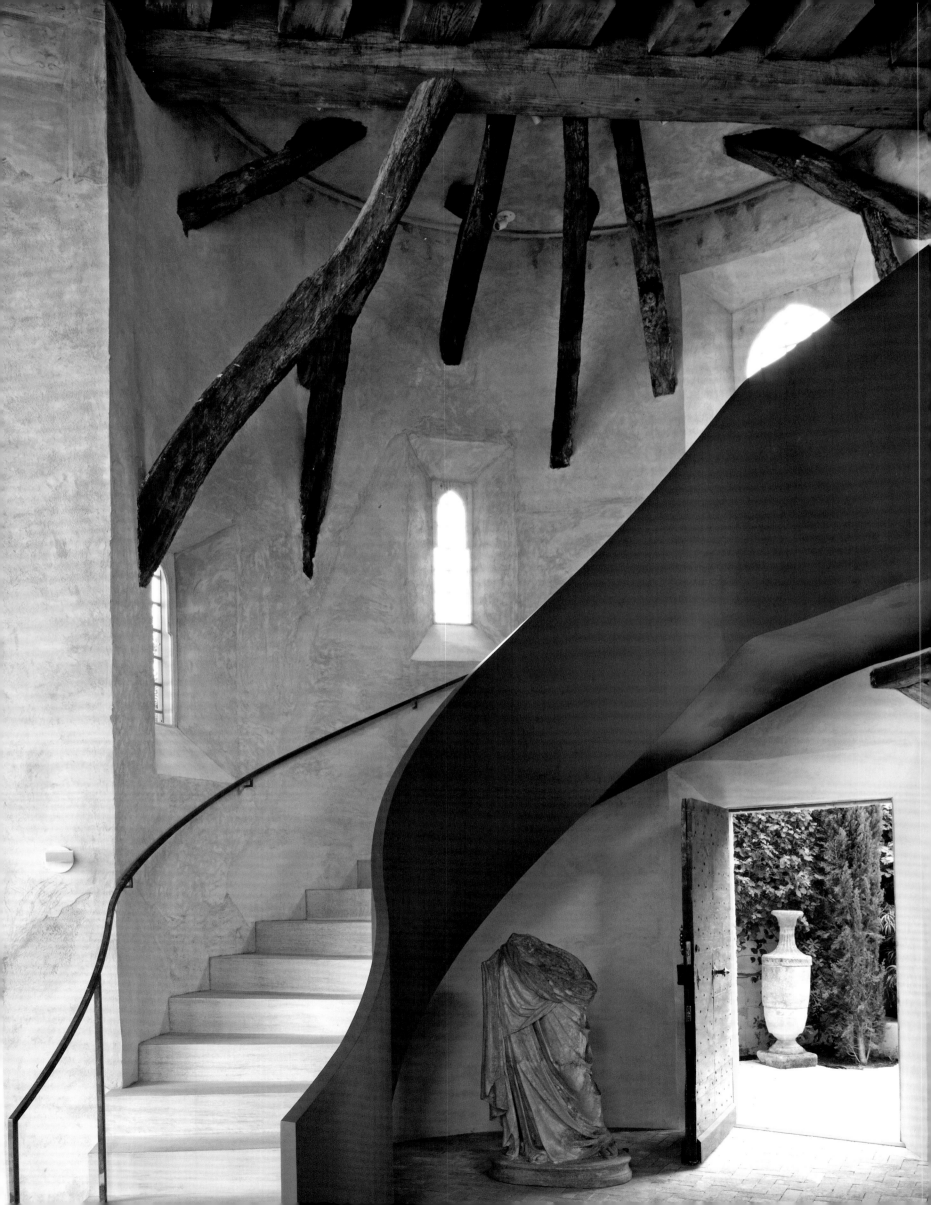

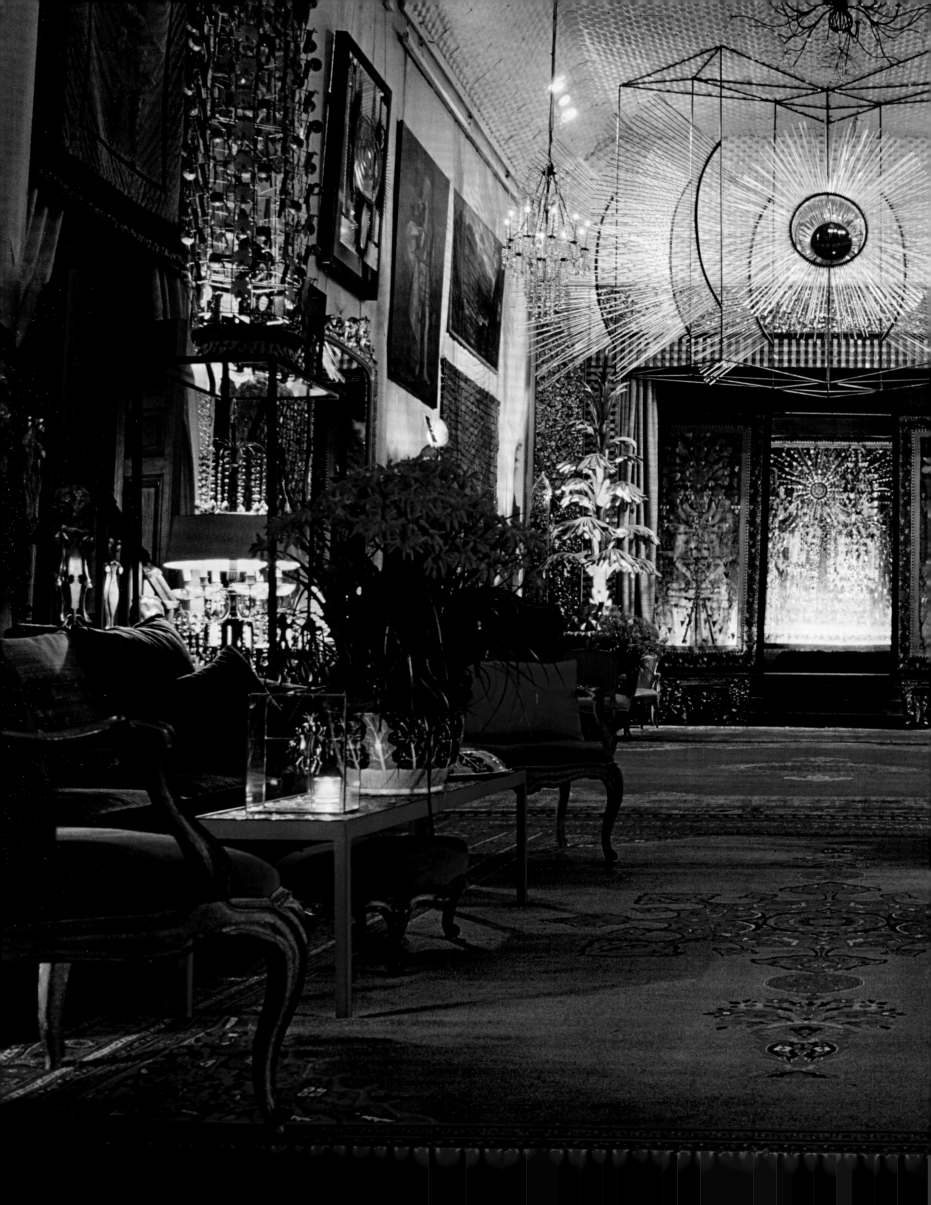

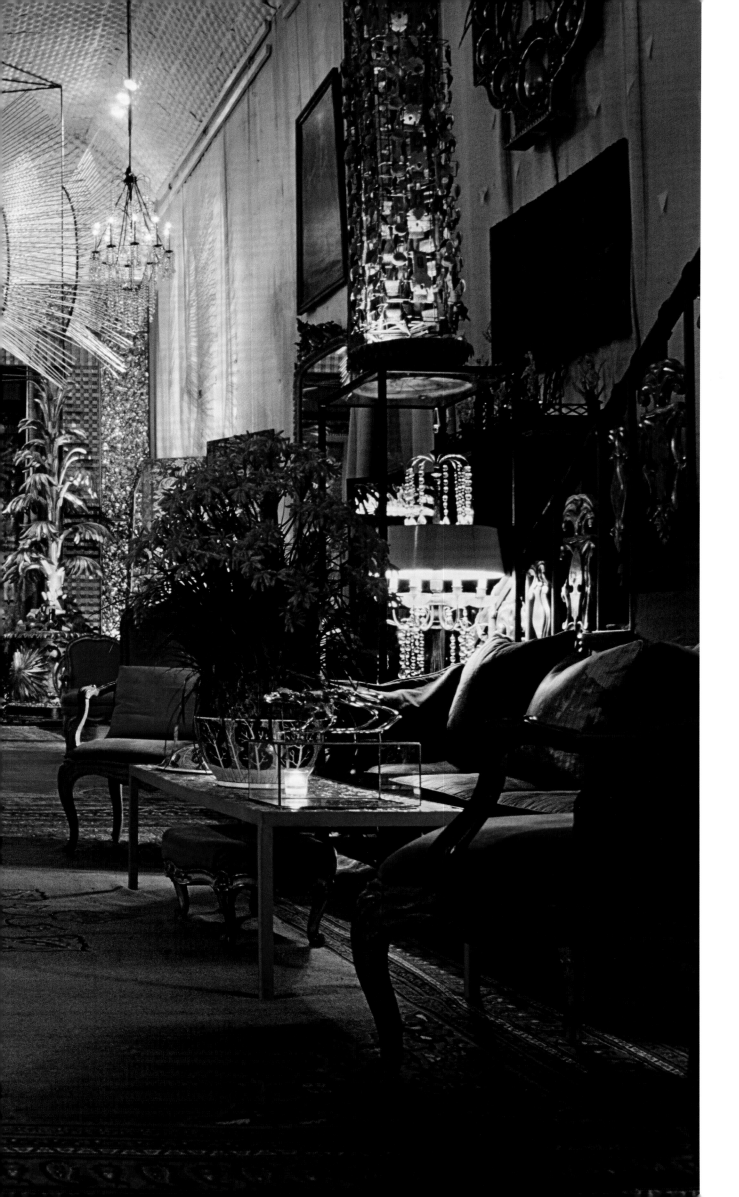

March 1978
Beverly Hills

HOMEOWNER/DESIGNER
Tony Duquette

Duquette's theatrical vision is on full display in the salon of the legendary studio/house he shared with his artist wife, Elizabeth Johnstone. Looking toward the stage, a model for his *Primal Sun* sculpture hangs from a textured ceiling created with egg cartons. "I love gold and rich fabrics but, like the Greek peasant who cannot gild his icon and so makes an exquisite one out of gold paper, I work equally with burlap and velvet," said Duquette. "Beauty, not luxury, is what I value."

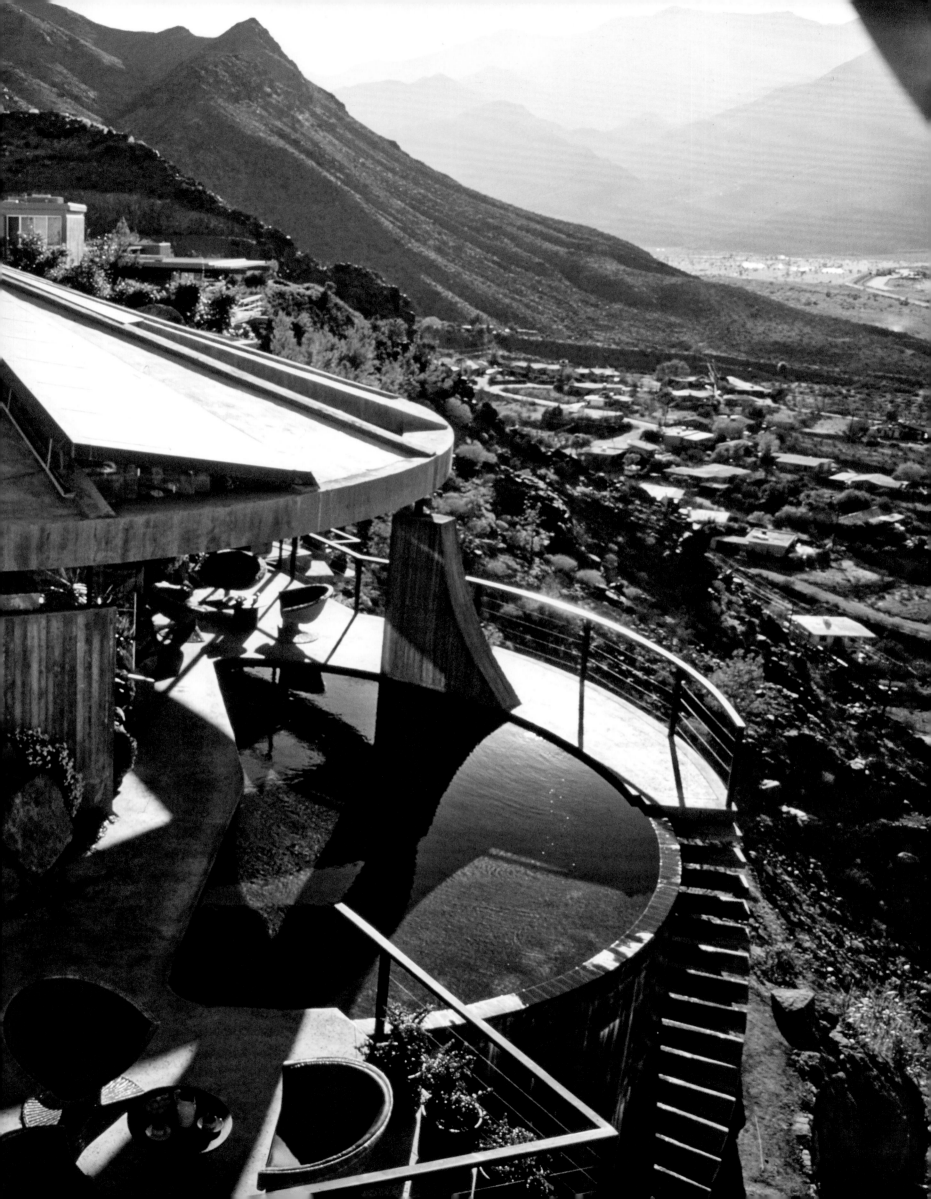

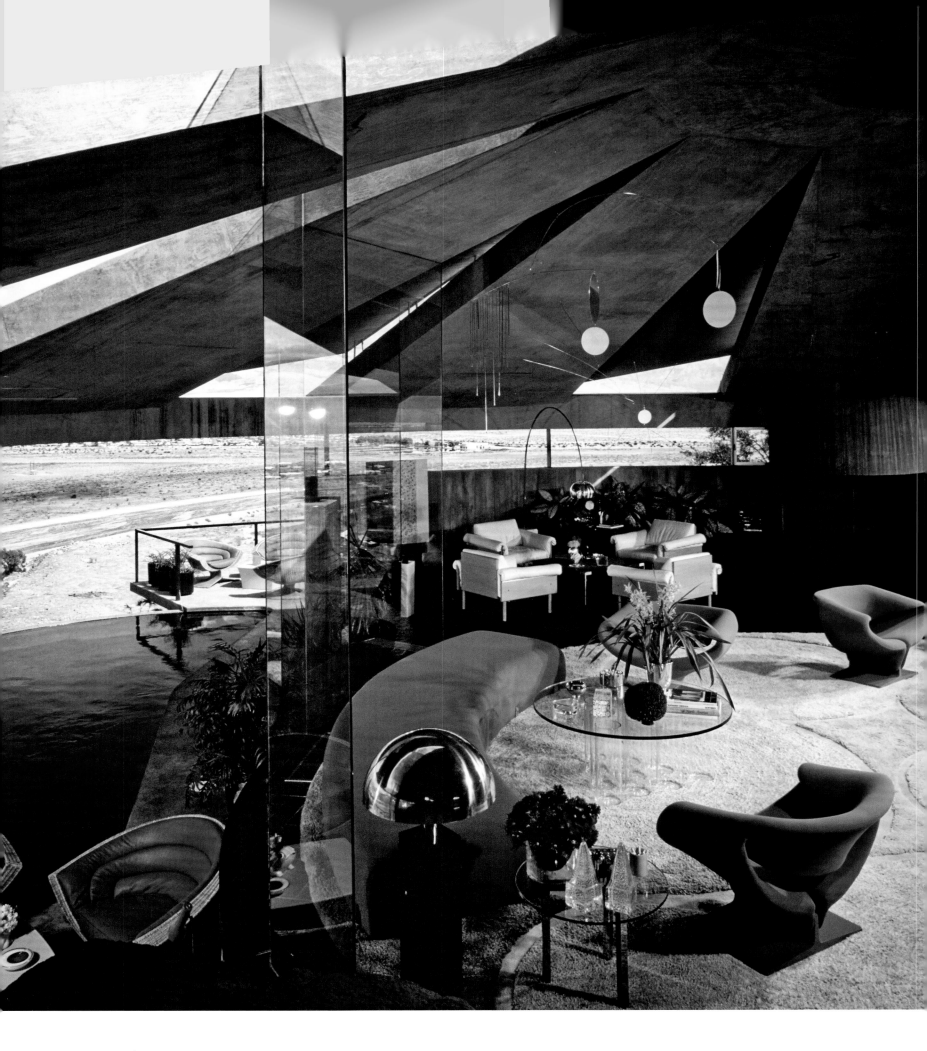

Spring 1970 | Palm Springs

Elrod House HOMEOWNER/DESIGNER Arthur Elrod ARCHITECT John Lautner

For Elrod's own home overlooking the Sonoran Desert, Lautner all but moved a mountain, creating a 60-foot-diameter concrete canopy seemingly carved from the rocky elevation. Elrod filled the home with similarly dramatic, sculptural furniture, including signature Pierre Paulin lounge chairs.

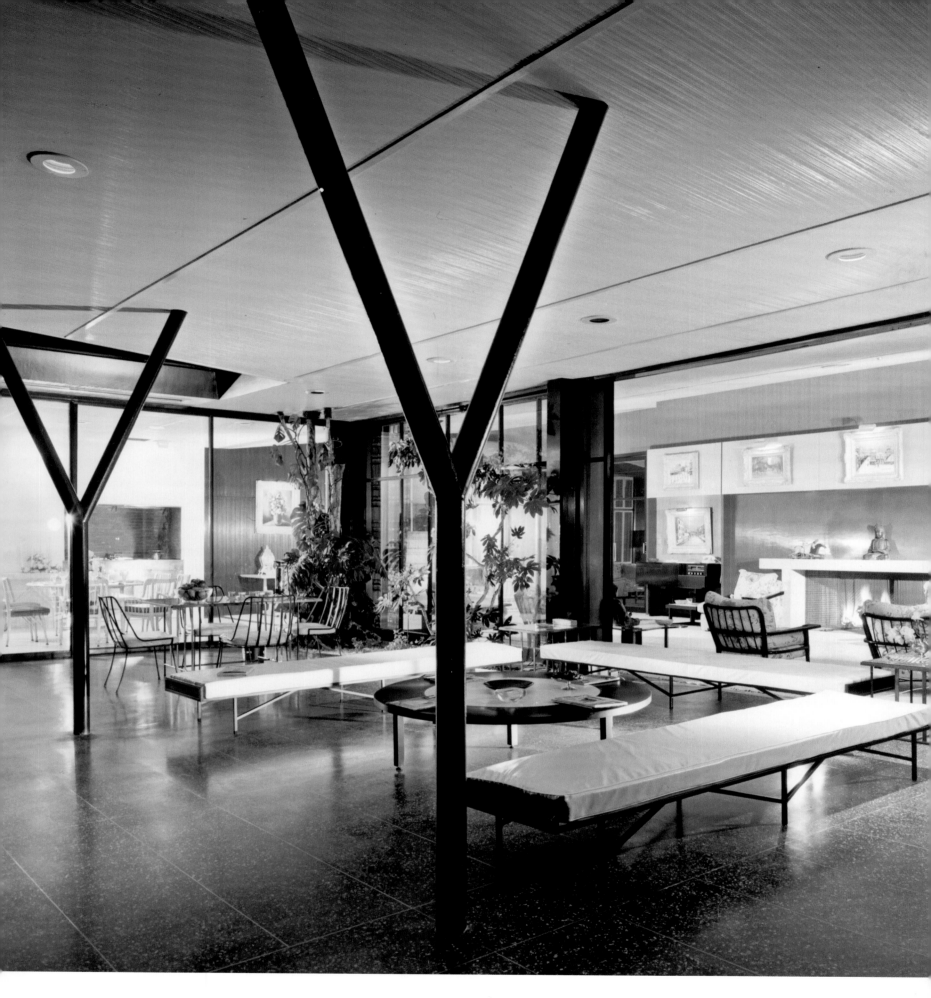

Volume 15, Number 4 1958 | Brentwood

HOMEOWNER/ARCHITECT Paul László

As with all of his projects, Hungarian-born László—architect to many California stars—approached the Brentwood house that he shared with his wife, actress Maxine Fife, as a total work of art. Every facet of the project was given meticulous attention. In addition to the architecture, he designed the fabrics, fixtures, furniture, and lighting. As László once said, "Each work is important. Each work deserved respect."

August 1995 | Venice

HOMEOWNER Perry Farrell ARCHITECT Steven Ehrlich

"The design is my response to who Perry is," said Ehrlich of the home he created for Farrell, best known as the front man for the alternative-rock band Jane's Addiction. Ehrlich turned a classic beach cottage on its head, creating a cubistic composition of wood, stucco, and glass, as well as a barrel-vaulted structure that houses the living-dining room and a lofted sleeping area. The results, Farrell declared, are "subtle and graceful, and the lines are good."

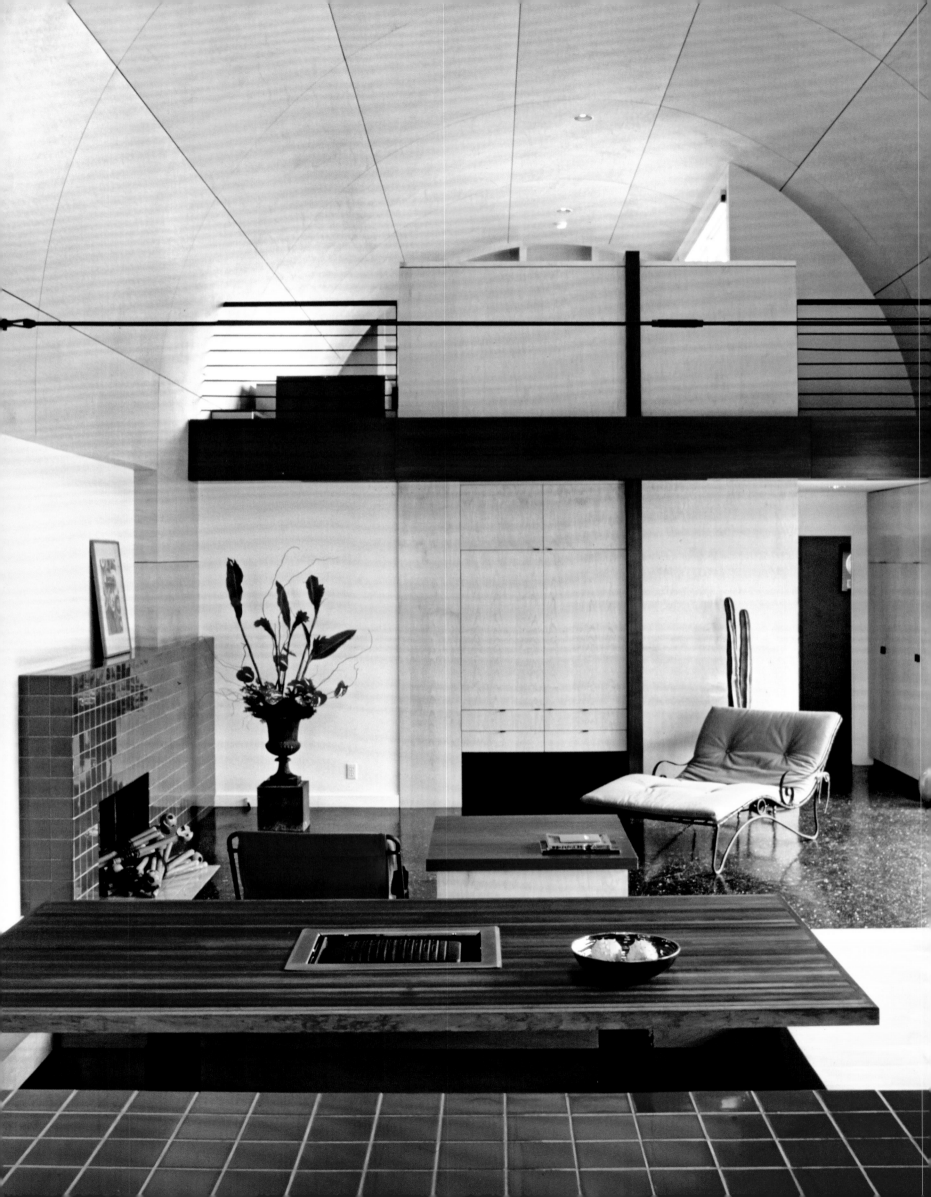

July 2016
Malibu

ARCHITECT
John Lautner
DESIGNER
Waldo's Designs

For business dynamo
Jamie D. McCourt, Waldo
Fernandez and Kovac
Design Studio collabo-
rated on the renovation
of a 1980 Lautner beach
house. Under a copper-
topped roof that sweeps
from the sculptural fire-
place across the living
room, Fernandez arranged
Charlotte Perriand cocktail
tables, Oscar Niemeyer
ottomans, and a Jean
Royère sofa and club chair.
"A house like this is very
specific, so you need to be
careful with the moves
you make," said Fernandez.

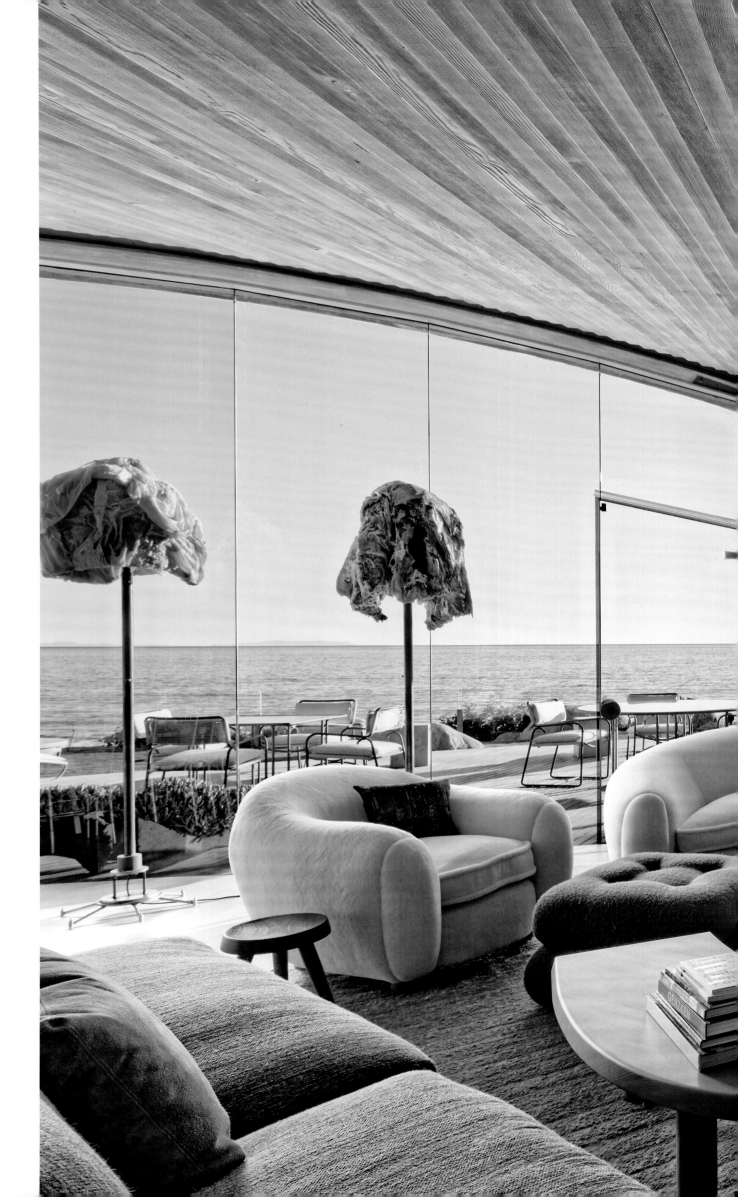

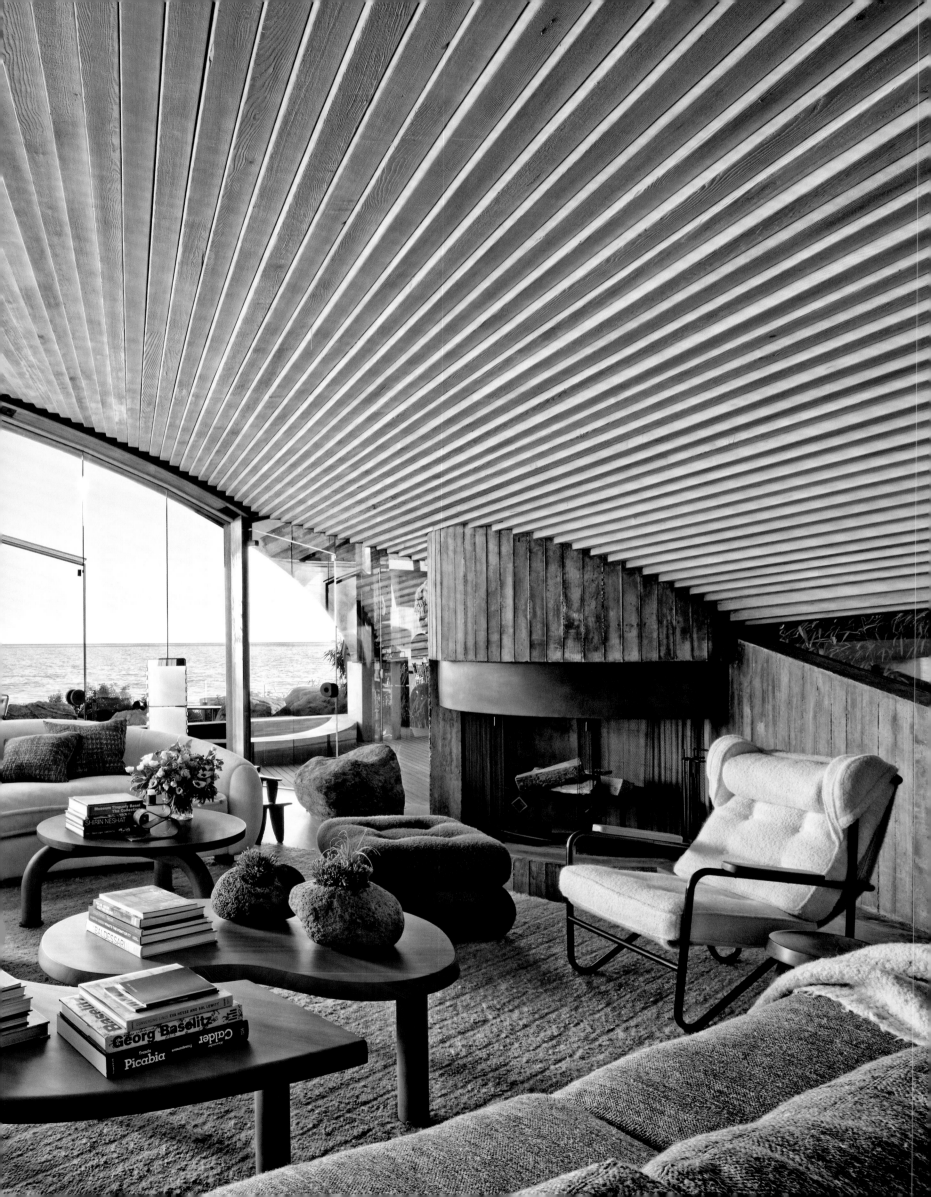

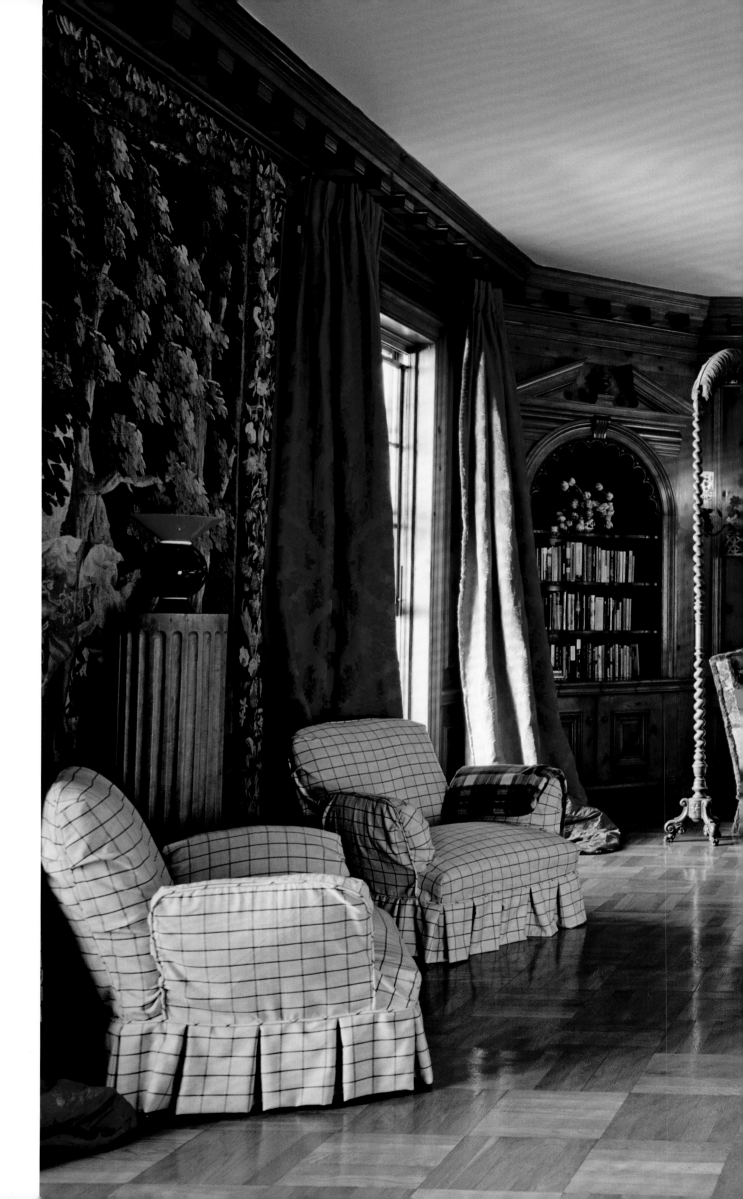

September 2016
Hollywood

HOMEOWNER
Matthias Vriens-McGrath

In the onetime home
of William Haines—the
leading tastemaker
of Hollywood's Golden
Age—antiques dealer and
photographer Vriens-
McGrath and his husband,
Donovan, created their
own vision of contempo-
rary chic. Leaving Haines's
knotty-pine paneling and
moldings intact, Vriens-
McGrath filled the space
with treasures spanning
centuries, from an
18th-century silk bedcover
to his own contemporary
photographs. He said
of his approach to decor:
"I don't care how many
exquisite objects you put
in a room—if it's not warm
and comfortable, no one
wants to be there."

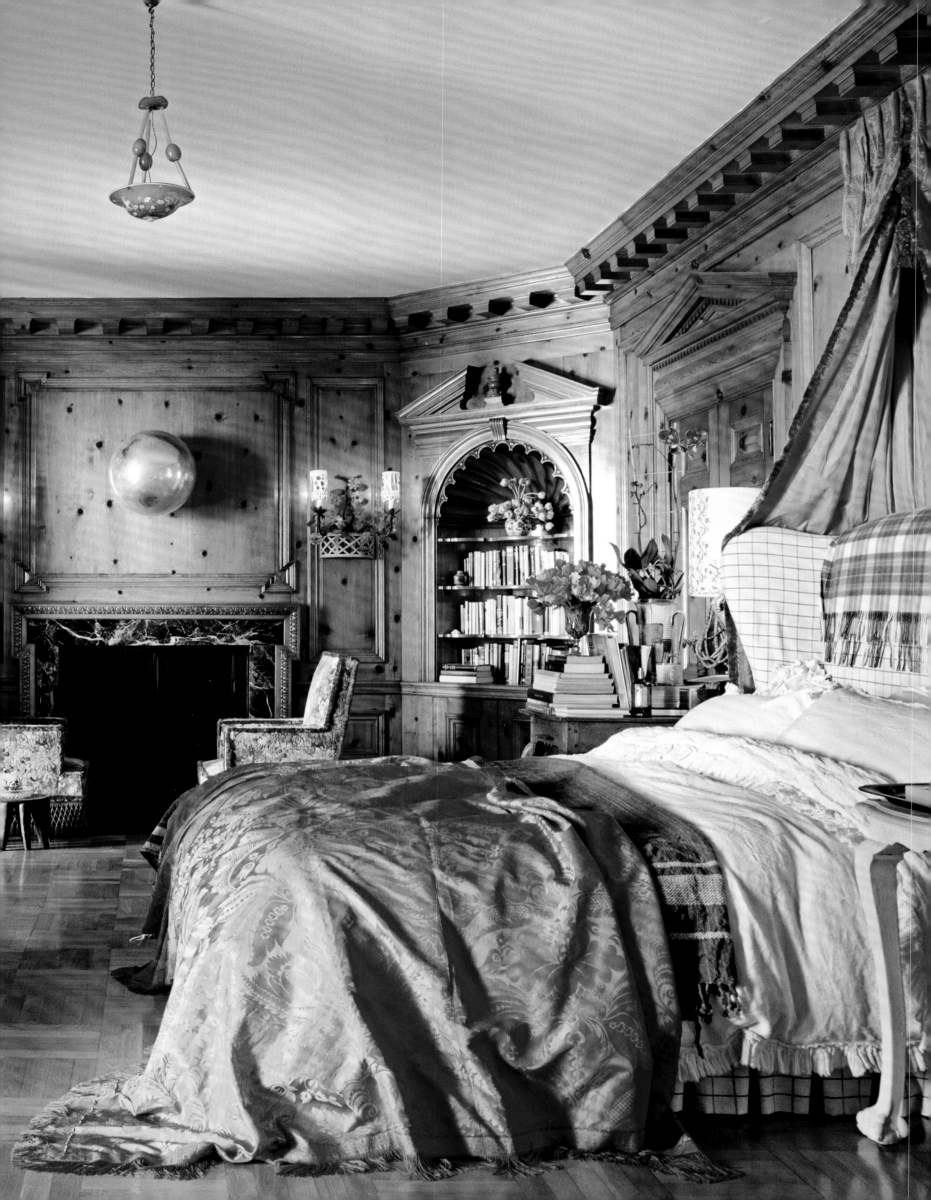

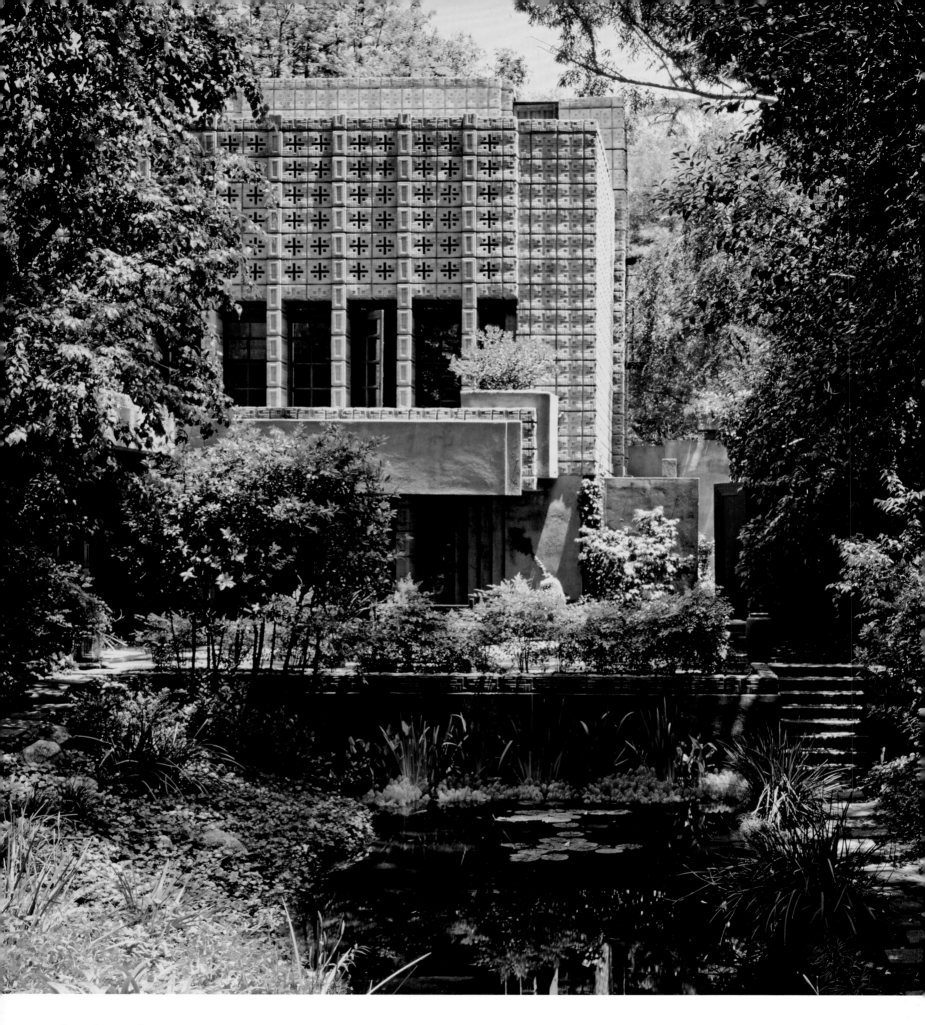

December 1994 | Pasadena

La Miniatura ARCHITECT Frank Lloyd Wright

The 1923 textile-block house reveals concrete's "hitherto unsuspected soul," said Wright, who designed the home for rare-book dealer Alice Millard. On a naturally jungle-like site, the exuberant façade rises like an exotic temple. "I would rather have built this little house than St. Peter's in Rome," the architect once declared. Decorator Annie Kelly, who worked on the restoration of the landmark property, called the house "Wright's little gem."

July 1988
Malibu

HOMEOWNER
David Geffen

The Hollywood mega-producer had lived in his Malibu retreat for 13 years before he brought in Michael Taylor to help give the getaway a distinctive sense of place. The two drew up plans for a simple, tranquil home, where nothing would distract from the sea or the art, including David Hockney's iconic *Portrait of an Artist (Pool with Two Figures)*. Before the plans could be set in motion, however, Taylor died, and designer John Cottrell realized the dream.

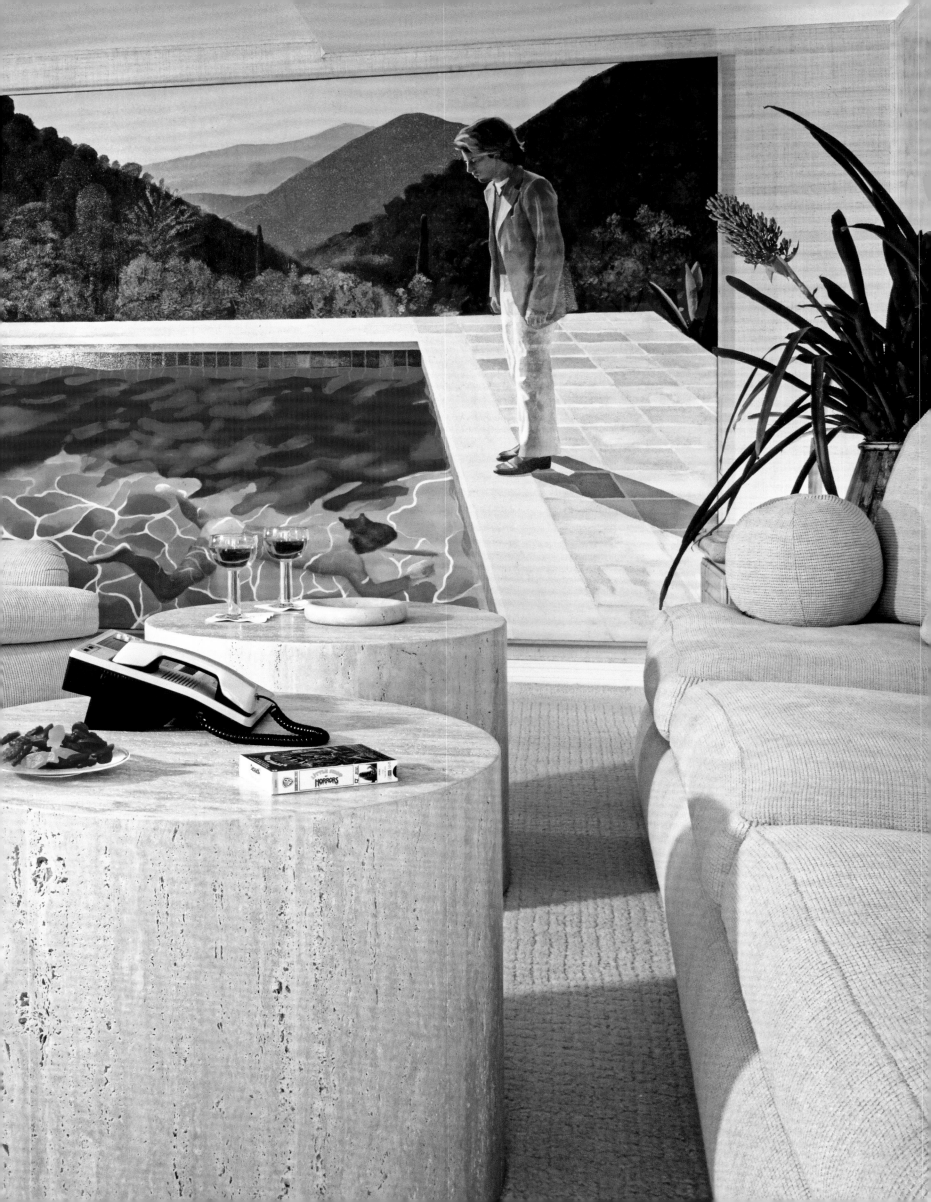

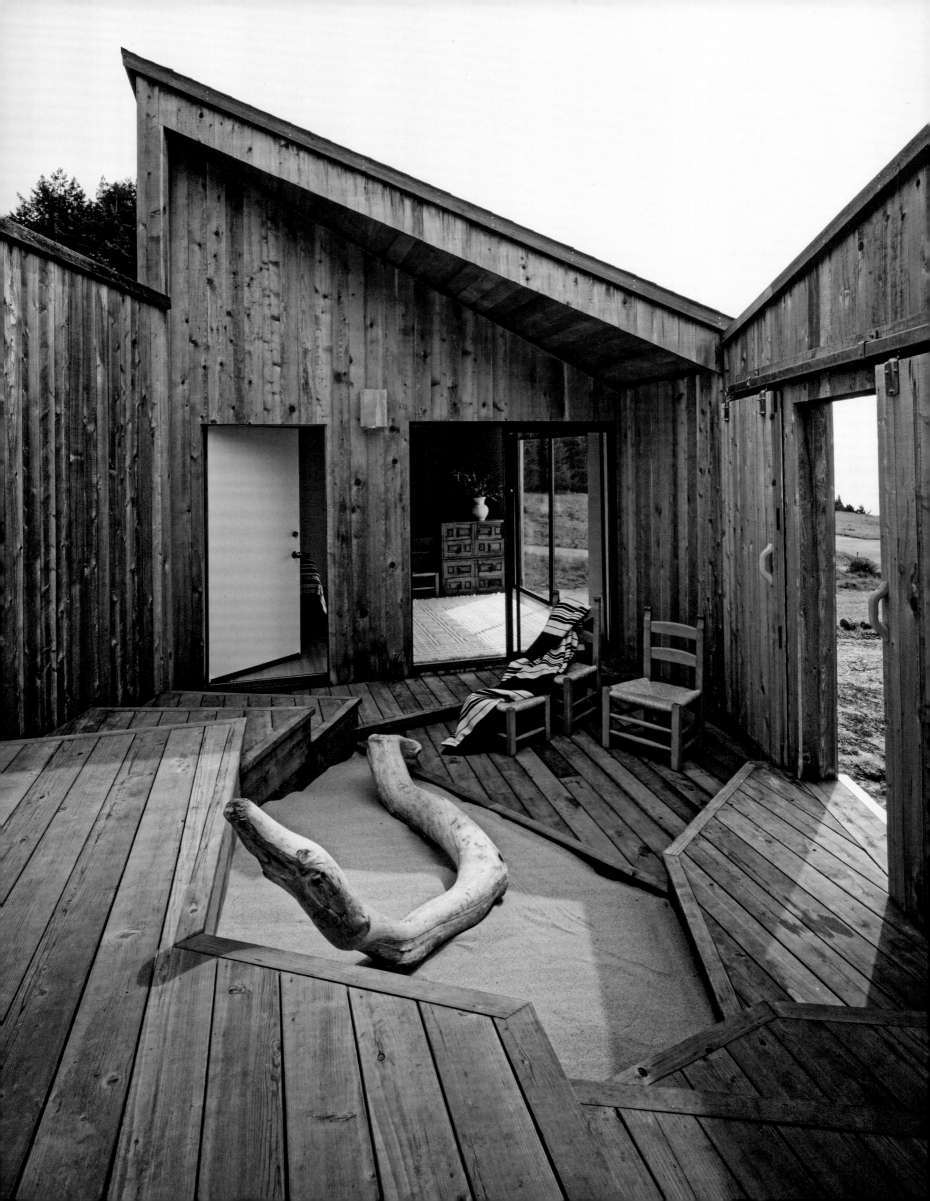

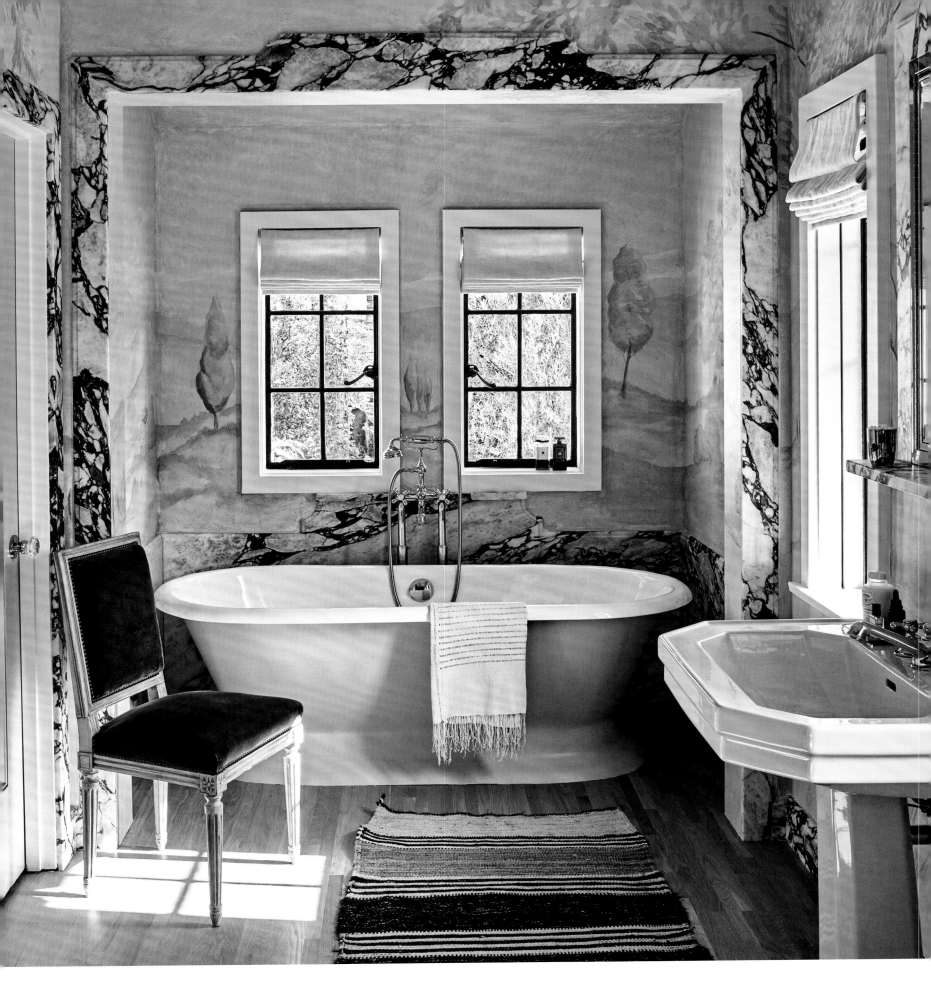

June 1988 | Sea Ranch

ARCHITECT Charles Moore

Nearly 20 years after Moore helped create the progressive planned community Sea Ranch in Northern California, the architect was asked to spearhead one more house. The resulting one-room-wide structure, designed in collaboration with Urban Innovations Group, actually comprises two buildings. The main house and small guest wing (seen in the background) are joined by a walled, trapezoidal, multilevel courtyard, an outdoor room that *AD* judged "exceptionally strong … a miniature version of an Italian piazza, rendered in wood."

January 2018 | Hancock Park

HOMEOWNERS/DESIGNERS Nate Berkus & Jeremiah Brent

Making over a 1928 Spanish Colonial Revival house was the "perfect assignment for two decorators," quipped Berkus. For their growing family, he and Brent layered rustic American, French, and Swedish furnishings with tailored Continental pieces, all in their shared signature neutral palette. One exception to the rainbow-of-beige rule that governs the home is the master bathroom, with its hand-painted murals and richly veined marble. "The stone's a little weird for us," confessed Berkus.

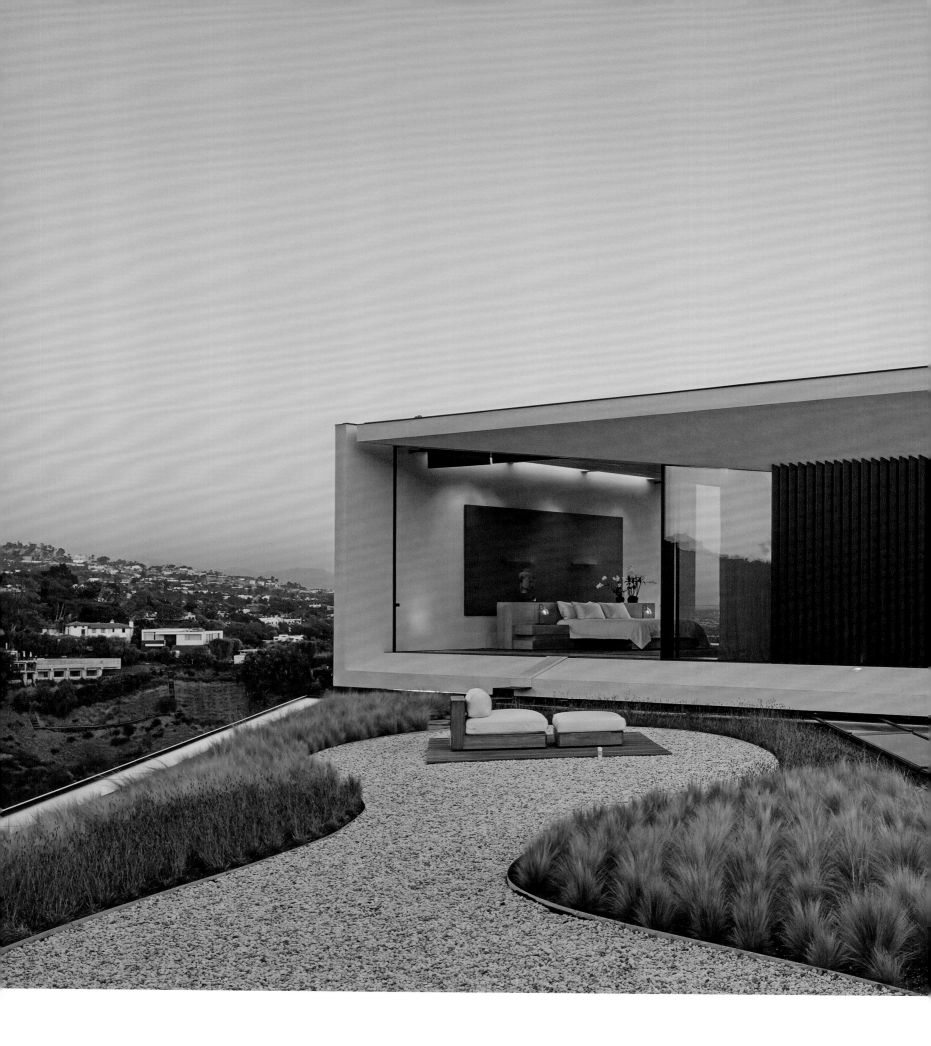

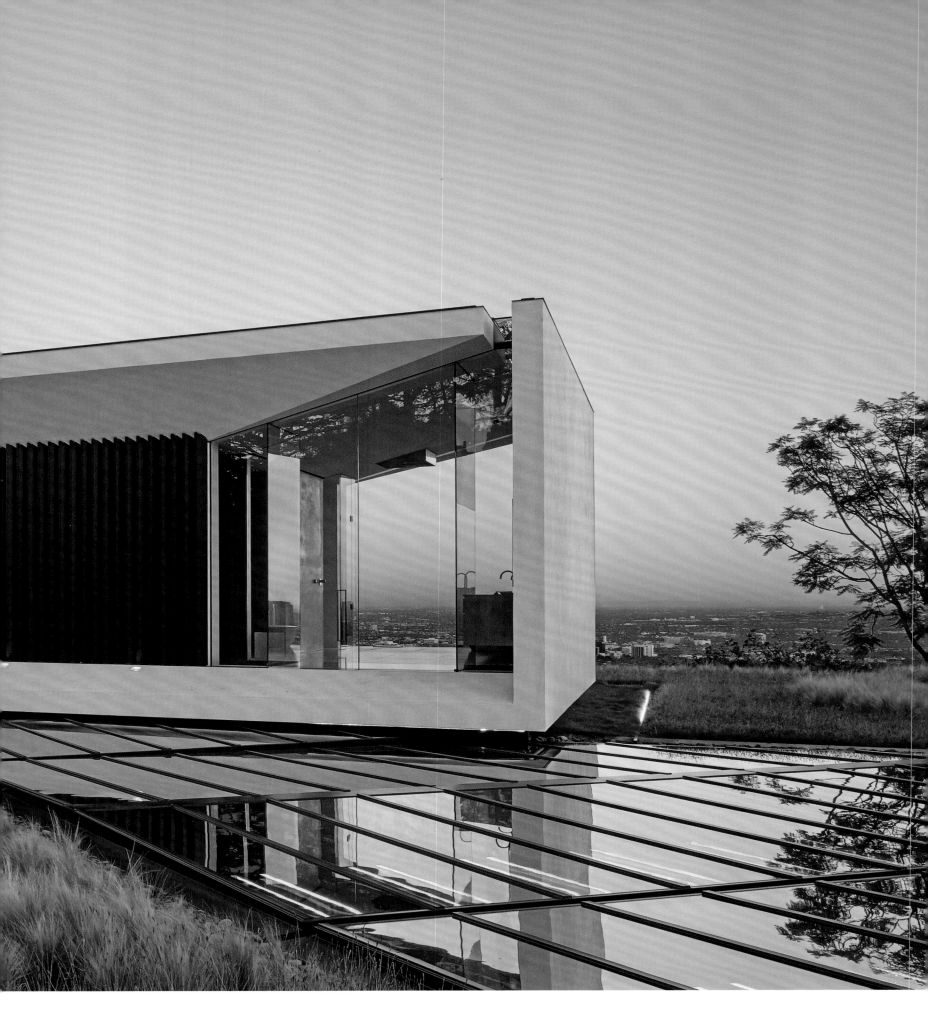

March 2015 | Los Angeles

HOMEOWNER Michael Bay

Filmmaker Bay's three-story aerie overlooking Los Angeles, conceived by architect Chad Oppenheim and realized by Rios Clementi Hale Studios, is a modernist stunner: a seemingly weightless stack of independent volumes with column-free spans and sweeping views. The uppermost level serves as a master suite and opens onto a rooftop terrace. Designer Lorraine Letendre, who outfitted the interiors with a mix of bespoke and vintage furnishings, noted, "The house is not about small gestures."

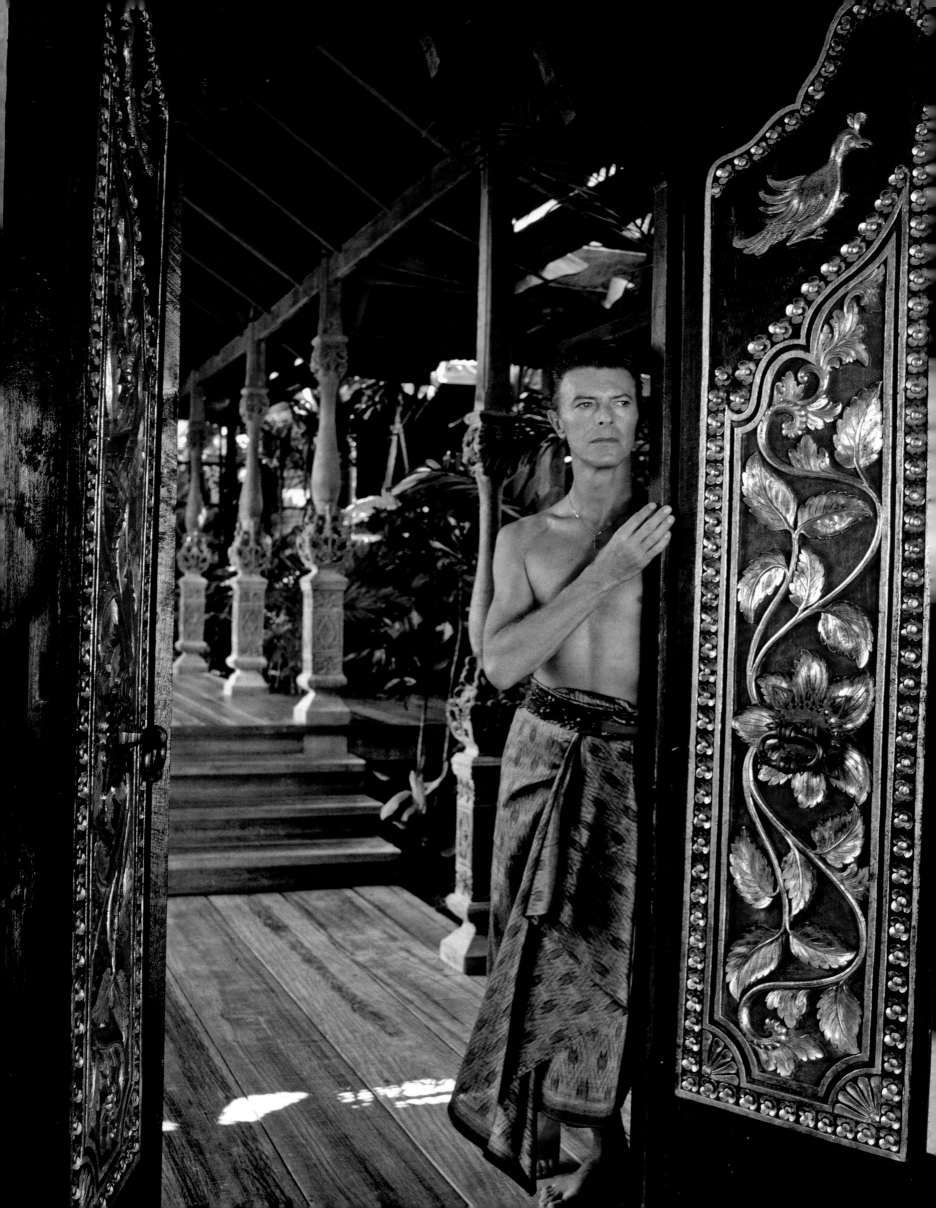

David Bowie & Iman
Sylvester Stallone
Jennifer Aniston
Barack & Michelle Obama
Robert Downey Jr.
Sir Elton John & David Furnish
Mandy Moore
Liza Minnelli
Jayne Mansfield
Tina Turner
Ellen DeGeneres & Portia de Rossi
Julianne Moore
Buster Keaton
Ricky Martin & Jwan Yosef
Candice Bergen
Bette Midler
Bette Davis
Naomi Watts
Alex Rodriguez

Celebrities

Elizabeth Taylor
Will & Jada Pinkett Smith
Jane Fonda
Marlene Dietrich
Mariah Carey
Martha Stewart
Robert Redford
Barbra Streisand
Anjelica Huston
John Legend & Chrissy Teigen
Julia Child
Sting & Trudie Styler
Liev Schreiber
John Travolta & Kelly Preston
Carole Lombard
Kylie Jenner
Kris Jenner
Fred Astaire

BORN AND RAISED in Los Angeles, *Architectural Digest* has always recognized the popular appeal of celebrity culture. From its earliest decades, *AD* chronicled the homes of Tinseltown grandees both on-screen and off-, celebrating the titans of an industry that would come to define American culture in the 20th century.

The love affair with Hollywood royalty began with luminaries of the silent-movie era such as *Harold Lloyd* and *Buster Keaton*, whose famous Beverly Hills estate, with its cascading outdoor staircases and fountains, was published in 1928. As talkies became all the rage in the late 1920s and '30s, and as celebrity taste moved away from the insane opulence of the silent era, *AD* ushered its readers into the relatively restrained homes of *Clark Gable, Shirley Temple, Jeanette MacDonald, Zeppo Marx*, and a host of others.

The magazine followed the celebrity diaspora from Los Angeles to Palm Springs, New York City, Europe, and beyond as decades passed and styles evolved along endlessly shifting tides of taste. Certain stories crystallized particular moments in time with indelible images of stars at home, among them *Liza Minnelli*'s Manhattan apartment, decorated by Donghia Associates; *David Bowie*'s exotic Mustique getaway; and *Barbra Streisand*'s Art Deco fantasy in Malibu, to name just a few.

Along the way, several especially discerning celebrities became staples of the *AD* mix as the magazine charted the trajectory of their careers through the lens of home design. From the

1970s to the present, *Elton John*, *Candice Bergen*, *John Travolta*, and *Robert Redford* each made multiple appearances. Naturally, designers who found favor among actors, musicians, and other glitterati were lauded side by side with their high-profile clients. Erstwhile silent-film star *William Haines* went on to achieve design-world acclaim for the spectacular domestic settings he created for screen sirens *Joan Crawford*, *Carole Lombard*, and *Gloria Swanson*. In more recent years, *Martyn Lawrence Bullard*, who has worked with everyone from *Cher* to *Kylie Jenner*, has been responsible for many of *AD*'s most dazzling features.

Celebrity coverage continues to be an important part of our DNA to this day. Design-addicted actors such as *Julianne Moore* and *Jennifer Aniston* happily invite the magazine in, while stars on the order of *Robert Downey Jr.* and *Ricky Martin* demonstrate the joy of home decor as a family affair. Indeed, in the age of social media, when celebrity obsession has risen to dizzying heights, *AD* offers new digital channels to view the world's ever-changing constellation of pop stars. ◢▶

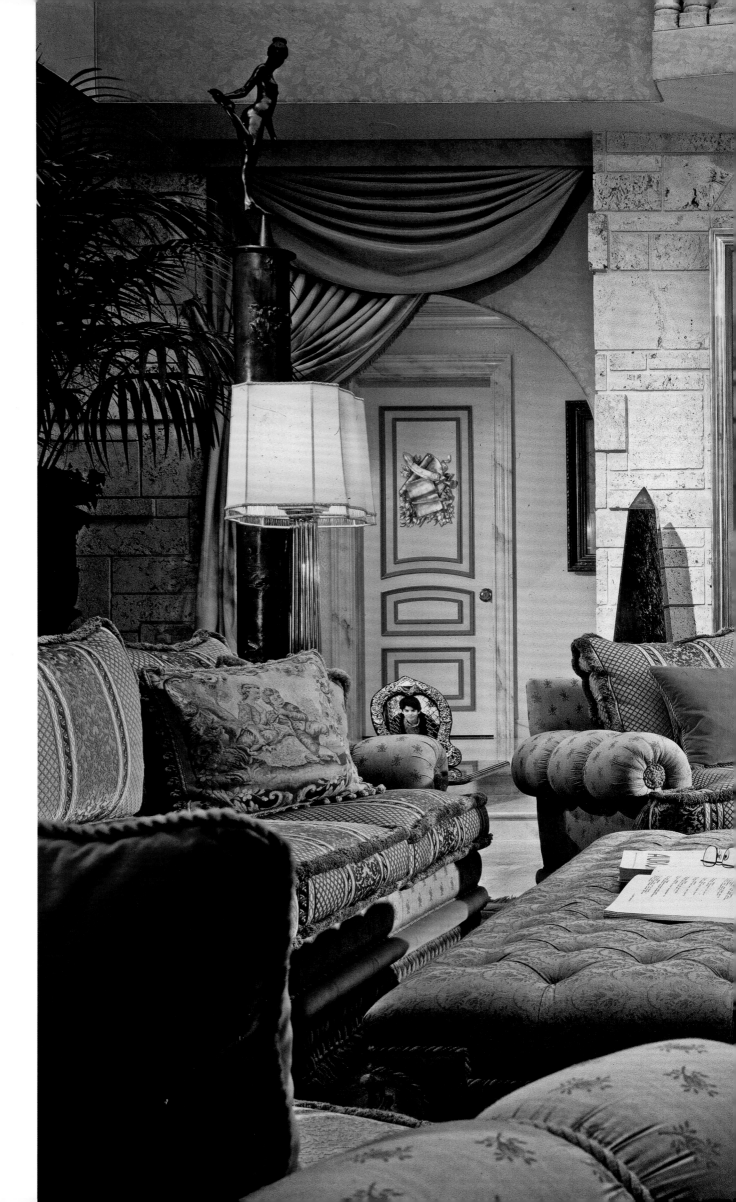

November 1997
Miami

HOMEOWNER
Sylvester Stallone

Paintings and sculptures fill the neoclassical-style manse, designed by Massimo Papiri, which sits on a sprawling 14-acre plot overlooking Biscayne Bay. Francis Bacon's *Oedipus and the Sphinx* is set between two obelisks in the atrium, where Stallone usually watches television sitting on the overstuffed sofa and chairs. The stone-clad room, the actor said, "was inspired by the Danieli in Venice."

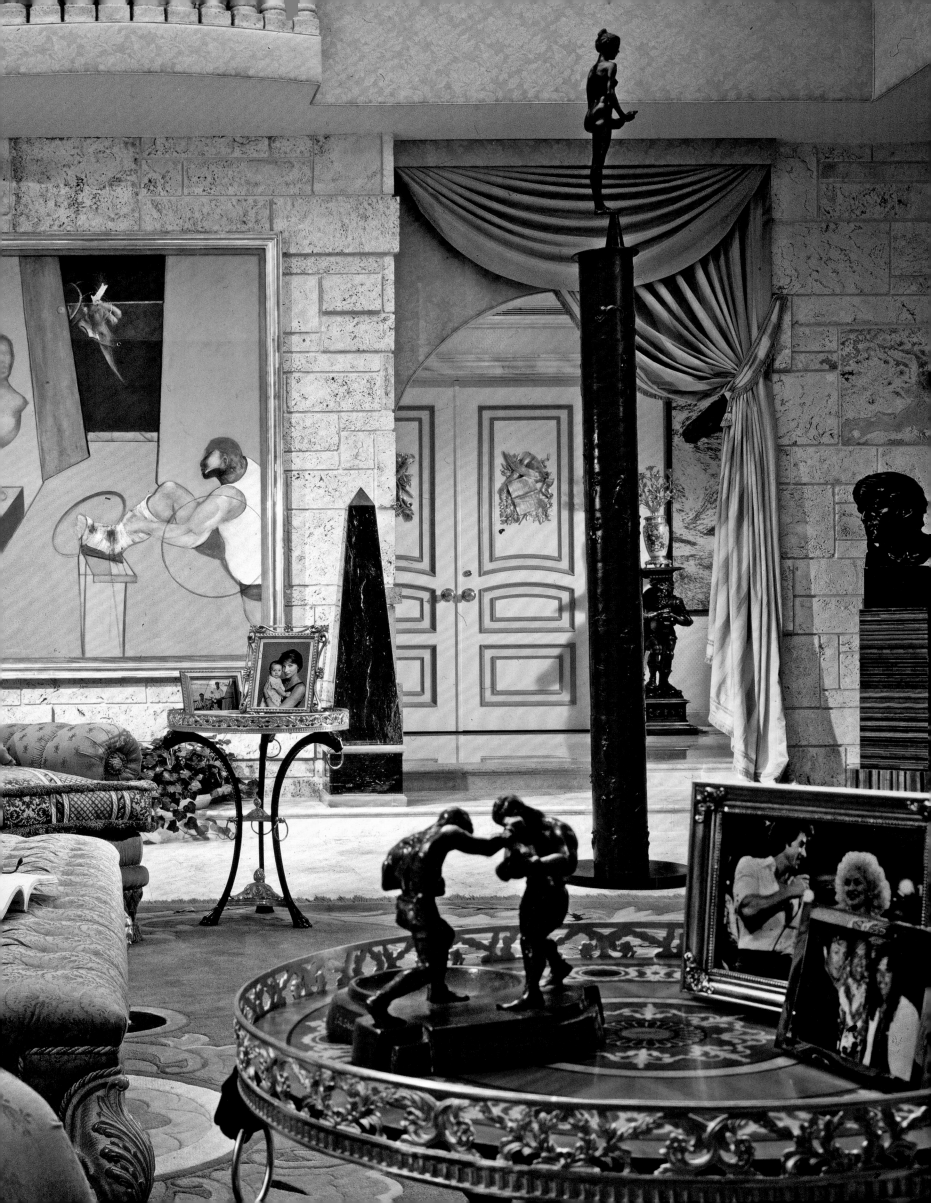

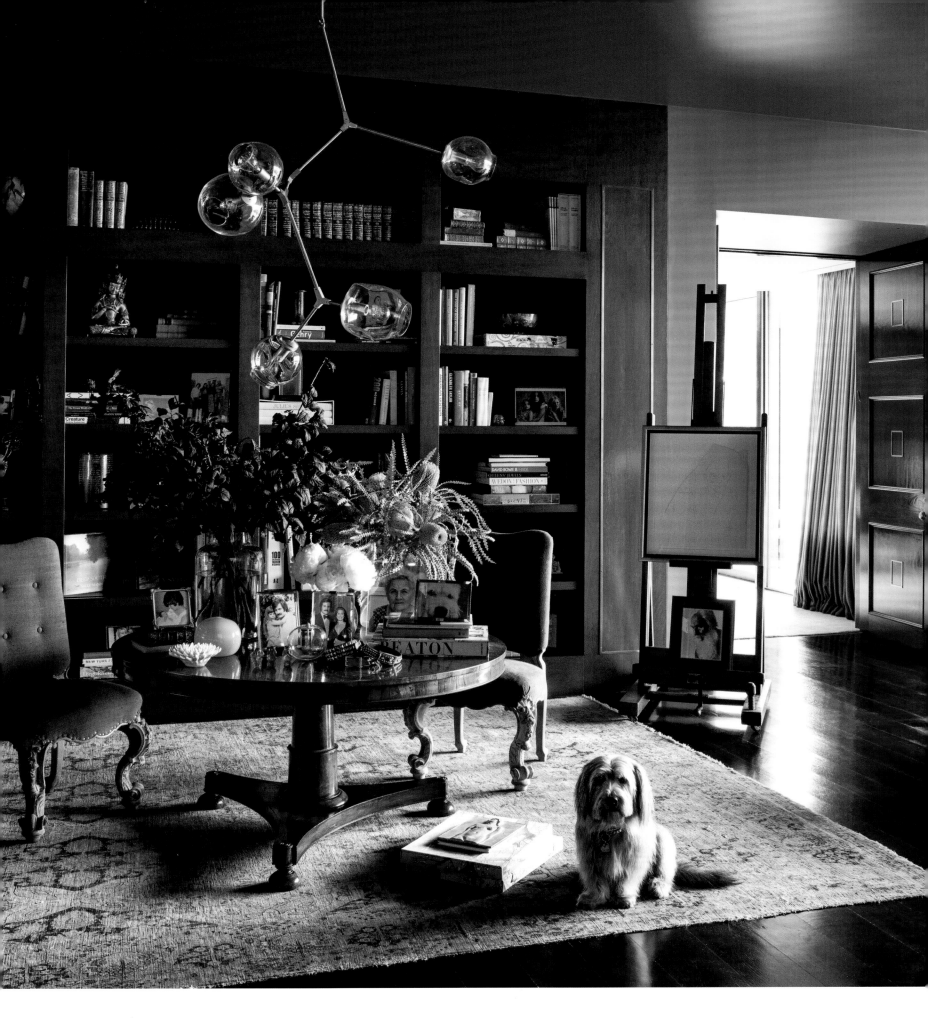

March 2018 | Bel Air, California

HOMEOWNER Jennifer Aniston

"I'm all about cozy," said the A-list actress, who reimagined her A. Quincy Jones–designed residence with the help of designer Stephen Shadley. Despite Aniston's girl-next-door persona, she outfitted the house with important furnishings, including pieces by Jean Royère, Jacques Adnet, and Arturo Pani. Her library features antiques and a contemporary Lindsey Adelman chandelier, while the backyard deck offers sweeping vistas of the city below. "If I wasn't an actress, I'd want to be a designer. I love the process," she said. "There's something about picking out fabrics and finishes that feeds my soul."

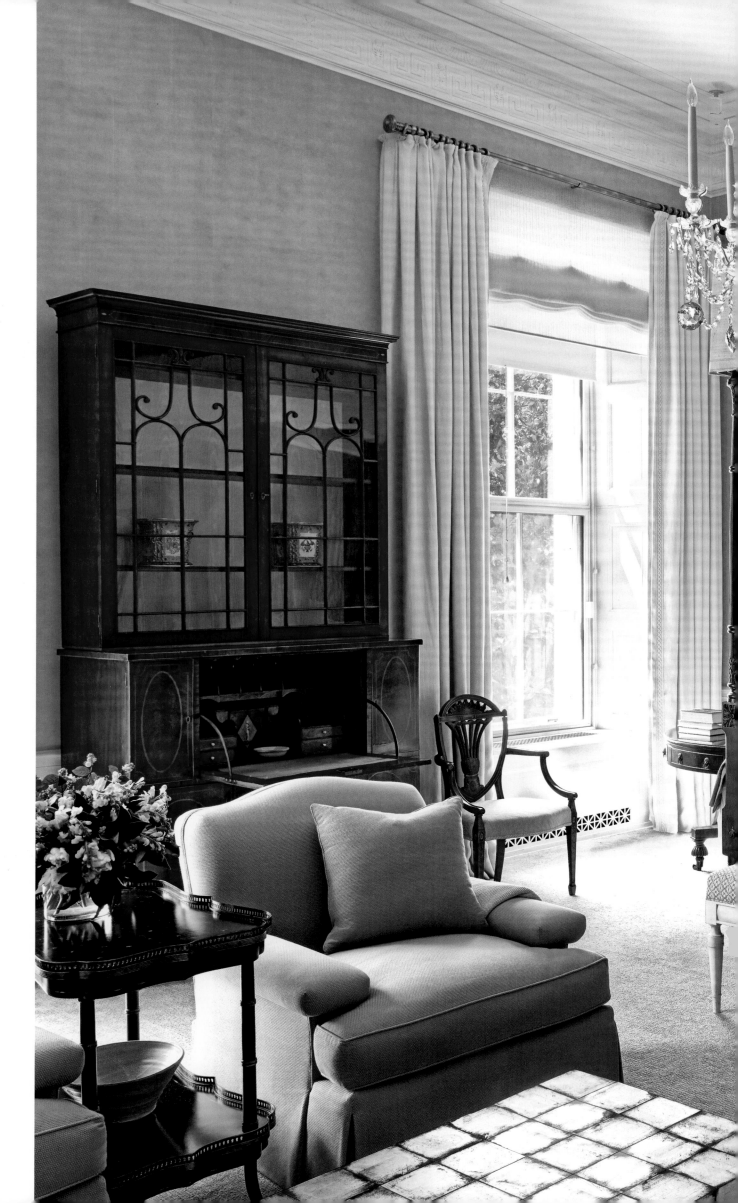

December 2016
Washington, D.C.

The Obama White House

Decorated by Michael S. Smith for the Obamas, the White House's private quarters were as worldly and relaxed as the family that called them home. "The private residence of the White House has not only reflected our taste," Mrs. Obama said, "but also upheld the proud history of this building." The monochrome master suite mixed an antique canopy bed and cabinet with a modern mirror. Smith explained, "This is their sanctuary—private, elegant, and calm. You really want to make sure that the President of the United States gets a good night's sleep."

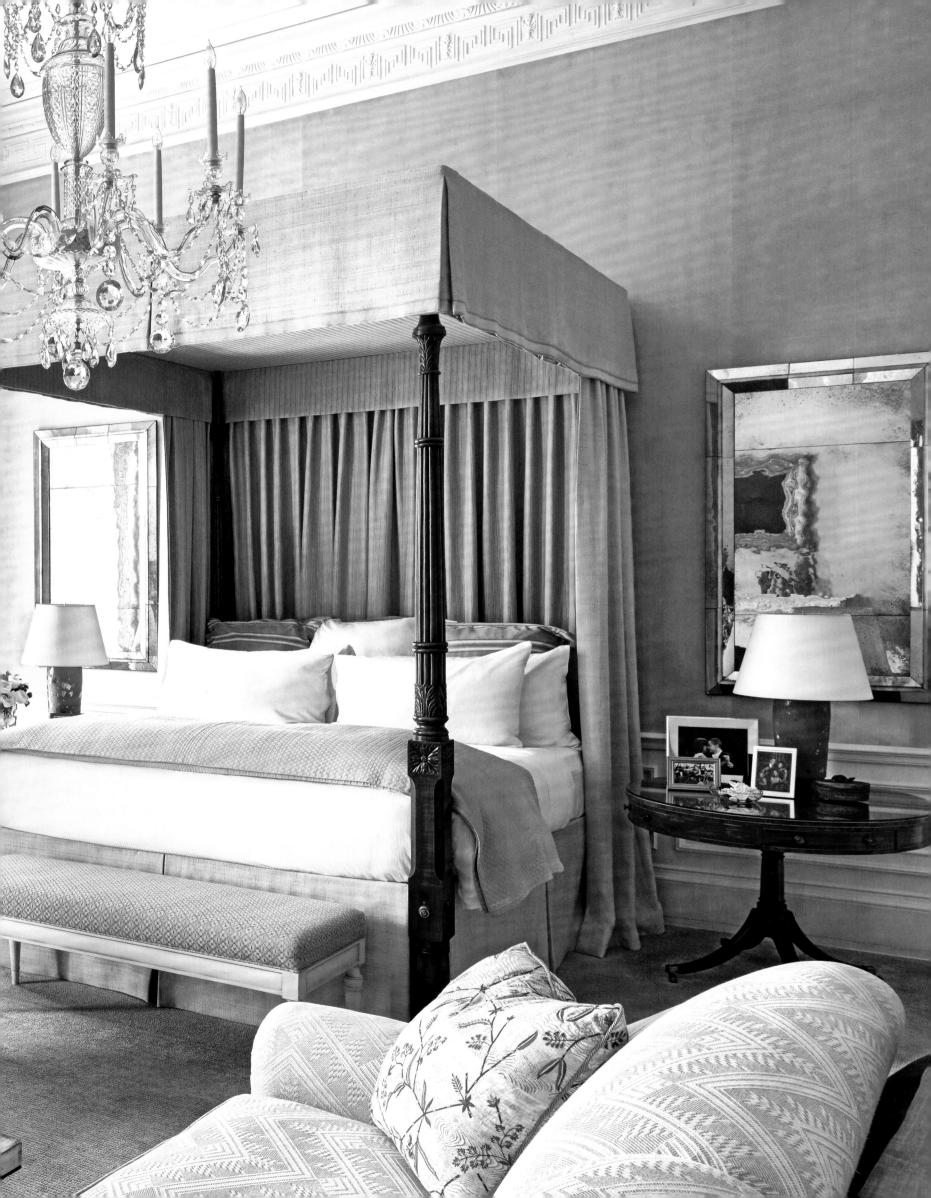

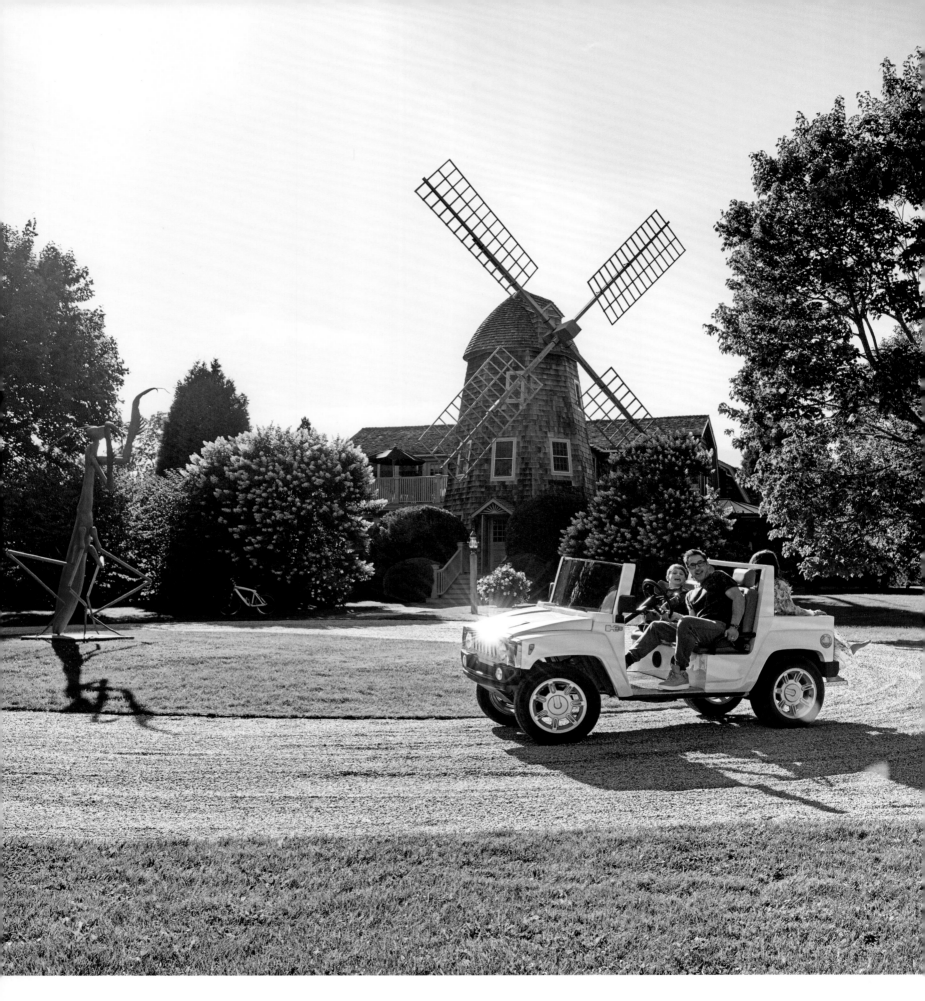

December 2017 | The Hamptons

HOMEOWNER Robert Downey Jr.

The actor and his family take a break from Tinseltown at their fairy-tale Long Island compound, where a turn-of-the-century windmill folly was enlarged and renovated decades ago to become a proper house. Designer Joe Nahem shepherded the latest reimagining of the estate. "We didn't set out to do something conspicuously wacky. We just enjoy a bit of whimsy and fun," Downey said of the vivid, art-filled decor. "And we definitely don't like boring."

May 2000 | Old Windsor, England

Woodside HOMEOWNERS Sir Elton John & David Furnish

For the legendary pop star, more is more. That philosophy applies to his onstage persona as well as his collecting and decorating habits. "There's nothing more relaxing than an afternoon of shopping," John told AD. "It's the only addiction I have left." In the attic of his country home, designed by Andrew Protheroe and Adrian Cooper-Grigg, shelves hold sunglasses he has collected since the mid-1970s.

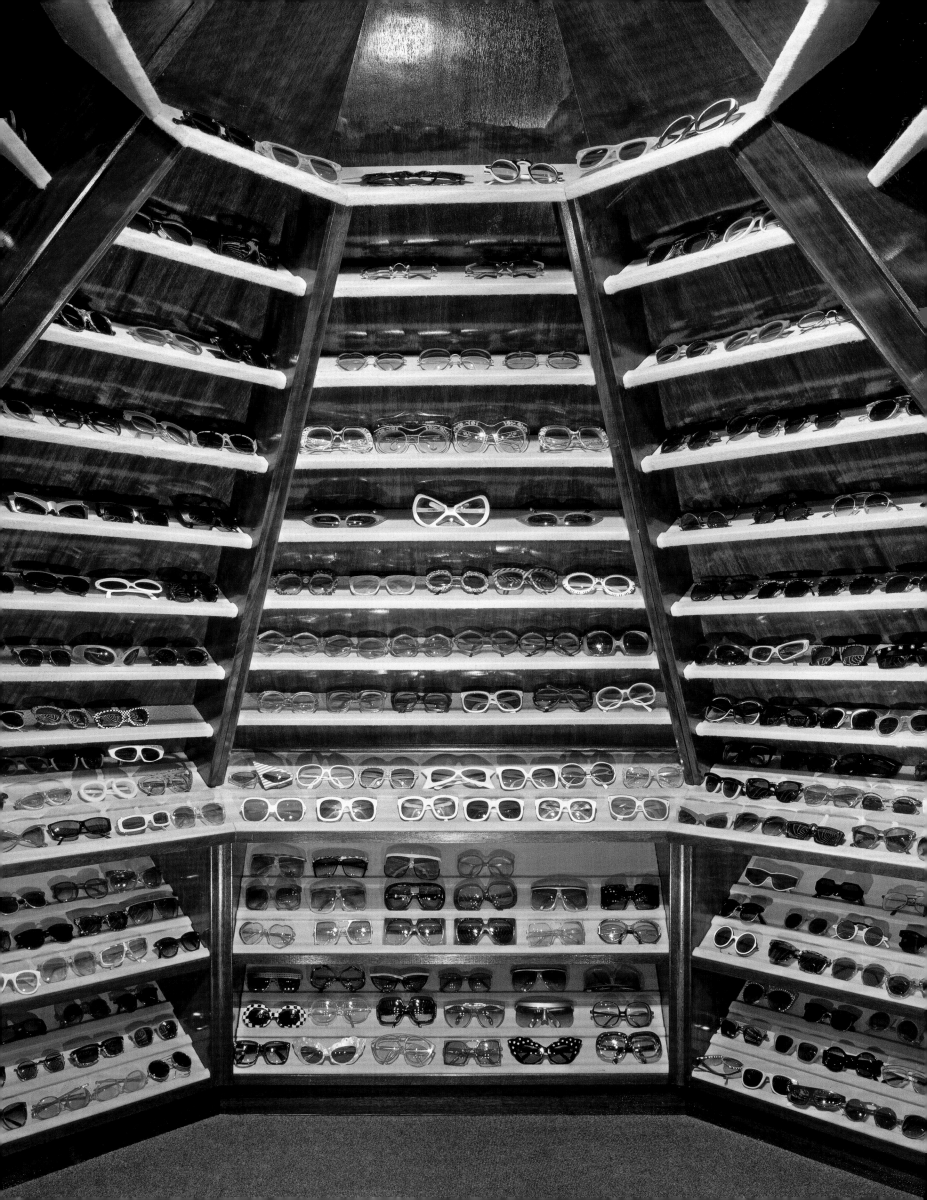

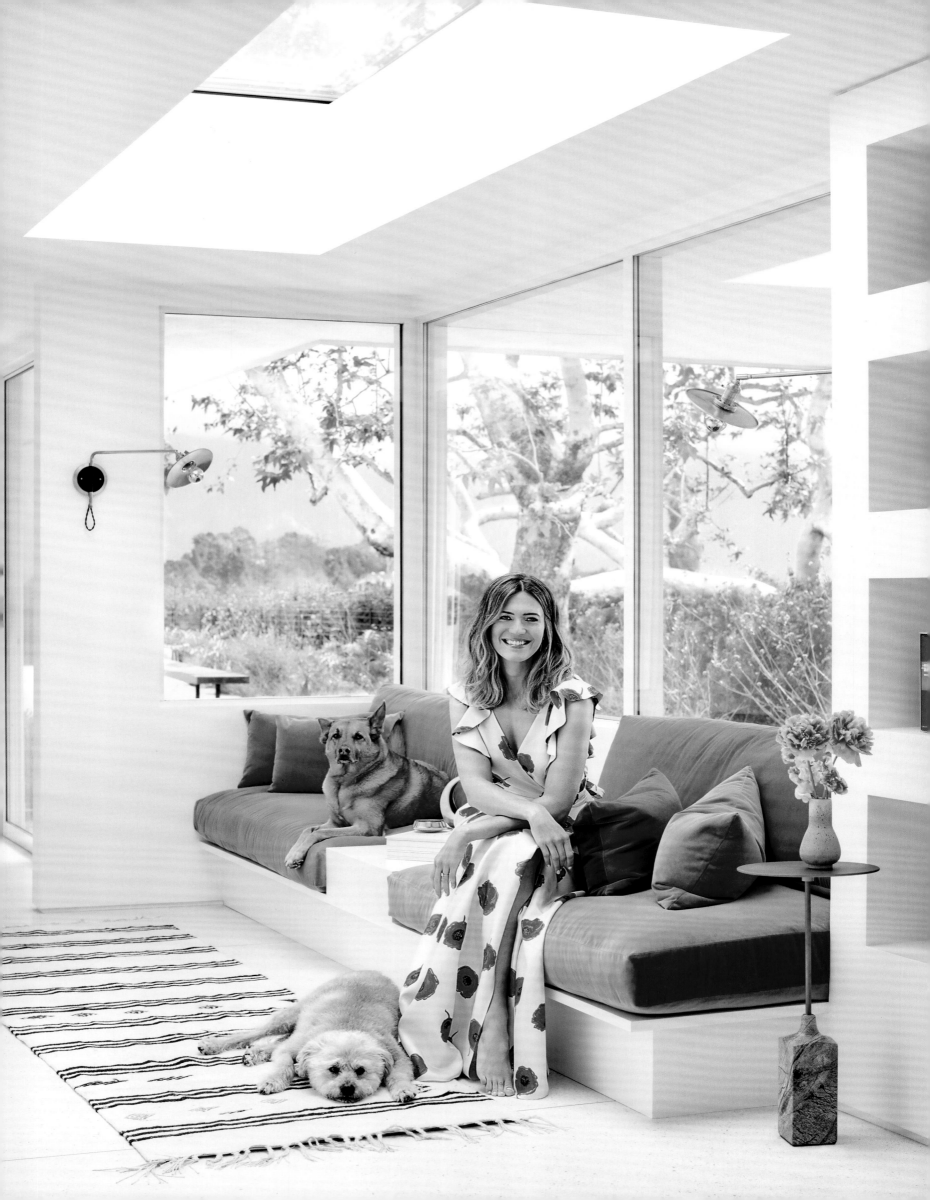

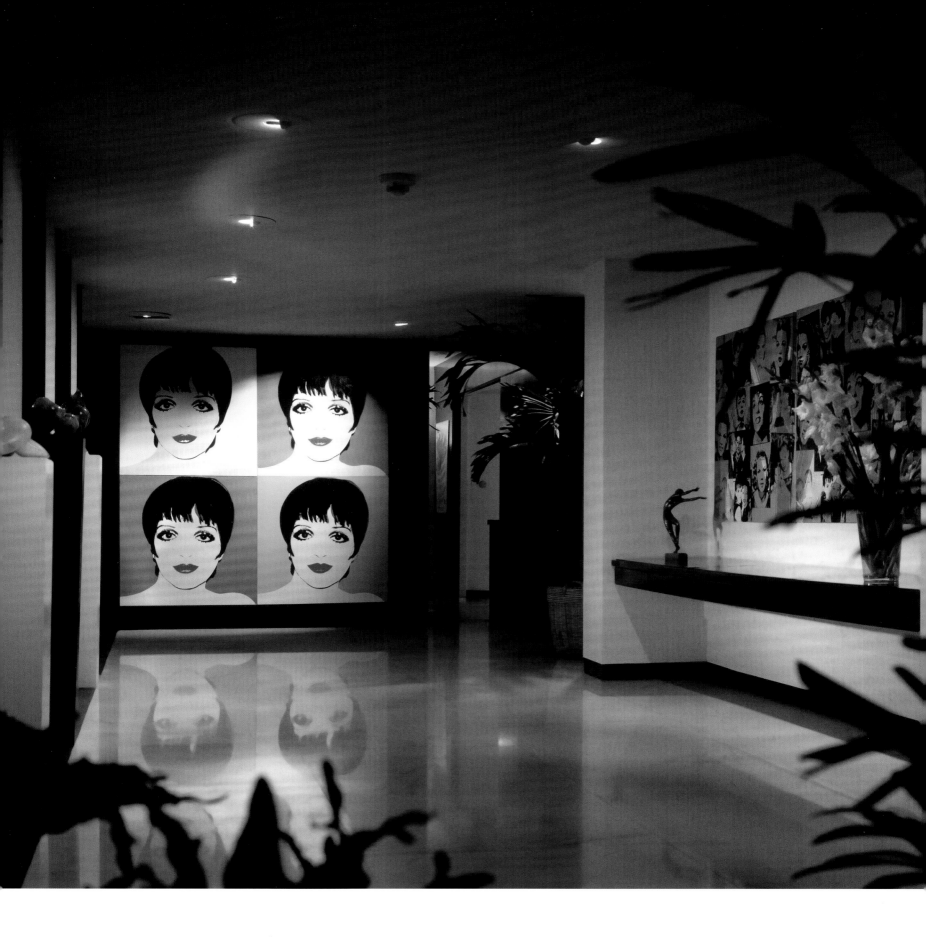

July/August 2018 | Pasadena, California

HOMEOWNER Mandy Moore

"This house signifies the next chapter of my life—as an adult, a woman, and a performer," the actress-singer told *AD*. After searching for nearly a year, she and her husband, Taylor Goldsmith, settled on a classic 1950s residence with sweeping vistas of the San Gabriel mountains and valley. The house was renovated by architect Emily Farnham and designer Sarah Sherman Samuel. Moore, on a goldenrod velvet sofa in the library, poses with dogs Joni and Jackson.

October 1981 | Manhattan

HOMEOWNER Liza Minnelli

"I'm finally home," the actress said of the chic apartment she shared with her sculptor husband, Mark Gero, which was designed by Timothy Macdonald of Donghia Associates. A four-panel painting of Minnelli by her friend Andy Warhol brightens the entrance hall, which has a sleek Carrara marble floor. Minnelli added, "For someone who has spent a large part of her life in hotels and rented houses, this is a breakthrough."

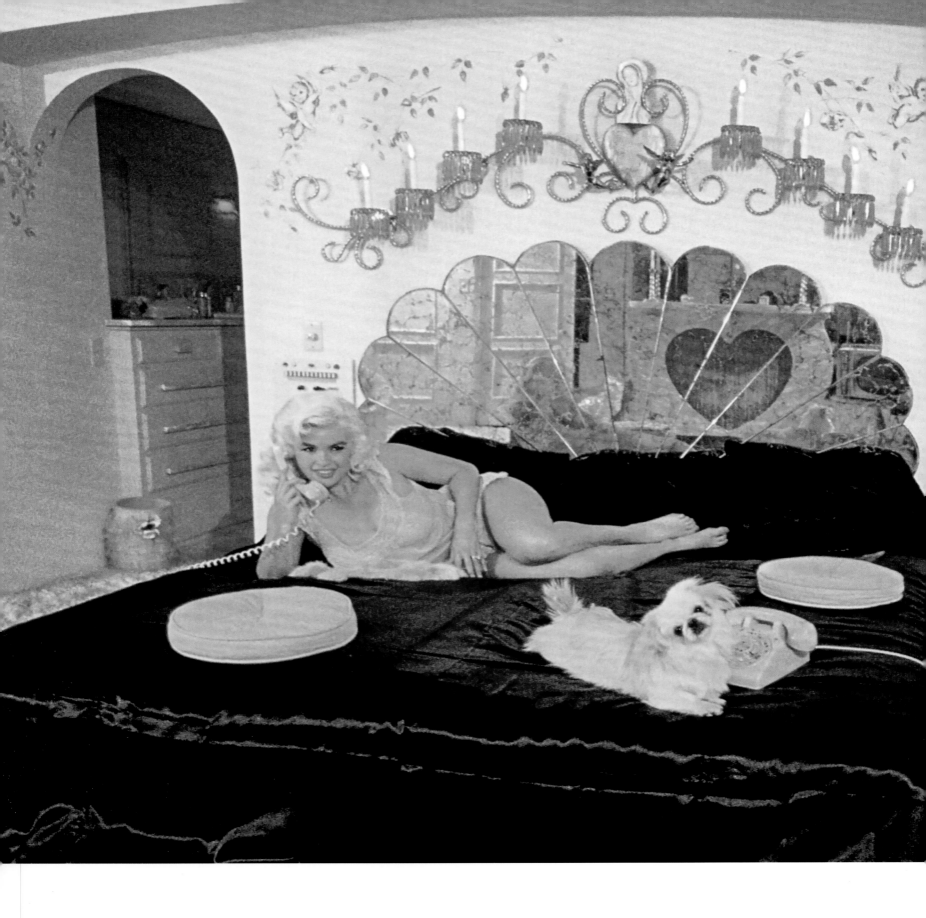

April 1996 (photograph circa 1960s) | Los Angeles

HOMEOWNER Jayne Mansfield

"I believe in flashy entrances," said the famously voluptuous actress, whose Pink Palace on Sunset Boulevard provided plenty of opportunity to dazzle. To decorate her dream house, she traded promotional appearances for an estimated $150,000 worth of furnishings and accessories. In her bedroom, Mansfield lounges with Powderpuff, a Pekingese, beneath a twisting candelabra and mirrored headboard.

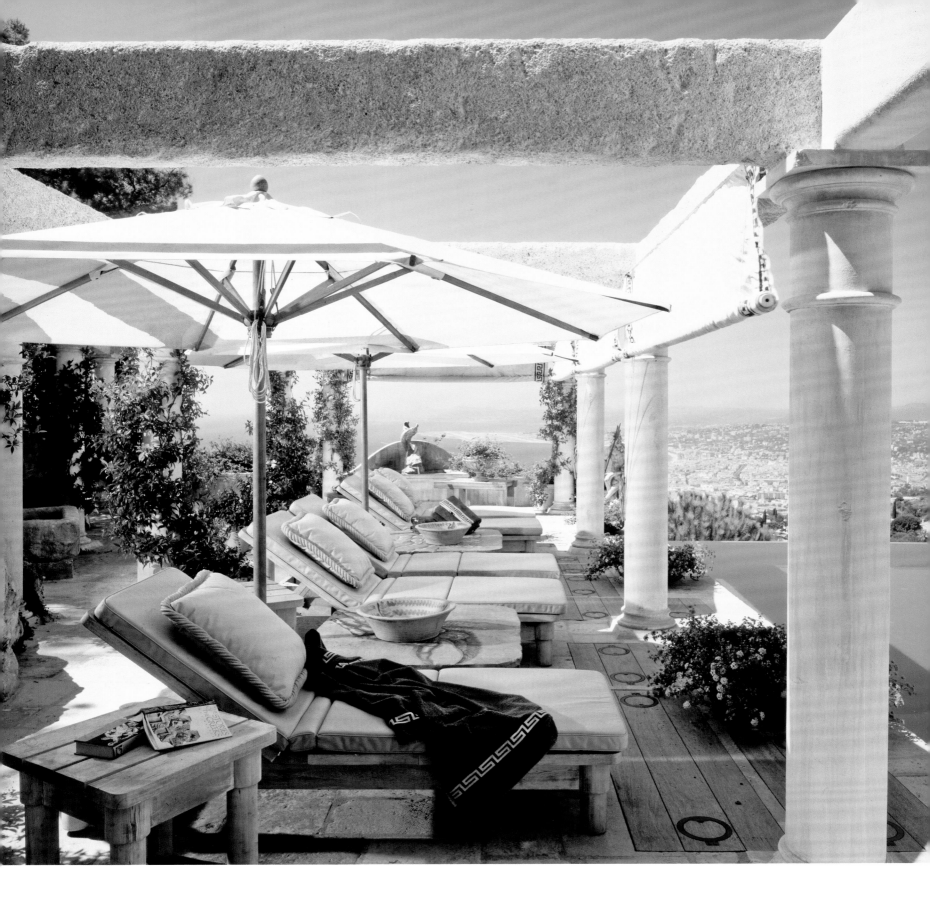

March 2000 | French Riviera

HOMEOWNER Tina Turner

The charismatic performer takes refuge at her villa on the Mediterranean coast. On the pool terrace, which evokes the ruins of a classical temple, a colonnade leads to an installation of statuary. "I like to come alone, walk around the grounds, and notice the subtle changes in the landscape," said Turner, who worked with Sills Huniford on the interiors.

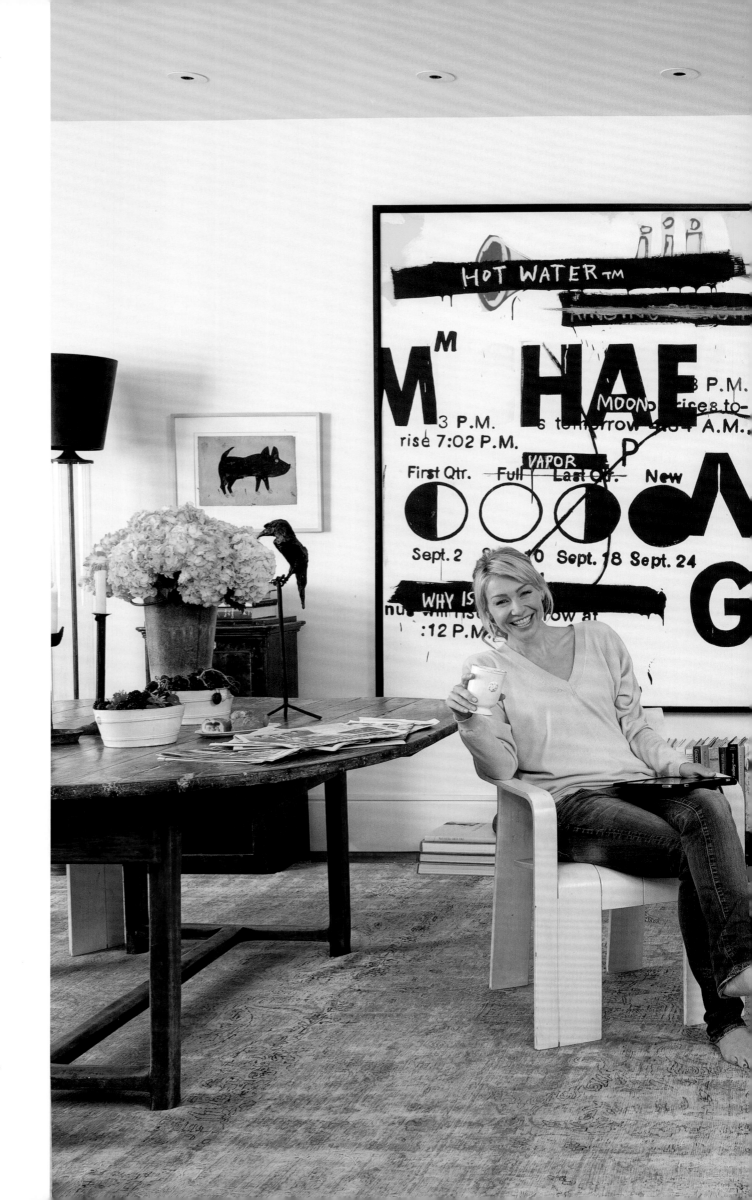

November 2011
Beverly Hills

HOMEOWNERS
Ellen
DeGeneres &
Portia de Rossi

For the Emmy Award–
winning talk-show host
and her actress wife,
home was once a Buff
& Hensman–designed
compound layered
with blue-chip contem-
porary art, classic
modern designs, and
highly textured antiques.
A painting by Andy
Warhol and Jean-Michel
Basquiat commands
one living area.

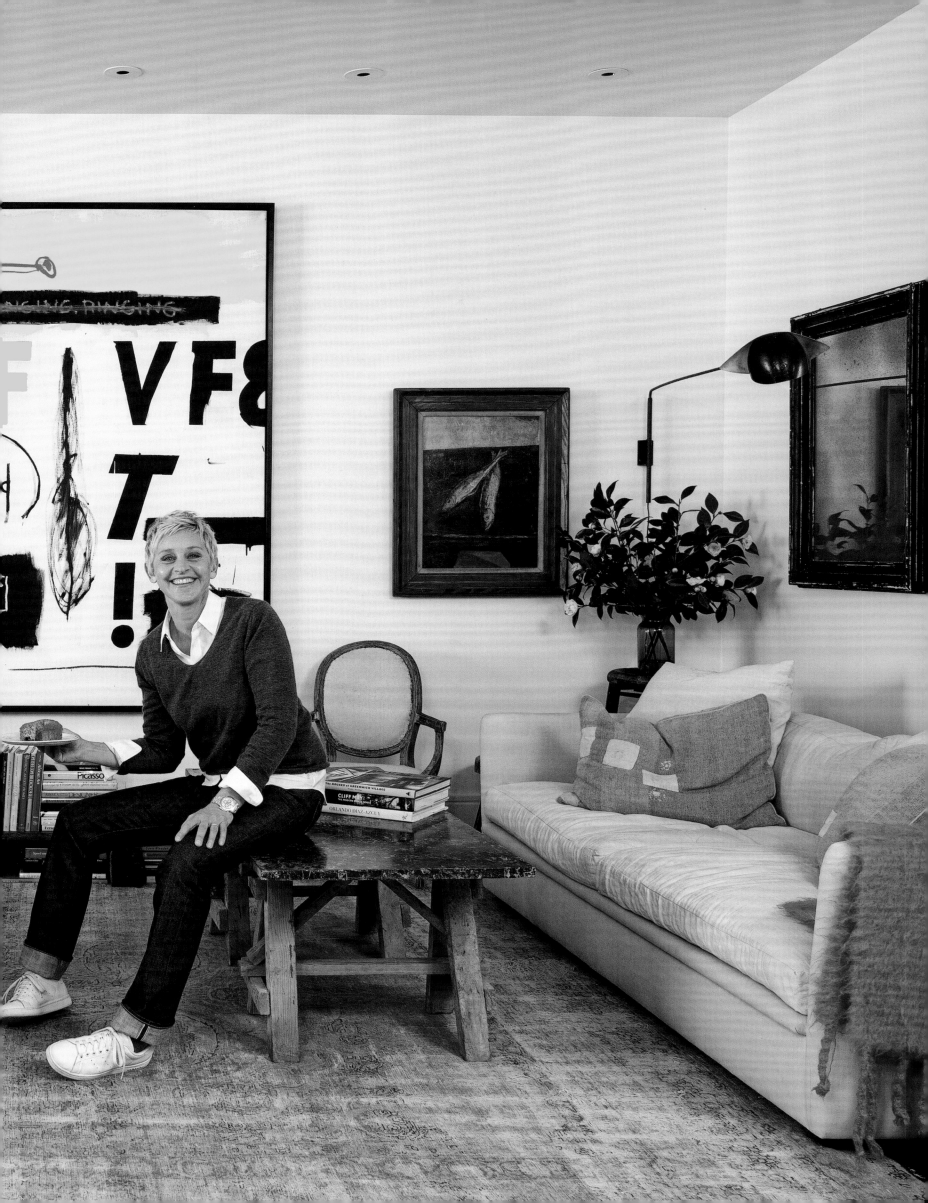

November 2017 | Manhattan

HOMEOWNER Julianne Moore

"For years I dreamed about living in a townhouse in the West Village," said the Oscar-winning actress. A scrupulous aesthete, Moore filled the interiors with midcentury furnishings and contemporary artworks from her personal collection. In the living room, a Noguchi lantern hangs above a George Nakashima cocktail table and Martin Eisler chairs, while the Sawyer|Berson–designed garden boasts an Alma Allen sculpture. Moore added, "I like things that feel human, things that tell a story. If it's coming into my home, it has to have real meaning."

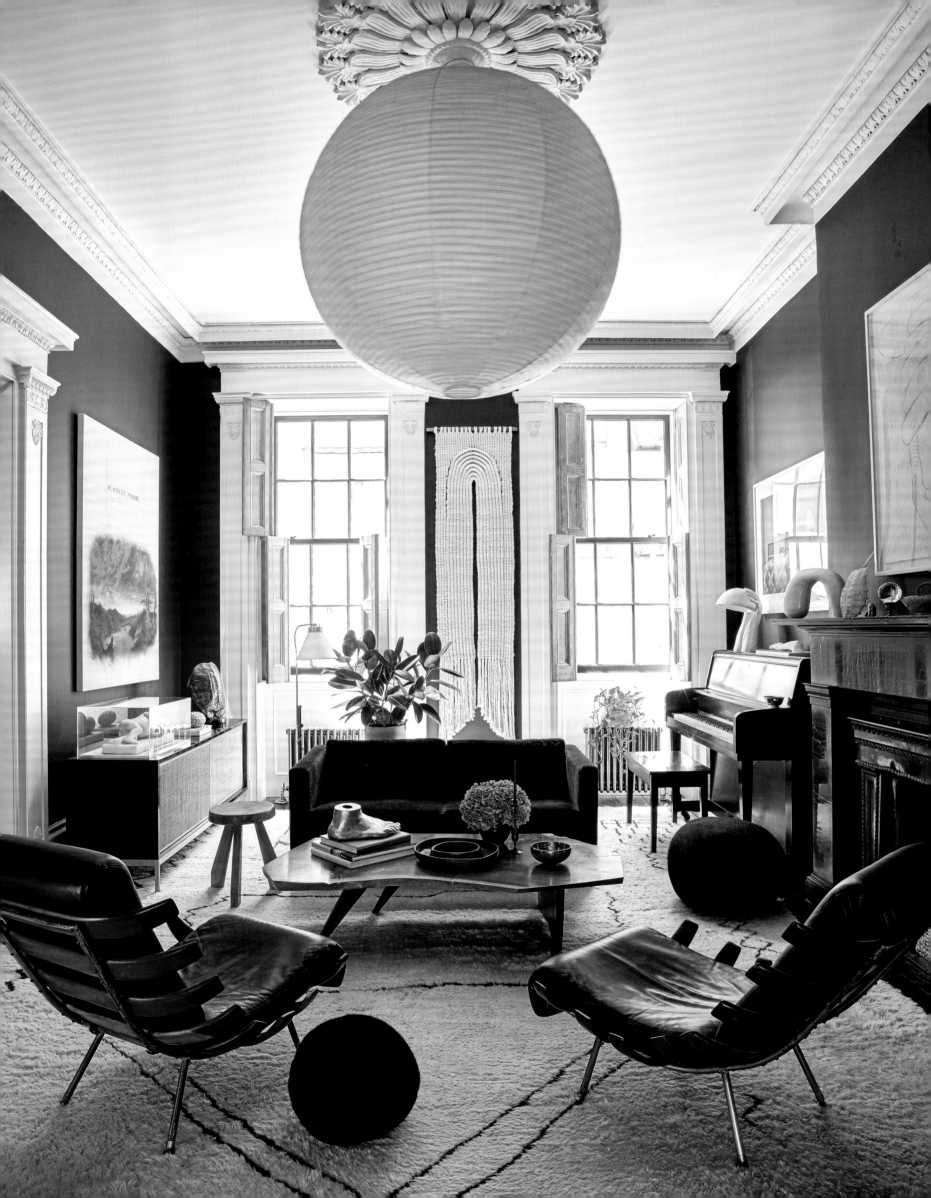

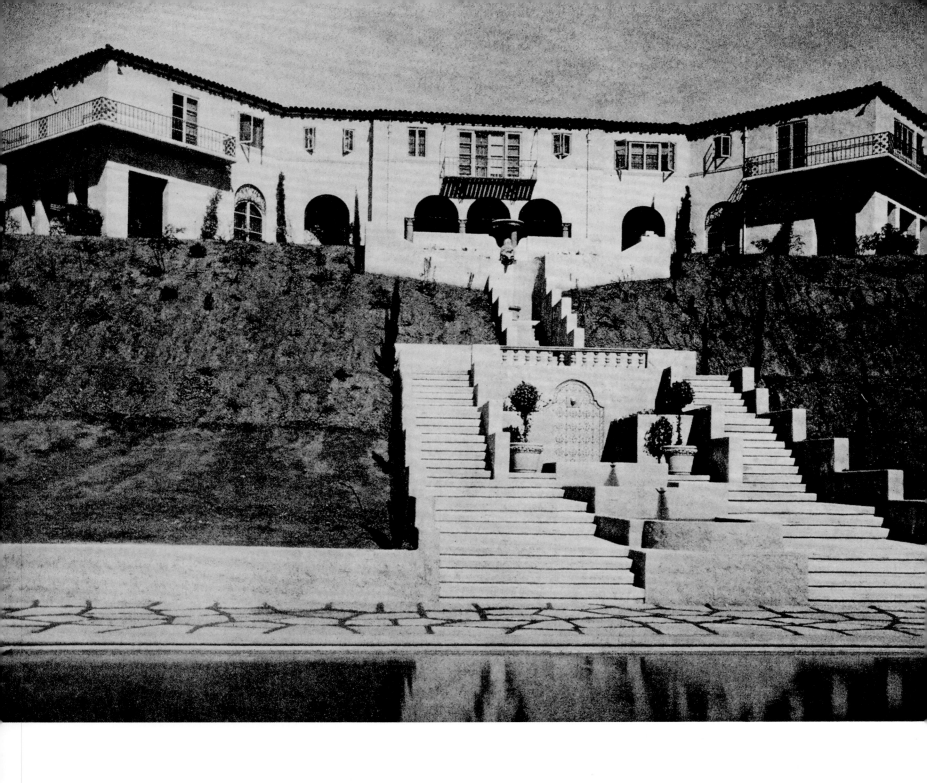

Volume 6, Number 3 1928 | Beverly Hills

HOMEOWNER Buster Keaton

The silent-film star resided in a Spanish-style estate devised by architect Gene Verge. The manse became a watering hole for Hollywood luminaries, and later counted Cary Grant, Barbara Hutton, and Marlene Dietrich as owners and tenants. From the flagstone pool deck, a dramatic stair leads up to the main house.

February 2018 | Beverly Hills

HOMEOWNERS Ricky Martin & Jwan Yosef

"Tino and Matteo were born on the road," said Martin of his two sons. "Wherever we happen to be, that's home." But with an assist from designer Nate Berkus, the globe-trotting superstar and his artist partner, Yosef, planted more permanent roots in a renovated and expanded midcentury residence. Explained Berkus, "Ricky and Jwan are both artists, and they have very particular ideas about how they wanted to live. Ultimately, I helped give them a solid, neutral foundation that they can cultivate together to make the home truly theirs."

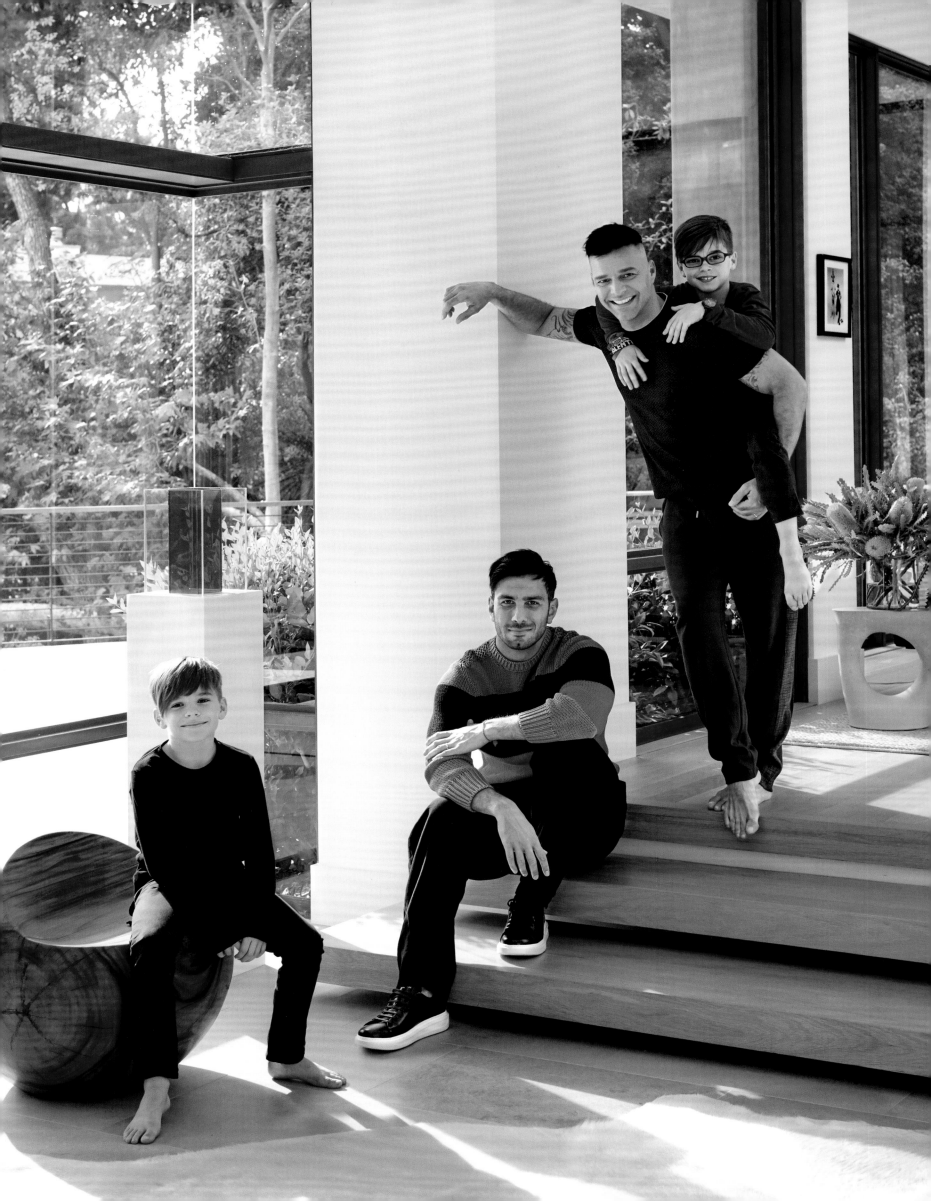

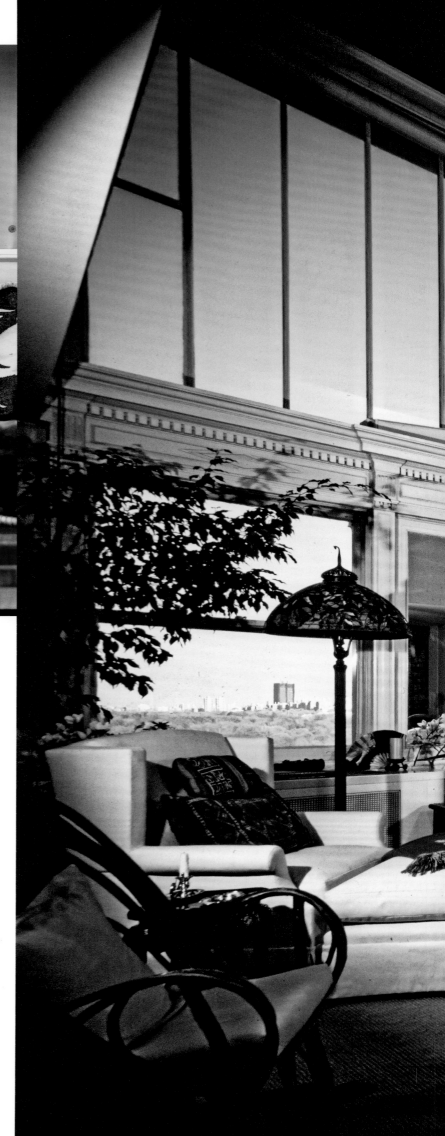

June 1979 | Manhattan

Candice Bergen

High above New York, a circa-1915 duplex provided the raw material for the actress's eminently comfortable home. The two-story living room, rendered in a medley of earth tones, offers enviable views of Central Park. "Well, in a way, this is my first grown-up apartment," Bergen said. "I've lived on my own since I was 19, but this is the first time I've really put away my toys." The result was a space as compelling and confident as the homeowner herself.

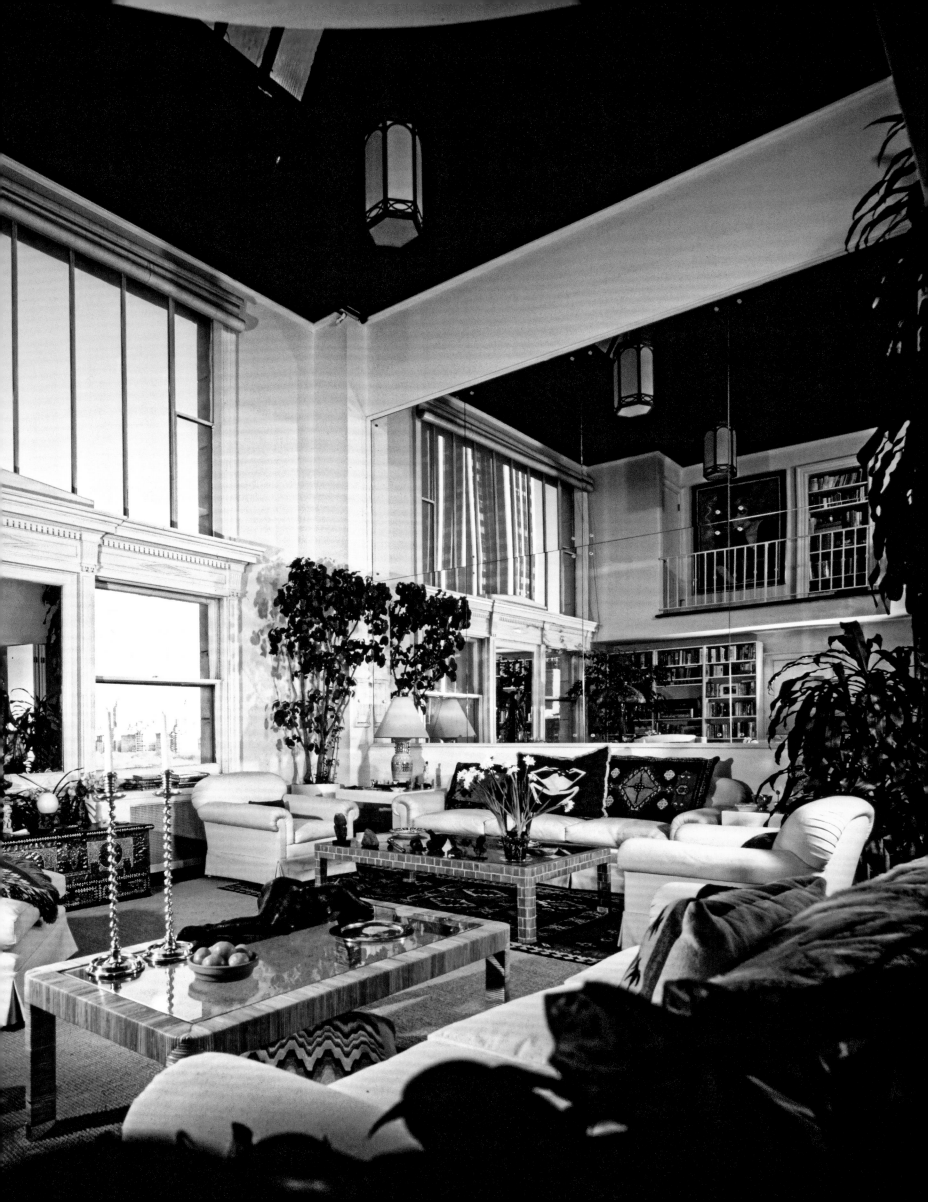

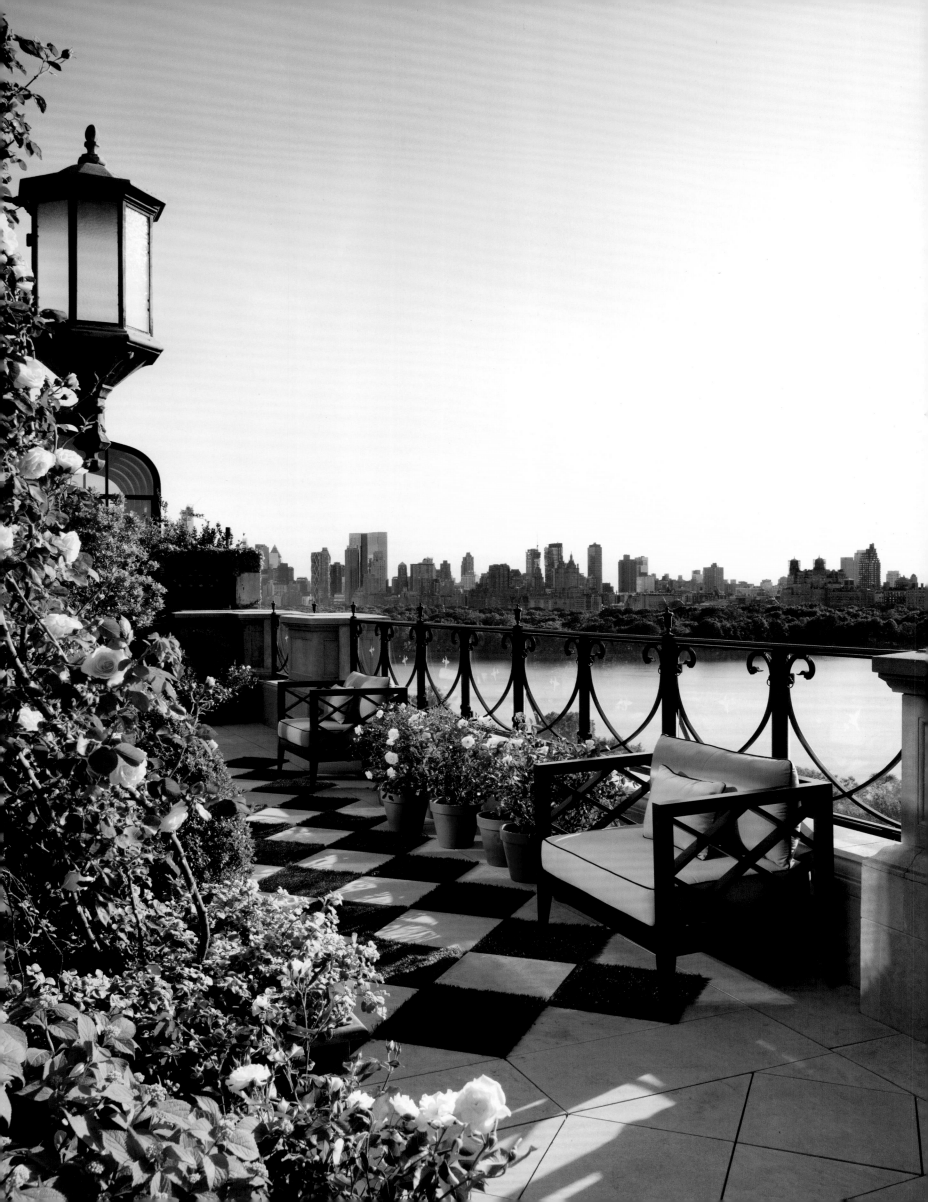

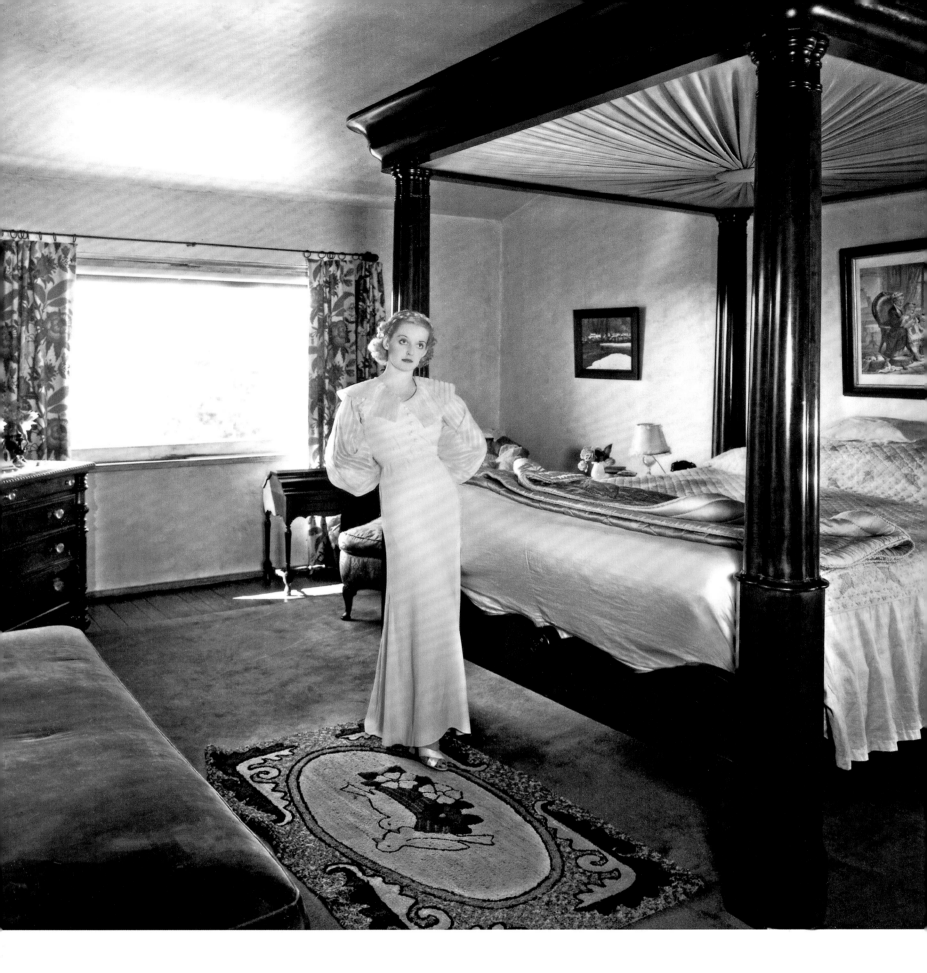

June 2014 | Manhattan

HOMEOWNER Bette Midler

For the Divine Miss M, there is perhaps no space as important as one's garden. "I grew up around people who worked with their hands," said Midler, who founded the New York Restoration Project to revitalize the city's gardens and green spaces. She called on the design firm Sawyer|Berson to mastermind the terraces of her Fifth Avenue penthouse, where roses climb the brick walls and limestone pavers alternate with turf.

March 2006 (photograph circa 1930s) | Beverly Hills

HOMEOWNER Bette Davis

Down a hedge-lined driveway in Beverly Hills, a 1926 Spanish Colonial Revival house was home to one of the greatest stars of old Hollywood. In her bedroom, Davis stands beside a stately four-poster. "A nest was always being improvised," she said of her lifestyle. "Favorite cigarette boxes and ashtrays have followed me around the world."

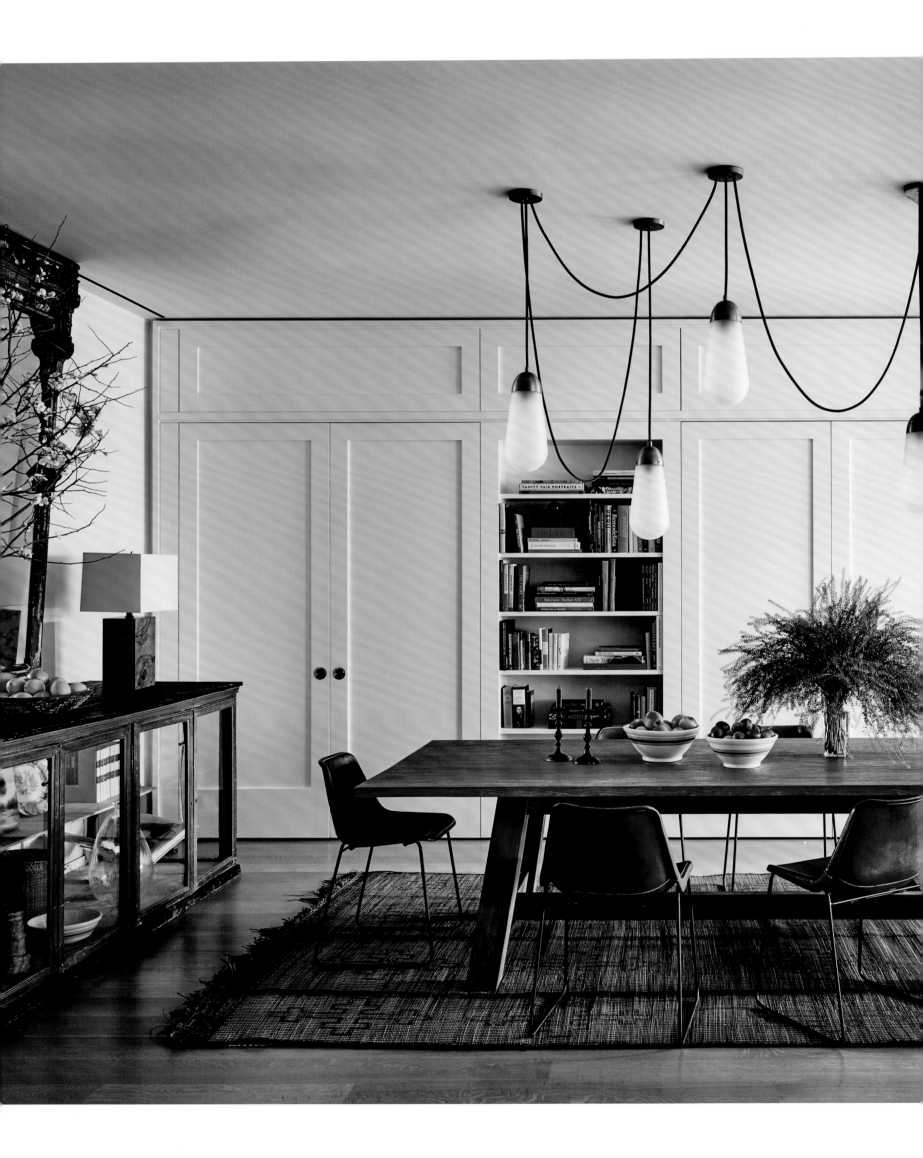

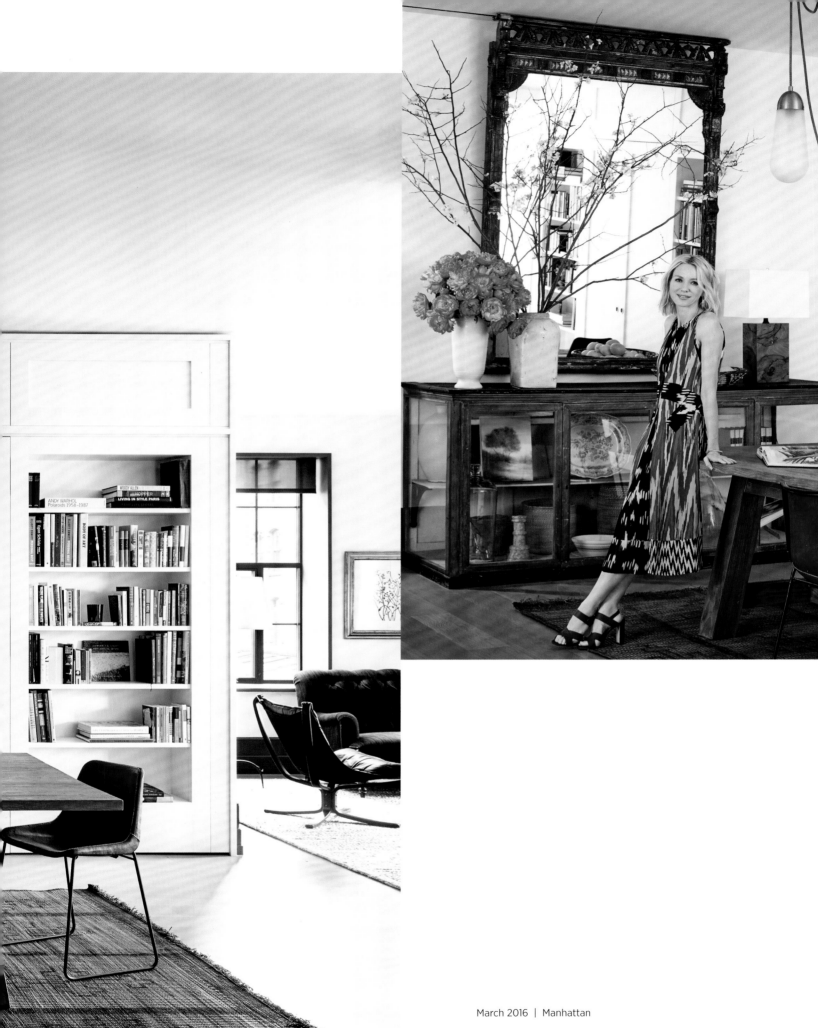

March 2016 | Manhattan

HOMEOWNER
Naomi Watts

The Oscar nominee turned to design firm Ashe + Leandro to transform a Tribeca artist's loft into an inviting oasis for her and then-partner Liev Schreiber and their two children. In the spare dining room, a sculptural Apparatus hanging fixture illuminates the farmhouse-style table, while a rug purchased in Morocco adds a warm note. Watts said, "I didn't want to make a showhouse."

June 2016
Coral Gables, Florida

HOMEOWNER
Alex Rodriguez

The baseball star's home in South Florida proves that cutting-edge art need not be at odds with family life. "It's fun to tell my girls who Basquiat was, who Warhol was," Rodriguez said. In the living room, blackened steel panels provide a rugged backdrop for a Keith Haring painting and a Gérard Van Kal Mon sculpture. The picture on the right is by Andy Warhol. Designer Briggs Edward Solomon attested, "Sometimes I'll catch Alex just standing back and looking at a painting. He gets this huge smile on his face."

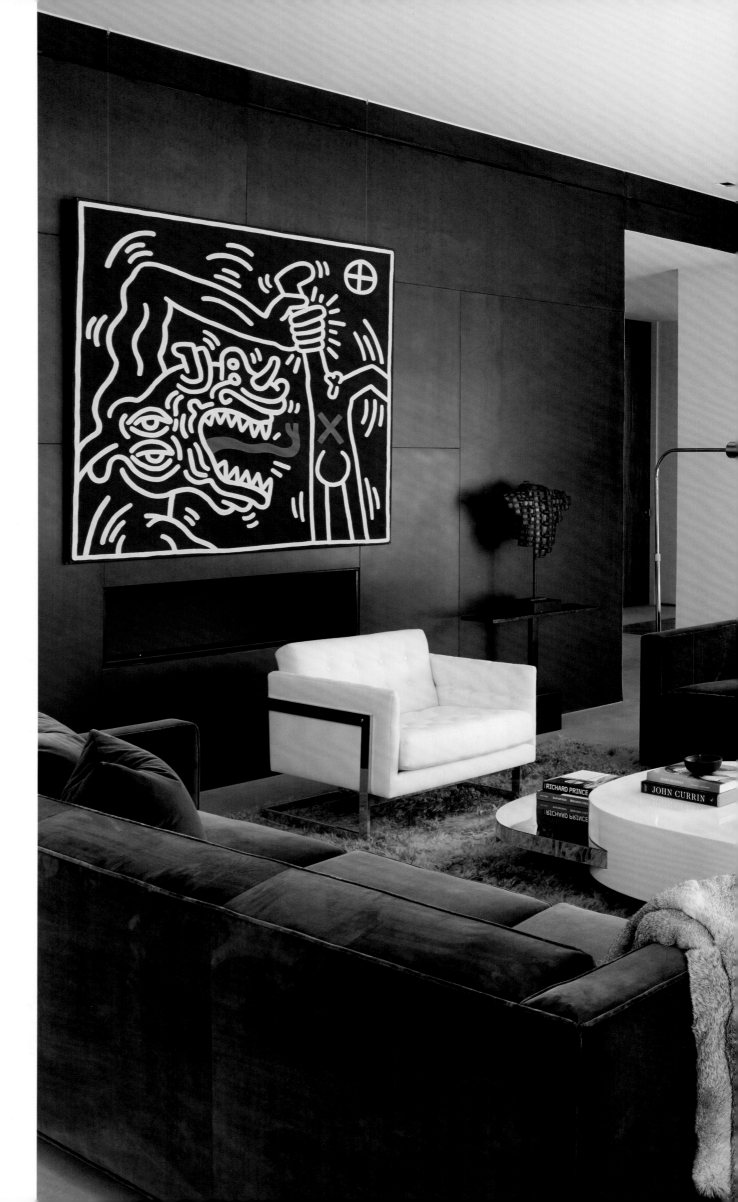

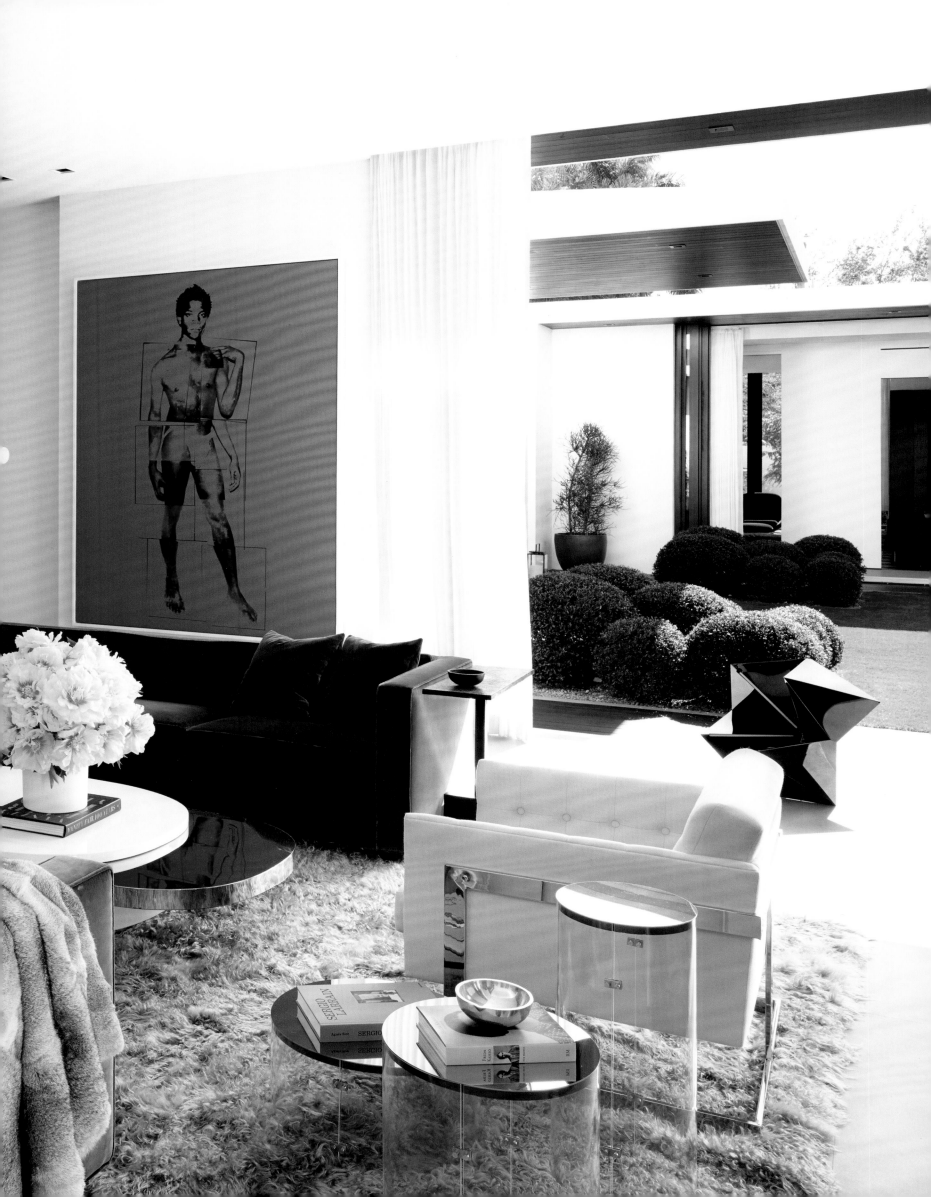

July 2011
Bel Air, California

HOMEOWNER
Elizabeth Taylor

Like the actress herself, Taylor's Bel Air estate was defined by beauty, effervescence, and an air of mystery. Her well-loved garden was a special source of pride. Climbing roses festoon an arbor, while pink cestrum and golden breath of heaven grow around a bench. Nearby, the actress's namesake flower—a shocking-pink hybrid tea rose—flourishes. "Her desire was for color and more color," landscape designer Nicholas Walker explained. " 'Let's be bold!' she said."

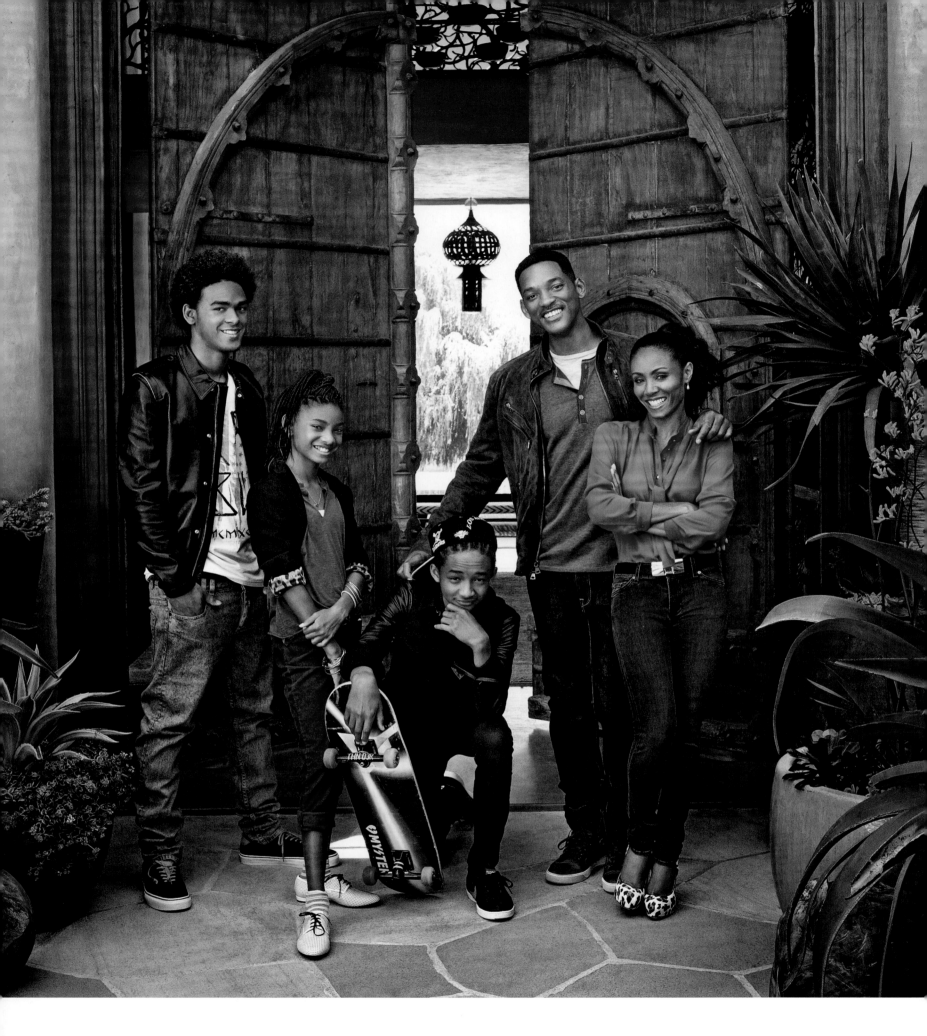

September 2011 | Calabasas, California

HOMEOWNERS Will & Jada Pinkett Smith

At the famous family's retreat, it all comes down to craftsmanship. "Everything needed to be done by hand," Will said. "We wanted to feel the love and labor that went into every piece of this place." Designed by architect Stephen Samuelson, the sprawling home still maintains an intimate, earthy feel. In the living room, resin tusks flank the entryway and a retractable skylight keeps the space bright.

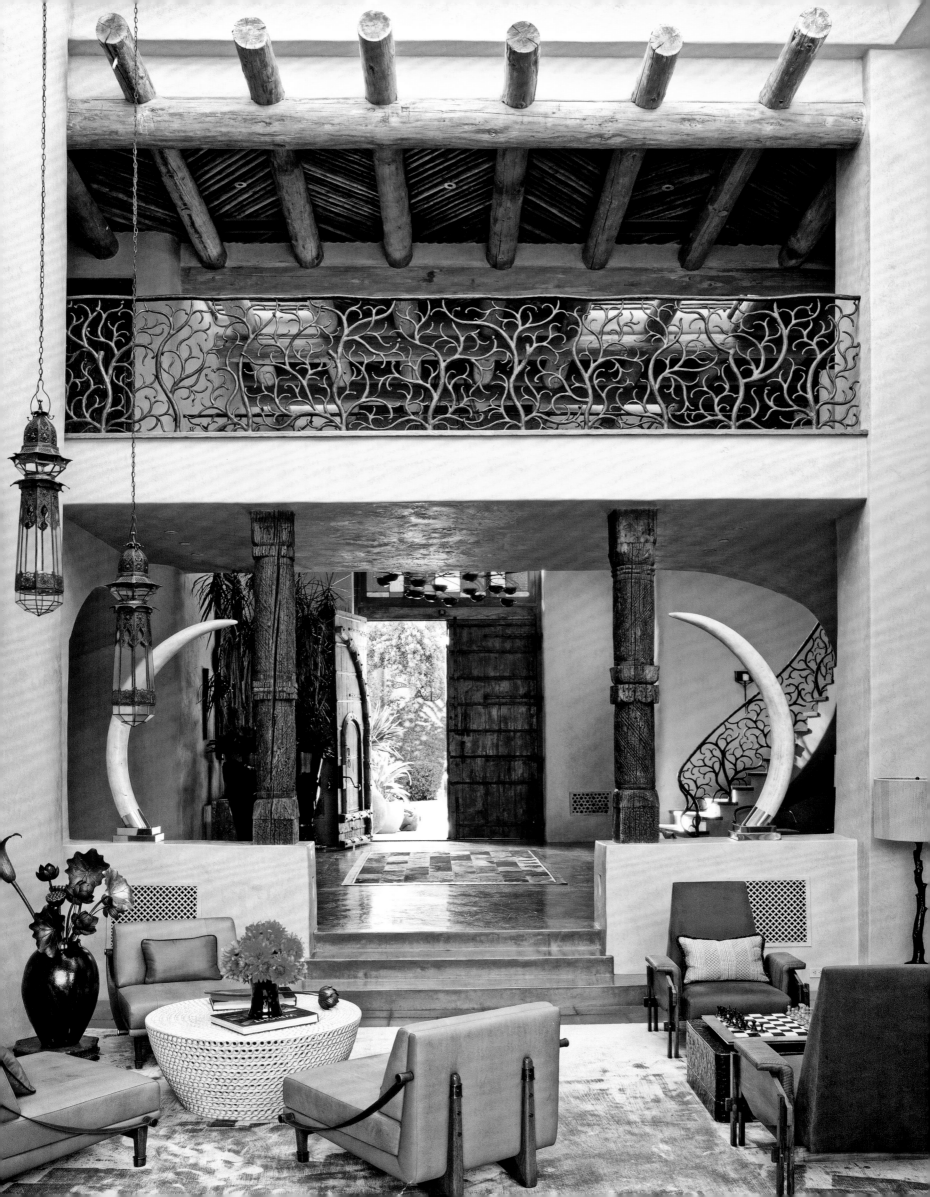

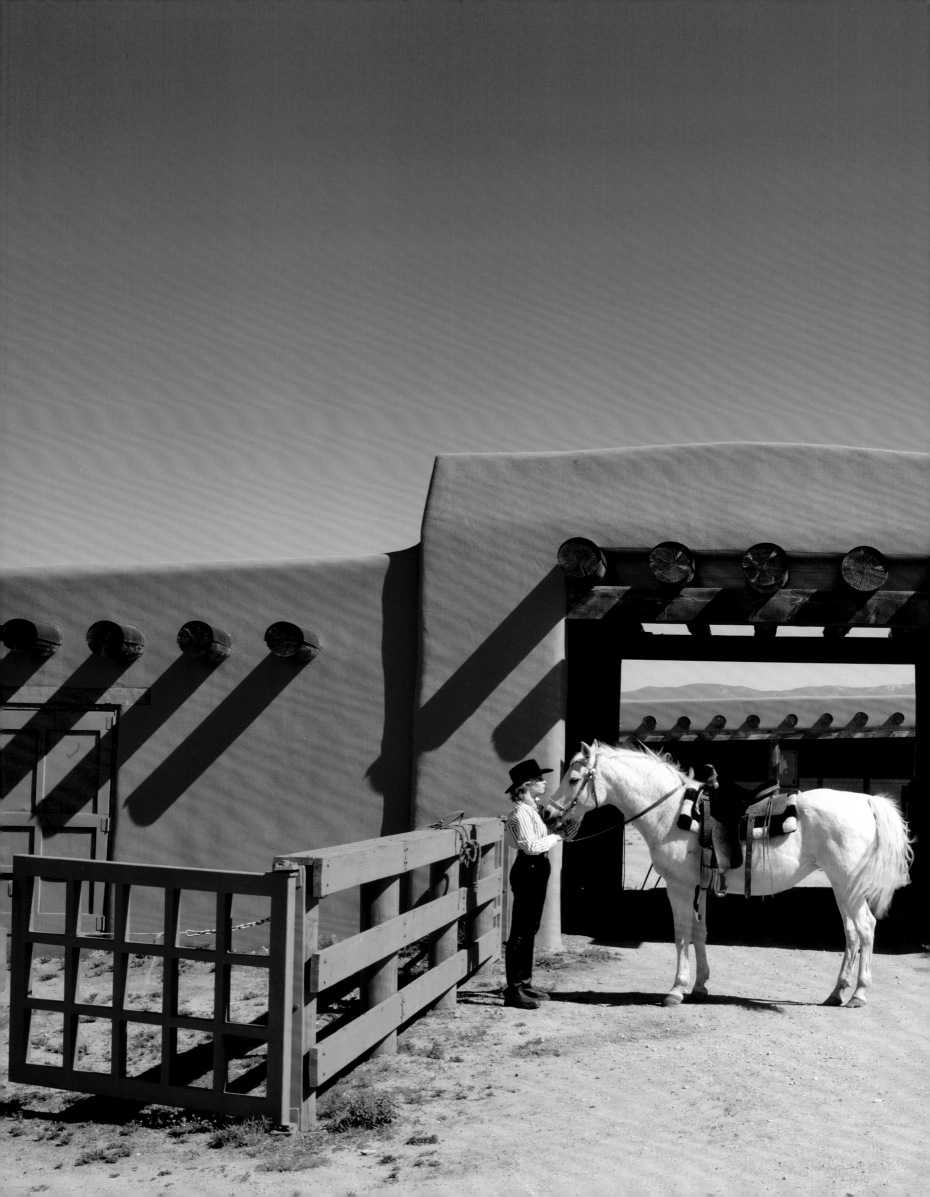

March 2014
Santa Fe

Forked Lightning Ranch

HOMEOWNER
Jane Fonda

At her New Mexico ranch, the actress lives a life far removed from the Hollywood grind. "It's where I healed after my marriage—it's where I came to understand my life so far," Fonda said. Stocked with Navajo rugs, rustic antiques, and colorful artifacts, her home serves as a personal oasis. In front of a barn, Fonda stands with her Arabian mare Gitane.

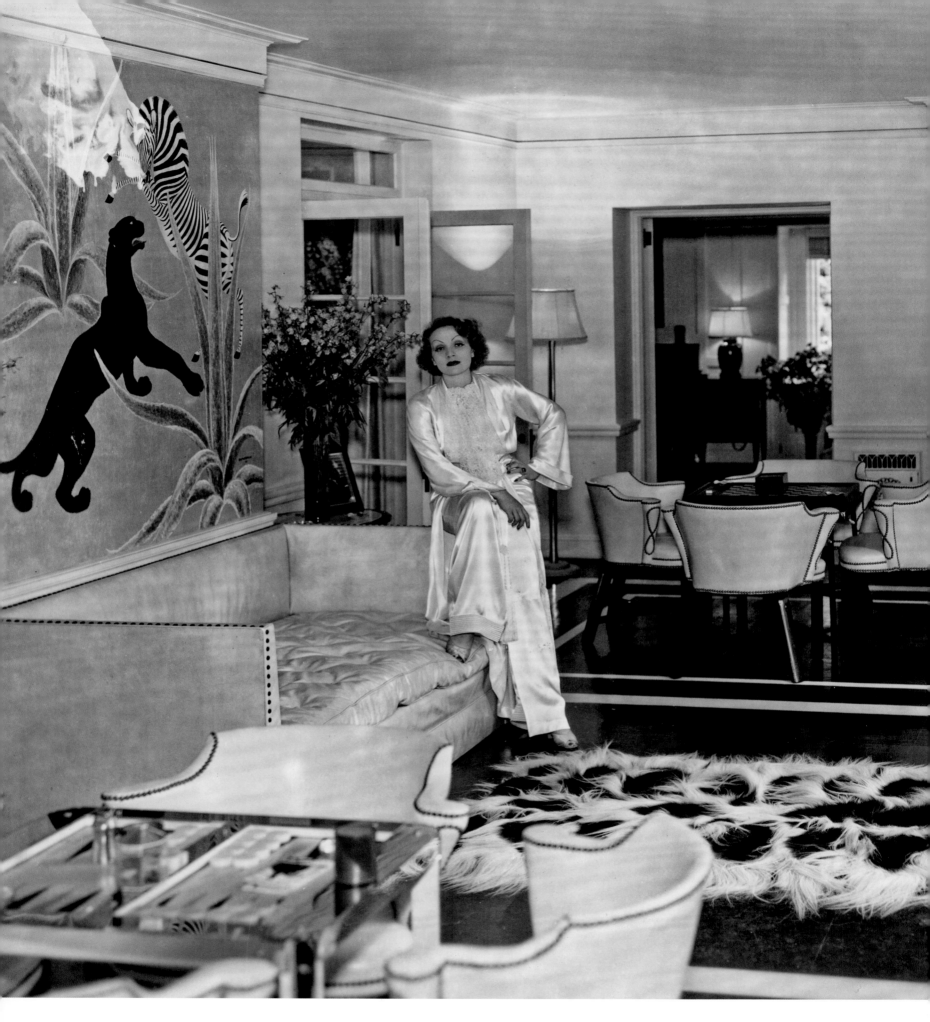

April 1990 (photograph circa 1930s) | Beverly Hills

HOMEOWNER Marlene Dietrich

Despite never bringing her most treasured furnishings to America, the German-born actress lived in a Beverly Hills showplace designed by the pioneering decorator Elsie de Wolfe. Dietrich granted interviews in her seductive lounge, which featured an Art Deco mural, tuxedo sofa, and de Wolfe's preferred pale palette.

November 2001 | Manhattan

HOMEOWNER Mariah Carey

Glitter and glamour abound in the singer's New York triplex, designed by the one and only Mario Buatta. In the unabashedly opulent dressing room, the open viewing arrangement and monochrome furnishings put her extensive wardrobe on full display. Buatta put it simply: "Mariah loves luxury."

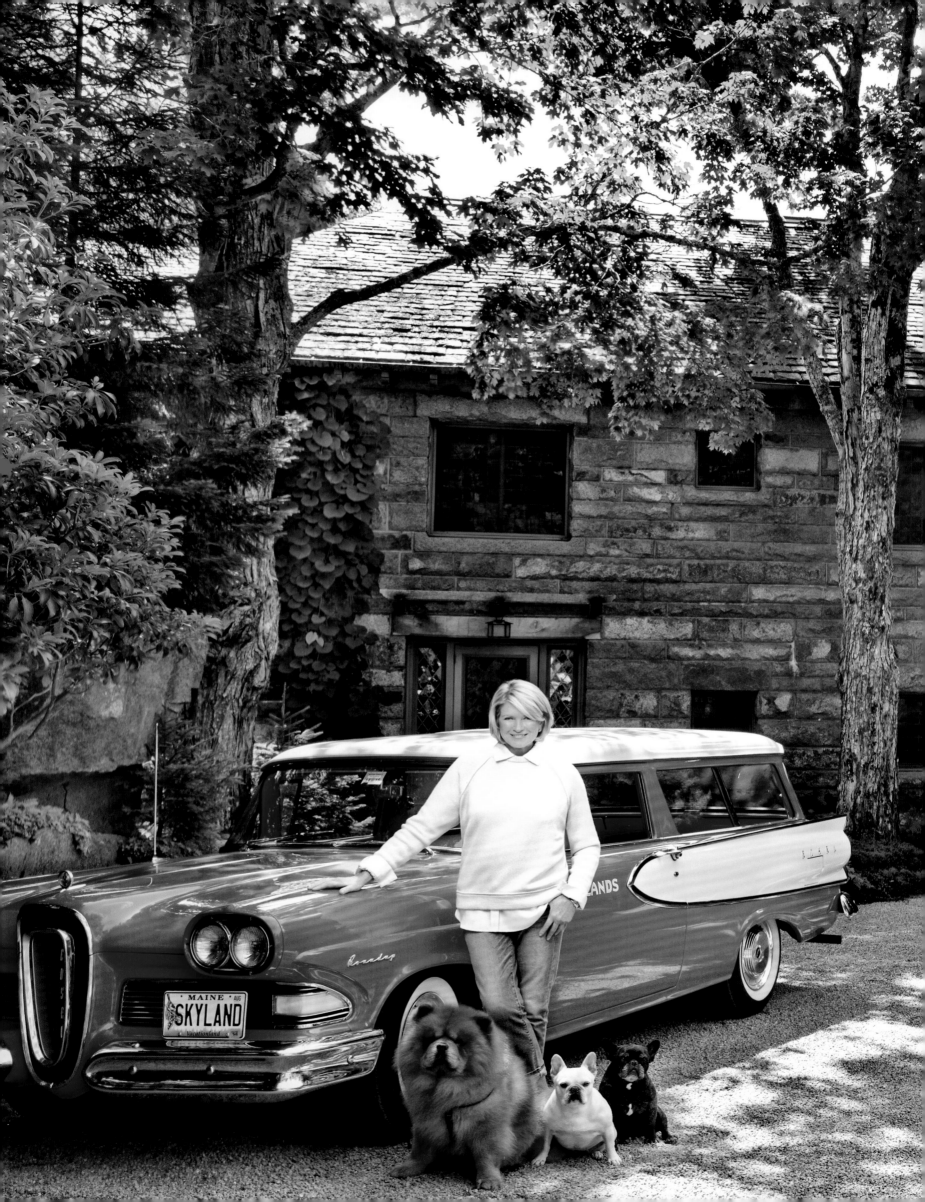

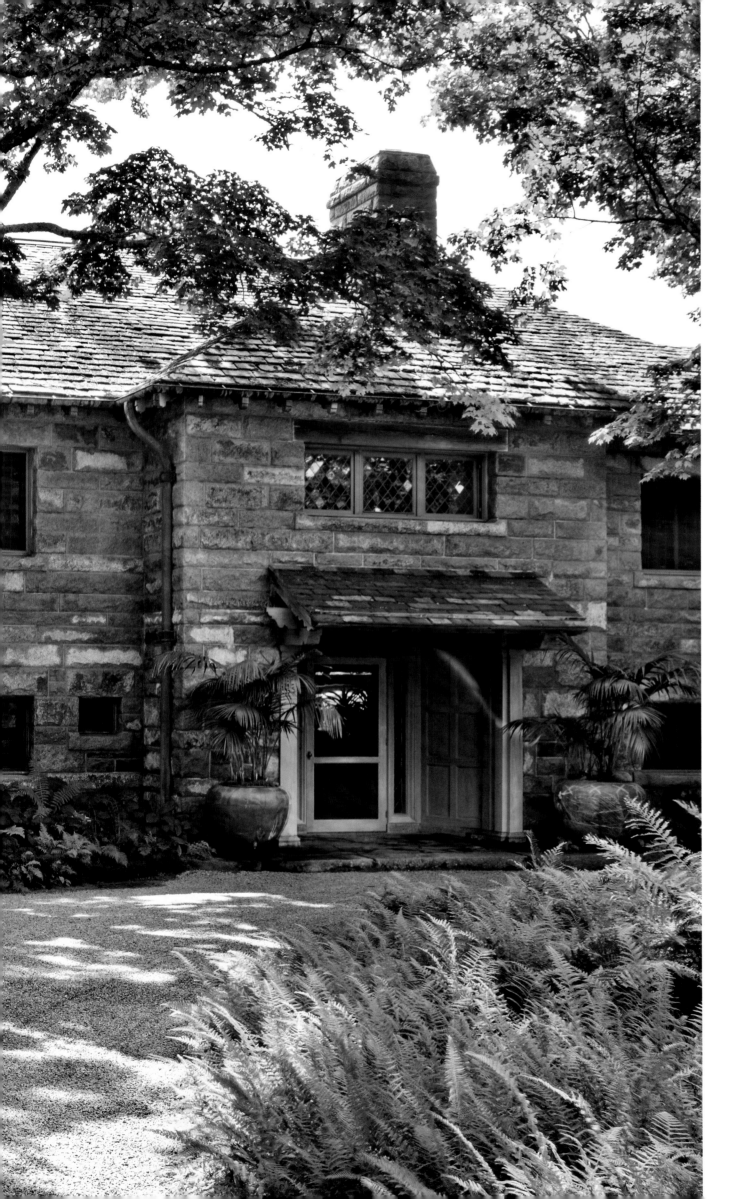

July 2015
Seal Harbor, Maine

Skylands
HOMEOWNER
Martha Stewart

At her estate in Maine, the domestic goddess preserves the legacy of a great American country house. Completed in 1925 for automotive executive Edsel Ford by architect Duncan Candler, the broad-shouldered home sits high on a hill overlooking Seal Harbor. "I look at myself as the caretaker of an American treasure," Stewart said. In front of the stone-clad residence, she poses with her chow chow Ghenghis Khan and French bulldogs Sharkey and Francesca.

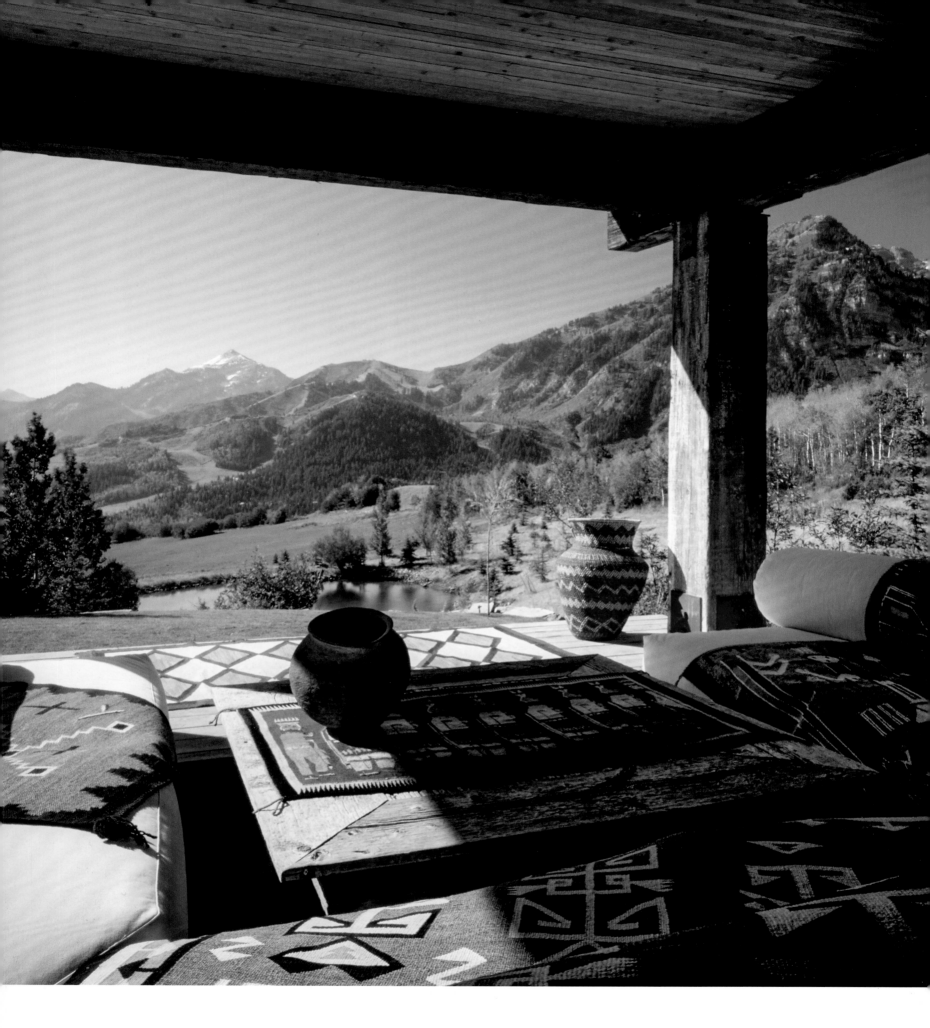

April 1989 | Sundance, Utah

HOMEOWNER Robert Redford

"Sundance is a mixture of old and new, lush and spare, sophisticated and primitive—like art itself," said the actor-director, who spent decades developing the Utah ski resort into a community dedicated to the arts. Thanks to his efforts, the town is now synonymous with its namesake film festival. At Redford's home, alfresco pavilions and soaring glass windows capture dramatic panoramas of the majestic local scenery.

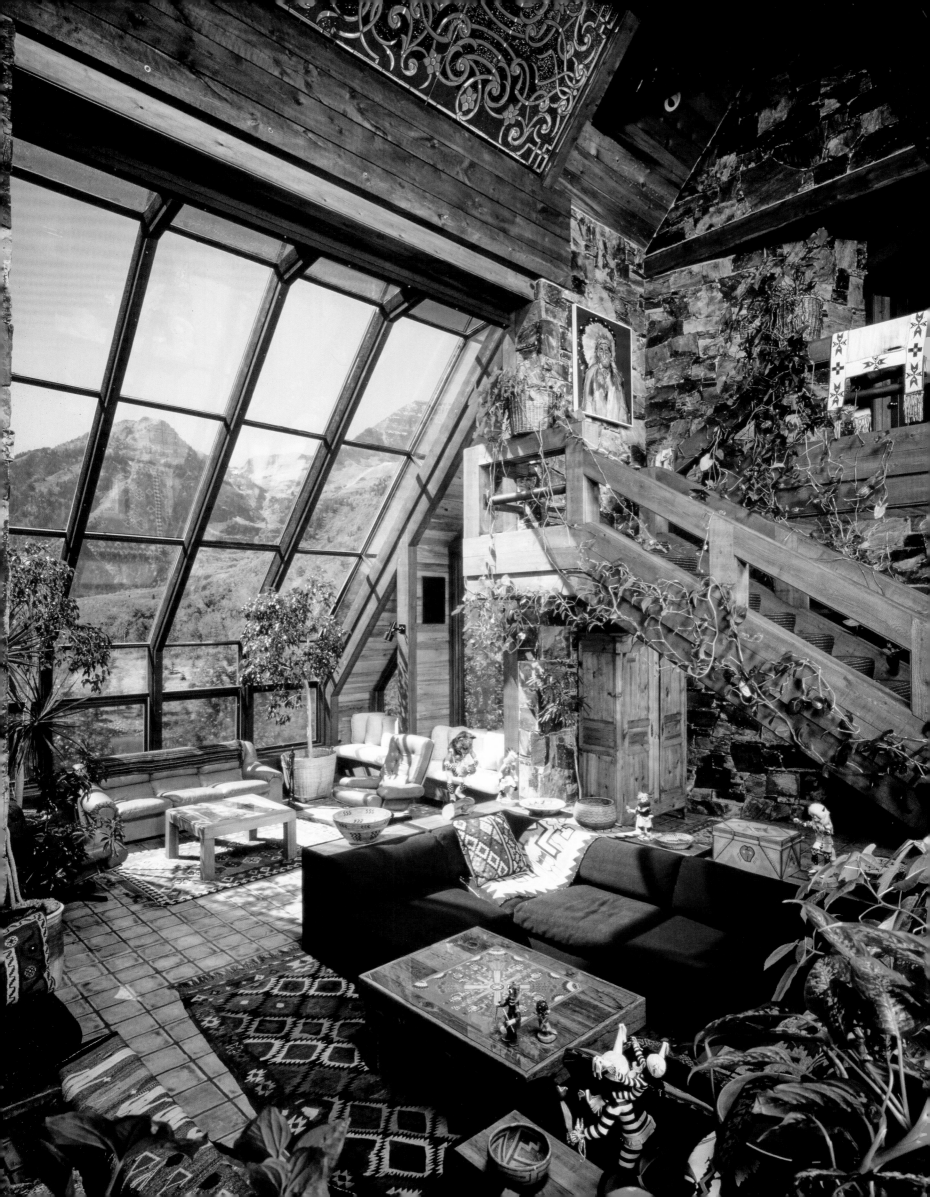

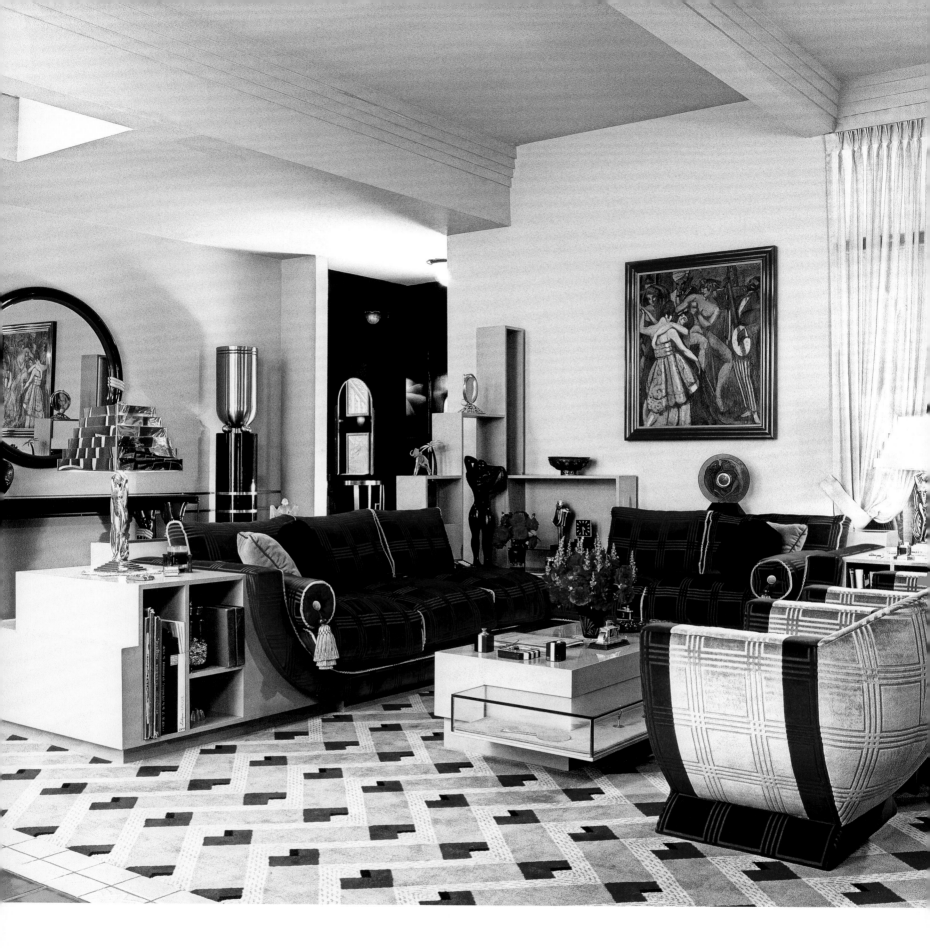

December 1993 | Malibu, California

HOMEOWNER Barbra Streisand

The multi-talented megastar is known as an inveterate collector, learning everything about a particular style or period when she is decorating a home. "It's designed as a total vision," she reflected of her pumped-up Art Deco abode in Malibu, which was first conceived in the 1970s. True to form, her house is meticulously detailed down to the smallest Lalique vase.

April 1996 | Venice, California

HOMEOWNER Anjelica Huston

The actress resides in a boxy, white volume of a house designed by her sculptor husband, Robert Graham. "Bob is training me in restraint," Huston said, "but not in austerity or minimalism." Huston stands in the home's living room, which is clad in unpainted plaster. "He gave me a beautiful shell in which to place my oyster."

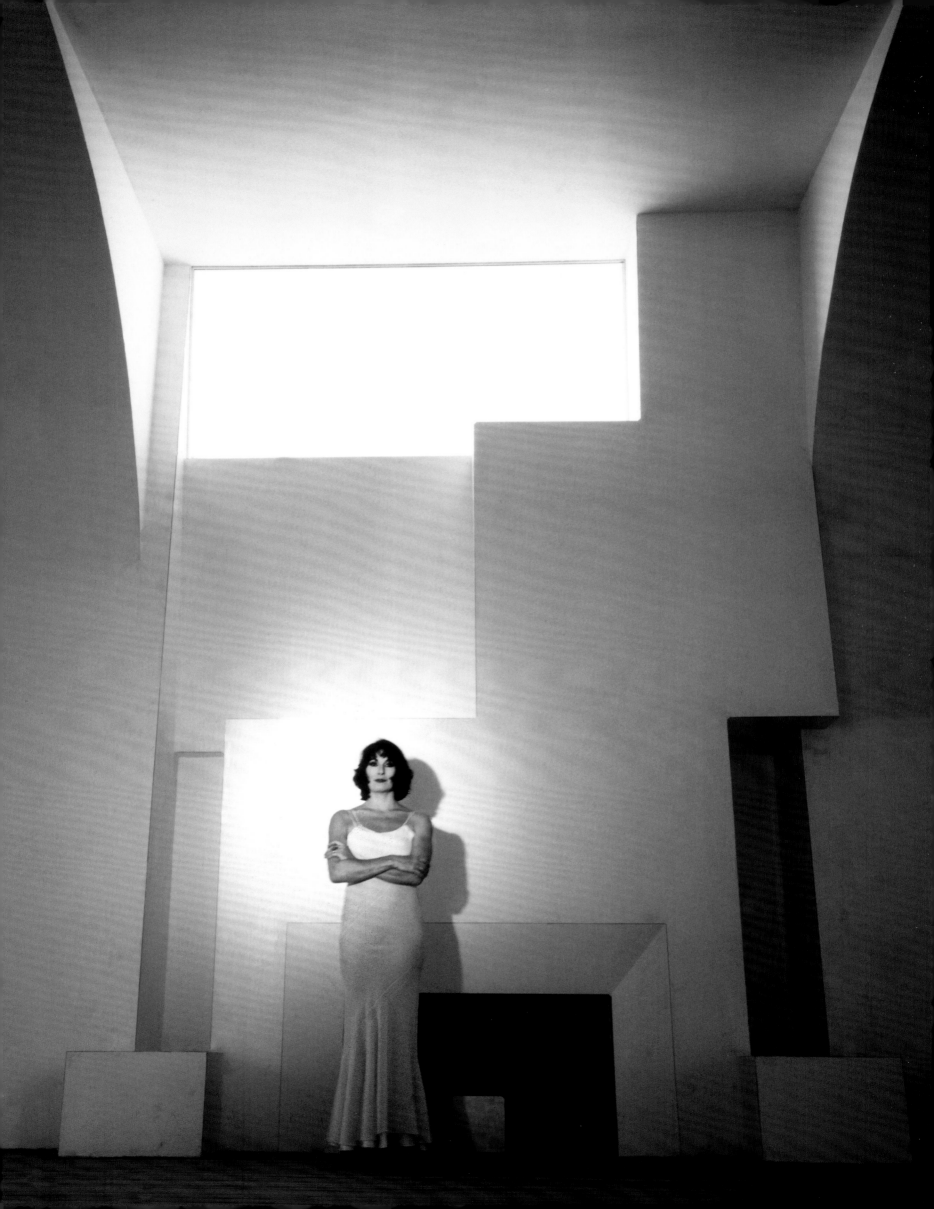

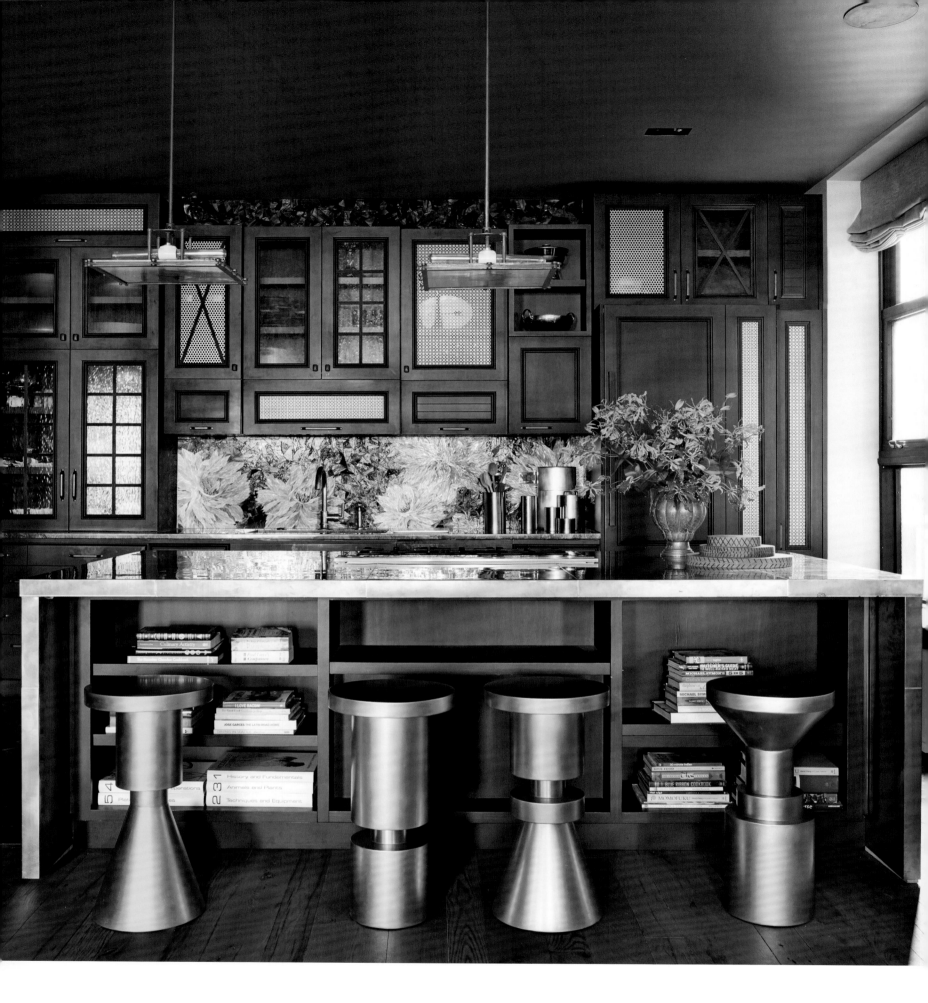

February 2015 | Manhattan

HOMEOWNERS *John Legend & Chrissy Teigen*

For their retreat from the fast lane, the award-winning singer-songwriter and his model wife crafted a homey apartment with the help of designer Don Stewart. The loftlike one-bedroom instantly drew the couple in with its dark, moody atmosphere. "We tend to look for the opposite of what most people want," Legend said. Rich metallic finishes coalesce in the kitchen, which features a bronze-wrapped island, dark cabinetry, and a custom mosaic backsplash.

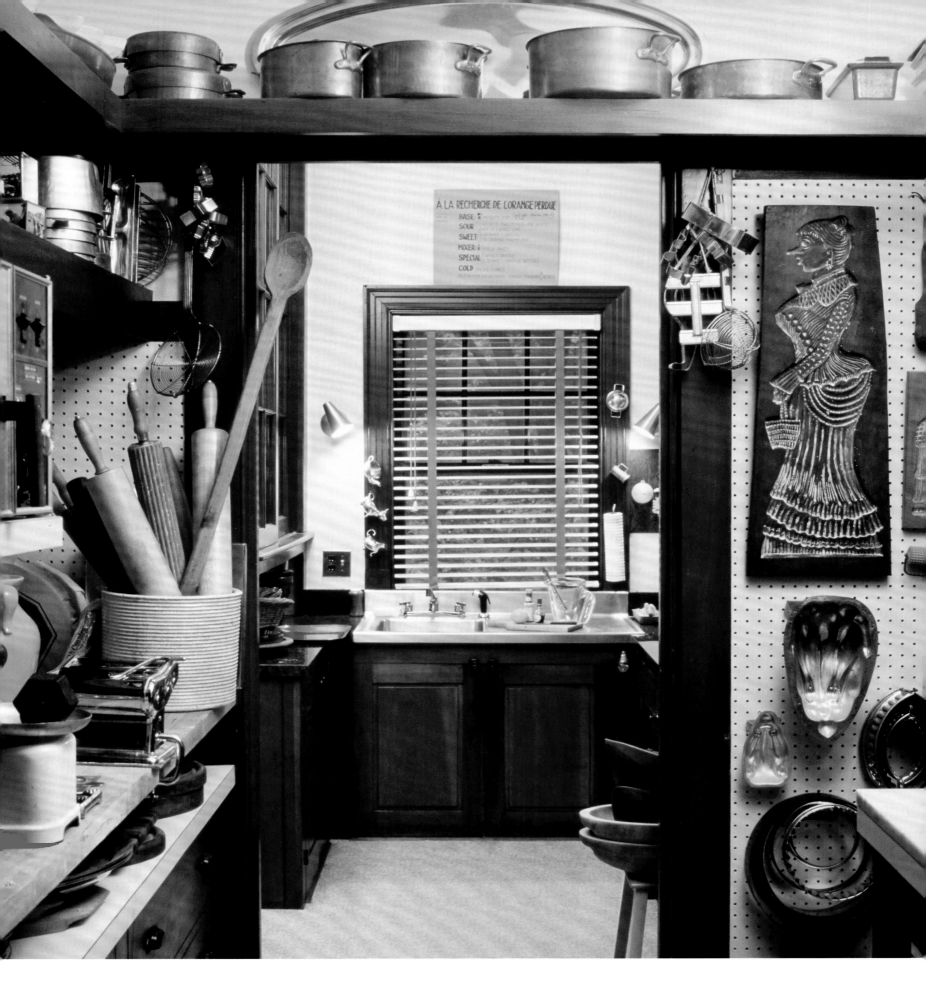

July/August 1976 | Cambridge, Massachusetts

HOMEOWNER Julia Child

The groundbreaking chef's home was centered, predictably, on the kitchen. It was the "beating heart" of her clapboard house, which was packed to the gills with cooking tools and personal artifacts. In the pastry room, baskets of rolling pins and other utensils abound. Child said the kitchen "is certainly the most-loved and most-used room in the house."

January 2011
Tuscany

Villa Il Palagio
HOMEOWNERS
Sting & Trudie Styler

Near Florence, landscape designer Arabella Lennox-Boyd conceived a heavenly garden for the musician and the movie producer. The seven-year, seven-acre project transformed the landscape with a sprawl of olive trees, boxwood, and mature cypresses. "Arabella believes more is more in a garden, with lots of color and texture, and I applaud that," Styler said. A terrace offers views of the couple's biodynamic vineyards and the Chianti hills beyond.

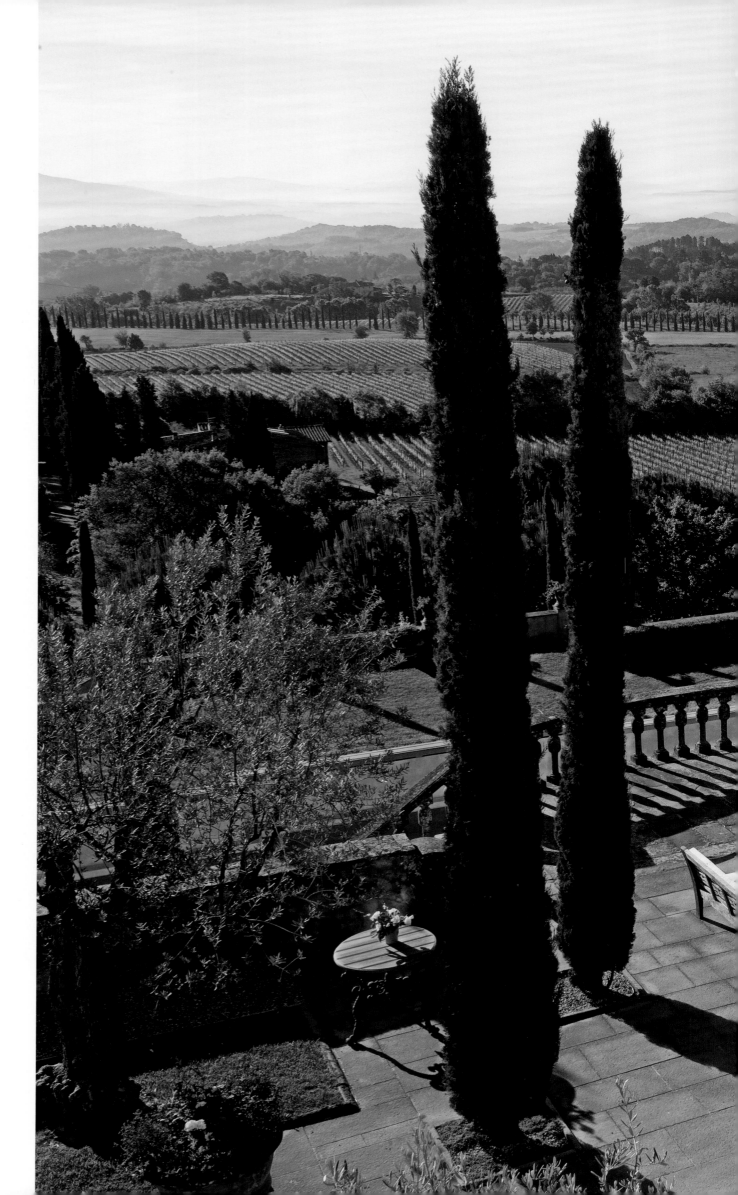

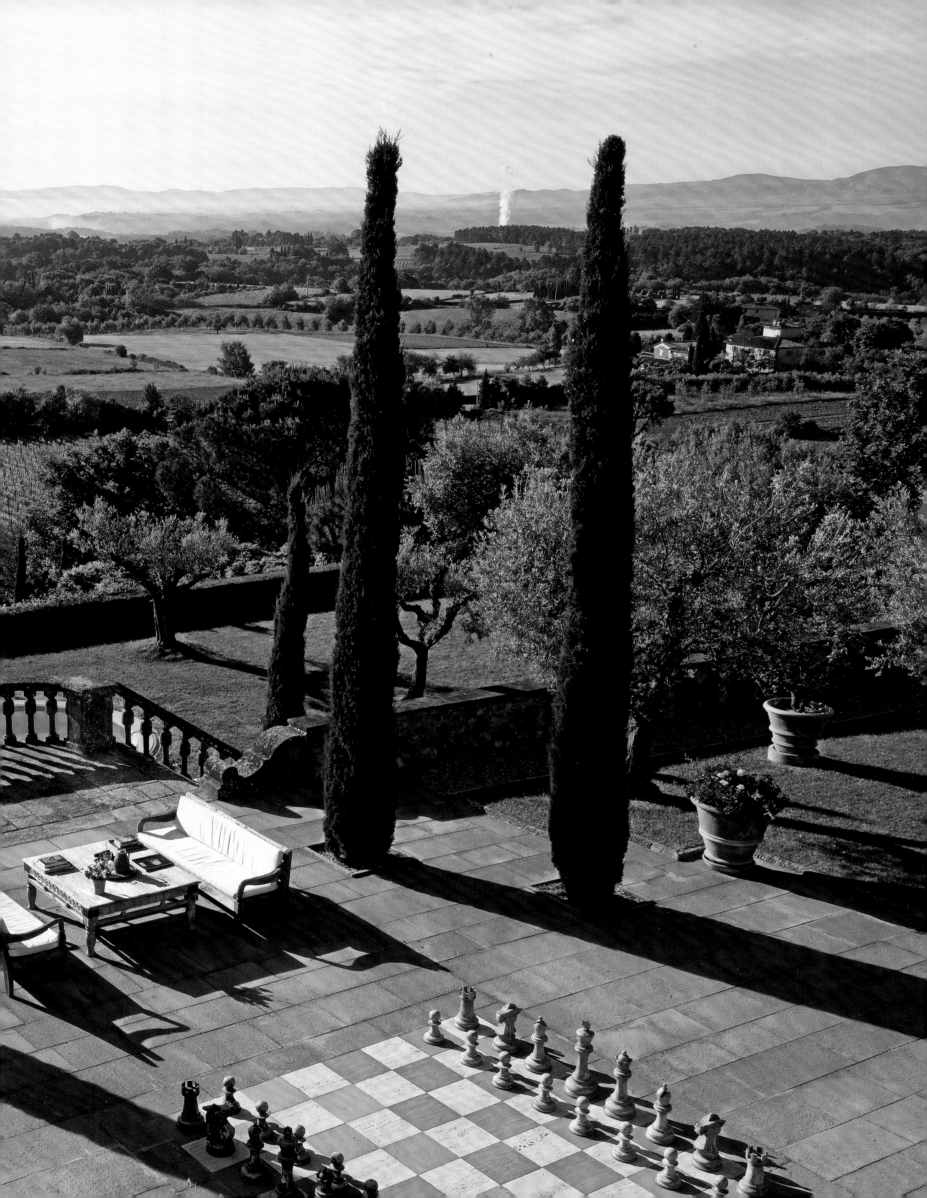

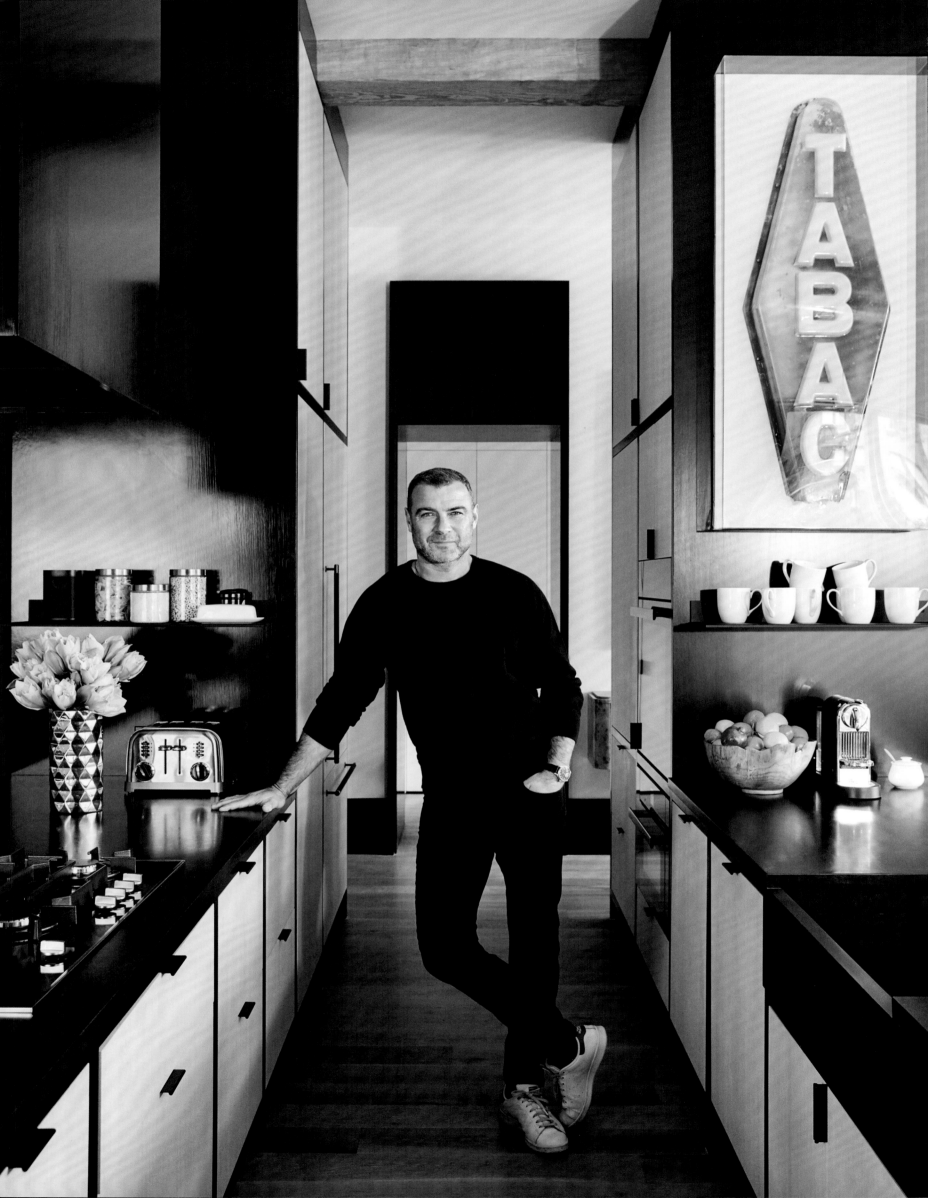

June 2018 | Manhattan

HOMEOWNER Liev Schreiber

When the actor wanted to retool his triplex apartment in Manhattan's NoHo district, he was clear about one thing—he did not want a bachelor pad. "He wanted a real home, one that catered to family and kids," said Reinaldo Leandro of design firm Ashe + Leandro, who warmed up the raw, open space with Douglas fir cabinetry in the kitchen. Schreiber said of his reborn digs, "I never dreamed I'd own a place like this."

September 1992 | Mustique

Mandalay HOMEOWNERS David Bowie & Iman

"I think Mustique is Duchampian—it will always provide an endless source of delight," said the music icon of his Caribbean getaway. The sprawling Indonesian-style retreat offered twists and turns around each corner, no two rooms having the same aesthetic. A formal living area with 19th-century-style furnishings was topped with a vintage chandelier, found in London. Bowie added, "It's a whim personified."

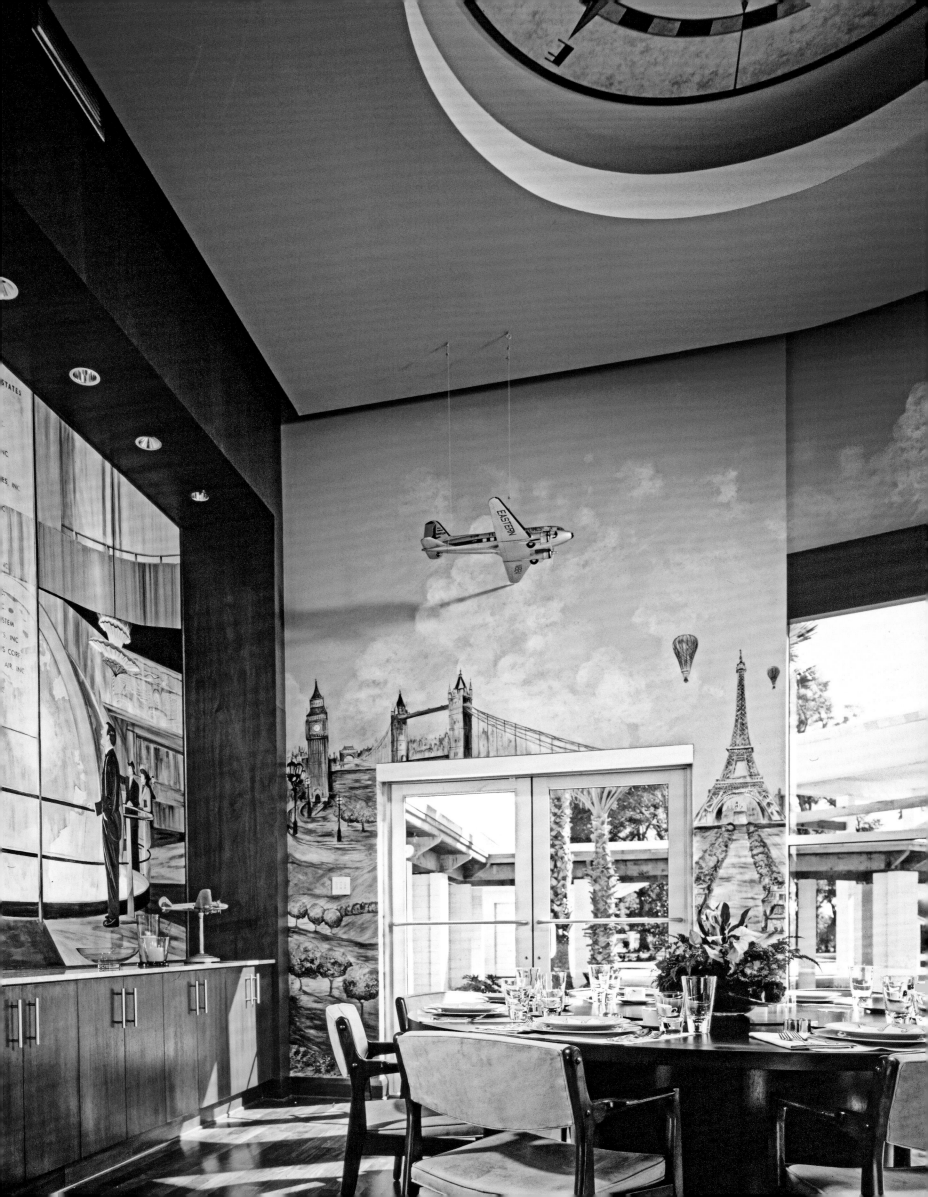

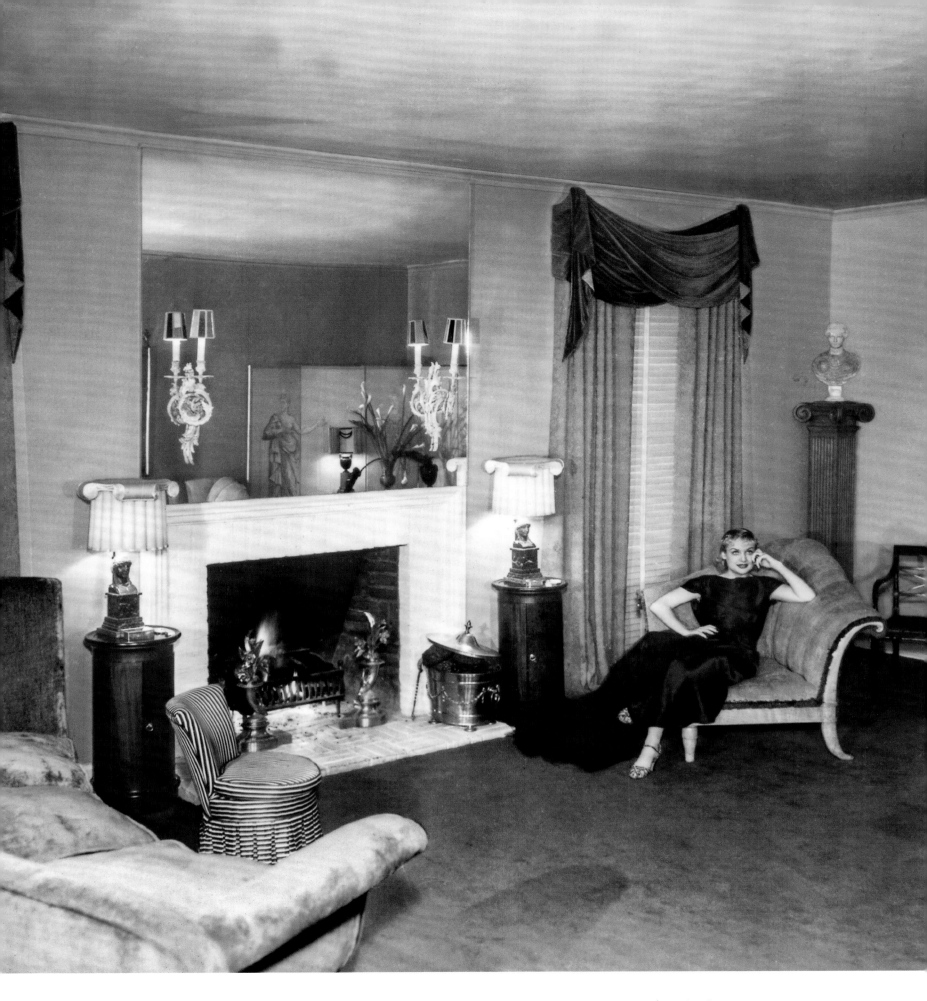

April 2004 | Florida

HOMEOWNERS John Travolta & Kelly Preston

The airplane-obsessed actor put his hobby front and center in his family's Florida home, covering the dining room with an aviation mural by Sandra Hilliard. "When I was a kid, I imagined that by the turn of the century everyone would have his own plane in the backyard," Travolta said. Though history didn't live up to his lofty prediction, Travolta made it a personal reality—his 707 is parked out back on a full-size runway.

March 2006 (photograph circa 1930s) | Los Angeles

HOMEOWNER Carole Lombard

A star of the Golden Age of cinema, Lombard enlisted friend and actor William Haines to mastermind the interiors for her Dutch-style residence in the Hollywood Hills. This project was the fledgling designer's big break, catapulting him to fame beyond the silver screen. In the living room, custom lamps fashioned from marble busts flank a fireplace while Lombard poses on a tufted chaise.

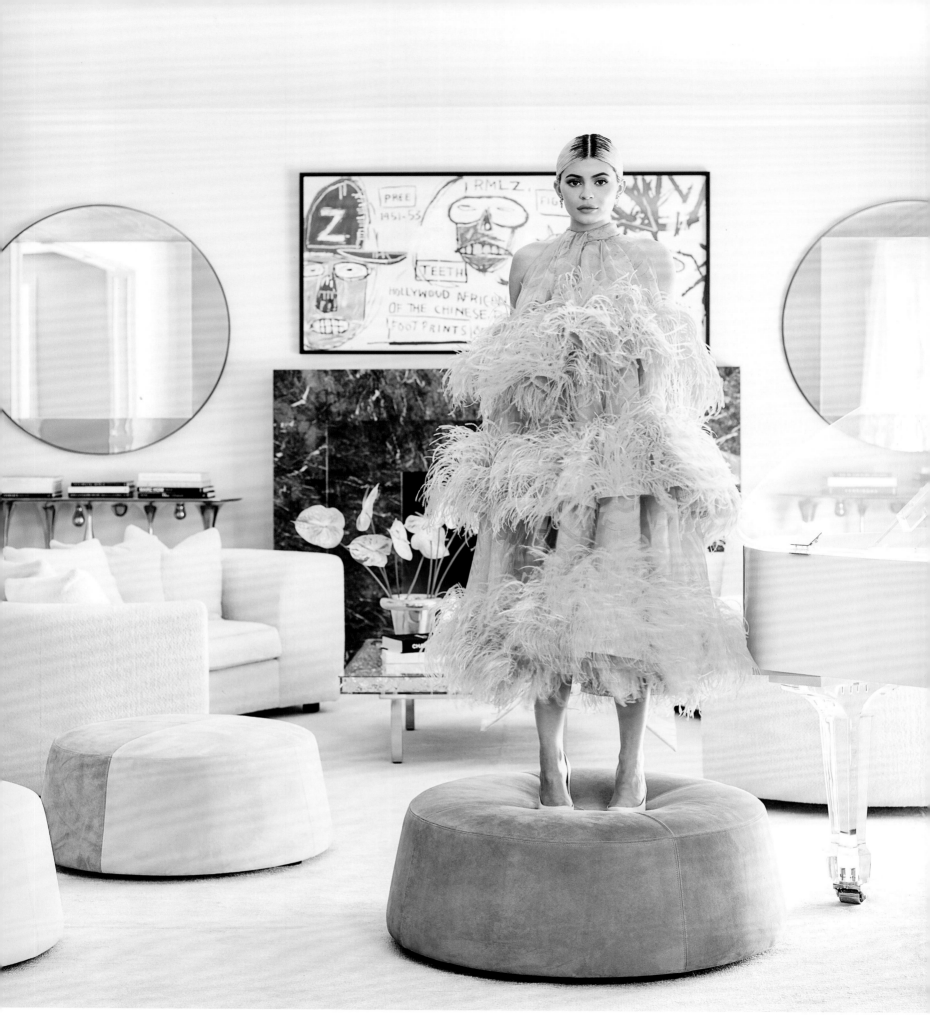

March 2019 | Hidden Hills, California

HOMEOWNER Kylie Jenner

The makeup tycoon, reality-television starlet, and youngest member of the Jenner-Kardashian clan savors the sweet smell of success
at a dazzling home decorated by Martyn Lawrence Bullard. In her living room, Jenner stands atop a suede pouf next to a grand piano,
while a Jean-Michel Basquiat screen print hangs above the marble-surround fireplace.

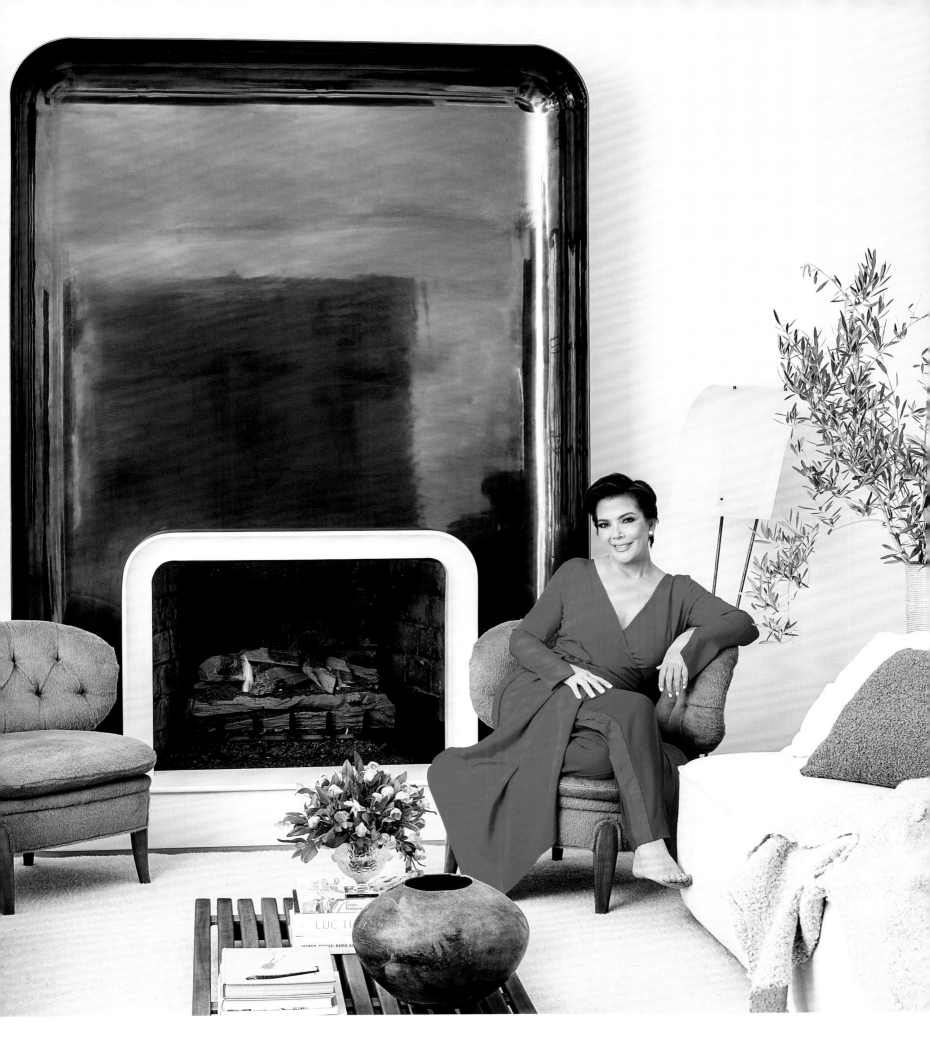

March 2019 | Hidden Hills, California

HOMEOWNER **Kris Jenner**

"I wanted my home to feel like a sanctuary, perfectly calm and peaceful," said the self-described "momager" of her private getaway, designed by Waldo Fernandez in collaboration with Tommy and Kathleen Clements. Her zenlike pad is awash in classic pieces by 20th-century design notables from Perriand to Royère. In the living room, Jenner lounges on an alpaca wool–clad chair.

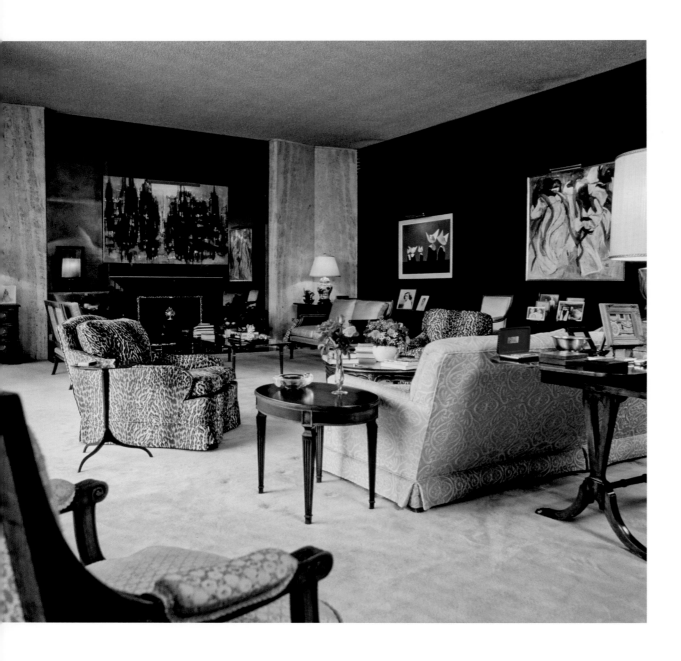

March 1977
Beverly Hills

HOMEOWNER
Fred Astaire

"I don't think too much about my house," said the beloved dancer and actor. "I just enjoy it." Relaxation came easily at Astaire's Beverly Hills home, tucked on a quiet, tree-lined road far from the bright lights of Hollywood. In classic indoor-outdoor style, the living room opens onto a slate terrace that faces the pool and rose gardens.

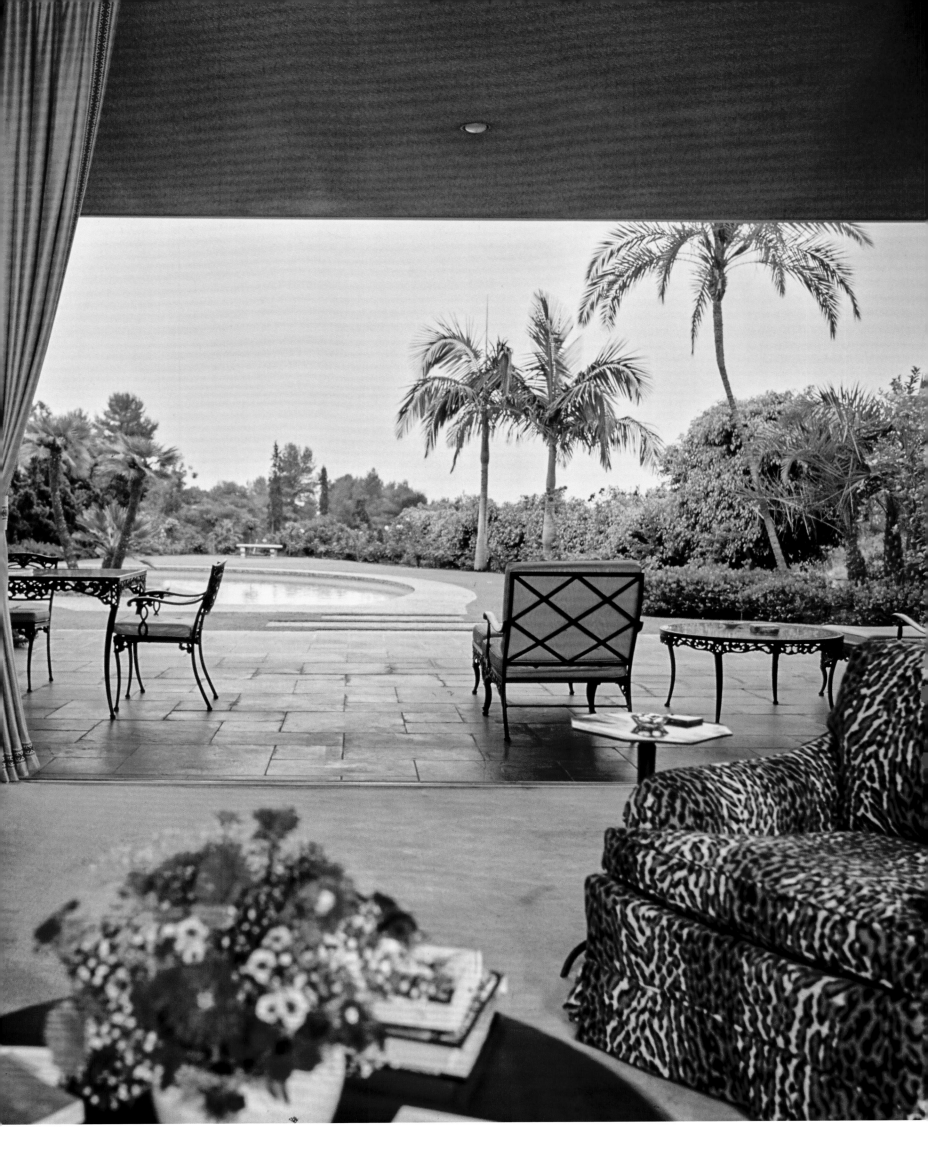

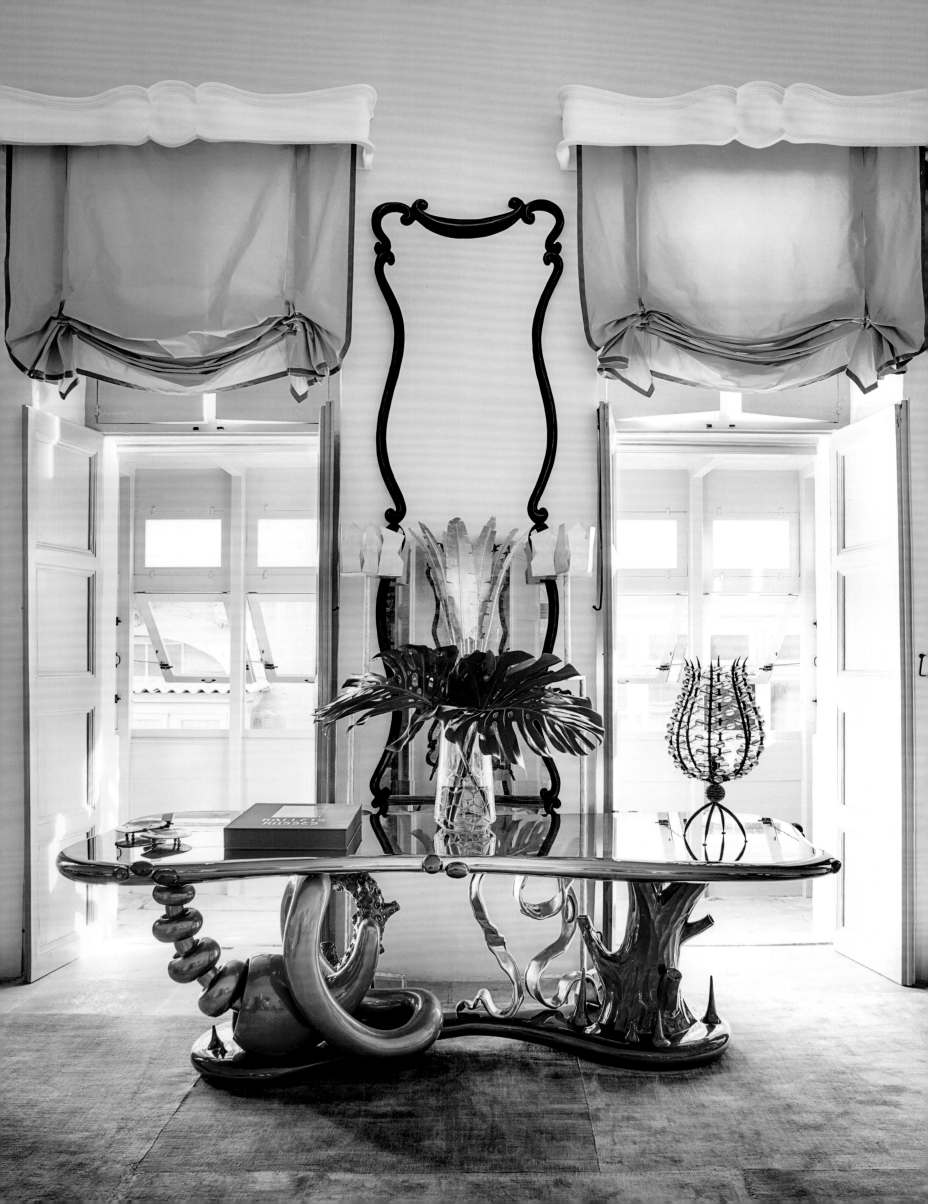

Francis Sultana
Monique Gibson
Ashley Hicks
Bunny Williams
John Fowler
Oscar Niemeyer
Tino Zervudachi
Juan Pablo Molyneux
Rose Tarlow
Alex Papachristidis
Marie-Anne Oudejans
Elsie de Wolfe
Peter Pennoyer & Katie Ridder
Nancy Lancaster
Tom Scheerer
Markham Roberts

Designers' Own Homes

Peter Marino
Mario Buatta
Muriel Brandolini
John Stefanidis
Fernando Caruncho
Veere Grenney
Axel Vervoordt
Daniel Romualdez
Thomas O'Brien & Dan Fink
Lee F. Mindel
Jay Spectre
Michael S. Smith
Albert Hadley
Henri Samuel
Laura Sartori Rimini
Michelle Nussbaumer
Frank Lloyd Wright

PREVIOUS SPREAD
A console by
Mattia Bonetti
anchors the Grand
Salon of Francis
Sultana and David
Gill's Maltese palace
(*AD* April 2018; see
page 132).

HELPING OTHERS realize the home of their dreams can be a 24/7 job. A typical project takes years to complete, with hours of shopping, conversing, and, let's be honest, compromising. So you might be forgiven for thinking that floor plans and color palettes would be the last things a designer wants to think about on his or her downtime. But most don't turn it off when they get home. In fact, they turn it up, using their residences as laboratories while enjoying the ultimate luxury: working to please themselves.

As *Architectural Digest* has chronicled for decades—and since 1996, spotlighted in its annual *Designers' Own Homes* issue—these are places where the best in the field indulge fantasies, satisfy whims, and experiment. In his London apartment, *Ashley Hicks* painted a panoramic mural depicting Constantinople circa 1818 that cheekily incorporates elements of his own Oxfordshire getaway, including portraits of the beloved chickens he keeps there. *Muriel Brandolini*, a fearless colorist, used no fewer than 23 shades of paint throughout her Hamptons home, at least two different hues in each room.

Intrepid decorators and architects often think nothing of creating a space entirely from scratch. *Arthur Elrod* commissioned *John Lautner* to design an architectural tour de force that perches on a rocky ridge above Palm Springs. *Frank Lloyd Wright* nestled his Taliesin into the rolling Wisconsin countryside. And *Peter Pennoyer* and *Katie Ridder* built

their family's dream house, a four-square Greek Revival manse, from the ground up on six bucolic acres in upstate New York.

On the other hand, many can't resist the siren call of the past. See, for example, *Axel Vervoordt*'s Venetian flat in a 15th-century palazzo, *Francis Sultana*'s 16th-century Maltese palace, or *Juan Pablo Molyneux*'s suite of rooms in a Parisian 17th-century hôtel particulier. Of her beloved Villa Trianon in Versailles, *Elsie de Wolfe* recalled that when she first glimpsed it in 1903, it was like "a beautiful woman who had had a tragic history and who had grown worn and faded before her time." Stirred to rescue the house, de Wolfe spent the next 45 years transforming the elegant 18th-century *pavillon* into the beau ideal of 20th-century taste and style. (The house remained such a paragon that *AD* documented it in 1996, nearly 50 years after de Wolfe's death.)

In the hands of masters like *Albert Hadley* or *Stephen Sills* and *James Huniford*, even cookie-cutter New York City apartments can become glorious personal statements. When *AD* visited *Mario Buatta*'s own diminutive yet treasure-filled Upper East Side flat in 1974, the gregarious designer put his finger on the appeal—and the possible pitfalls—of seeing a professional's own residence: "Sometimes people come into my apartment and say, 'Oh, give me a room like this one.' I can't. One just cannot. It's a very difficult thing to do because one's home is usually personal, especially mine." ▲D

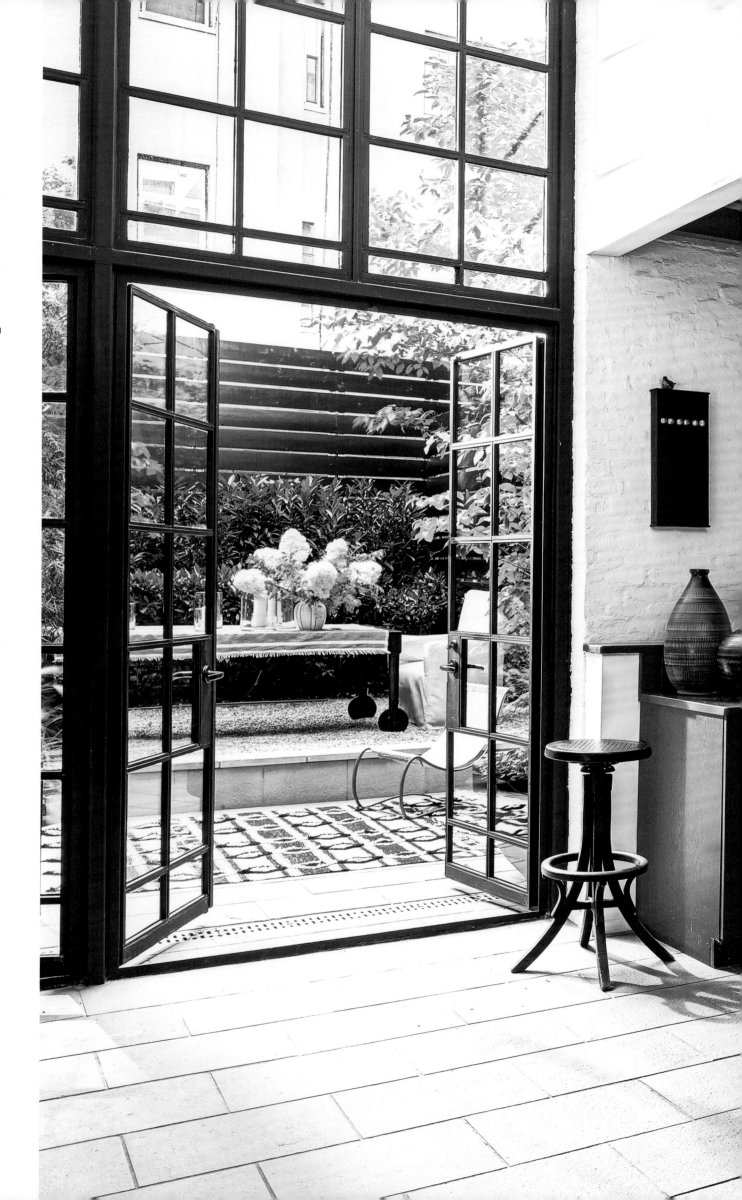

April 2018
Manhattan

HOMEOWNER/DESIGNER
Monique Gibson

"It's a living canvas," the designer said of her East Village townhouse, which does double duty as home and office. "Sometimes things come in and go out very quickly." Though Gibson believes that "we're just the temporary keepers of things," she did admit a certain fondness for a piece by Israeli furnituremaker Gal Gaon. "Sometimes it's my desk, sometimes it's my meeting room, sometimes it's my kitchen table." Taking a convivial approach to her work, she often entertains clients in the space. "I'll bring in a chef, set everything up, and do the meeting right here."

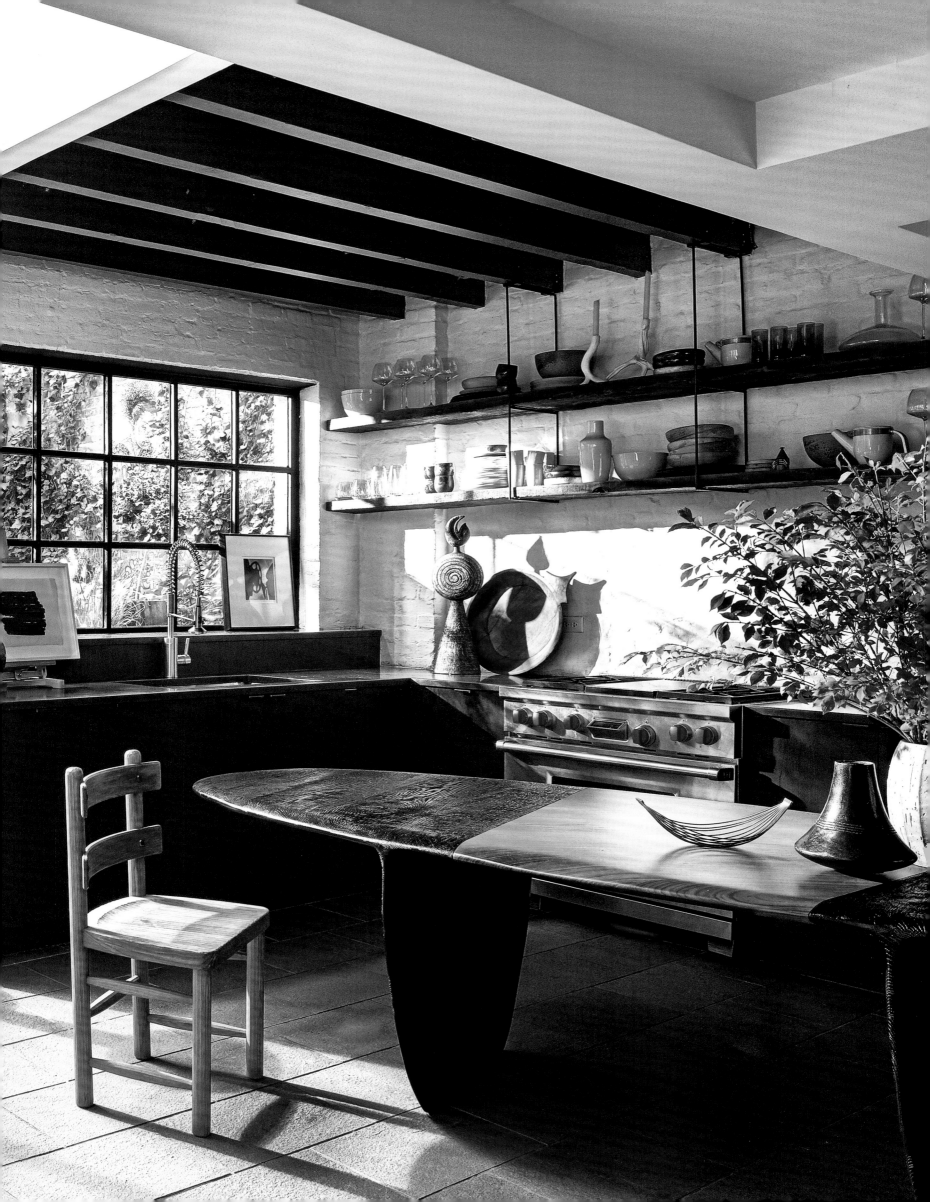

April 2017
London

HOMEOWNER/DESIGNER
Ashley Hicks

When he took over
his parents' apartment
in the historic Albany
complex, Hicks—son of
the Promethean designer
David—immediately
set to putting his own
distinctive stamp on
the space. Idiosyncratic
touches include the
romantic hand-painted
sepia-tone mural on the
living room walls and
the carpeting's graphic
chain-link motif. The
diminutive space is so
full of noteworthy details
that Lady Pamela Hicks,
Ashley's mother, declared,
"One magazine story?
It needs a whole book!"

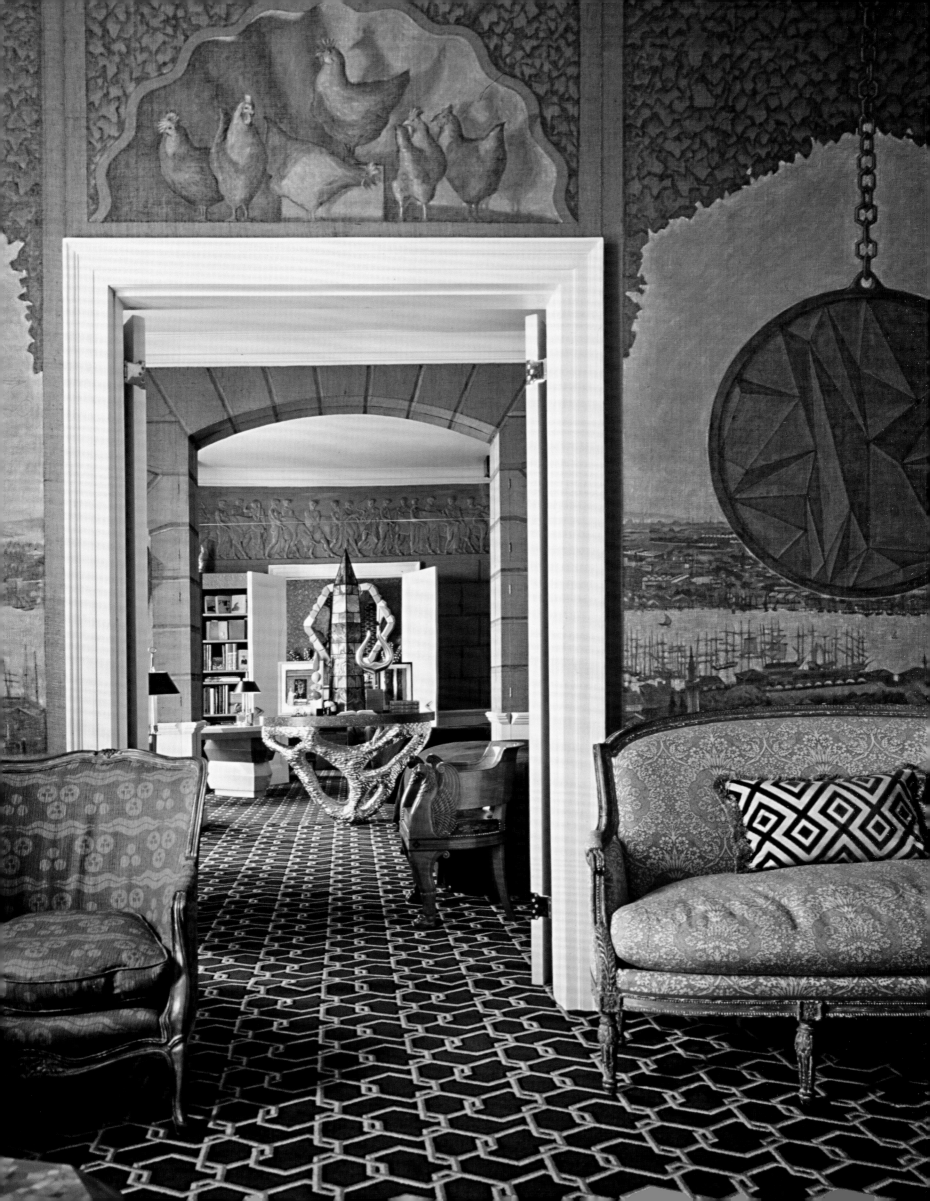

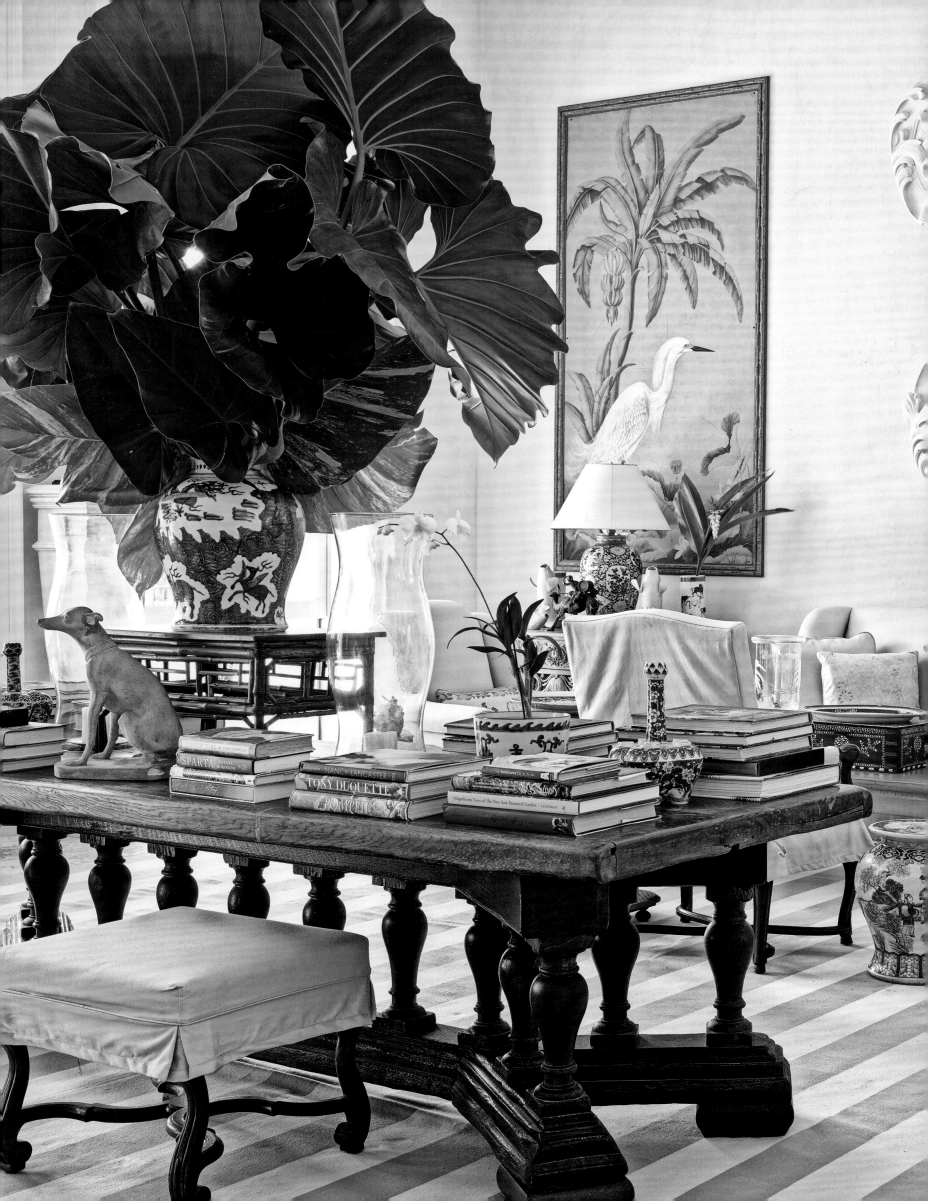

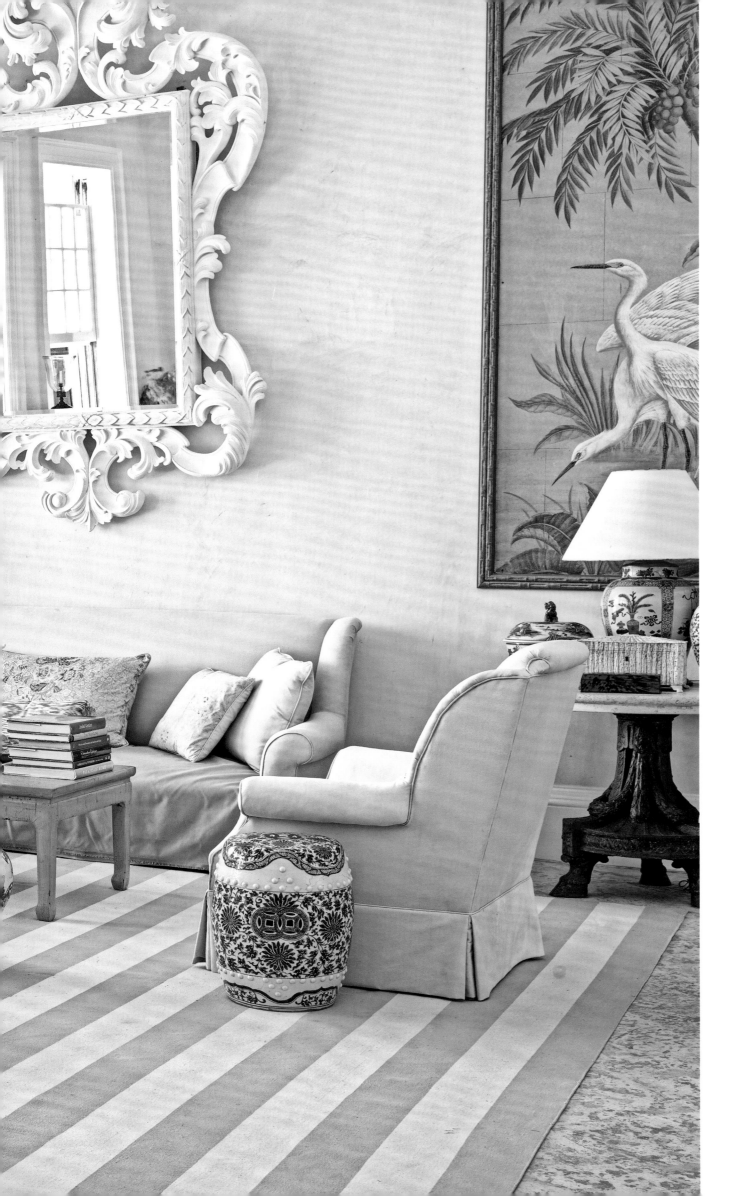

June 2017
Punta Cana,
Dominican Republic

La Colina

HOMEOWNER/DESIGNER

Bunny
Williams

In the living room of the
Dominican Republic
retreat of Williams and
husband antiques dealer
John Rosselli, the oversize
furniture is perfectly
scaled to the 21-foot-
tall walls. "With a high
ceiling, you can't be
afraid of going big,"
Williams advised. "It
actually makes a room
more intimate." This
logic also applies to the
nine-foot-tall rococo-
style scroll mirrors that
Williams found and had
painted white to look like
plaster. On either side
of the mirrors hang four-
by-eight-foot panels
painted in imitation of 18th-
century Chinese designs.

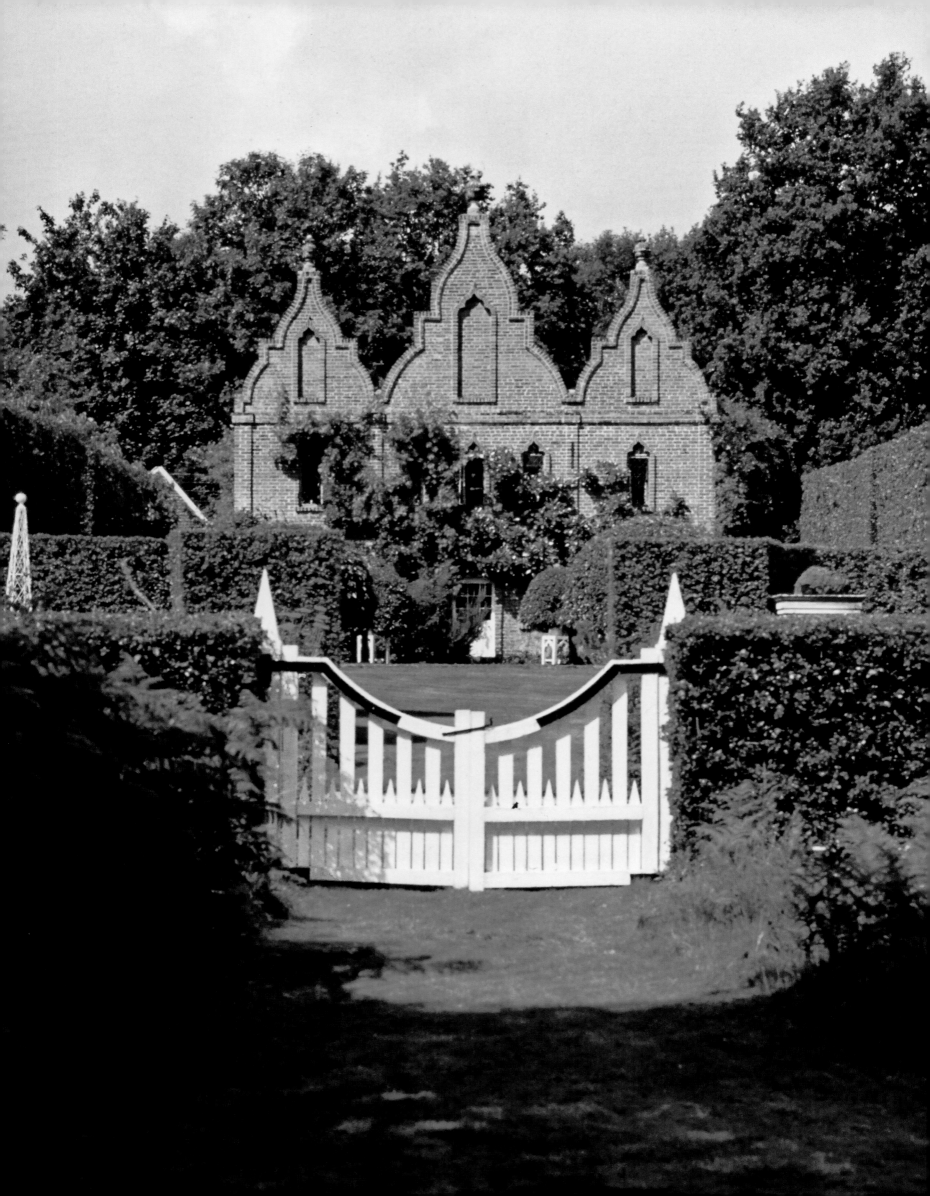

January/February 1975 | Odiham, Hampshire, England

Hunting Lodge HOMEOWNER/DESIGNER John Fowler

Fowler, partner in the legendary design firm Colefax and Fowler, bought the dilapidated 18th-century Jacobean-style folly he called Hunting Lodge in 1947 and spent the next three decades breathing new life into it and its gardens. In one hall, a 17th-century plaque of Emperor Tiberius hangs above a marble-topped Louis XVI table, and an Aubusson floral rug covers the scrubbed chestnut floor. "What I wanted here was something utterly unpretentious, very comfortable, with a veneer of elegance and informality," the designer said. The house's stylish legacy continued after Fowler died in 1977, leaving it to the National Trust; the following year it was leased by decorator Nicky Haslam, who still uses it as a weekend getaway.

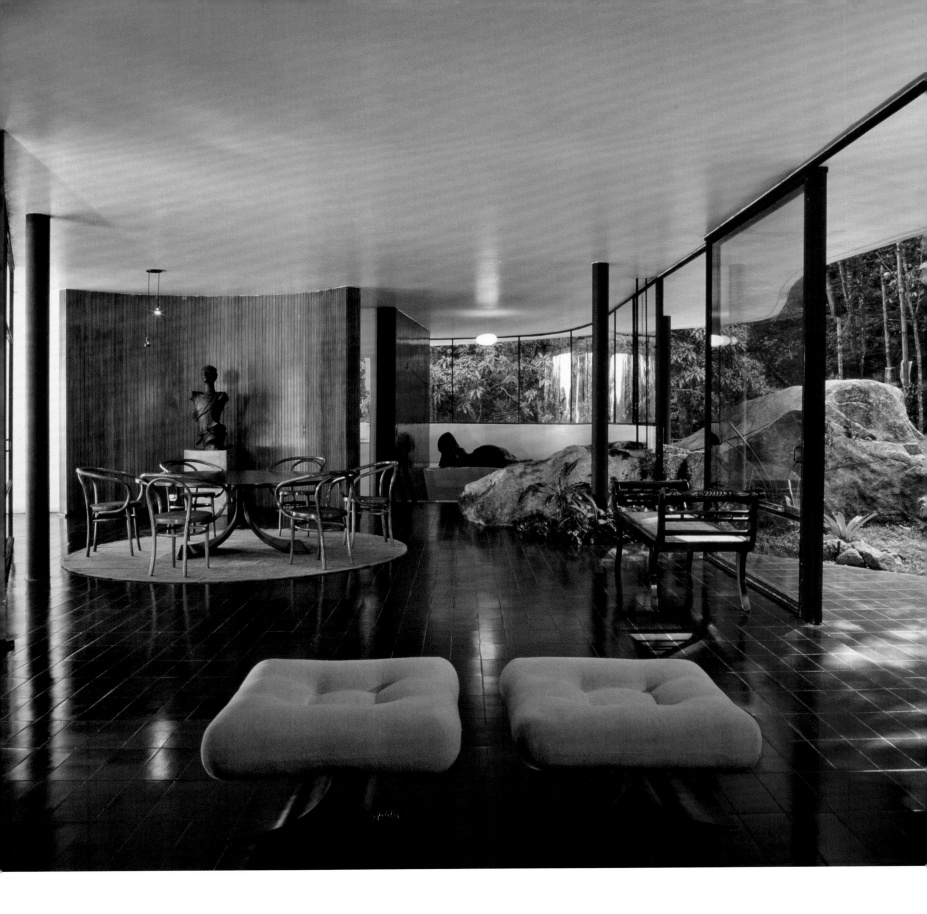

April 2018 | Valletta, Malta

HOMEOWNER/DESIGNER Francis Sultana

The 16th-century Maltese palace of Sultana and his partner, gallerist David Gill, blends baroque and modern to dazzling effect. In the grand salon, the cocktail table, bench, armchairs, and lamps are all by Mattia Bonetti, the sofa is by Sultana, and the marble side tables are by the Campana Brothers, while the ceiling beams have been transformed into a site-specific installation by artist Daniel Buren. "I wanted to get the right balance of traditional—as in original—and contemporary," said Sultana.

May 2003 | Rio de Janeiro

HOMEOWNER/DESIGNER Oscar Niemeyer

With its undulating walls and warm earth materials, the living/dining room of the architect's 1954 house celebrates organic forms. Symbolized by a giant boulder that literally straddles indoors and out, the house fully embraces nature. "It is not the right angle that attracts me," Niemeyer explained. "What attracts me is the free and sensual curve—the curve that I find in the mountains of my country, in the sinuous course of its rivers."

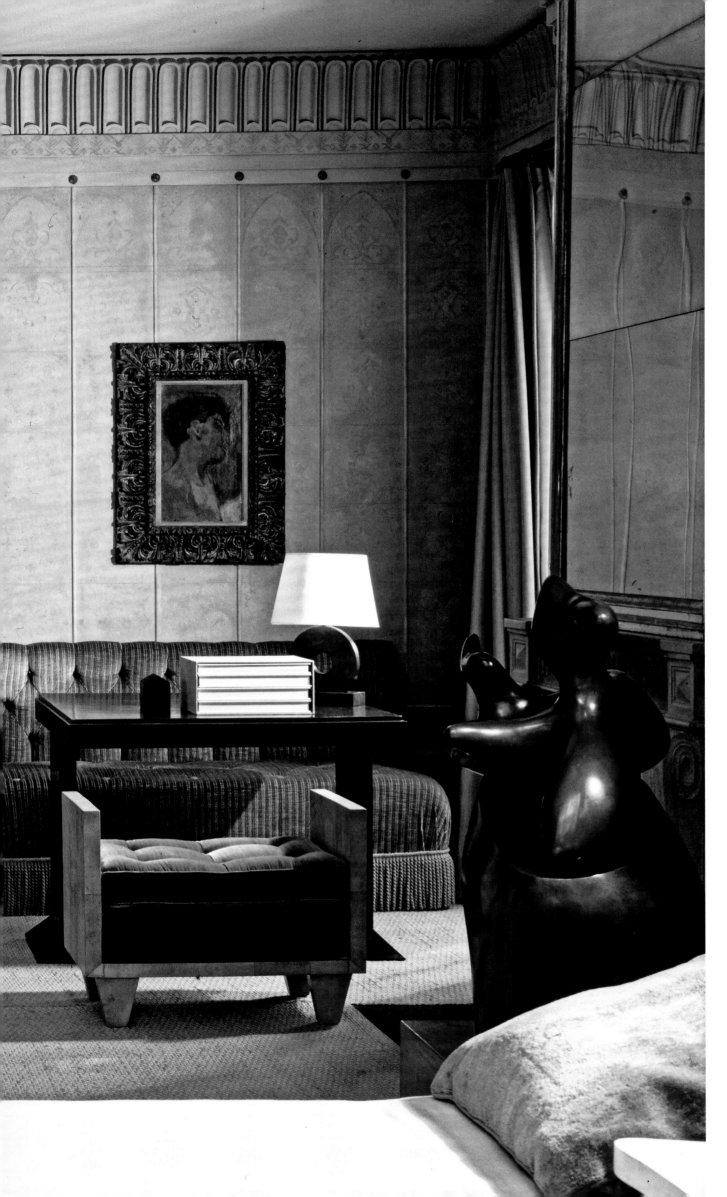

September 1998
Manhattan

HOMEOWNERS/DESIGNERS
Stephen Sills & James Huniford

Perched atop a prewar building sat a compact three-room penthouse that the designers Stephen Sills and James Huniford (then a couple, as well as business partners) had fashioned into what *AD* called a little temple of perfection. "We don't have a lot of room to showcase pieces," Sills said, "so what we have is highly edited." The living room features a pair of shagreen cubic benches and a leather club chair by Jean-Michel Frank, and a Jean Arp sculpture.

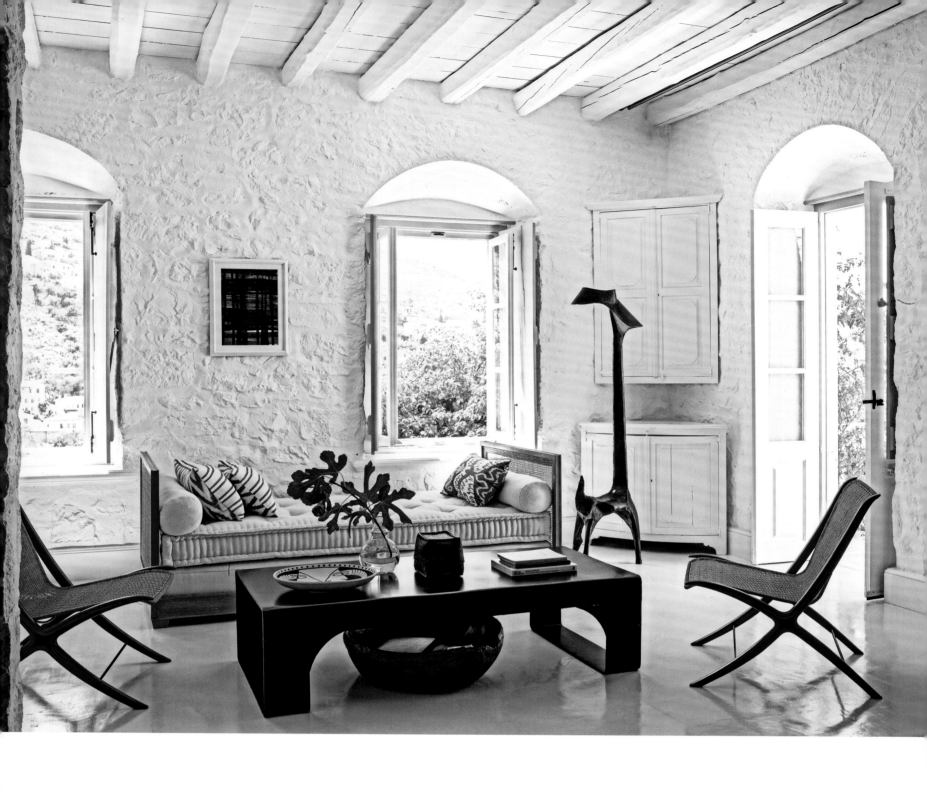

April 2017 | Hydra, Greece

HOMEOWNER/DESIGNER Tino Zervudachi

Whitewashed walls create a cool backdrop for the carefully curated furnishings
in Zervudachi's haven on the Greek isle. In the living room, Danish wicker chairs and
a 1950s caned daybed surround an iron cocktail table. The animalistic lamp is
by François Thévenin. As AD observed, the house exudes "pure distilled simplicity,
elegance and comfort in perfect equilibrium."

March 2004 | Paris

HOMEOWNER/DESIGNER Juan Pablo Molyneux

A modern-day singerie fantasy, the dining room in Molyneux's Paris apartment
features wall canvases depicting the interior designer as a monkey at key moments
in his life. The murals culminate in a scene of Molyneux escorting his wife, Pilar
(also portrayed as a monkey), to a ball.

March 1989
London

HOMEOWNER/DESIGNER
Rose Tarlow

Treasures collected
over many years furnish
Tarlow's living room:
a Japanese bronze hawk
on a leather-topped
Régence beechwood
table, Régence chairs
upholstered in Gobelins
tapestry, a 17th-century
limestone fireplace
framed by a pair of
potted birches. "It isn't
decorated in the con-
ventional sense," Tarlow
told *AD*. "All you need
are the right proportions,
pleasing colors, and
things you really love."

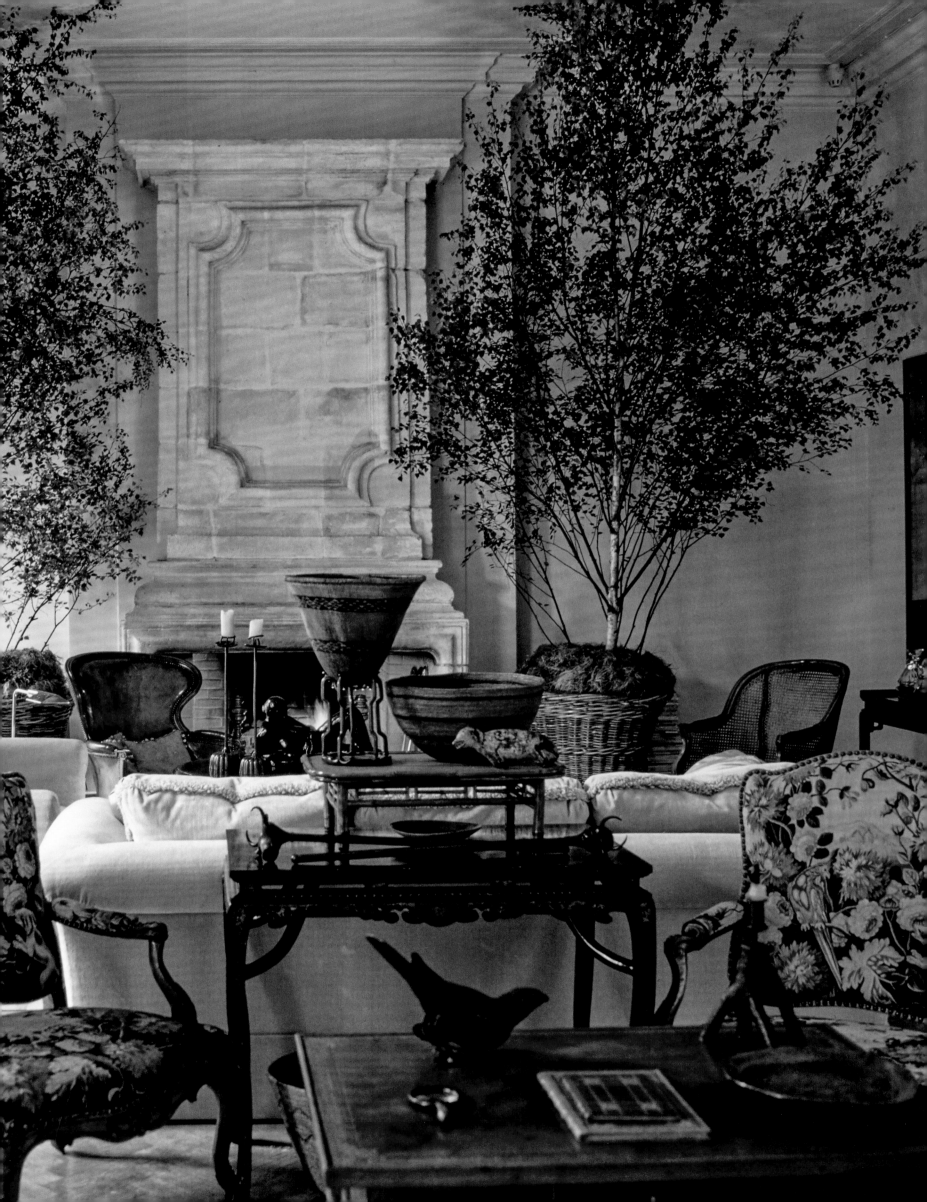

November 2012 | Bridgehampton, New York

HOMEOWNER/DESIGNER Alex Papachristidis

The entrance hall of the Hamptons house Papachristidis shares with his entire clan, as well as cousins and friends who show up on any given weekend, is defined by its grandly sweeping staircase and hand-stenciled flooring.

April 2017 | Jaipur, India

HOMEOWNER/DESIGNER Marie-Anne Oudejans

Oudejans, a former fashion designer, put a personal, characteristically colorful stamp on her one-bedroom flat in the romantic Hotel Narain Niwas Palace. Local painters created Mughal-style flower murals on the kitchen wall.

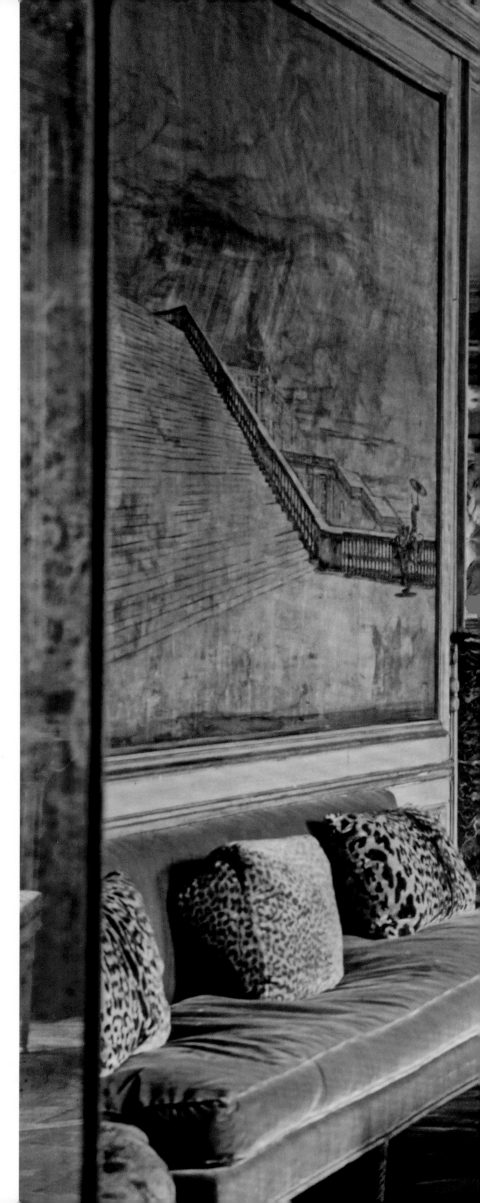

September 1996
Versailles, France

Villa Trianon
HOMEOWNER/DESIGNER
Elsie de Wolfe

The long gallery in de
Wolfe's beloved Villa
Trianon epitomized her
French-inflected, widely
influential approach to
l'art de vivre: fine antiques
alongside inviting modern
upholstered pieces, plen-
tiful animal prints (here,
leopard and ocelot), and
well-placed mirrors that
invite light into all corners.
As designer Tony Duquette,
a de Wolfe protégé, wrote
in *AD*'s pages: "Kings,
statesmen, generals,
artists—they all admired
their reflections in her
magic mirrors and danced
at her garden fêtes."

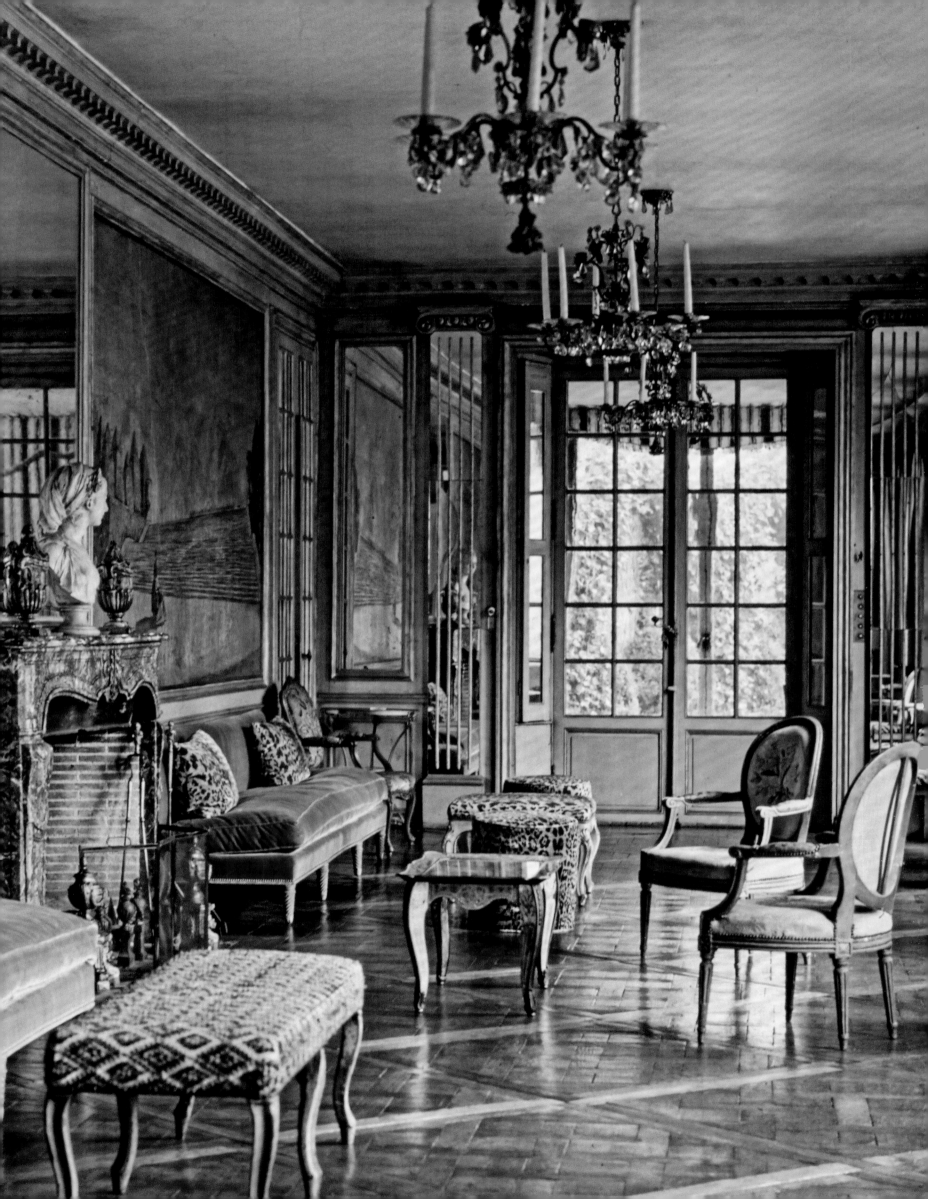

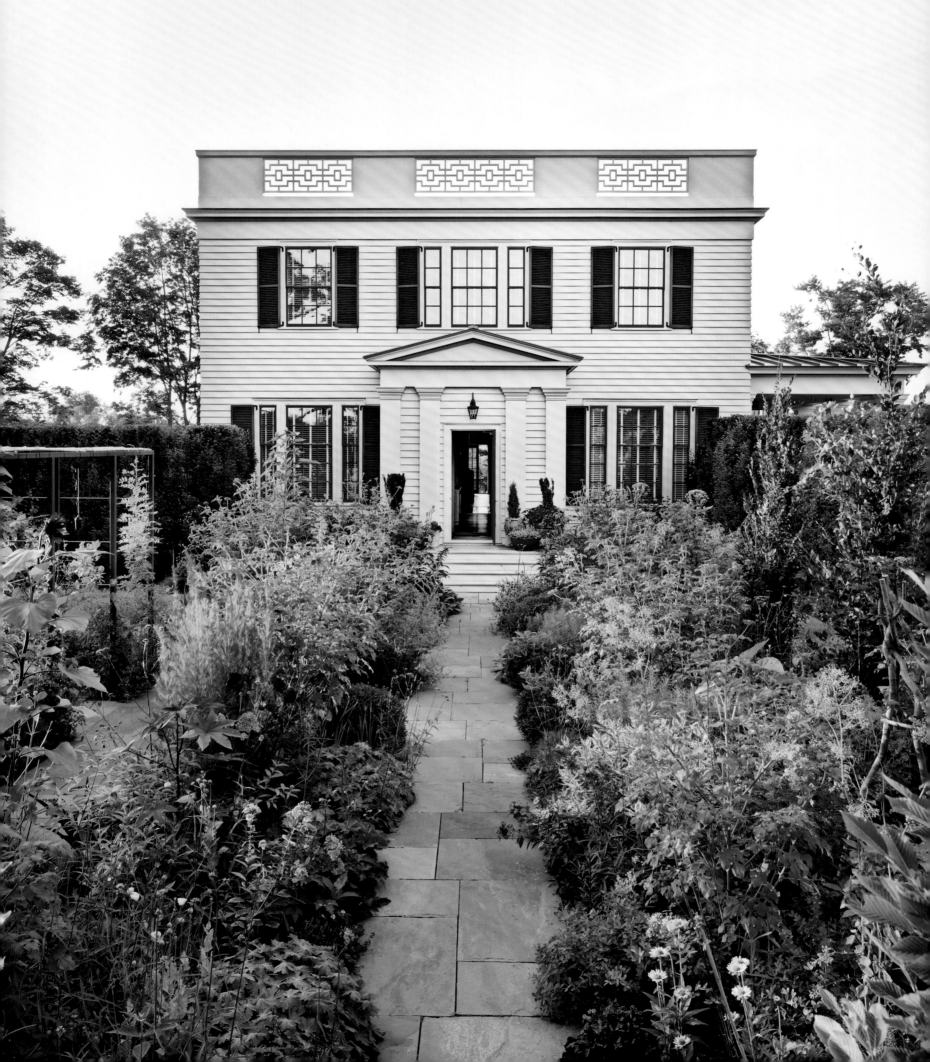

August 2015 | Millbrook, New York

HOMEOWNERS/DESIGNERS Peter Pennoyer & Katie Ridder

A bluestone walk leads through the flower garden to a stately side entrance—elegantly distinguished by pilasters and a pediment—of the handsome, distinctively square-shaped Greek Revival structure that Pennoyer devised for his family in upstate New York. Ridder, the architect's decorator wife, oversaw the gardens as well as the interiors.

Volume 13, Number 1 1951 | Beverly Hills, California

Woodland HOMEOWNER/DESIGNER James Pendleton

Designed by architect John Elgin Woolf for Pendleton and his wife, Mary Frances, in 1942, Woodland came to define Hollywood Regency style, that glamorous fusion of neoclassical design, modernism, and stage-set panache. The house went on to achieve even more fame as the home of legendary film producer Robert Evans.

September 1996
London

HOMEOWNER/DESIGNER
Nancy Lancaster

Often cited by other designers, the drawing room in Lancaster's London home is one of the most influential interiors of the 20th century. The American tastemaker had John Fowler, her partner in the firm Colefax and Fowler, and artist George Oakes paint it a distinctive butter-yellow, varnished to a high gloss, that warms the space and infuses all with an irresistible golden glow. "I sit in this room, I eat in it, and I wish I had my bed in it," Lancaster once said.

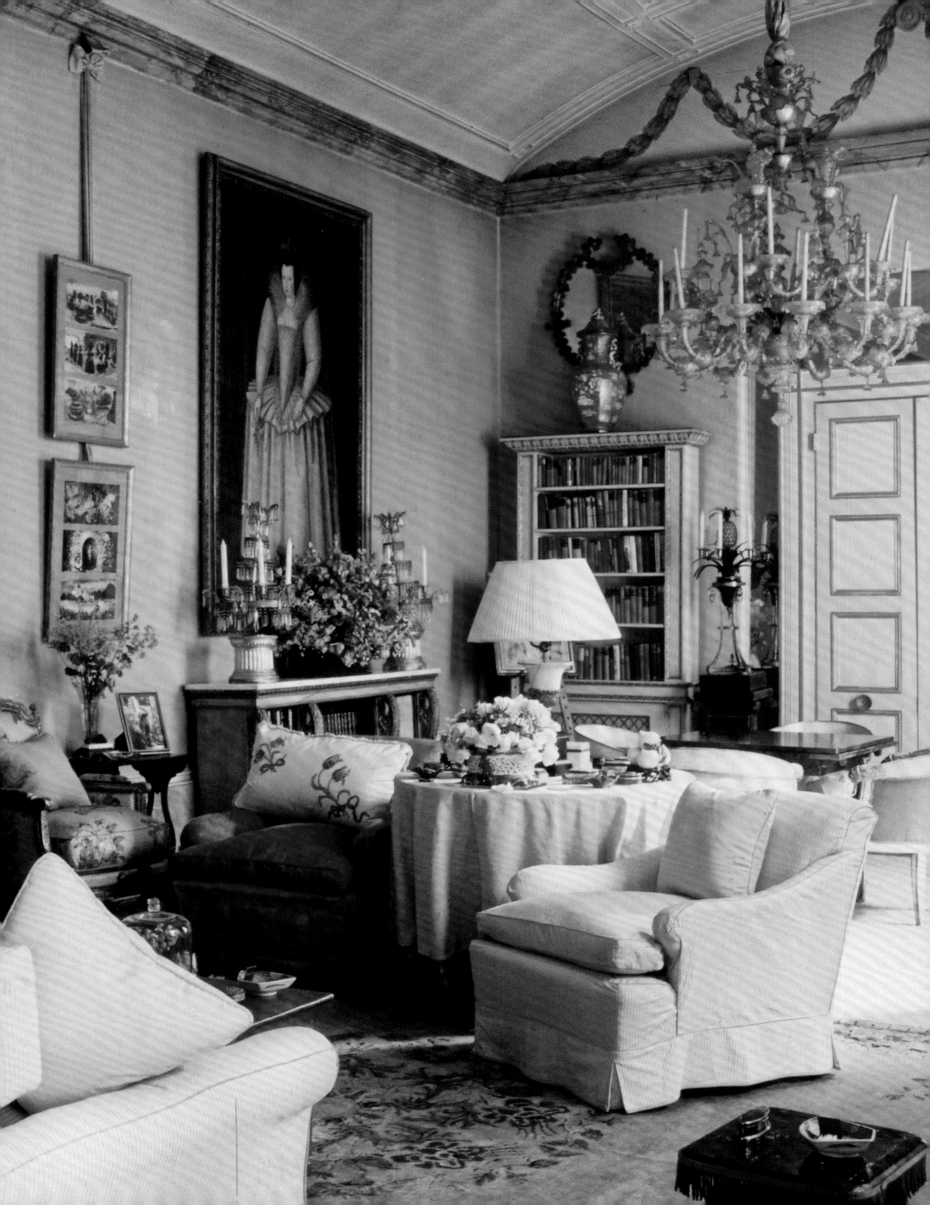

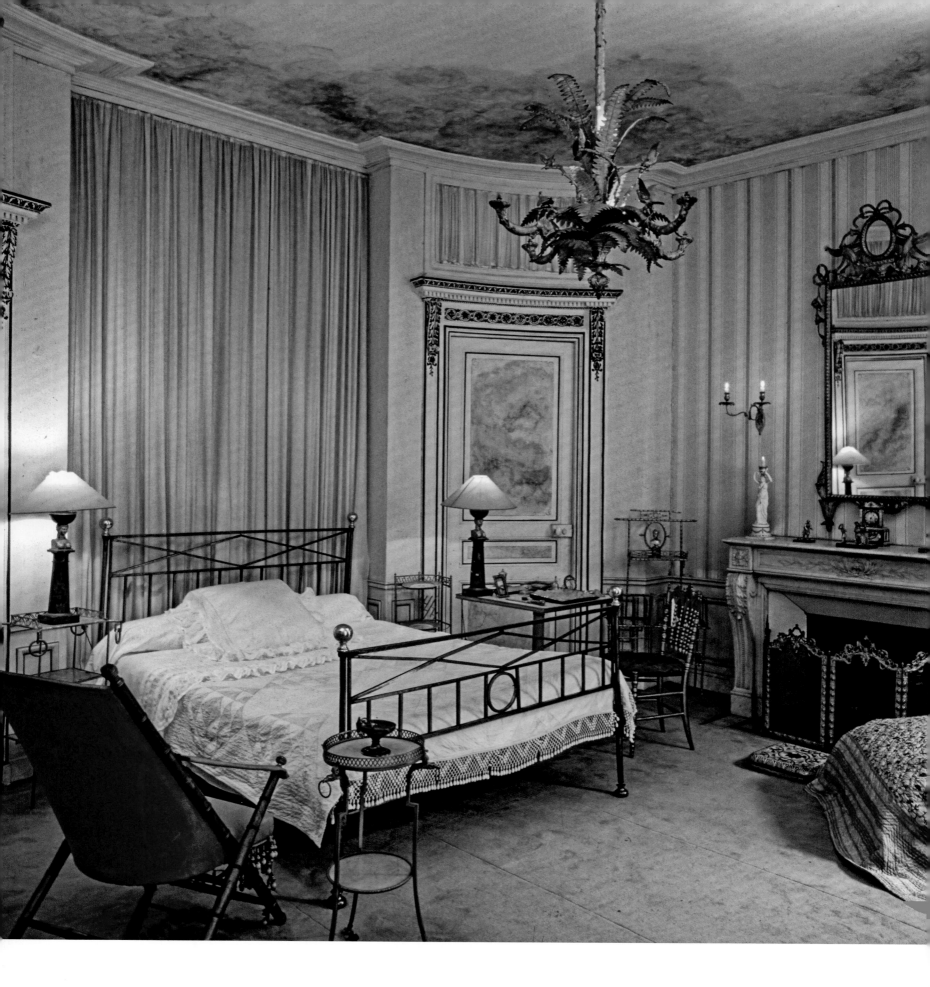

September 1977 | Paris

HOMEOWNER/DESIGNER Madeleine Castaing

"Personally, I just follow my instinct, amuse myself in creating an atmosphere, mix up all sorts of things I like," Castaing explained. Case in point: her pastel-tone Paris bedroom composed of a heady mix of treasures, including gilt-bronze, faux-bamboo furniture that once belonged to a sister of Napoléon III, an 18th-century gilt-wood mirror and mother-of-pearl mantel clock, and a 19th-century bronze doré chandelier and gilded fire screen.

July/August 2019 | Paris

HOMEOWNER/DESIGNER Tom Scheerer

"I was jolted into a time capsule," interiors stylist Carolina Irving said of her friend Scheerer's apartment on the Île Saint-Louis. One of the two bedrooms features a Louis XVI tester bed unusually fashioned out of teak, vintage cane-backed Thonet armchairs, and custom wallpaper whose pattern was inspired by an antique Kashmiri shawl. "Tom has such a seductive eye, there's nothing superfluous about him; his touch is dry, reductive, and old-fashioned in the most elegant way."

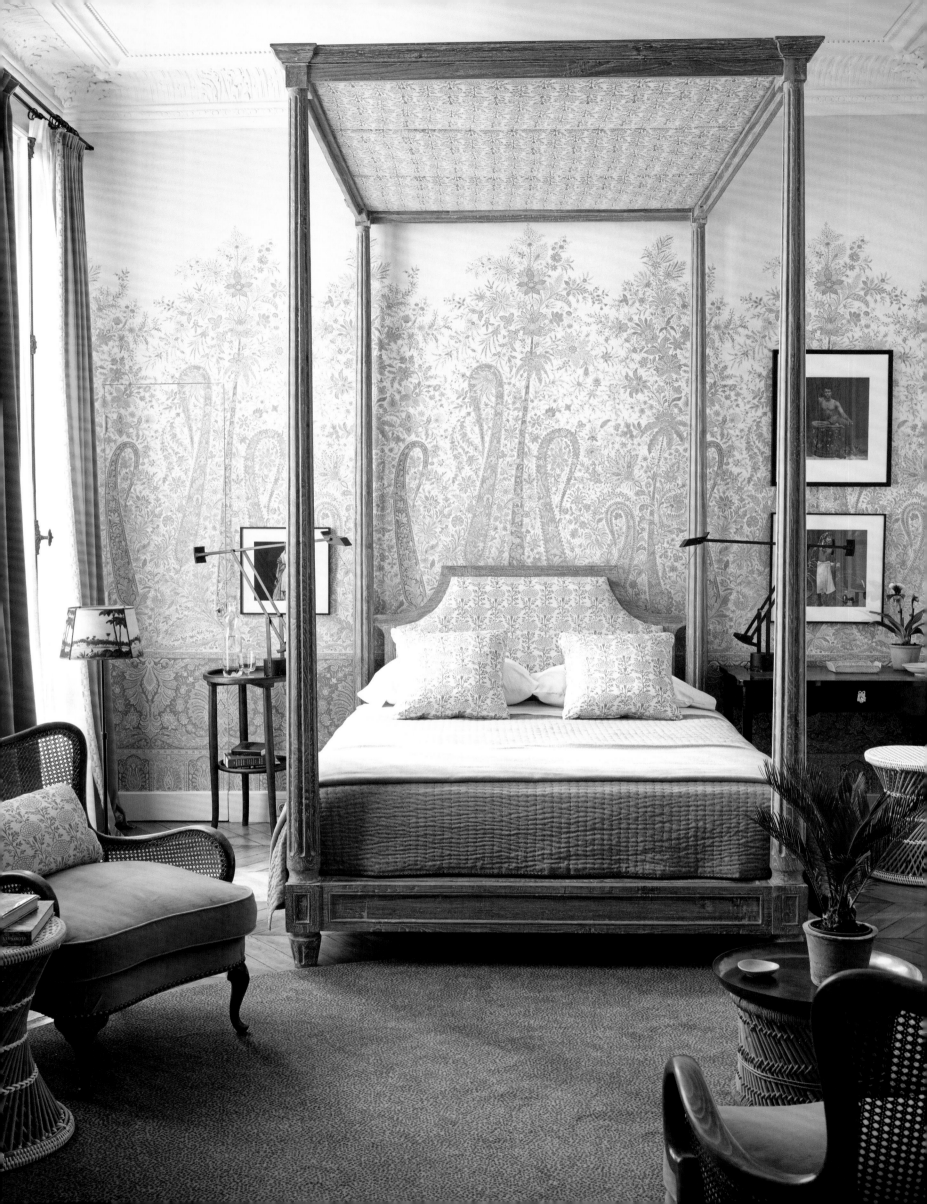

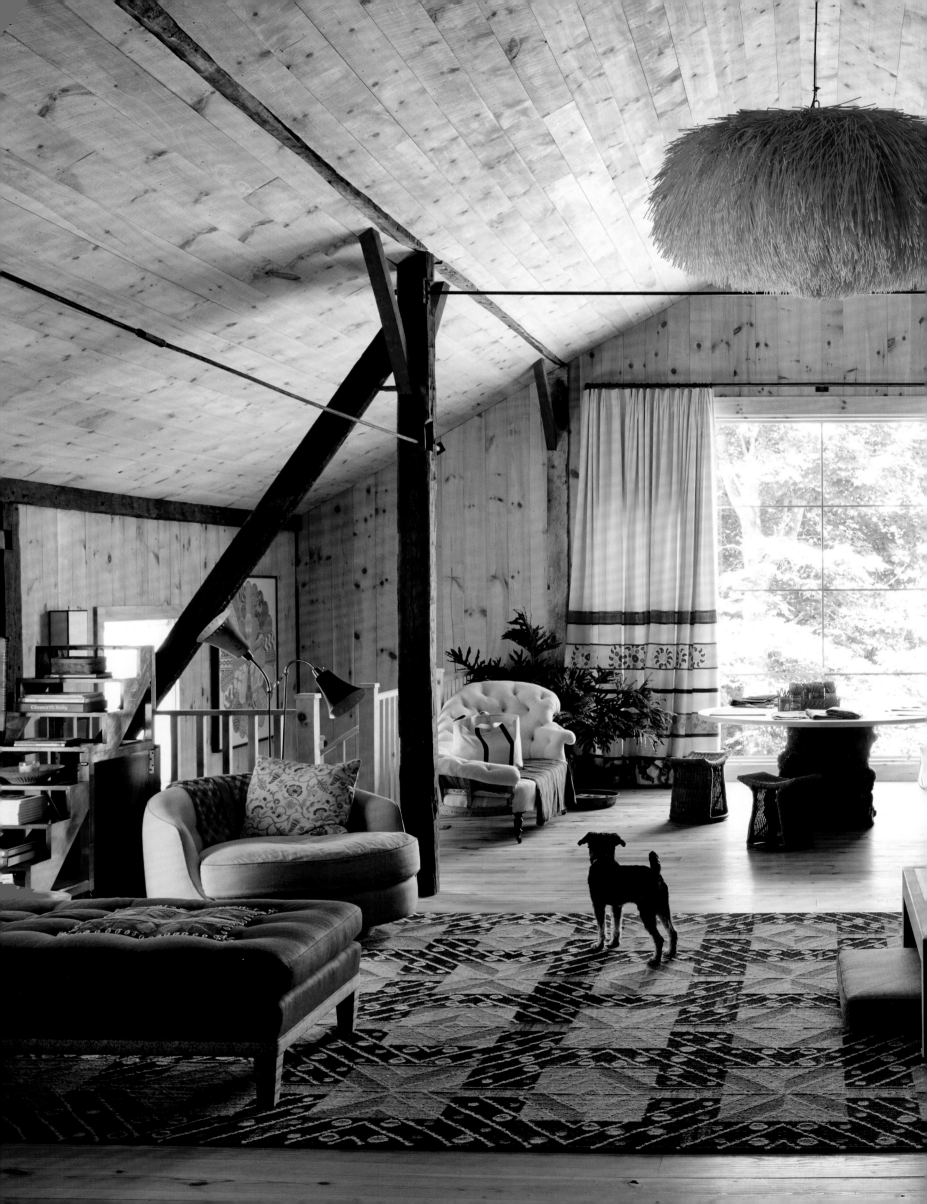

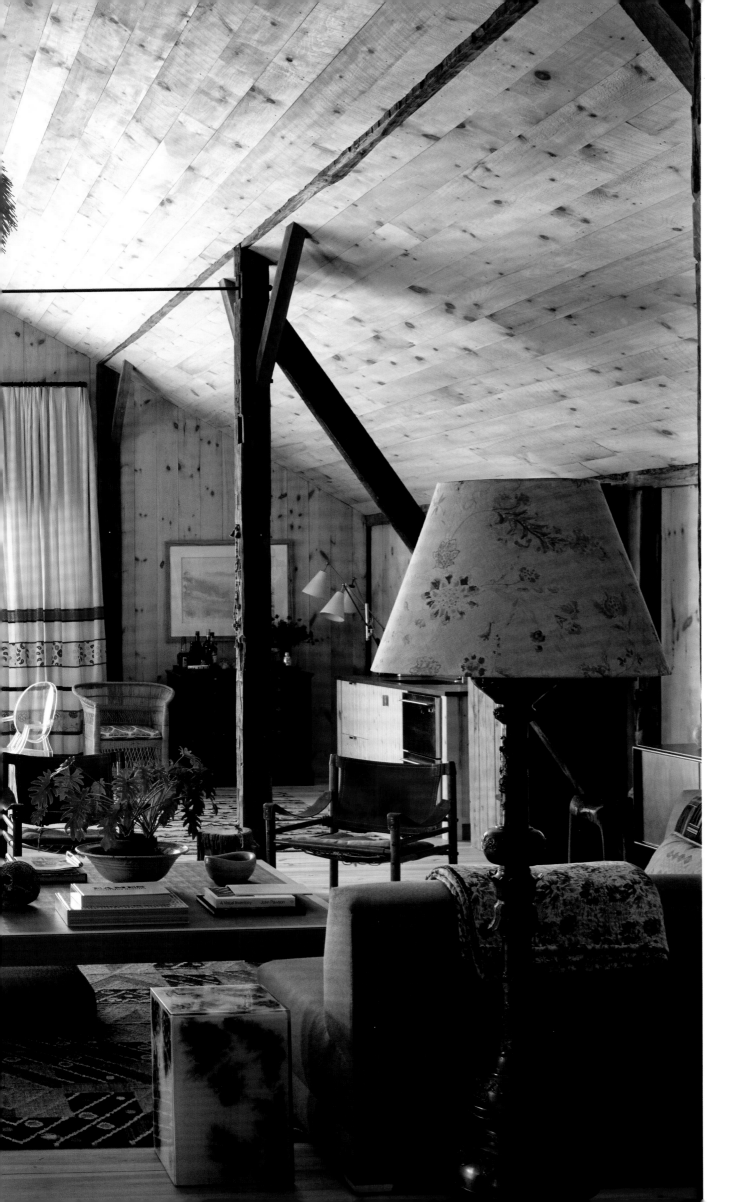

June 2019
Clinton Corners,
New York

HOMEOWNER/DESIGNER
Markham
Roberts

Harriet, the designer's
poodle-schnauzer mix,
stands on a Swedish-
motif rug in the studio
Roberts created atop a
barn across the road
from his and antiques
dealer James Sansum's
house in upstate New
York. Furnished in a mix
of heirlooms and other
personal treasures,
the loftlike space is
a rejuvenating retreat
where the designer
can dream up decora-
ting schemes. "I always
buy what I like," he
professed, "and when
I put it together,
it ends up working."

April 2014
Southampton, New York

HOMEOWNER/DESIGNER
Peter Marino

On a dozen bucolic acres, the Hamptons garden of Marino and his wife, Jane Trapnell Marino, reveals a soft, romantic contrast to the black leather–wearing, motorcycle-riding public image of the architect behind chic boutiques the world over. An antique French fountain surrounded by Anah Kruschke rhododendrons stands at the center of the purple garden, which is composed of beds filled with nepeta, heliotrope, and verbena and edged with miniature rhododendrons. "Gardening is like decorating," Marino averred. "It's all about placement."

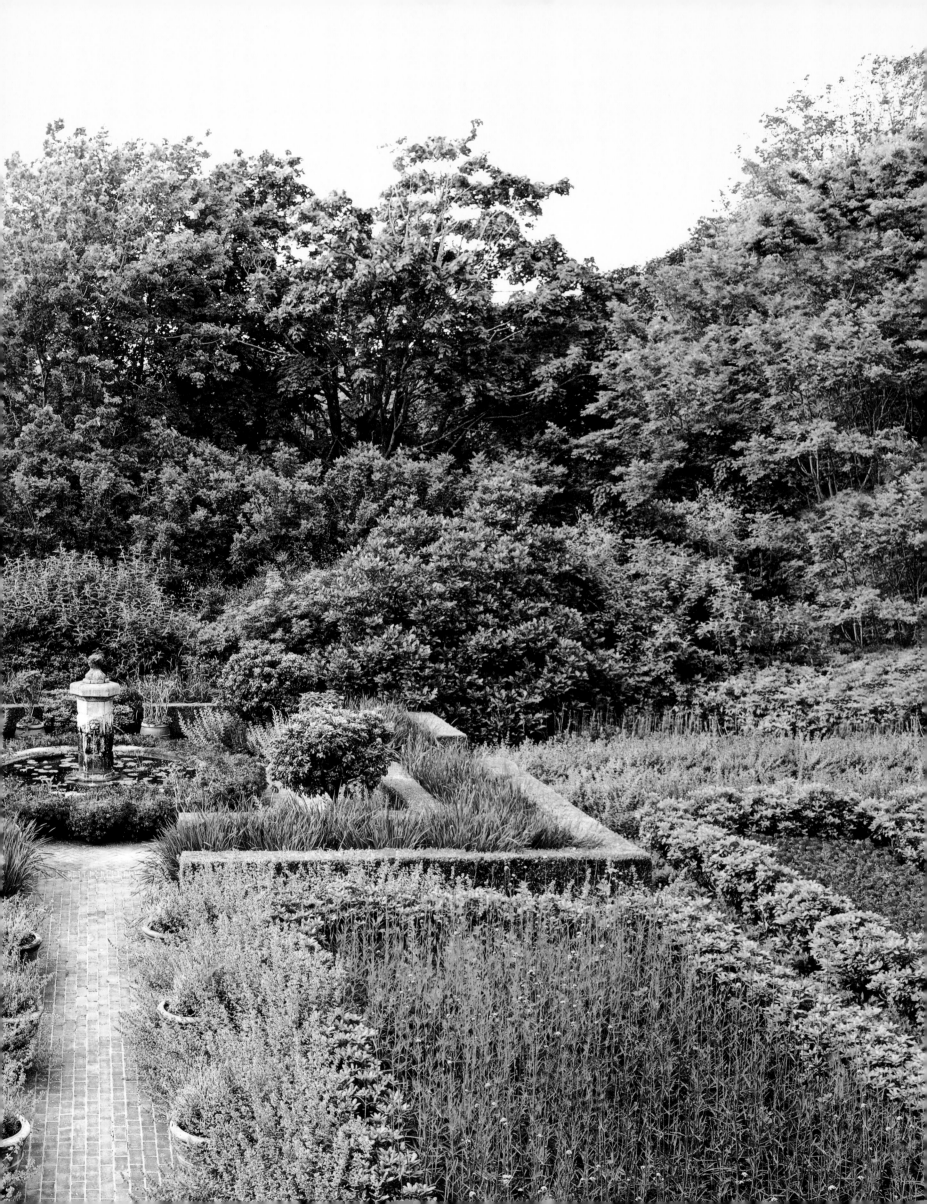

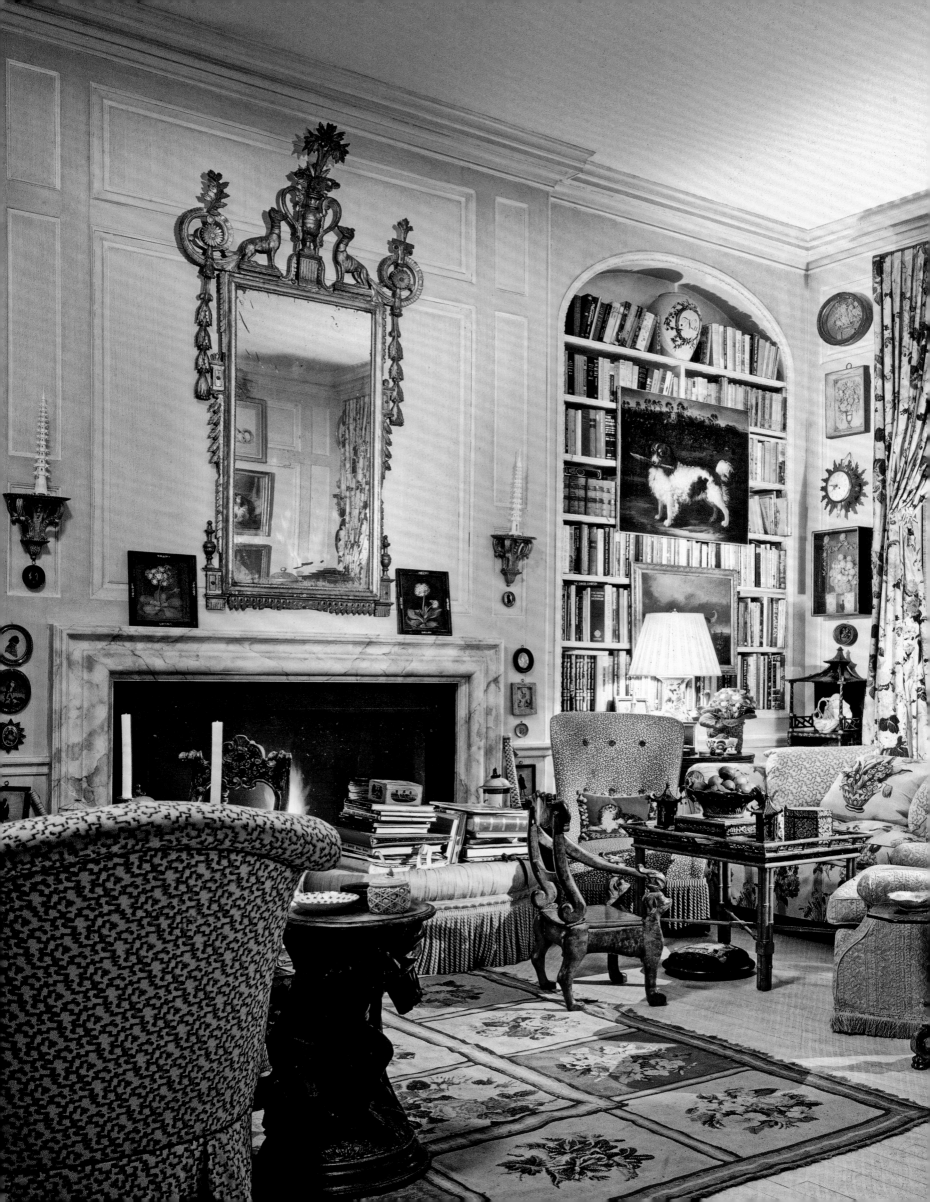

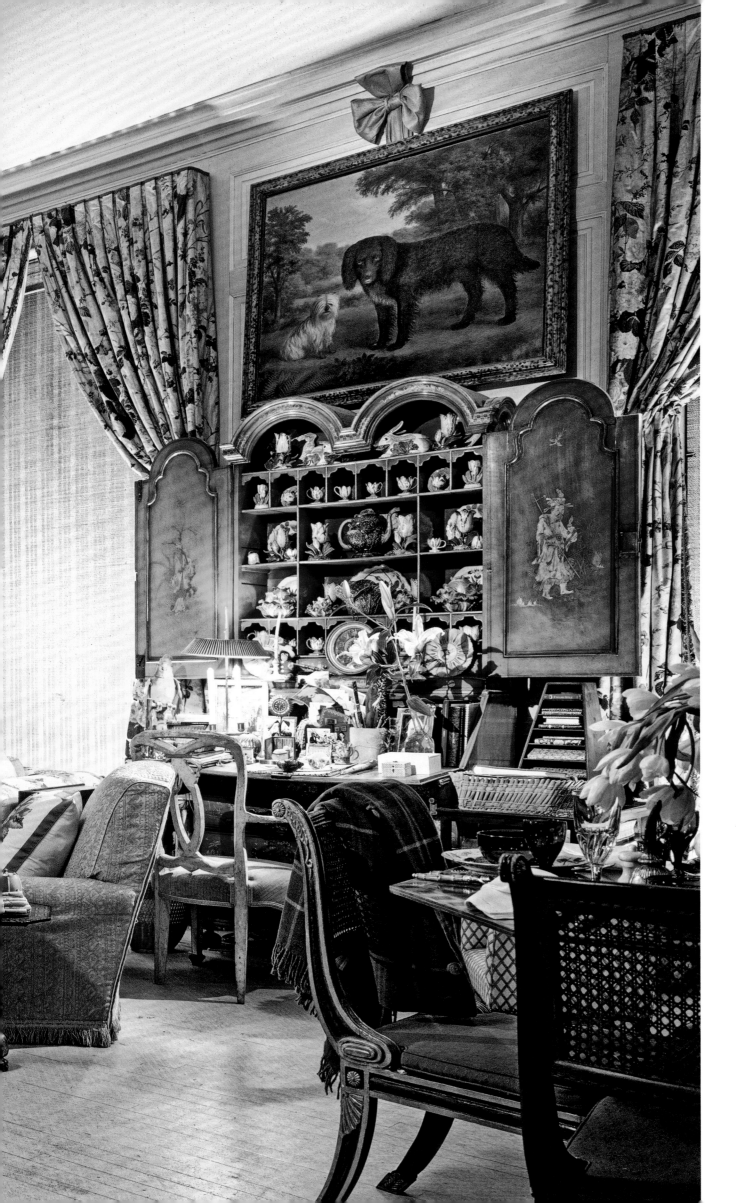

September 1997
Manhattan

HOMEOWNER/DESIGNER
Mario Buatta

Buatta embraced the English-country house style in his Upper East Side apartment. "I am a collector," he said. "I love a house full of things that have been collected for years. I love having clutter around me; organized clutter, that is. I can't see parting with things. Each one tells a story."

April 2014
Hampton Bays,
New York

HOMEOWNER/DESIGNER
Muriel Brandolini

After a decade spent weekending in a ho-hum house on the same property, the designer and her husband commissioned architect Raffaella Bortoluzzi to build them a sprawling new getaway spectacularly sited atop a bluff overlooking the water. In the glass-walled living room, a vintage sofa wearing a bold vibrant fabric curves around a midcentury cocktail table, and sculptural lamps top circa-1980 side tables. Brandolini designed the slipper chair and had it covered in a patchwork of antique fabrics and trims. When asked to point out any favorite pieces, the designer demurred. "I love it all," she explained, "because of how it works."

May 1987
London

HOMEOWNER/DESIGNER
John Stefanidis

Parts of Lindsey House, the Thames-front mansion in Chelsea where Stefanidis has an apartment, date back to the 17th century, with some remodeling done over the ensuing centuries. Such careful accretion appealed to the designer's sensibility. "Design for design's sake is unnecessary," he stated. "Littering a place with too many clever objects is no way for an intelligent and caring person to function." The sitting room's stenciled wallpaper is based on Bukharan embroidery. A trompe l'oeil montage and a pair of covered Song Dynasty jars decorate the mantel.

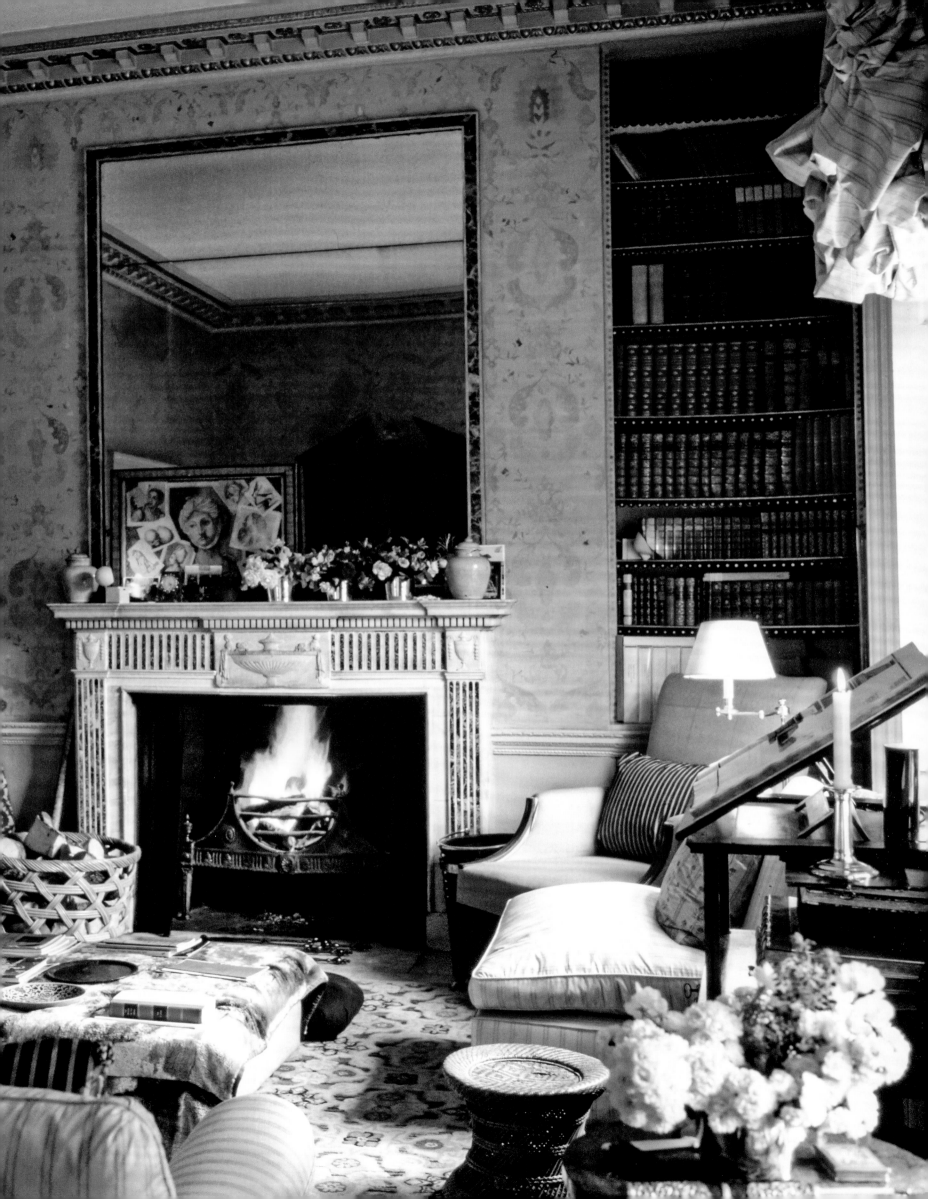

October 2016
Madrid

HOMEOWNER/DESIGNER
Fernando Caruncho

After his famously austere garden was ravaged by a mysterious blight, the landscape architect had to start from scratch. Now the beds are filled with thousands of swaying, chest-high white cosmos that rise up each summer in joyful contrast to the architectural severity that encloses the space. "Rebirth is the miracle of gardens," Caruncho noted. "And that is something that will be with me for the rest of my life."

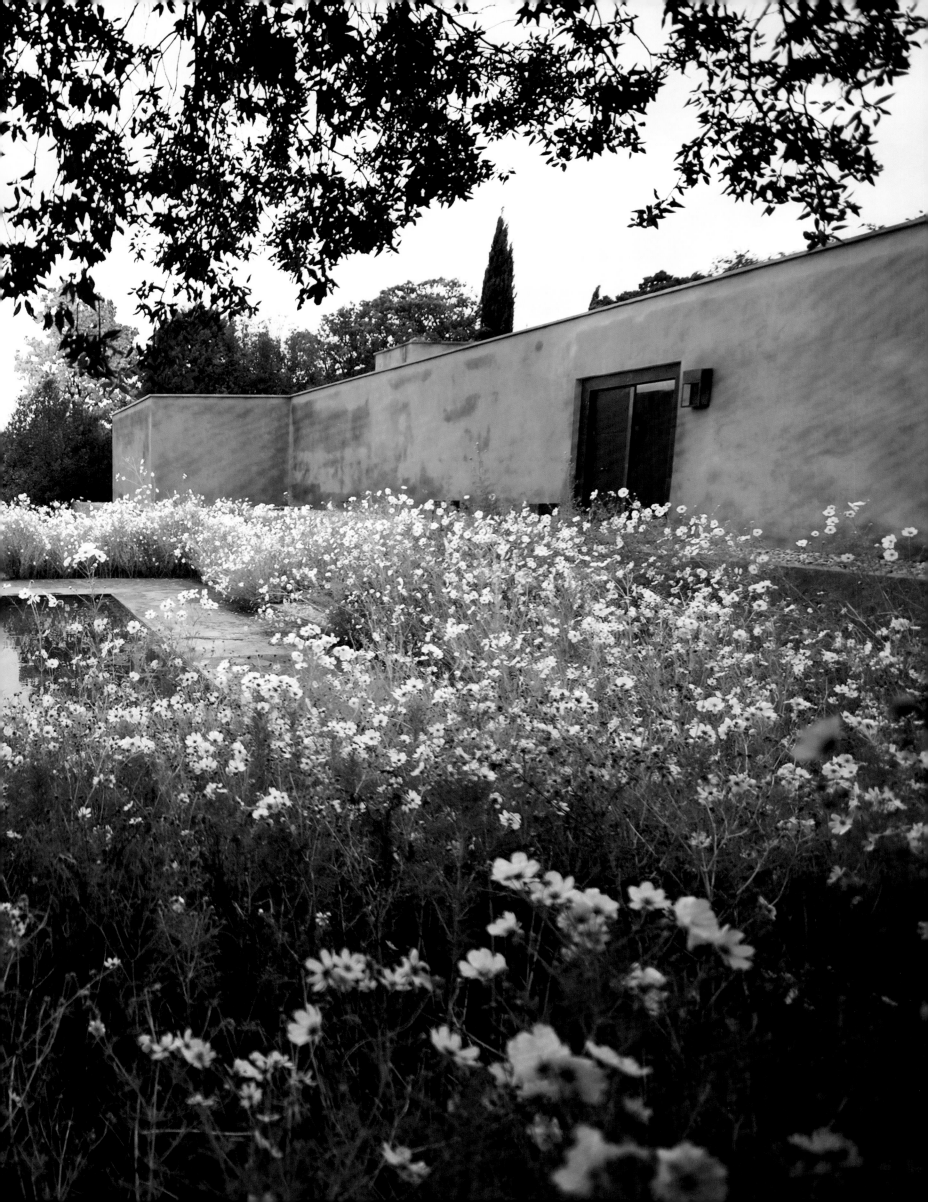

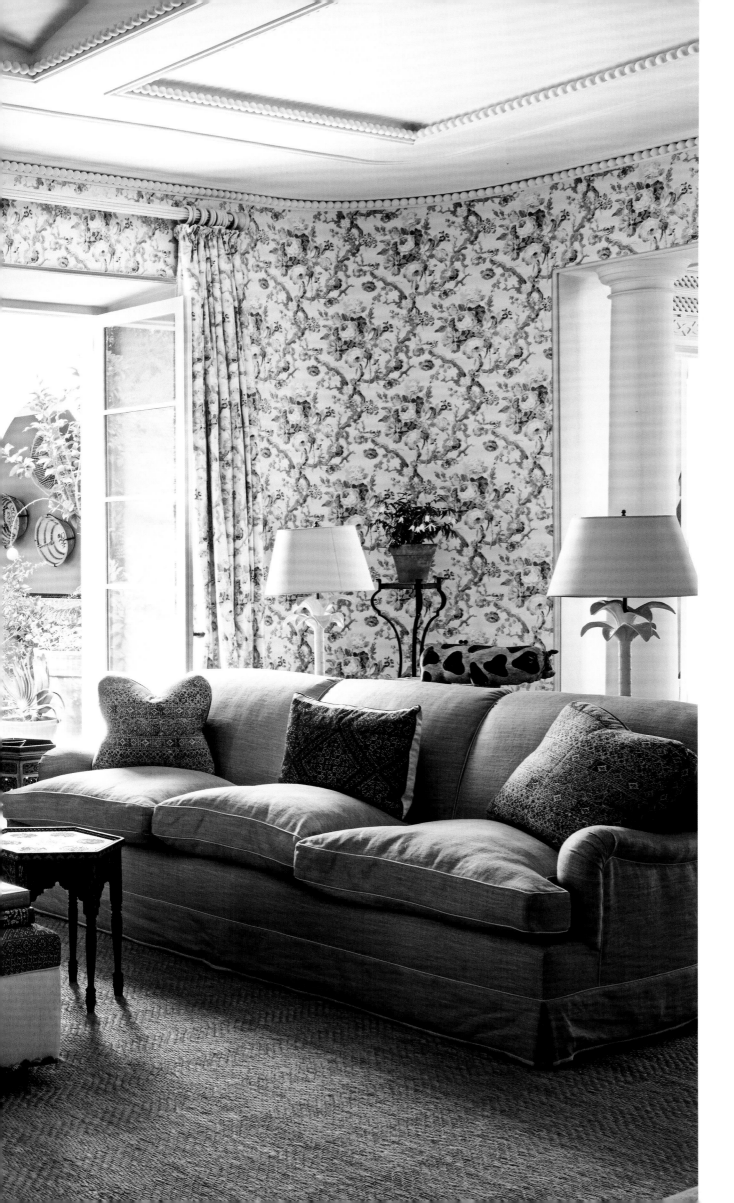

April 2018
Tangier, Morocco

Gazebo

HOMEOWNER/DESIGNER

Veere Grenney

Grenney is one of the leading torchbearers for the great English tradition of creating rooms that are both beautiful and comfortable. And yet.... "The thing about Englishness is, it's impossible to describe in words," the designer pronounced. That said, the drawing room at his Moroccan getaway, known as Gazebo, eloquently evinces that hard-to-express ideal. A lush floral chintz envelops the space, and plush upholstery invites long afternoons by the fire. English and Moroccan oil paintings hang above the Grenney-designed mantelpiece.

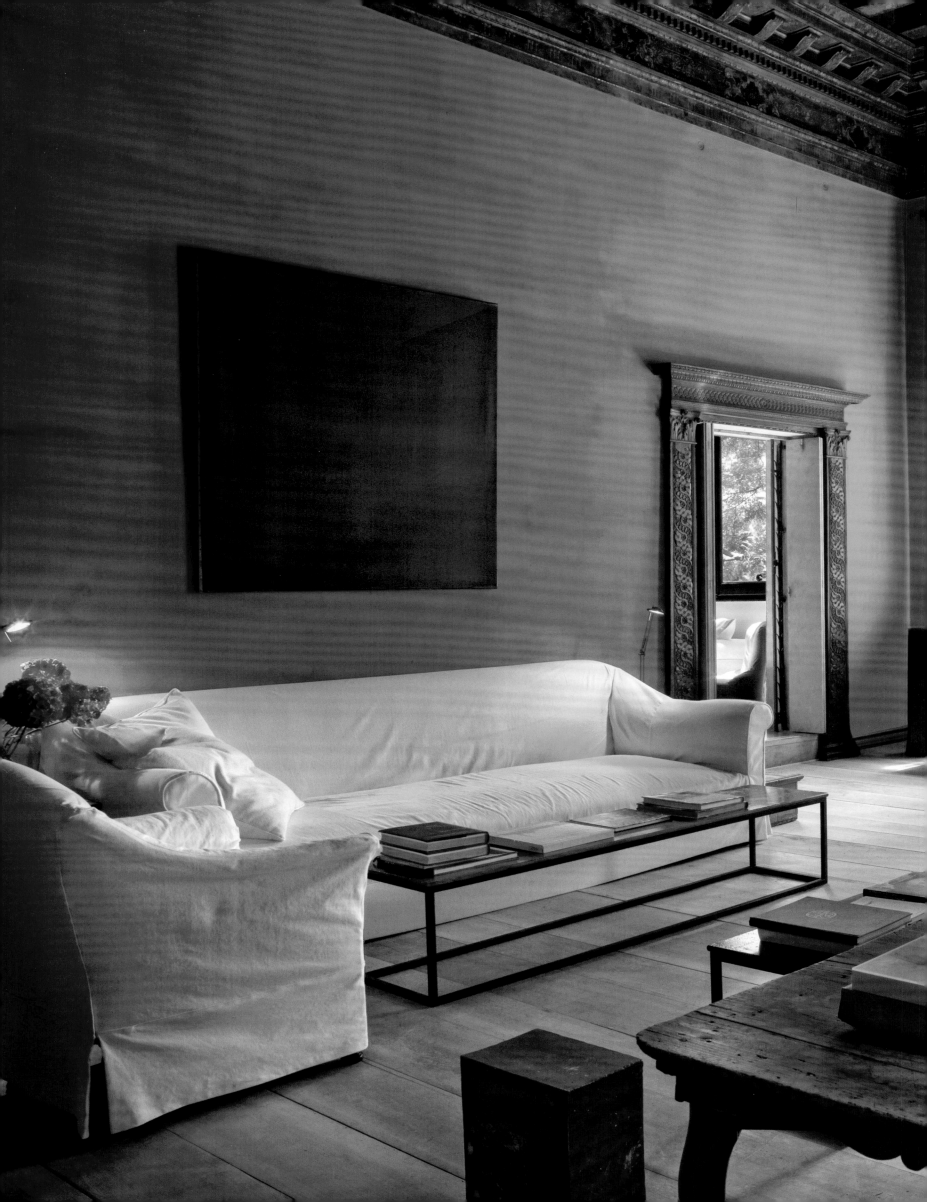

September 2008
Venice

HOMEOWNER/DESIGNER

Axel Vervoordt

To mark his 60th birthday, Vervoordt acquired a flat on the piano nobile of the 15th-century Palazzo Alverà, on Venice's Grand Canal. In the living room, which features his signature mix of antiques and contemporary pieces, he installed a new poplar floor and painted the walls terra-cotta to set off the elaborate woodwork. "When architecture is boring, you put in a lot. When it is as splendid as this, you put in very little," Vervoordt told *AD.*

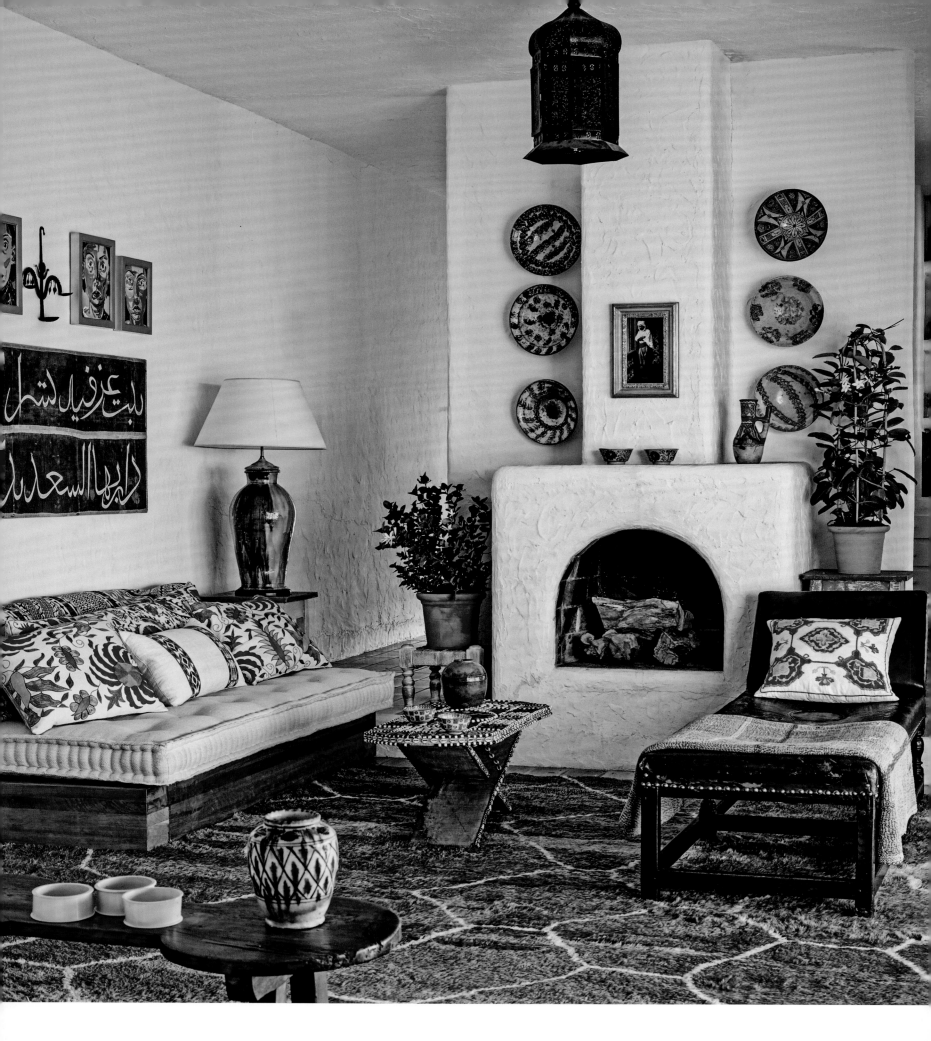

June 2017 | Ibiza, Spain

HOMEOWNER/DESIGNER Daniel Romualdez

Nestled on a sun-drenched cliff, the architect's Ibizan bolt-hole offers a dreamy blend of solitude and sociability. "When I'm in Ibiza I'm the most-relaxed version of myself, so I wanted the house to reflect that," he said. In the living room, antique ceramics and colorful fabrics pop against the whitewashed walls. Romualdez called the courtyard, devised by landscape designer Miranda Brooks, his favorite room of the house.

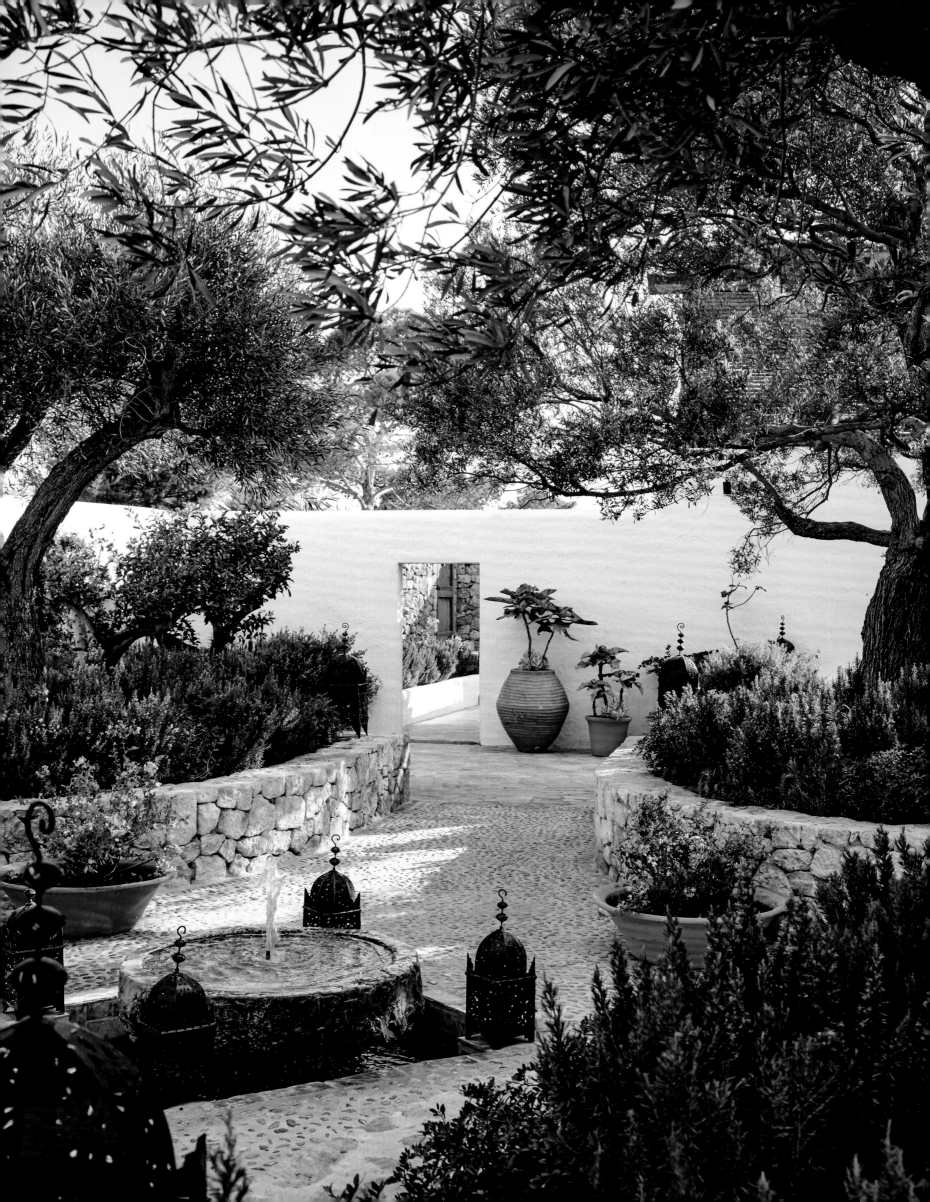

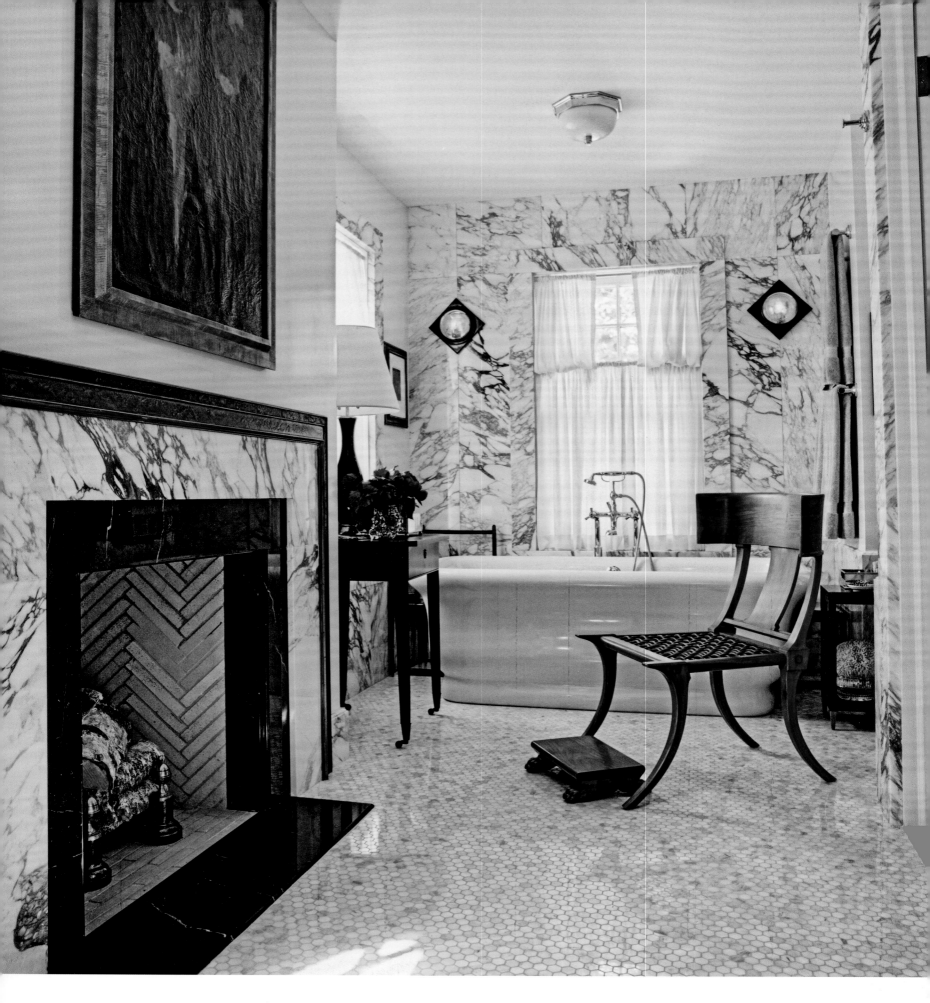

January 2017 | Bellport, New York

The Library

HOMEOWNERS/DESIGNERS Thomas O'Brien & Dan Fink

Every room in the Library, one of O'Brien and Fink's houses on Long Island, is filled with delights. With its T. H. Robsjohn-Gibbings klismos chair and footstool, even the Calacatta marble–clad master bath is no exception. This elegant space epitomizes the designers' credo that "beautiful things will always find a home."

June 2007 | East Hampton, New York

HOMEOWNER/DESIGNER Lee F. Mindel

The double-height living room of the Hamptons getaway the architect designed for himself is furnished with objects from a consummate collection. An Arne Jacobsen floor lamp speaks to a Charlotte Perriand shelving unit, which nods to a Ron Arad chair. "They say such interesting things together," Mindel noted. "It's an international language of form shared across time."

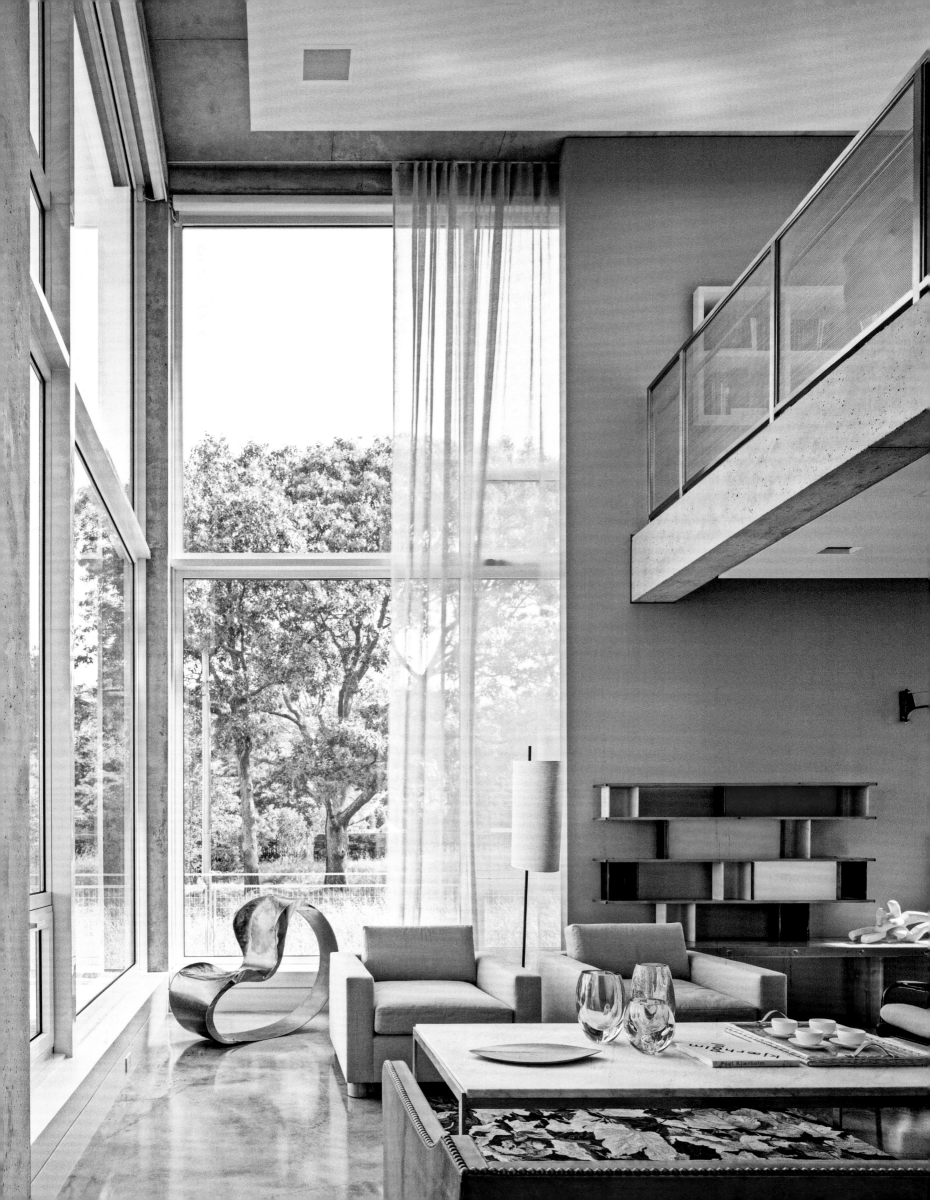

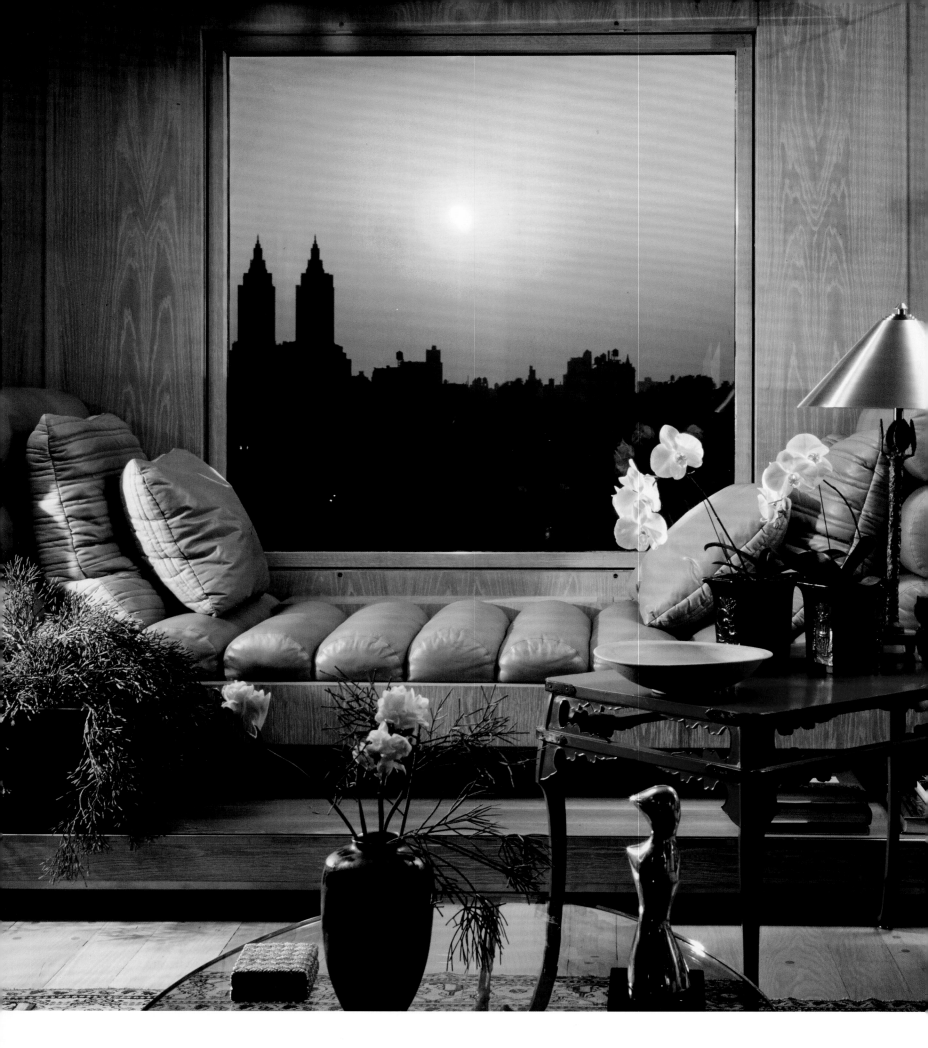

March 1984 | Manhattan

HOMEOWNER/DESIGNER Jay Spectre

Situated on the eighth floor of a gracious prewar building on Fifth Avenue, Spectre's apartment offered a view to the west across Central Park that the designer framed—and celebrated—by incorporating a sumptuous leather-upholstered window seat.

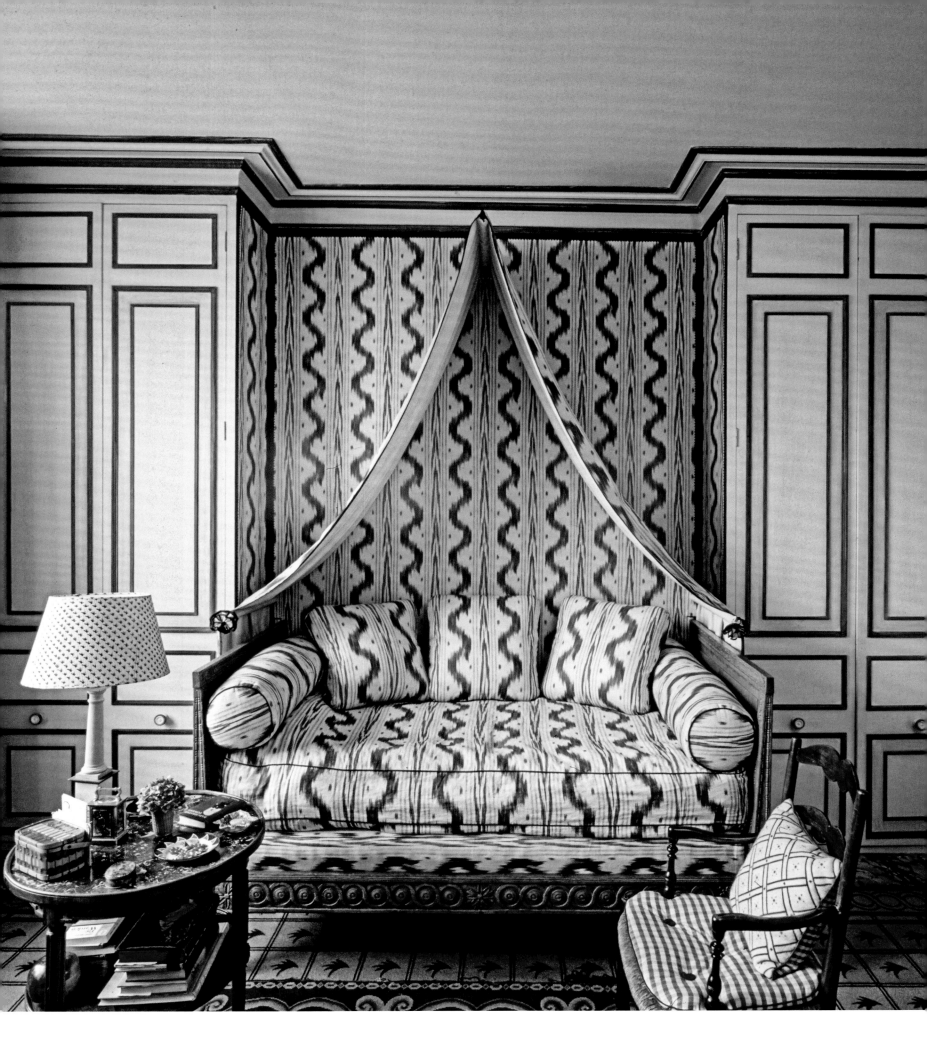

May/June 1976 | London

HOMEOWNER/DESIGNER Stanley Falconer

Falconer, a partner at Colefax and Fowler, transformed a bedroom into another sitting room where he would sometimes even host dinners.
"My home does reflect my particular sort of style," declared the designer. "Cozy, practical, and, I suppose, rather sophisticated."

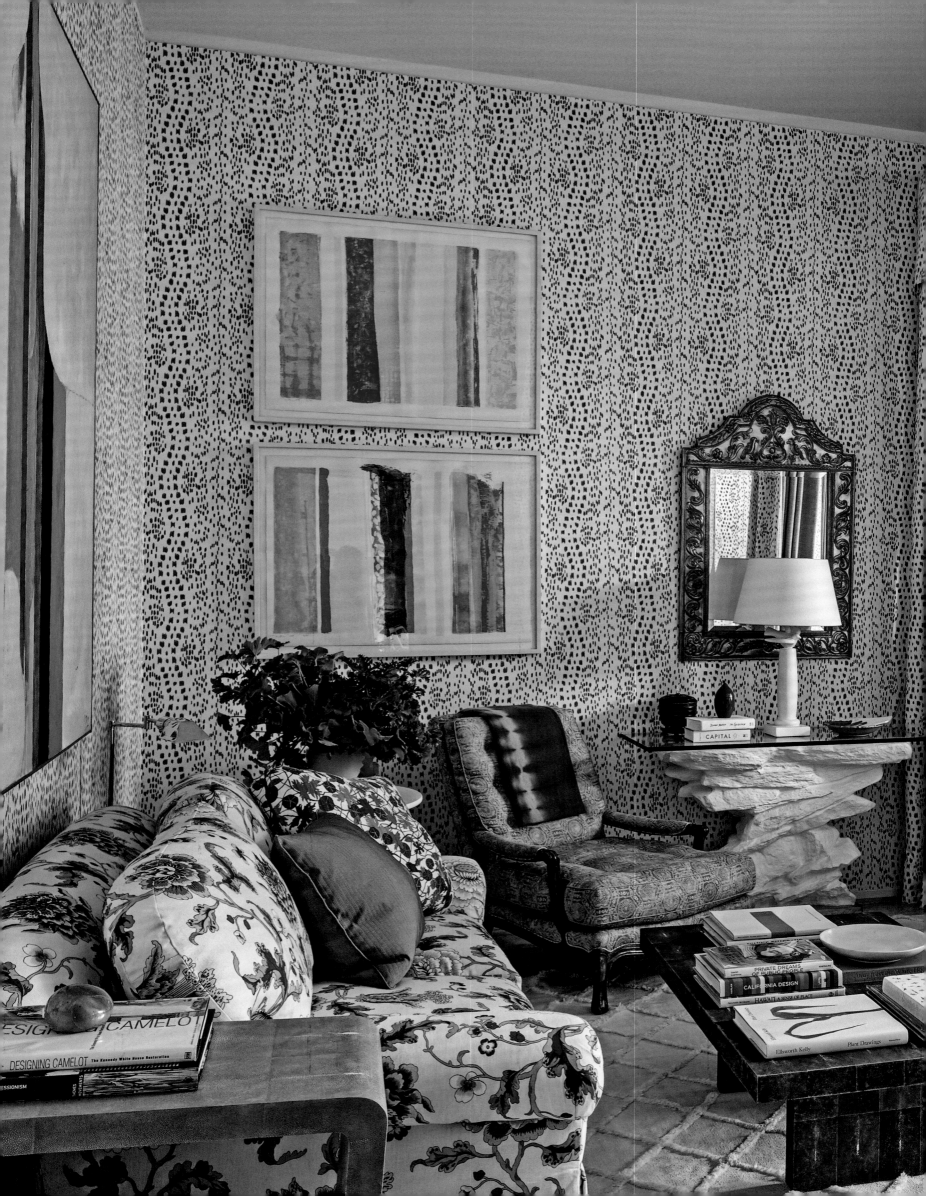

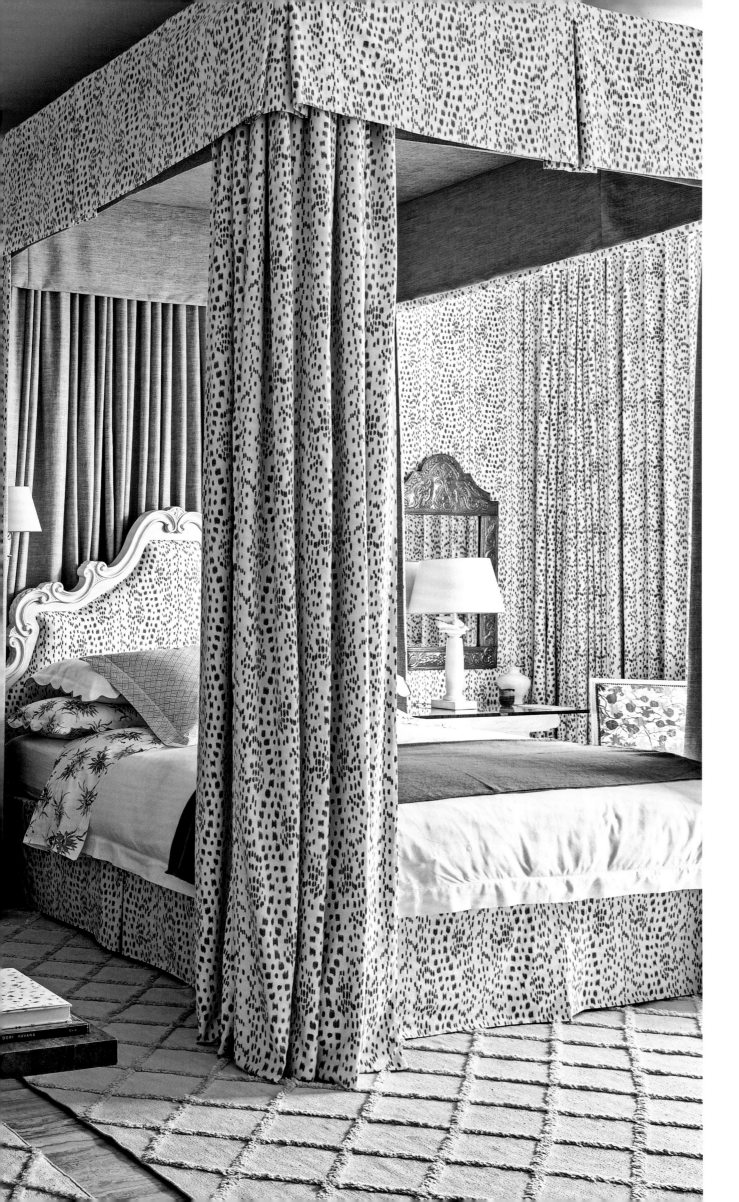

April 2015
Rancho Mirage, California

HOMEOWNER/DESIGNER
Michael S. Smith

An exuberant green-and-white fabric swathes the main guest room's walls and canopy bed at the desert retreat of Smith and then–U.S. ambassador to Spain James Costos. "Going all-in on a print is interesting," asserted the designer of the space, which has hosted clients Michelle and Barack Obama. "You might think the effect would be old-fashioned, but to me it feels modern."

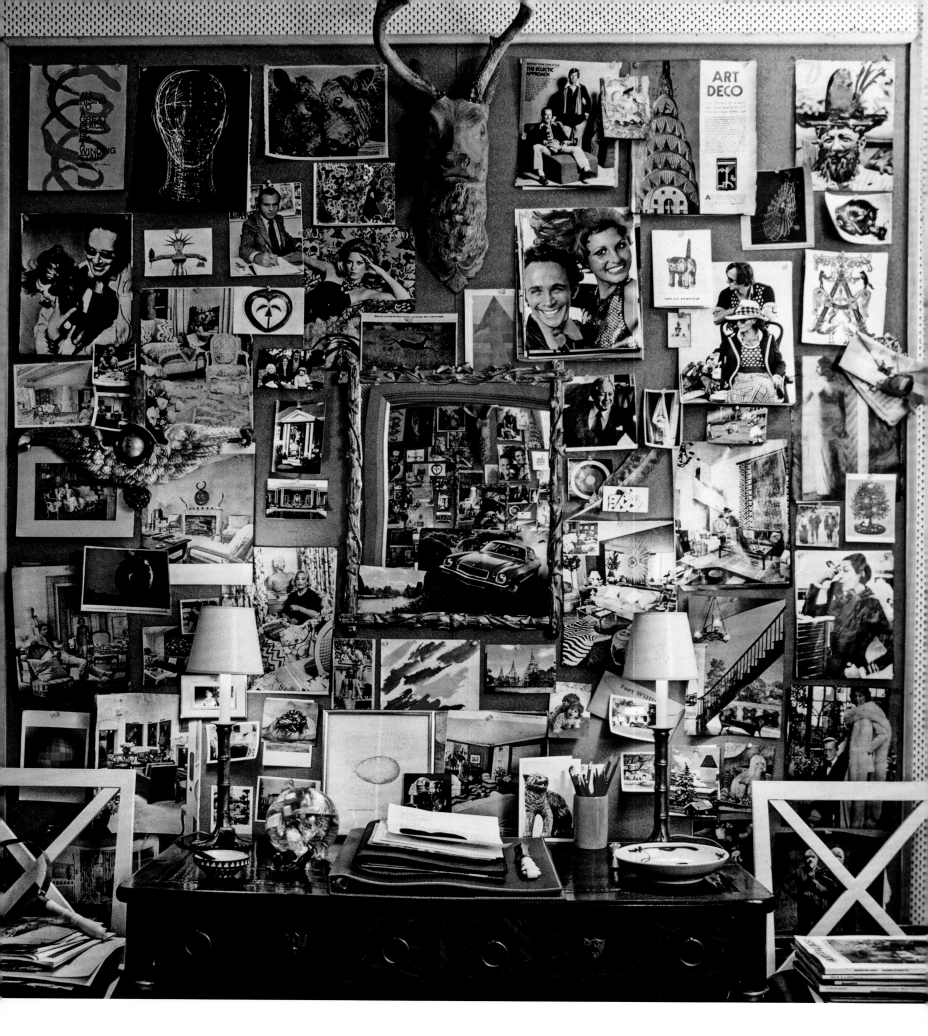

July/August 1976 | Manhattan

HOMEOWNER/DESIGNER Albert Hadley

The small studio–guest room of Hadley's apartment featured the designer's inspiration board: "my changeable tapestry," he called it. Late-18th-century American chairs flank the leather-topped Directoire mahogany writing table.

November/December 1974 | Paris

HOMEOWNER/DESIGNER Henri Samuel

As a designer better known for his work in a historical mode, Samuel's apartment showed that he was equally at home in a more modern key. "I'd be bored living all in the 18th century," Samuel once stressed. "I'm a 20th-century eclectic."

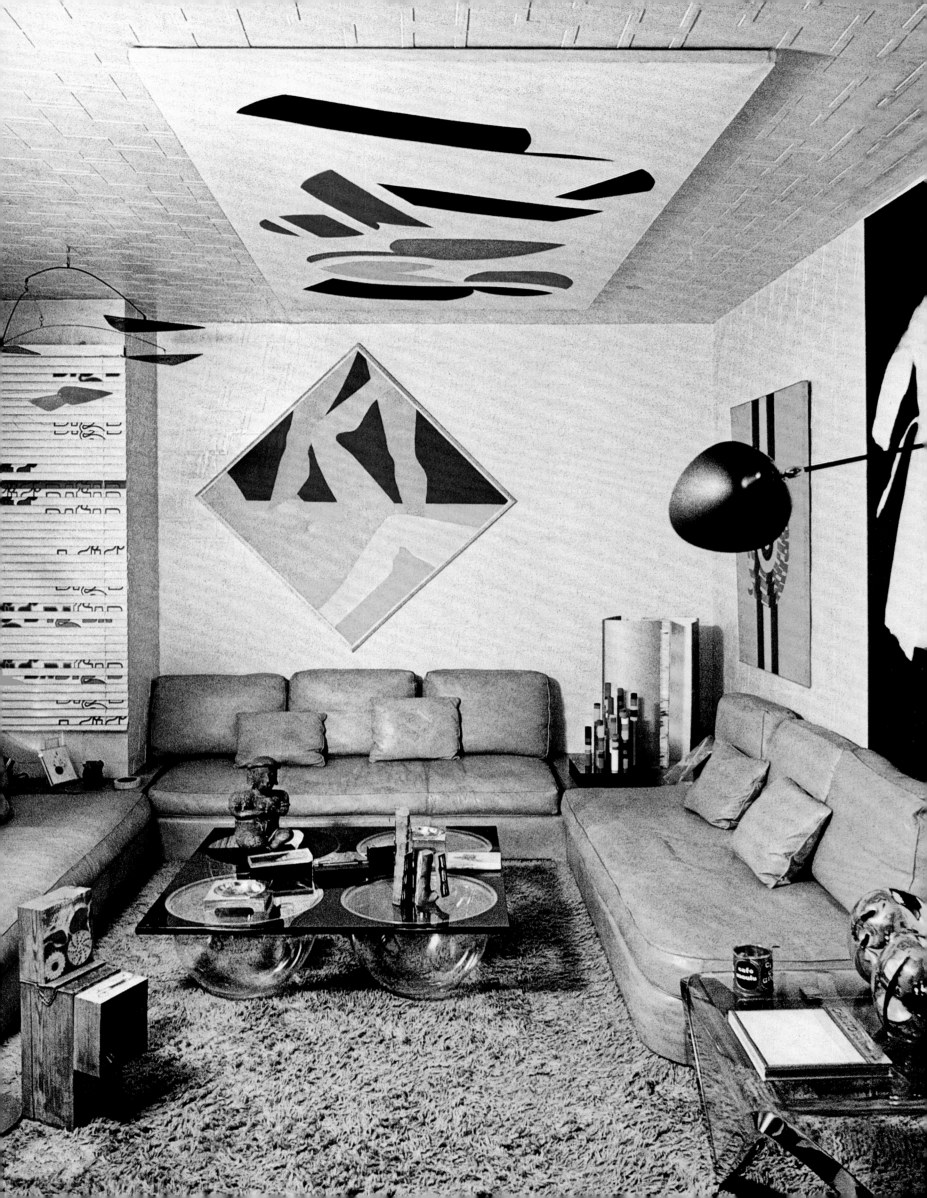

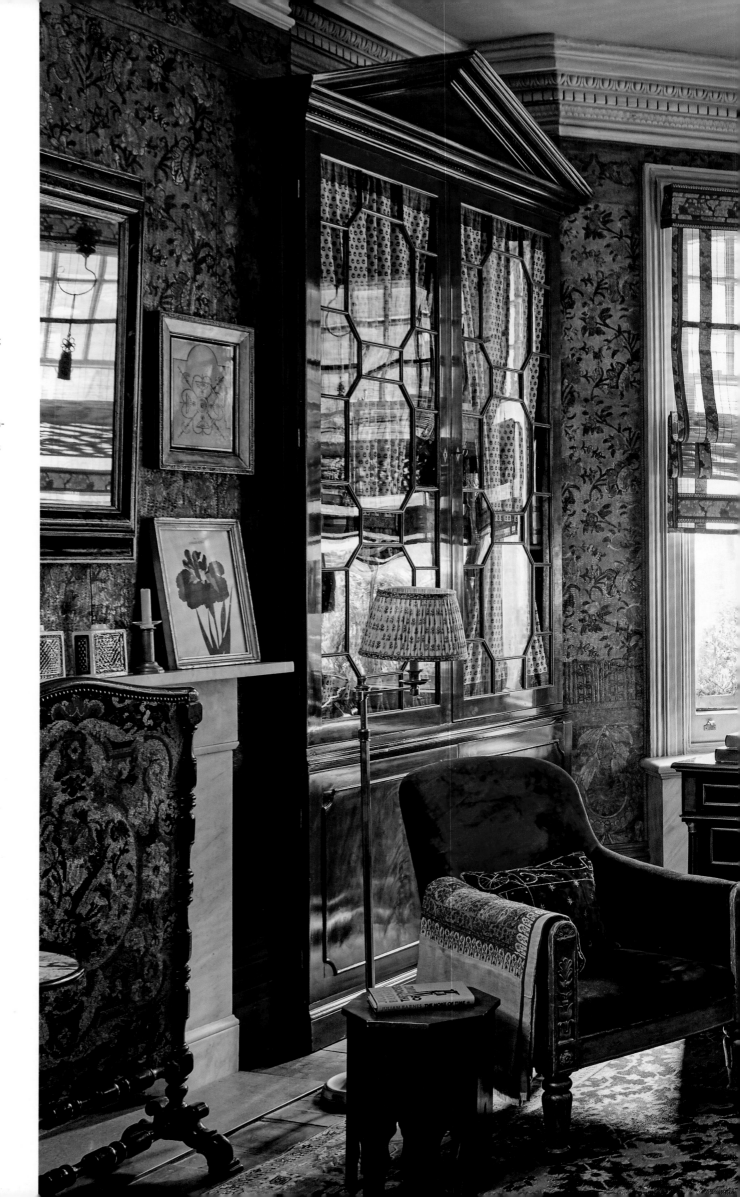

April 2019
London

HOMEOWNER/DESIGNER
Laura Sartori Rimini

The Studio Peregalli designer's home base is an apartment in Milan, but she has set up house in many other places as well: the Swiss Alps, Paris, Capri (owned in tandem with her partner in design, Roberto Peregalli), and here London. The living room brims with treasures from the past—a late-18th-century tapestry fireplace screen; a 19th-century Italian neoclassical bookcase and Napoléon III desk; shades fashioned from antique Japanese *sudare*—accented by contemporary touches, like a Hervé van der Straeten table lamp. "I love to mix things," Rimini said. "It's a question of open-mindedness about putting all these different elements together—with a good sense of balance."

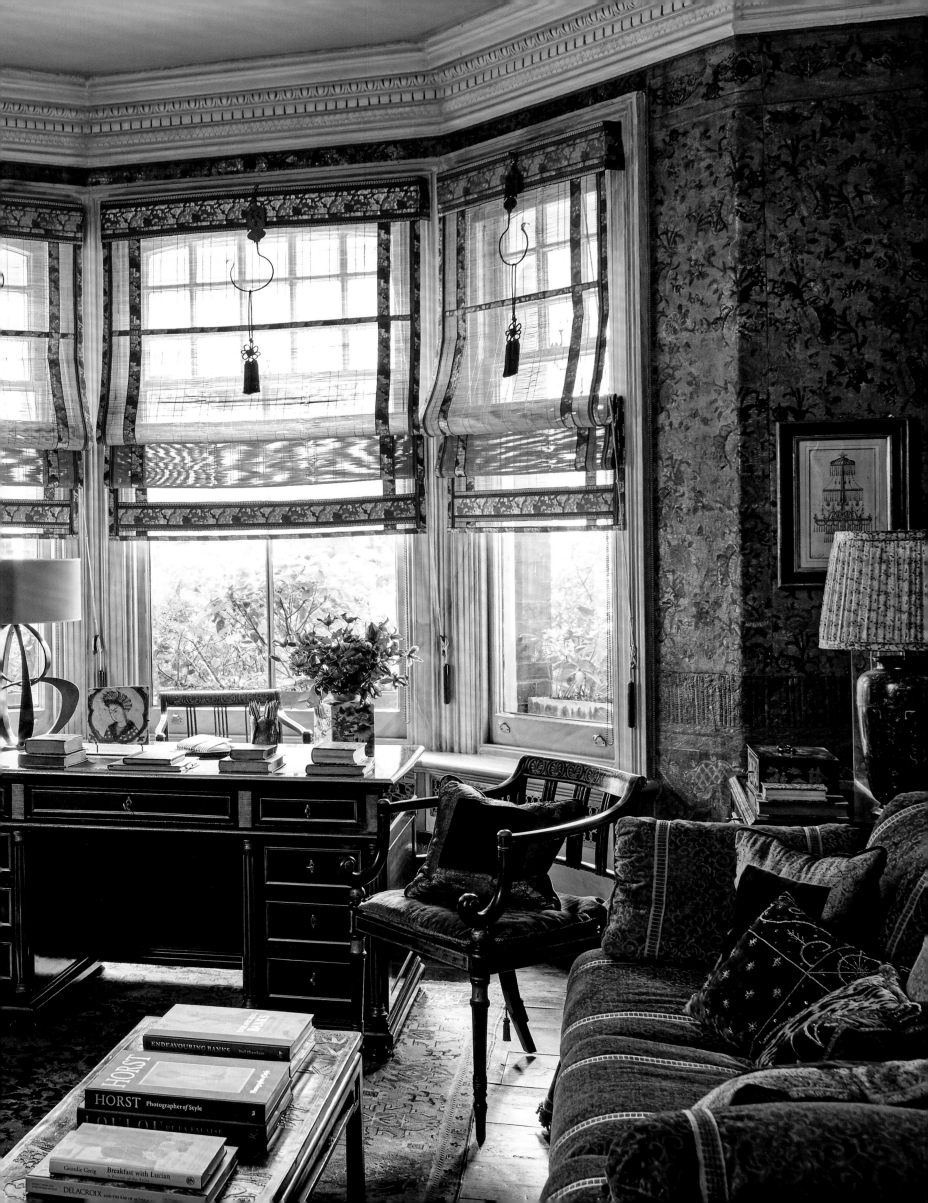

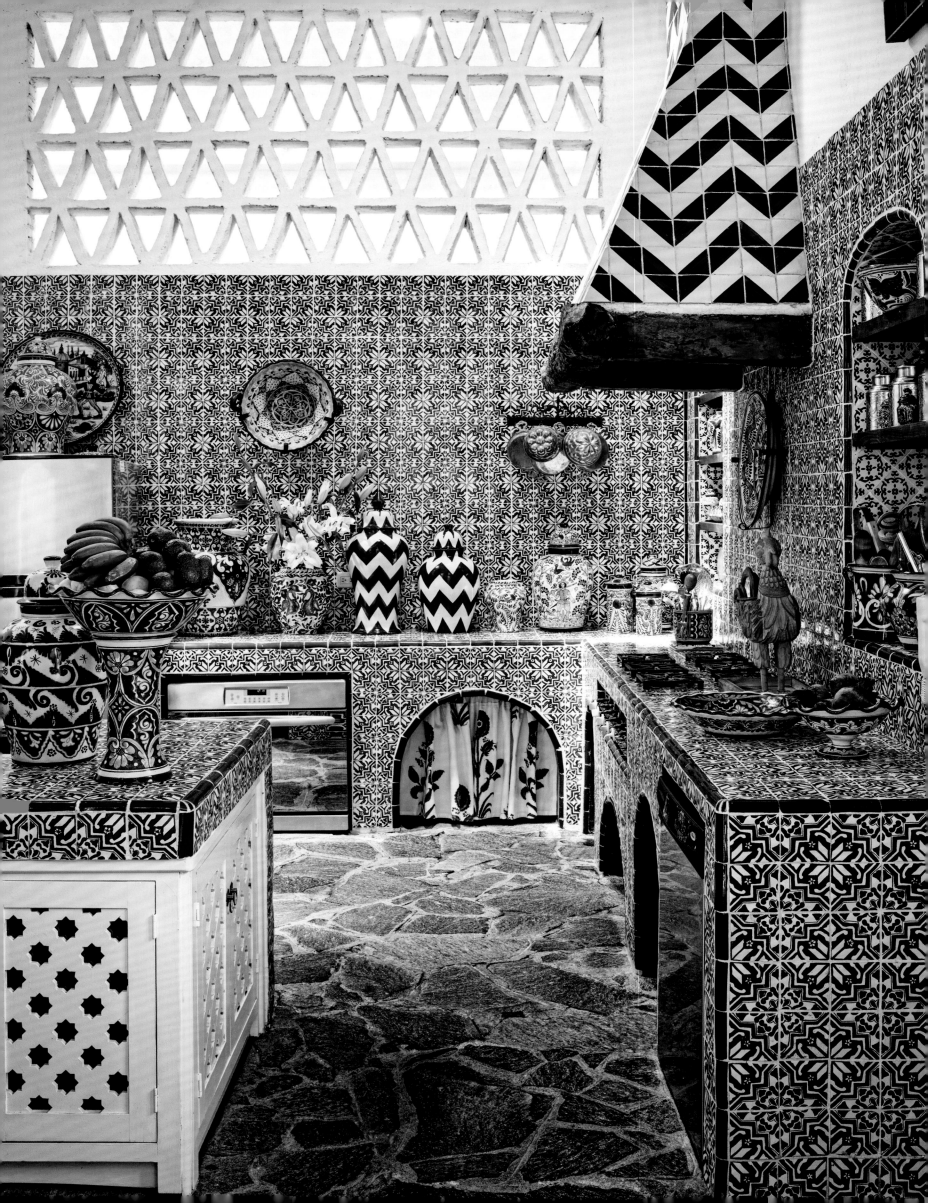

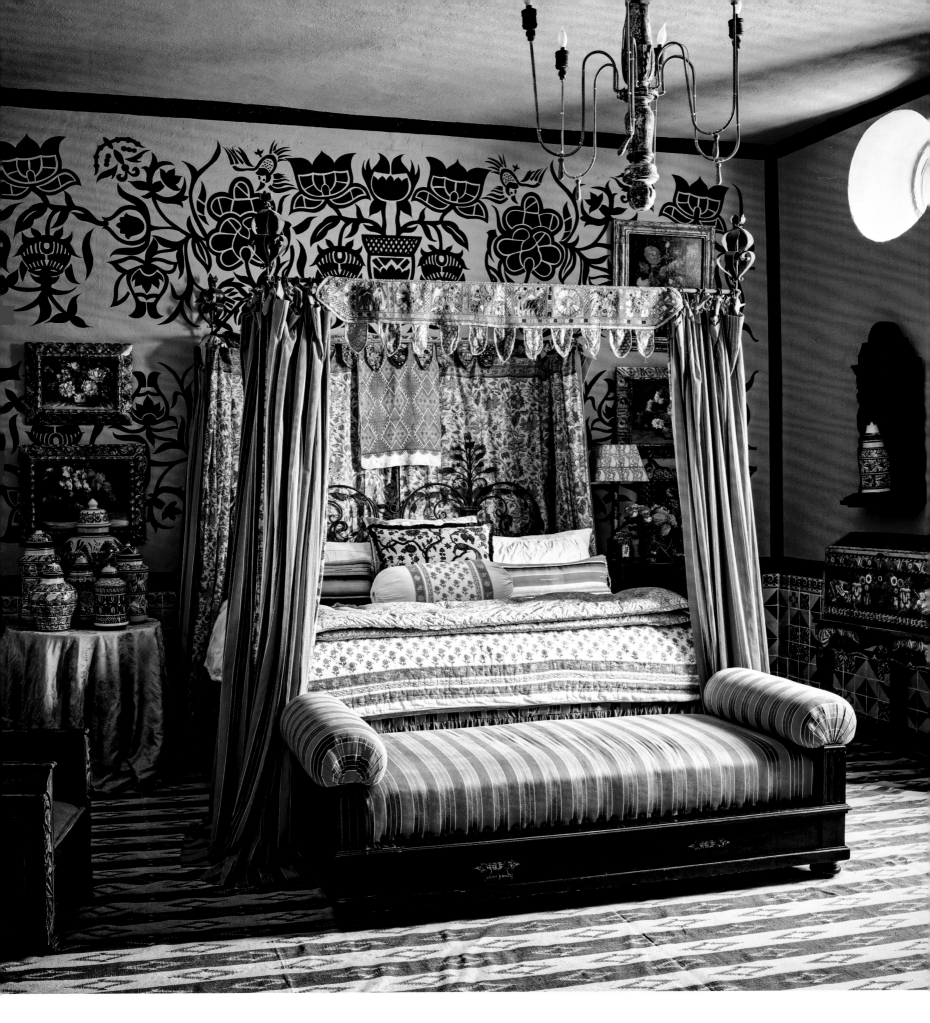

April 2019 | San Miguel de Allende, Mexico

Hacienda Buena Fe HOMEOWNER/DESIGNER Michelle Nussbaumer

Created from scratch, the kitchen in the Dallas-based designer's Mexican retreat is, as she put it, "an explosion of blue and white." The tiles (her own design) are custom-made copies of antiques she discovered in historic Puebla churches. A 1940s Mexican motif ("a Frida Kahlo kind of thing") was adapted for a bedroom's walls, adorned with floral paintings by Nussbaumer's artist mother, Barbara Stephens-Dunlap. Nussbaumer also designed the bed and fabrics.

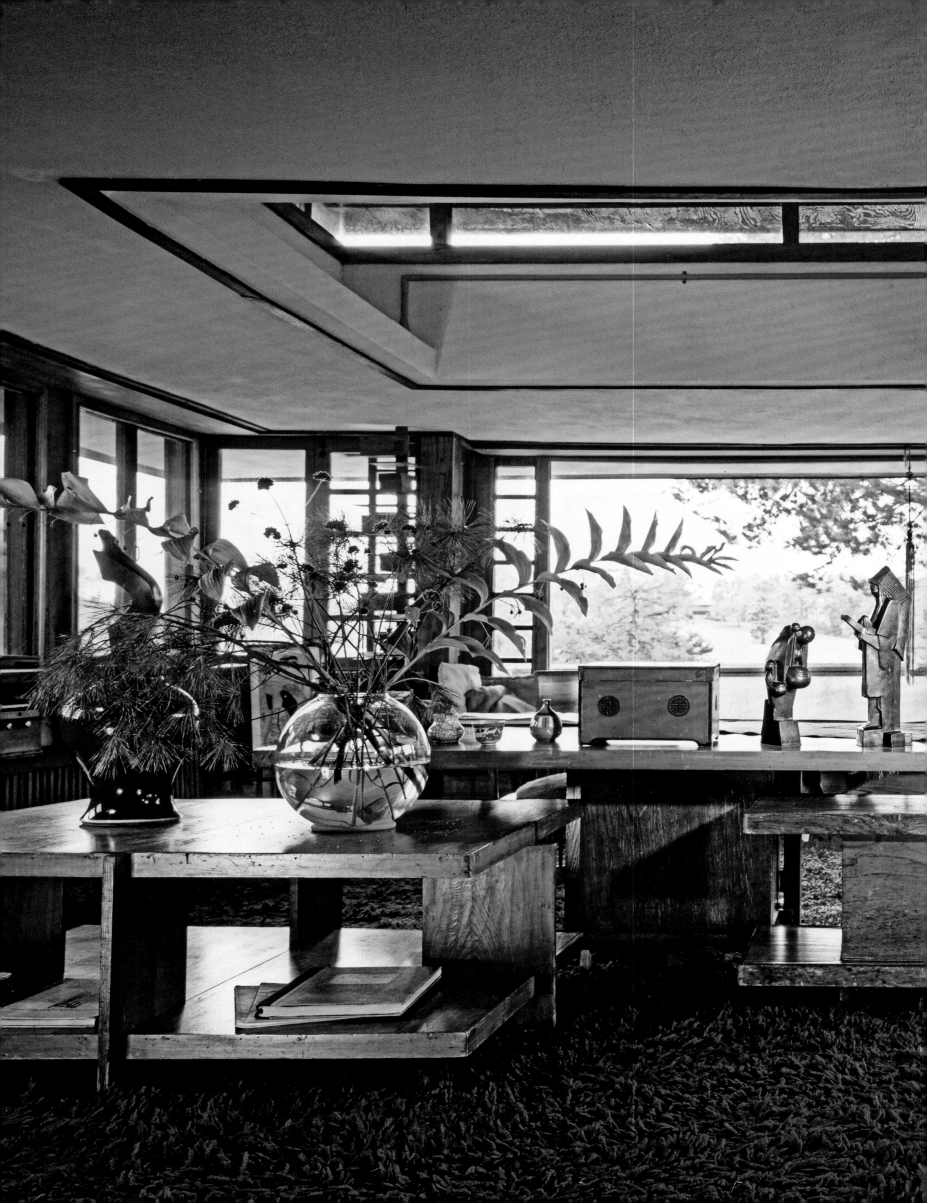

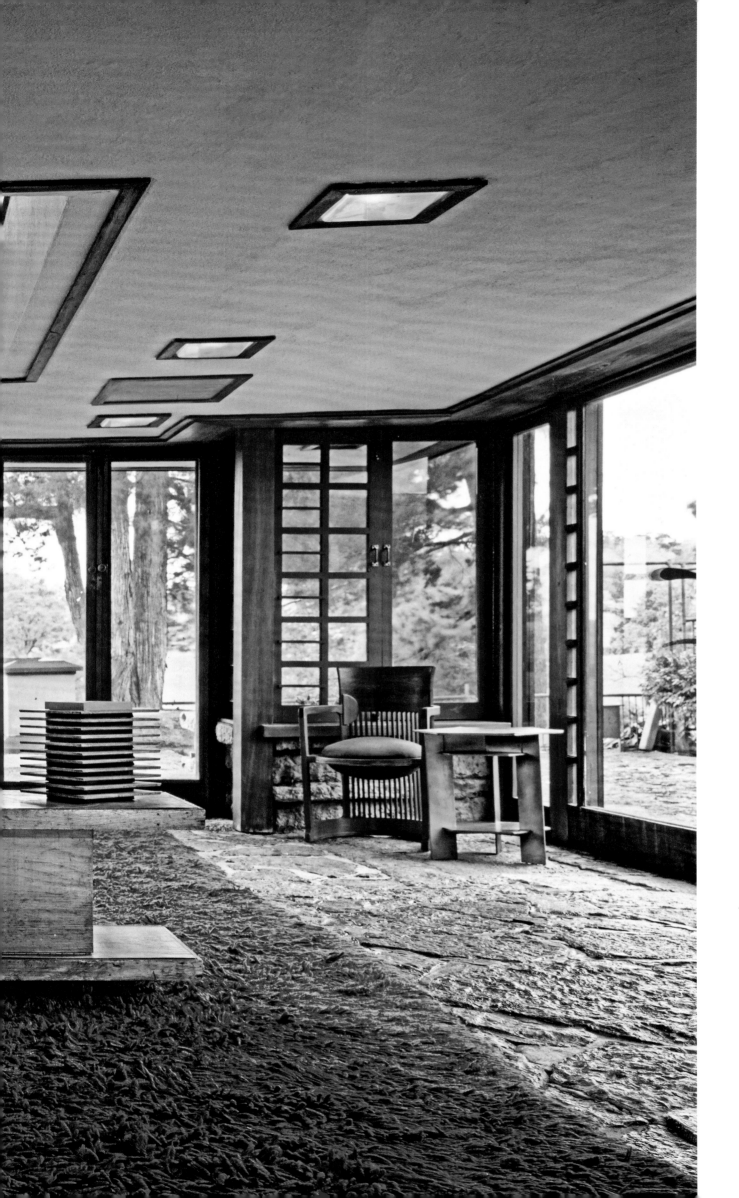

May 2004
Spring Green, Wisconsin

Taliesin
HOMEOWNER/DESIGNER
Frank Lloyd Wright

"Study nature, love nature,
stay close to nature; it
will never fail you," Wright
often advised his appren-
tices. The master heeded
that principle at Taliesin,
his home in rural Wisconsin
from 1911 until his death
in 1959. The windows of his
bedroom frame the view
of the rolling Wisconsin
countryside as if it were a
Japanese wood-block print.
Bronze reproductions of
his Nakoma and Nakomis
statues face each other
atop one of several tables
he also designed.

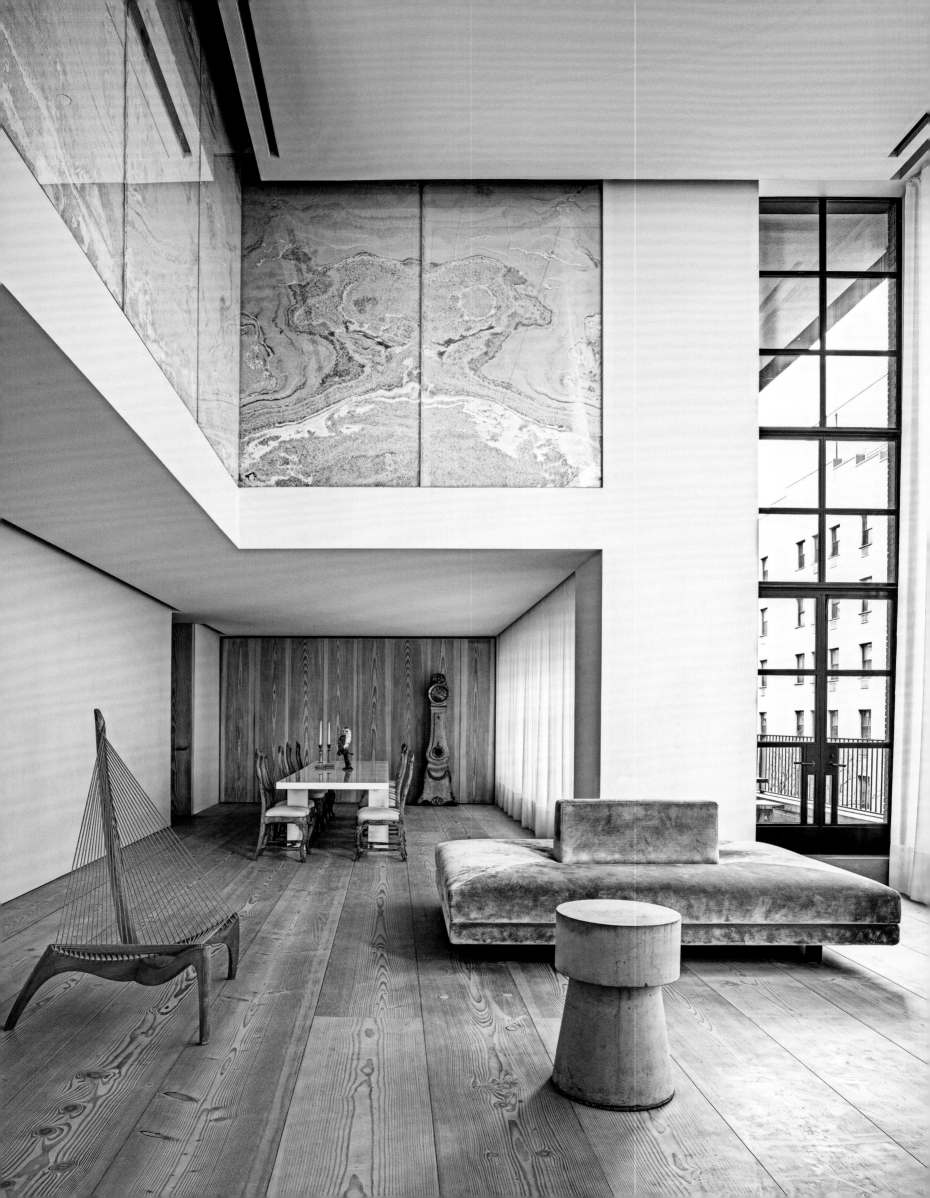

Jill & Dan Dienst
John Pawson
Gachot Studios
Maja Hoffmann
India Mahdavi
John Derian
Studio Peregalli
Ferguson & Shamamian
Mattia Bonetti
Rose Uniacke
Rudolf Nureyev
Nathaniel Rothschild
Anne-Gaëlle & Christophe Van de Weghe
Annabelle Selldorf
Pierre Passebon
Dean & Dan Caten
Dimore Studio
Jenny & Trey Laird
Jeffrey Bilhuber

City

Stéphanie Busuttil & Sébastien Janssen
Campana Brothers
Rafael de Cárdenas
Daphne Guinness
Sofía Sanchez & Alexandre de Betak
Lapo Elkann
Lee Radziwill
Ilse Crawford
Laure Heriard Dubreuil & Aaron Young
Giovanna Battaglia & Oscar Engelbert
John Richardson
Miles Redd
Clarissa & Edgar Bronfman Jr.
Amy Lau
Stefano Tonchi & David Maupin
François Catroux
Gabriel Hendifar & Jeremy Anderson
Isabelle Stanislas

PREVIOUS SPREAD
Architect John
Pawson devised a
spare but sensual
duplex for Jill Dienst,
a Manhattan dealer
in Scandinavian
treasures, and her
investor husband,
Dan (*AD* March
2017; see page 195).

JUST NAME a city and it's highly likely that *Architectural Digest* has been there. Its writers and photographers chronicle urban redoubts that have been enriched with fantasy, wit, and even defiance by metropole tastemakers, from old-guard uptowners living amid gilt-wood and chintz to pioneering downtowners devoted to cutting-edge furniture and contemporary art. The end result has been *AD* taking not only the measure of residents but also the pulse of the location, its vibrancy and variety.

Blue-chip historic addresses like Manhattan's Dakota and London's Albany—home to *AD* subjects art historian *John Richardson*, society swan *Evangeline Bruce*, and aesthete *Pauline de Rothschild*—are prime perches that show up in the magazine time and again, proving that some buildings, regardless of their age, possess eternal charisma. Factory lofts and artists' studios began infiltrating *AD*'s pages in the 1980s as intrepid tastemakers began a Pied Piper trek to underexplored environs. Joining them are Greek Revival townhouses, Victorian brownstones, Jazz Age duplexes and triplexes, and starchitect skyscrapers where startling expressions in living are concealed behind otherwise anonymous façades.

Idiosyncrasy is the thread that connects *AD*'s big-city tales, the kind of nose-thumbing that a big pond seems to invite. A São Paulo house by the provocative sibling team of *Fernando* and *Humberto Campana* presents a straw-covered front so shaggy that its resident children have

compared it to a woolly mammoth. For Hong Kong patrons, *Mattia Bonetti* conjured up a carnival of pencil-scribbled walls, polychrome patchworks, and gleaming lacquered furnishings. *Daphne Guinness*, singer, songwriter, and siren, craved "a sort of savage modernism," and she got it in a Manhattan apartment that architect *Daniel Romualdez* warmed with scarlet paint formulated to match the British expat's custom-blended nail polish. *Lee Radziwill*, on the other hand, wandered amid delicate flowers that bloomed on the walls, upholstery, and carpets of her Upper East Side penthouse: "I suppose I wanted to lull myself into thinking I was in the English countryside," the former Oxfordshire resident told *AD* in 1982.

Turning his back on his family's legacy of elegance, Milan-based product designer *Lapo Elkann* delighted in a rebel-chic mash-up of brilliant blue lacquered walls, bamboo-frond wallpaper, and zigzag-pattern floors. The cheeky SoHo loft that was renovated in barnlike fashion by *Sofía Sanchez de Betak* and her husband, *Alexandre* of fashion-show fame, comes with a saucy reflective stripper pole that provides entrée to a hidden lounge. As far as they are concerned, though, the swing's the thing. "It's very important to have a swing nearby when you feel like swinging," *Sanchez de Betak* matter-of-factly said of the unexpected amenity that dangles in the living room and from which she can observe the city from the privacy of her highly personal perch. ◢◣

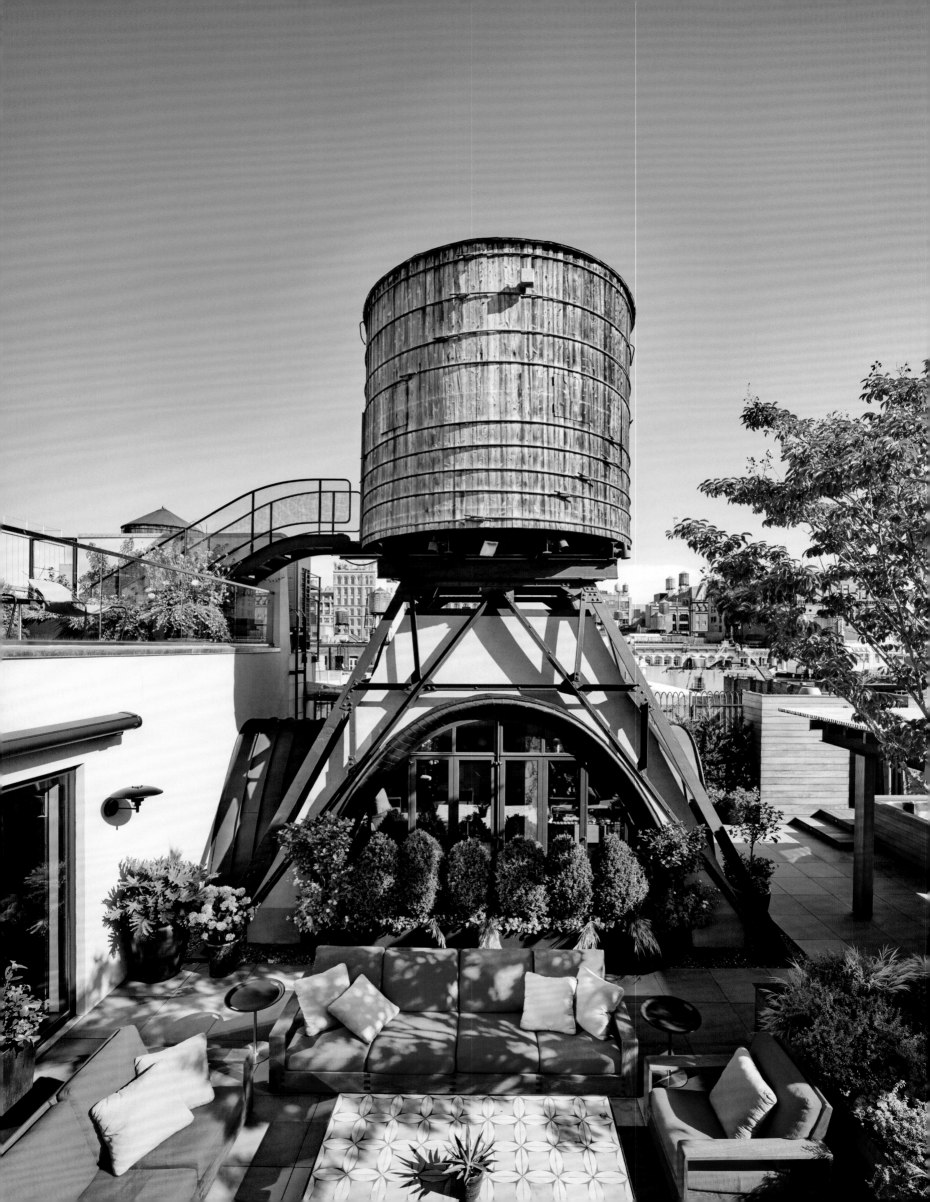

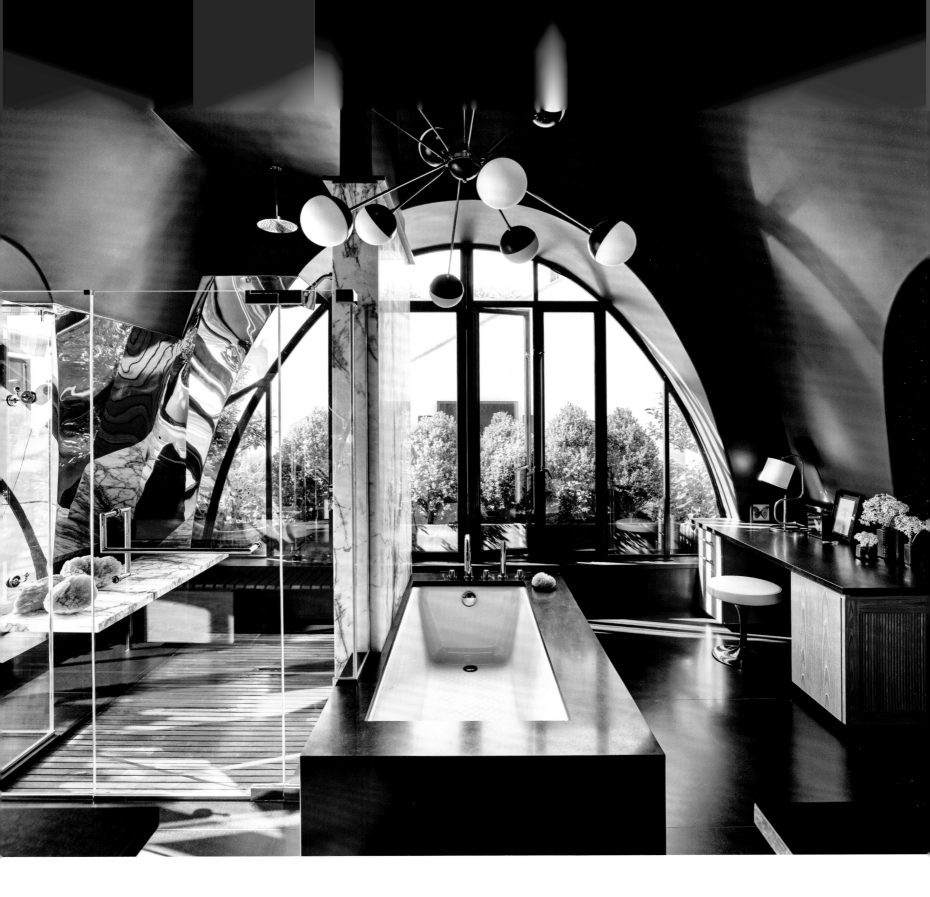

October 2016 | Manhattan

DESIGNERS Joe D'Urso, Gachot Studios

A decommissioned water tower housing a North African–themed meditation space stands atop a stunning SoHo triplex whose design was initiated by minimalist master Joe D'Urso, then taken over by Christine and John Gachot. The 3,100-square-foot double-decker terrace also includes a pergola, a hot tub, a bar, and inviting areas for lounging and dining. Nestled beneath the water tower's metal support structure is the teak-and-granite master bath, where semi-elliptical windows take in the skyline while a battalion of pyramidal boxwoods maintains privacy.

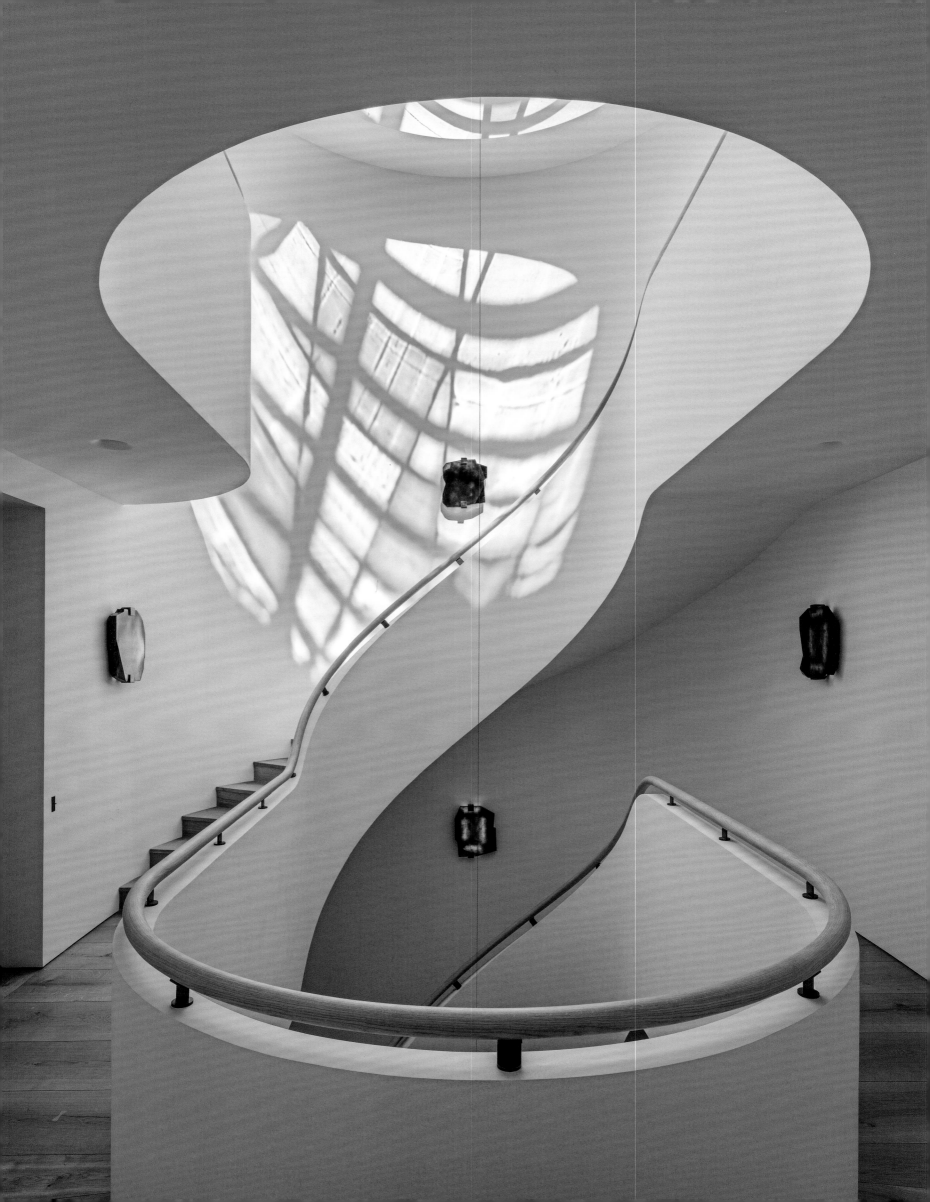

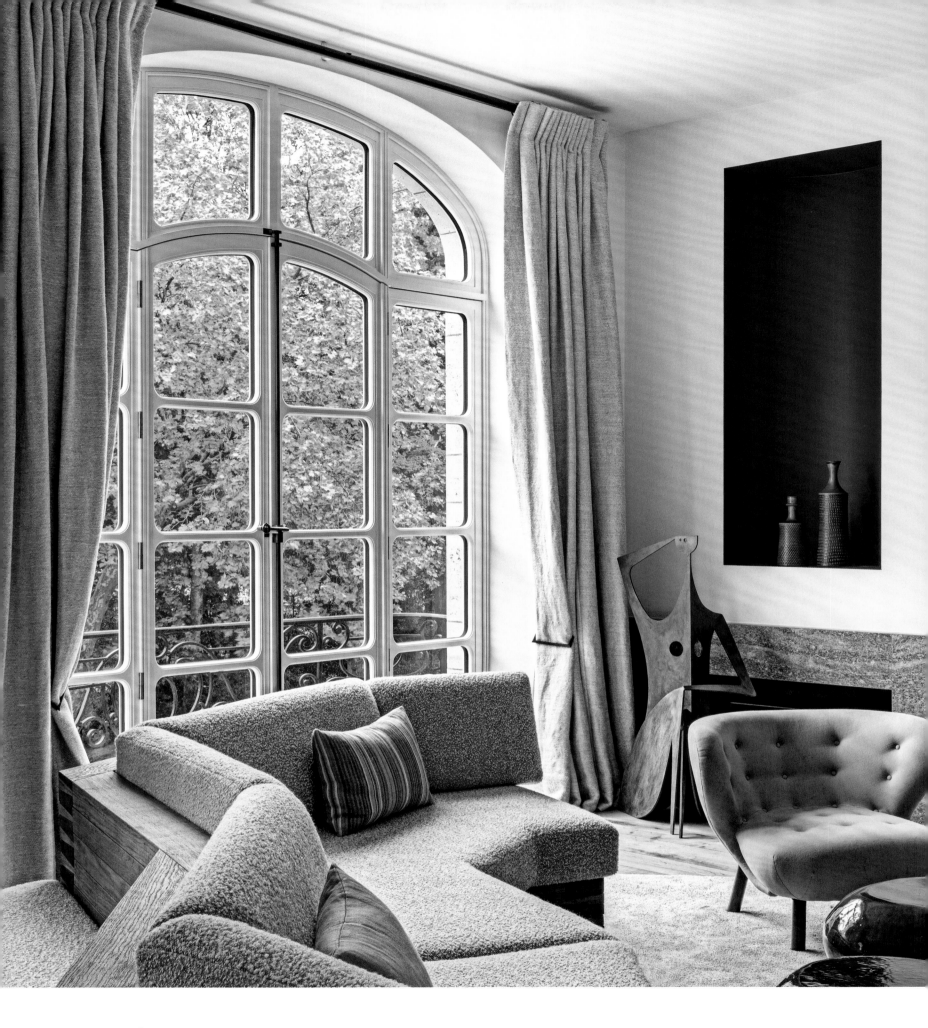

January 2018 | Brussels

DESIGNER Pierre Yovanovitch Architecture d'Intérieur

"If you want a creation to not look industrial, you're obliged to work with artisans," said Yovanovitch, the modern-minded Paris talent, who transformed a 1910 house that had been previously ruined by a conversion into offices. His interiors celebrate craftsmanship, from the hand-sculpted staircase that coils up three stories like a ribbon of taffy ("People say it looks like the Guggenheim Museum," the clients explained) to the living room's plush but angular sofa, which was custom-made by one of the designer's favorite master carpenters.

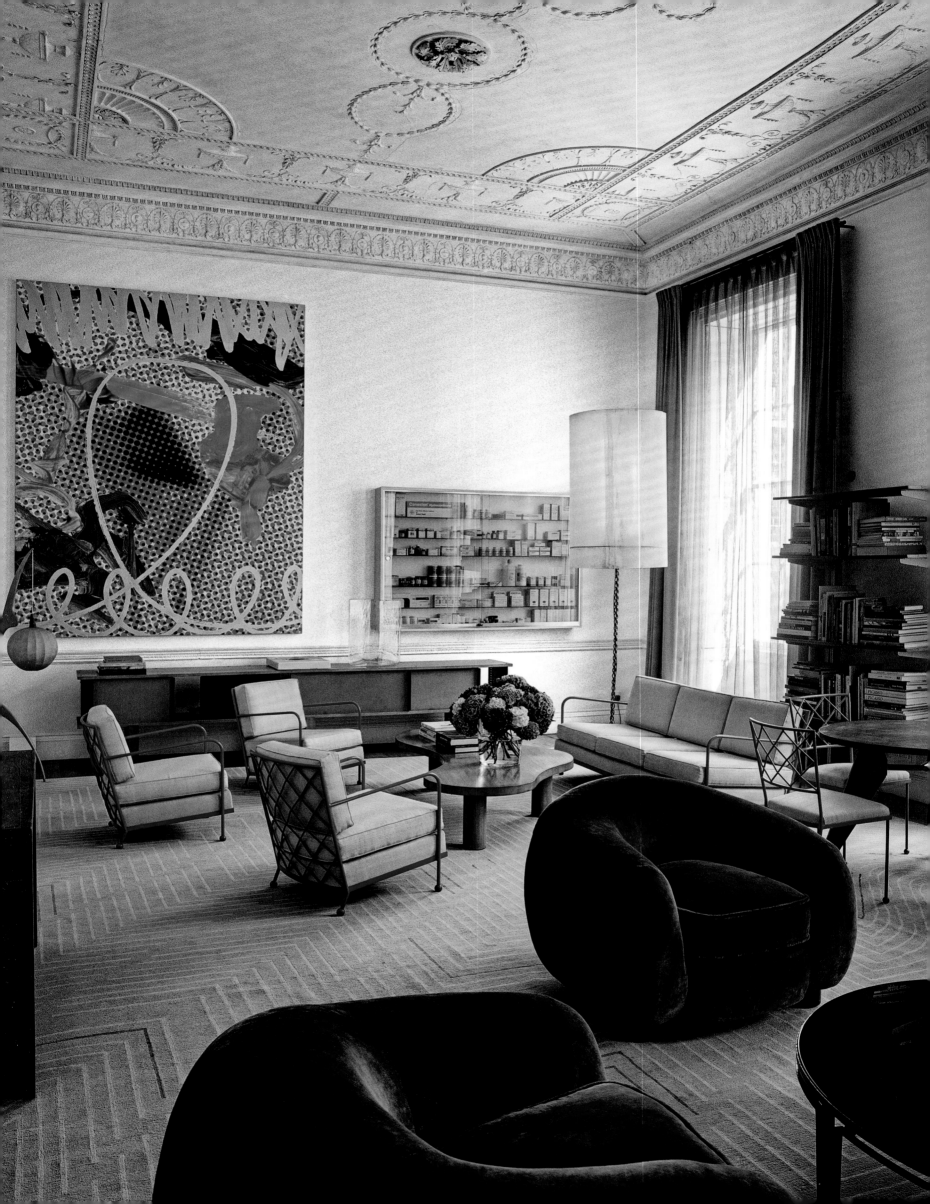

January 2019 | London

HOMEOWNER Maja Hoffmann DESIGNER India Mahdavi

"It's vast and very vertical, but it's also cozy, intimate, and always luminous," Hoffmann, a renowned art collector, said of her home, a renovated combination of two late-18th-century residences. Pieces by Jeff Koons and Damien Hirst anchor the drawing room, and a tropical garden occupies what was once the courtyard of one of the dwellings.

February 2019
Manhattan

HOMEOWNER/DESIGNER
John Derian

The decoupage maestro's
home perfectly encapsu-
lates the sensibility of an
artist, with the ethereal
beauty of timeworn patina,
chipped paint, and the
glories of nature. In his
classic East Village apart-
ment, just upstairs from
his namesake shop,
he juxtaposed an 18th-
century Swedish wall
with a pressed-tin ceiling
and exposed pipes to
create an otherworldly
effect that is pure Derian.

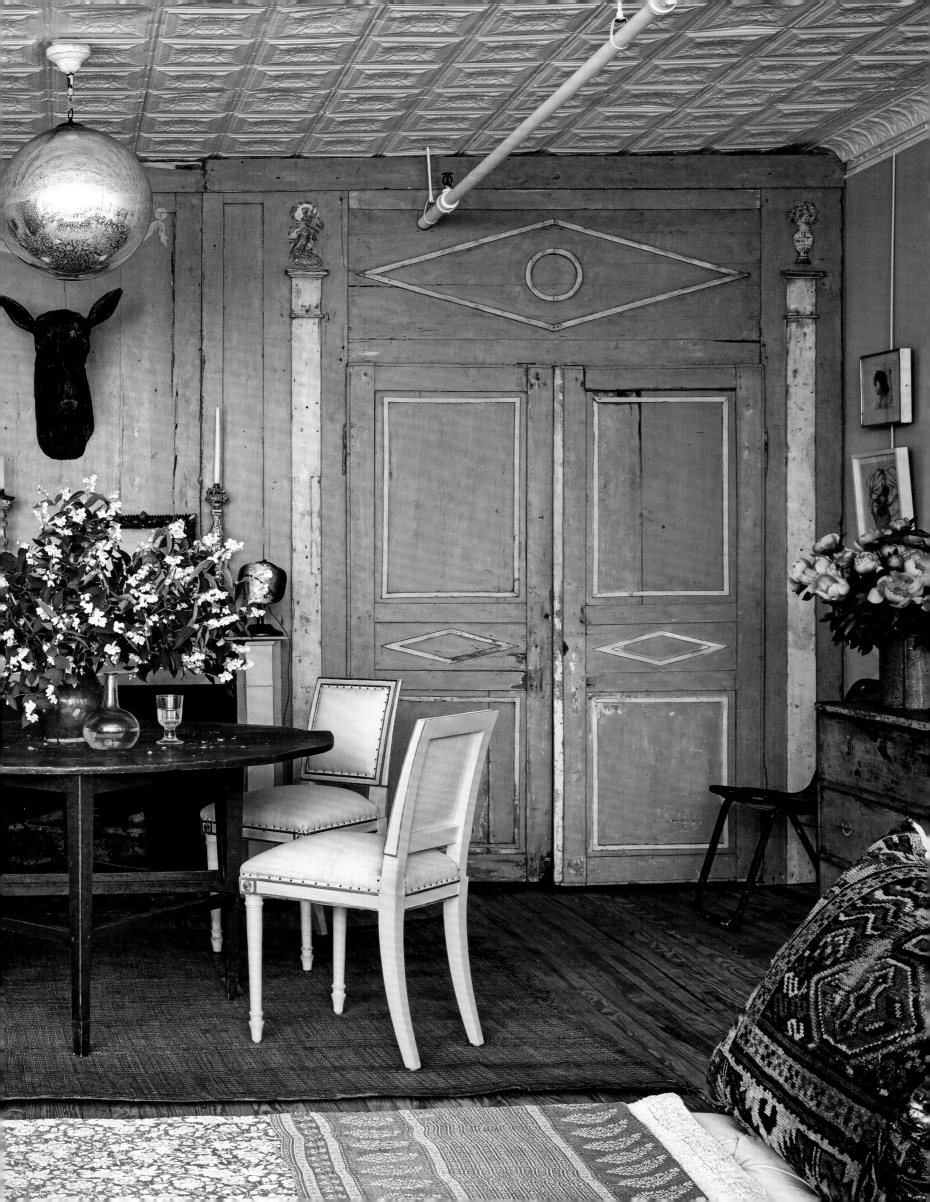

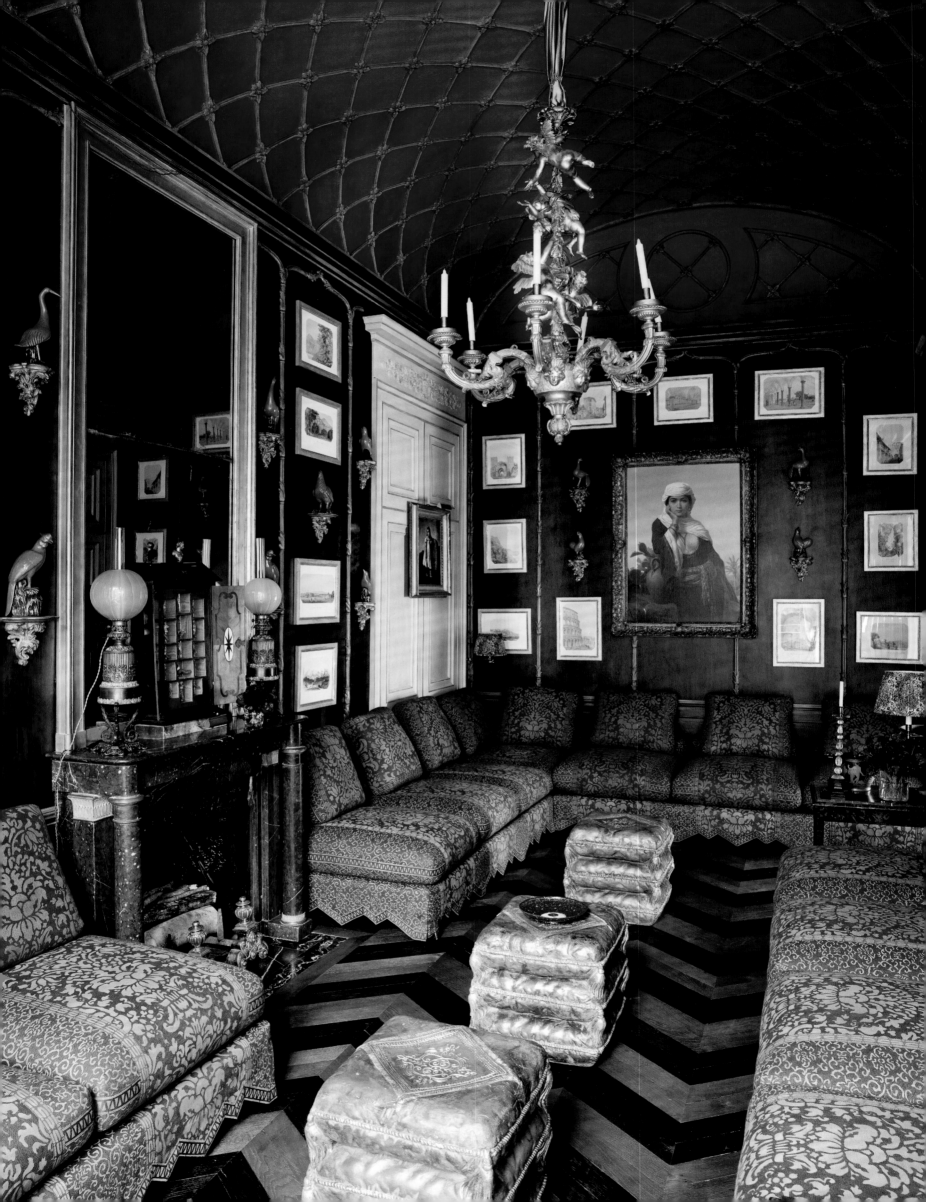

May 2015 | Paris

HOMEOWNER **Pierre Bergé** DESIGNER **Studio Peregalli**

"You should enter a room and not know if it is old or new," said designer Roberto Peregalli. His firm's Orientalist petit salon for the fashion magnate's 18th-century duplex was made to order, from the gilded barrel ceiling to the faux-bois paneling to the dynamic chevron floor—only the art, chandelier, and terra-cotta stools are antique. "One day, no doubt," Bergé said, "this will all vanish just as quickly as it arrived. In the meantime, it's mine."

March 2017 | Manhattan

HOMEOWNERS **Jill & Dan Dienst** ARCHITECT **John Pawson**

The pink-gold western light that glints off the Hudson River is what intrigued Pawson the most about this West Village commission for Jill Dienst, the proprietor of the New York City antiques mecca Dienst + Dotter, where Scandinavian relics reign. From this starting point, he fashioned a soaring terrace off the living/dining area and outfitted the home with double-height rooms and enormous windows.

October 2018
Manhattan

ARCHITECT
Ferguson &
Shamamian
DESIGNER
Michael S.
Smith Inc.

"In every room there is
something discordant,
that doesn't belong—
that's fabulous," said
the owner of an eight-
bedroom duplex suavely
conjured up from neigh-
boring apartments in
a classic 1920s Rosario
Candela building. The
master bedroom's lyrical
garden-scene wallpaper
is unexpectedly joined by
jazzy abstract paintings
by Jean Arp and Georges
Vantongerloo; the canopy
bed echoes one that
was designed by Pauline
de Rothschild.

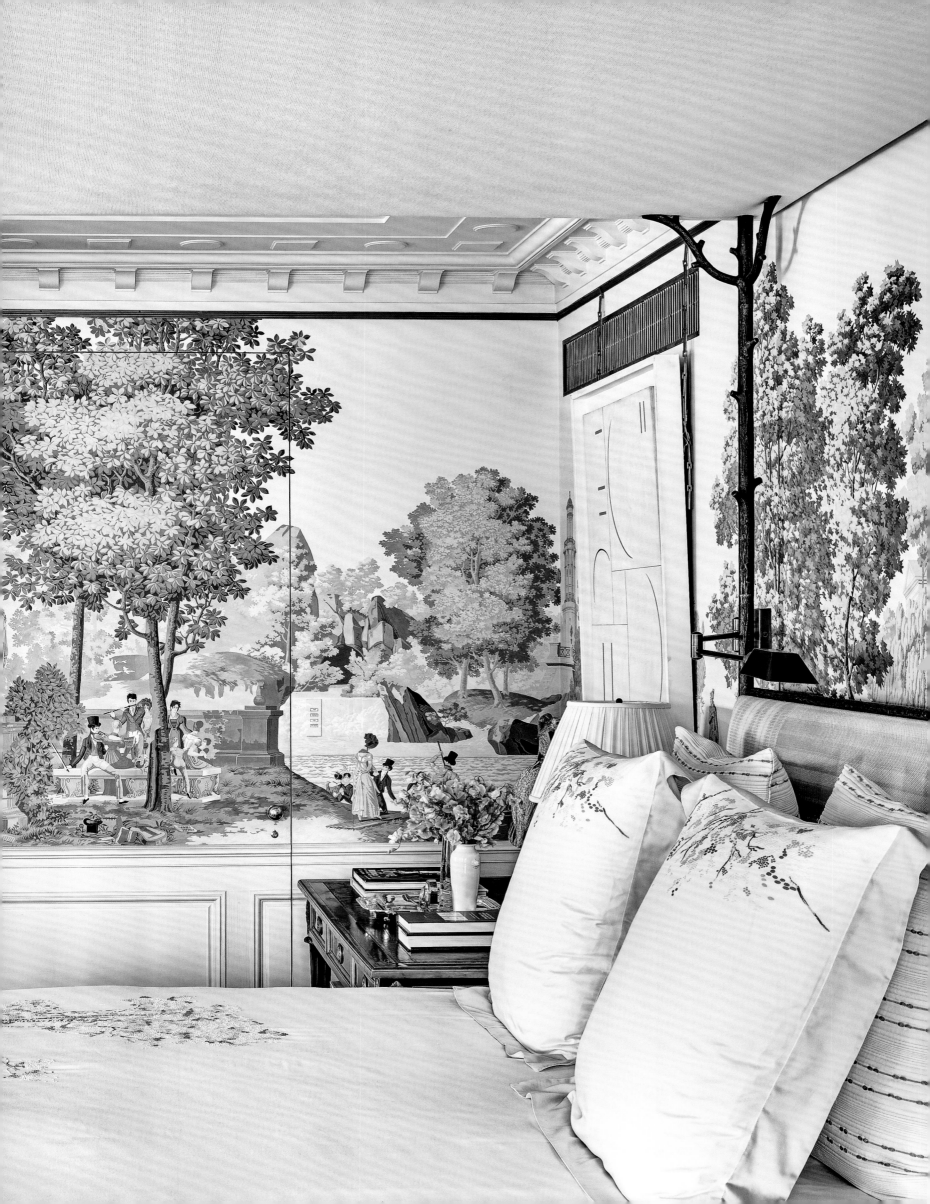

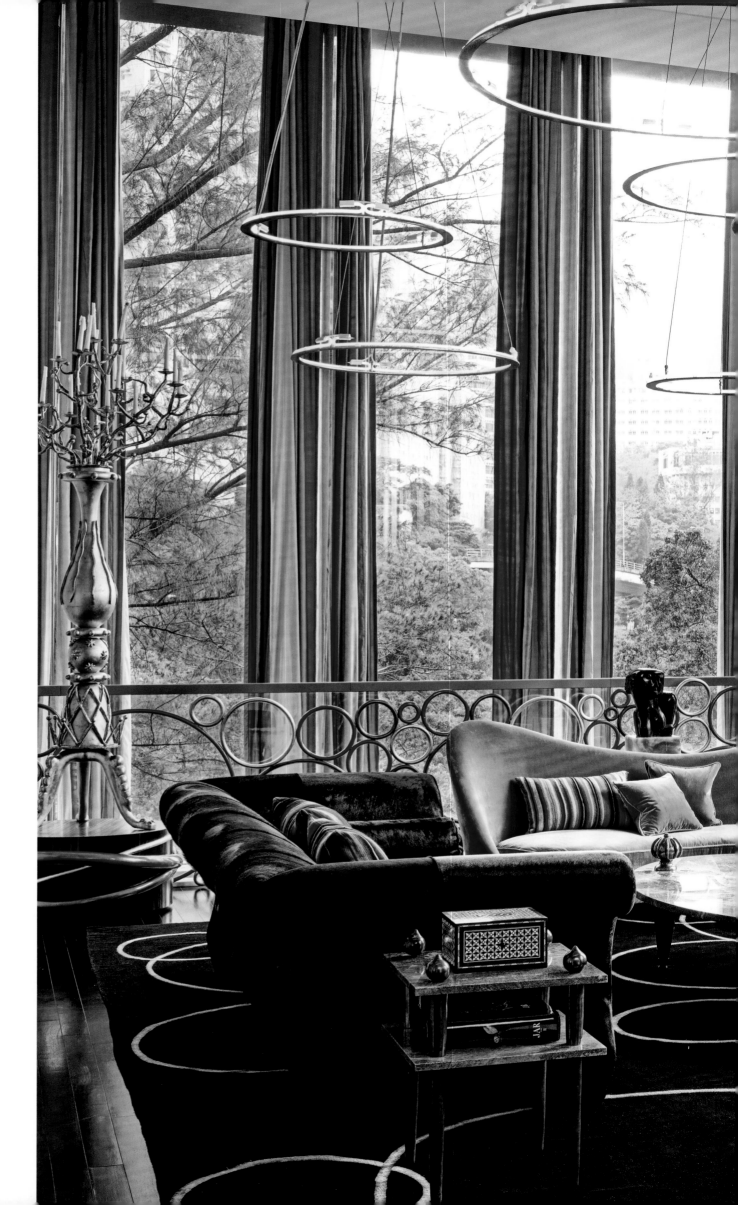

August 2016
Hong Kong

DESIGNER
Mattia Bonetti

After taking on a building
that was to be occupied
by longtime clients and
their grown children,
French enfant terrible
Bonetti went wild, as is his
wont: "If people who can
afford incredible decors
keep commissioning bland
minimalist interiors," he
asserted, "it's the end of
decoration." His hoop-
shaped pendants, their
silhouettes echoed in the
carpet, hover over the
shared living room, where
Bonetti seating, tables,
and torchères are joined
by blue-chip art by Naum
Gabo and Henry Moore.

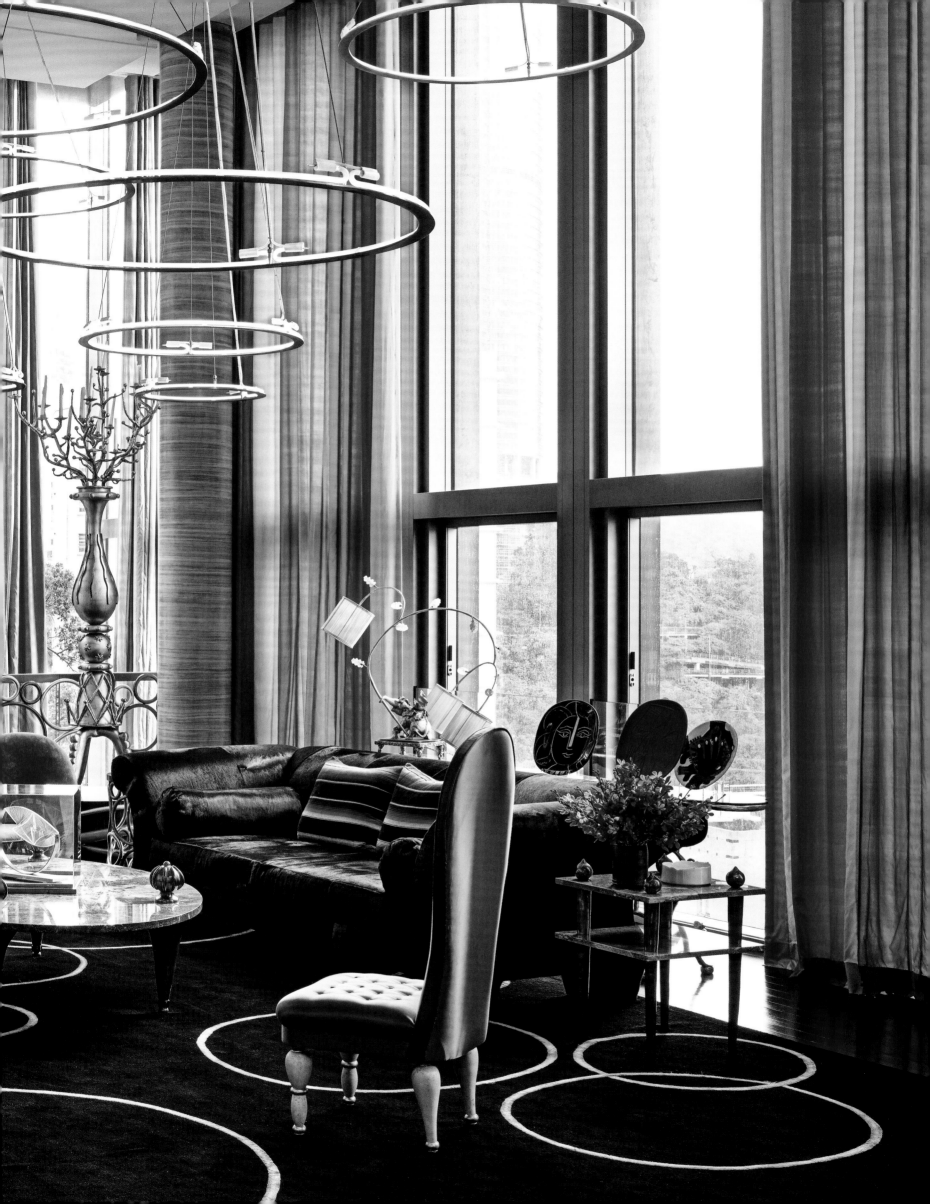

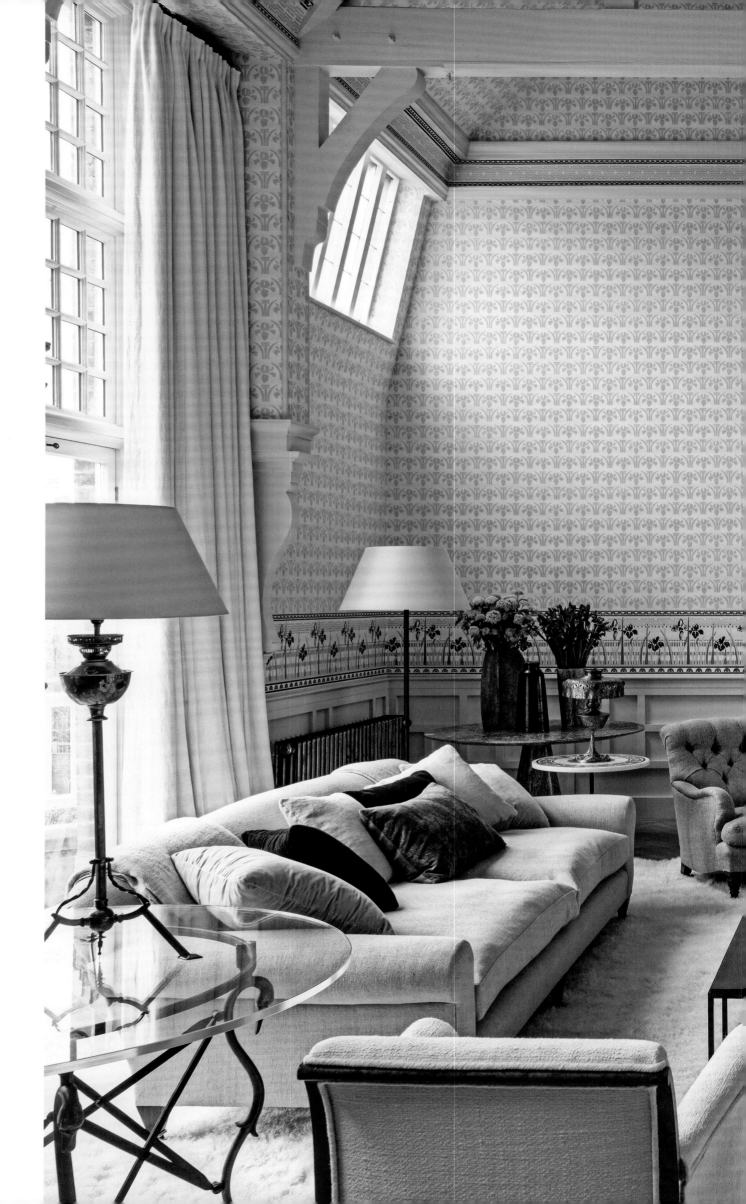

January 2018
London

DESIGNER

Rose Uniacke
Studio Ltd.

Following a full-bore
architectural restoration
of Oscar Wilde's former
digs, Uniacke devised a
decor in which Victorian
bohemianism meets
20th- and 21st-century
furnishings in a dégagé
manner that is plainly,
comfortably now. "My
clients were keen to
respect history but didn't
want an academic re-
creation of an Aesthetic
Movement scheme," she
explained. The double-
height living room is
wrapped with a verdant,
hand-blocked wallpaper,
a facsimile of a sample
found in the Victoria and
Albert Museum archives.
"It's like being inside an
apple," Uniacke added.

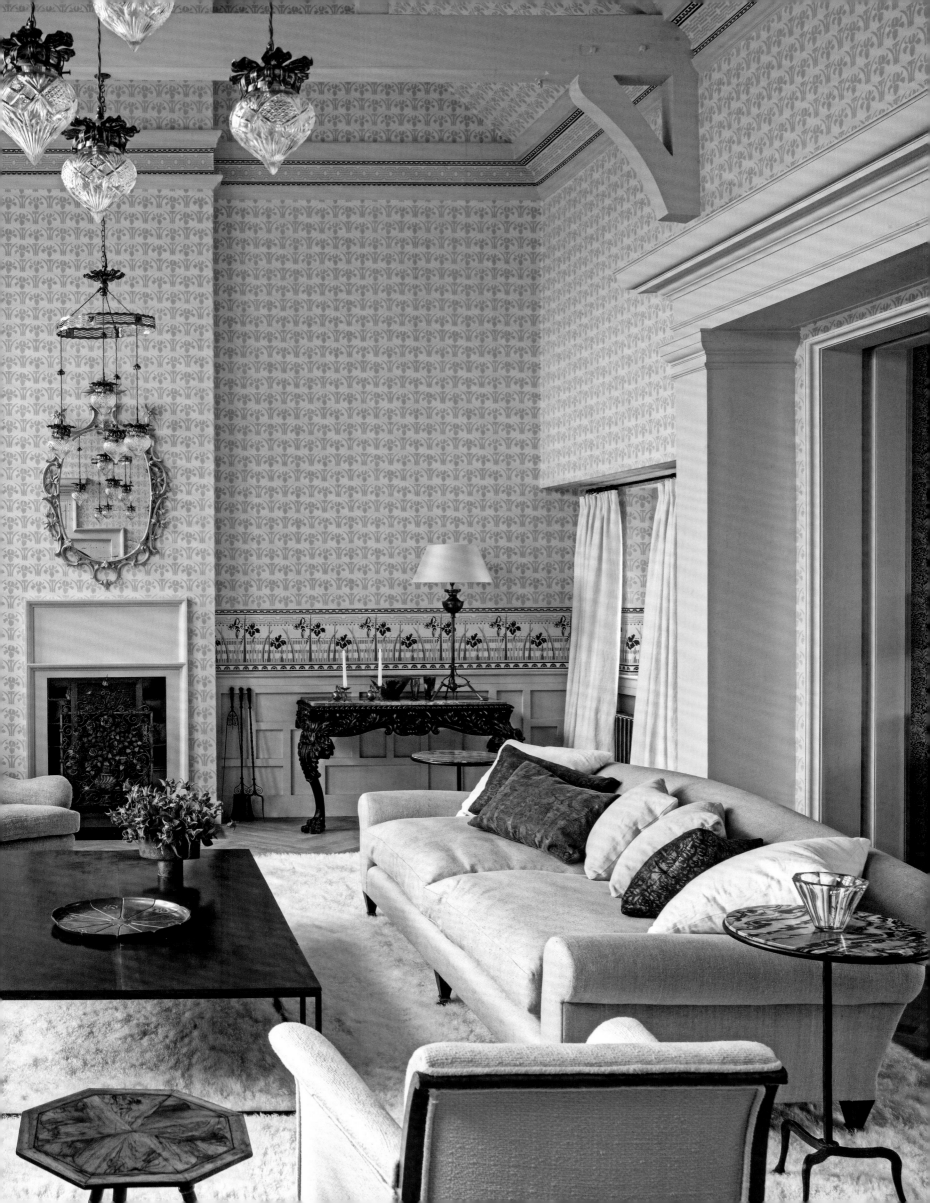

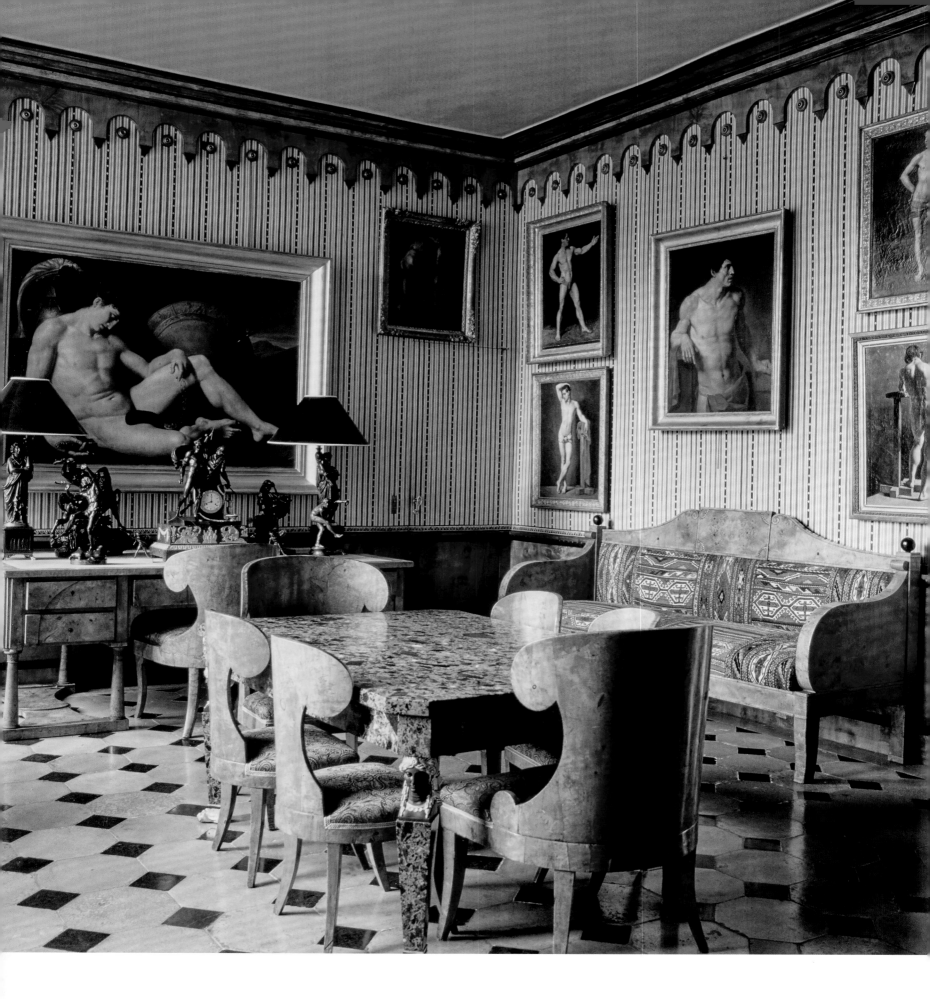

September 1985 | Paris

HOMEOWNER Rudolf Nureyev

Designer Emilio Carcano renovated the ballet star's duplex in a romantic early-19th-century mode, in association with Pierre François, an architect, and his sister, Douce, a close Nureyev friend. In the stone-paved dining room/library, French academic nudes in the manner of Théodore Géricault overlook Russian Biedermeier furniture upholstered in a paisley fabric and patchworked kilims; the table is made of Vert des Pyrénées marble.

February 2011 | Rio de Janeiro

HOMEOWNER Nathaniel Rothschild

The financial titan's Brazil getaway—designed in the 1980s by architect Claudio Bernardes and renovated for Rothschild by decorator Tino Zervudachi and architect Luciano Pedrosa—features a palm-shaded swimming pool that rolls out from the glass-walled house like an abstract carpet. The syncopated black-and-blue tilework is based on Roberto Burle Marx's famous Rio promenades.

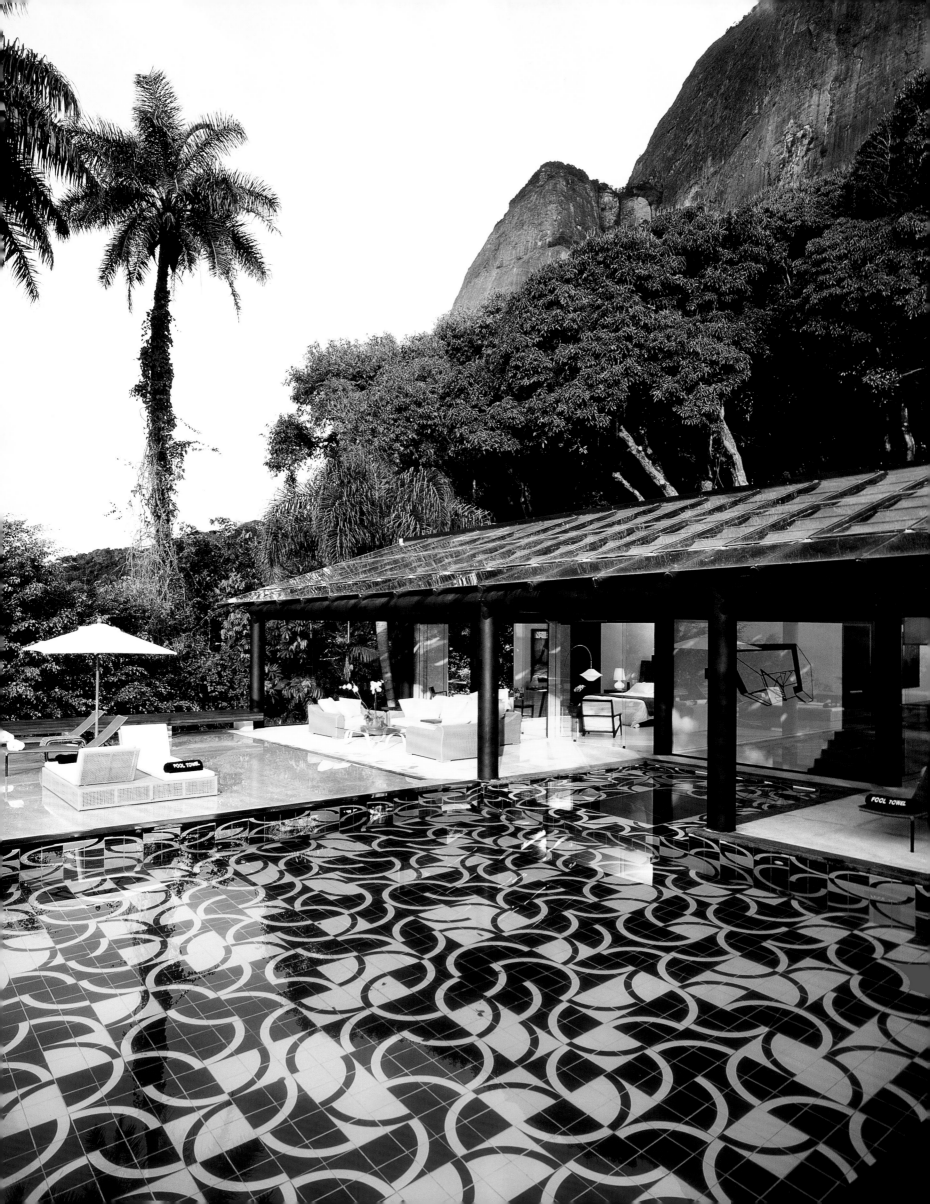

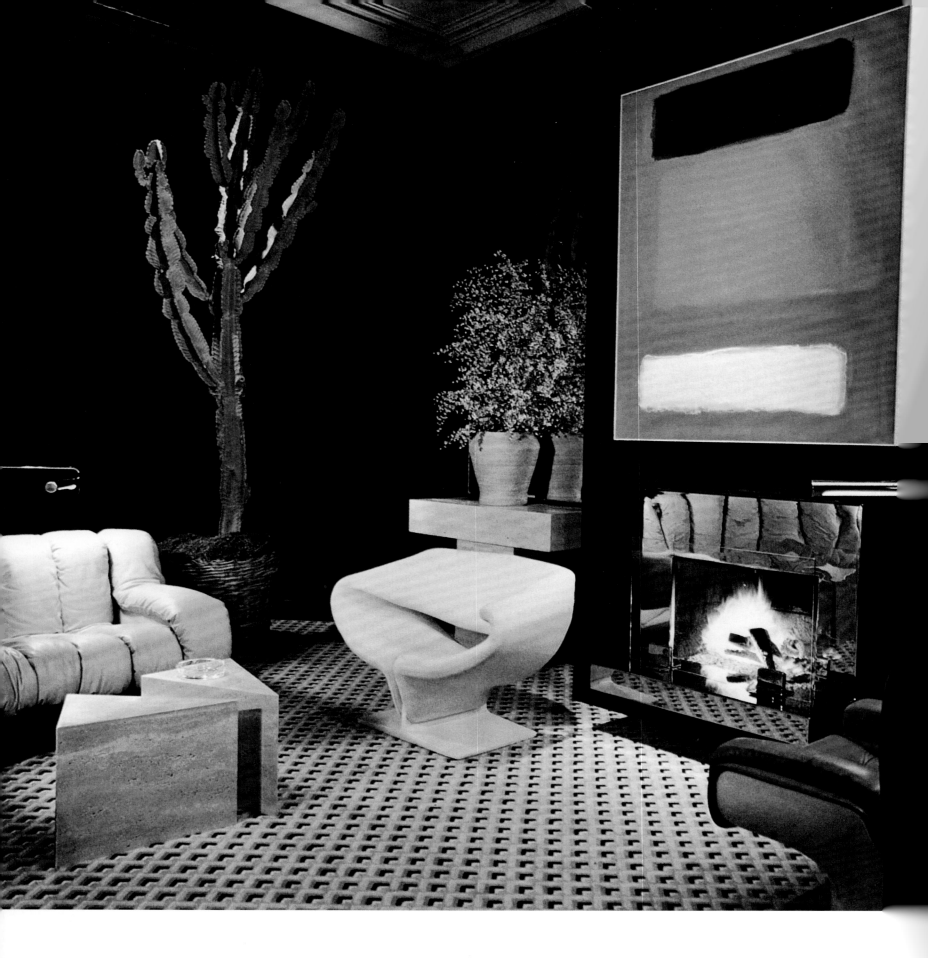

November/December 1975 | San Francisco

DESIGNER William G. Gaylord Interior Designs

For a young psychiatrist and his writer wife, Gaylord—who liked the idea of being called "an interior dramatist"—gave a 19th-century townhouse thoroughly modern innards. The living room was executed in browns and creams, from glossy chocolate-dark walls to pale travertine tables to a wicker basket holding a cactus. The limited palette, *AD* observed, was "all the better to show off the paintings like the Mark Rothko, the plants and flowers and—more importantly— the people, who are the real decor."

January 2014 | Manhattan

HOMEOWNERS Anne-Gaëlle & Christophe Van de Weghe
ARCHITECT Selldorf Architects DESIGNER D'Apostrophe Design

"Basically we bought a façade and a giant hole—it was nothing but an empty shell," said art dealer Christophe Van de Weghe of the 1880s Upper East Side townhouse that he and his wife transformed with Annabelle Selldorf and Francis D'Haene. A sinuous wood staircase now links the five levels, their rooms sun-drenched thanks to a rear elevation of sliding glass walls.

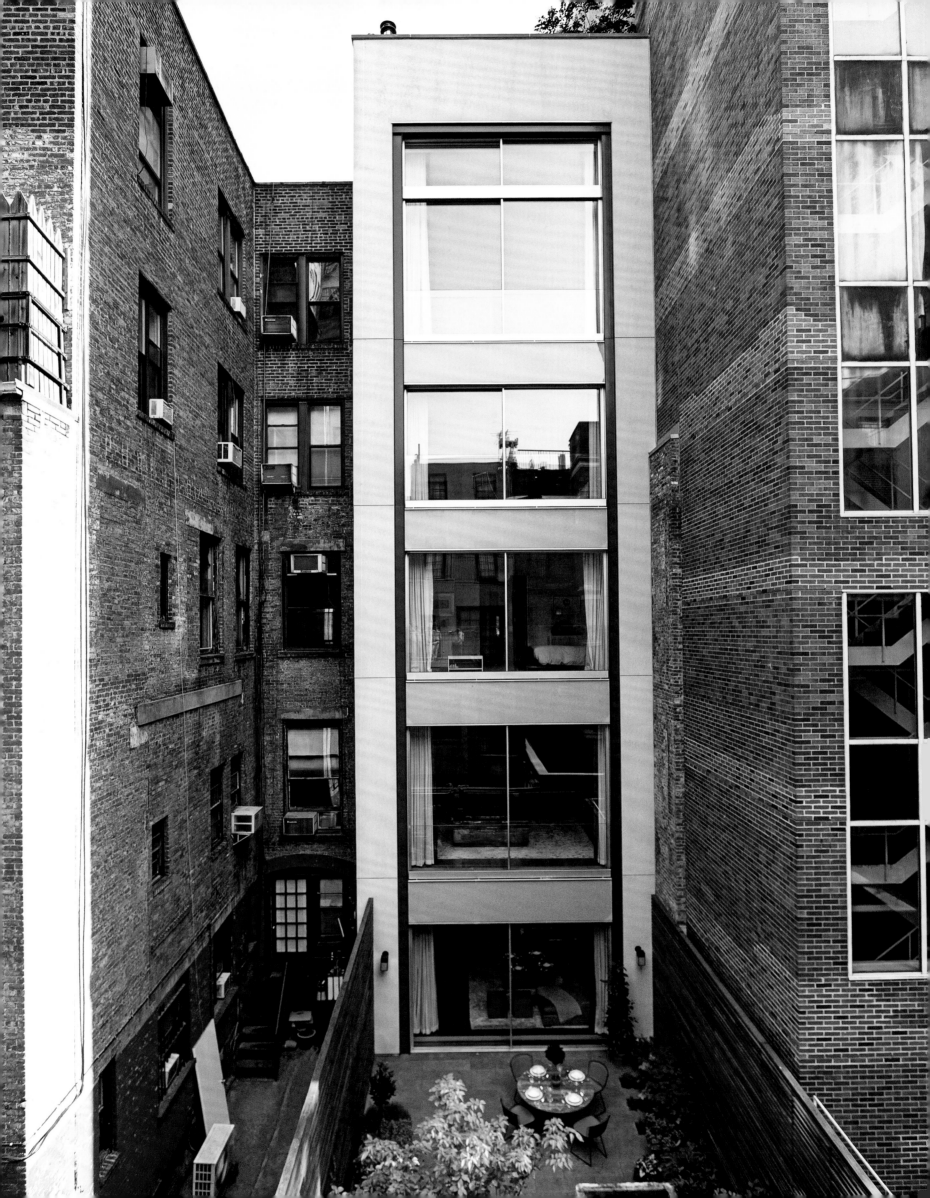

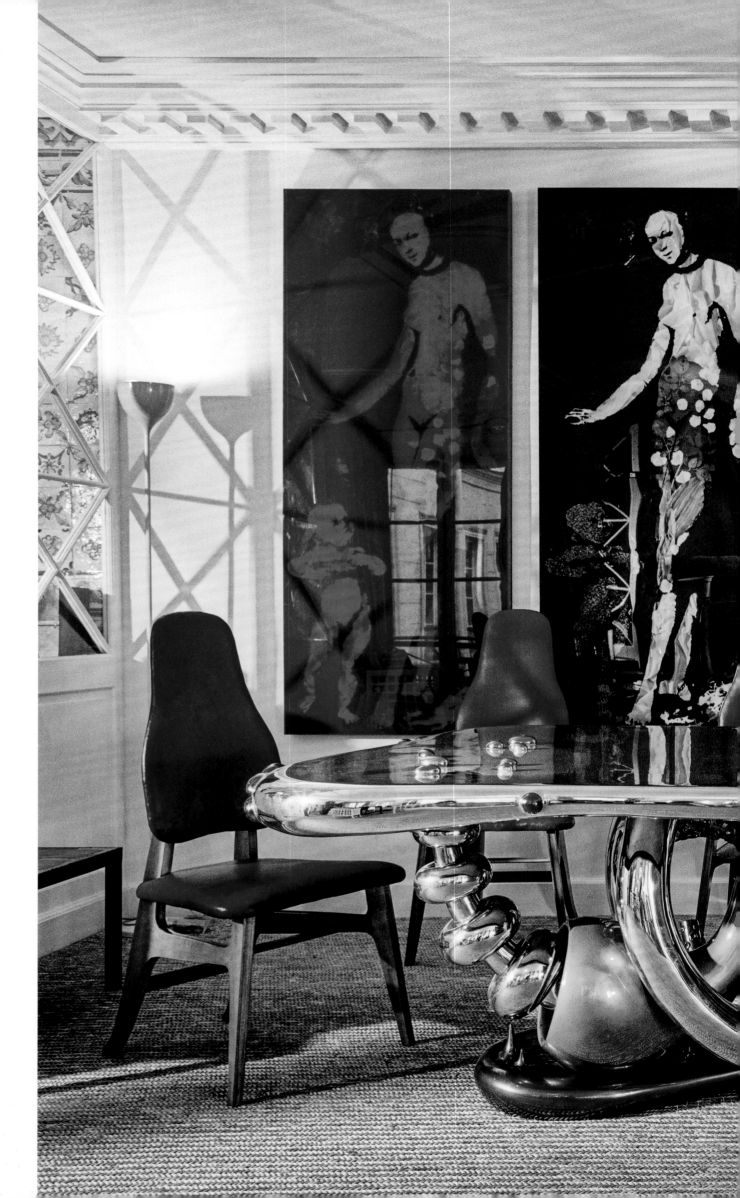

March 2011
Paris

HOMEOWNER
Pierre
Passebon

A writhing Mattia Bonetti
table complements
the sumptuous palette
of Gino Marotta's multi-
panel work *Amore Mio*
at the decorative-arts
dealer's apartment, which
he cheekily described
as "Alice in Wonderland
on acid." The punchy,
polychrome decor was
concocted with designer
Jacques Grange, his long-
time companion. "The
mix is what makes it
interesting," Passebon
observed. "It leads to
a vibe and to emotion."

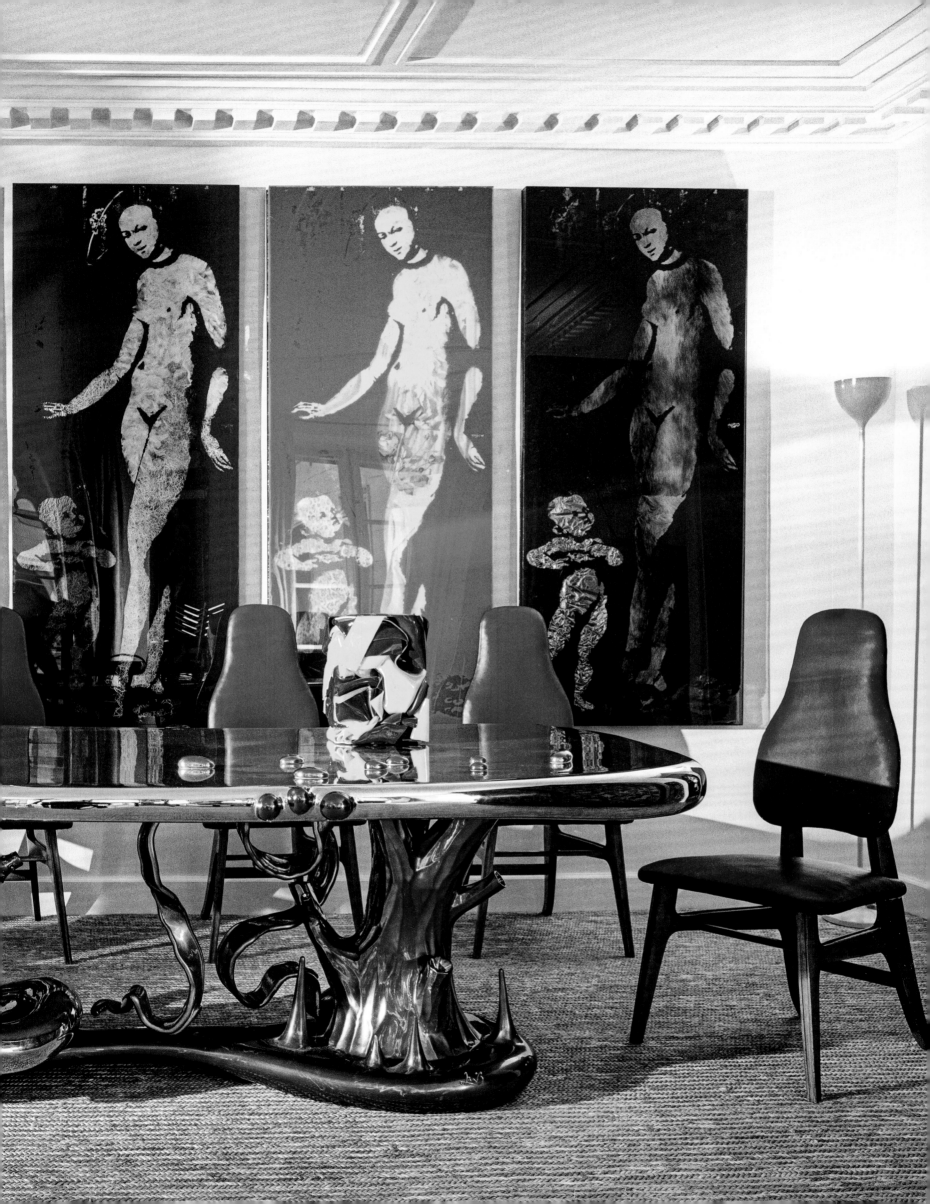

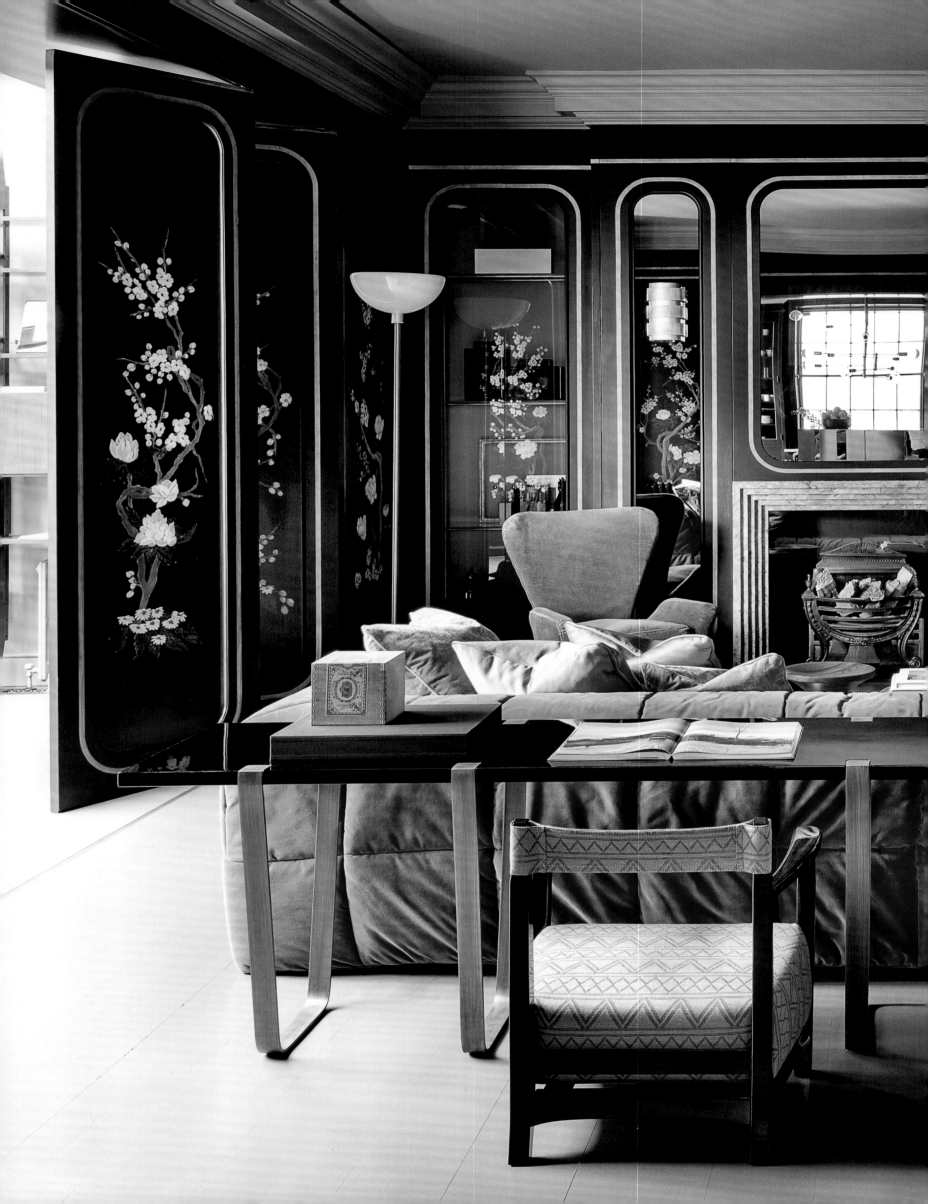

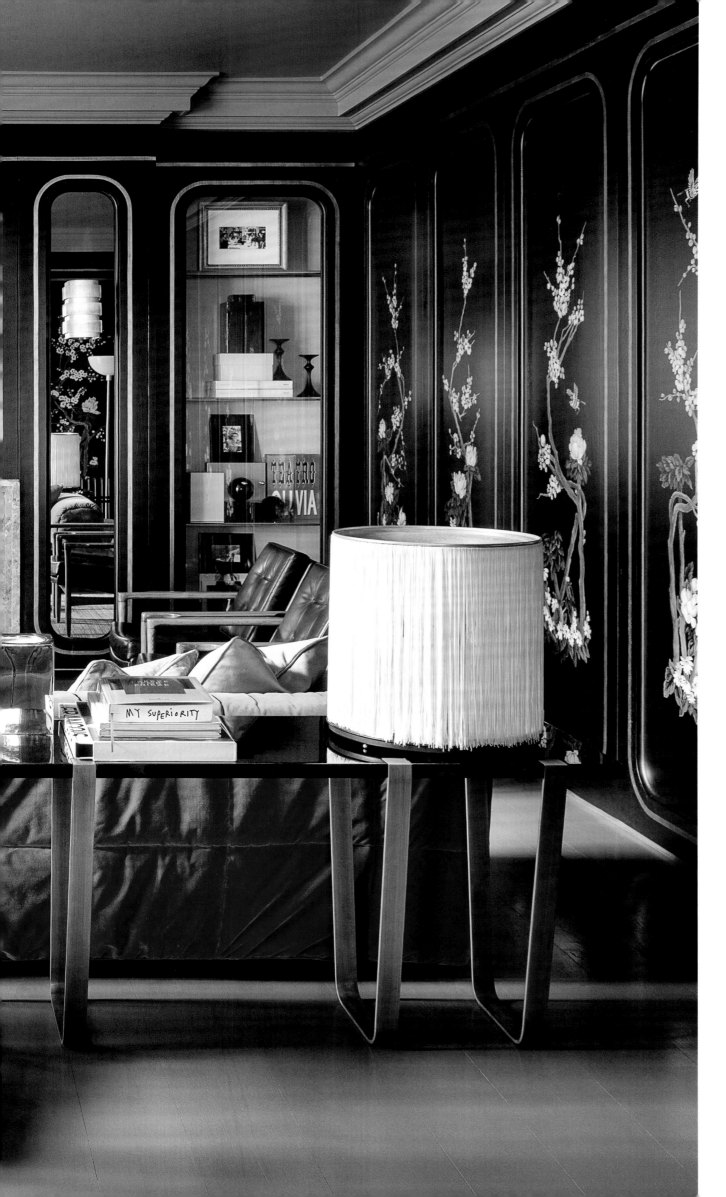

January 2019
London

HOMEOWNERS
Dean &
Dan Caten
DESIGNER
Dimore Studio

Dimore Studio's
Emiliano Salci and Britt
Moran revisited an
old idea for the house
that the twin brothers,
cofounders of the
fashion label Dsquared2,
share in the Little Venice
neighborhood. "Emiliano
once did a black-and-
gold Asian room at
Salone del Mobile," Dan
recalled, "and he knew
we loved that." The Catens'
living room replaces
the previous bird motif
with cherry blossoms
in a painted and gilded
boiserie that incorpo-
rates inset mirrors and
display cabinets.

February 2012
Manhattan

HOMEOWNERS
Jenny &
Trey Laird
DESIGNER
Bilhuber
and Associates

For the 1870s brownstone
owned by the Lairds (he of
fashion-world advertising
fame), Bilhuber channeled
the Victorian era's eclecti-
cism and *horror vacui* but—
informed by tastemakers
such as Madeleine Castaing
and Yves Saint Laurent—
with fresh orchid colors,
mix-master patterns, and
a breezy attitude that's
thoroughly of the moment.
Sam Samore photographs
climb a living room wall;
timeless tiger-stripe velvet
and earthy Indonesian ikats
join forces on a sofa; and
a brilliant blue slubbed
silk dresses a pair of old
Danish side chairs. Colorful
lampshades dapple the
space like exotic blossoms.

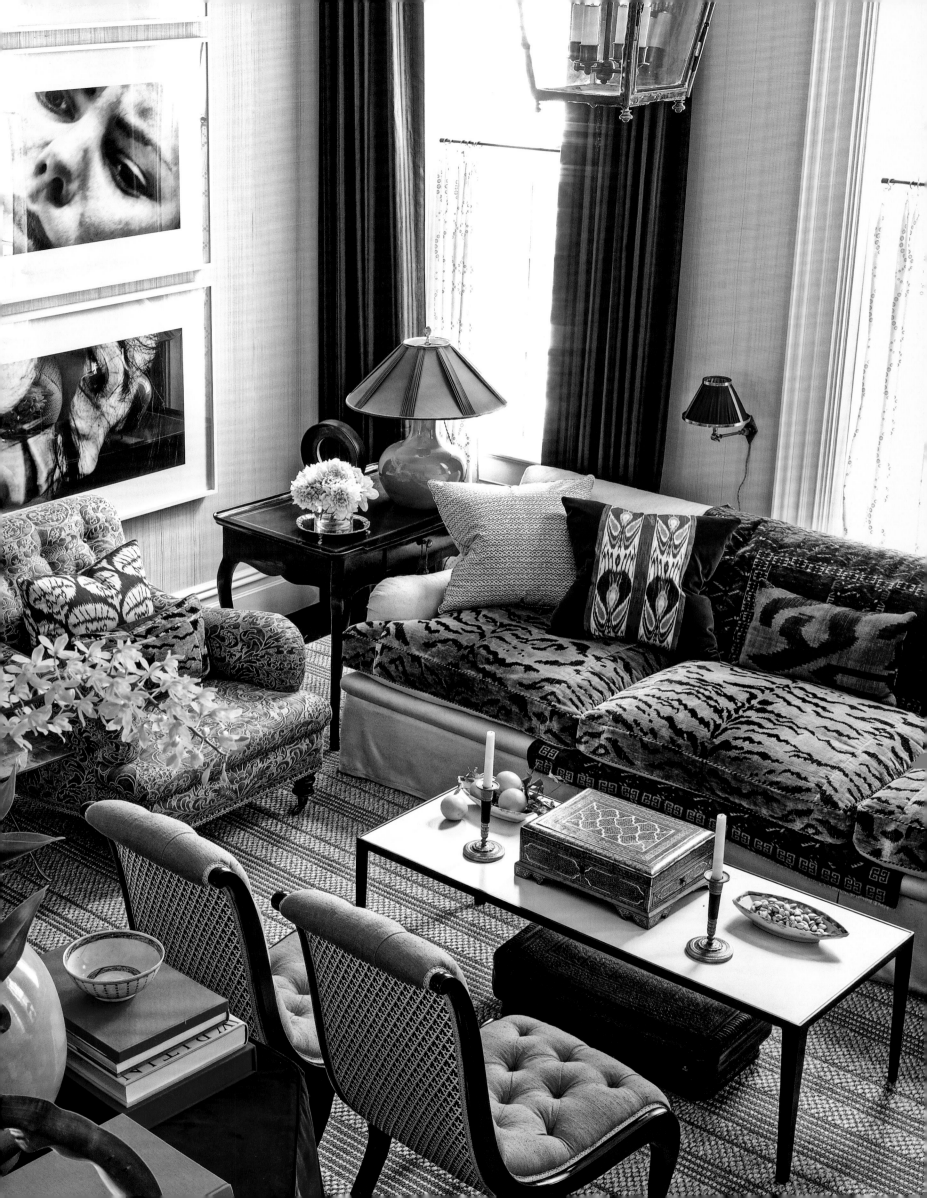

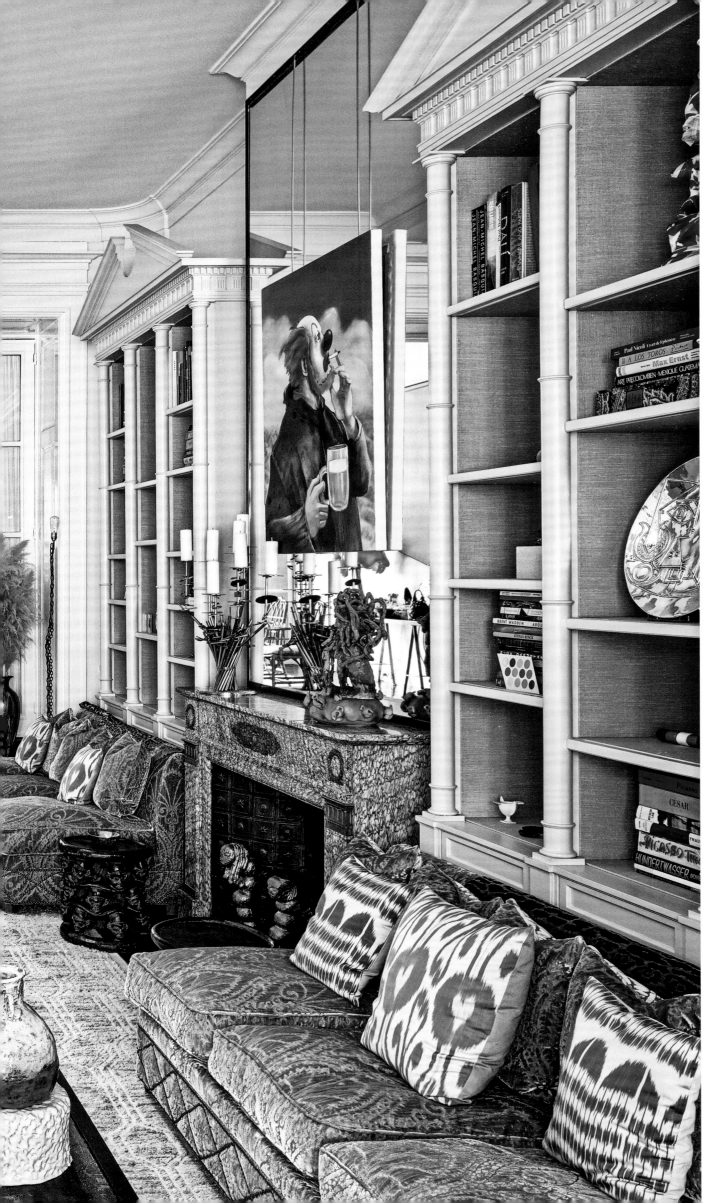

December 2017
Brussels

HOMEOWNERS
Stéphanie Busuttil & Sébastien Janssen

"Within the decorative arts, we more or less like everything," explained Busuttil, who is the wife of gallerist Janssen and the last love of César, the late Nouveau Réalisme sculptor. The couple's living room proves her assertion: It is bedecked with an Art Nouveau desk, 19th-century Japanese gilt-wood flowers, an oval Philip and Kelvin LaVerne cocktail table, a witty bronze "foot" stool, and neoclassical bookcases by French decorator and architect Alain Demachy. A debauched Sean Landers clown turns away from it all.

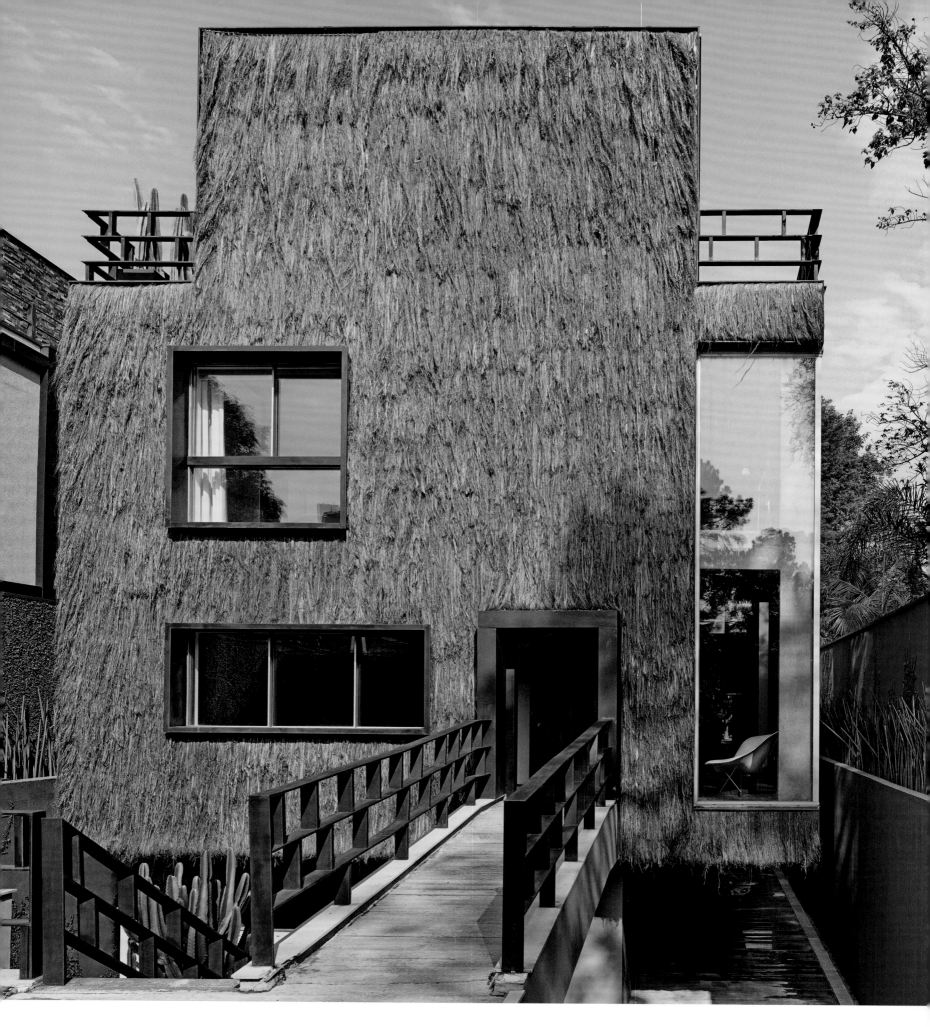

May 2016 | São Paulo

DESIGNERS Campana Brothers

"The boys call it the Mammoth House," homeowner Solange Ricoy, a marketing exec, said of the nickname that her and advertising CEO Stefano Zunino's children have given the family's redoubt, which designers (and brothers) Fernando and Humberto Campana blanketed in shaggy palm fibers.

February 2015 | Manhattan

DESIGNER Rafael de Cárdenas Ltd./Architecture at Large

Reminiscent of everything from classic ocean liners to the work of midcentury architect Jean Prouvé, portholes speckle the pale-gray cabinets in a Greenwich Village kitchen created for a London expat.

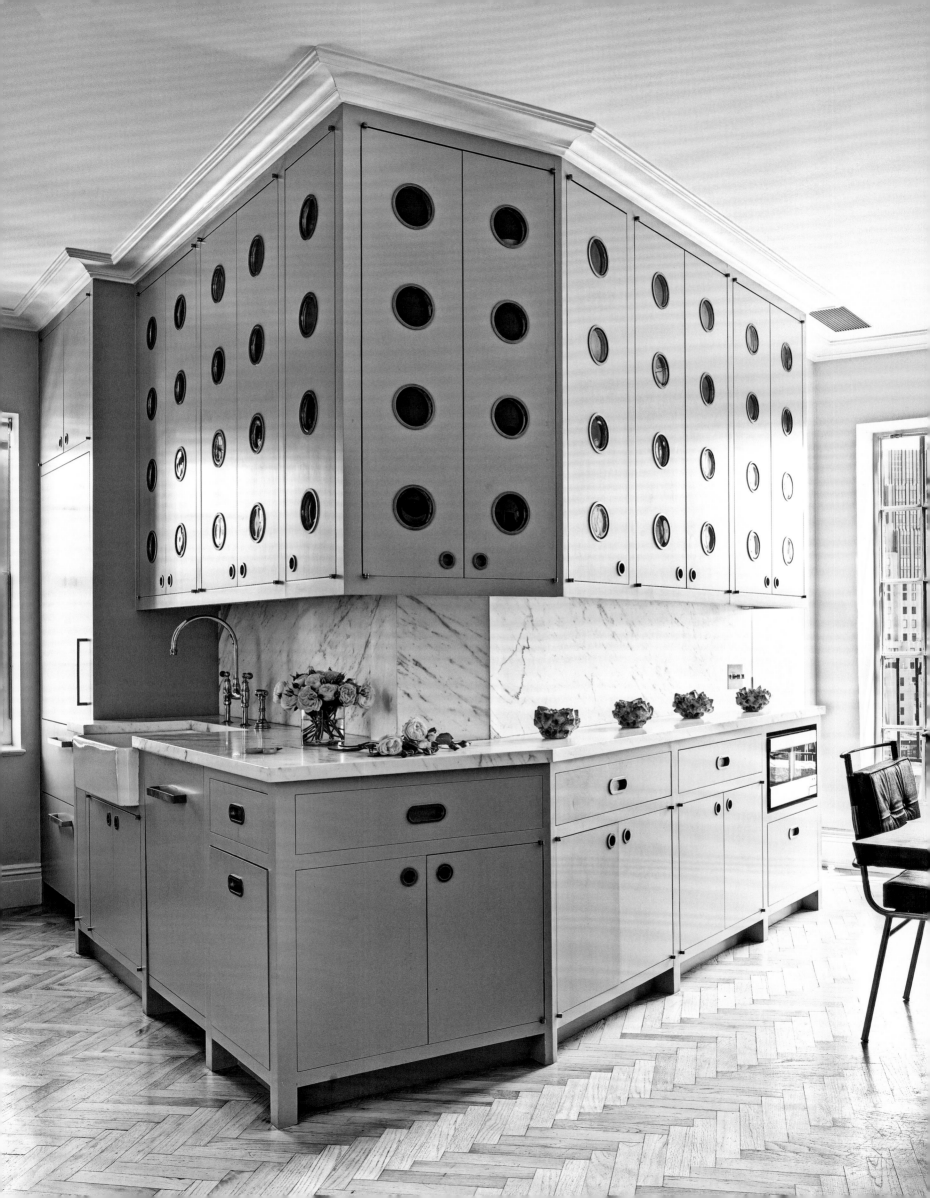

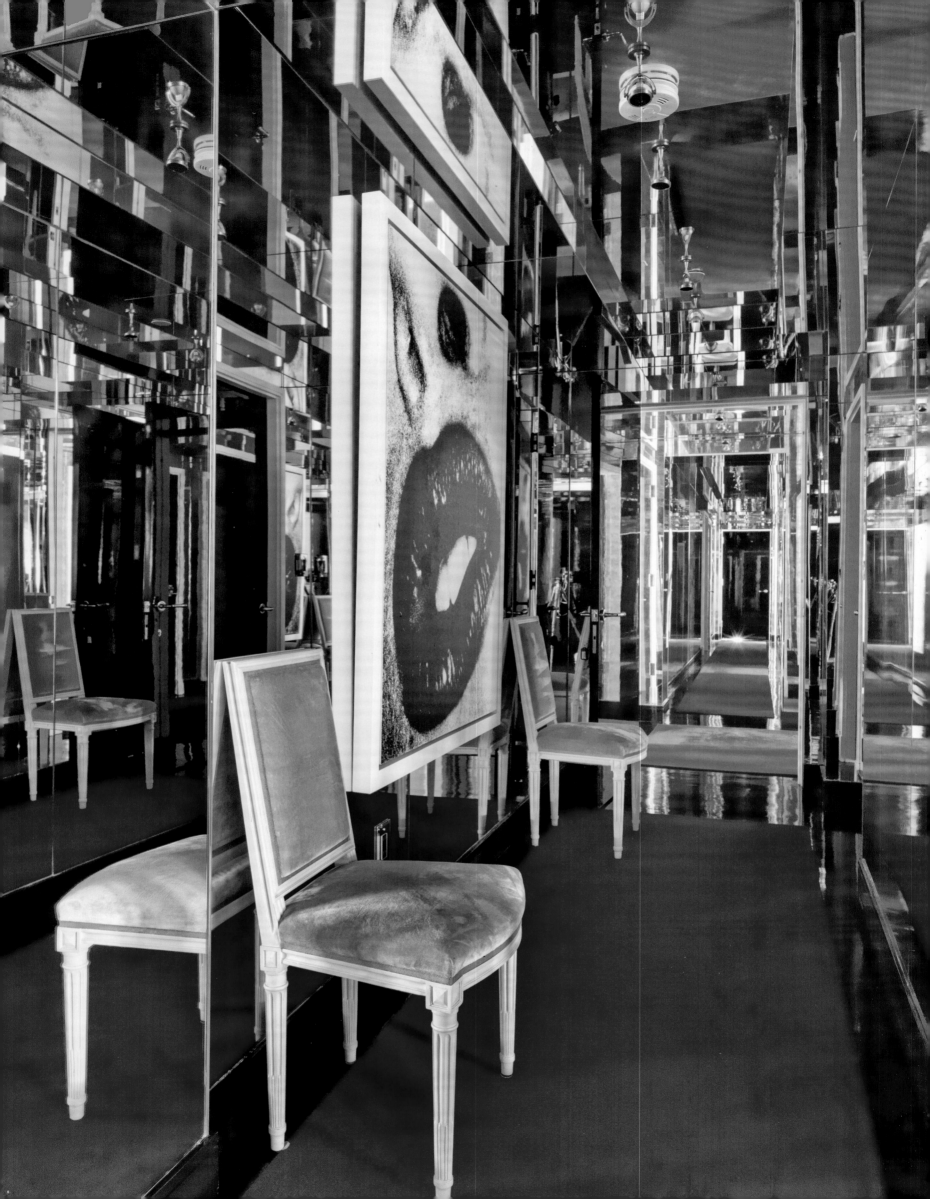

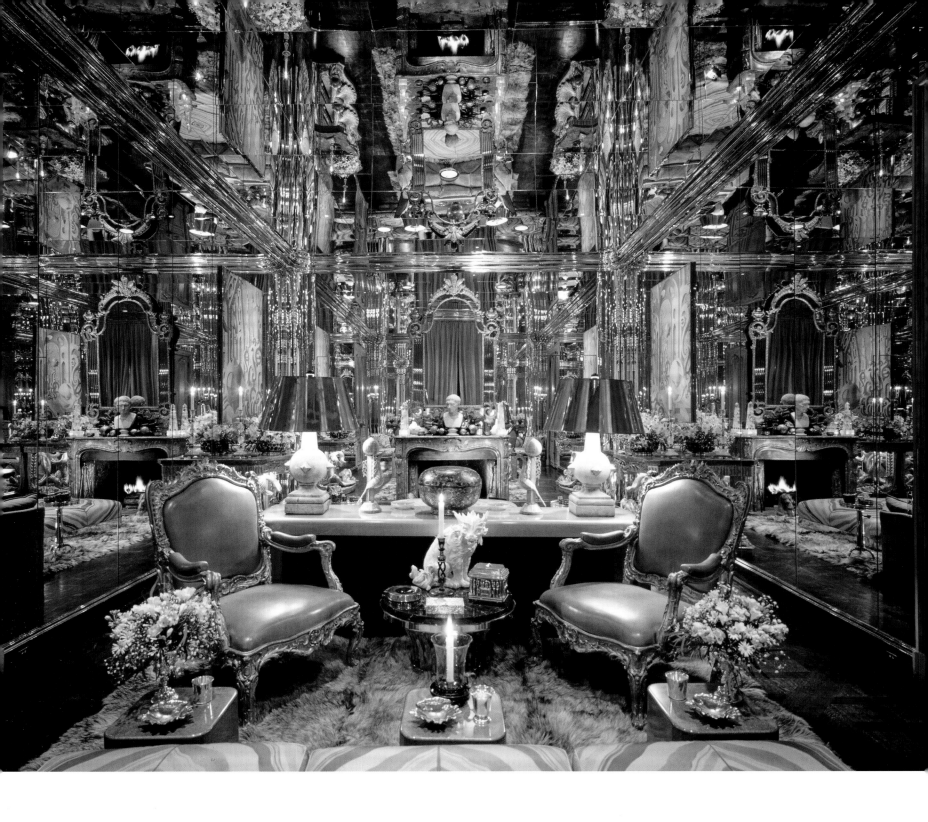

March 2011 | Manhattan

HOMEOWNER Daphne Guinness
DESIGNER Daniel Romualdez Architects

For the British-born singer, songwriter, fashion designer, and style provocateuse, Romualdez matched carpets to his friend's custom-made red nail polish. The mirrored-glass ceiling and walls, hosting a dramatic Daido Moriyama photograph, transform the entrance hall into a fun house of reflectivity. "Do I want a corridor or do I want an *experience* every time I walk in the door?" Guinness said.

October 1989 | Paris

HOMEOWNER/DESIGNER Jean-François Daigre

The salon of Daigre's residence in rue du Bac, created with the help of his business partner, decorator Valerian Rybar, is a decadent evocation of the Hall of Mirrors at Château de Versailles, with the ceiling, cornices, and baseboards all mirrored. It is a glamorous fantasy space where Japanese, Roman, and French treasures—plus satin hand-painted to resemble malachite—are endlessly reflected.

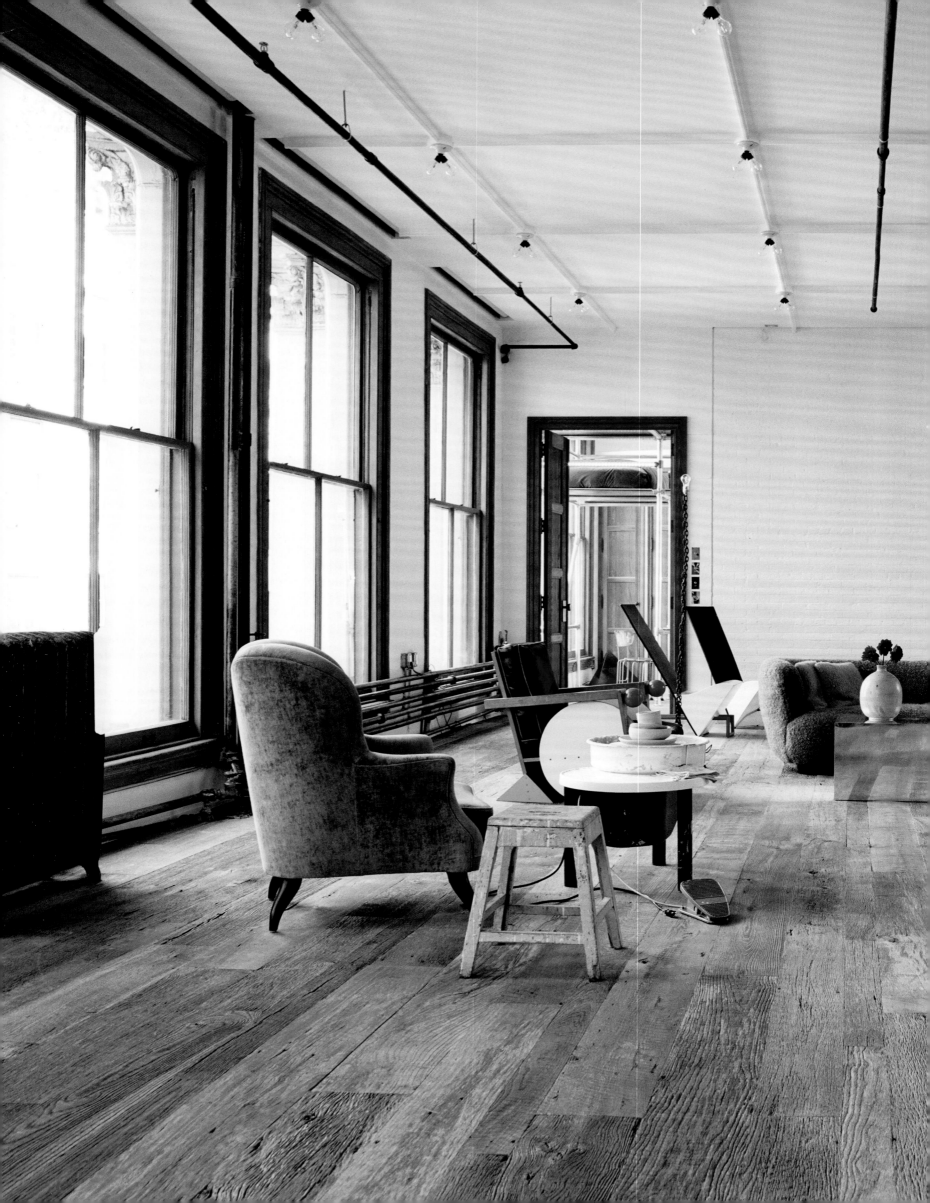

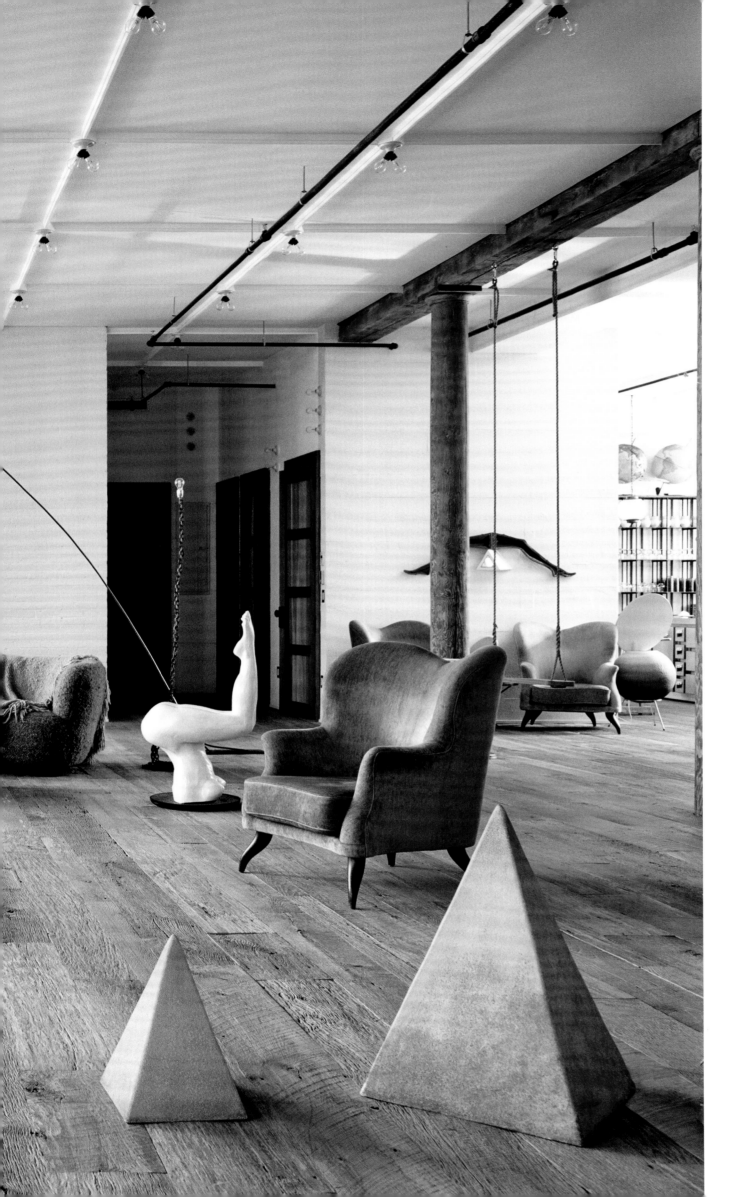

February 2018
Manhattan

HOMEOWNERS
Sofía Sanchez & Alexandre de Betak

In the living area of the downtown loft of the fashion-show impresario Alexandre and his art-director wife Sofía, weathered wood and exposed pipes make for a "raw but warm" family home. "The huge room is incredibly versatile, not just for entertaining but also for mounting exhibitions and playing around with different elements from the shows I design," Alexandre noted of the space, which also features a swing. "It's the kind of space that begs for creative experimentation."

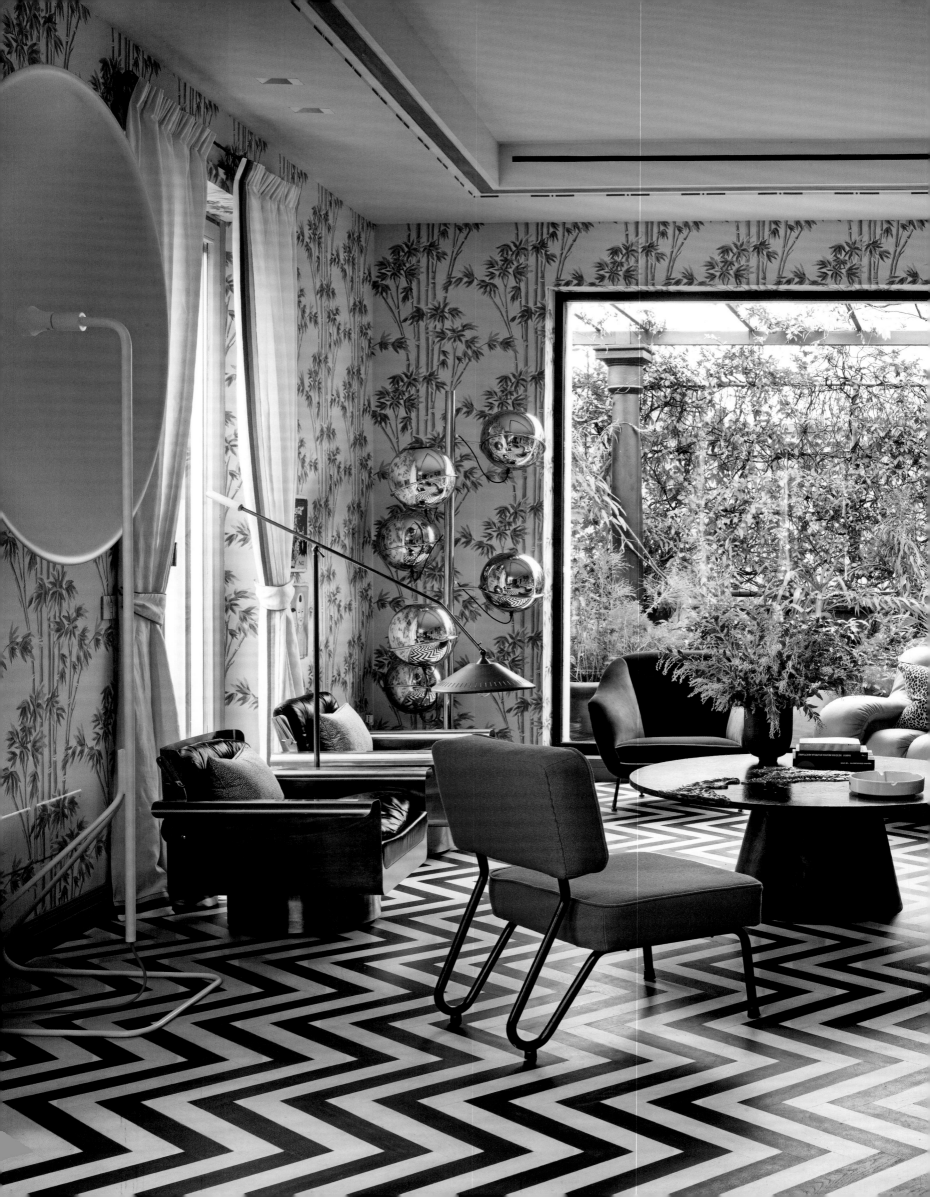

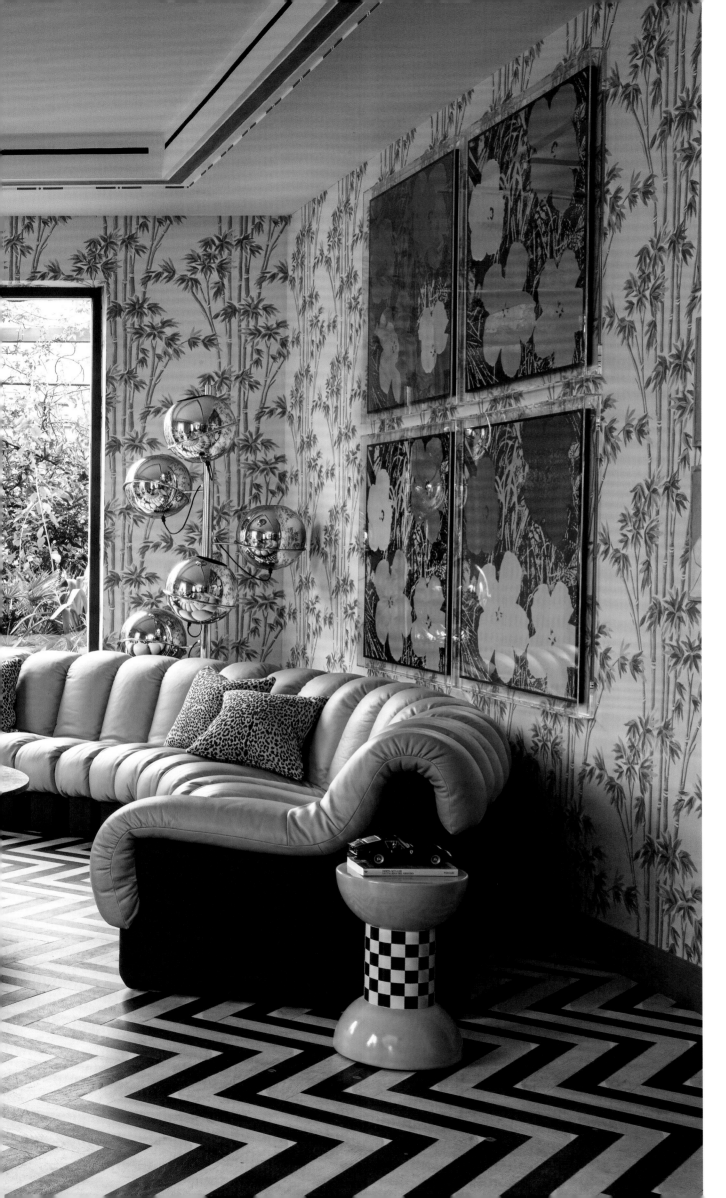

March 2015
Milan

HOMEOWNER/DESIGNER
Lapo Elkann

"My houses are my houses, and I don't want them to be the houses of my family," said the product and sportswear designer, who also happens to be a notably dapper member of Italy's *più elegante* Agnelli clan. Working with architect Natalia Bianchi in renovating his palazzo penthouse, he devised a daredevil living room that's a polychrome paradise. Bamboo-motif wallpaper meets a zigzag painted floor, and a sinuous Ueli Berger sofa sits beneath Andy Warhol screen prints. "Color is a job; it's not frivolous," Elkann insisted. "Putting the right color on a pair of glasses or on a car makes all the difference."

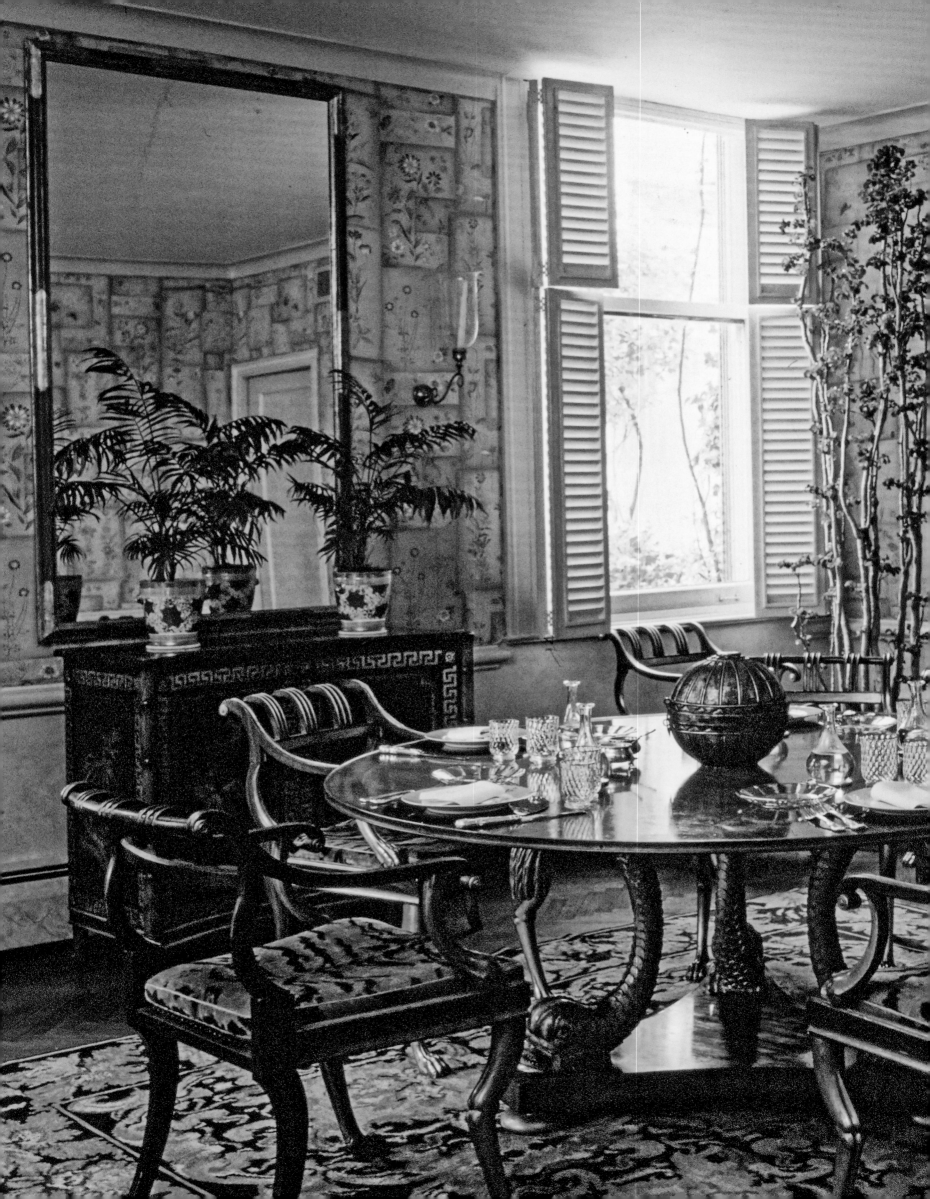

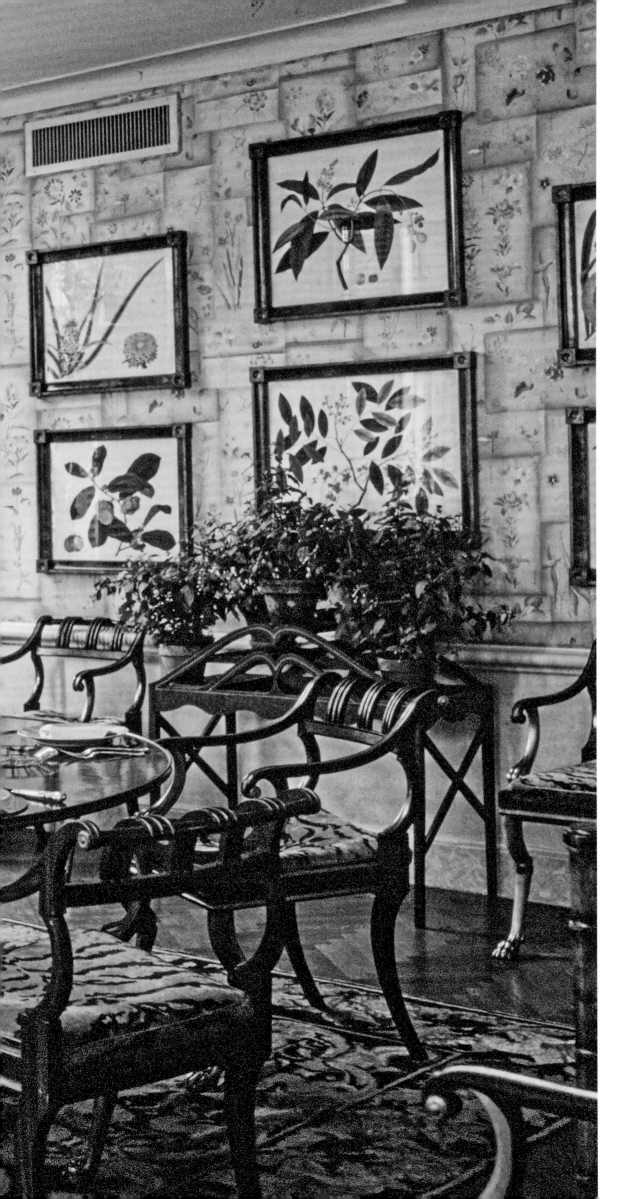

January 1982
Manhattan

HOMEOWNER/DESIGNER
Lee Radziwill

Nineteenth-century Anglo-Indian botanical studies, a gift from a British duke, blossom and bear fruit in the dining room of the fashion icon's flowered apartment, which she decorated herself. "I suppose I wanted to lull myself into thinking I was in the English countryside," explained Radziwill, who once lived in Oxfordshire. Decoratively speaking, she said, she was aiming for a "level of tranquility, a sweetness of tone, an uncomplicated background for the ongoing complexity of life." Tiger-stripe velvet cushions the English Regency–style armchairs.

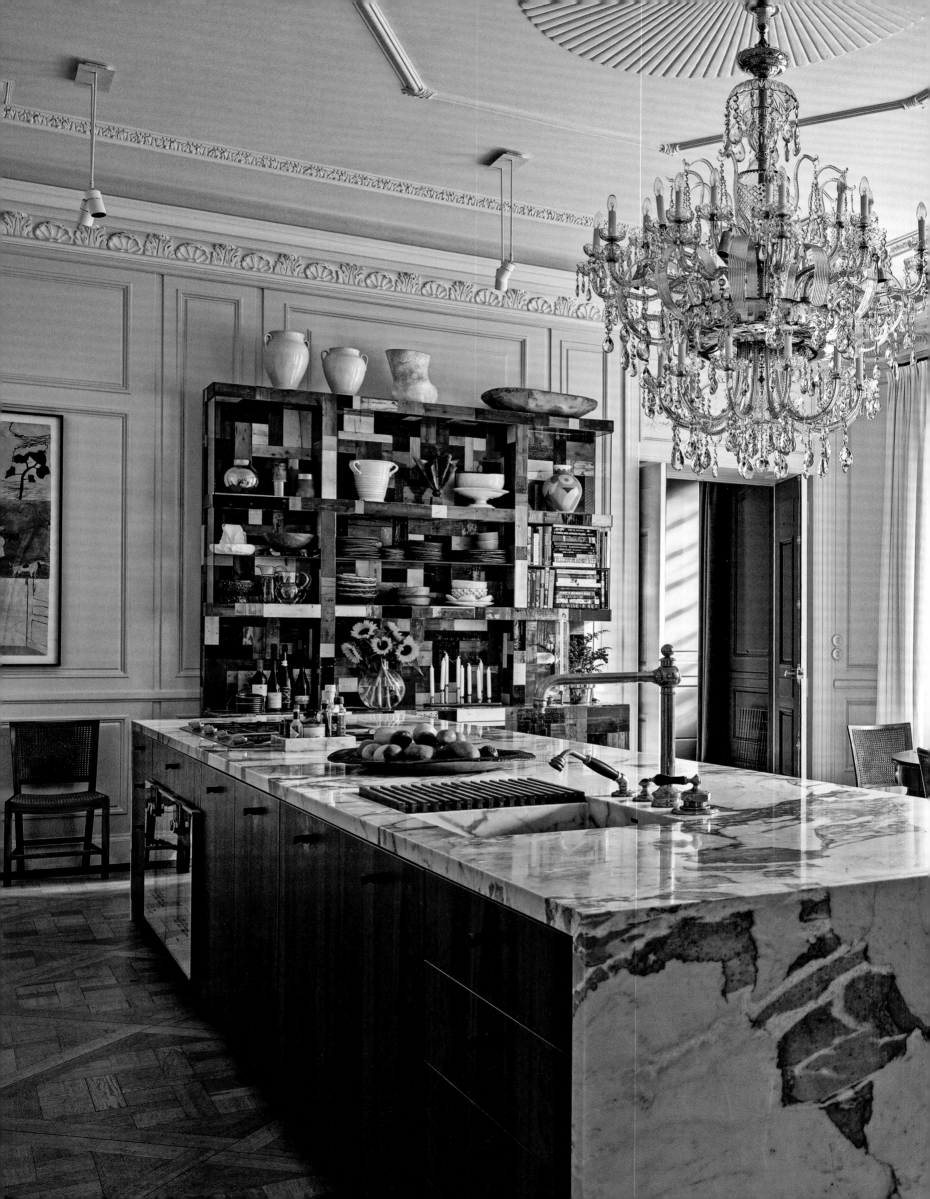

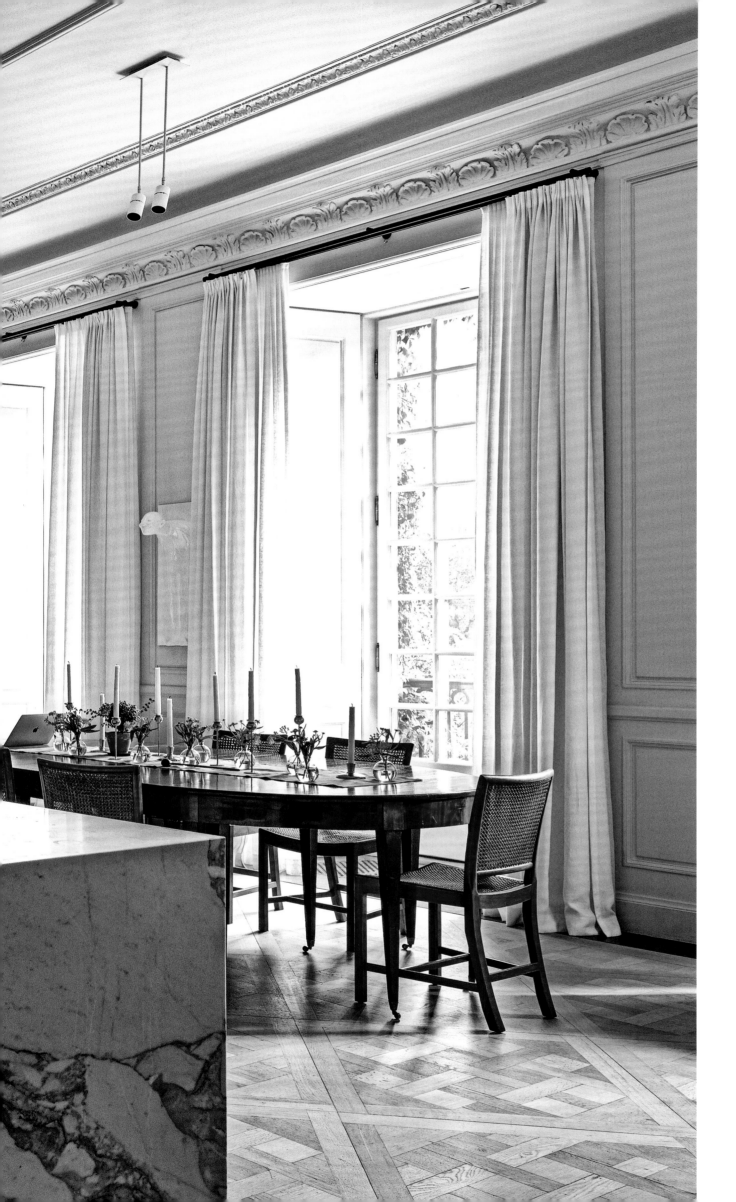

February 2019
Stockholm

DESIGNER
Studioilse

For Jeanette and Harald Mix, the proprietors of Ett Hem, a 12-room cozy-chic hotel just blocks away, designer Ilse Crawford daringly reanimated the couple's floor plan by transforming the rarely used formal drawing room into a spacious kitchen that offers access to all the rooms on the main floor. As for the former kitchen, it's now a family lounge.

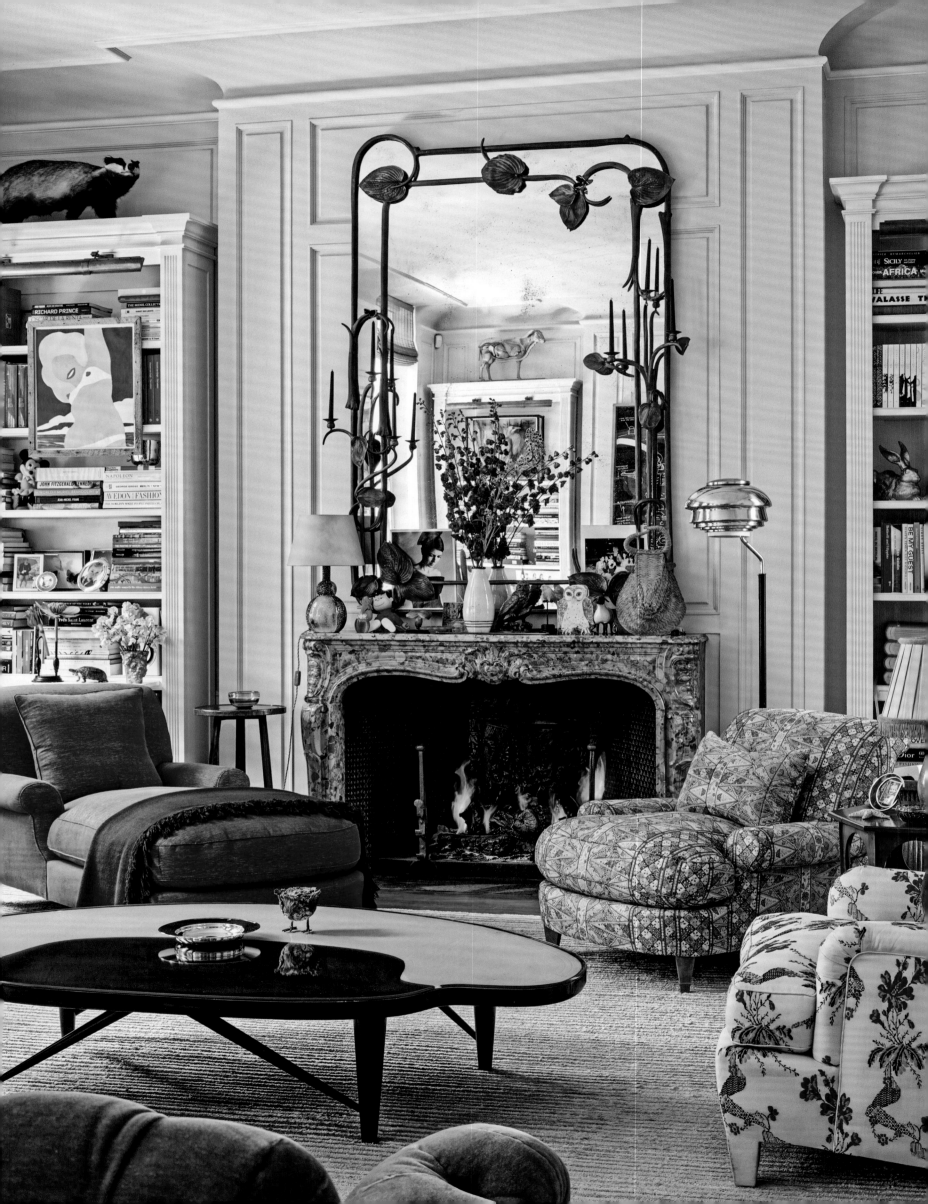

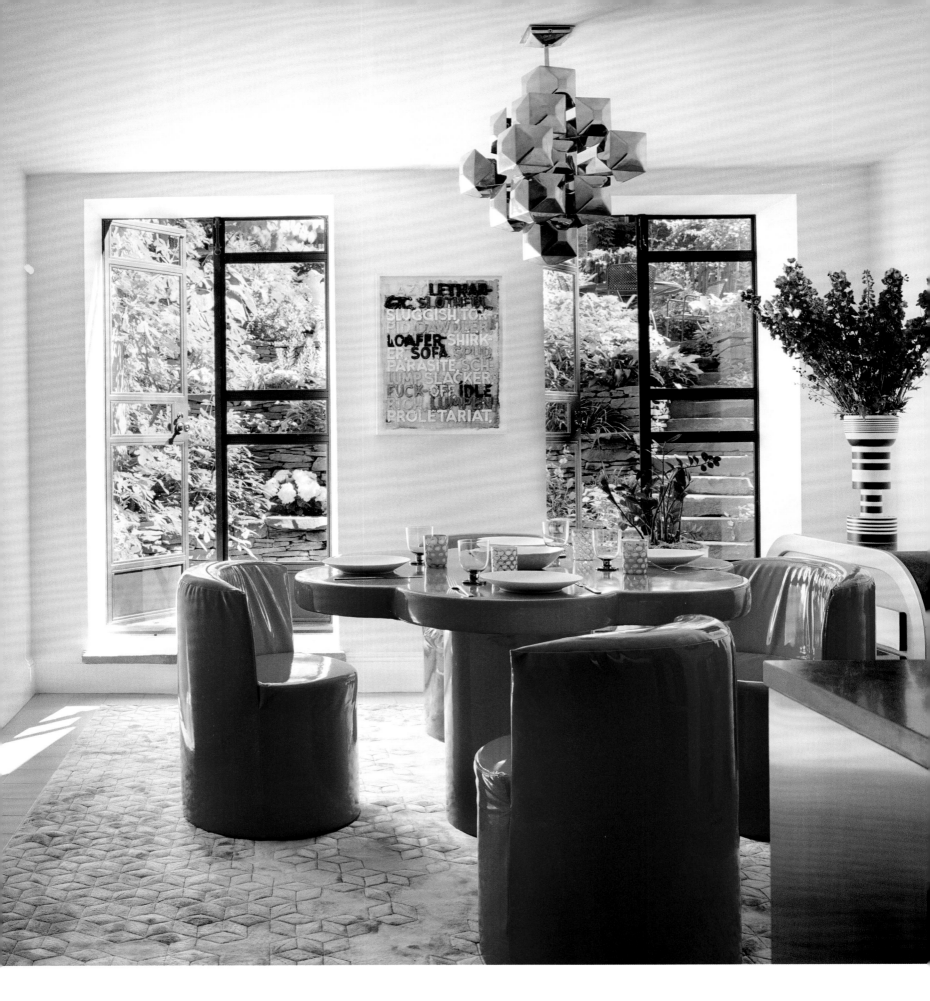

December 2017 | London

DESIGNER Jacques Grange

"There's a lot of history here," said the owners of this 1914 residence, once a prime gathering spot for the Bloomsbury set. To complement that arty past, the drawing room has been bohemianed with mismatched fabrics, a splashy work by Tom Wesselmann, a tendriled mirror by Claude Lalanne, and English Arts and Crafts antiques. The result is an old structure sympathetically infused with modern sensibilities.

September 2016 | Manhattan

HOMEOWNERS Laure Heriard Dubreuil & Aaron Young

"Laure is all about sunshine and color and wants everything to be vibrant," said designer Chris Osvai, who helped Heriard Dubreuil articulate her vision (and who also collaborates with her on interiors for her fashion emporium the Webster). So a 1960s dining set by Giuseppe Raimondi makes a scarlet splash in her East Village kitchen, set beneath a faceted Blackman Cruz pendant.

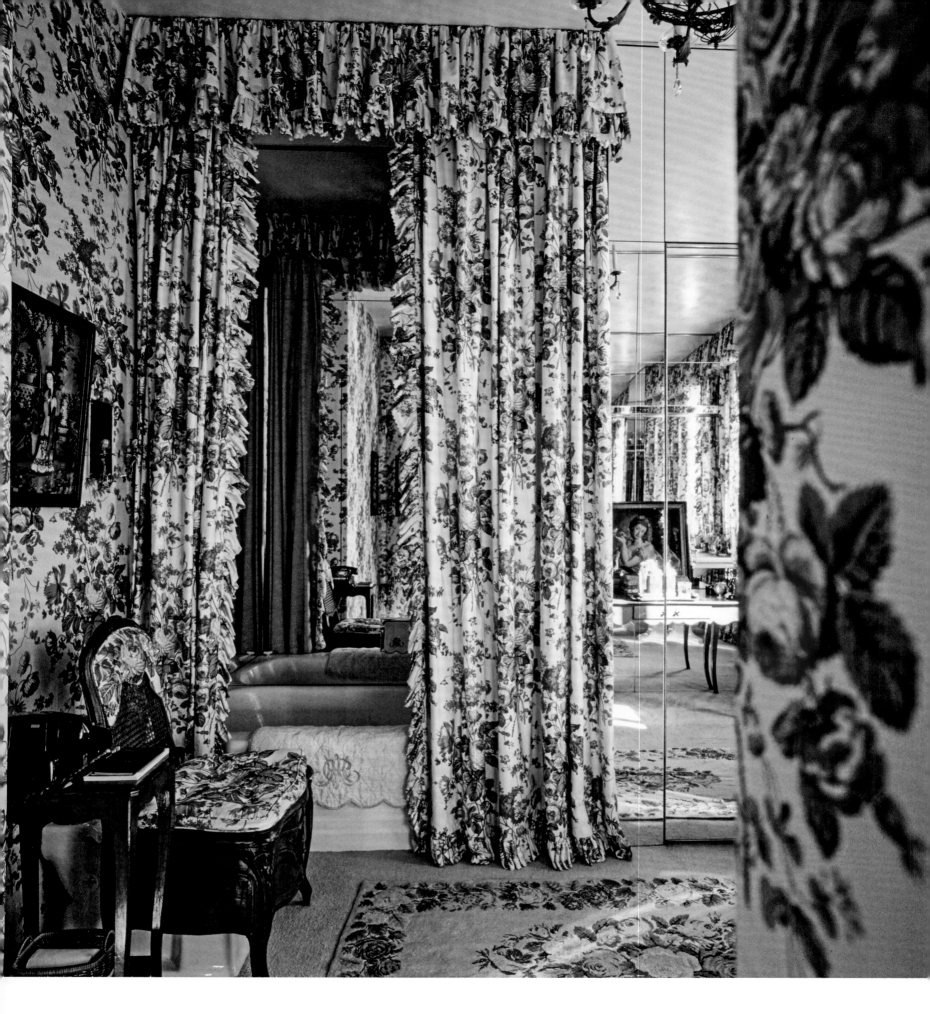

December 1988 | London

HOMEOWNERS Catherine & Douglas Auchincloss

The American couple's master bath is a bower completely wrapped in roses—walls, upholstery, curtains, and floor. It's a pastoral scheme that echoes the apartment's views of the Chelsea Physic Garden.

September 2016 | Stockholm

HOMEOWNERS Giovanna Battaglia & Oscar Engelbert

"The home is 100 percent a reflection of what we like and what we collect," Engelbert, a real-estate developer, said of the apartment he shares with his color-loving fashion-editor wife. The dining room's teak table and armchairs, by Pierre Jeanneret, rest beneath a gleaming vintage chandelier. The sunroom beyond, graced by Ionic pilasters, overlooks one of the city's many waterways.

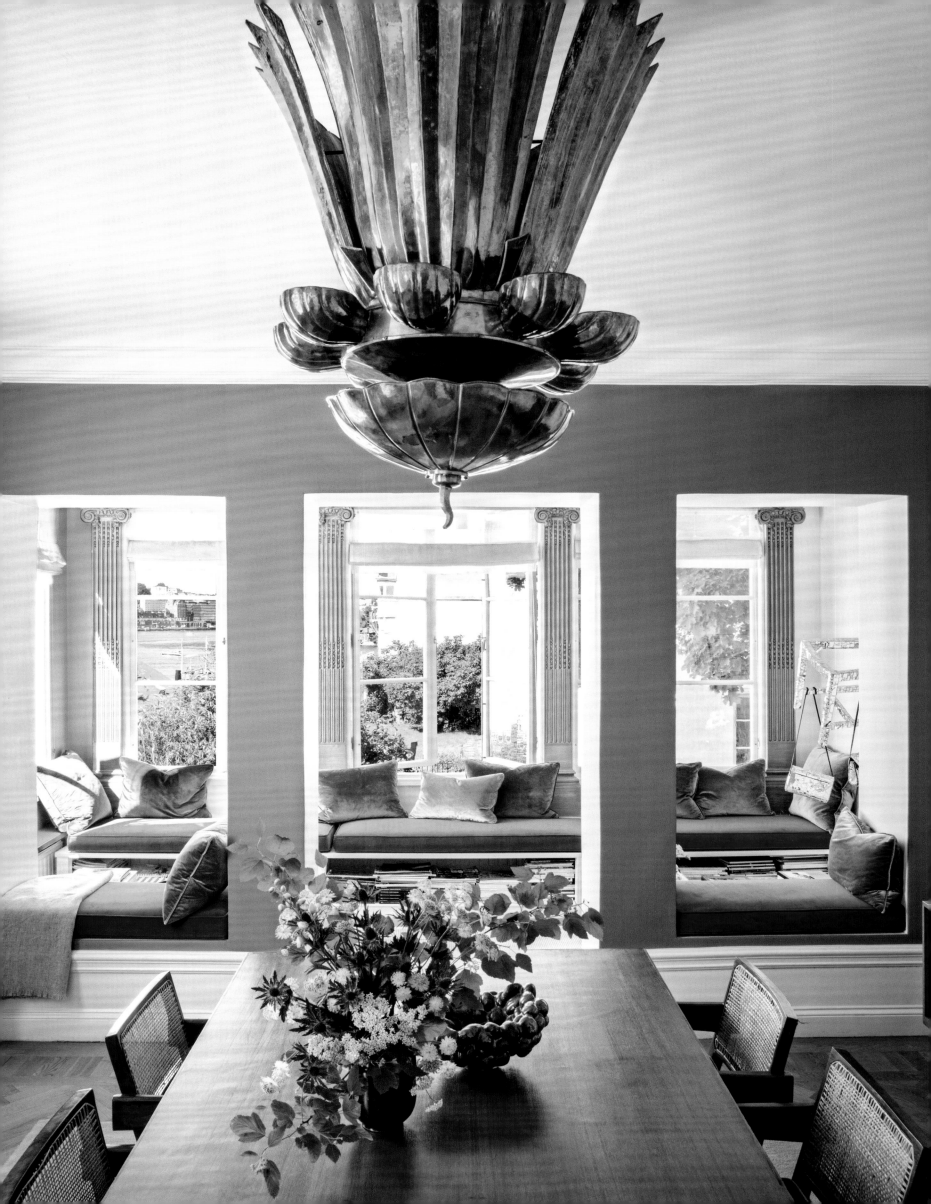

December 2018
Manhattan

HOMEOWNERS
Allison & Warren Kanders

DESIGNER
Ingrao Inc.

"It's hard to hang contemporary art on walls with moldings," Allison, an arts patron, said, so Tony Ingrao and Randy Kemper gutted her townhouse, ripping out flooring, removing one of the two living room fireplaces, and designing a new staircase à la Jean Royère. Now the living room showcases works by contemporary masters (Christopher Wool, Jeff Koons, Gabriel Orozco) and vintage French furniture, as a cloudlike Jeff Zimmerman light fixture floats overhead.

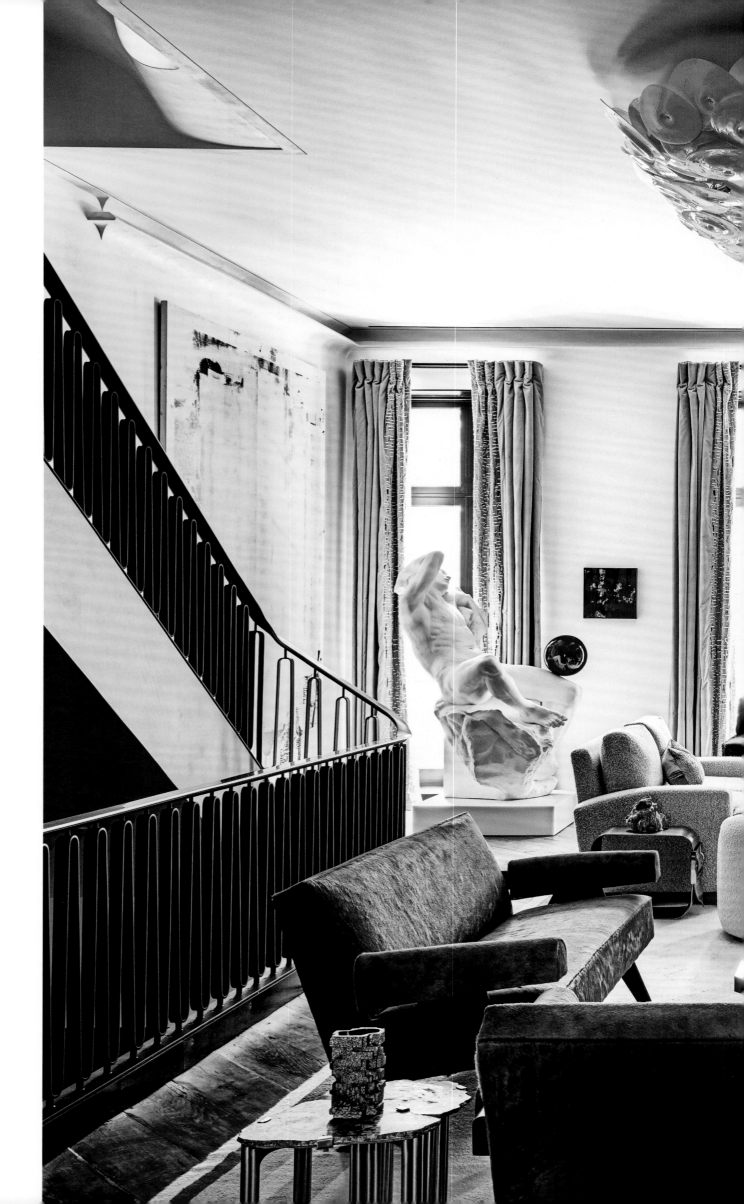

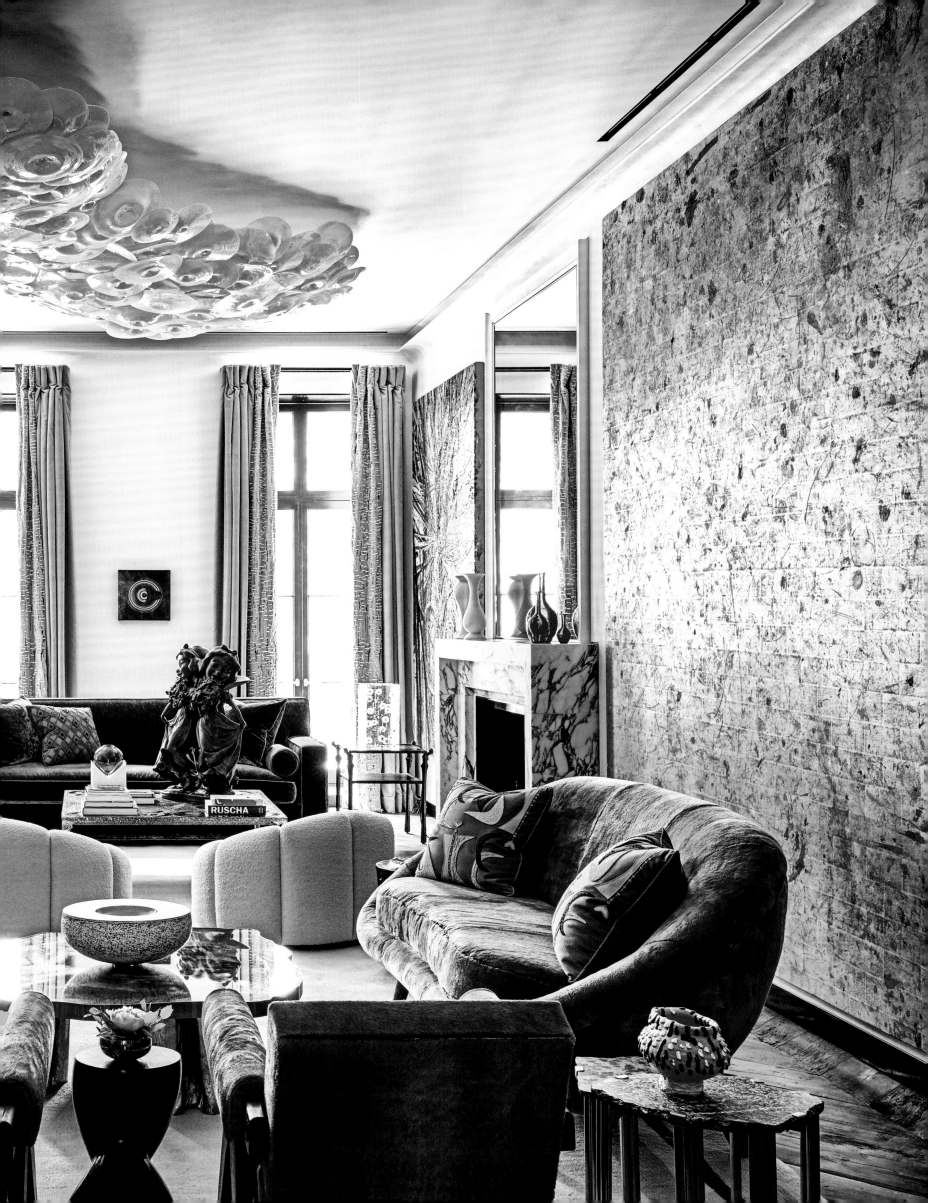

November 1979 | London

HOMEOWNER John Richardson

"Just things that I like and accumulate," the art historian observed of his chambers at Albany, an apartment house that has been the city's most fashionable address since 1802. "My father was a Victorian general and had rooms filled with big leather and mahogany chairs." Richardson's bath followed suit, with hearty 19th-century seating deployed amid wallpaper that architect A. W. Pugin designed for the Houses of Parliament in the 1840s; the muralist Josep María Sert painted the grisaille panel.

January 2018 | San Francisco

ARCHITECT G. P. Schafer Architect DESIGNER Miles Redd

Painted by artist Agustin Hurtado, the groin-vaulted entrance vestibule of this house in tony Pacific Heights is a miniaturized version of the big trompe l'oeil–tented room at Casa degli Atellani in Milan. Furnishings include a palazzo-perfect rococo-style table, a grandiose 18th-century Swedish cartel clock, and French Abstract Expressionist watercolors.

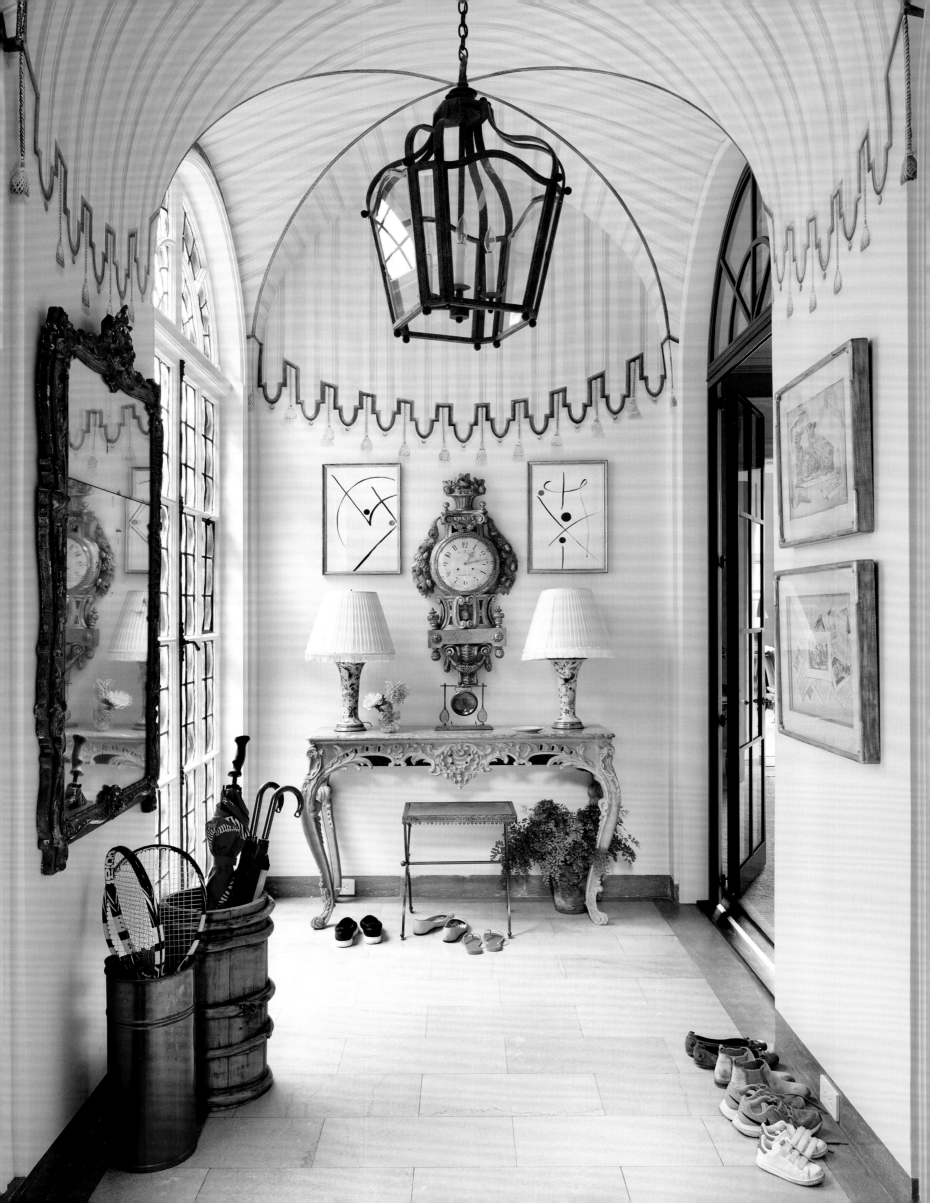

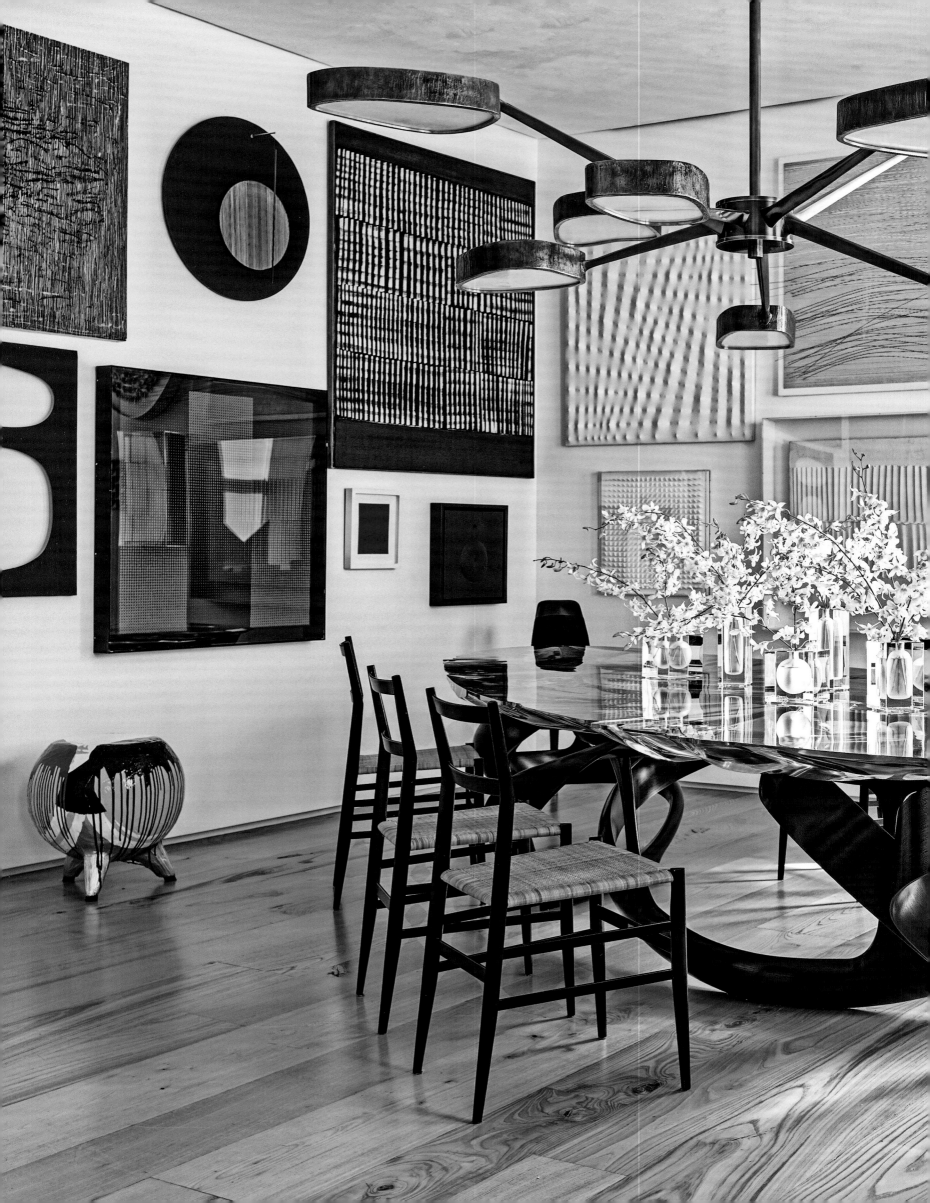

December 2016
Manhattan

HOMEOWNERS
Clarissa &
Edgar
Bronfman Jr.
DESIGNER
Amy Lau
Design

"The architecture has the right balance—it's on par with and equal to the art but doesn't overpower it," Lau noted of the superstar collectors' Upper East Side penthouse, renovated by Clarissa's brother, architect Frank Alcock. Lau took the A-list art and statement furnishings firmly in hand. In the dining room, a dynamic eight-armed chandelier by Italian architect Achille Salvagni illuminates a sculptural table and chairs by Joseph Walsh Studio and vintage Gio Ponti seats.

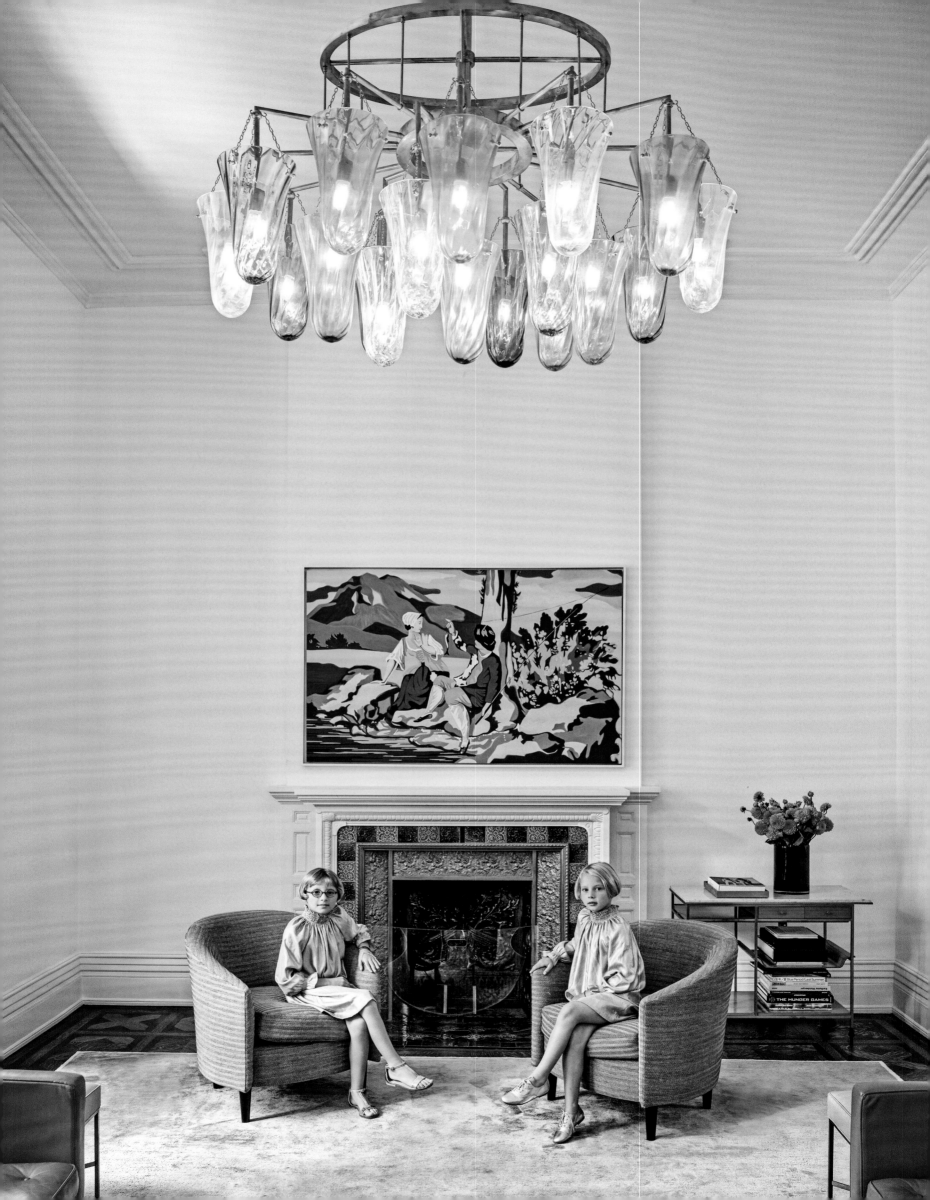

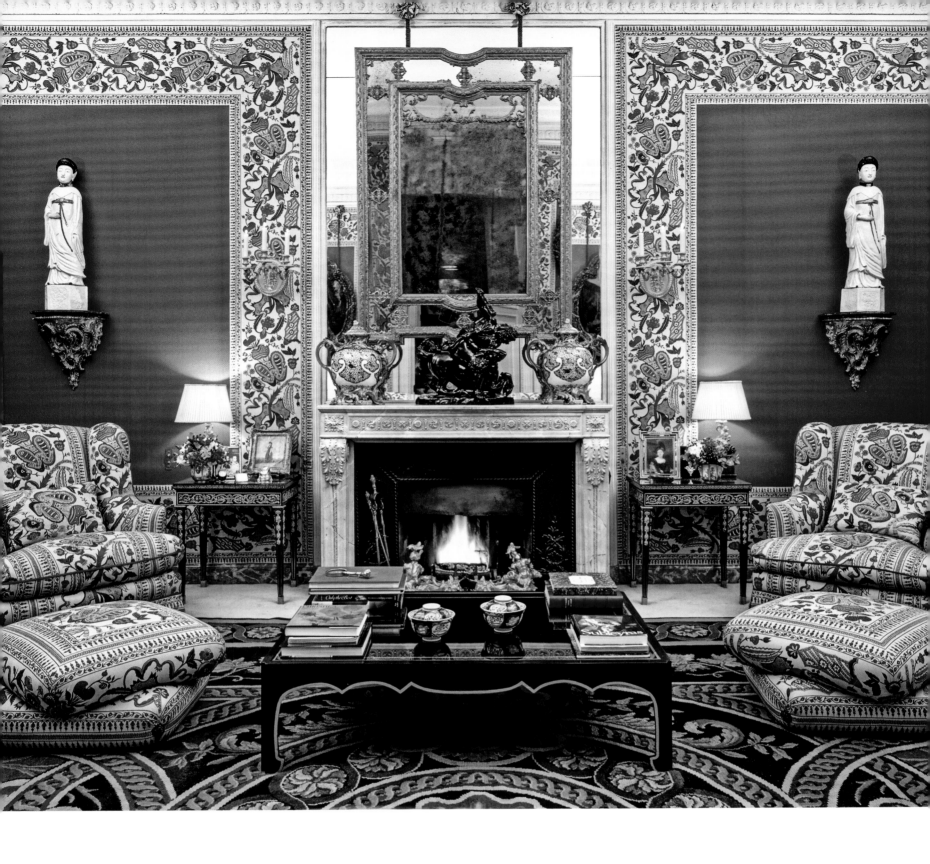

May 2019 | Manhattan

HOMEOWNERS Stefano Tonchi & David Maupin
ARCHITECT Selldorf Architects

When Tonchi (the editor of *W*) and his gallerist husband were expecting twin girls, they set out in search of a bigger apartment. Opting for the Osborne, a 14-story, brownstone-clad, Gilded Age mishmash of styles and materials, the couple enlisted their architect friend Annabelle Selldorf to help make it their own. In the living room, which is illuminated by a custom Murano glass chandelier, daughters Isabella and Maura sit in front of an original fireplace crowned by a David Salle painting.

January 1989 | Paris

HOMEOWNER Beatriz Patiño
DESIGNER Atelier François Catroux

"I'd become accustomed to the 18th century, which was a somewhat tyrannical era in interior decoration," the best-dressed, jet-setting hostess explained. "The Victorian period is fairly new to me, but I like it very much." Catroux gave her apartment, located near Parc Monceau, a highly patterned look reminiscent of Victoria's England and Napoléon III's France. "I emphasized details like braid and other unusual trimmings, deeply upholstered chairs, ottomans—everything that would reinforce the sensation of well-being," he said.

October 2018
Manhattan

HOMEOWNERS/DESIGNERS

Gabriel Hendifar & Jeremy Anderson

"We set a high bar for the things we live with and the things we put out into the world," said Hendifar, creative director of Apparatus, the innovative design studio that he and Anderson, his life partner, founded. A 1930s Albert Emiel canvas mounted on a divider makes a pastoral backdrop in their loft's dining area, which the couple furnished with numerous Apparatus creations, including the perforated-wood shutters; the dining chairs, though, are vintage 1970s.

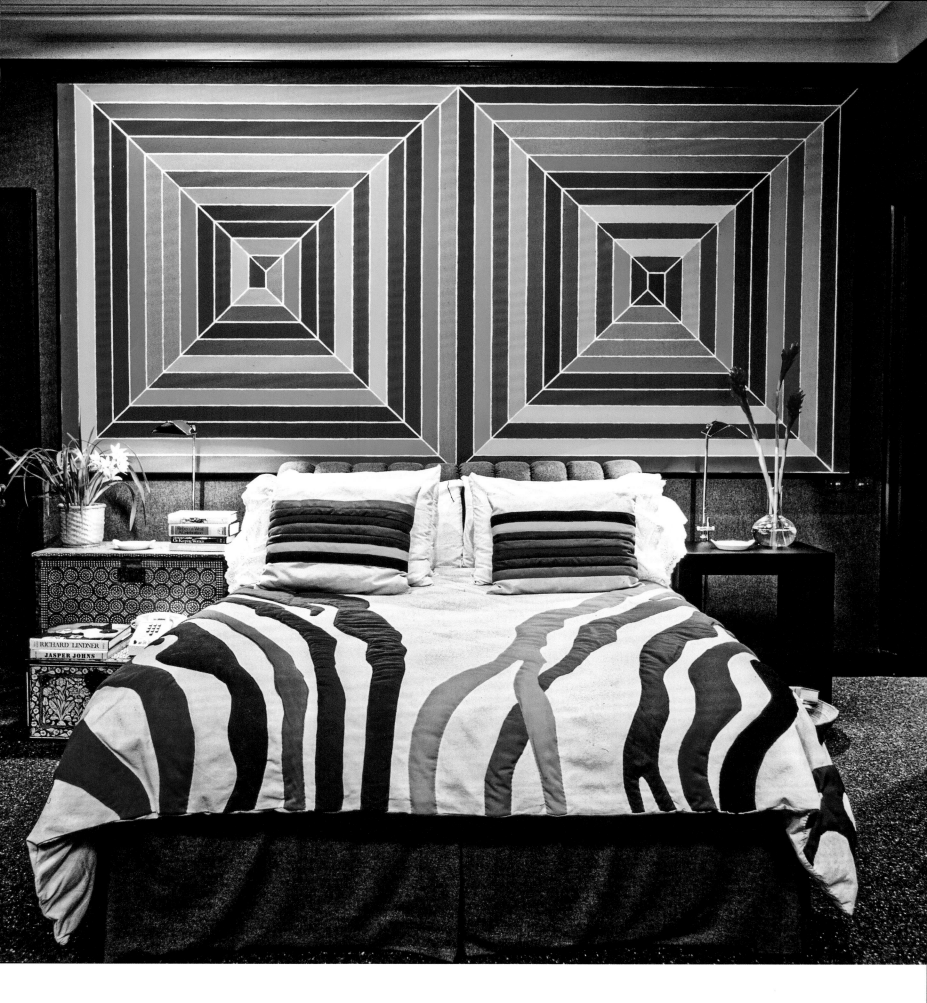

January 2019 | Paris

DESIGNER Isabelle Stanislas Architecture

"I love being in spaces steeped in history," said Stanislas, who contrasted a 17th-century residence's woodwork and lofty, parquet-floored rooms with contemporary, Native American, Asian, and Polynesian art that has been collected by her clients, an artist and a television producer. Antiques are part of the mix, too, as is custom-made furniture that was designed by Stanislas.

September 1978 | Chicago

DESIGNER Bruce Gregga Interiors Inc.

"Nothing was radically transformed," Gregga observed of the elegant 1920s apartment of arts patrons Susan and Lewis Manilow. The architecture may have remained neoclassical, but Gregga's fizzy decor mixed the antique with the mod. Gray flannel wraps the master bedroom, where a Frank Stella painting seems to melt into a bedcover inspired by a Morris Louis work. Flanking the bed are Islamic chests inlaid with mother-of-pearl and a glossy black Parsons table.

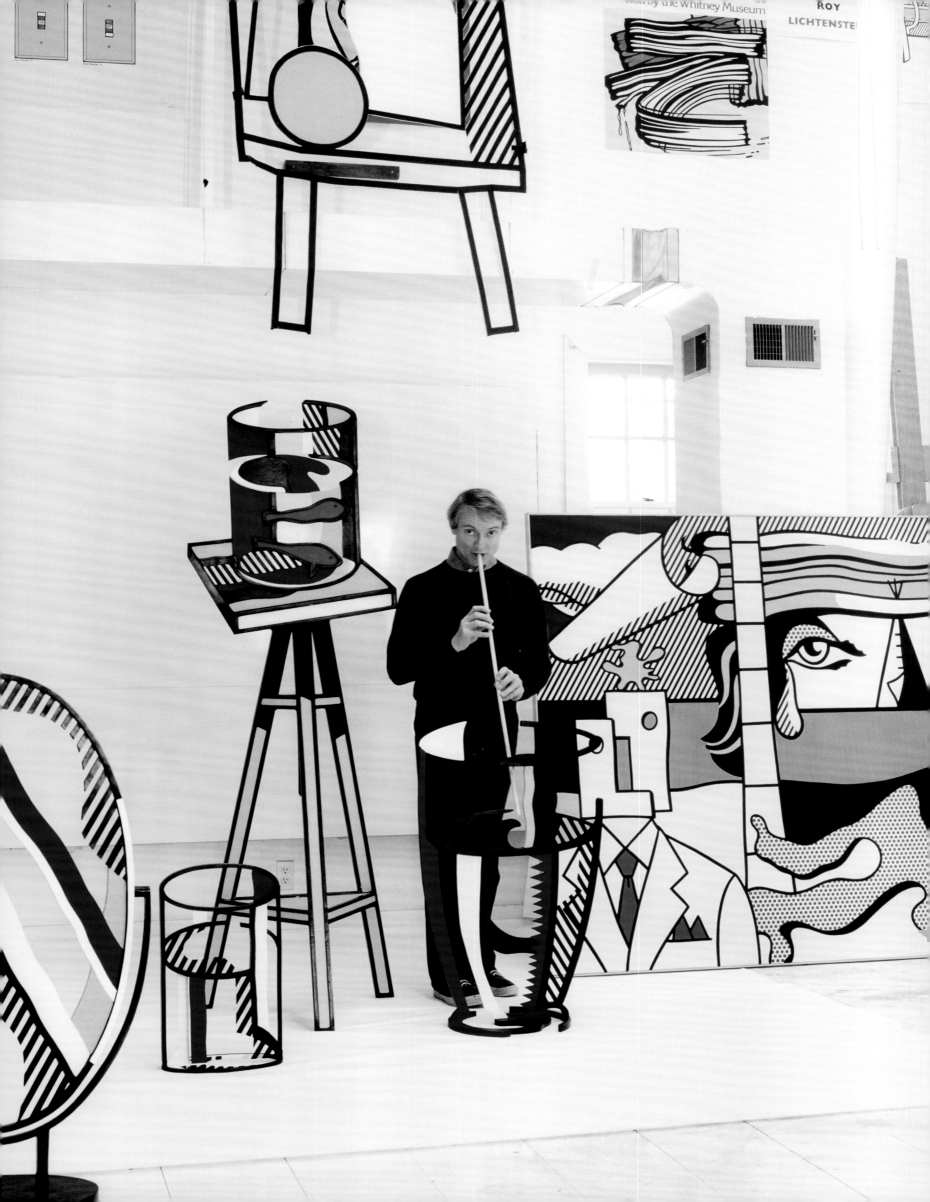

Roy Lichtenstein
KAWS & Julia Chiang
Robert Indiana
Julie Mehretu
Willem & Elaine de Kooning
David Hockney
Marc Chagall
Sterling Ruby
Niki de Saint Phalle
Fernando Botero
Jack Pierson
Al Held
Claude & François-Xavier Lalanne
Alex Katz

Artists

Georgia O'Keeffe
Joan Miró
Ugo Rondinone & John Giorno
Henry Moore
Jeff Koons
Urs Fischer
Barbara Hepworth
Rachel Feinstein
David Salle
Frank Stella
Jorge Pardo
Louise Bourgeois
Katharina Grosse

PREVIOUS SPREAD
Roy Lichtenstein
poses in his
Southampton,
New York, studio
with his Pop
creations (AD
July/August 1978;
see page 268).

ANY TEXTBOOK can tell the history of art through paintings, sculptures, and photographs. *Architectural Digest* has done so through interiors, chronicling the spaces where artists themselves have lived and worked. From Abstract Expressionists (*Willem de Kooning, Helen Frankenthaler*) to Pop pioneers (*Roy Lichtenstein, Robert Indiana*) to contemporary stars (*Katharina Grosse, Urs Fischer*), the past century's seminal talents have opened their doors to *AD*, allowing the magazine to trace the evolution of postwar art to today in a particularly intimate manner.

What such legends choose to live with or without will forever fascinate us. "If you're an artist, you're not obsessed with objects—with things," *David Hockney* told *AD* in 1983, reflecting on his brightly painted (if humbly furnished) ranch house in California. *Brian Donnelly*, a.k.a. *KAWS*, might disagree. He and his wife, sculptor *Julia Chiang*, have filled their Brooklyn home with a trove of treasures, among them rare pieces by *Wendell Castle, Takashi Murakami*, and the *Campana Brothers*. As KAWS noted in 2017, "I spend all day every day surrounded by my own work. When I come home, it's refreshing to focus on other artists."

The scale alone of a space can be revealing. When *Joan Miró* tapped architect *Josep Lluís Sert* to design his Majorcan studio, the artist requested a room large enough for the painting he was making for Harvard University. *Julie Mehretu*, meanwhile, rented a deconsecrated Harlem church in order to realize her

monumental commission for the San Francisco Museum of Modern Art. But just as artists' work informs their workspace, so too does the workspace inform their work. *Georgia O'Keeffe's* New Mexico home—published by *AD* in 1981 and again posthumously 14 years later—became a subject unto itself. "That wall with a door in it was something I had to have," she said. "It took me ten years to get it—three more years to fix the house so I could live in it—and after that the wall with a door was painted many times."

If many of the homes featured are extensions of an artist's practice, some are just places to unwind. Of *Cindy Sherman's* Long Island house, which appeared in 2013, *AD* noted: "Having shed her props and prosthetics, her greasepaint and getups, Sherman simply enjoys the Arcadian delights in the Springs, a quiet, curiously un-Hamptons-like hamlet that was once home to *Jackson Pollock, Lee Krasner, Willem de Kooning,* and other mandarins of 20th-century art."

Over the years, of course, the very concept of art has changed. When *AD* visited *Claude* and *François-Xavier Lalanne* at their French farmhouse in 1981, the writer wondered, "In what category do these fabricated animals, disguised as chairs and writing tables and bathtubs, belong? Are they furniture, or are they sculpture?" That the two should be mutually exclusive sounds almost silly today, when the lines between art and design have long been blurred. "Simply think of them as Lalannes," responded Claude and François-Xavier. Four decades later, we definitely do. ◢◗

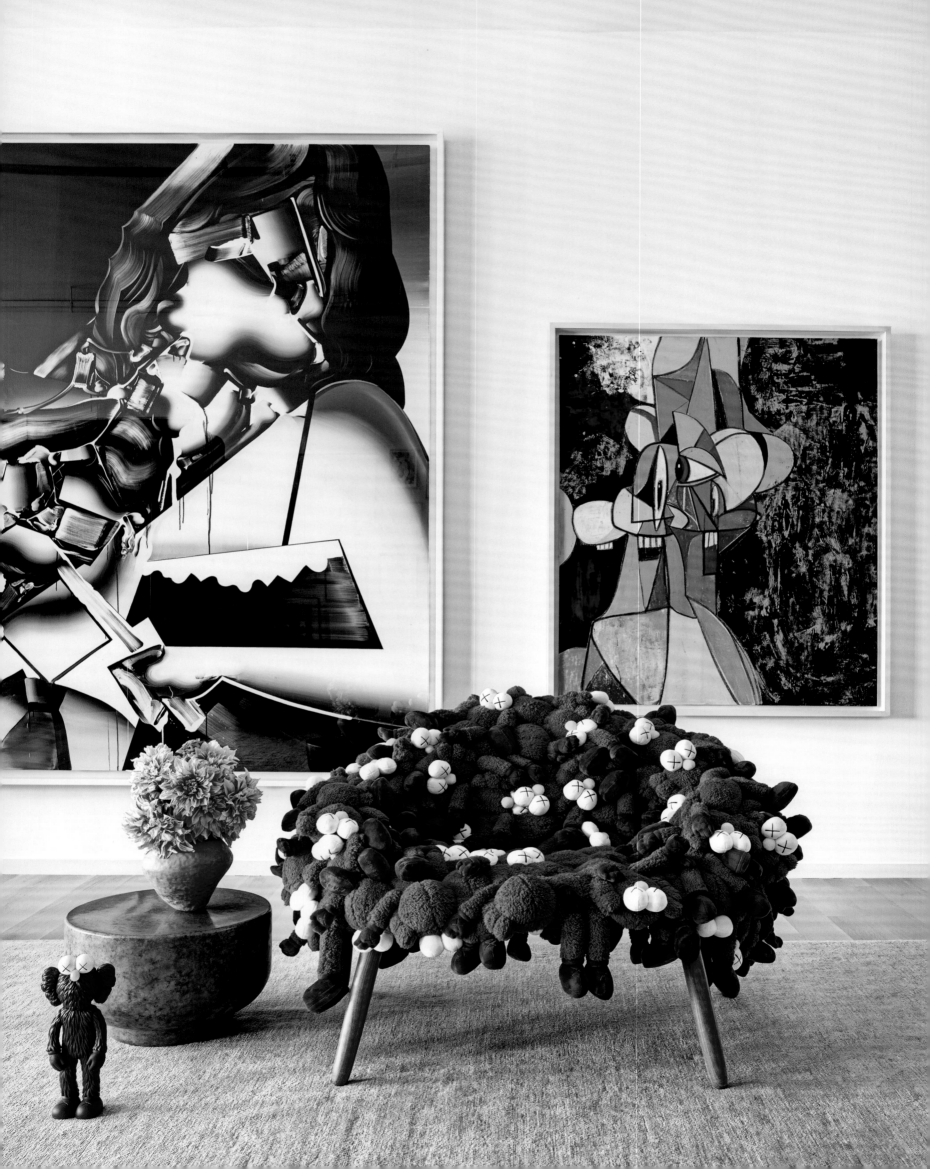

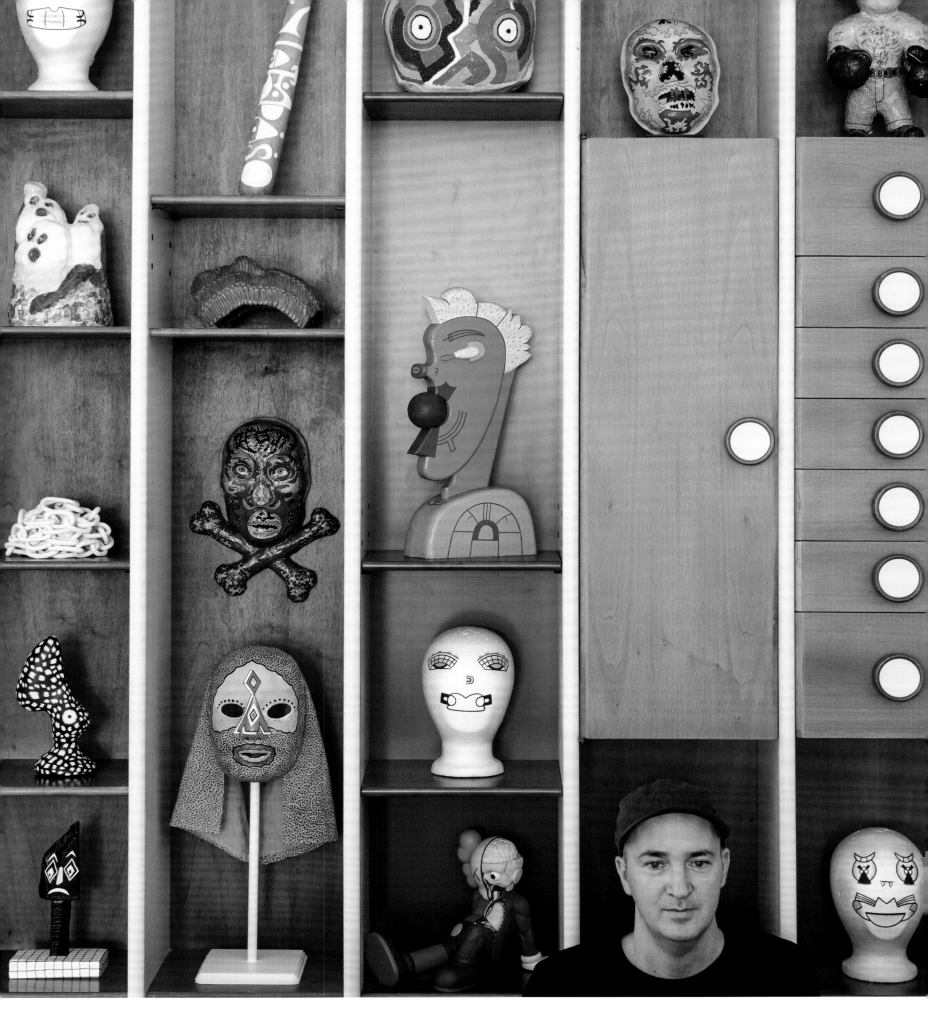

December 2017 | Brooklyn

HOMEOWNERS KAWS & Julia Chiang

Brian Donnelly (a.k.a. KAWS) and his wife transformed an industrial building into a kid-friendly home for their family of four. The residence doubles as a light-filled showcase for the couple's vast collection of art and design, ranging from the 1950s to the present day. "I don't buy art to put in specific places," Donnelly explained. "I just collect what I love and hope to find a place for it to be visible."

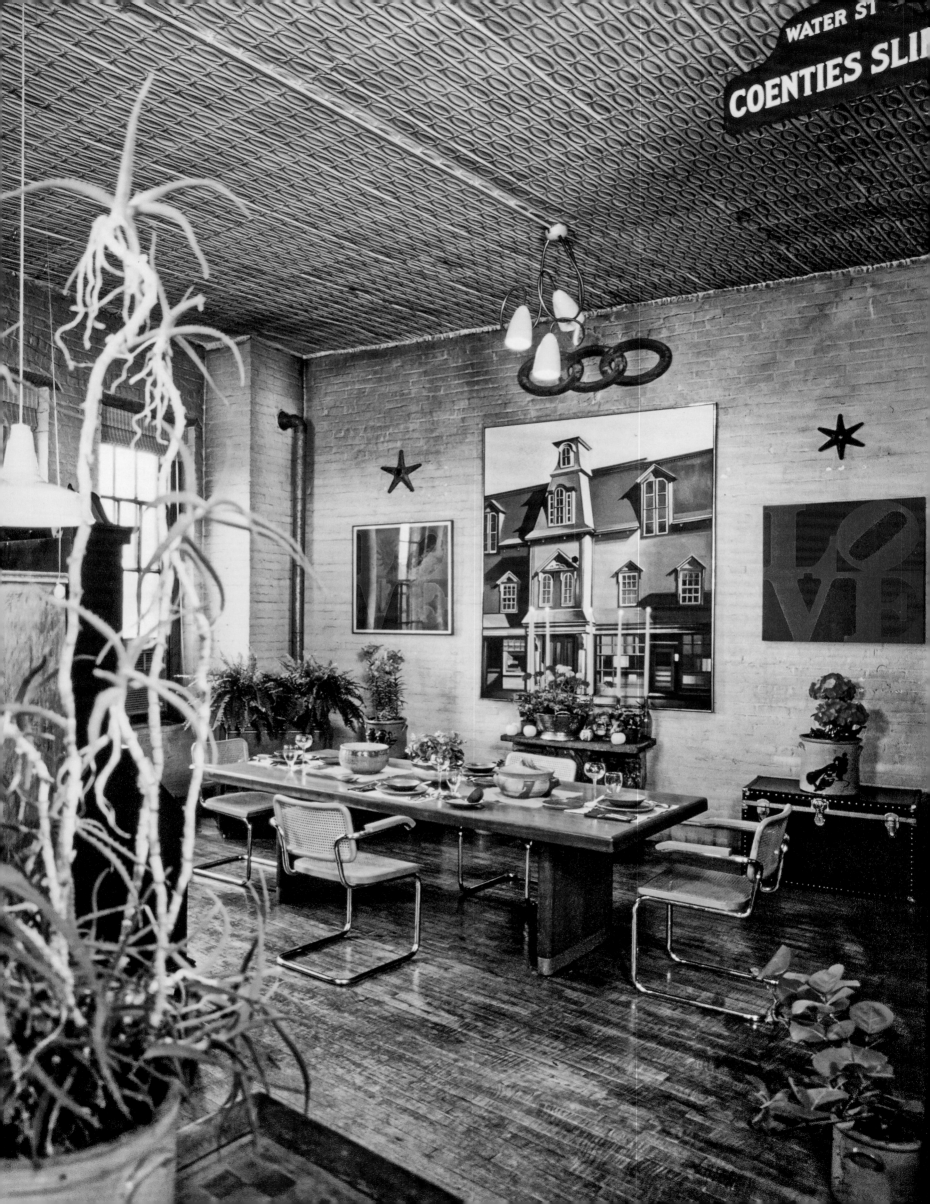

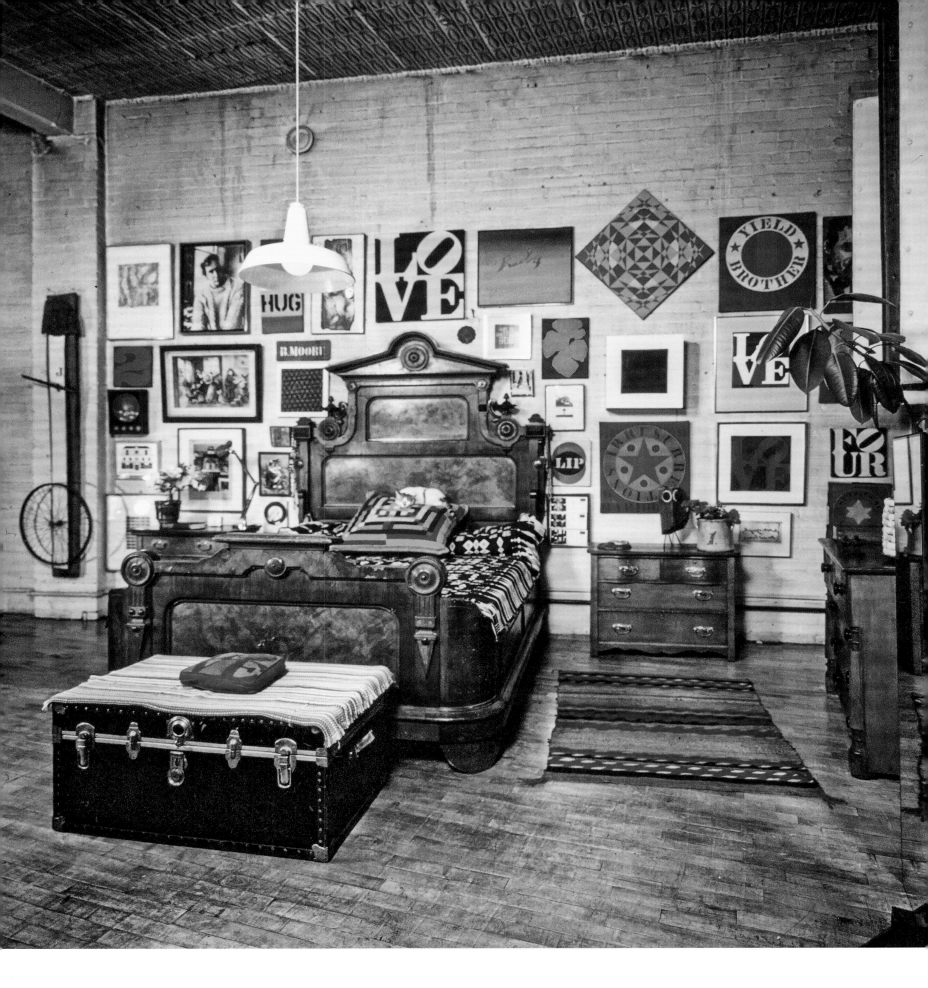

November 1978 | Manhattan

HOMEOWNER Robert Indiana

"Everything that ever happened to me—with few exceptions—is right here," Indiana said of this home and studio, a Lower East Side building that he filled with artwork by himself and his friends. "Over a period of time, things have accumulated, and I'm a keeper. I just don't discard things."

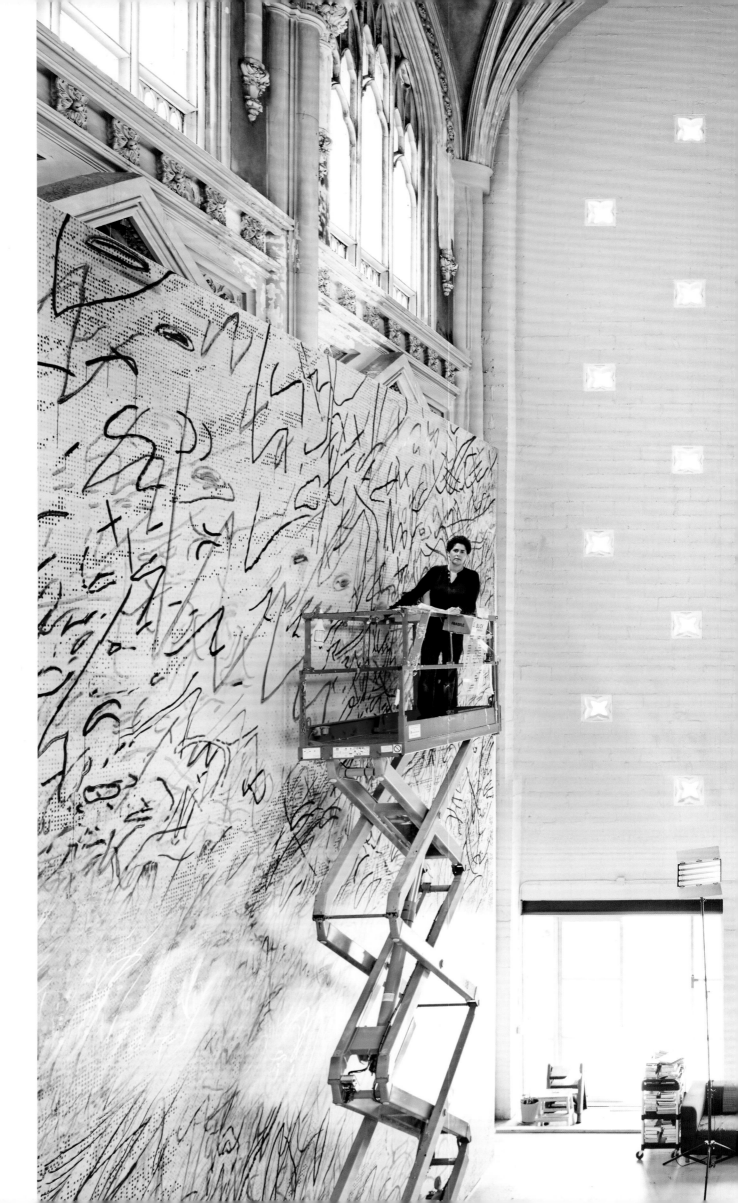

September 2017
Manhattan

Julie Mehretu Studio

When her studio proved too small to realize an immense commission for the San Francisco Museum of Modern Art, Mehretu found room to create in the lofty nave of a deconsecrated Harlem church. "It was really just me, by myself, for months. Hours just staring at the canvases," she recalled. "The most interesting work confounds, confuses, and creates headaches."

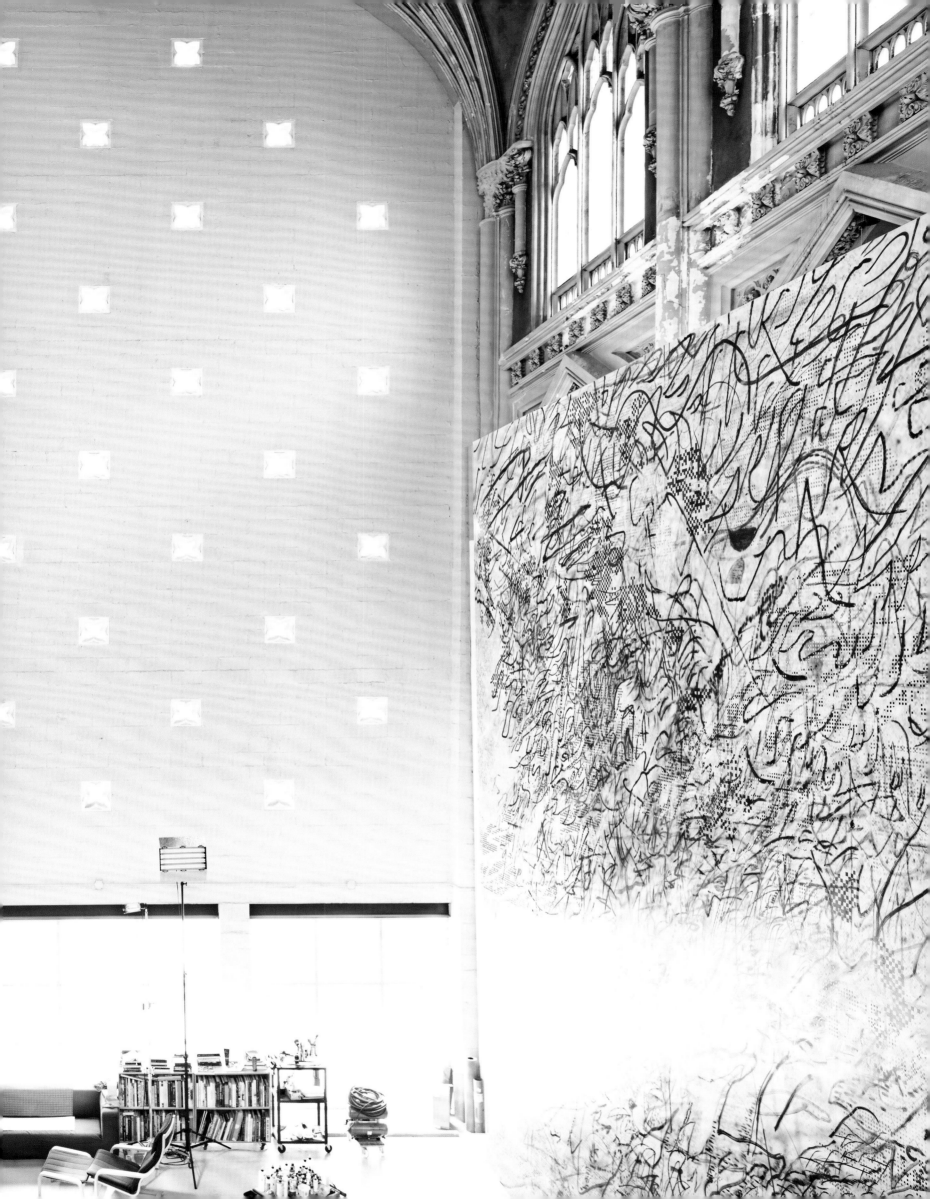

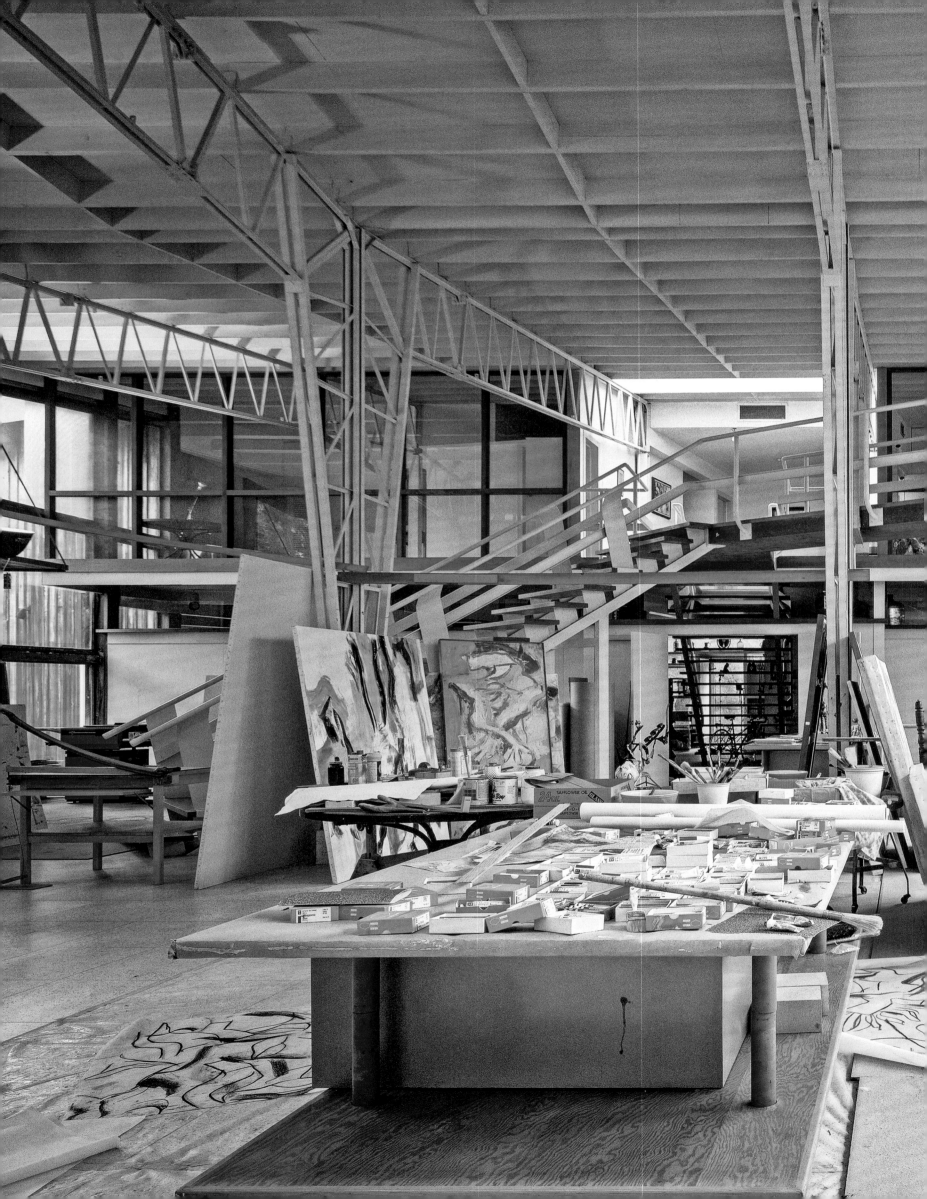

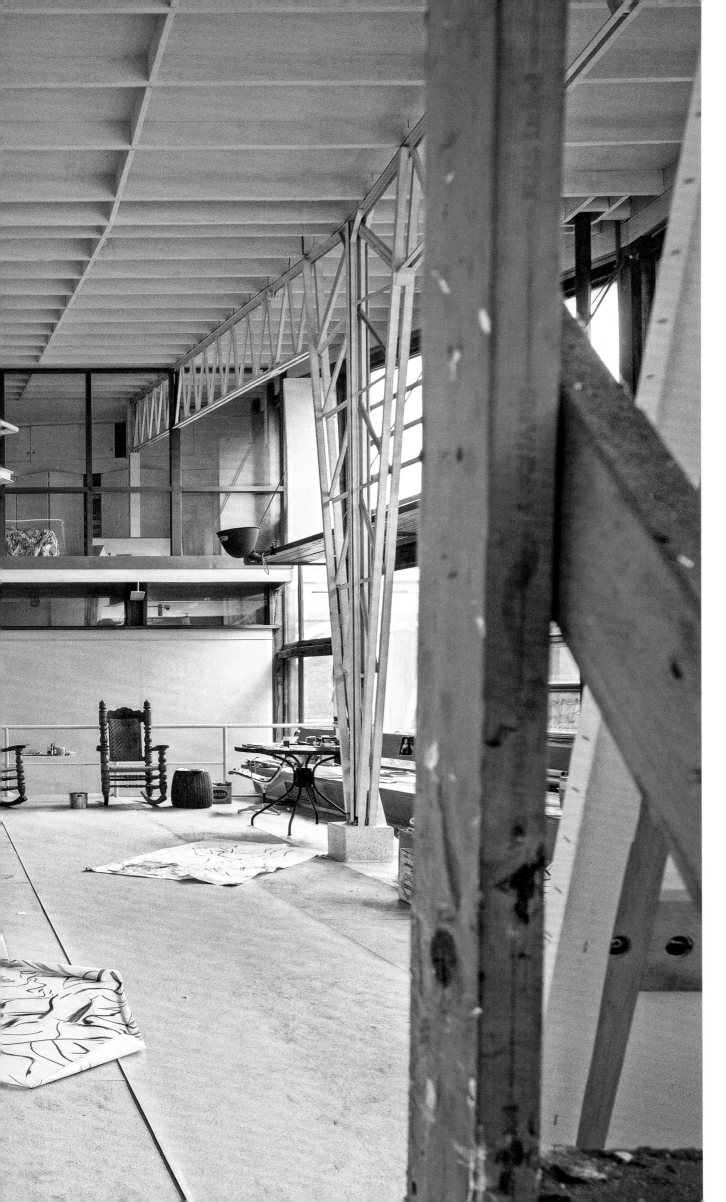

HOMEOWNERS
Willem & Elaine de Kooning

In the early 1960s, the legendary Abstract Expressionist and his wife, Elaine, moved from Manhattan to East Hampton, where they had been occasional weekend guests of Jackson Pollock. "The land, so near the water, and the quality of the light reminded him of his native Holland," Elaine said of her husband, who added, "I knew what I wanted and designed the house myself."

April 1983 | Los Angeles

HOMEOWNER David Hockney

Hockney's house—like the man himself—flies in the face of convention. But as he reflected in a conversation with *AD,* "Everyone who comes here likes it. People don't dare such colors usually." Whereas the artist's living room became the studio, cluttered with paintings in progress, the pool became a work of art, with Hockney brushstrokes that mimic rippling water. "What I am doing, slowly, is making my own environment— room by room—as artists do," he said. "Of course it's fun."

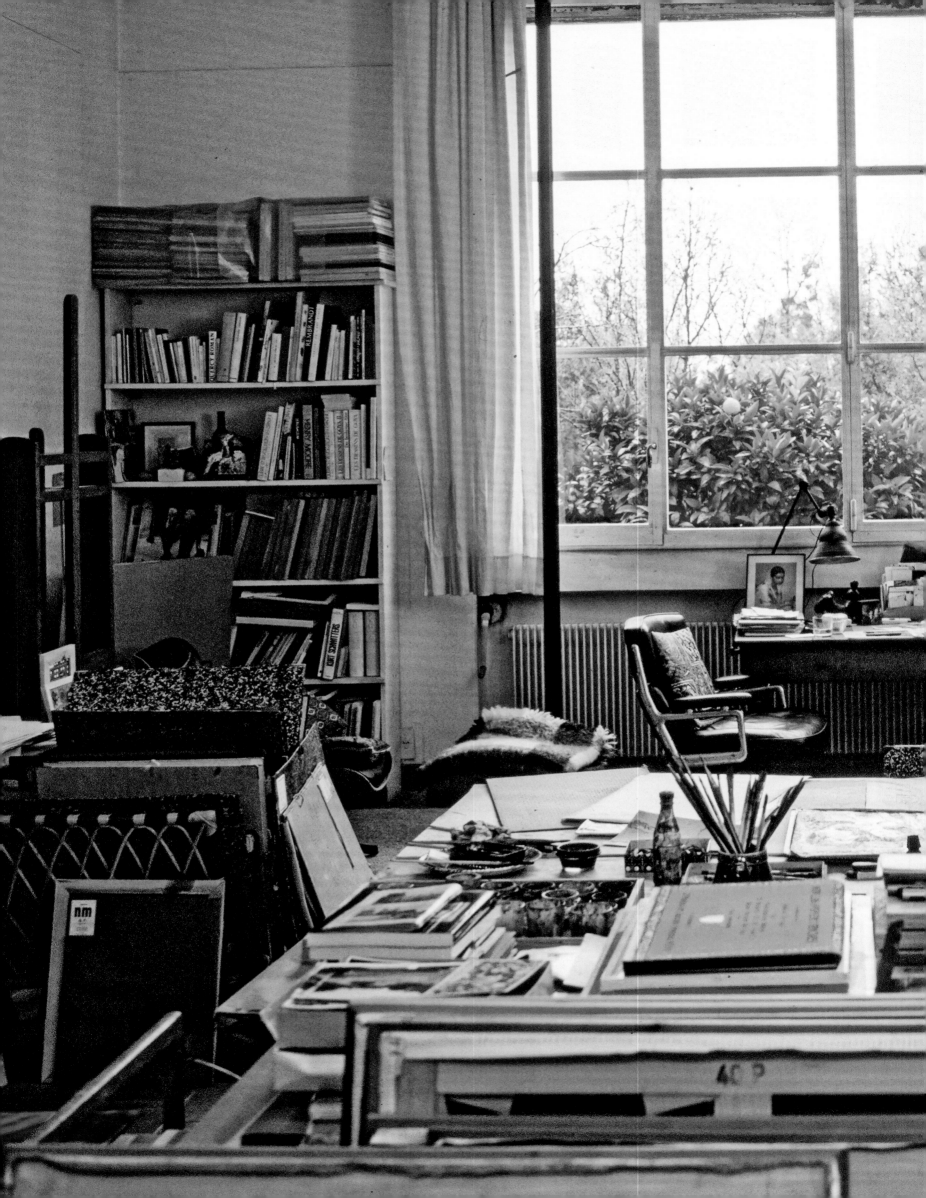

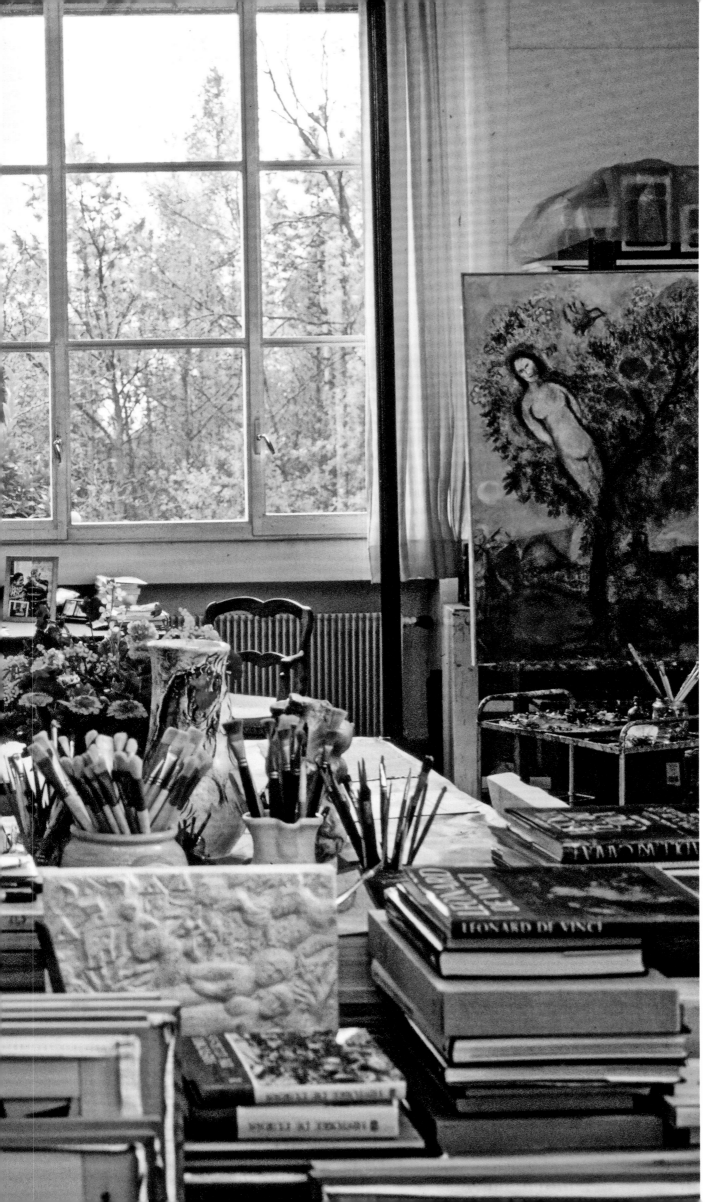

August 1984
Saint-Paul-de-Vence,
France

HOMEOWNER
Marc Chagall

Chagall's secluded home studio bore eloquent witness to an artist who worked hard, day in and day out. Every meticulously ordered table exhibited gouaches, lithographs, and sketches, while an easel displayed a large painting. Asked what time of the day he found best for working, he retorted, "I'm working even when I'm asleep!"

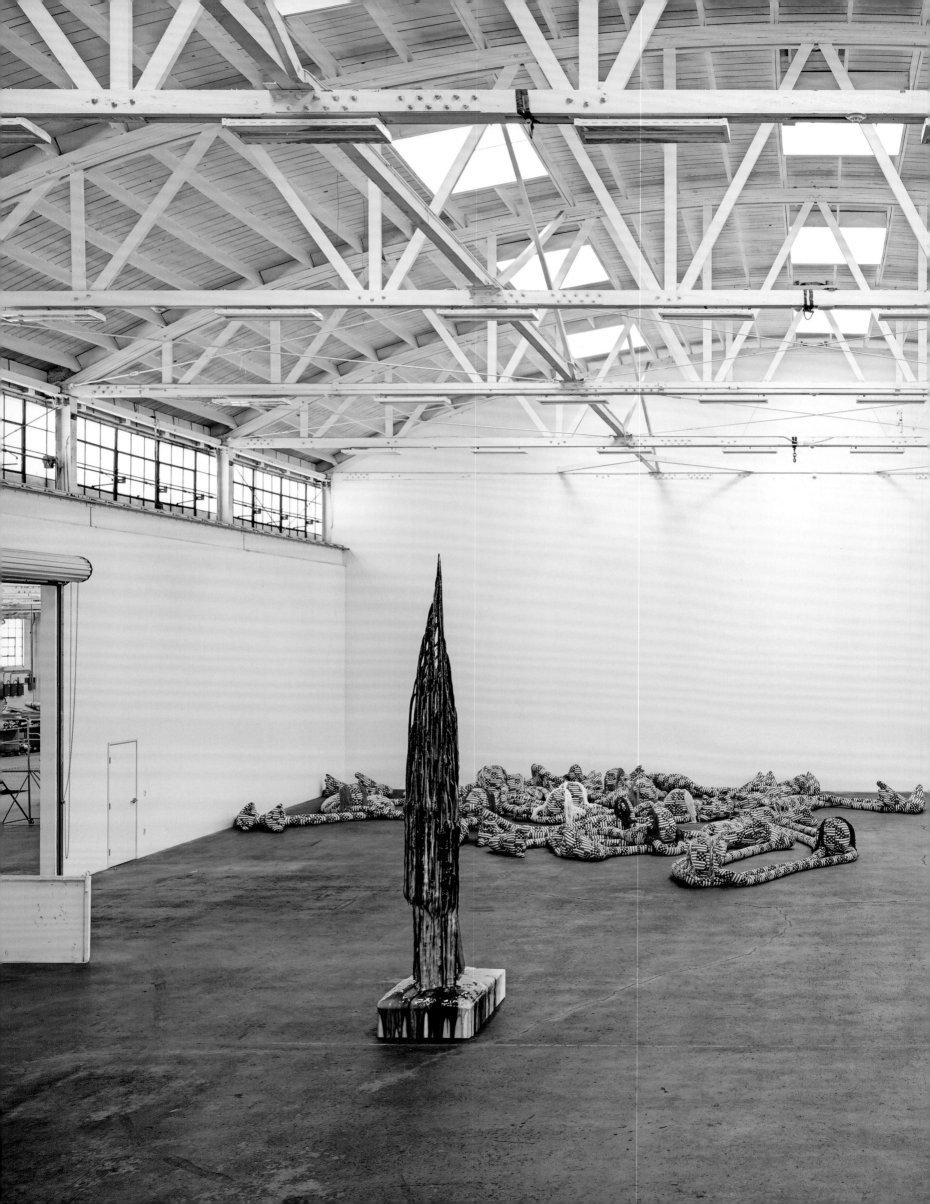

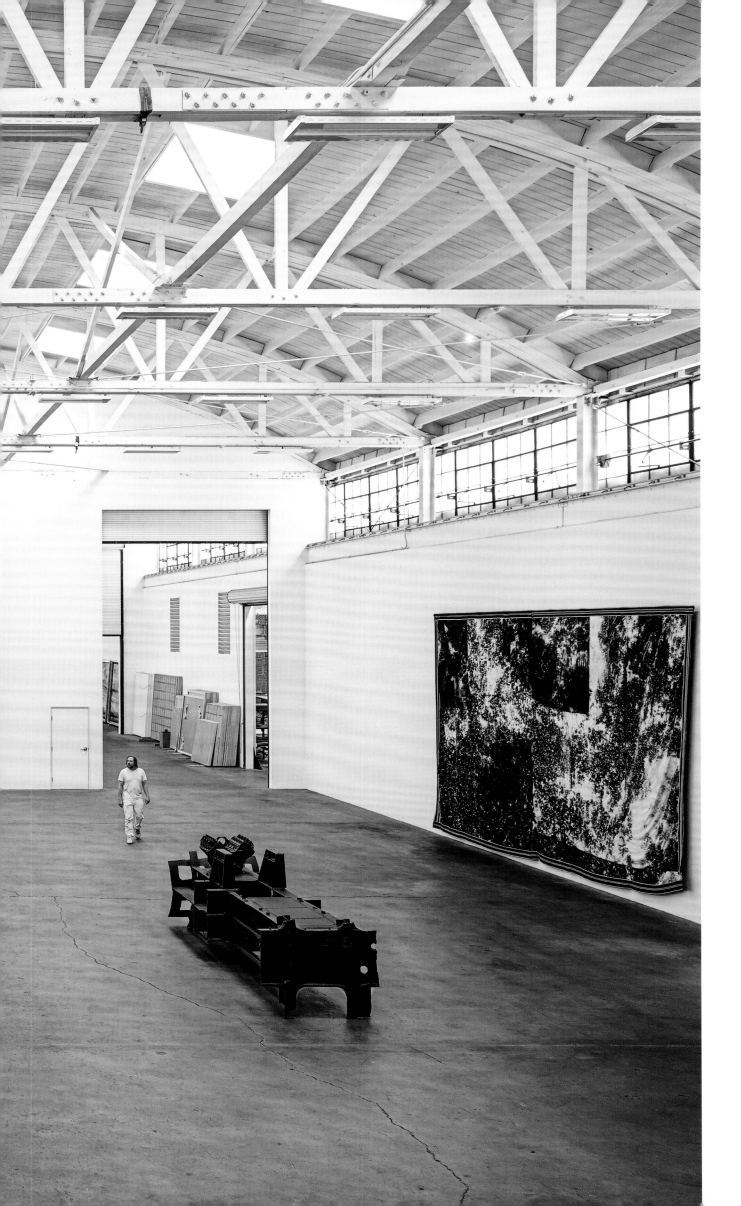

October 2018
Vernon, California

Sterling Ruby Studio

Just five miles south of downtown Los Angeles, the artist's vast studio sits on four acres, with roughly 122,000 square feet of indoor space. In addition to structures dedicated to various media, as well as viewing rooms, storage, and technical facilities, Ruby has a 10,000-square-foot gallery where he can install exhibition mock-ups at full scale. "I get manic, so I like to move around," he explained. One senses that, despite his team of assistants, he often inhabits the space alone.

September 1987 | Pescia Fiorentina, Italy

Niki de Saint Phalle's Tarot Garden

For two decades, Saint Phalle labored over her Tarot Garden, a complex of 22 artworks—set on the grounds of an Agnelli family farm—that represent the cards. During that time, she resided in the Empress sculpture, her bedroom in its breast.

July 1982 | Paris

Fernando Botero Studio

Colombian-born Botero worked in a two-story studio of what had been the Académie Julian art school, using different rooms for different media. He organized his schedule to only paint for months, then would switch to concentrate on sculpture.

December 2016
Manhattan

HOMEOWNER
Jack Pierson

In 2008, after a dispiriting search, the artist and photographer jumped at the opportunity to purchase a one-bedroom Greenwich Village flat. He soon set about decorating it like something he had magically lucked into. "I decided that I wanted it to look like an apartment that a rich aunt—one I didn't know I had—had left to me, and that I had taken over in my gay-bachelor way," said Pierson, who called upon a friend, designer Fernando Santangelo, for help. "But, just to be clear, I don't have a rich aunt."

June 1989 | Woodstock, New York

HOMEOWNER Al Held

For many years the painter left his Manhattan loft for the quietude and isolation of his Catskills farm, a weekend place where a barn roughly the length of a city block served as his studio. "Woodstock is very different from places like East Hampton or Provincetown, where you have an extension of the New York art scene, sort of like summer camp," said Held. "I know almost nobody in Woodstock."

February 1981 | Ury, France

HOMEOWNERS Claude & François-Xavier Lalanne

At their home on the edge of Fontainebleau forest, the couple set up respective ateliers, each space cluttered with tools and models. Here they became country people, installing themselves in the manner of village blacksmiths, though they didn't exactly think of themselves as craftsmen or even as artists. Describing their fanciful creations, they matter-of-factly said, "Simply think of them of Lalannes."

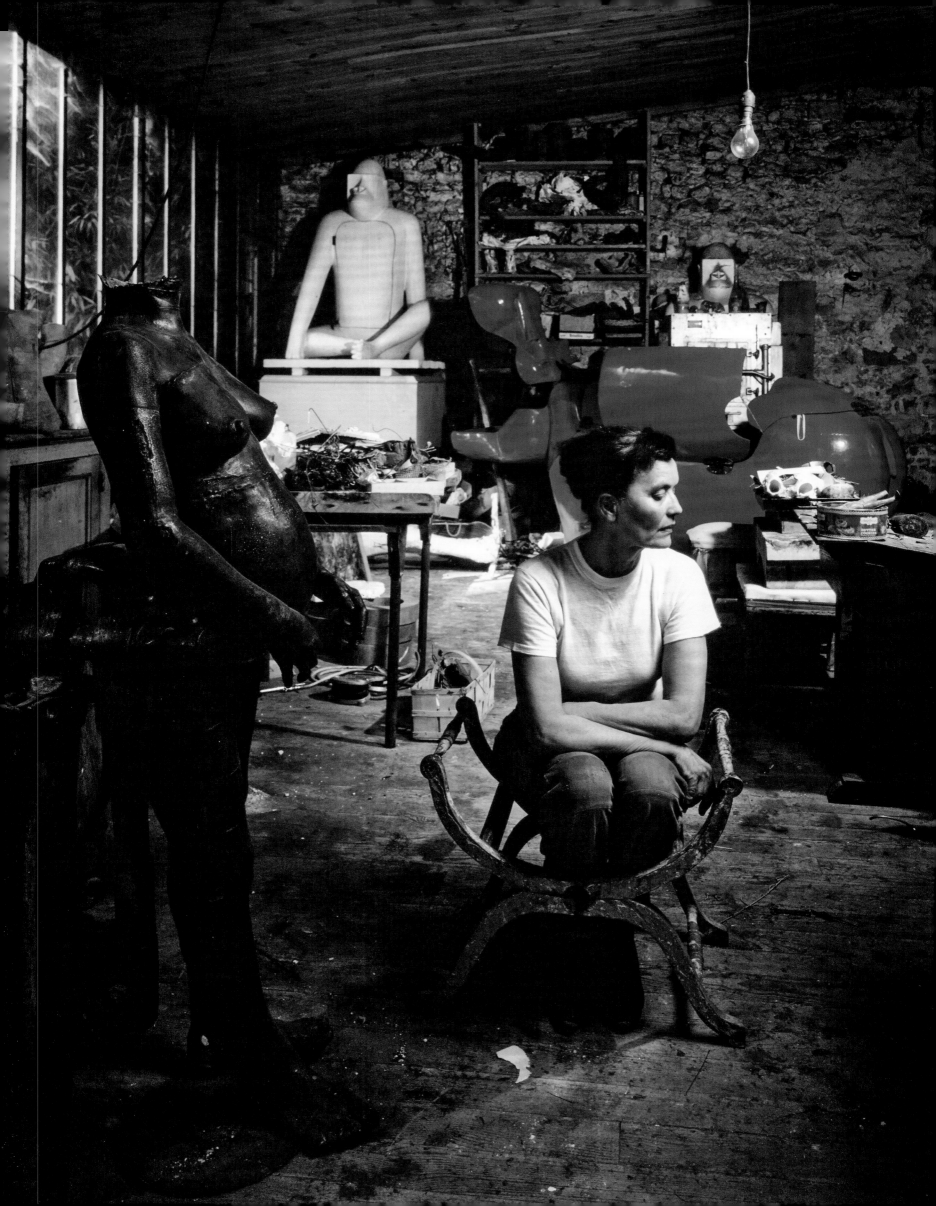

March 2012
Manhattan

HOMEOWNER
Alex Katz

The figurative master
has lived and painted
in a cavernous top-
floor loft in the heart
of SoHo since 1968—
back when, he recalled
with wistful affection,
the neighborhood "really
was an industrial slum."
Here, as at his summer
haven in Maine, Katz is
a seven-days-a-week
kind of guy, starting each
morning at 7:30 with
300 push-ups and 400
sit-ups. After that, "I'm
pretty much consumed
by work," he noted.

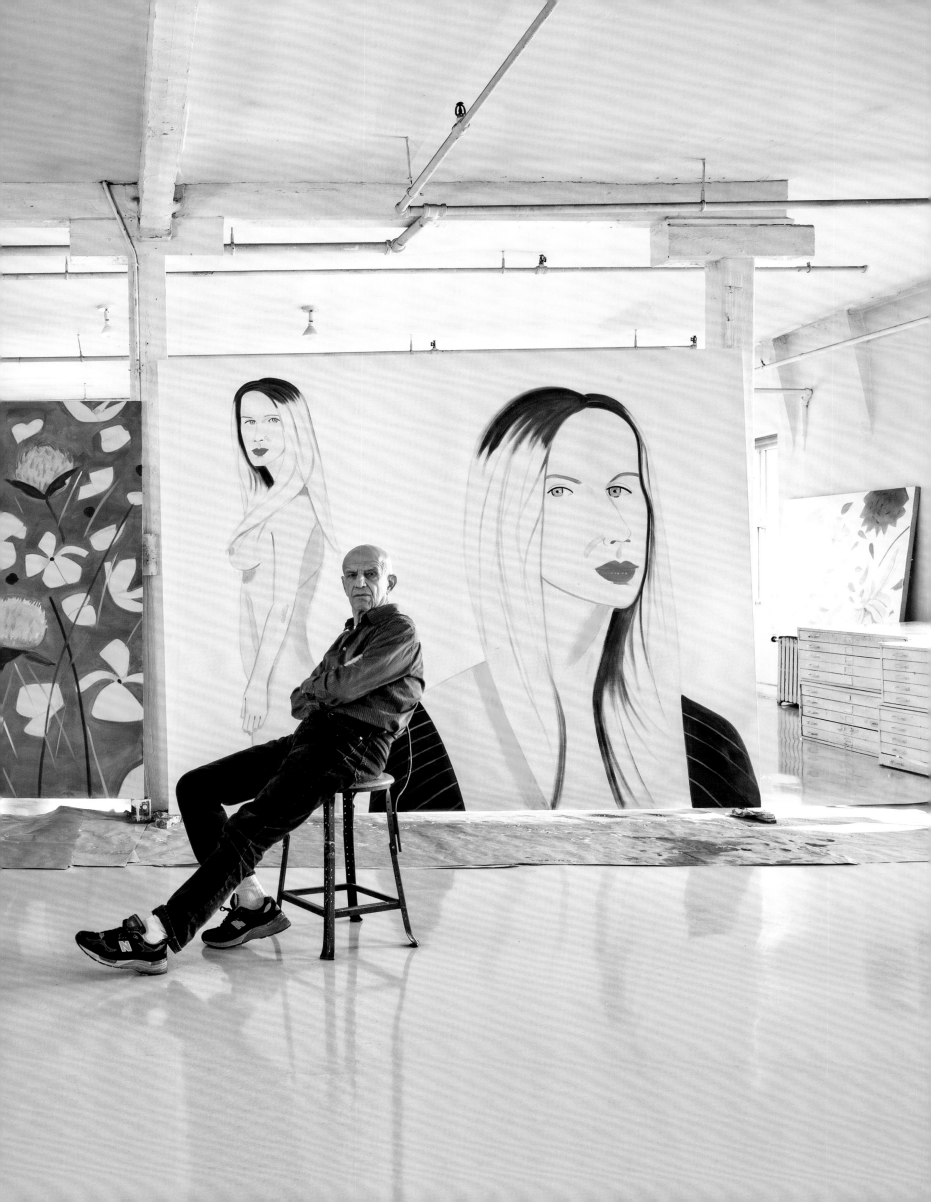

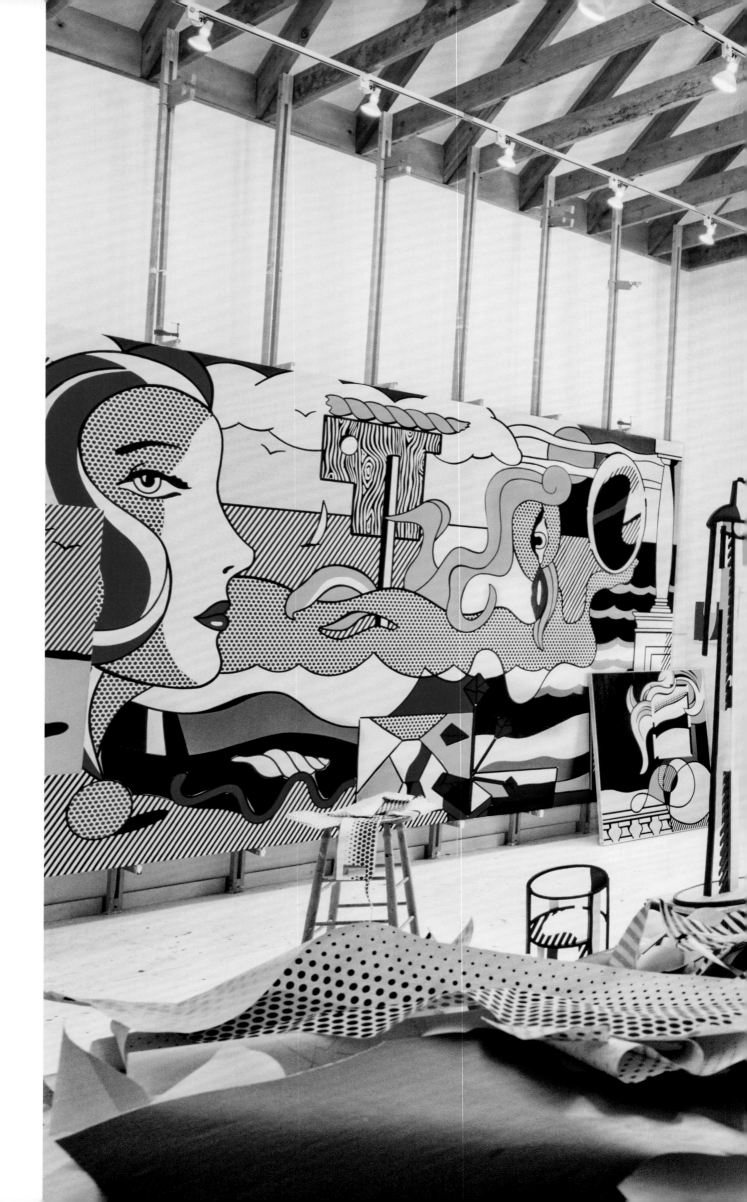

July/August 1978
Southampton, New York

HOMEOWNER
Roy
Lichtenstein

In 1973, the legendary
Pop star traded
Manhattan for the East
End of Long Island,
hoping to avoid the inter-
ruptions of city life. There,
about a half mile from
the beach, he settled into
a converted coach house
and barnlike studio, the
crisply painted exterior
of which gave no clue to
the fantasy inside. "The
work I do always amuses
me. But it is not a joke,"
he remarked. "I think
there is something funny
about each of the figures
I do. Not hilarious or
slapstick, but funny in
the sense of being odd,
peculiar, off a little bit
in some strange way."

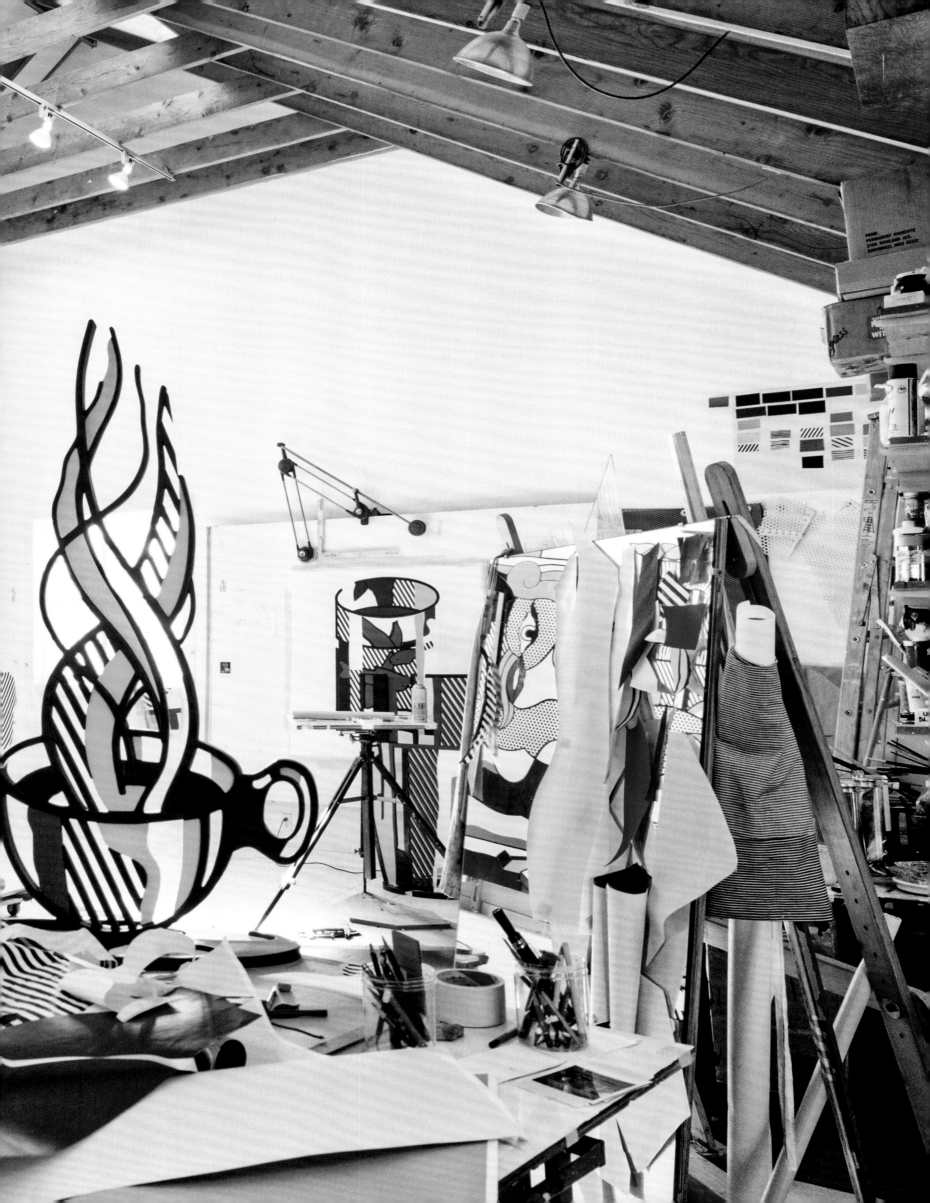

July 1981
Abiquiu, New Mexico

HOMEOWNER
Georgia O'Keeffe

"If you ever go to New Mexico, it will itch you for the rest of your life," said O'Keeffe, who spent much of her time there from the 1930s until her death, in 1986. When she first saw the house she would long occupy, it was not for sale, but after 15 years she managed to buy it for $10 from the Catholic church. "When I bought the house, it was totally uninhabitable. Architecturally it is not a masterpiece but a house that grew."

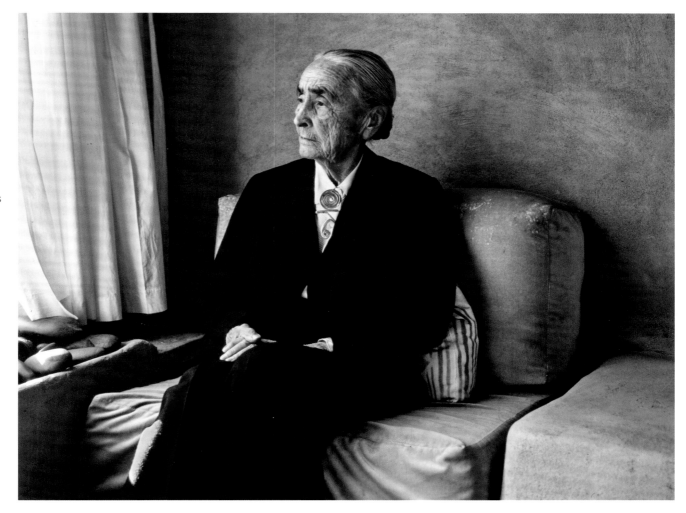

January/February 1979
Palma de Mallorca, Spain

HOMEOWNER
Joan Miró

Around 1960, Miró—
son of a Majorcan
mother and husband
of a Majorcan wife—
found a plot of land
near Palma de Mallorca
and commissioned
his friend and fellow
Catalan Josep Lluís Sert
to build him a new house
and a new studio. The
architect, in return, asked
only one question: How
long was the studio to
be? Long enough, Miró
answered, to hold the
huge painting he was to
do for Harvard University.

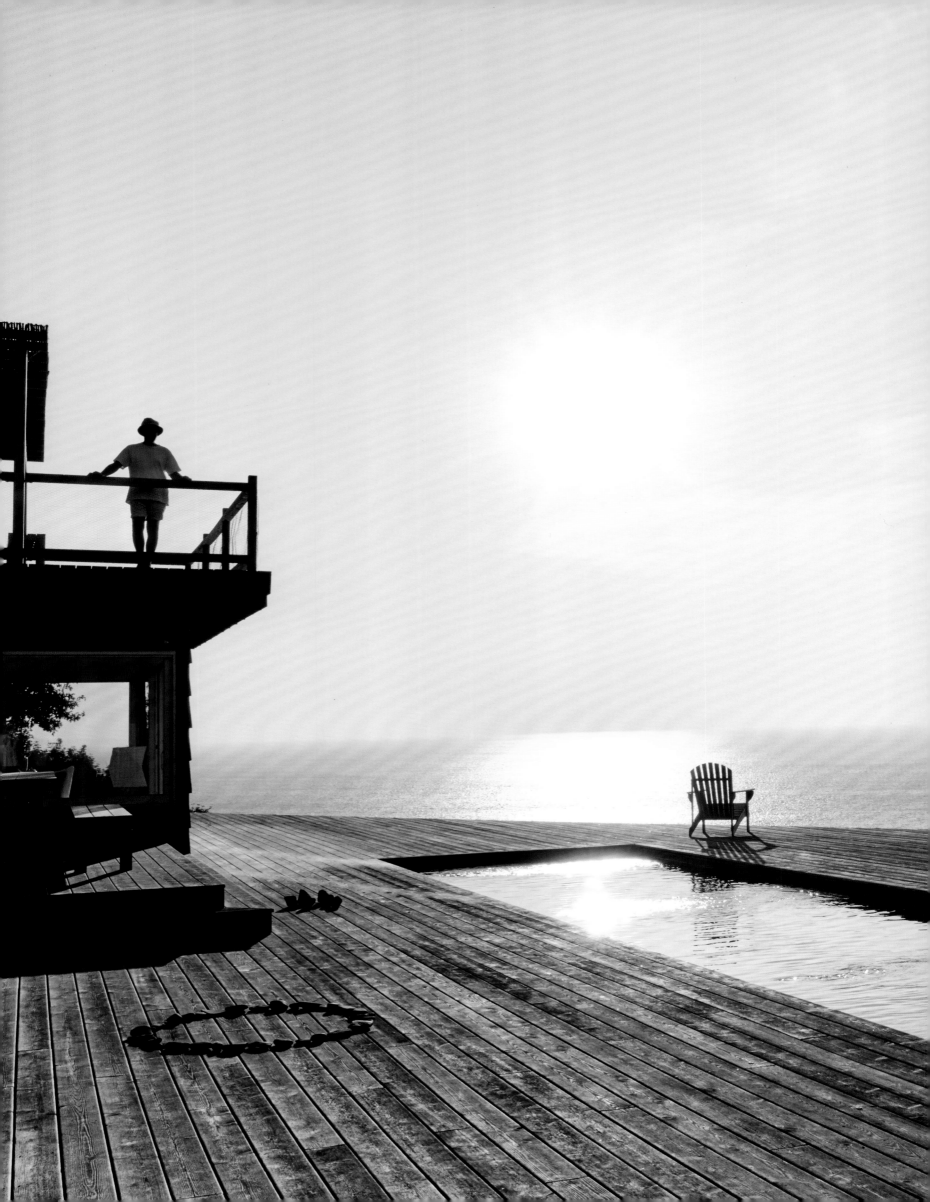

December 2018
Long Island, New York

HOMEOWNERS
Ugo Rondinone & John Giorno

When Rondinone and Giorno first saw their waterfront house, on the North Fork of Long Island, it was an awkward yet magnificently situated 1960s structure. With the help of architect Neil Logan, the couple dramatically renovated the building to embrace the stunning view, adding glass walls, broad windows, and a sprawling deck that is punctuated by a pool and tree trunks. "One of Ugo's great talents is sculpture," said Giorno. "He has a clear vision about form and space, which he thinks about endlessly."

March 1980 | Hertfordshire, England

Hoglands HOMEOWNER Henry Moore

For more than 40 years, Moore, one of the great sculptors of the 20th century, lived in an Elizabethan farm cottage surrounded by a complex of studios. "I like to work morning, noon, and night. Work is what one lives for," he reflected. "I hope that after I'm gone, young sculptors will come to Hoglands to see how I worked."

June 2014 | Manhattan

Jeff Koons Studio

On the eve of his blockbuster 2014 Whitney retrospective—the museum's final show in its uptown Marcel Breuer building—Koons posed for a portrait, gazing ball in hand, with his team of painters hard at work in the background.

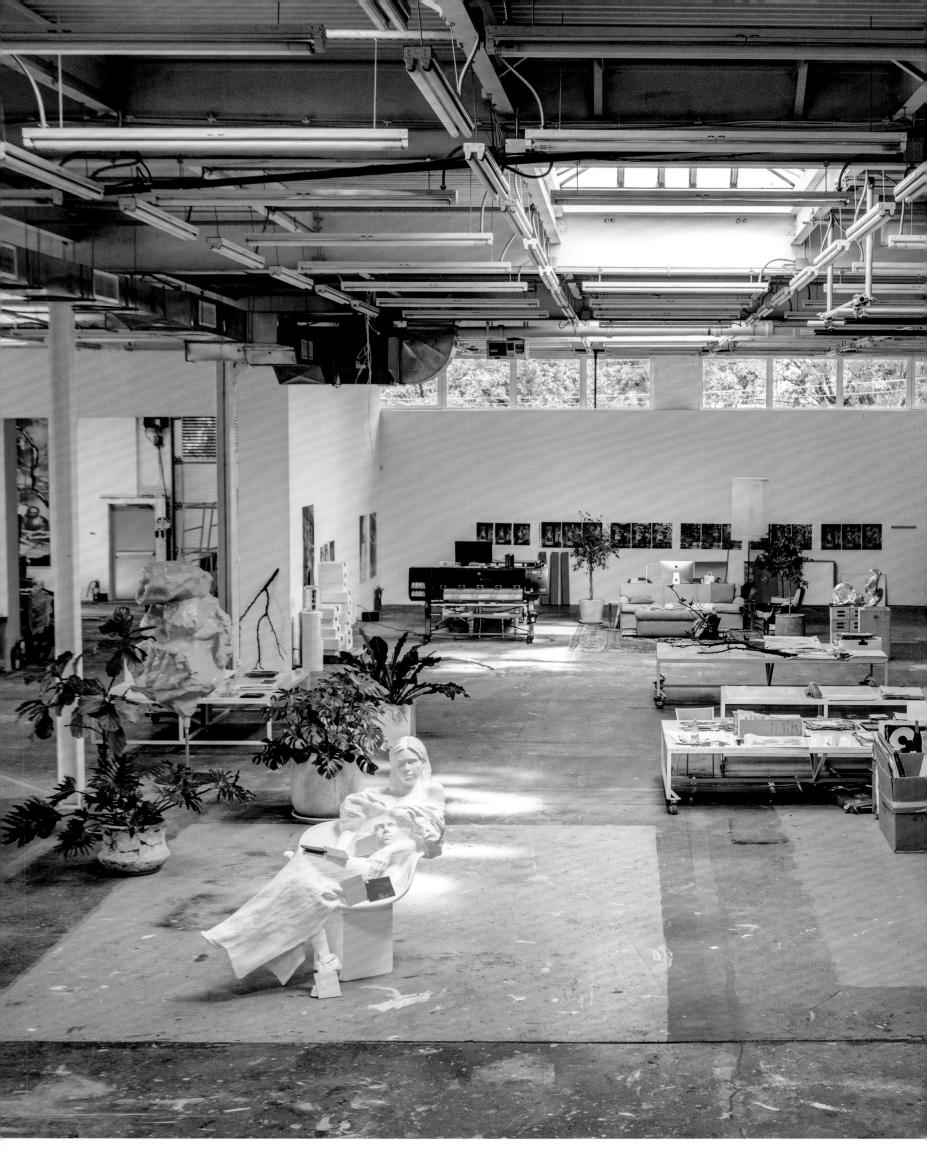

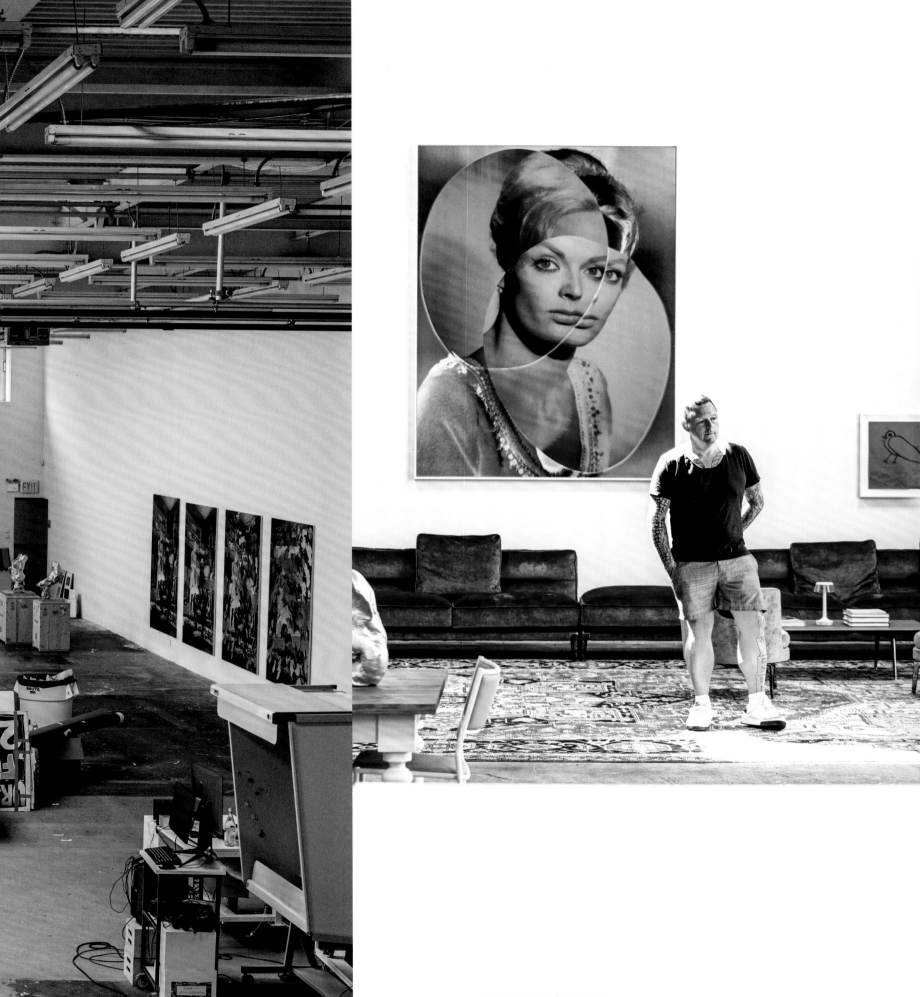

December 2018 | Brooklyn

Urs Fischer Studio

Steps from New York Harbor in Red Hook, the 24,000-square-foot space where Fischer creates his irreverent sculptures and installations feels not only more like home but much more fun. "We spend our days in warehouses, half of our life, so let's try to make it a little bit pleasant," said the artist, who has a master-of-the-universe view of works in progress from the elevated kitchen and dining area, reached by an elegantly minimal wooden staircase.

April 1981 | St. Ives, England

Trewyn Studio HOMEOWNER Barbara Hepworth

Upon buying Trewyn Studio in 1949, Hepworth turned her attention to its prim parterres, replacing them with Cornish palms and native bamboo.
Her studios spilled out into the garden. As she once said, "I love my blocks of marble, always piling up in the yard like a flock of sheep."

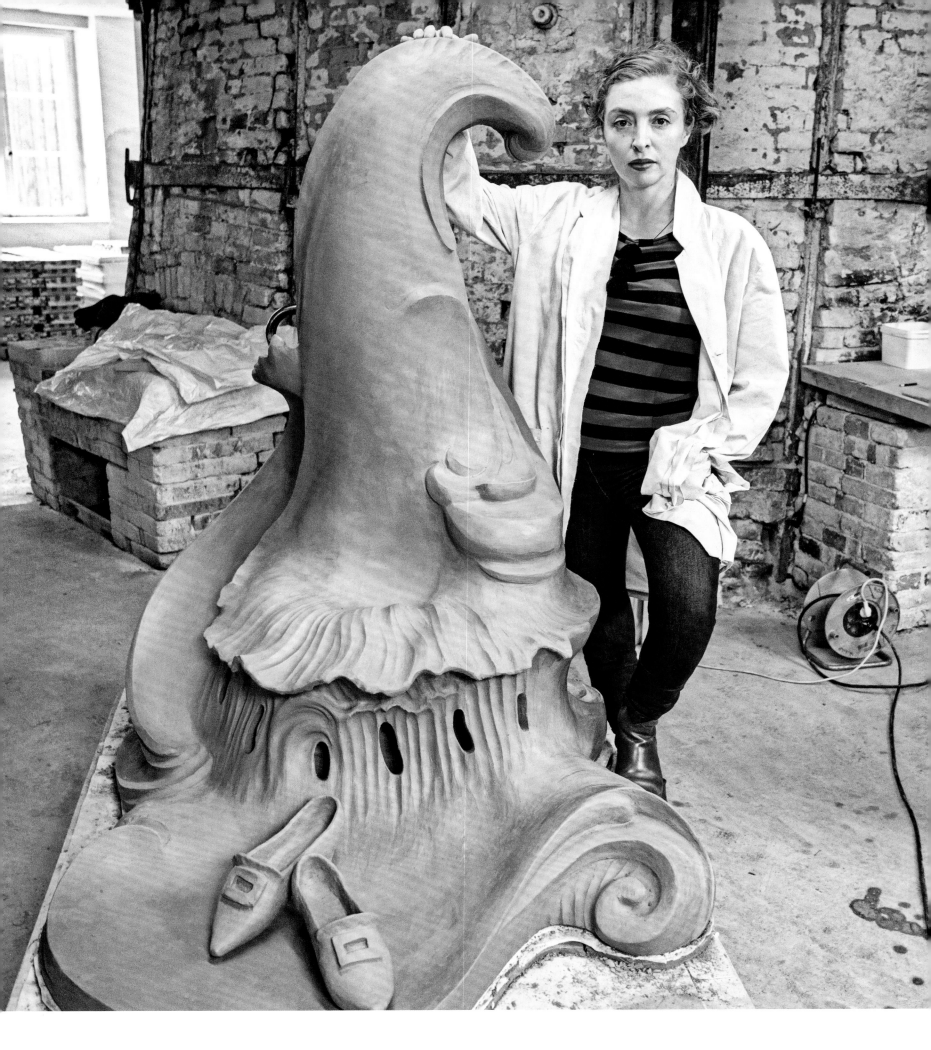

February 2018 | Munich

Rachel Feinstein at Nymphenburg

During a trip to Bavaria, Feinstein fell under the spell of Nymphenburg, the legendary porcelain factory on the grounds of a 17th-century palace.
She would later use the facilities to fabricate the ceramic pedestals for her 2018 Gagosian exhibition, a project captured in progress by *AD*.

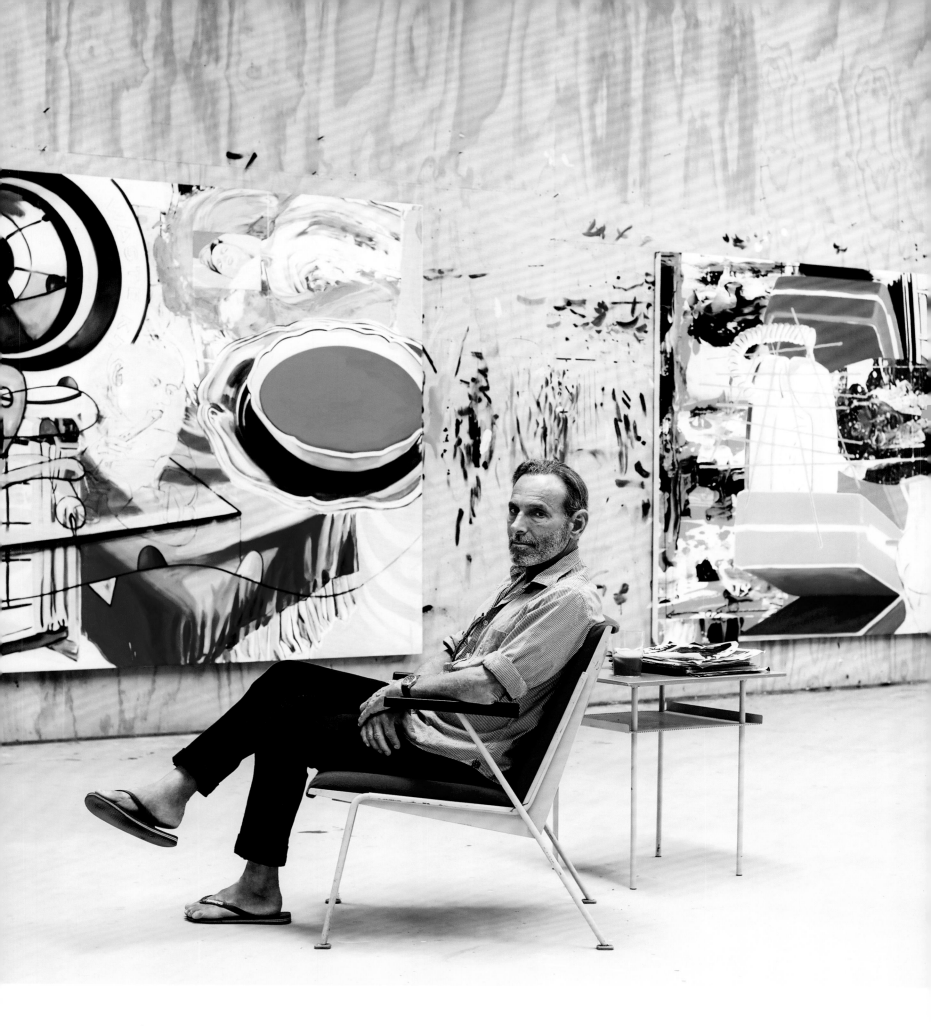

December 2015 | East Hampton, New York

HOMEOWNER David Salle

When Salle bought his four-acre getaway, its two antique barns and 1920s chicken coop had already been cobbled into a residence. "My goal was to preserve the home's character and charm while creating a unified campus for the house and new structures," said Salle, who added a garage, pool and poolhouse, gym, and painting studio, the last a stucco box shrouded in Boston ivy and paneled inside with dramatically figured plywood. "The house is there to support the studio. And the studio is perfect."

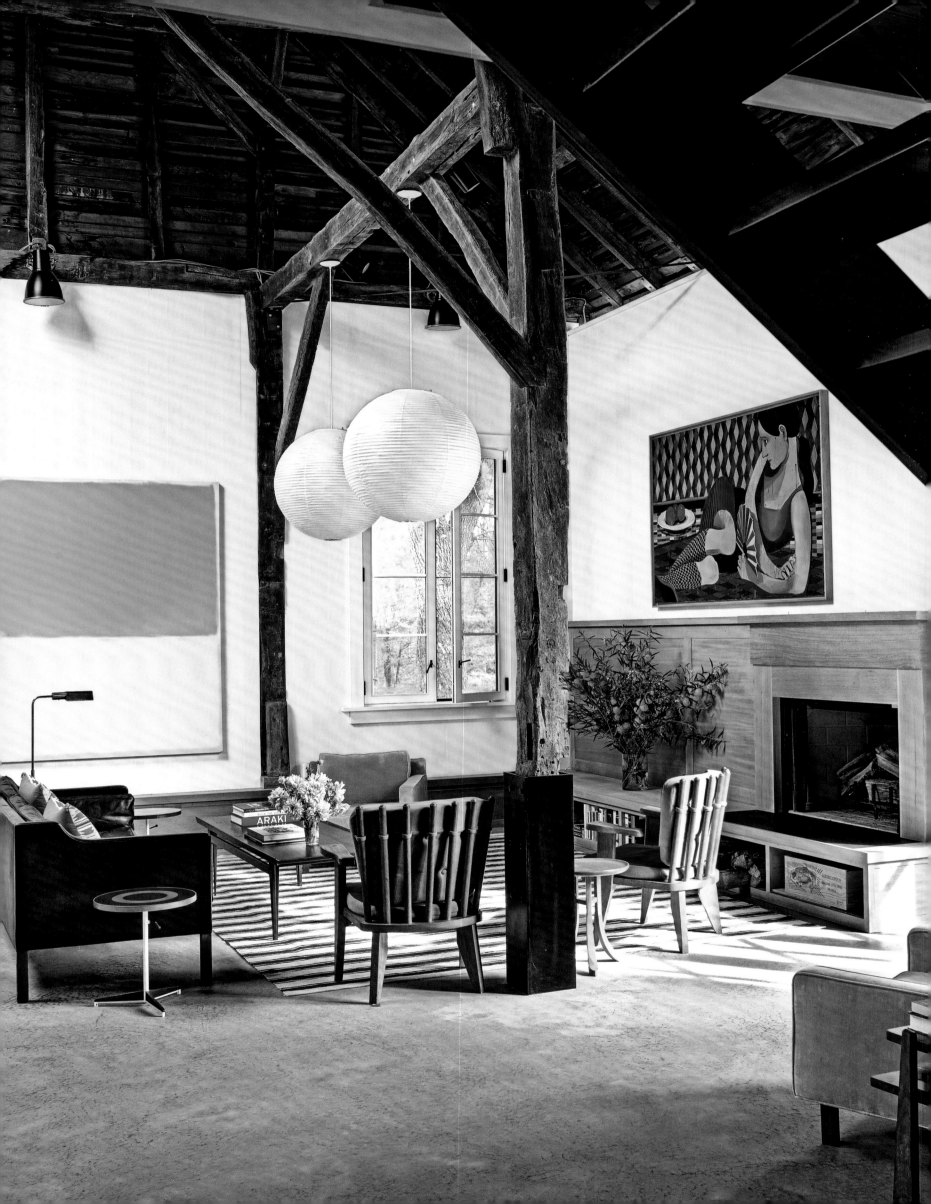

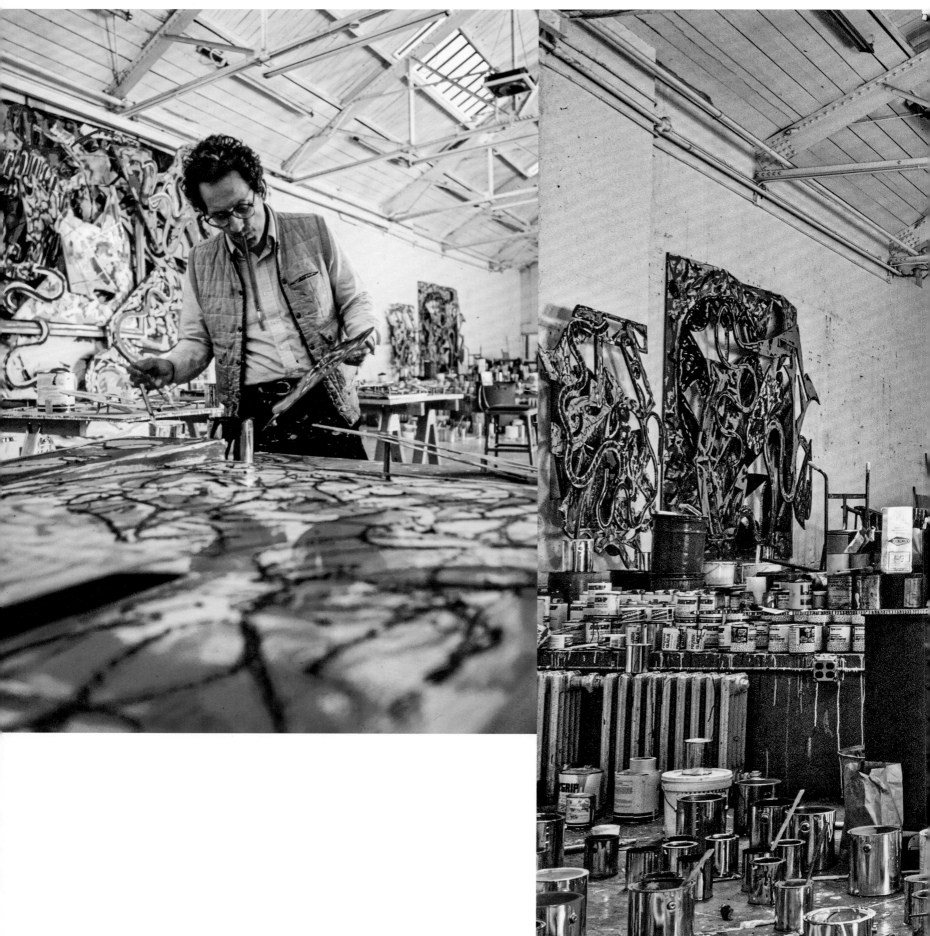

September 1983 | Manhattan

Frank Stella Studio

Amid the rows of sawhorse tables, paint cans, and oddly shaped remnants at his lower Manhattan studio—formerly stables—Stella created the relief sculptures that came to define his work in the 1980s. Assistants enlarged shapes from his drawings, while he painted and assembled maquettes, fabricating pieces and making radical changes as he went along. "I'm driven by anxiety," he said of his willingness to break away from past successes, "but not by doubt."

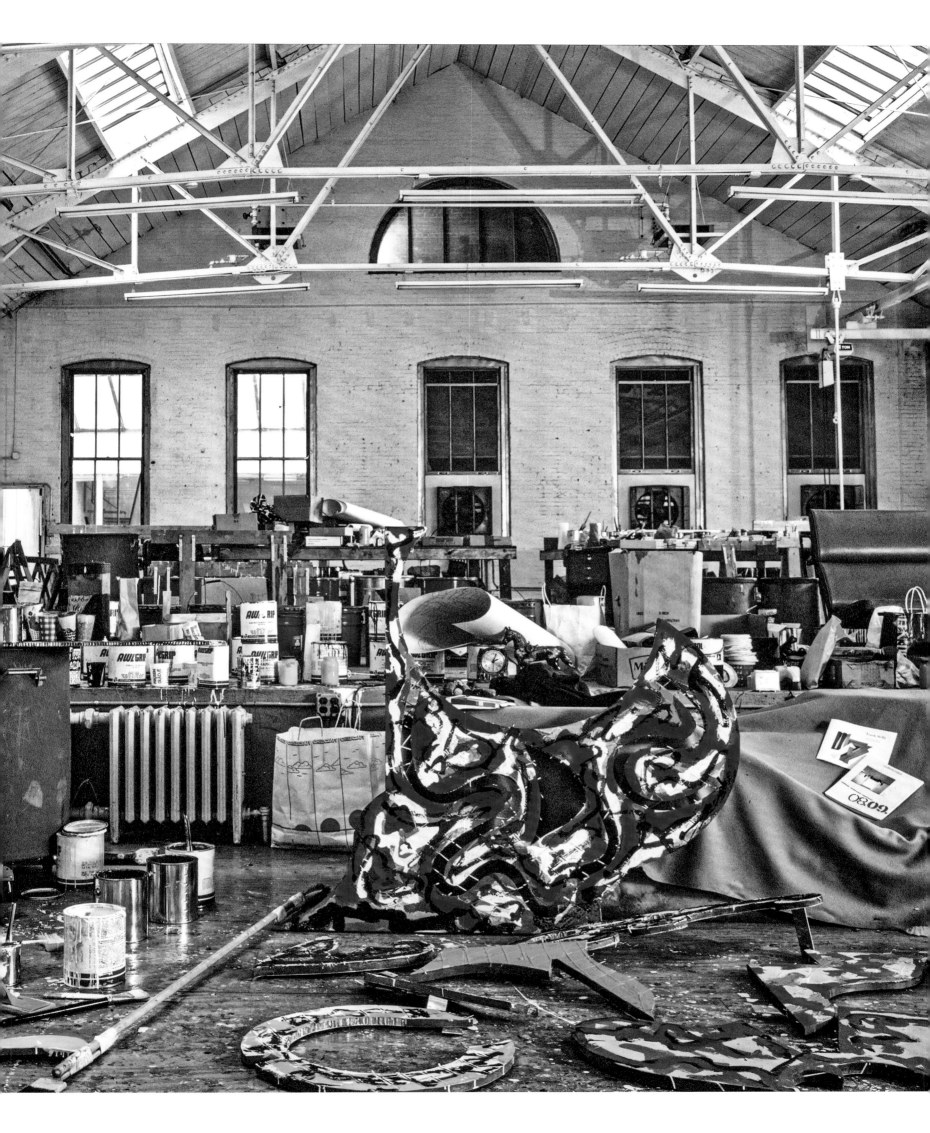

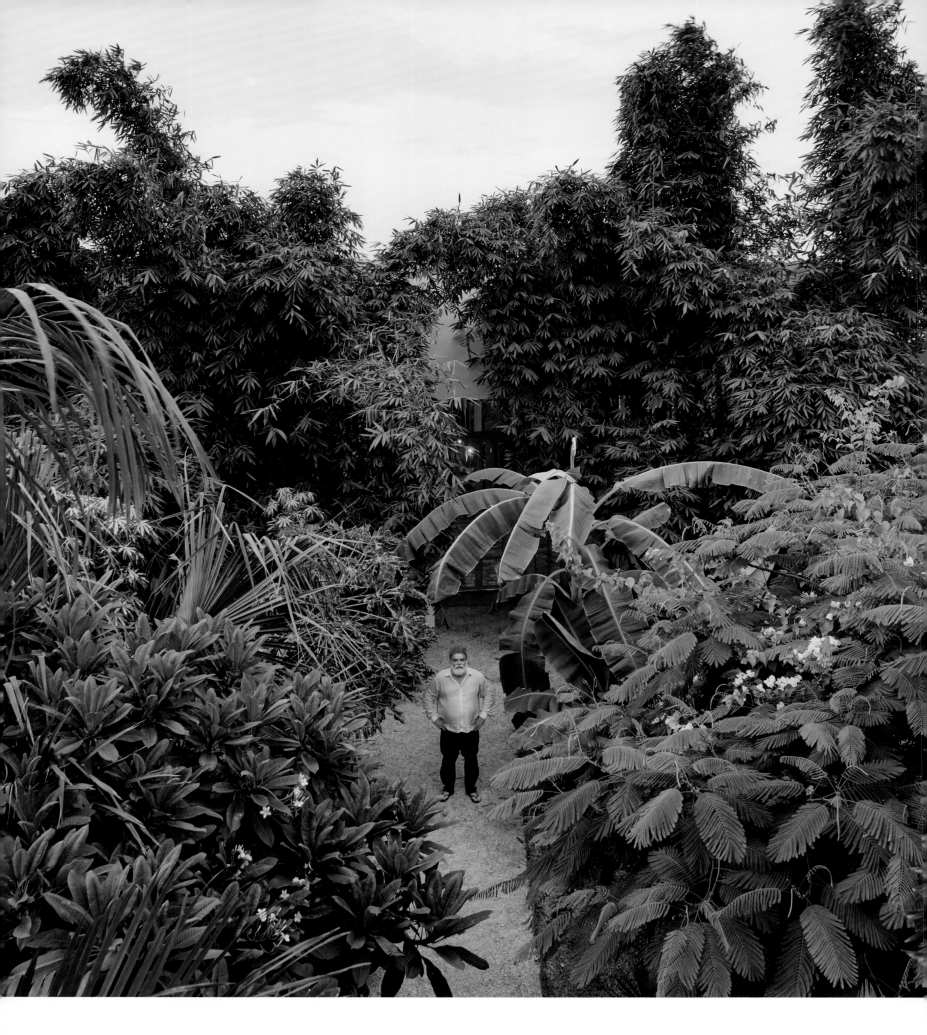

December 2018 | Mérida, Mexico

HOMEOWNER Jorge Pardo

"It's like a playground for me," Pardo said of his walled Yucatán oasis, a succession of structures—punctuated by lawns, trees, and a pool—that can be accessed either from outside or directly from the living area. "I wanted to make a place where you didn't 'go' to the garden, but you're in the garden." The buildings all bear his colorful stamp, from laser-cut lamps to ceramic tiles that transform floors into abstract paintings.

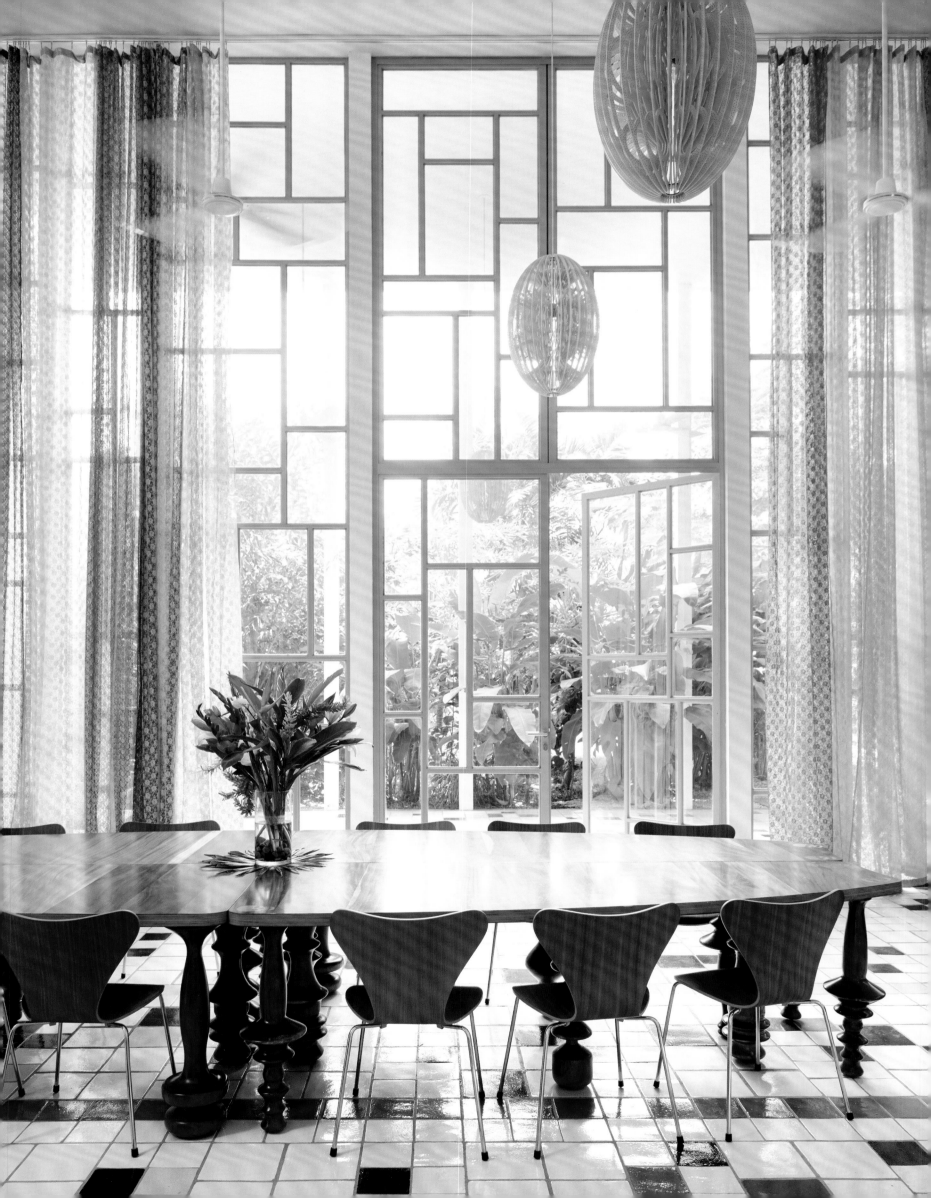

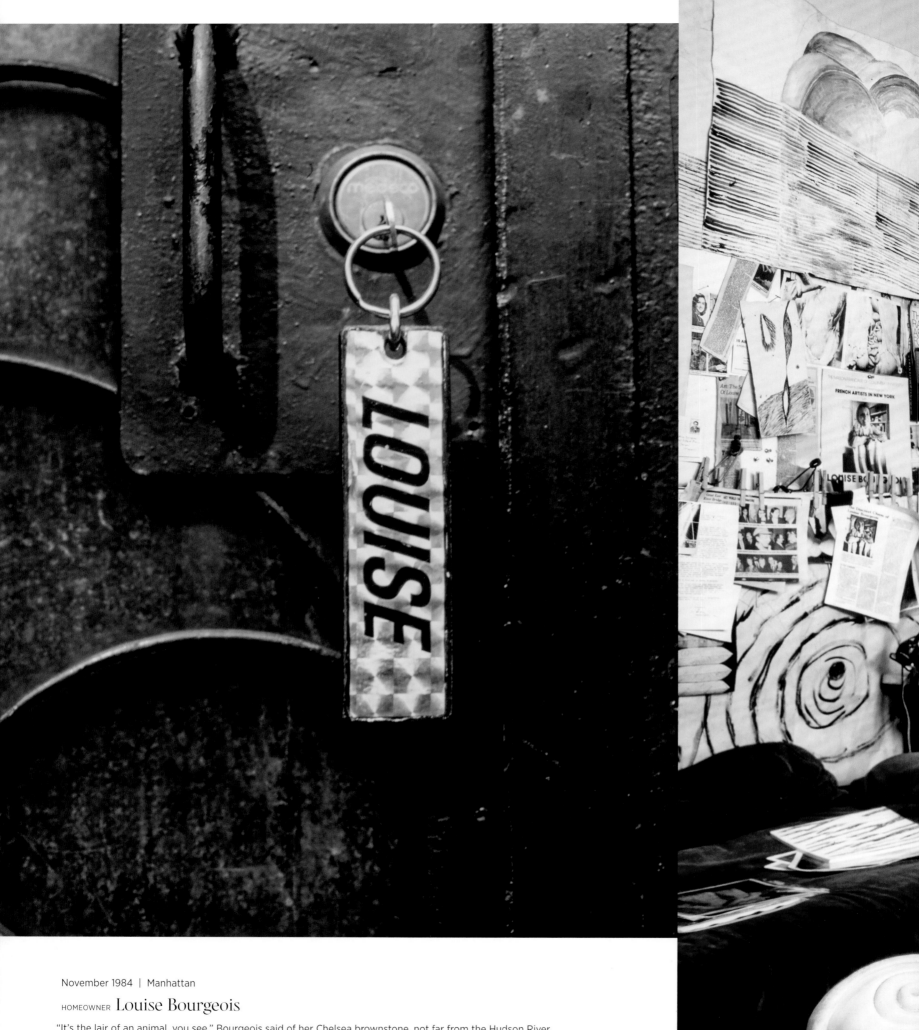

November 1984 | Manhattan

HOMEOWNER Louise Bourgeois

"It's the lair of an animal, you see," Bourgeois said of her Chelsea brownstone, not far from the Hudson River. The house had no living room, no dining room, the smallest hole of a kitchen, and few cozy touches—just works in progress everywhere. She described it as "my defense against the open road, the open world where you are likely to get pushed around. It is the center of my whole work."

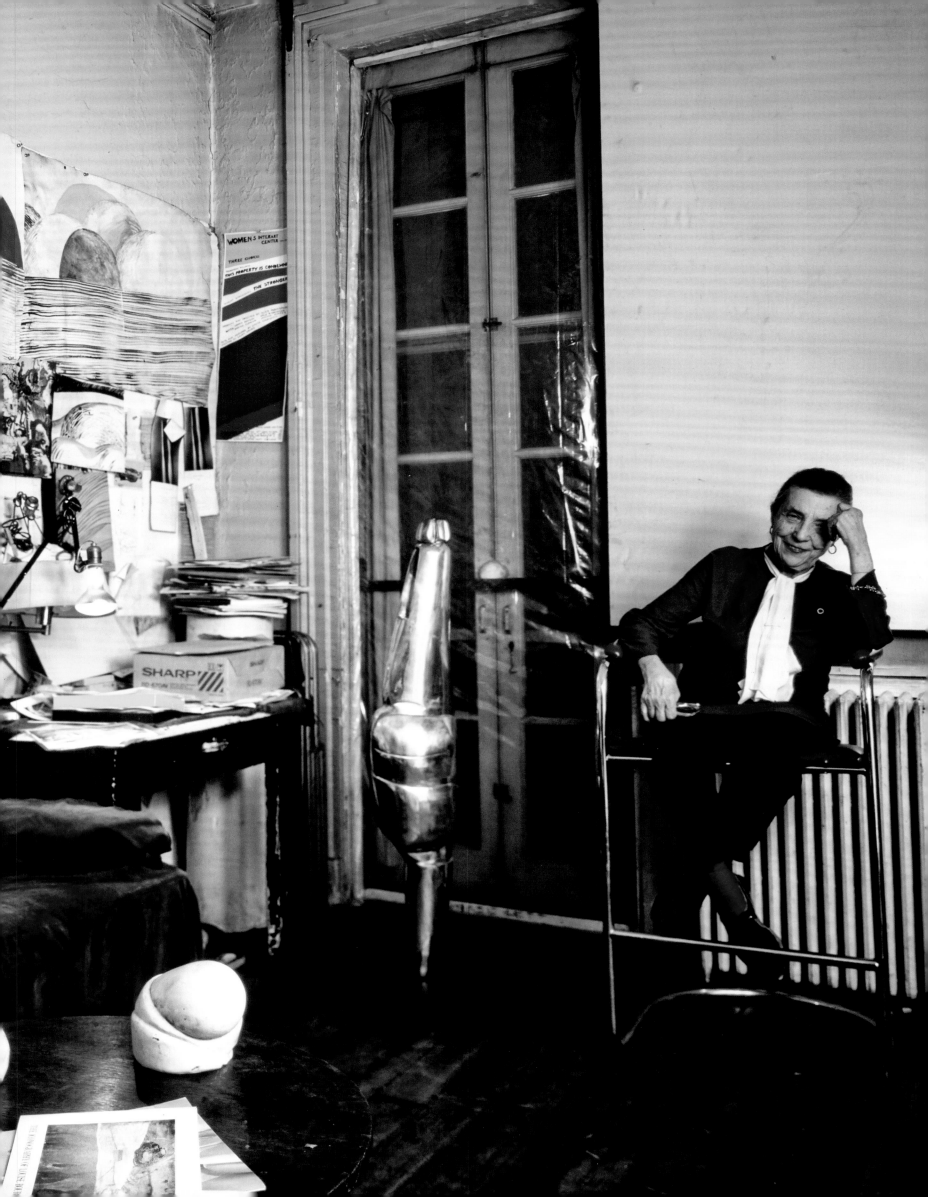

February 2017
Berlin

Katharina Grosse Studio

Photographed in
anticipation of her
2017 debut show with
Gagosian gallery, the
artist posed among
the foam stencils she
uses to make her vibrant
paintings. "Color is
very intimate," she said.
"It triggers your responses
right away. I also use
it to retrace my thought
structure, which is
what I think a painting
basically is."

McLean Quinlan
Amanda & Christopher Brooks
Marella Agnelli
Nacho Figueras & Delfina Blaquier
Gae Aulenti
Michael Graves
Jean Cocteau
Madeleine Castaing
Philip Johnson
Dennis Wedlick
Joy Sohn & Oberto Gili
Cecil Beaton
Sir Edwin Lutyens
Robert Couturier
Pierre Yovanovitch & Matthieu Cussac
Sister Parish

Country

Alison Spear & Alexander Reese
Babe & William S. Paley
Russell Page
Flore de Brantes &
Count Amaury de La Moussaye
Tigerman McCurry Architects
Toshiko Mori
Venturi, Rauch and Scott Brown
Gil Schafer
Deborah Nevins
Brooke & Julian Metcalfe
Pierre Bergé
Luis Barragán
Miranda Brooks
Studio Sofield
Renzo Mongiardino

COUNTRY LIVING is defined by what it lacks—hustle and bustle—as well as by what it offers, from acreage secluded enough to escape the madding crowd to a connection to Mother Nature. "It is in this tranquil setting that *Mr. Beaton* writes and paints and pursues his hobby of gardening," *Architectural Digest* observed on its 1969 jaunt across the pond to record *Cecil Beaton* at Reddish House in deepest, greenest Wiltshire. Amid rose-spattered chintzes, wine-color velvets, and armloads of deliciously scented flowers, the magazine continued, Beaton and his guests (*Greta Garbo, David Hockney*, and the like) slowed to a "complete change of pace."

For decades after it was founded in the Golden State, *AD*'s country coverage was largely limited to getaways in Southern California, where movie stars and business moguls romped in custom-made hameaux constructed in styles ranging from Spanish Colonial Revival mongrels to forward-thinking homes created by icons such as *Cliff May* and *J. E. Dolena.* French châteaux, Mexican haciendas, Montana cabins, and Austrian hunting lodges followed as the magazine's editorial vision broadened, ultimately leading, in 1985, to the release of its first country-house special edition. That popular annual salute encompasses out-of-the-way addresses where simpler, more laid-back lives are lived—even if the architecture, interiors, and gardens have been masterminded by those genres' innovators and provocateurs.

Architect *Gae Aulenti*'s villa in Italy's Emilian plain, designed for a Milanese lawyer in the 1970s,

is an exquisite case in point. Whitewashed fir trunks are deployed as a colonnade and repeated indoors as towering columns and hefty rafters, while the pool's sunbaked-brick surround seeps into the barnlike structure. Modernist aeries by *Olson Kundig, McLean Quinlan*, and *Studio Sofield* are designed to make the most of sweeping eagle's-eye views of their spectacular mountain settings. *Renzo Mongiardino*'s scheme for the *Mondadori* family's villa near Venice is a garden indoors and out, with flowers on the curtains as well as in the parterres.

AD's country-house coverage also celebrates bohemian aplomb, residences that handily fulfill sans-souci tenets of country style. "We threw out all the rules," American writer *Brooke Metcalfe* said of the vivacious rooms in her family's 17th-century Oxfordshire house. At Ireland's romantic Birr Castle, *Lord and Lady Oxmantown* spice up the Gothic Revival setting with objects reflecting her Chinese heritage. And in the Piedmont region of Italy, globe-trotting photographers *Oberto Gili* and *Joy Sohn* revel in their back-to-the-land life, right down to cocks crowing and bread baking. The movie-set mock-rusticity that *AD* fervently championed in the 1920s has given way a century later to earthy authenticity, where the knowing meets the naive in perfect harmony. ◣◗

September 2016
Chipping Norton,
Oxfordshire, England

HOMEOWNERS
Amanda & Christopher Brooks

"I resigned from my job, applied for a visa, rented out our Manhattan apartment, and found a school for the kids." So wrote Amanda Brooks, a Barneys New York executive turned Cotswolds shopkeeper, about relocating to her husband's family farm, where she introduced "some decorating modifications that respect the English aesthetic." Which means, in the living room, a reclaimed-wood table, fringed lampshades, a zesty stripe for the sofa, and a Louis XV gilt-wood mirror hung on raw plaster.

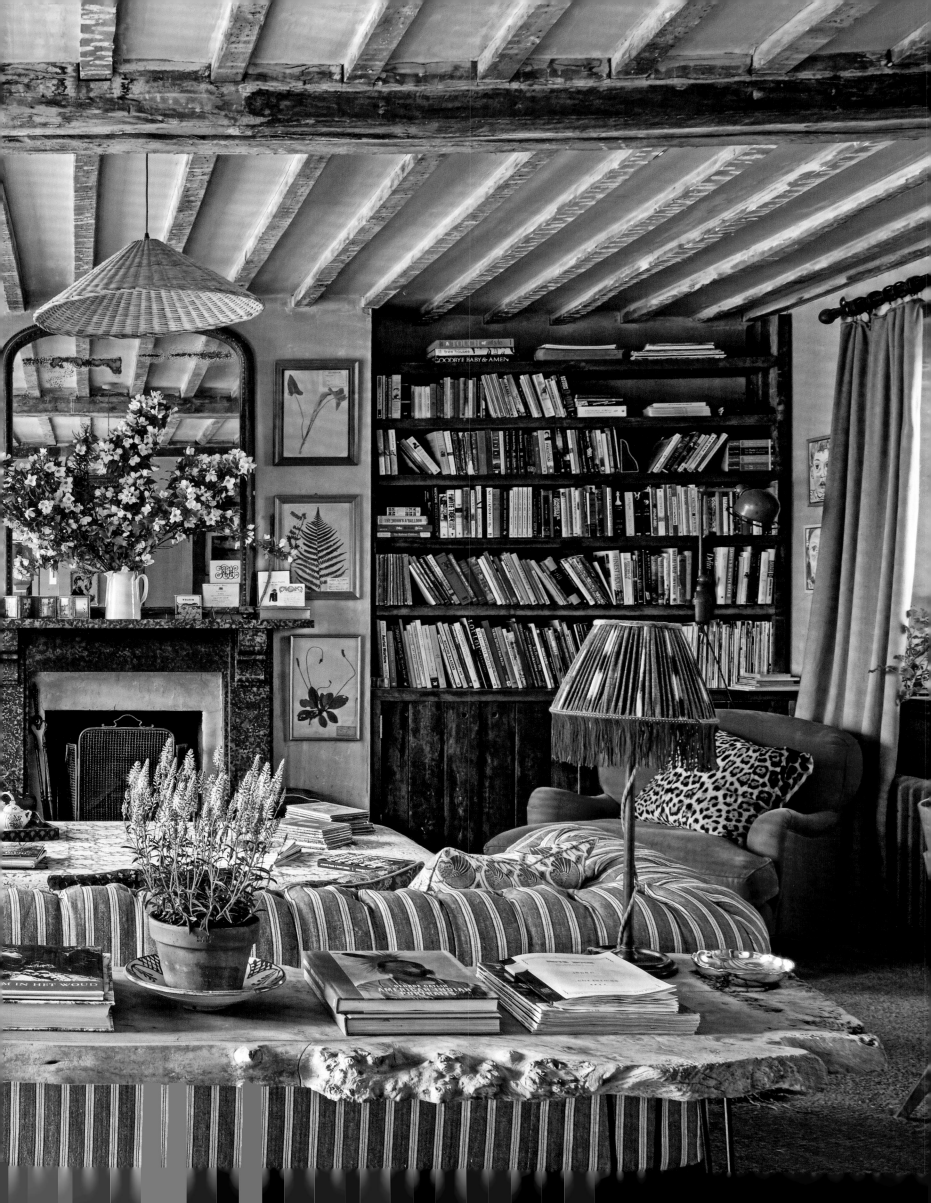

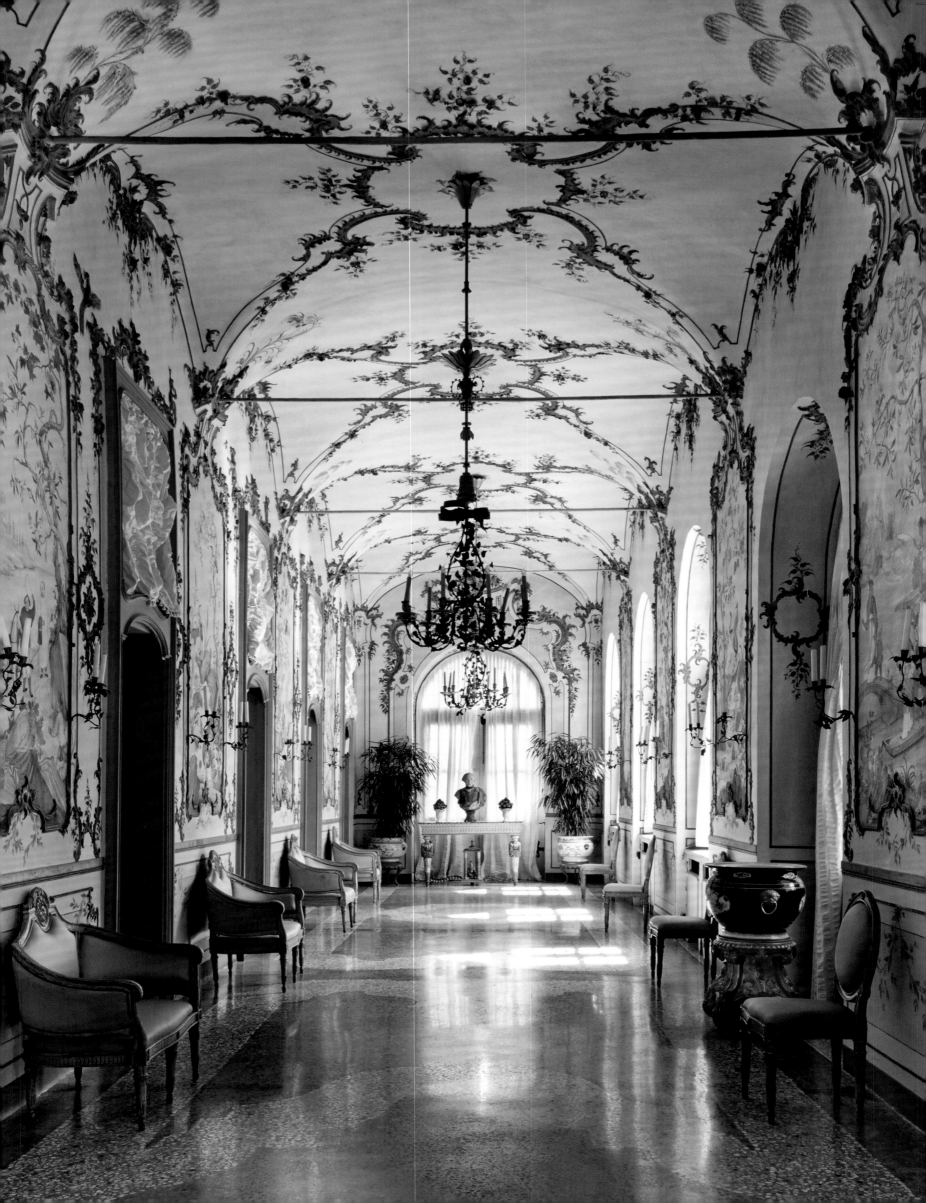

September 2014 | Villar Perosa, Italy

Villa Agnelli

"There was this sense of being in an enchanted time warp," Marella Agnelli, the Italian-American widow of Fiat chairman Gianni Agnelli, said of her first visit, in 1953, to her future husband's 18th-century family seat. She restored the Piedmontese Baroque chinoiserie gallery, where antique painted furniture of the region is arranged on an original terrazzo floor, with Stéphane Boudin, the Frenchman who also decorated the Kennedy White House.

November 2017 | South Cumbria, England

Levens Hall

"The art of persuasion" is what Richard Bagot, trimming an English yew, called the madcap pruning that has gone on at his and wife Naomi's ancestral home since the 1690s. Head gardener Chris Crowder, who oversees the fantasy acreage, noted, "I like tiered shapes that resemble cake stands, if you like, where a large disc is topped with a smaller disc and so on."

May 2017
General Rodríguez,
Argentina

HOMEOWNERS
Nacho
Figueras &
Delfina
Blaquier

"The staircase is like a
sculpture, and when you're
there you forget you're
anywhere else," the polo
star said of the concrete
pièce de résistance at his
horse farm outside Buenos
Aires. The monumental
stable, designed by archi-
tect Juan Ignacio Ramos
and housing 44 fleet steeds,
was inspired by the work
of Luis Barragán, Ludwig
Mies van der Rohe, and
Tadao Ando.

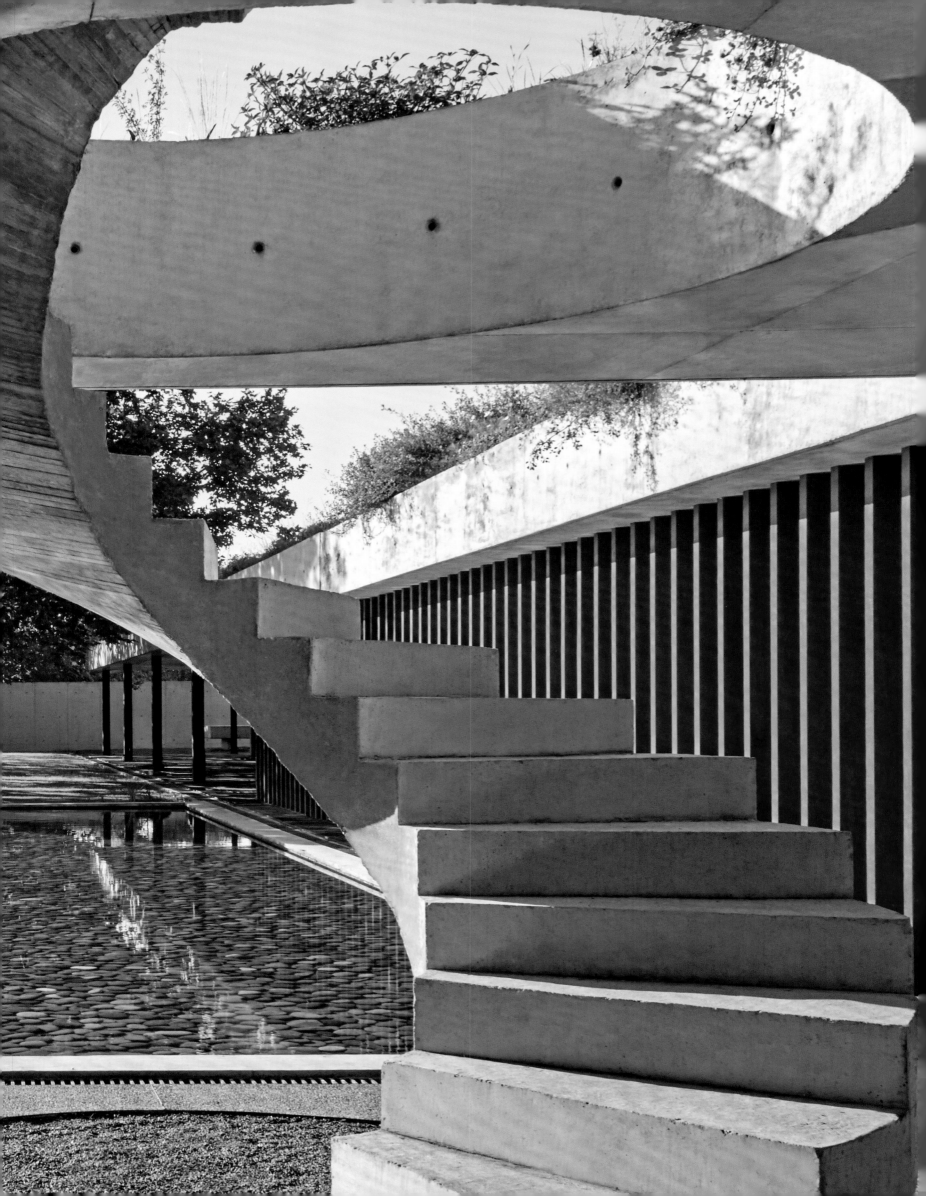

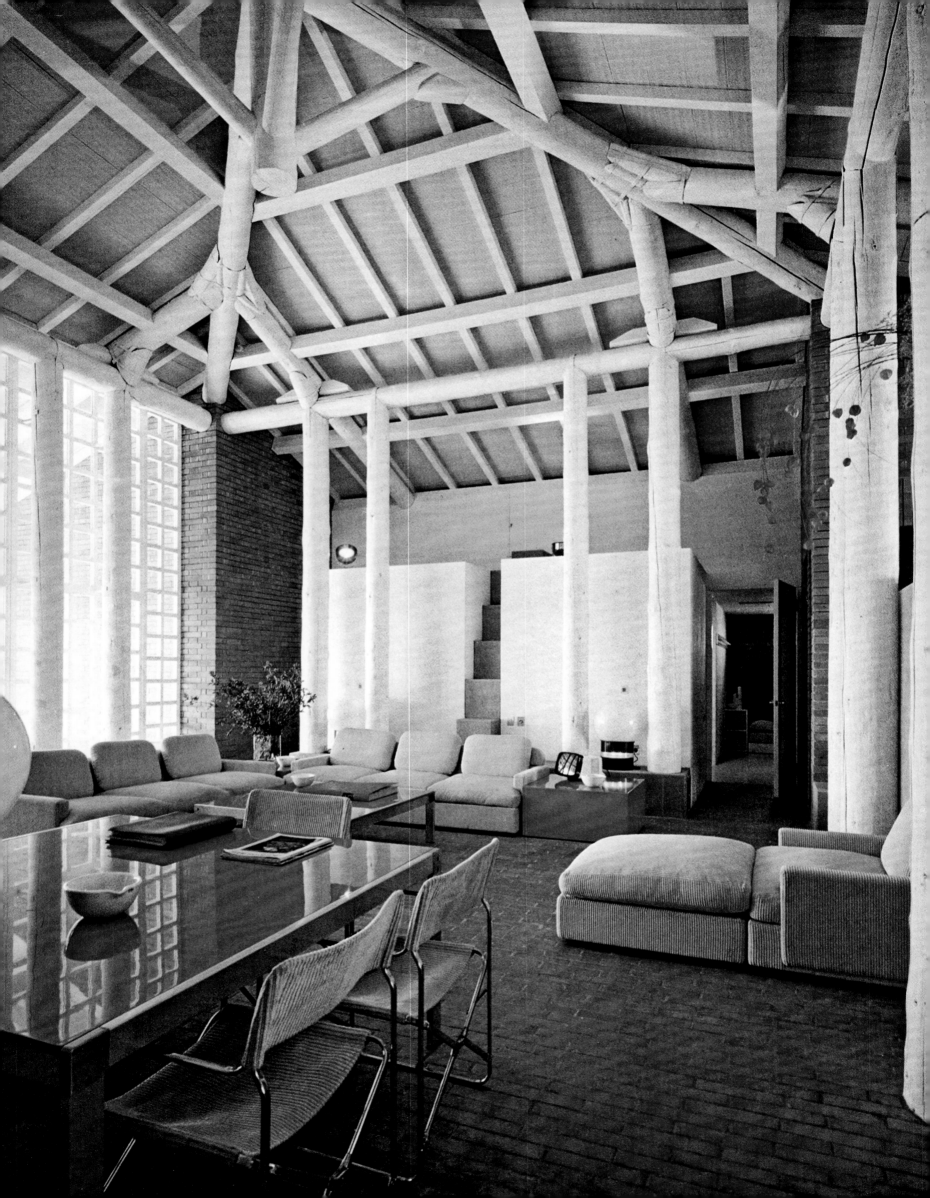

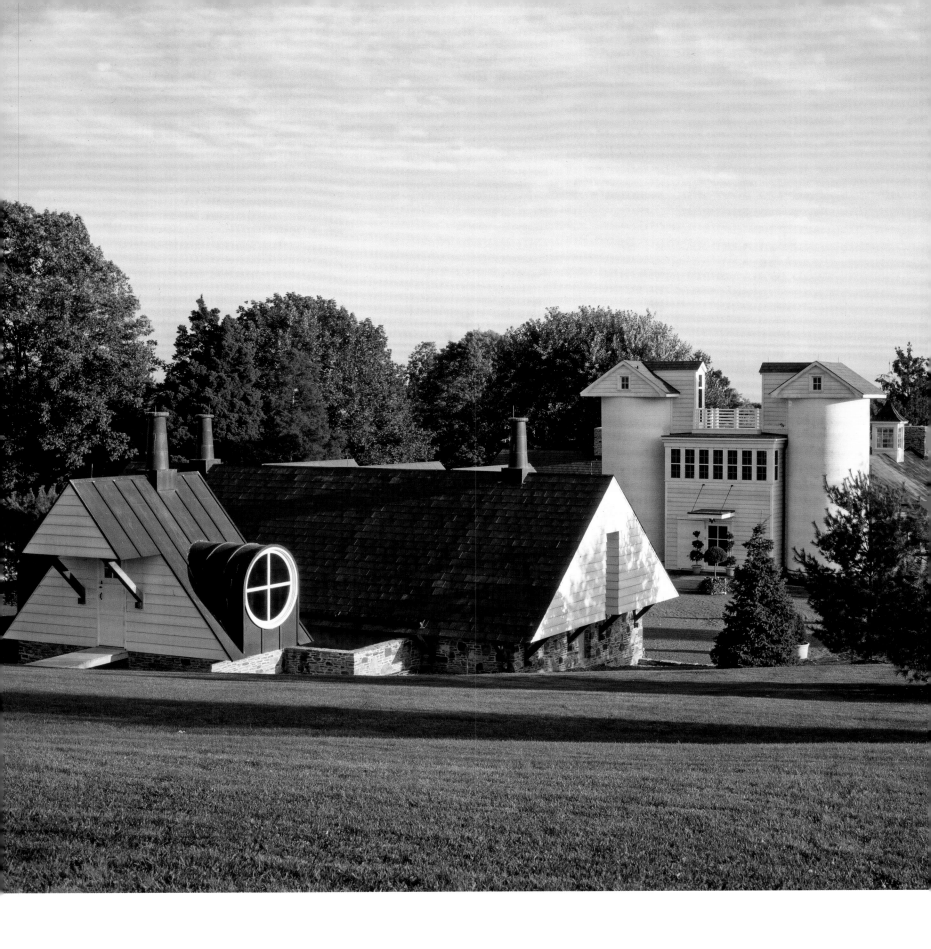

November/December 1975 | Emilia-Romagna, Italy

ARCHITECT Gae Aulenti

"I have been careful to use only the materials and methods of the farmhouses in the region," Aulenti said of this getaway for a Milanese lawyer, where whitewashed Austrian fir trunks articulate the lofty living room. "They all have structures like this. It's just that you don't see them," she continued. "What I have done is remove the ceiling and walls to show the frame."

May 1994 | New Jersey

ARCHITECT Michael Graves

Twin silos flank the new entrance to a rambling residence that was once a dairy barn, constructed in the 18th century and then added onto through the 1950s. Graves adapted one silo to contain the main staircase, while the other accommodates a powder room, bath, and tower bedroom.

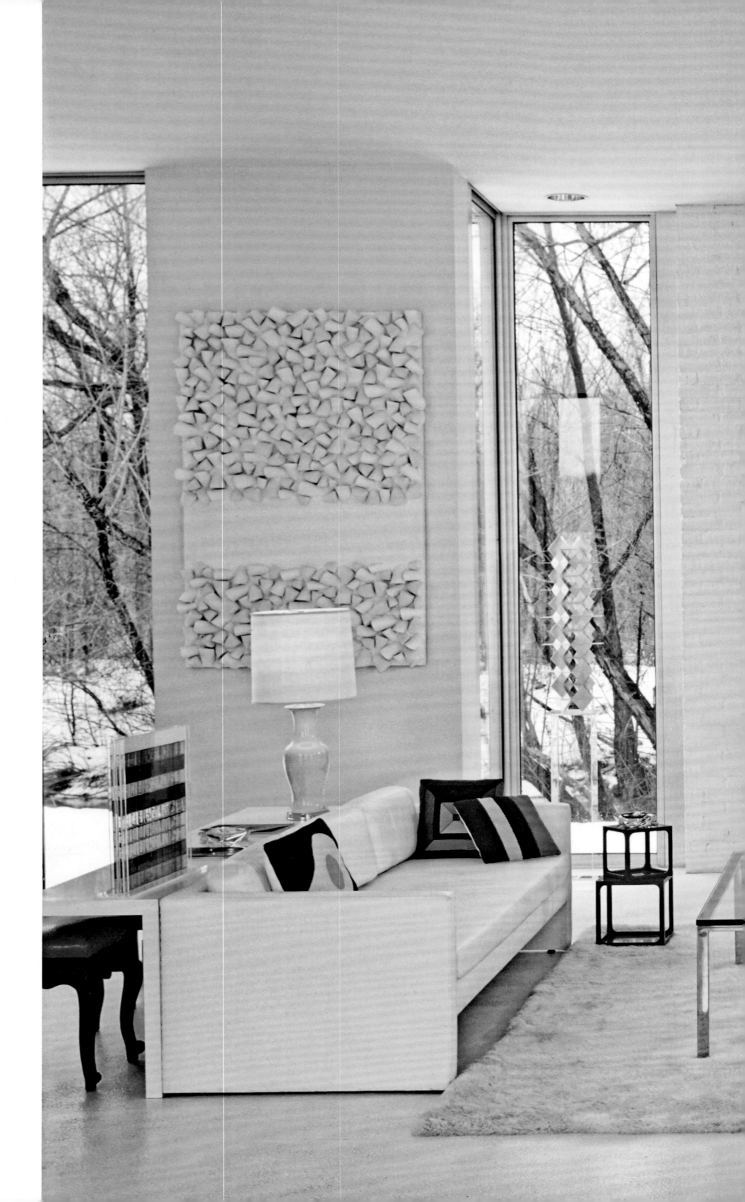

Summer 1969
Northbrook, Illinois

HOMEOWNER/DESIGNER
Richard Himmel

"The scale, the color scheme (or the lack of it), and the straightforward lines have proven … flattering to all, whether the occasion calls for slacks or black tie," *AD* noted of the house that interior designer Richard Himmel created for his young family. In the living room, "all the furnishings are geared for a see-through, no-color effect, so that the eye is drawn immediately to art objects," among them works by Charles Hinman, Andy Warhol, and Sergio de Camargo.

July 1983
Great Saling,
Essex, England

Saling Hall

"Paths are where paths
have to be: round
the edges and along the
length of the center,"
said the horticulturalist
and wine writer Hugh
Johnson of the walled
garden at his and his
wife, Judy's, country
house. He added clipped
cypresses, Irish junipers,
and dwarf box hedges
("looking to me rather
like green trains puffing
away into the distance")
to make an architectural
contrast with the "irre-
deemable informality
of the flowers." Apple
trees are part of the
scheme as well, trimmed
into parasol shapes.

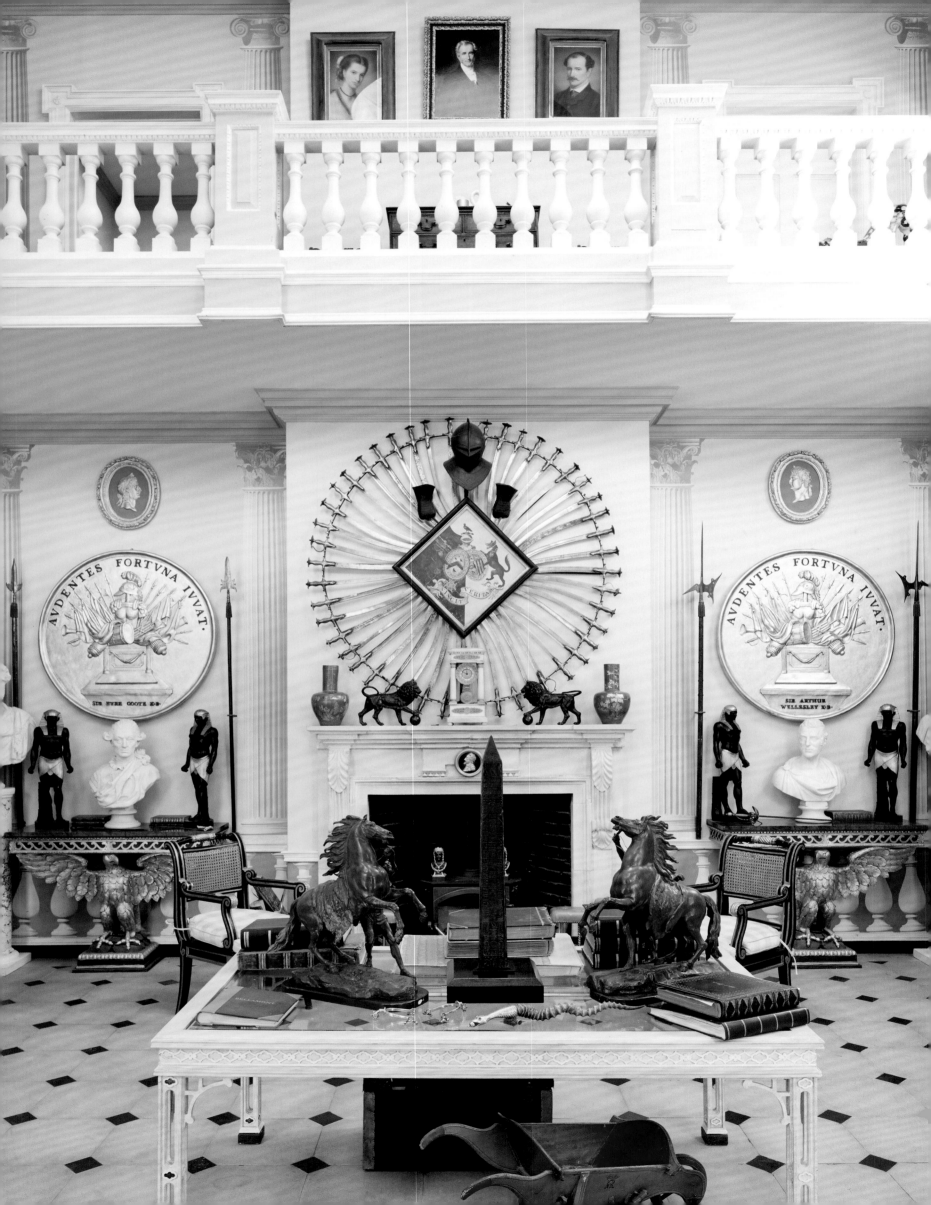

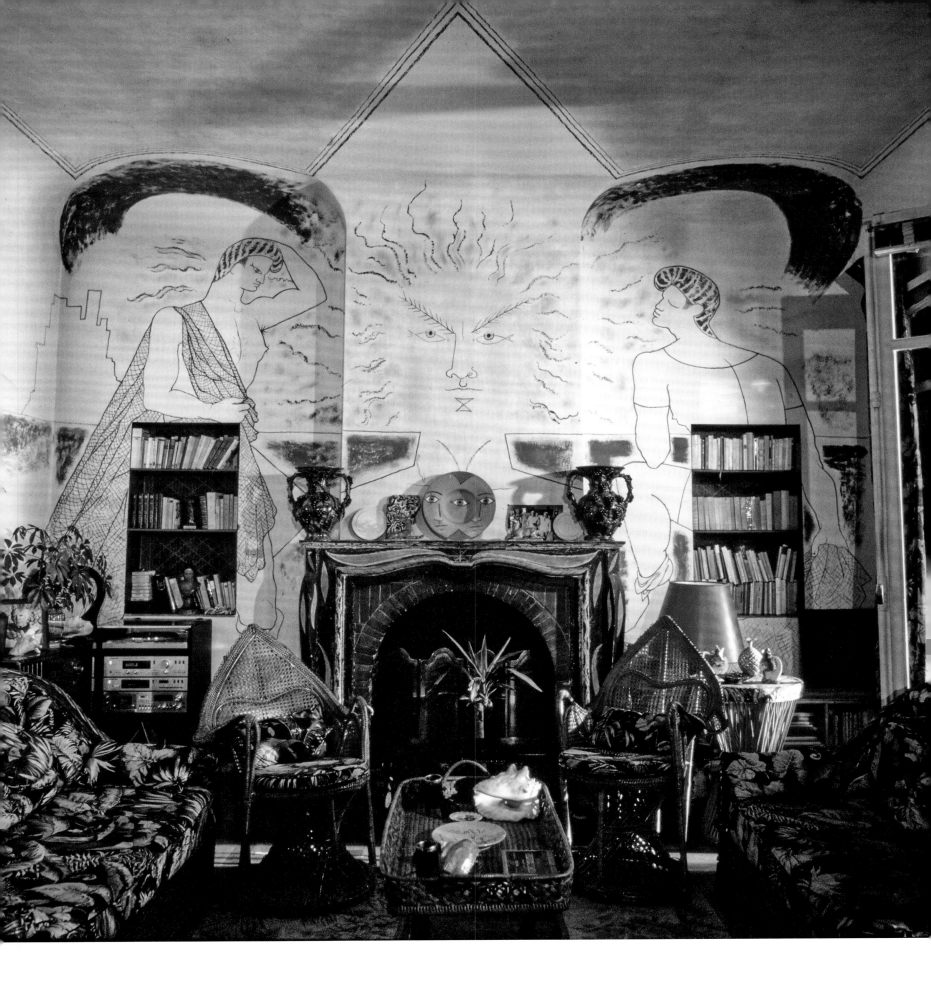

November 2016 | Long Bredy, Dorset, England

Bellamont House

A delightful 1990s sham-Gothic fantasia fashioned of concrete blocks—architect Anthony Jaggard designed the house with the owners, Harriet and Anthony Coote Sykes—Bellamont is a paradise of DIY trickery. Trompe-l'oeil wallpaper pilasters (Corinthian order below, Ionic order above) stripe the double-decker entrance hall with brilliant blues. Shimmering swords, snapped up on a trip to India, pinwheel above the mantel.

July 1983 | Saint-Jean-Cap-Ferrat, France

Villa Santo Sospir

"Eight days after he arrived, he asked permission to paint an Apollo above the fireplace," homeowner Francine Weisweiller said of Jean Cocteau, who first visited the socialite's Côte d'Azur getaway in 1950. She agreed—and before long every room had been mythologically frescoed. The wicker-rich decor was conceived in collaboration with Madeleine Castaing, the legendary Paris decorator.

June 2017
Oualidia, Morocco

Lagoon Lodge

"Here you have everything: earth, wind, water, sun," said Katrine Boorman of the house she and husband Danny Moynihan own in the Moroccan countryside. "There are very few places where all those things come together quite so perfectly." The pool, which overlooks a lagoon that is a pit stop for migratory birds, is the first "natural" one in the country. Water plants of various kinds grow in the trough that runs the length of the pool and clean the water organically.

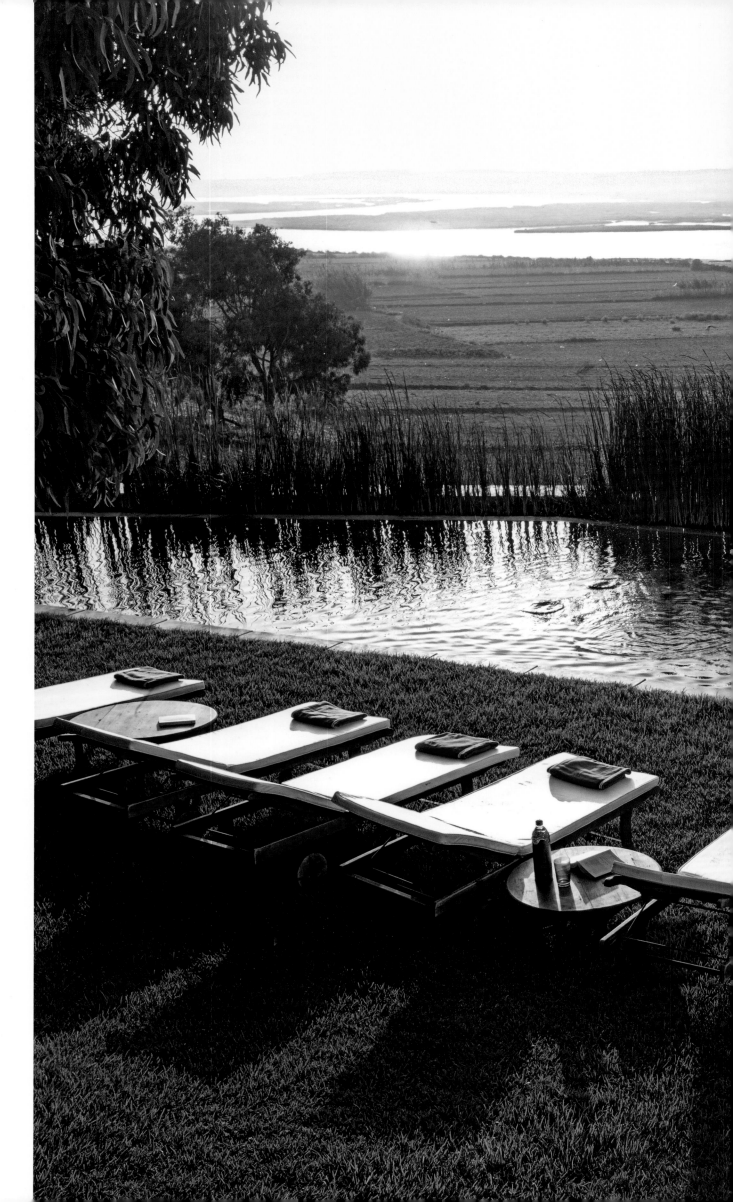

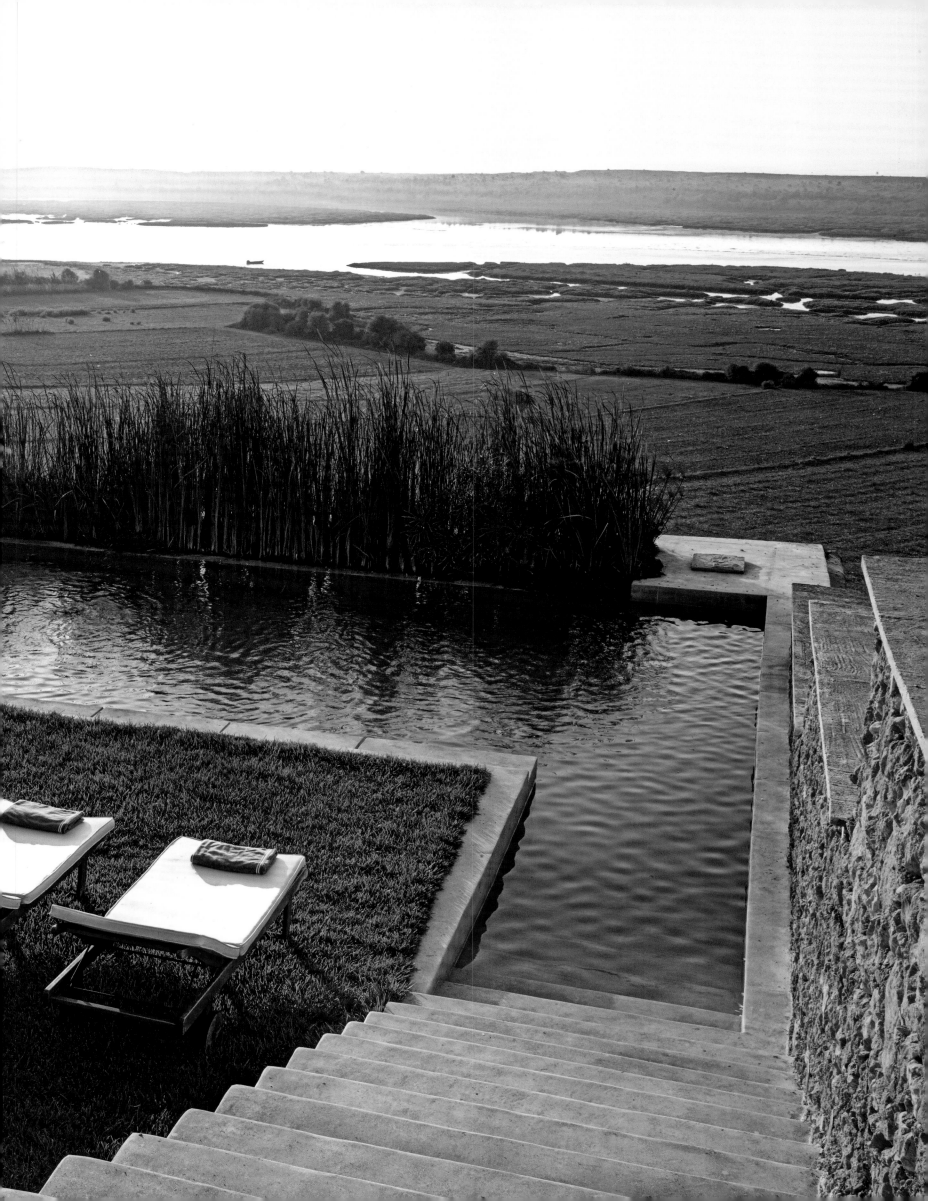

February 1998 | Irvington, New York

Oneto House
ARCHITECTS Philip Johnson, Dennis Wedlick

Wedlick's copper-clad additions to Johnson's 1951 structure were conceived to "look less like buildings than like objects or overgrown plantings," he explained. "That way the original house would be the only thing you read clearly as a piece of architecture." Impressed, Johnson declared: "It's a fascinating thing he's designed."

February 2017 | Bra, Italy

HOMEOWNERS Joy Sohn & Oberto Gili

"It's like living inside the garden," Sohn said of the farmhouse she and her photographer husband share. African mud cloth, Colombian molas, and Indian saris hang at the windows, drape chairs, and swathe beds, while floors are enlivened with Moroccan and Romanian carpets dyed rose-red, sky-blue, and leaf-green—joined in the master bedroom by Alida Morgan flower paintings and chandeliers aplenty.

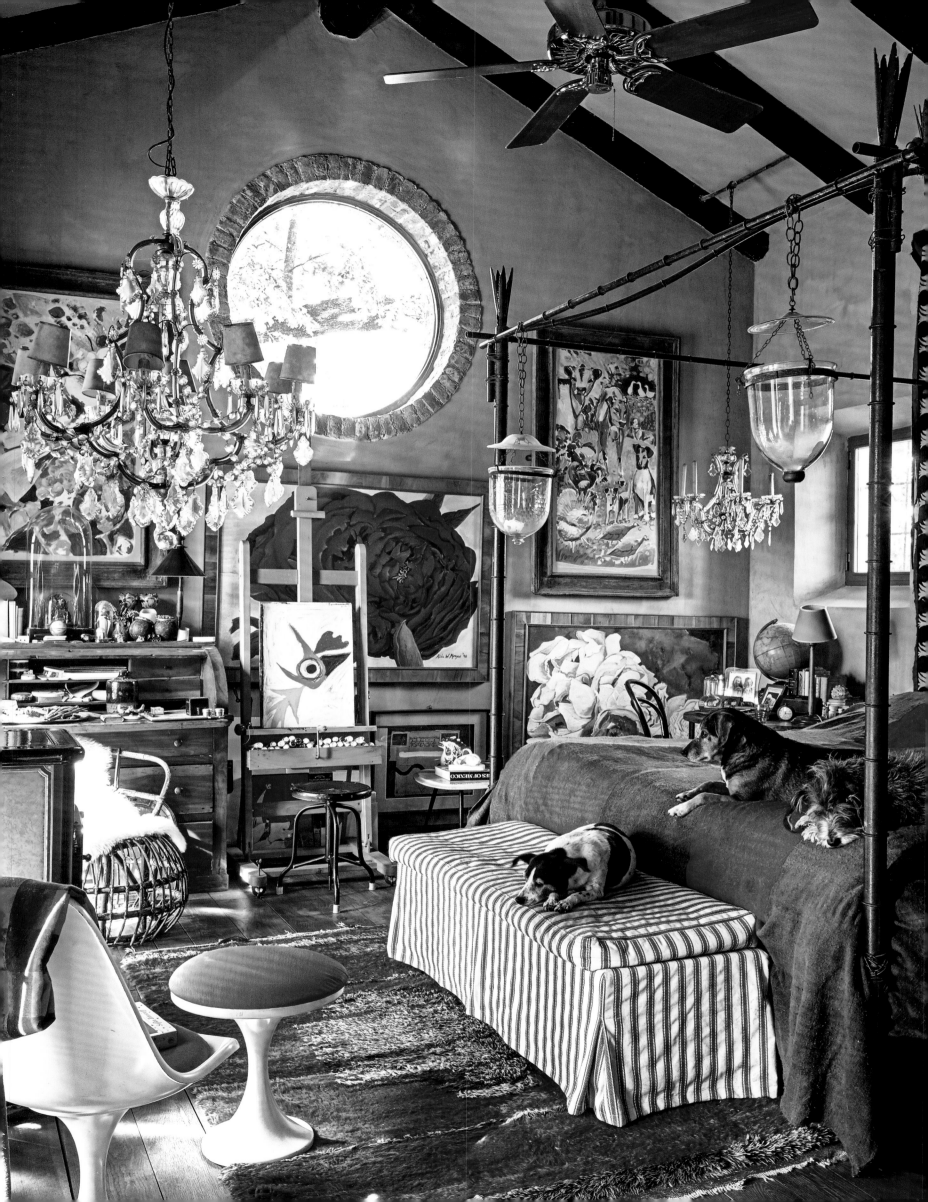

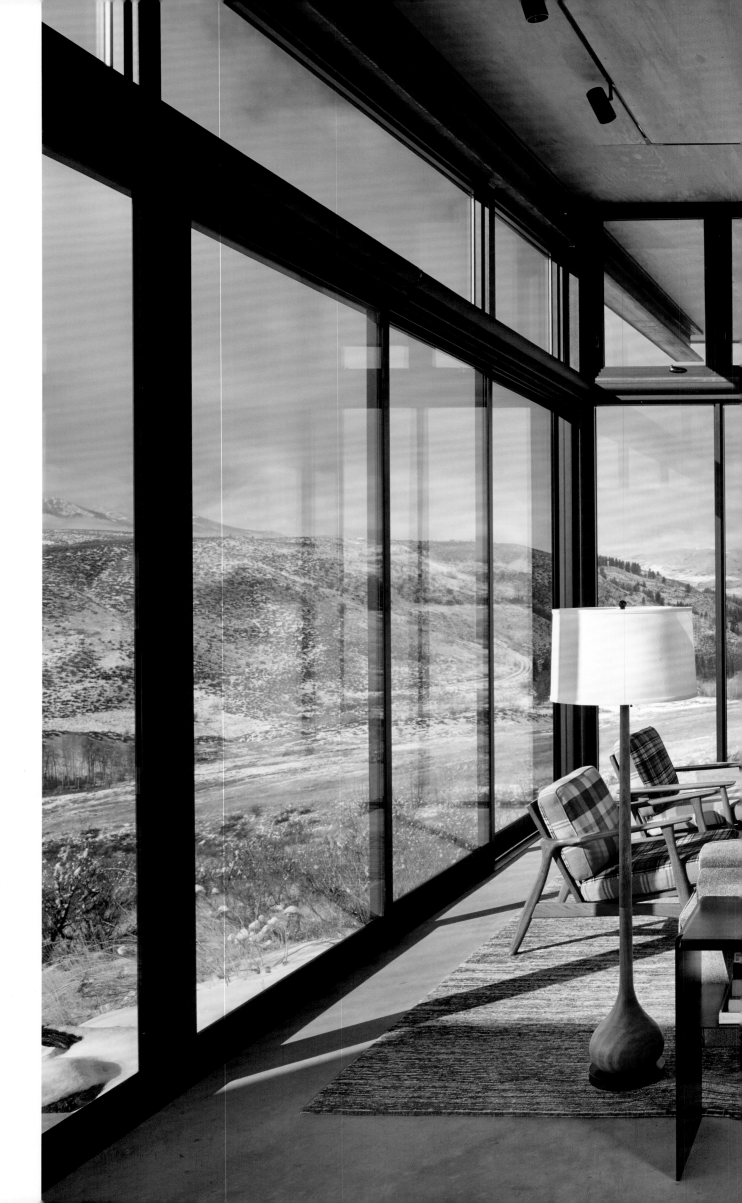

January 2015
Washington State

ARCHITECT
Olson Kundig

"We'd all rather be outdoors," digital-marketing CEO Shane Atchison said of his family (wife Tasha, children Keegan and Frances). That was the driving force behind the scattering of use-specific glass, steel, and wood structures—for sleeping, living, guests, and relaxing—that they commissioned for a 20-acre site in the Cascade Mountains. Sliding window walls open the pavilions to the land-scape, as well as to a courtyard that architect Tom Kundig compared to a campfire, a central feature where everyone gathers to talk at the end of a day spent hiking or skiing—and sometimes fall asleep on a chaise longue beneath the stars.

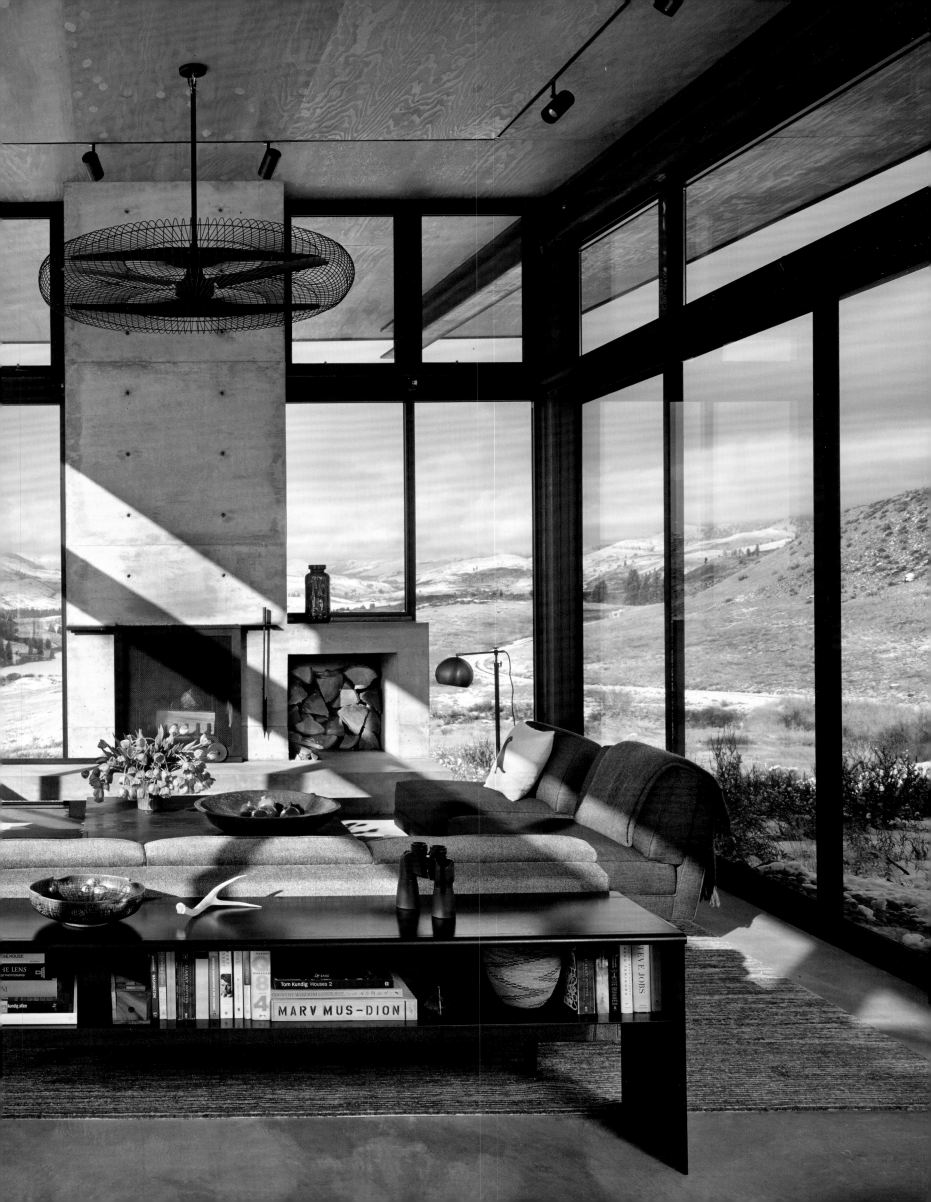

October 2014
Dijkerhoek,
The Netherlands

LANDSCAPE ARCHITECT
Ronald
van der Hilst

"I was listening to Mahler's
Sixth Symphony, which
has a strong rhythmic
structure, and I realized
that's what I wanted
to introduce into the gar-
den," the Belgian-based
van der Hilst recalled.
Achieving "different
moods and atmospheres,
from serenity to heavy
drama," meant reducing
the client's polychrome
floral displays and
emphasizing a cadenced
sequence of shrubs and
trees that "look beautiful
in every season," shaped
into totems and walls
or carved into rippling
waves. The crisscrossing
water feature references
the four heavenly rivers
in the Quran.

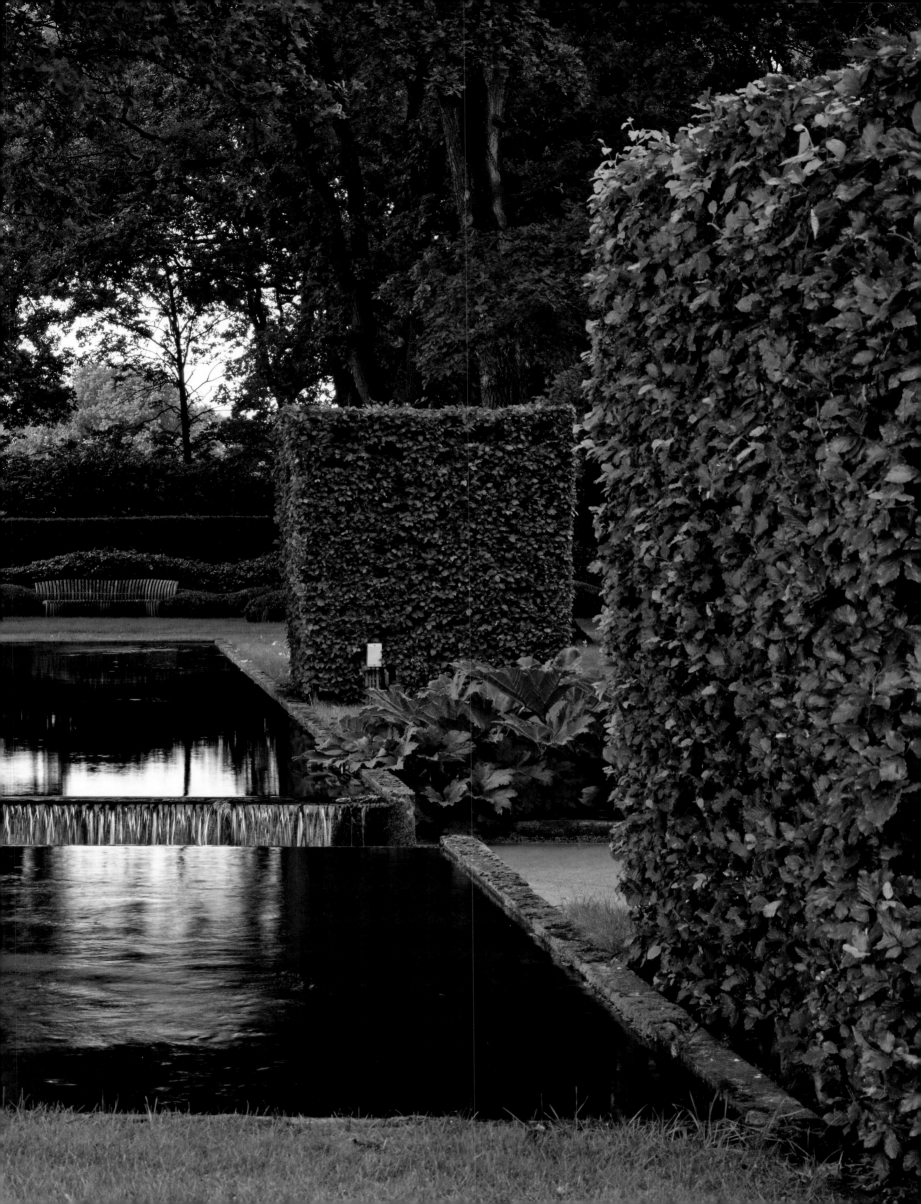

Winter 1969 | Broad Chalke, Wiltshire, England

Reddish House
HOMEOWNER Cecil Beaton

In 1955, the photographer and set designer added—with the help of decorator Felix Harbord—a Gothic Revival winter garden to his English Baroque retreat. Accented with split-cane moldings that traced the bamboo-paneled walls, the stone-floored space was a paradise of flowering plants and lacy vines twining up ropes that reached to the ceiling.

September 2011 | Stockbridge, Hampshire, England

Marshcourt ARCHITECT Sir Edwin Lutyens
DESIGNER Robert Couturier

An Ingo Maurer light fixture ripples above the library of the 1904 Lutyens masterwork. "We live in the 21st century," said Couturier, who refreshed the residence for new owners. "It's a classic country house looking into the future."

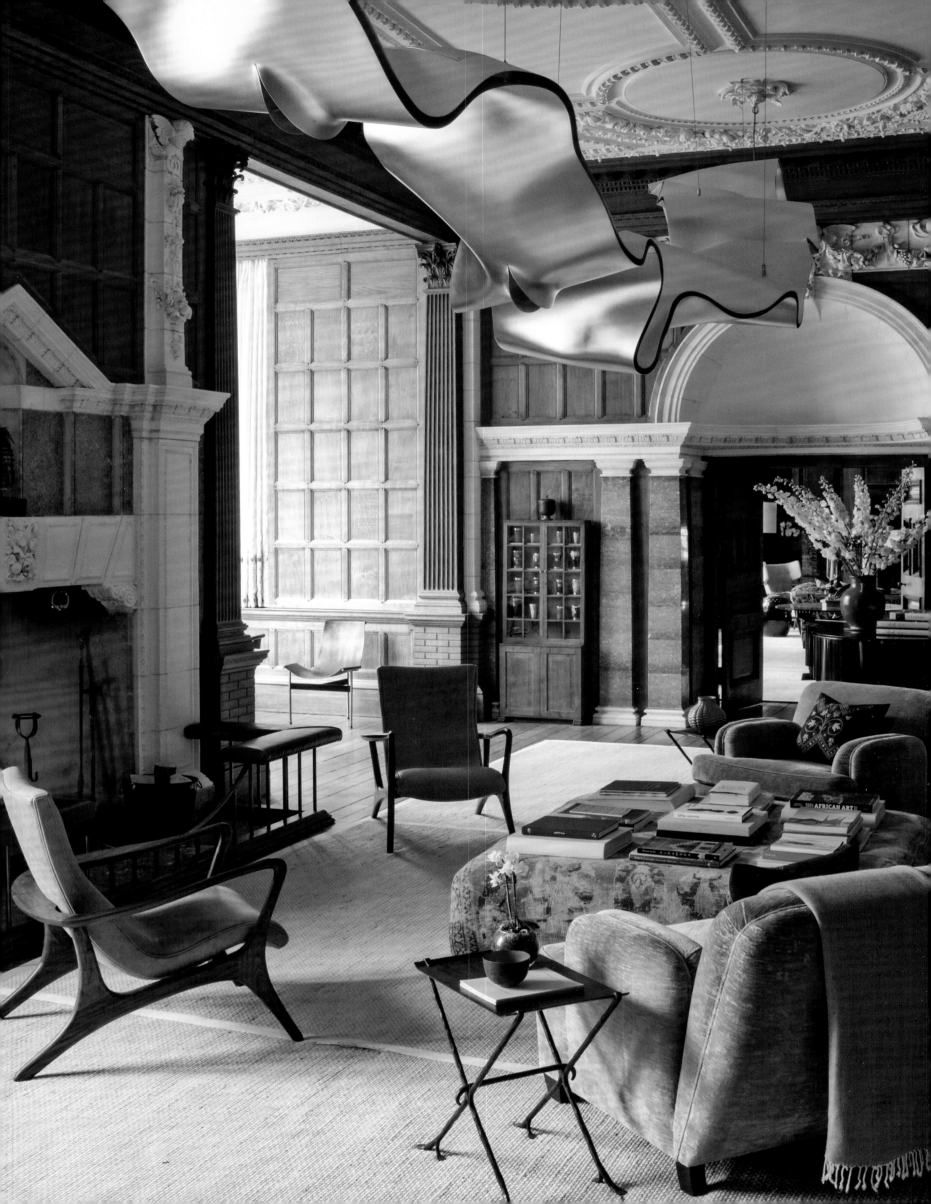

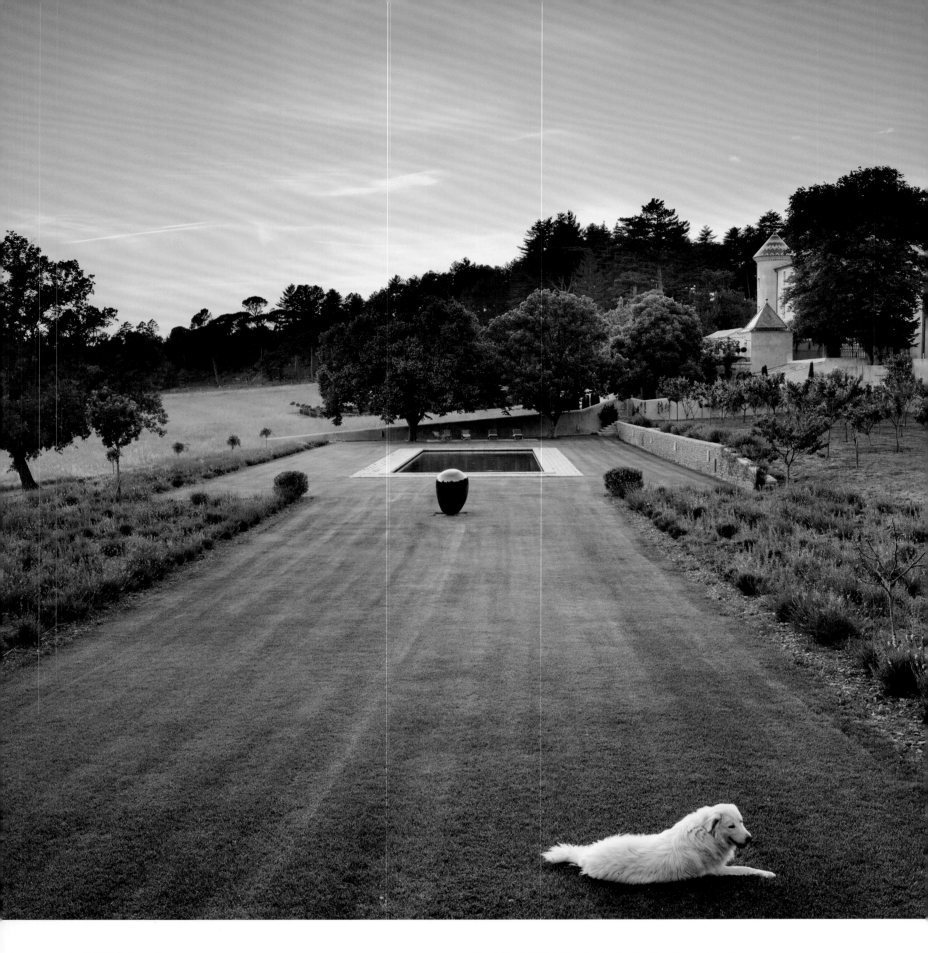

April 2018 | Aups, France

Château de Fabrègues

HOMEOWNER/DESIGNER Pierre Yovanovitch

LANDSCAPE ARCHITECT Louis Benech

"We bought a ruin with no path, no garden, nothing," interior architect Pierre Yovanovitch said of his and his husband, Matthieu Cussac's, home in the French countryside. "It was very romantic, full of pine trees and shadow—a fairy tale, but very dark, I must say." Today, thanks to garden guru Louis Benech, the land tells a more cheerful story. Kim, a Maremma sheepdog, reclines between beds packed with Mediterranean plants; an ovoid sculpture by Not Vital is set near the swimming pool.

March/April 1974 | Manchester-by-the-Sea, Massachusetts

ARCHITECT H. Page Cross

DESIGNER Sister Parish

In a Bermuda-style house that was created for Catherine and Thomas Jefferson Coolidge—a descendant of the third president—in the 1950s, Parish decorated the dining room in coral and cream, using painted faux-bamboo furniture that recalls Georgian originals. Circles add subtle rhythm, from the chair backs to the tabletop to the folding screen to the mantel's frieze, the latter's motif magnified for the trelliswork doors.

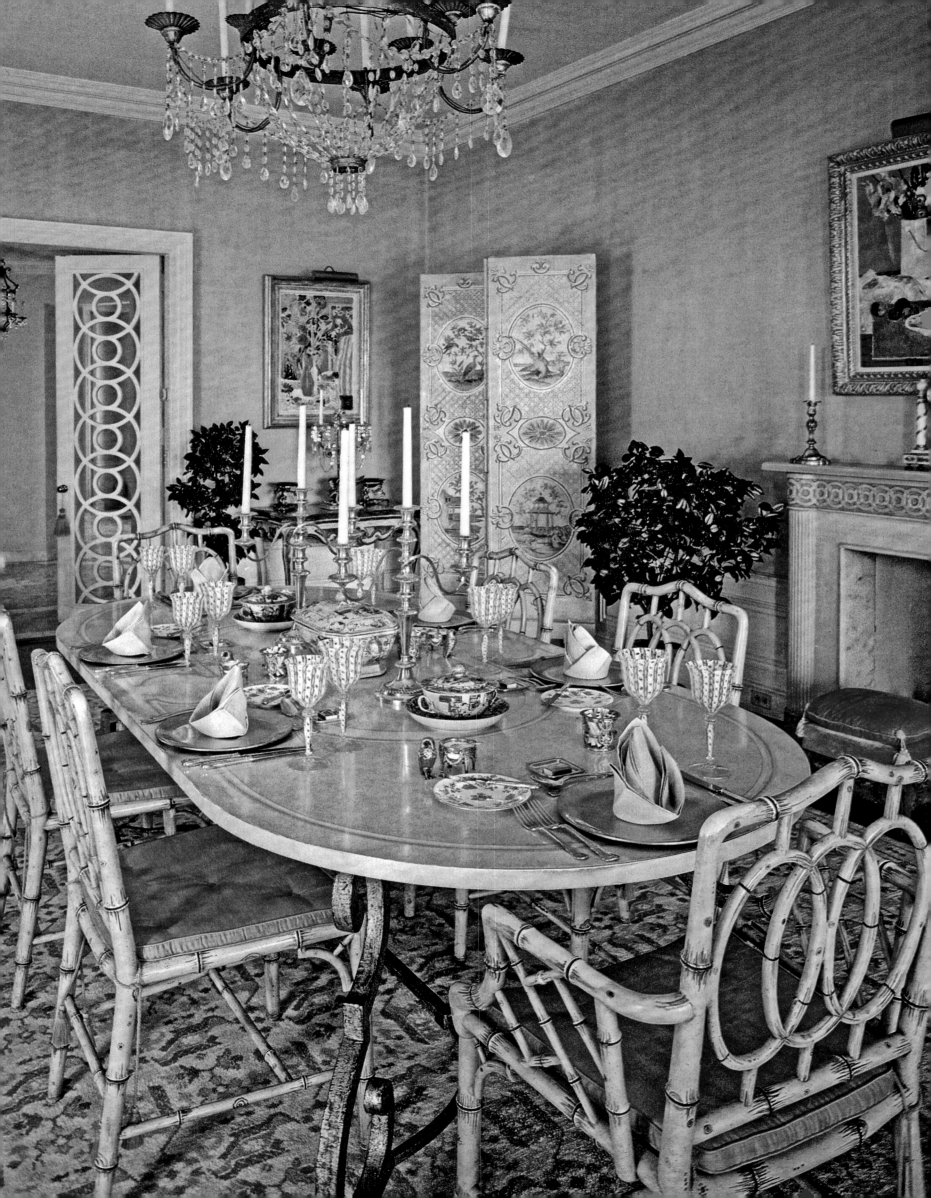

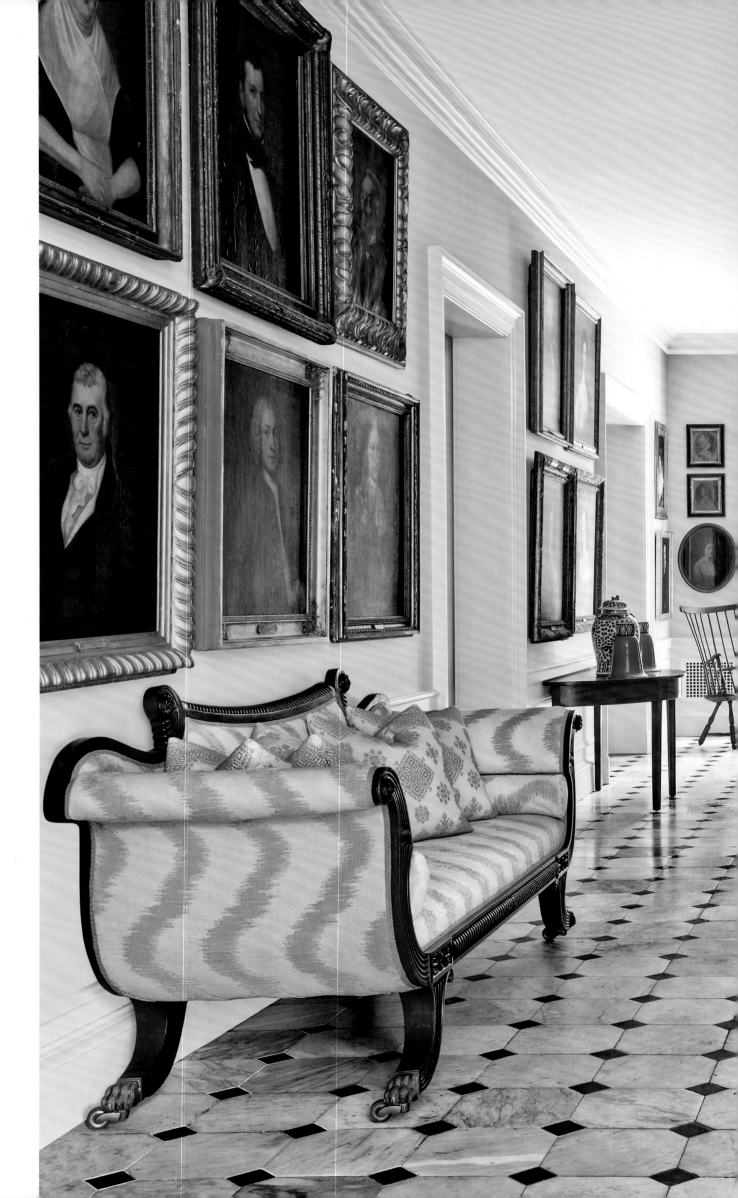

June 2013
Dutchess County,
New York

Obercreek

HOMEOWNERS
Alison Spear & Alexander Reese

Not long after their 2007 marriage, architect Alison Spear gathered her farmer husband's ancestral portraits, some dating to the 1600s, to display en masse in the entrance hall of their Hudson Valley residence. The dramatic result immerses visitors in a virtual family tree. Heirlooms, such as the 19th-century settees, have been updated with jazzy fabrics, and over-stuffed rooms have been clarified. "I come from a long line of pack rats," Reese admitted, "and I fervently want to kick the habit."

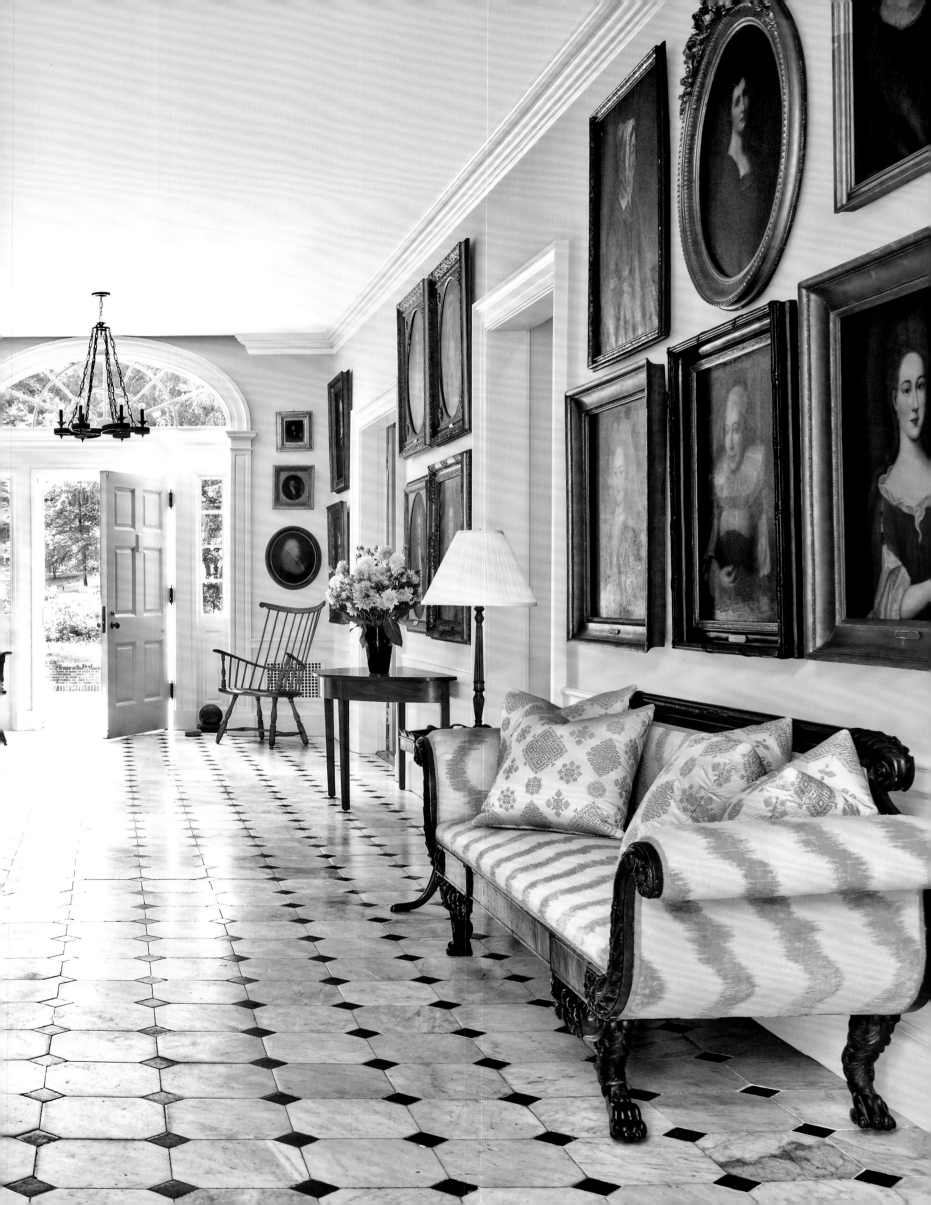

November/December 1975 | Manhasset, New York

Kiluna Farm
HOMEOWNERS Babe & William S. Paley
LANDSCAPE ARCHITECT Russell Page

Taking the gardens of her Long Island estate from pleasant to remarkable, style icon Babe Paley—working with the celebrated Page—created a dell centered on a circular pond that is fringed with white dogwoods, Japanese and Knap Hill azaleas, rhododendrons, and mountain laurel. More than 20 ground covers soften the transition between cultivation and wilderness, including violets and wild strawberries. "And I'm trying creeping thyme this year," she said.

October 2016 | Authon, France

Château du Fresne
HOMEOWNERS Flore de Brantes &
Count Amaury de La Moussaye

"With a château, there's always a project," said Brantes, a Franco-American gallerist who grew up at the 1770 manse that has belonged to her family since 1805. There are vegetables to be planted, forests to be harvested, dahlias to be cultivated, and interiors to be maintained. New slates now cover the roof, she said with a laugh, "so it doesn't rain inside anymore." Metal palm-tree lamps from the 1950s, among Brantes's funky recent additions, stand in the billiard room, where they flank an early-19th-century ancestral painting. Uzo, the family's cocker spaniel, rests on a velvet banquette.

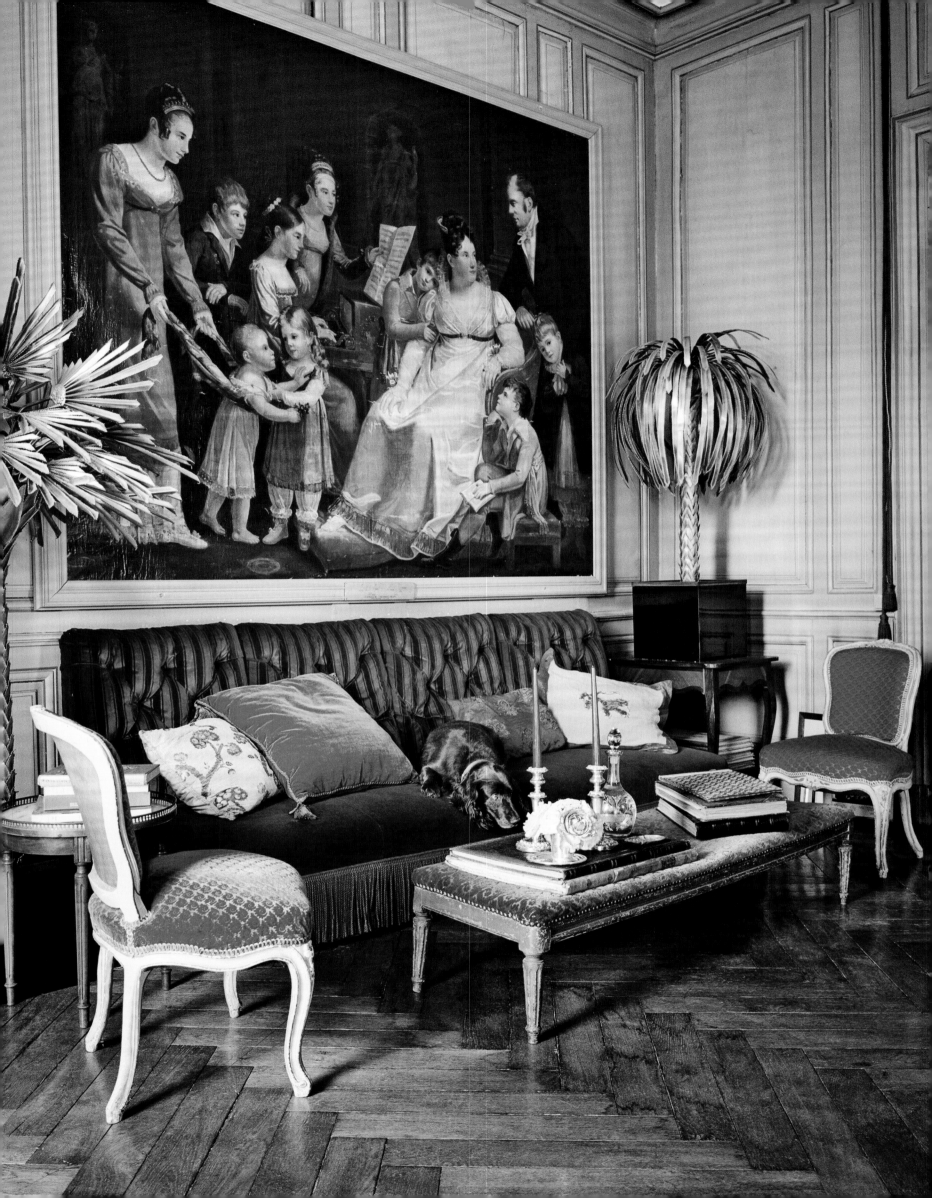

June 2009
Michigan

ARCHITECT
Tigerman McCurry Architects

Margaret McCurry wrapped a family's new country place with white-painted corrugated metal that takes its cue from grain silos and corncribs—and occasionally makes an impact indoors, too. "I was striving for a sense of place," she explained. "It's a lot about my client's Indiana childhood. It's a root thing. There's a purity that resulted: You can almost just look at it and smell the fresh-cut grass and feel the heat of summer."

June 2016
Ghent, New York

ARCHITECT
Toshiko Mori
Architect

"It's an anti-McMansion statement," said media executive Bob Greenberg of the discreet four-pavilion residence that Mori designed for him and his artist wife, Corvova Lee. Connected by raised concrete walkways, the small glass structures were planned for specific purposes, from cooking to exercising. Said the architect, "It's about living in the moment and appreciating the specific space one occupies."

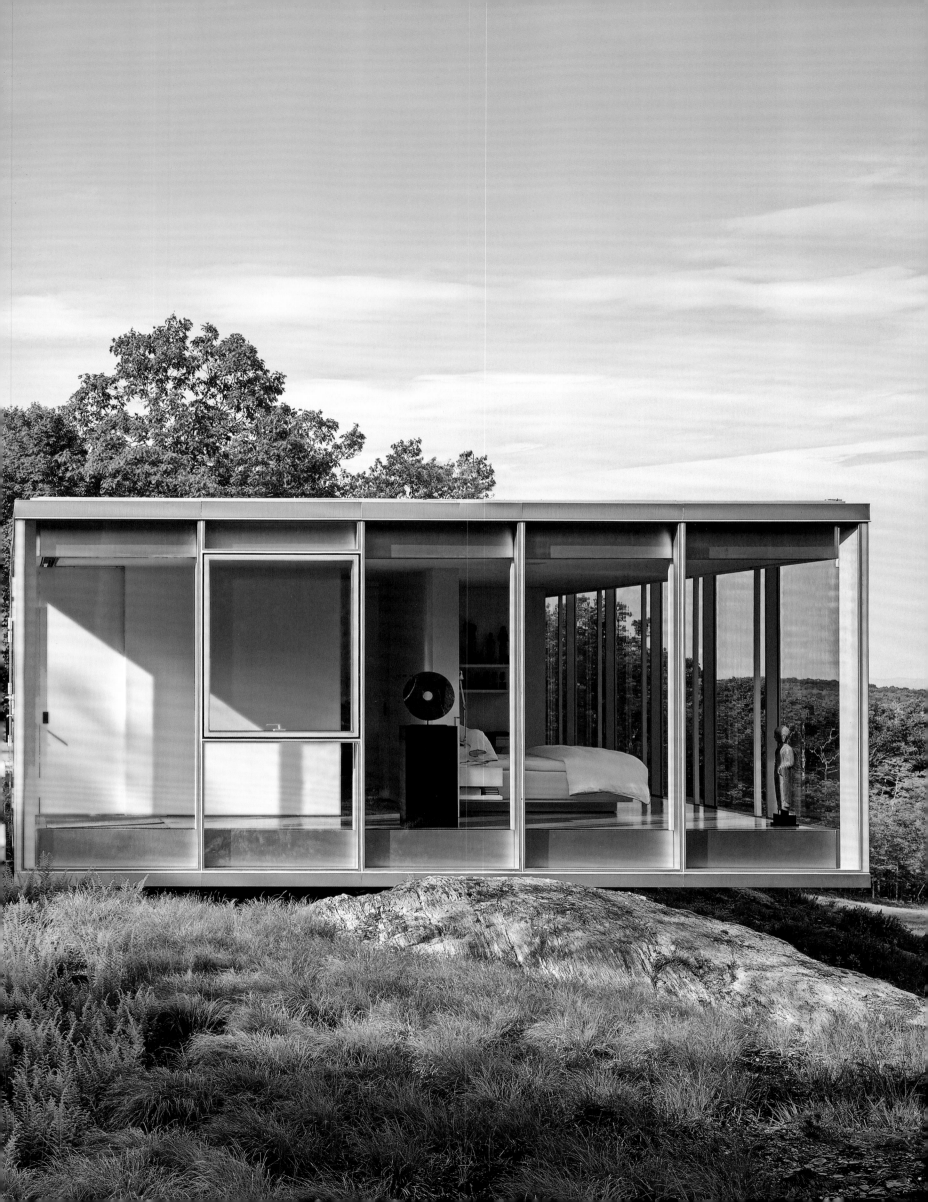

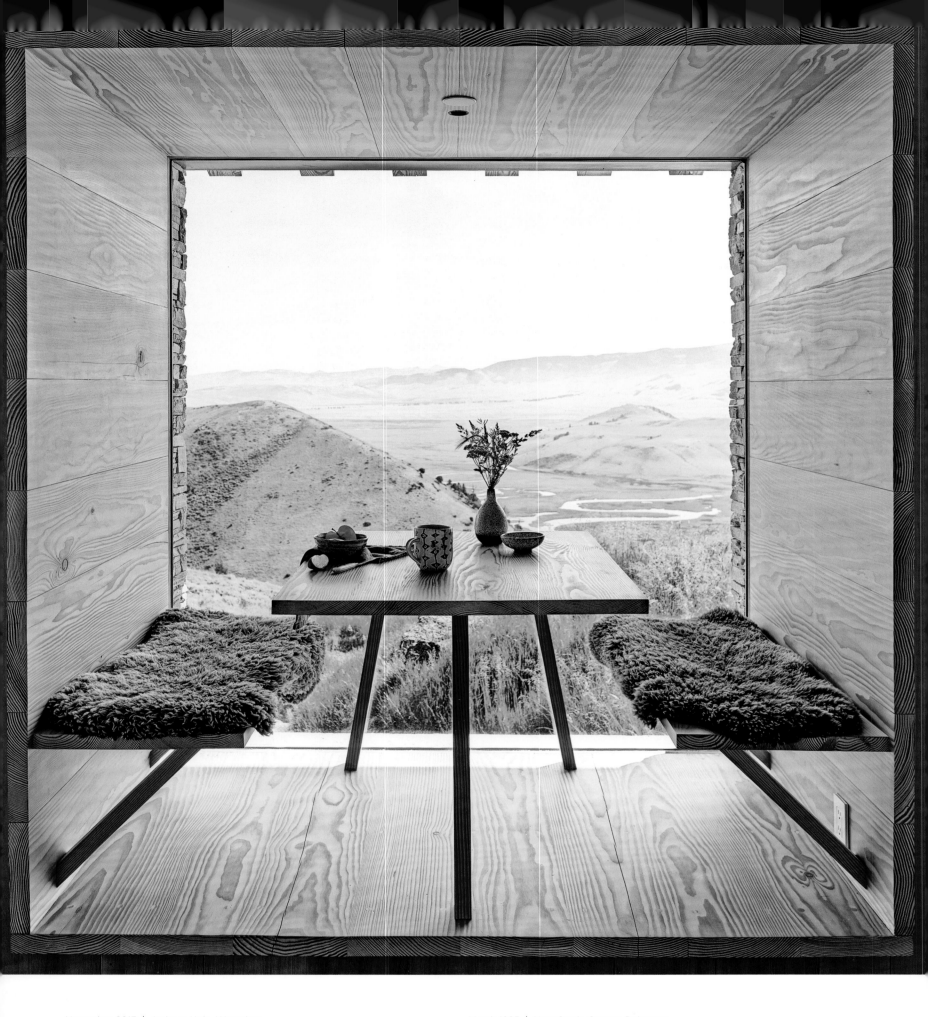

November 2017 | Jackson Hole, Wyoming

ARCHITECT McLean Quinlan

"I have a love affair with New Zealand's wide-open beach houses, and Rico has an affinity for chalets," designer Joanne Zorkendorfer said of the thinking behind the home she and her husband commissioned for Wyoming's most famous valley. McLean Quinlan, British architects, gave the couple a bit of both; the kitchen's snug breakfast nook is like a treehouse with canyon views.

March 1985 | New Castle County, Delaware

ARCHITECT Venturi, Rauch and Scott Brown

"To give the house an abstract quality," architect Robert Venturi explained, "many of the historical details became symbolic." In the second-floor music room, colorful cutout roof ties—the silhouettes evoke notes—and a matching chandelier that appears to have been painted by a toymaker lend a Germanic storybook air.

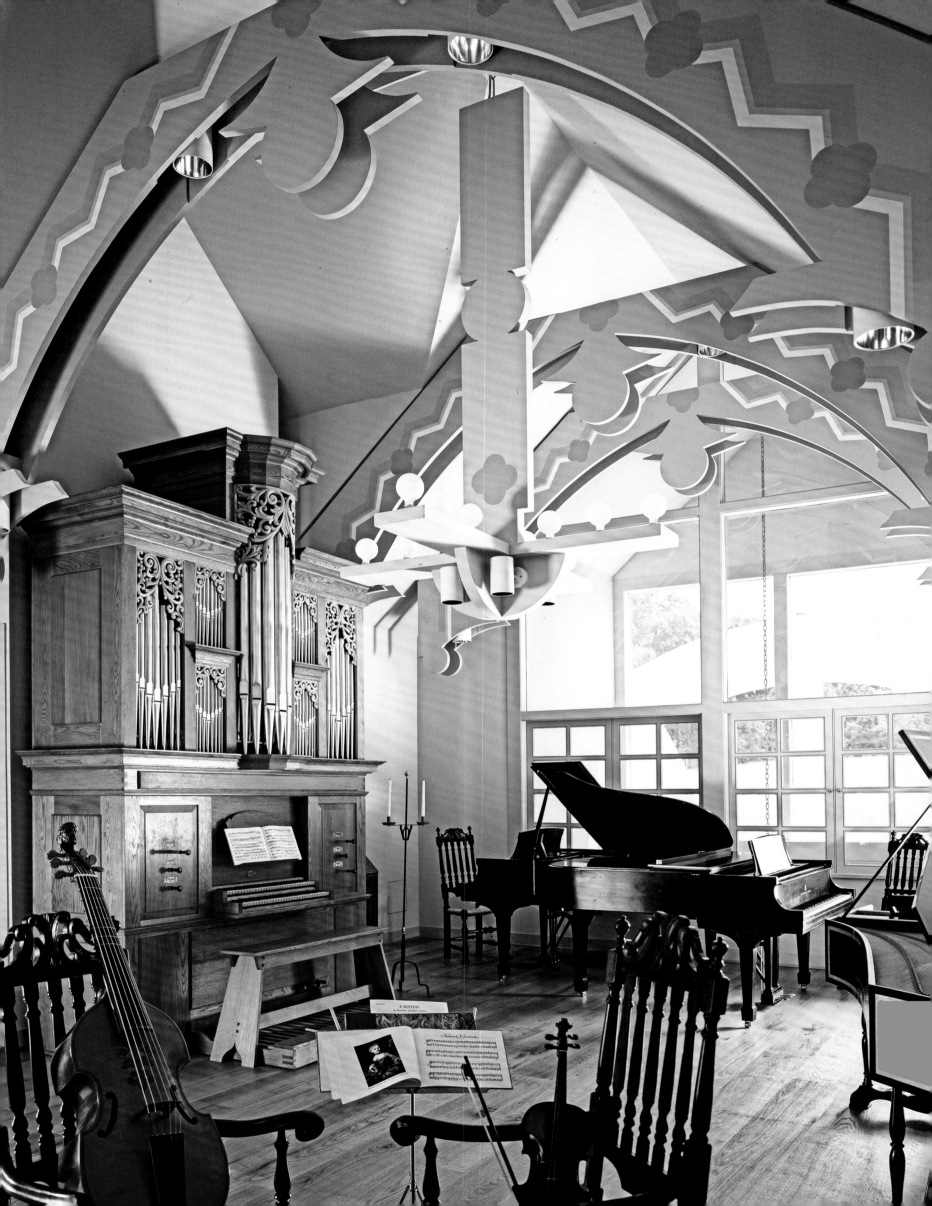

June 2012
Dutchess County,
New York

Longfield Farm

ARCHITECT
G. P. Schafer Architect

LANDSCAPE DESIGNER
Deborah Nevins & Associates

Cloudlike mounds of boxwood fill the walled entrance garden—designed by Nevins—of this Dutchess County house, which is primarily Georgian in appearance but includes a Federal Style wing, a Greek Revival veranda, and a Victorian carriage barn. Schafer described the stylistic narrative as "inventing a certain architectural mythology," noting that his goal was "to avoid a new-looking building in a bald field."

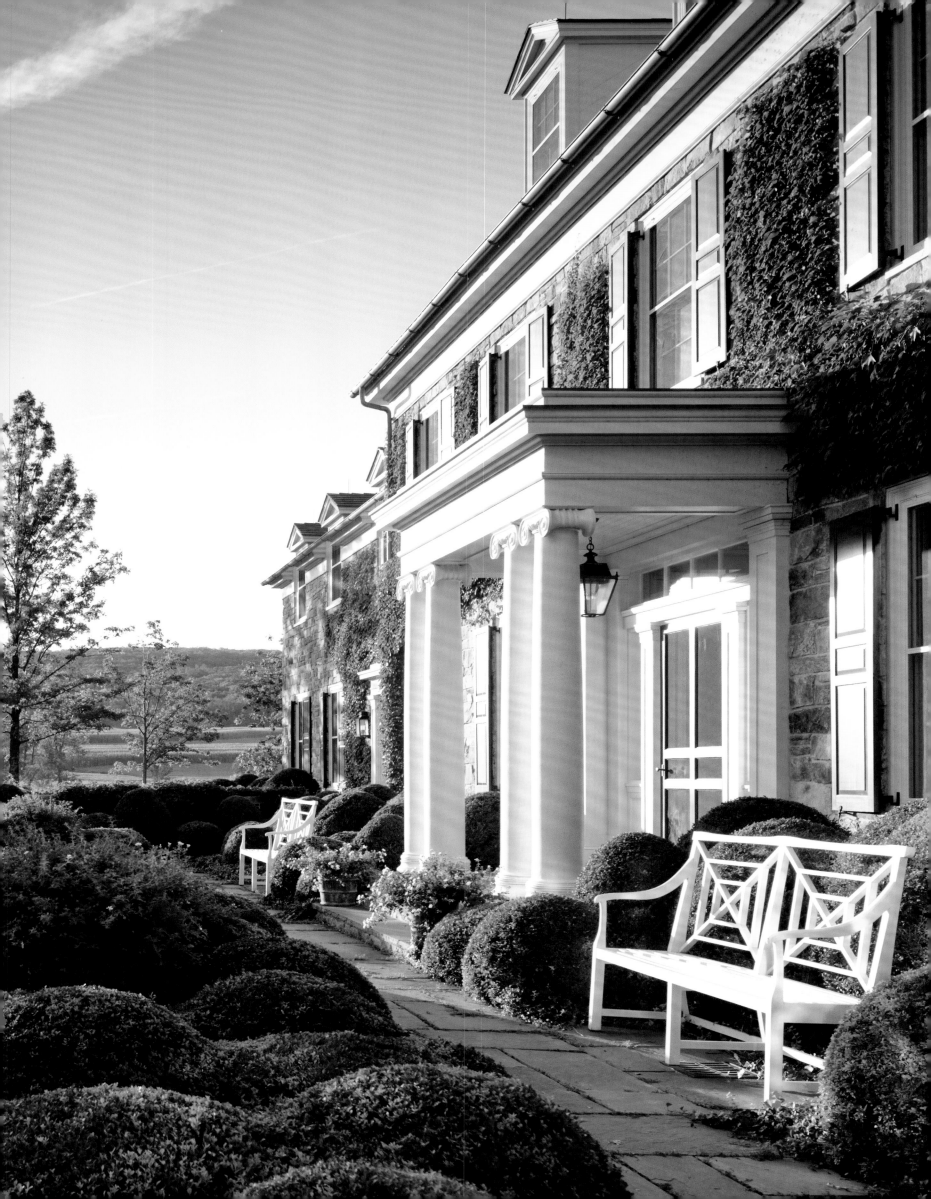

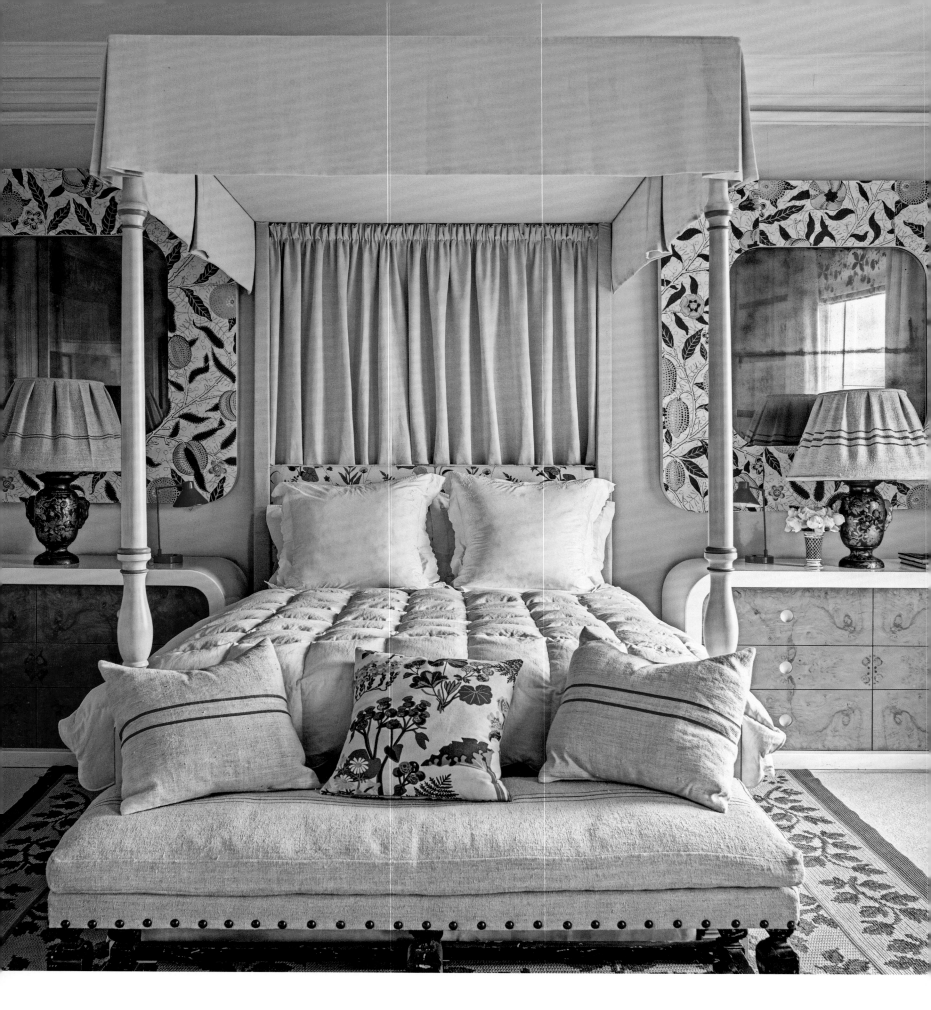

February 2018 | Great Haseley, Oxfordshire, England

HOMEOWNERS Brooke & Julian Metcalfe LANDSCAPE DESIGNER Bradley-Hole Schoenaich Landscape

"It's quite severe and architectural, but that means that we aren't fussing over dead flowers," writer Brooke Metcalfe said of her idyllic village retreat, which she and her husband—a cofounder of Pret A Manger and a great-grandson of Lord Curzon, viceroy of India—had landscaped by Christopher Bradley-Hole. Indoors, the idiosyncratic approach continues: "We threw out all the rules. Nothing had to fit any pattern or mood." In a nature-theme guest bedroom, mirrors wrapped with a fruit-motif wallpaper flank a canopy bed, the curtains are edged with a floral fabric, botanical watercolors climb a wall, and a needlepoint carpet is enriched with leafy vines.

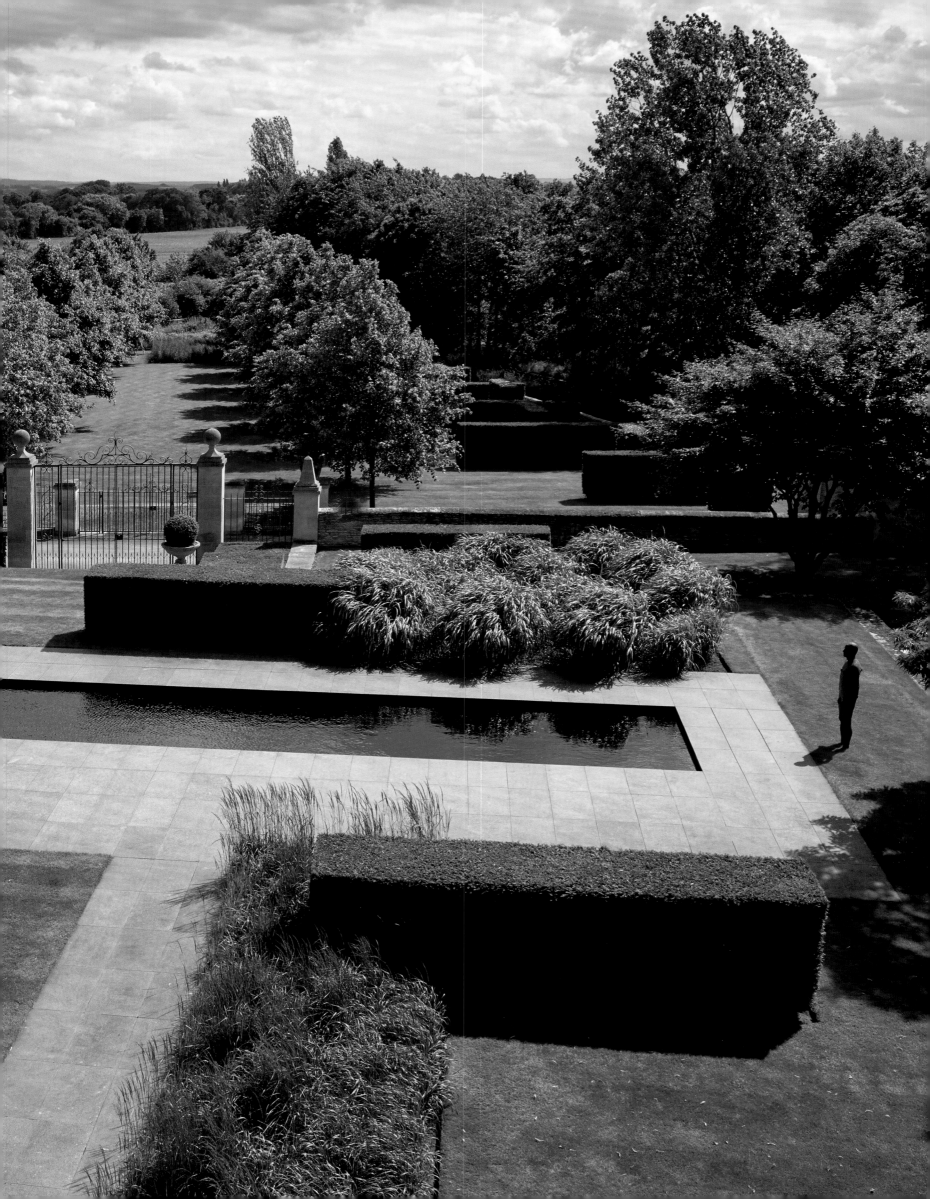

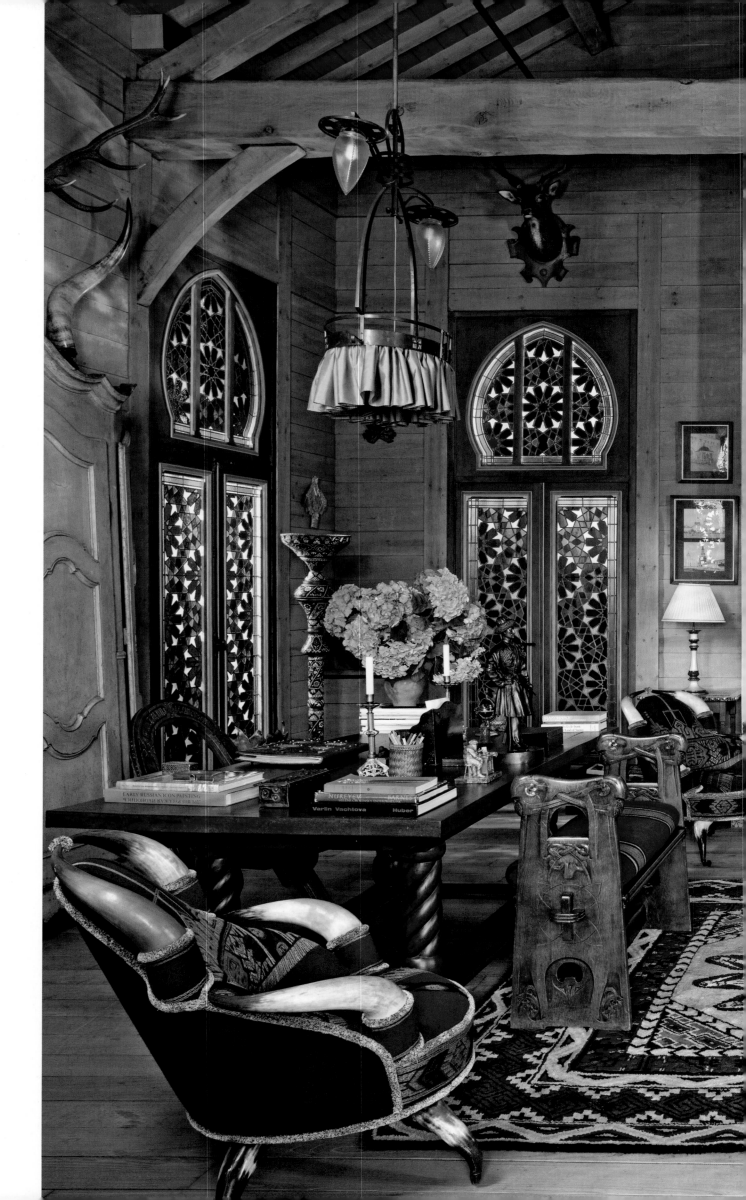

March 2014
Benerville-sur-Mer,
Normandy, France

La Datcha, Château Gabriel

HOMEOWNER
Pierre Bergé

Moroccan-inspired
stained-glass windows
line the Russian-style
log pavilion that the
industrialist Bergé and
his fashion-designer
partner, Yves Saint
Laurent, constructed at
their seaside estate
(see page 360). Designer
Jacques Grange decor-
ated the two-room
pavilion in Orientalist
fashion, blending
Russian Arts and Crafts
furniture with Austrian
horn seating upholstered
with Indian kilims; the
polychrome mantel
is 19th-century French.

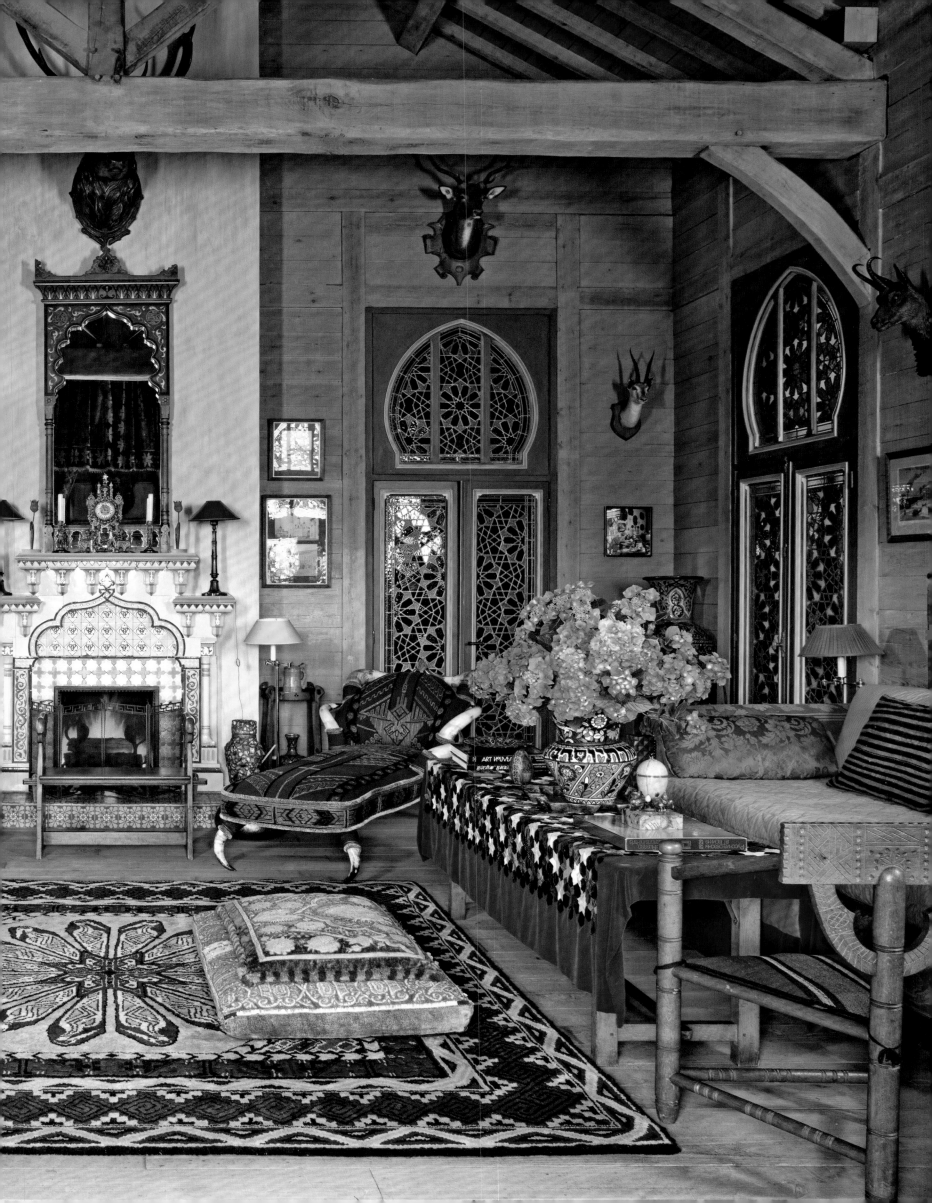

March 1979
Ciudad López Mateos,
Mexico

Cuadra
San Cristóbal

ARCHITECT
Luis Barragán

A suburban getaway
for Swedish industrialist
Folke Egerström and his
family is "like standing
inside a Surrealist paint-
ing," *AD* observed of
Barragán's 1968 master-
work. The white, pink,
red, blue, and purple
buildings and walls are
perforated with openings
that frame views and
activities, all intersecting
around a vast plaza.
There, a shallow pool
allows horses to be
exercised as water pours
down from an elevated
spout. The result is "a
composition of dream-
like mystery . . . that
seems to float in a realm
entirely its own," the
magazine noted.

October 2018 | New Preston, Connecticut

HOMEOWNER Daniel Romualdez LANDSCAPE DESIGNER Miranda Brooks

Architect Daniel Romualdez wanted a focal point that he could see from the house he shares with his partner, investment banker Michael Meagher, in winter, and that led Brooks to construct an eye-catcher—a stone pyramid that terminates an allée carved out of the woods. "After Miranda did the garden, I really felt like I was in the country. I'm in love," Romualdez said. "We rush home on the weekends to see what's new. It changed the way we live."

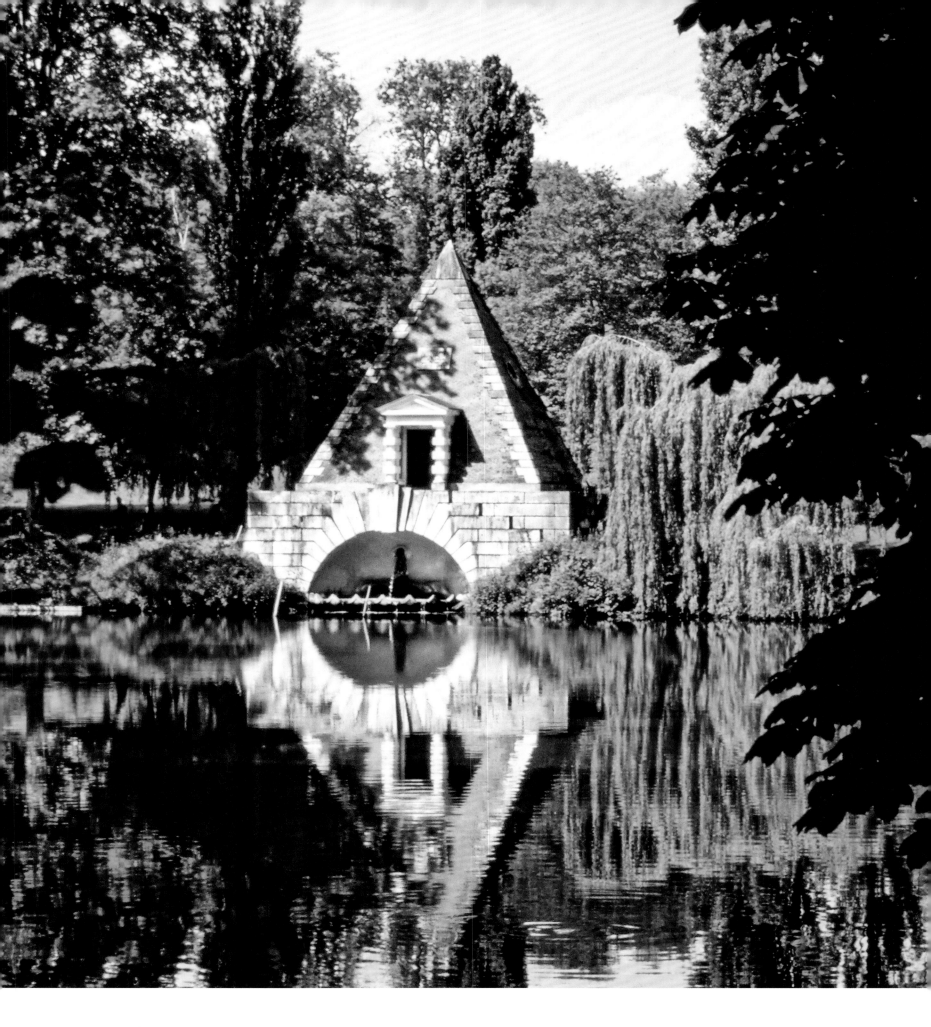

January 1982 | Montfort-l'Amaury, France

Château de Groussay

Collector Juan de Beistegui's uncle Carlos—he of the sublime taste and host of a legendary 1951 costume ball—ornamented the gardens of the family's château with fanciful follies. Among them is a neoclassical pink-brick pyramid that was created in 1968 by architect Emilio Terry, its base incorporating a spillway and a shell-shape basin.

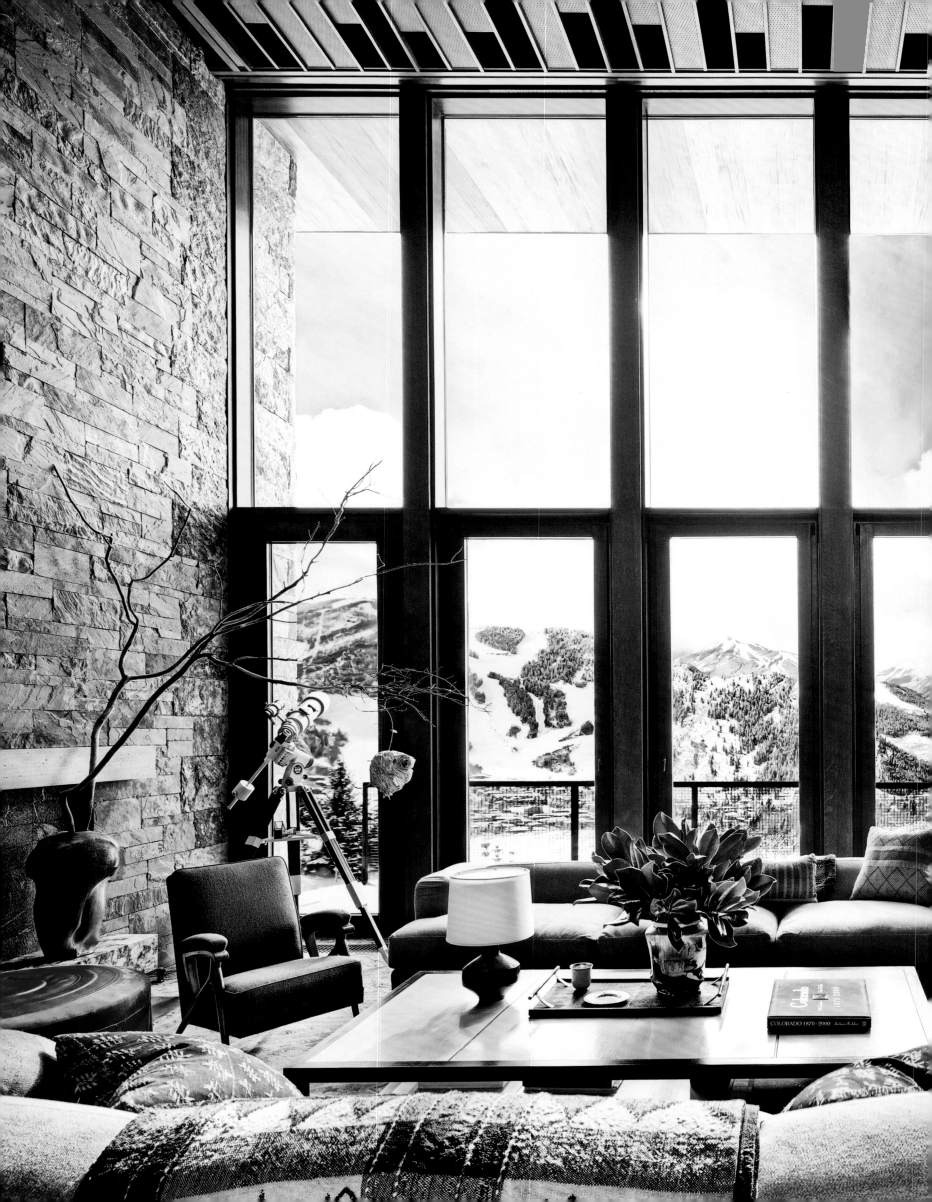

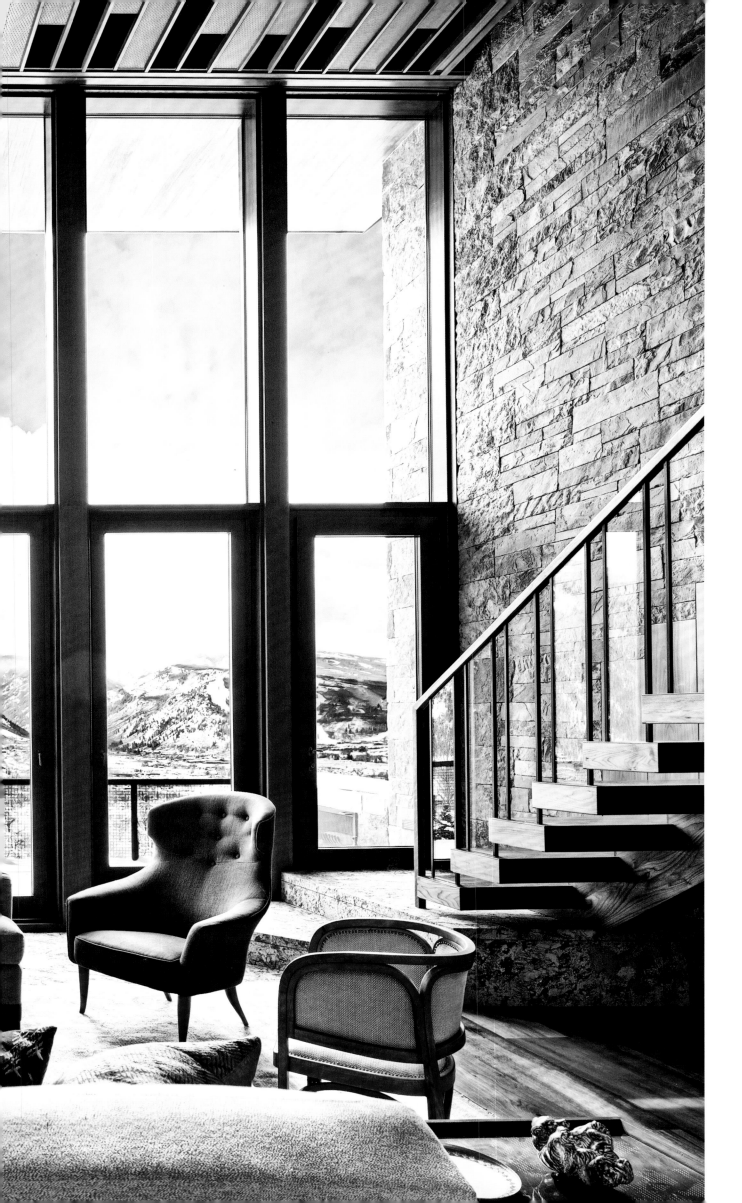

January 2013
Aspen, Colorado

DESIGNER
Studio Sofield

ARCHITECT
Studio B Architects

This Rocky Mountain retreat's double-height living room overlooks Aspen Mountain, the Maroon Bells, and other natural splendors of the region. The home very consciously reflects the personalities of both its owners. "The husband is a true modernist, so he would have lost his mind in a log cabin," William Sofield said. "And she's a bit more traditional, so the idea of traveling all the way from New York to Colorado just to be in a minimalist white box wasn't going to fly. The strength of this house lies in the tension between their aesthetics."

May 2015 | Birr, County Offaly, Ireland

Birr Castle

Fifteen generations of the Parsons family have lived at Birr Castle, which dates from the early 1600s. In the shadow of a Baroque urn, Olivia and William, the children of Lord and Lady Oxmantown (he's the heir to the earldom of Rosse) romp through a boxwood parterre that was created in the 1930s by their glamorous great-grandmother Anne, the Countess of Rosse. A suite of Gothic Revival furniture, reportedly made in the 19th century by carpenters employed on the estate, makes for a fantastical bedroom.

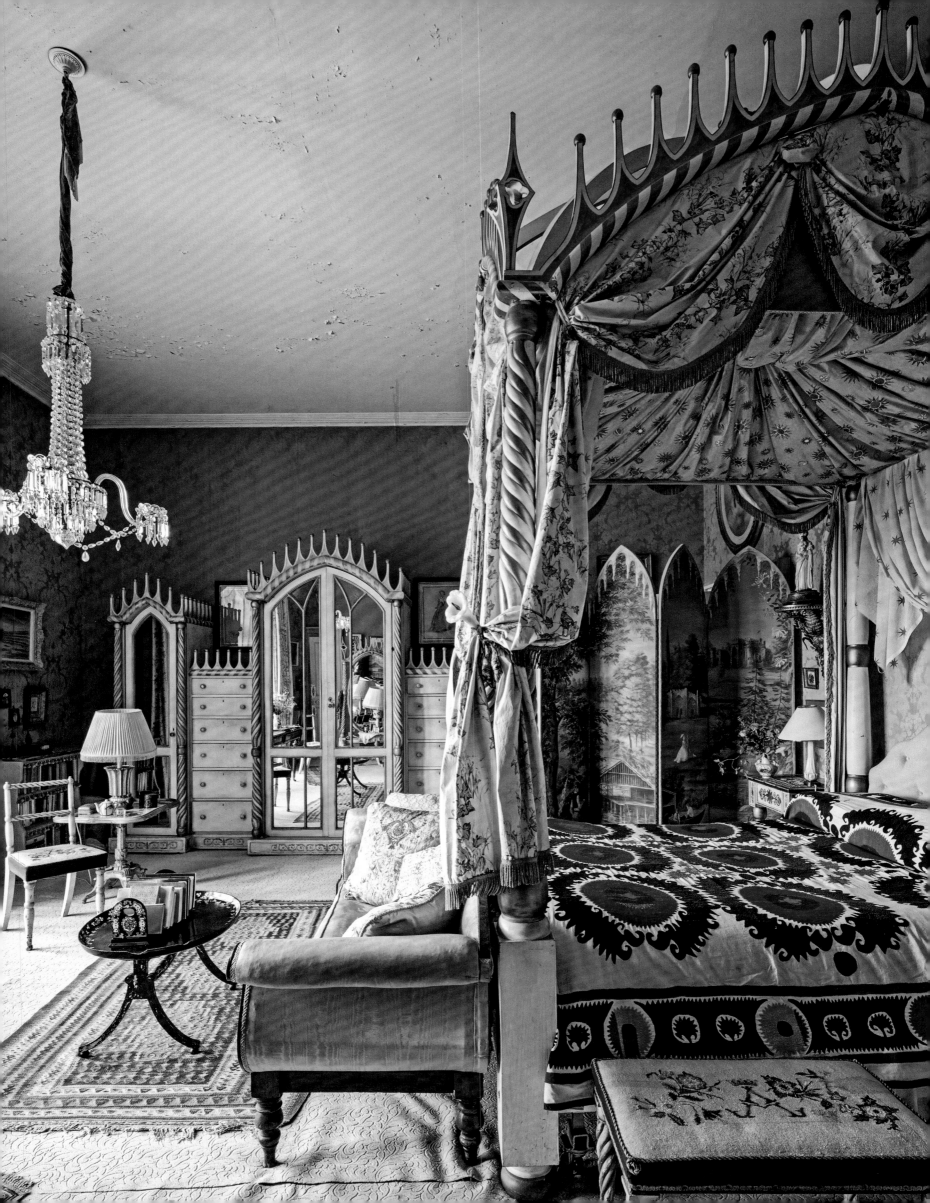

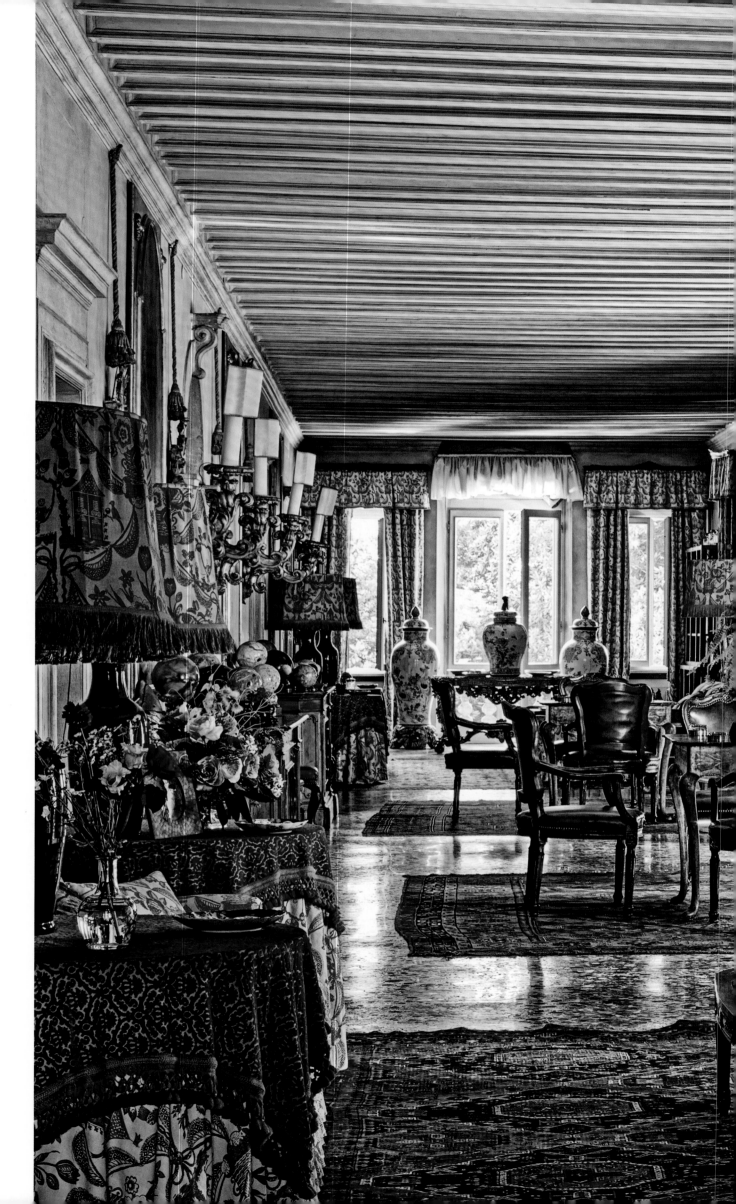

October 2017
Friuli Venezia Giulia, Italy

Villa Ronche
DESIGNER
Renzo Mongiardino

"He divided it into several cozy sitting areas, with sofas and curtains in a simple red-and-white toile de Jouy," publisher Martina Mondadori Sartogo wrote of the gallery of her family home, which Mongiardino decorated in the 1960s for her maternal grandmother. "In a typical Mongiardino flourish, the same fabric was used for the lampshades and table skirts." The 130-foot-long space (Mongiardino bemoaned its "disquieting length") became, and remains, the domestic hub, "conducive to reading, listening to music, playing games, or simply conversing."

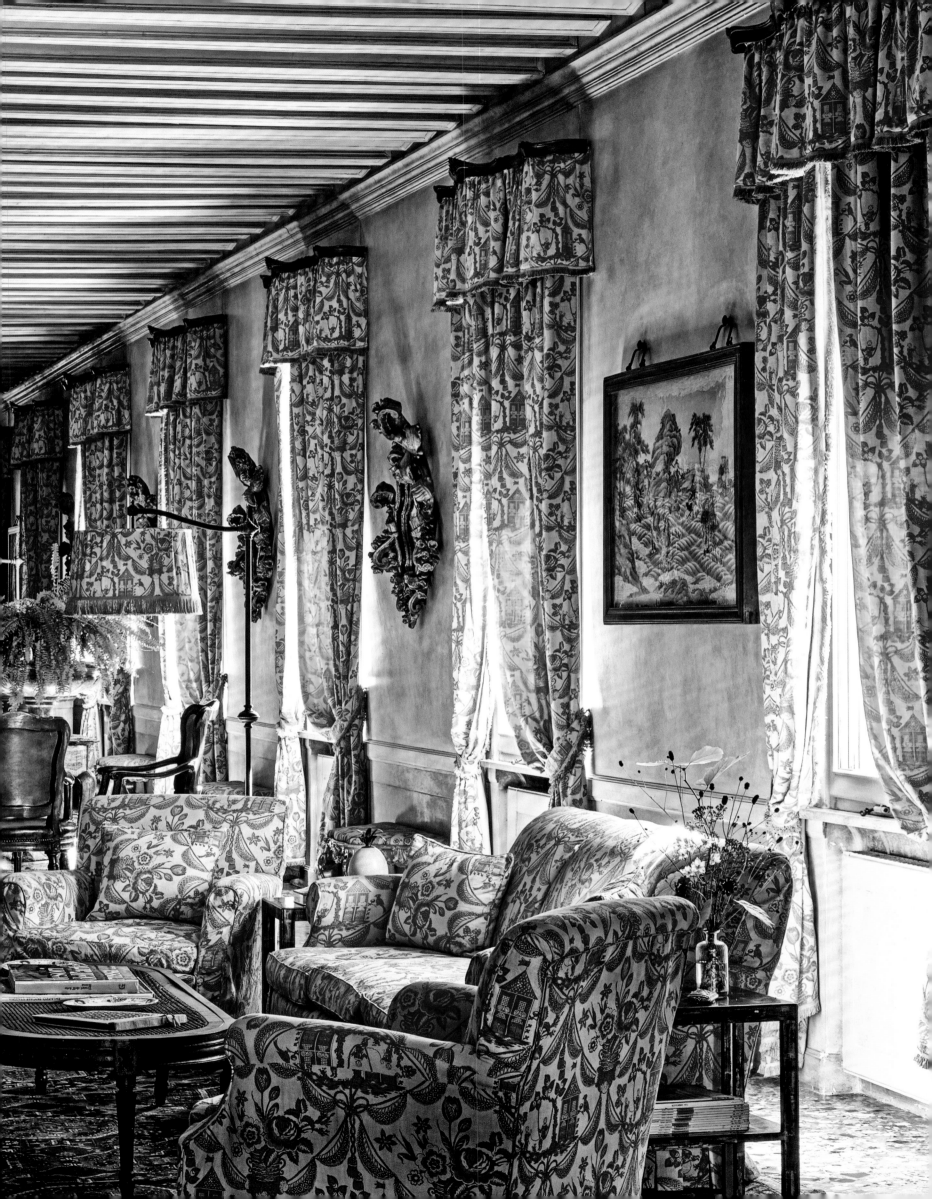

March 1984
Garsington, Oxfordshire,
England

Garsington
Manor

Enchanted in the 1920s
by an Italian villa she
had visited, Lady Ottoline
Morrell, noted hostess
of the Bloomsbury Group,
came home to establish
a formal garden that
would be "a coloured,
sweet-smelling carpet."
The 24 sections were
divided by boxwood
hedges, punctuated by
yews, and planted with
tulips, wallflowers, and
forget-me-nots. Architect
Philip Tilden designed
the Italianate loggia
and terrace.

Tory Burch
Valentino Garavani
Inez van Lamsweerde & Vinoodh Matadin
Yves Saint Laurent
Claudia Schiffer
Steven Klein
Ralph Lauren
Coco Chanel
Franca Sozzani
Margherita Missoni
Diana Vreeland
Marc Jacobs
Oscar de la Renta

Fashion Insiders

Giorgio Armani
Tommy Hilfiger
Julie de Libran
Donatella Versace
Michael Kors
Kenzo Takada
Hubert de Givenchy
Grace Coddington
Alexander Wang
Carolina Herrera
Kate Moss
Diane von Furstenberg

PREVIOUS SPREAD
Tory Burch asked
landscape architect
Perry Guillot to
transform the gardens
of her estate in
Southampton, New
York, into a gloriously
green wonderland
of epic proportions
(*AD* October 2017;
see page 358).

"THIS IS not a bourgeois home," *Donatella Versace* stated matter-of-factly in 1994, when *Architectural Digest* published her neoclassical Milanese residence, replete with Corinthian columns, Roman busts, and faux-marble walls. By Versace's account, it was her glamorous master bath where celebrity friends *Elton John* and *Linda Evangelista* would congregate at house parties. "A house itself isn't important," she mused. "It's what you do in it, how you give it life."

For the rich cast of fashion-industry legends whose homes have graced the pages of *AD*, such disregard for convention has been the overarching theme. Consider *Diane von Furstenberg's* New York City bedroom, a faceted-glass dome that sits atop an industrial building like an urban tree house. Or *Kenzo Takada's* compound of bamboo structures and Japanese rock gardens—all situated not in Kyoto but smack-dab in the middle of Paris. *Valentino Garavani* and partner *Giancarlo Giammetti* entertain in outsize splendor at Château de Wideville, their palatial mansion near Paris, which serves as a glamorous playground for the glitterati. Even *Carolina Herrera*, whose chintz-filled Upper East Side townhouse might appear rather traditional, had a surprise up her crisp white sleeve when *AD* paid a visit in 1987. "In New York, space is at a premium and one does not want to devote a room just to dining," her decorator *Robert Metzger* explained. "The Herreras were giving

a dinner party and they asked themselves, 'Where are we going to put everyone?' And they said, 'In here!'" So it was that the couple's dressing room came to double as their formal dining room, its toile de Jouy tenting concealing a full wardrobe of gowns, shoes, and jewels.

For many fashion insiders, home offers a seamless extension of brand. *Ralph Lauren's* various residences—four of which have been documented in *AD* over the years—perfectly mirror his singular take on preppy Americana. (They've also inspired his booming home decor business.) The same goes for *Giorgio Armani's* Tuscan retreat, with his signature clean lines and monochromatic rigor. And *Tory Burch's* Hamptons estate is utterly tasteful and without pretense, much like the designer herself. Still others view their private world as a place to disconnect from their public persona. You won't find any color in the Greenwich Village penthouse of *Michael Kors* and his husband, *Lance Le Pere*, who consider their Zen apartment to be a "palette cleanser."

In every case, personality takes center stage—serving at the enhancement, not the expense, of the characters who inhabit these spaces. As *AD* noted of editrix *Diana Vreeland's* crimson-coated Park Avenue pad in 1975: "The fact is that Diana Vreeland herself as a human being is more colorful than any apartment, even her own. It is she who emerges naturally as the star of the mise-en-scène, precisely because it is so truthful a reflection of her private self."▲D

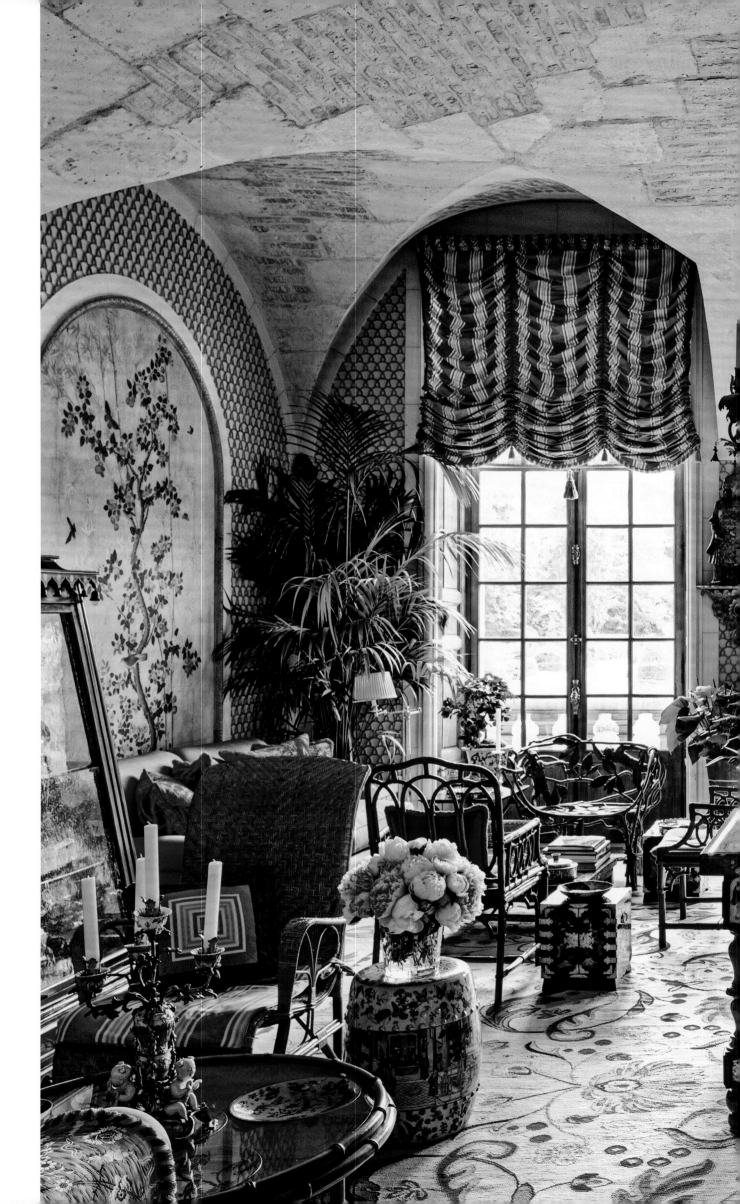

October 2012
Crespières, France

Château de Wideville

HOMEOWNERS

Valentino Garavani & Giancarlo Giammetti

Chinese panels fill the winter garden's arched niches at Garavani and Giammetti's residence outside Paris. The palatial property was originally built by Louis XIII's finance minister and later served as home to one of Louis XIV's mistresses. When the couple took ownership of it, they enlisted Henri Samuel to handle decorating duties.

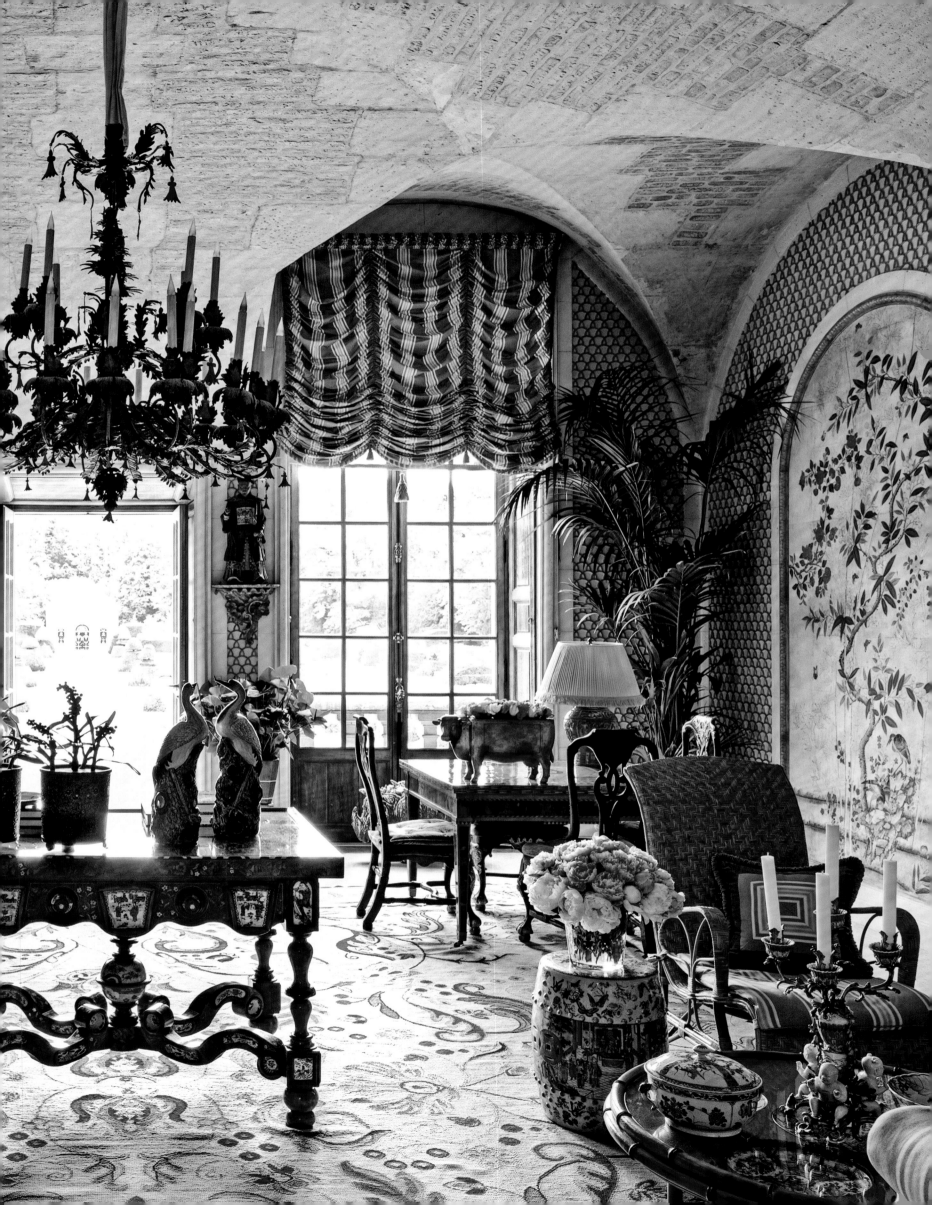

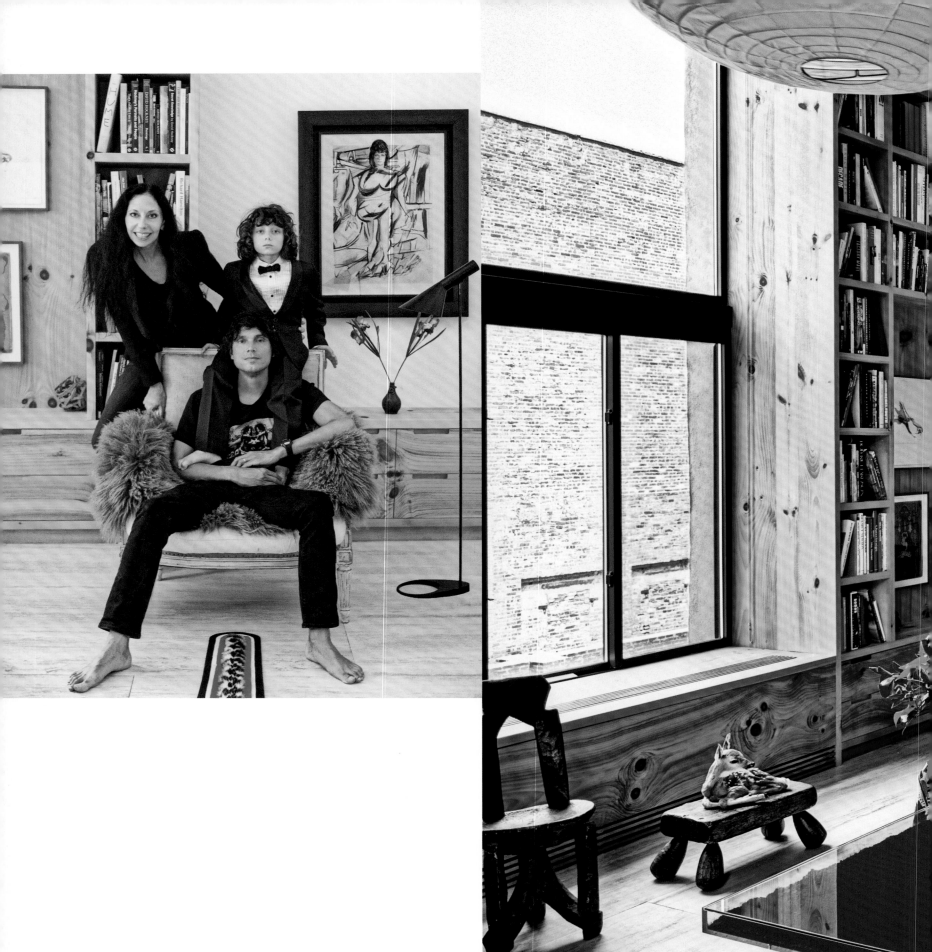

October 2011 | Manhattan

HOMEOWNERS

Inez van Lamsweerde &
Vinoodh Matadin

When the husband-and-wife photography duo combined three adjacent
lofts into a family home for them and their son, Charles, they sought to maintain
a rawness and openness while adding warmth. Simrel Achenbach oversaw
the architecture, with designer Daniel Sachs taking on the decor. An Yves Klein
table that acts as a centerpiece in the great room is surrounded by art and
photography. "The apartment is like a group show," said van Lamsweerde. "It's all
about our life together."

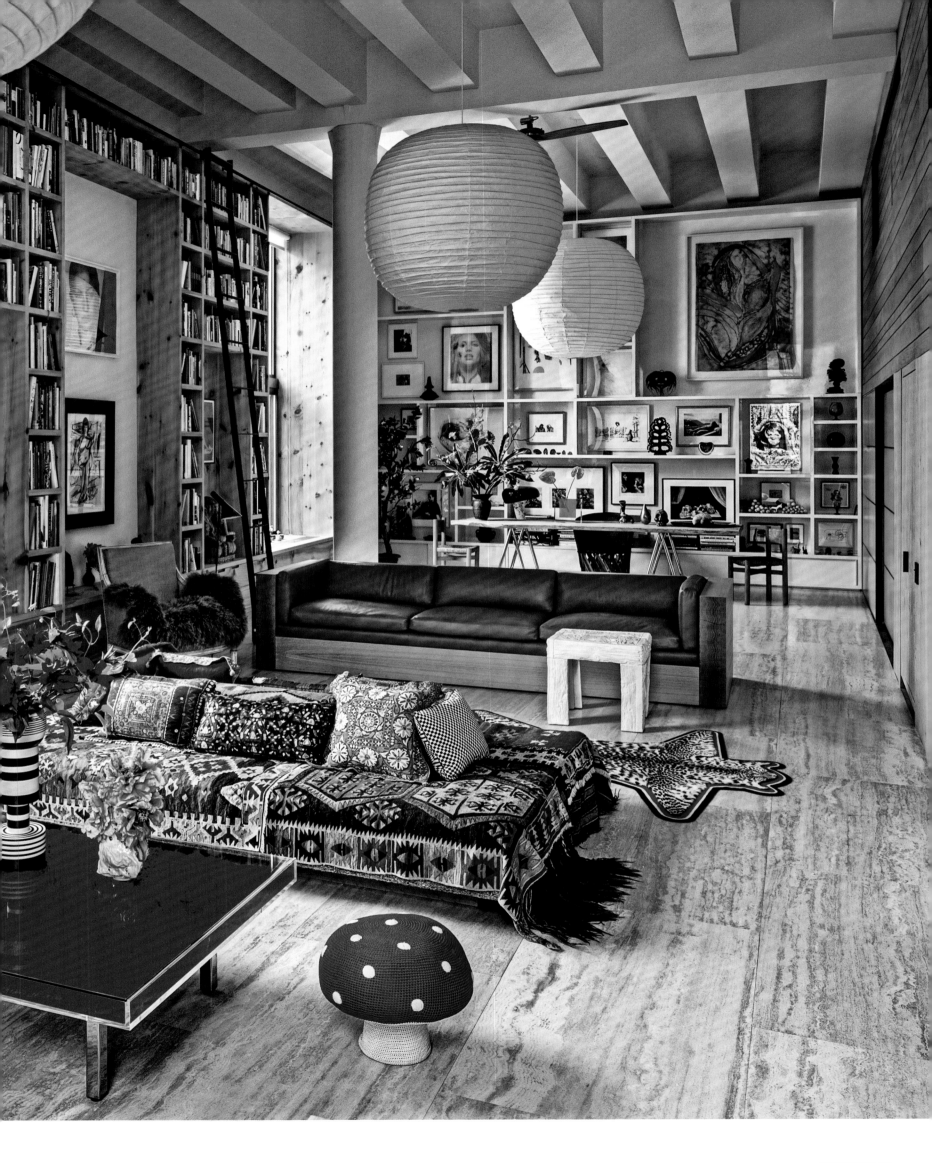

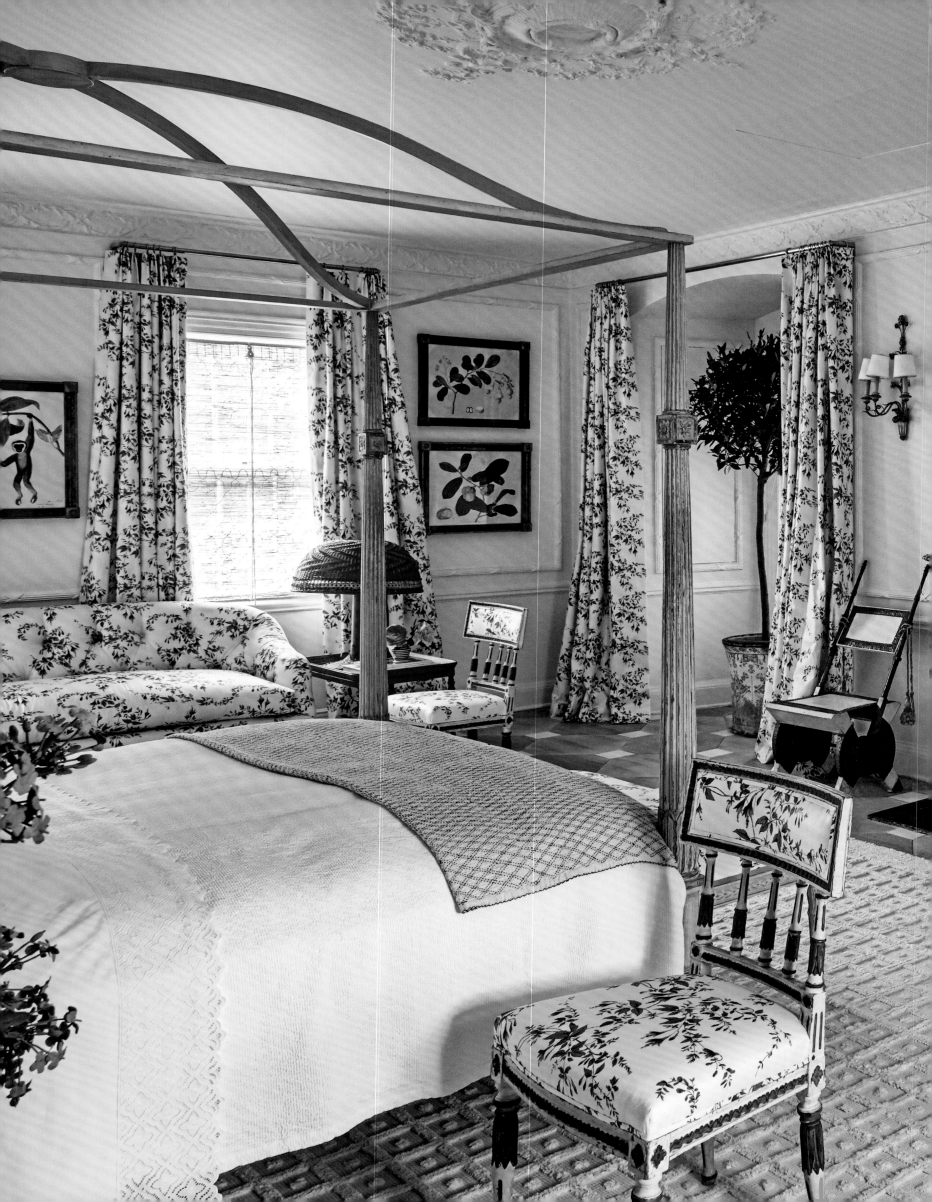

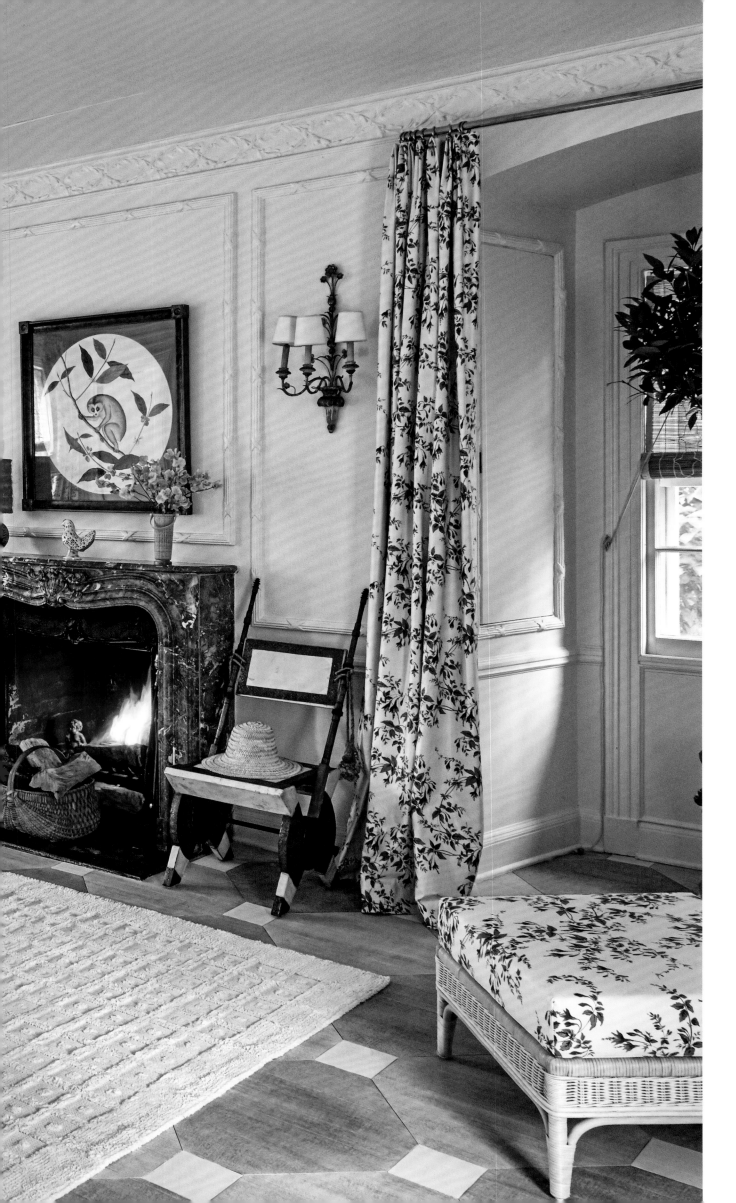

October 2017
Southampton, New York

Westerly

HOMEOWNER
Tory Burch

"The way Westerly has been decorated is the way a lot of those houses were done, before decorators played such a role," noted designer and longtime Burch collaborator Daniel Romualdez of the 1929 Georgian mansion he and his client spent nearly a decade bringing back to life. "In the era of the great American country house, from the 1890s to the 1920s, there was no storyboarding. It was much more organic." In the master bedroom, a Colefax and Fowler floral sets the tone.

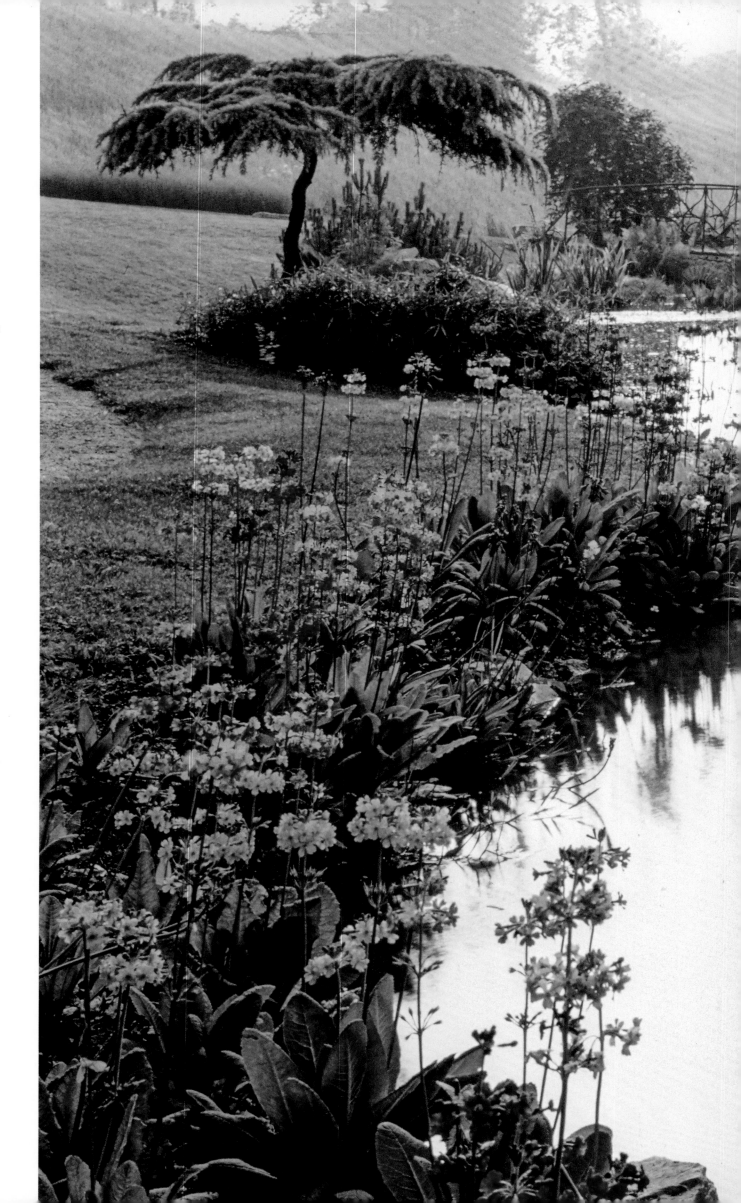

May 1987
Deauville, France

Château Gabriel

HOMEOWNERS
Yves Saint Laurent & Pierre Bergé

Saint Laurent and Bergé acquired Château Gabriel, on the coast of Normandy, in the early 1980s. At the time, the garden, long neglected, was merely a steep cow pasture—this served as their canvas for a total transformation. Landscape designer Franz Baechler added a meandering stream bordered by Japanese primroses. "I never tire of looking at all this," Saint Laurent said. "It changes from hour to hour. I never dreamed I would come to love the country here so much."

September 2017 | Suffolk, England

HOMEOWNERS Claudia Schiffer & Matthew Vaughn

The 14-bedroom Tudor mansion the supermodel shares with her film-director husband and their three children was built in 1574 in an H-shape, purportedly in honor of King Henry VIII. It was also where Guy Fawkes planned the Gunpowder Plot of 1605. Schiffer recalled how she and Vaughn came to own it in a moment of serendipity: "We basically knocked on the door and said, 'We love this place.'"

September 2014
Bridgehampton,
New York

West Kill Farm

HOMEOWNER
Steven Klein

The photographer
and avid equestrian
reimagined an erstwhile
woodworking studio
as the dramatic master
bedroom at West Kill
Farm, his country estate.
"White and green is not
a great color combina-
tion," Klein said of the
more typical palette
of the area. "Something
about those colors is
just wrong. It's so much
more appealing to have
this kind of cool dark-
ness against the light."
Klein's *Girl in a Lace Dress*
overlooks a seating
area with a pair of Mies
van der Rohe sofas
and a Blackman Cruz
cocktail table.

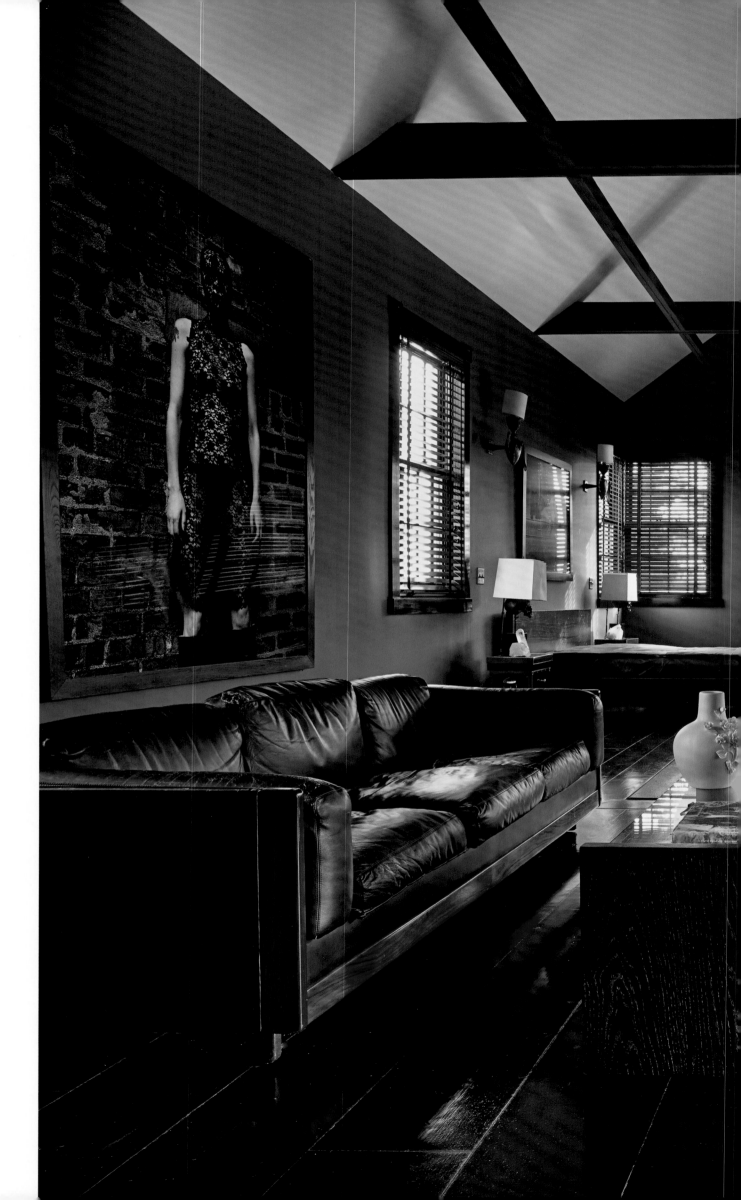

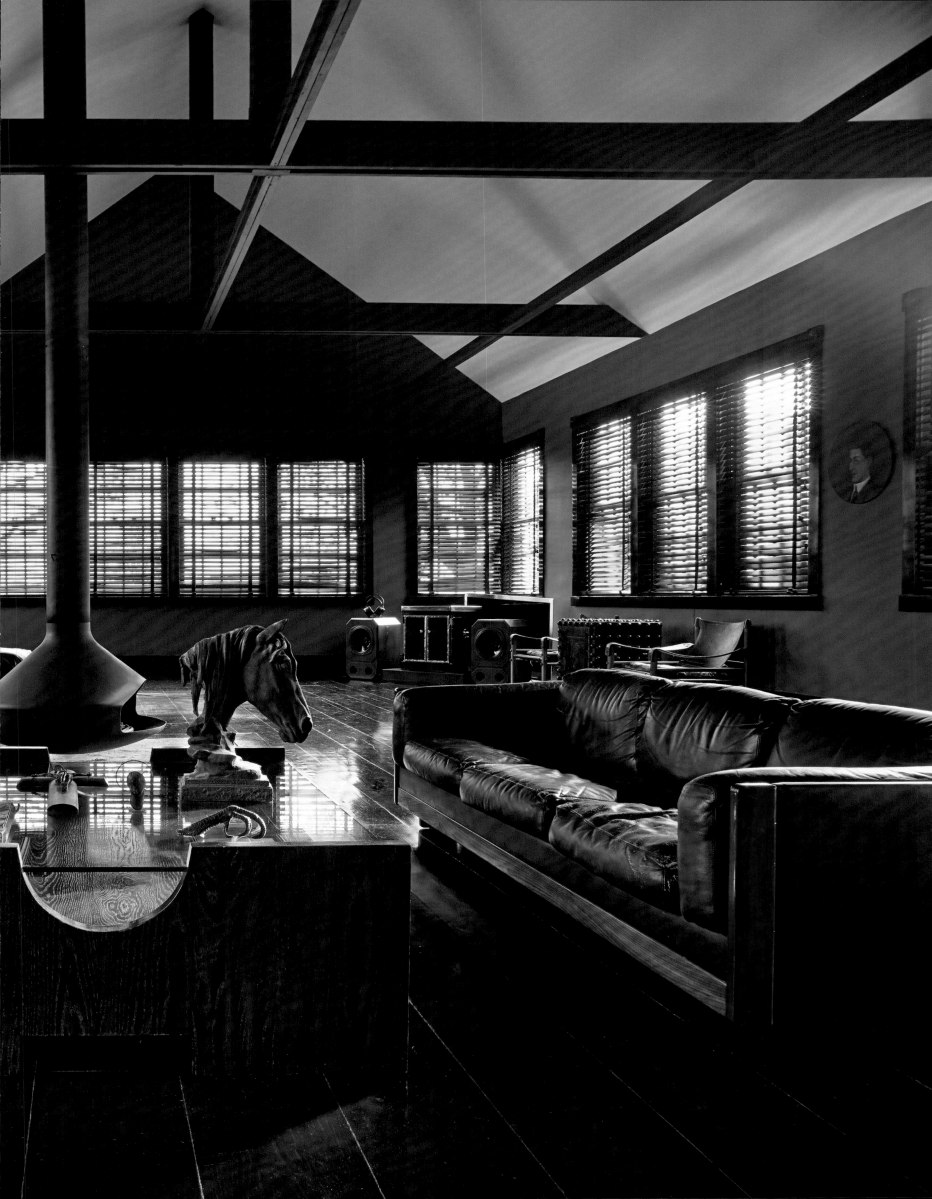

November 2007
Montego Bay, Jamaica

HOMEOWNERS
Ralph &
Ricky Lauren

The Laurens have
five homes scattered
across the U.S. and the
Caribbean, each serving
a different role in their
family's life. Perched on
Round Hill, near Montego
Bay, their Jamaica resi-
dence—Babe and William
Paley were its original
owners—stands alone
as the spot for relaxing.
"I live a very hectic life,"
said the fashion designer.
"In Jamaica I have no
obligations. It's very
serene, a different world,
far from everything."
With a pool deck and
accompanying beach
house, it's "like being on
a boat," he noted.

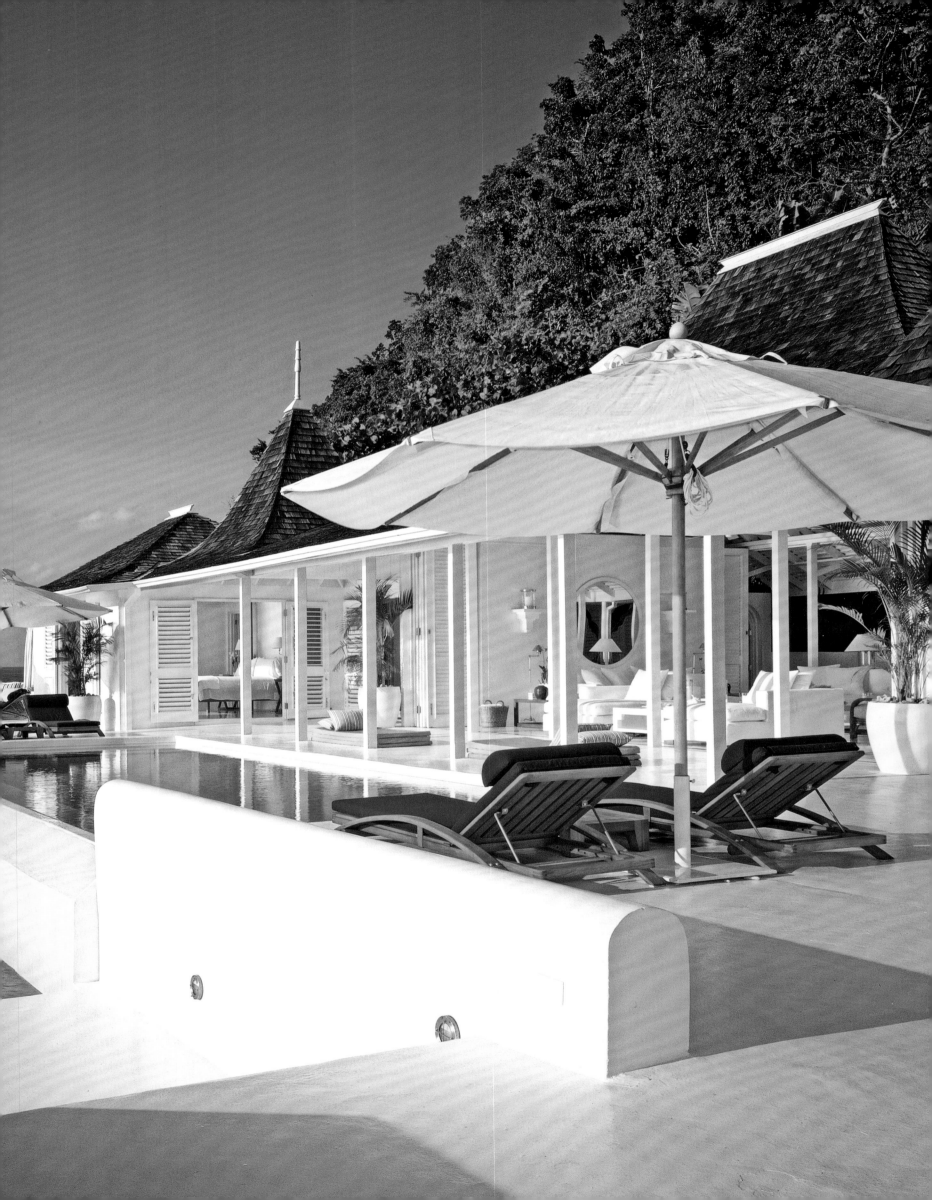

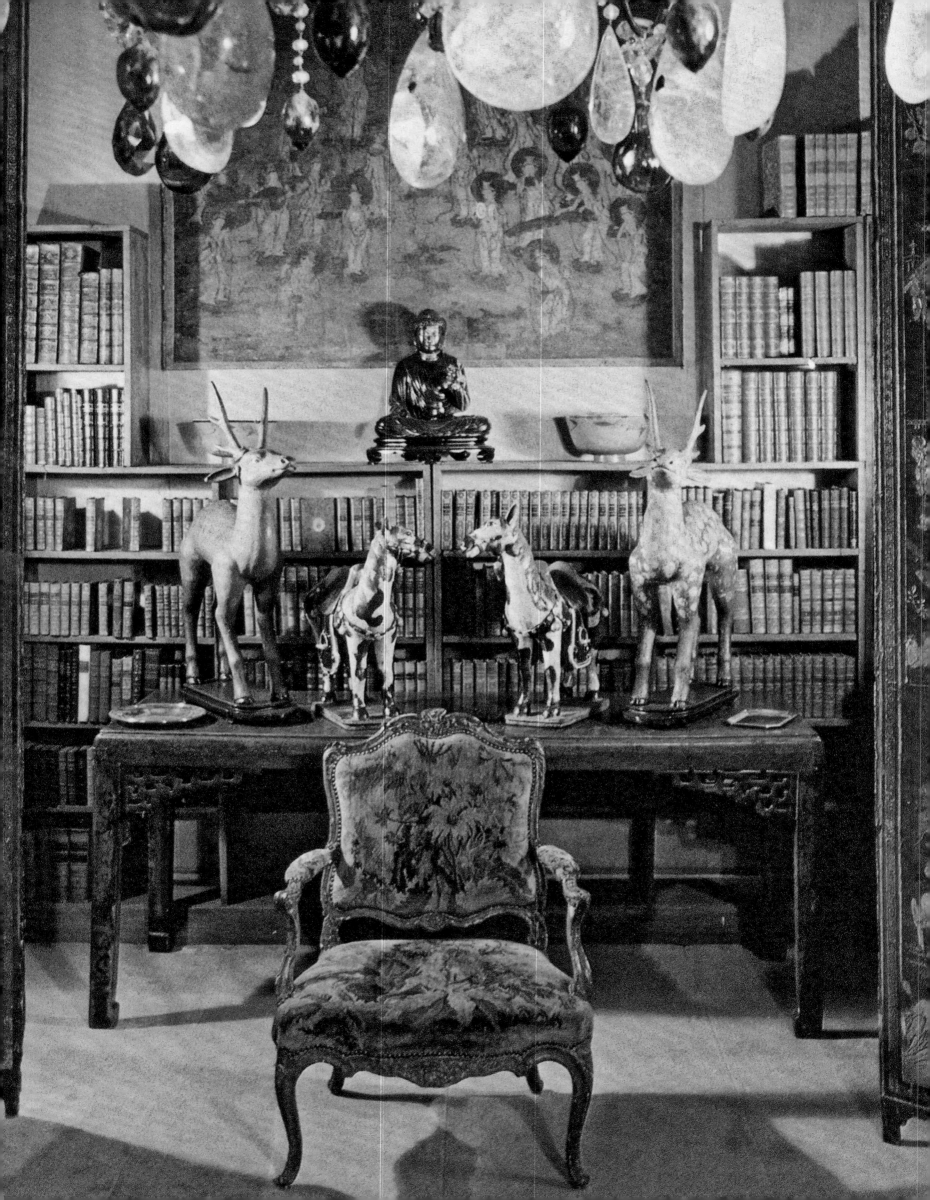

January 1973 | Paris

HOMEOWNER Coco Chanel

In her jewel-box apartment on the third floor of her rue Cambon atelier, a pair of Chinese Coromandel screens flank the alcove of the salon, joined by rare books and a Louis XV fauteuil. "She had an unerring sense of color, emphasizing the use of black, which she considered extremely chic, and of white, but eschewing bright colors, except in combination with a bold shade that would have a restraining effect," her friend Cecil Beaton observed during *AD*'s posthumous visit to her home. "Pastel shades, she said, were only for red-headed women."

March 2017 | Paris

HOMEOWNER Franca Sozzani

The Italian *Vogue* editor's Paris pied-à-terre, a 19th-century townhouse renovated by Massimiliano Locatelli, a longtime friend, reflects her enduring passion for art and design. In the media room, a photograph from Shirin Neshat's "Women of Allah" series hangs above the fireplace; the bookcase was designed by Locatelli. "Images speak more than any other form of art," said Sozzani. "My whole career has been based on images."

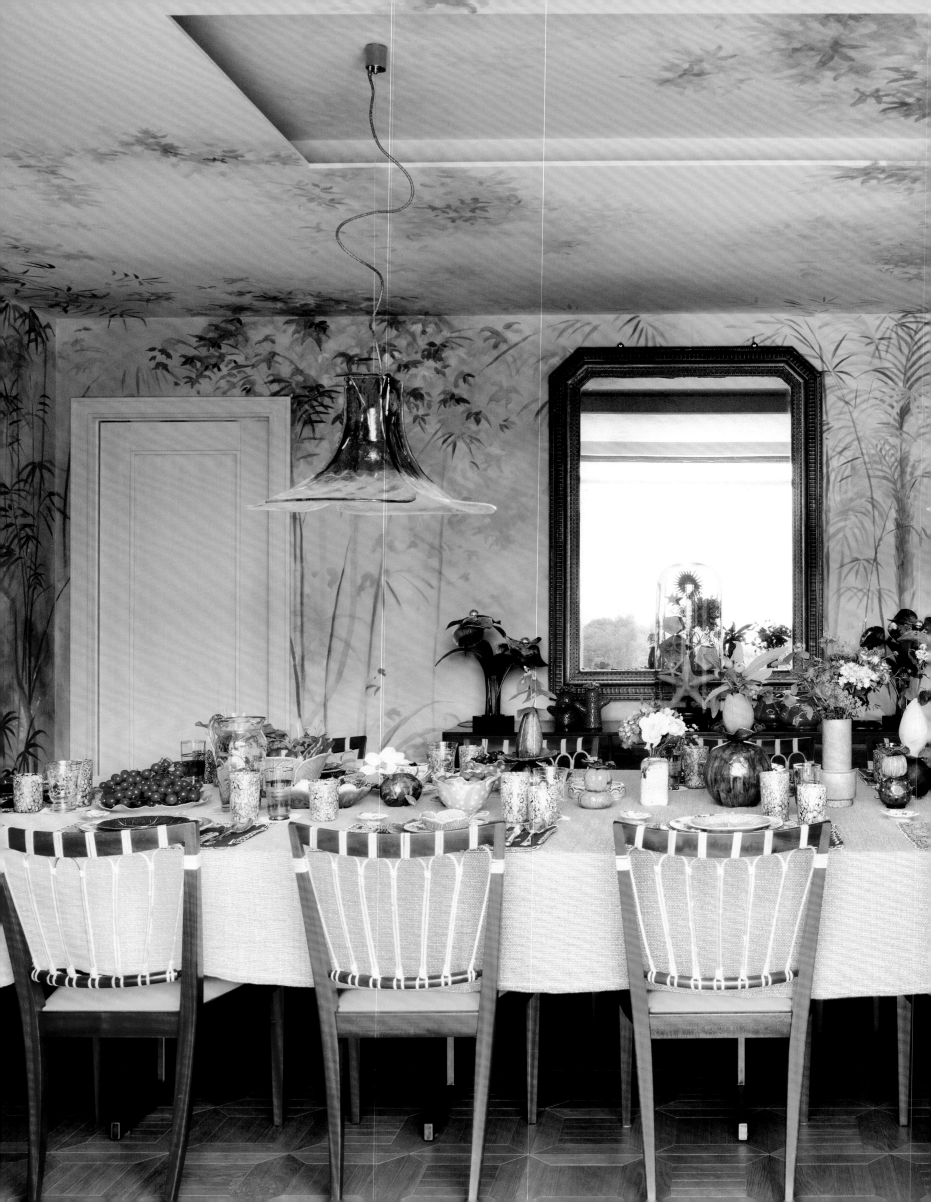

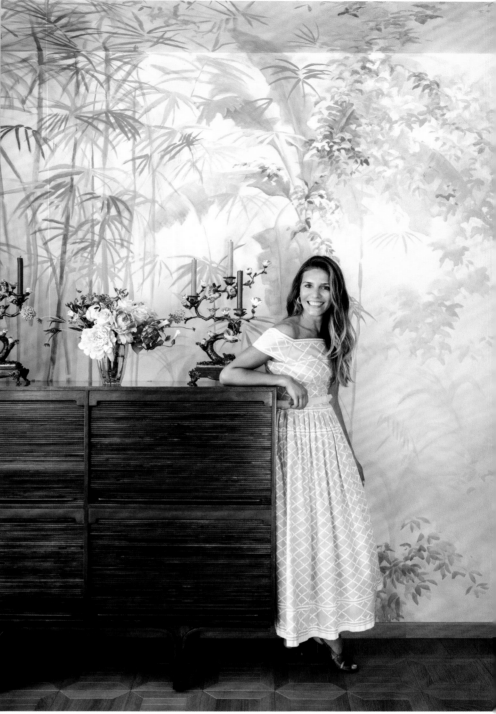

September 2018 | Varese, Italy

HOMEOWNERS

Margherita Maccapani
Missoni Amos &
Eugenio Amos

True to her family DNA, Missoni embraced a riot of color and pattern in the home
she designed for herself, her husband, and their children, commissioning Pictalab
to create the hand-painted garden mural in the dining room. "Color and shape took
priority over period coherence," she said of the delightful results.

September/
October 1975
Manhattan

HOMEOWNER
Diana
Vreeland

"I want my apartment
to look like a garden:
a garden in hell!" the
former *Vogue* editor
in chief quipped about
her Manhattan home.
A red motif fittingly
prevails, as do florals.
The painted leather
screen in front of the
living room's book-
shelves was acquired
by Vreeland's parents
on their honeymoon,
and she stitched the
playing-card needlework
pillows on the sofa.
"Anyone who could photo-
graph this place would
find the Sistine Chapel a
cinch," she added.

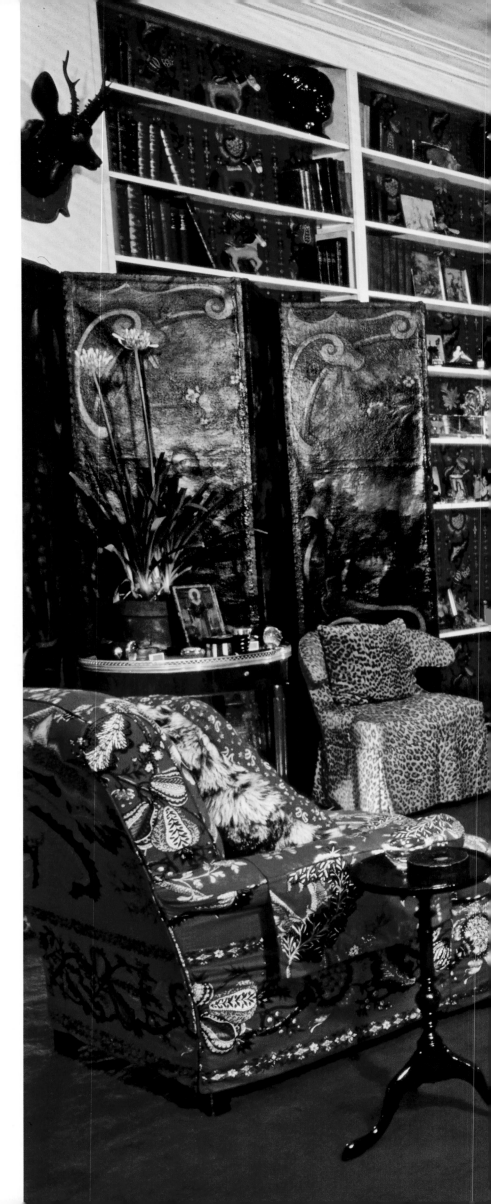

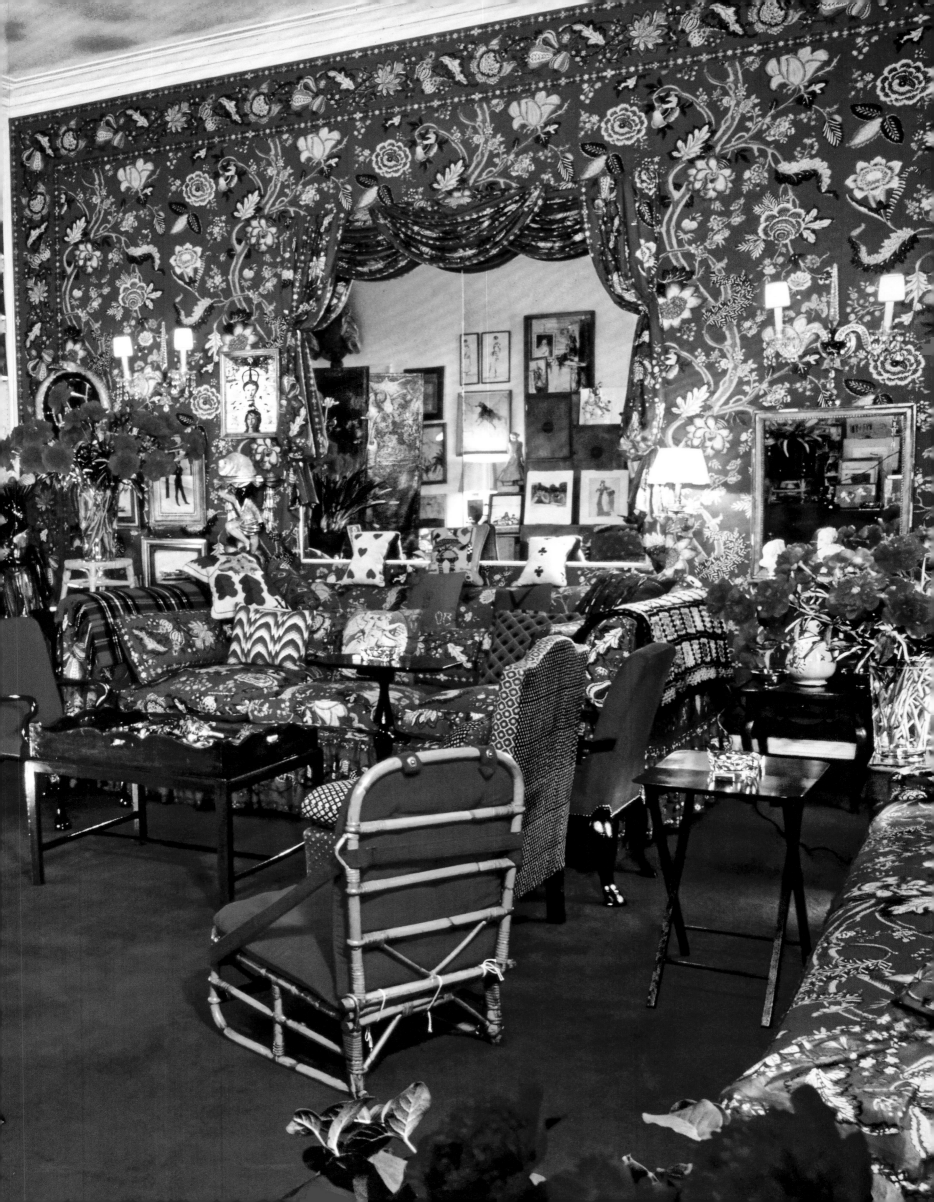

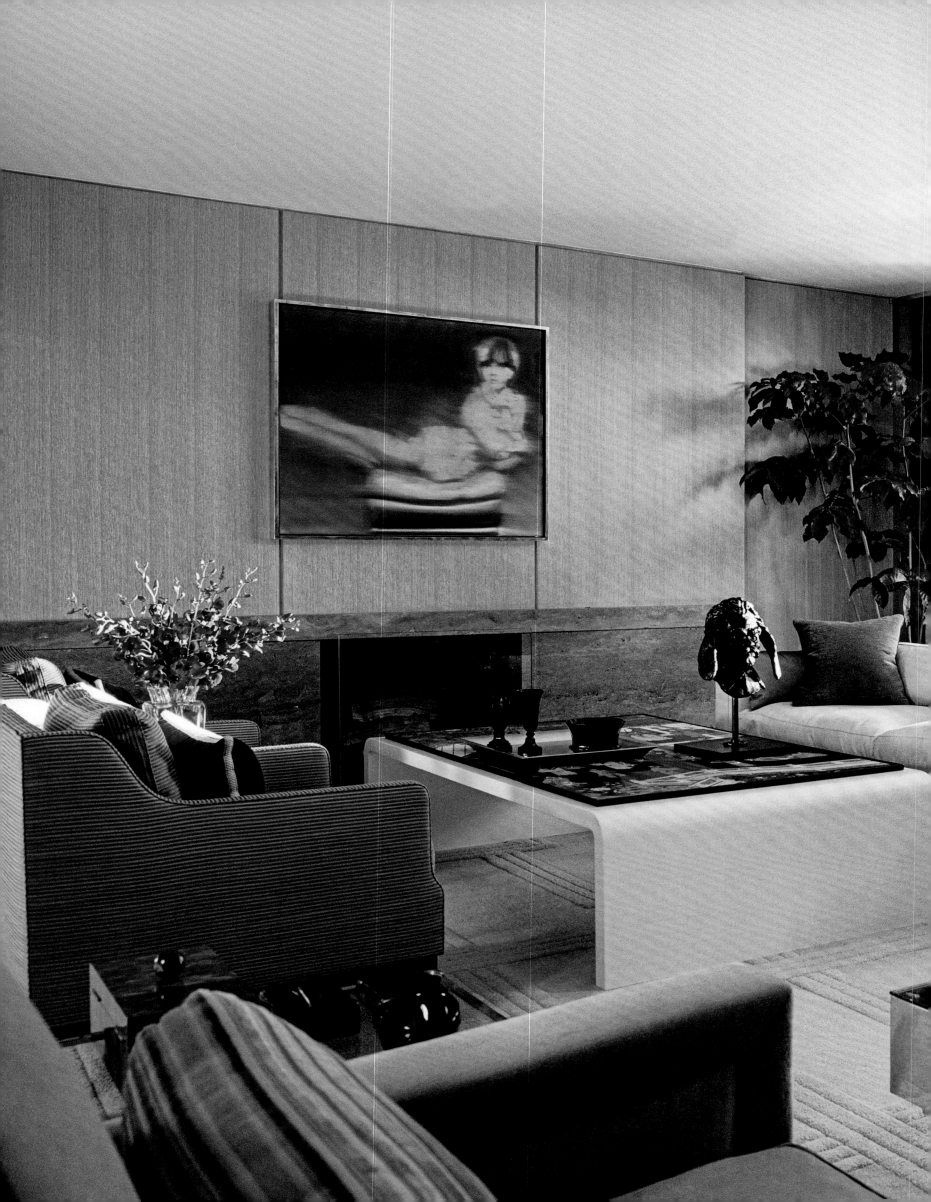

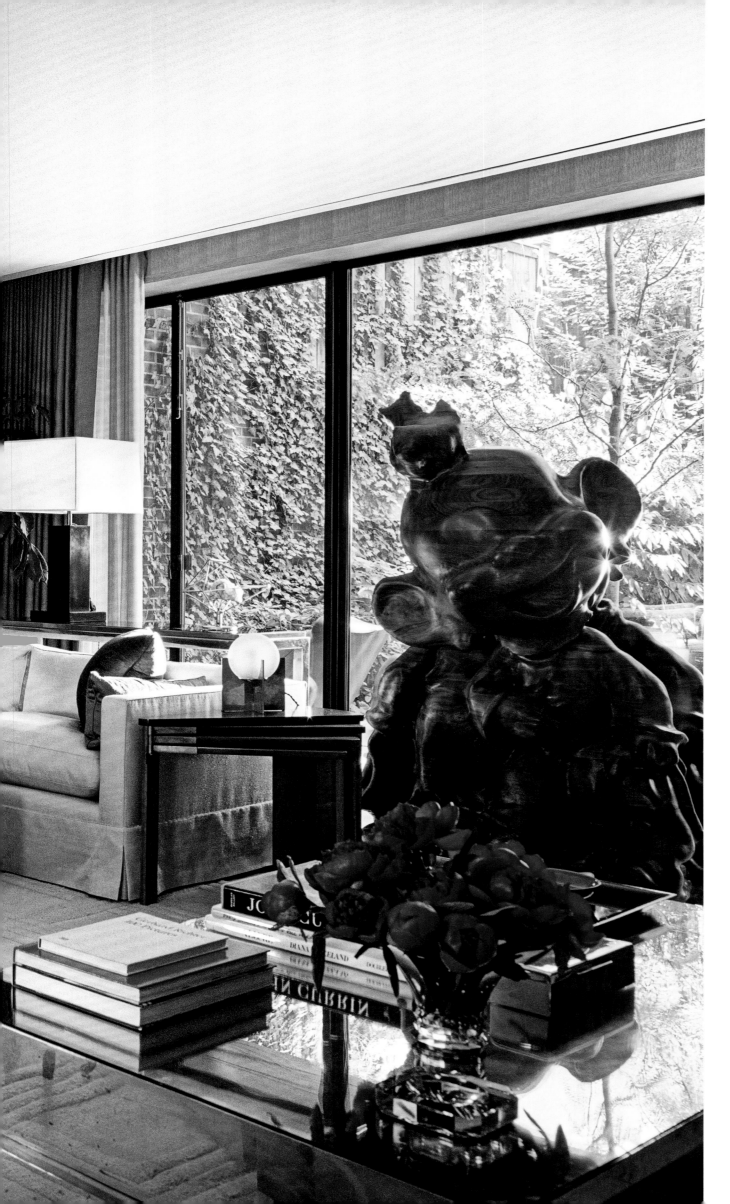

September 2016
Manhattan

HOMEOWNER
Marc Jacobs

Considering Jacobs's free-spirited temperament, one might reasonably expect his Manhattan home to be similarly irreverent, but it's quite the opposite. Impeccably composed and curated, the four-floor Greenwich Village townhouse—built by Andre Tchelistcheff Architects, and with interiors by Paul Fortune, John Gachot, and Thad Hayes—evokes an air of old-school chic, as in the television room anchored by a Gerhard Richter painting and a Paul McCarthy sculpture. "I'm not big on having a particular concept or look," Jacobs said. "I just want to live with things I genuinely love."

July 2012 | Punta Cana, Dominican Republic

HOMEOWNER Oscar & Annette de la Renta

The fashion designer, a noted green thumb, took great pride in the gardens he lovingly created in his home country, where he could often be found walking beneath blooming purple Petrea with his beloved canine companions. He referred to the grounds as a "small jungle" that effectively screened his entire compound from passersby. He almost exclusively planted native species here, benefiting from the experience of Sarah Bermúdez, an accomplished plantswoman from the city of Santiago de los Caballeros.

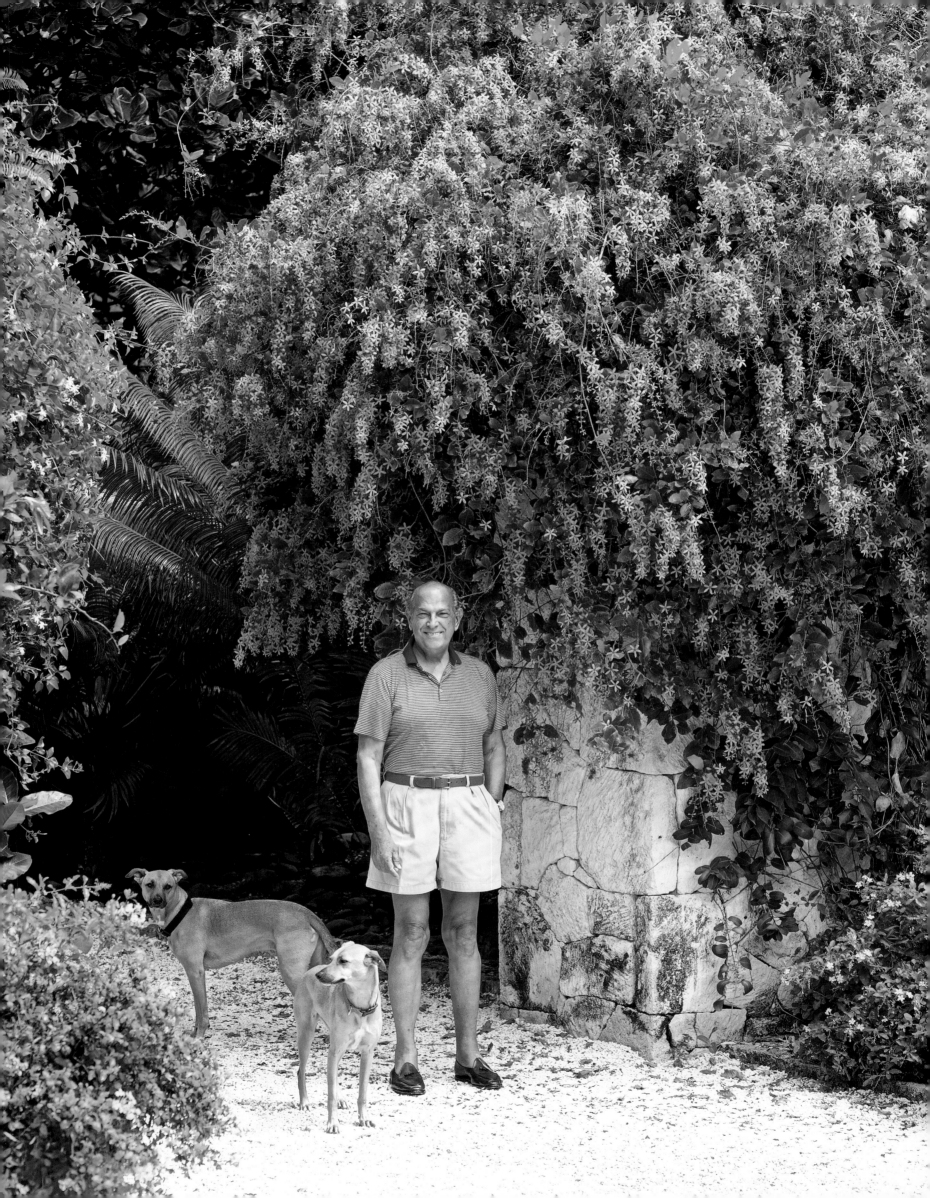

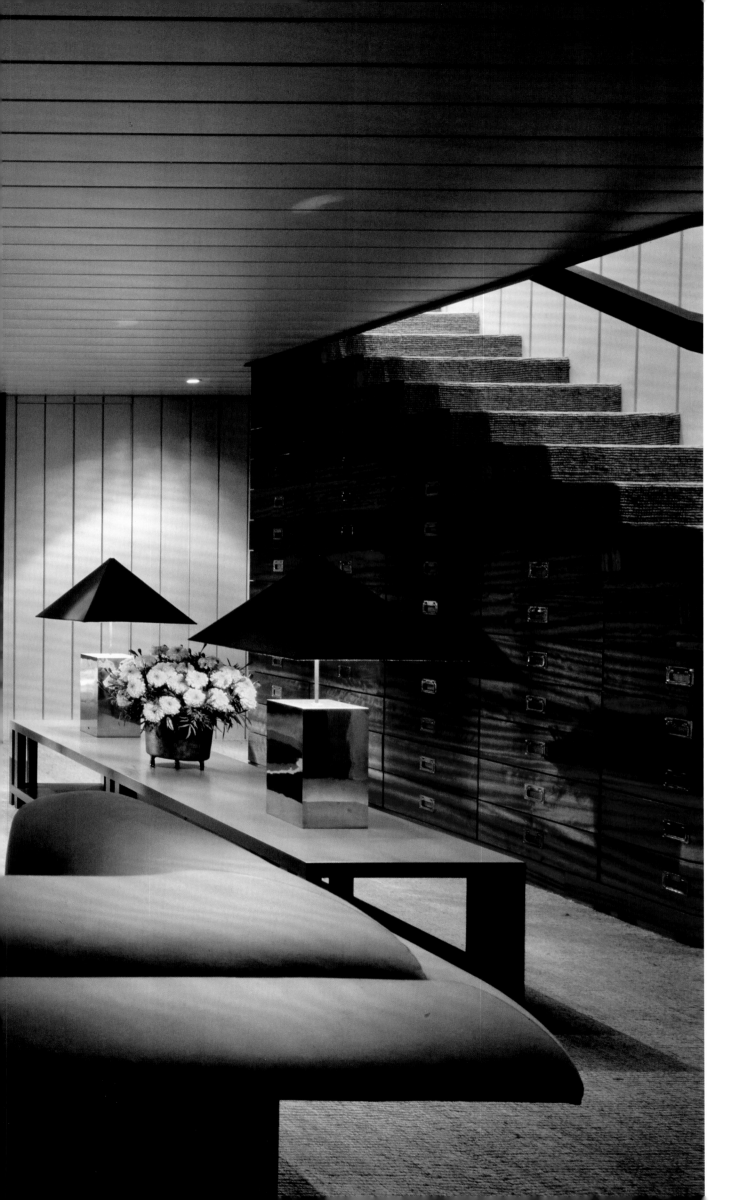

December 2004
Forte dei Marmi, Italy

HOMEOWNER
Giorgio Armani

"The house in Forte
was my first holiday
home . . . it holds a
special place in my heart,"
said Armani. "I decided
to decorate it with the
idea of creating a cabin
on the sea." While the
designer barely touched
the rustic exterior of his
two-story farmhouse,
the interiors got a modern-
ist update in the 1980s
that has proven timeless.
"I wanted a place where
you could walk barefoot
in the summer and sit
by a roaring fire in the
winter," he said.

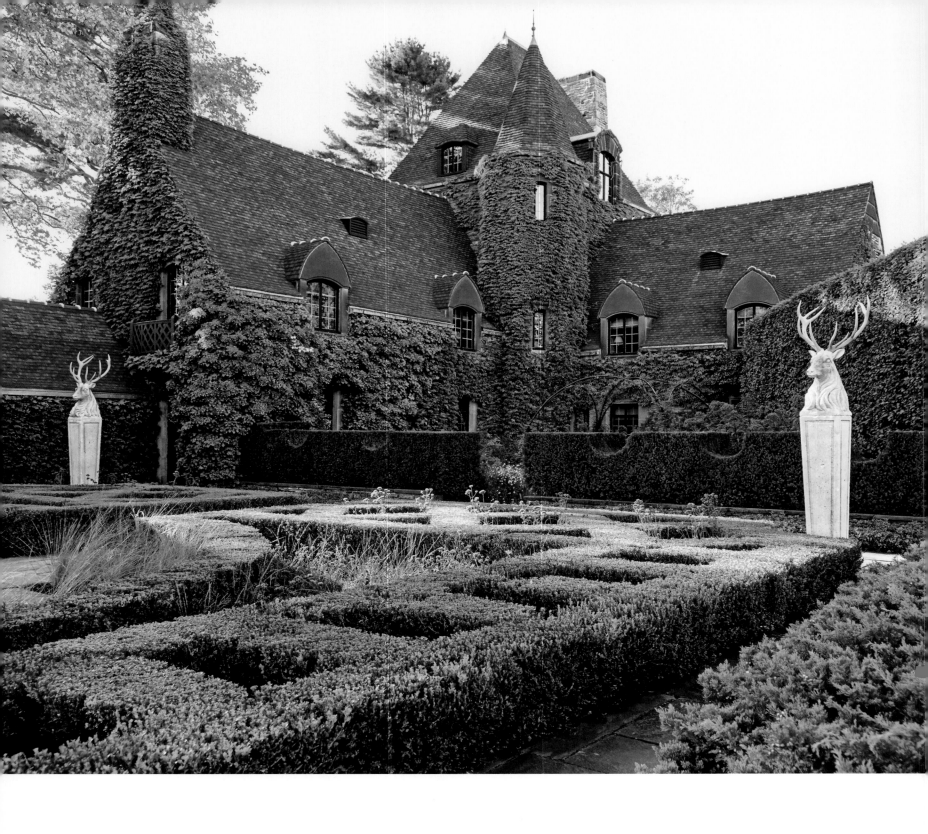

March 2017 | Greenwich, Connecticut

Round Hill HOMEOWNERS Tommy & Dee Hilfiger

Round Hill, née Château Paterno (named for the real-estate magnate Charles Vincent Paterno, who built it in 1939), was in a state of disrepair when Hilfiger and his wife, Dee, acquired it. Rather than Americanize the castle, they amplified the English manor-style architecture with decorator Martyn Lawrence Bullard and architect Andre Tchelistcheff. "We wanted to preserve that feeling of being in a European country home," Tommy noted. Miranda Brooks masterminded the landscape, and the baronial entry hall is outfitted with an antique iron chandelier and an 1840s Gothic Revival library table.

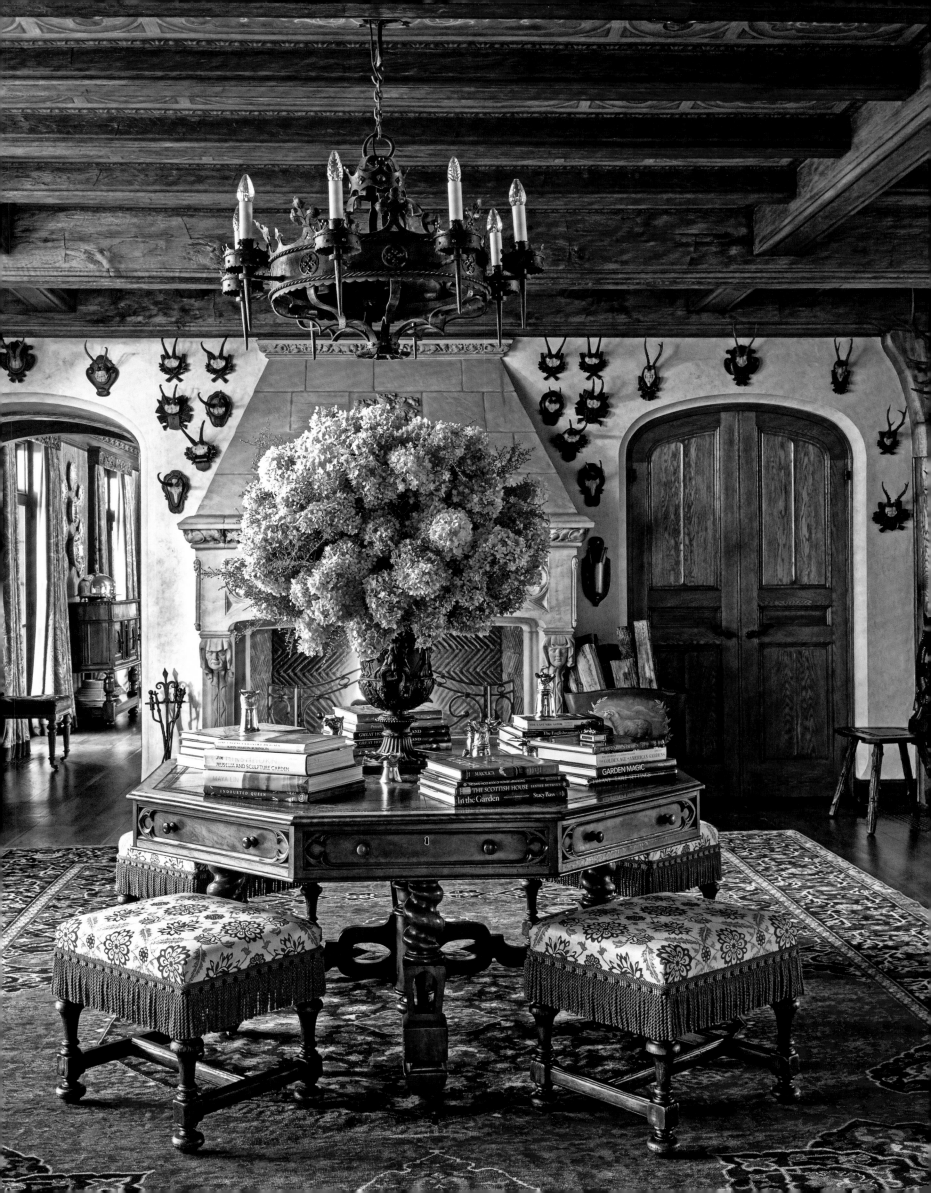

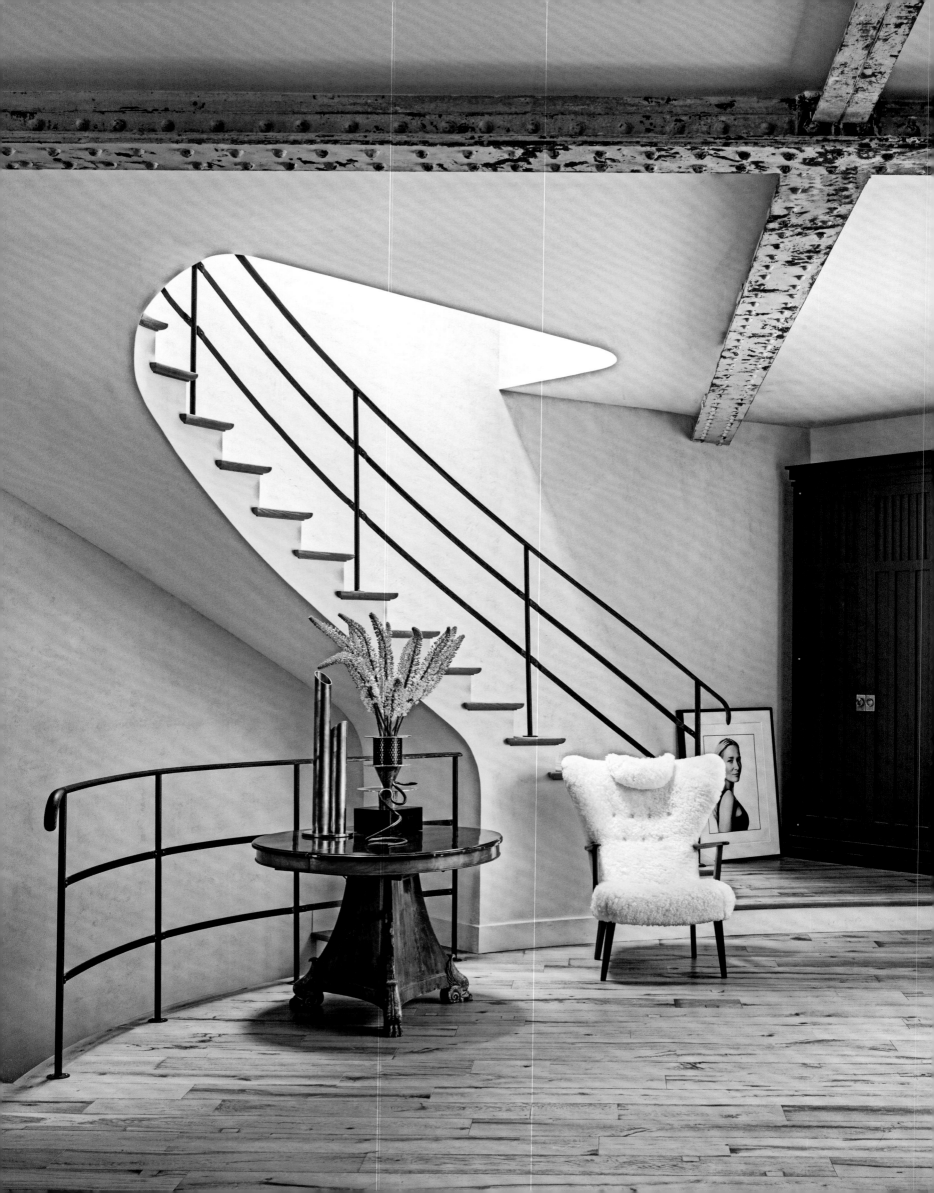

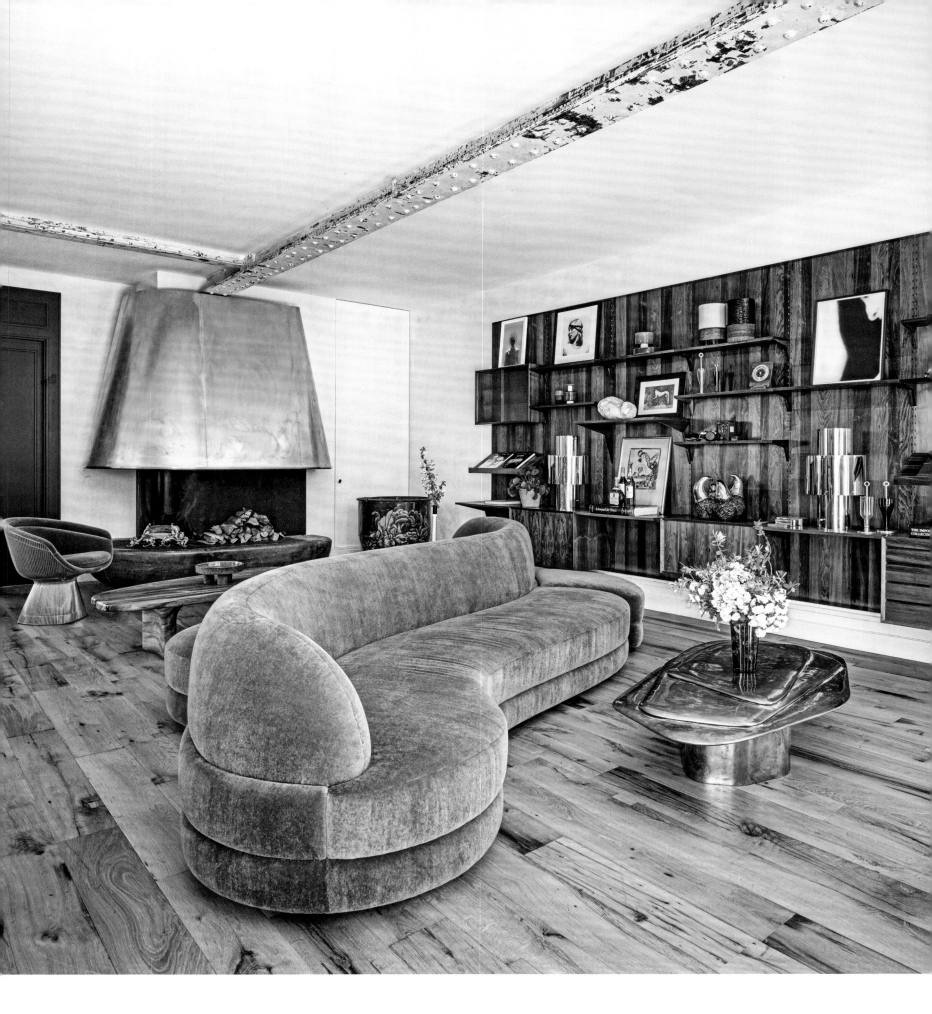

September 2018 | Paris

HOMEOWNER *Julie de Libran*

"It's quite industrial," said the Sonia Rykiel creative director of the home she designed with architect Charles Zana. "This is not the typical French architecture that you find in Paris." The loftlike space with exposed steel beams allows for plenty of sweeping design statements, like the wrought-iron stair rail created by artist Aurélian Raynaud, de Libran's cousin. In the living room, a custom sofa, patinated-bronze cocktail table, and brass fireplace hood, all by Zana, add formidable flair.

January 1994
Milan

Donatella
Versace

The fashion designer's
neoclassical apartment
fittingly showcases
many objets d'art that
her brother Gianni picked
out for her. Highlights
in the living room include
a pair of 19th-century
horses, a Roman terra-
cotta head on the low
table, and two bronzes,
*Allegory of Peace and
War,* under the painting
at right. "Don't ask me
about provenances," she
said. "I wouldn't know."

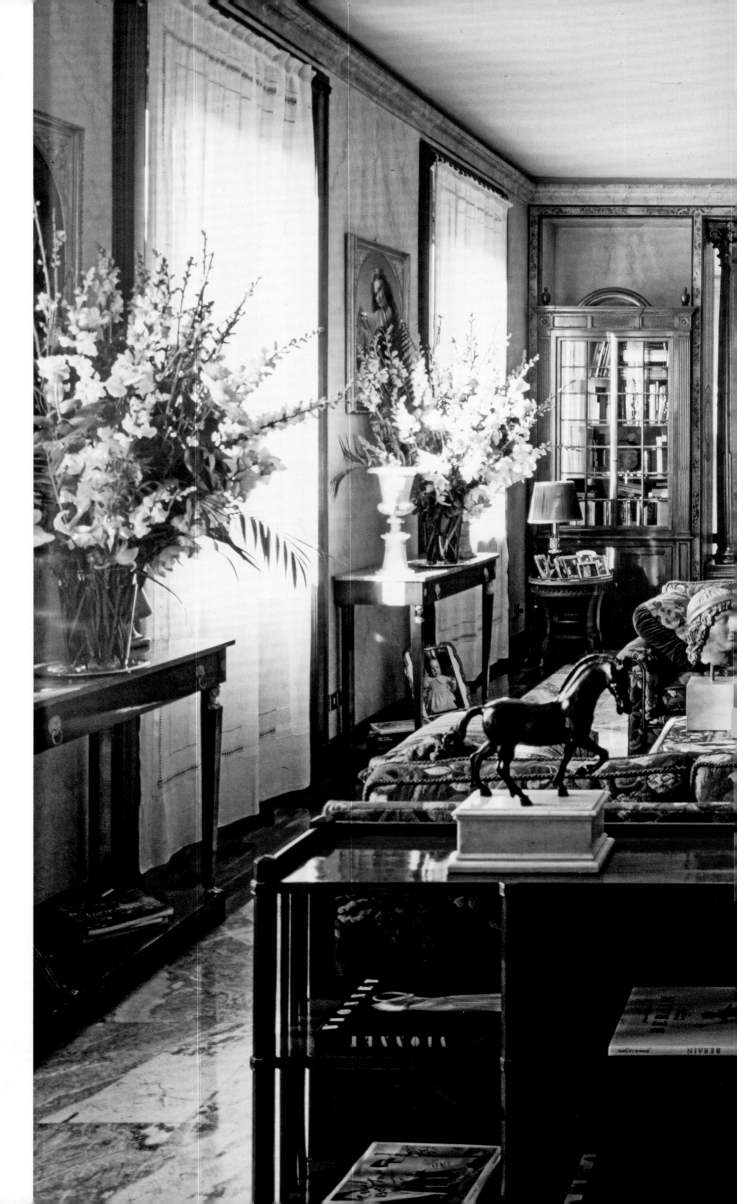

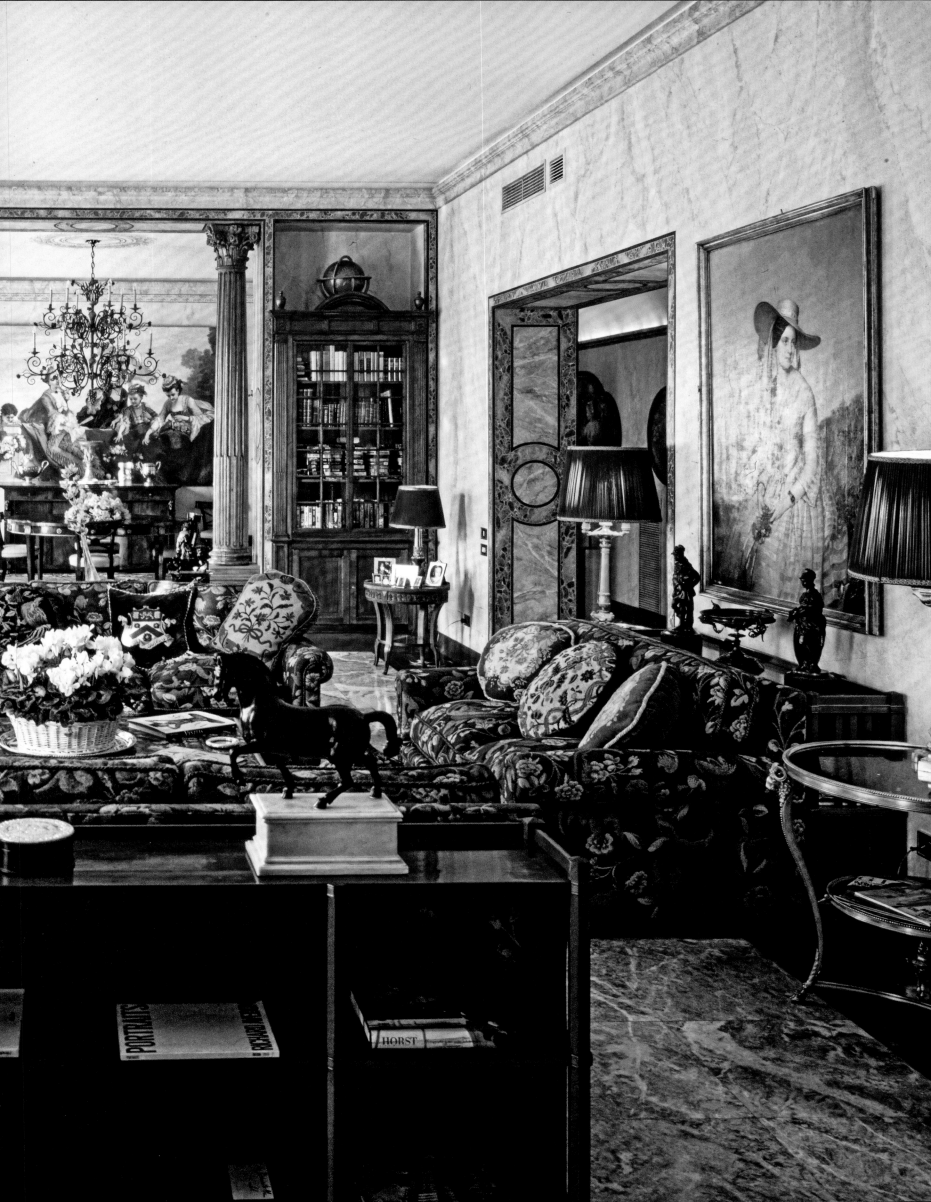

September 2018 | Manhattan

HOMEOWNERS Michael Kors & Lance Le Pere

"We wanted a casual formality, that tug-of-war between practicality and indulgence, comfort and rigor—if it's all one or the other, I'm bored," said Kors of his and his husband's airy Greenwich Village penthouse, which they designed with architect S. Russell Groves. Clean, neutral spaces highlight the spectacular views, as seen from the breakfast room and on the lush wraparound terrace. Noted Kors of the urban landscape just beyond: "It's a real indulgence. Space and light are the greatest luxuries in New York."

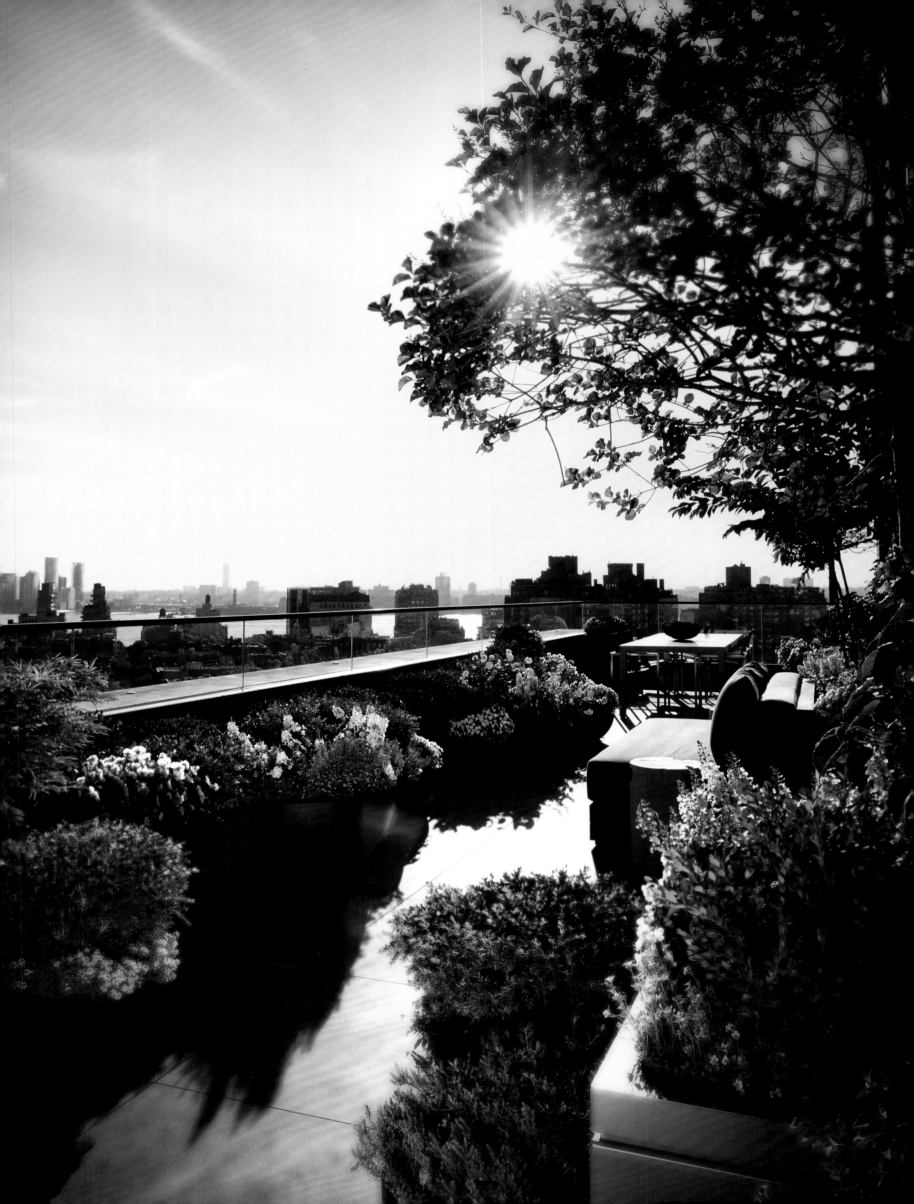

October 1990 | Paris

HOMEOWNER Kenzo Takada

"When I get nostalgic for Japan, I sleep in my little teahouse," Takada said of his Parisian home away from home. He designed the hideaway with friend Xavier de Castella after spending years looking for a garden and house that, de Castella explained to *AD*, "were in no way heavy or bourgeois, yet big enough to satisfy Kenzo's need for breathing space, originality, and solitude." The designer was also wont to invite guests to don kimonos and indulge in proper Japanese dinners there.

October 1994 | Paris

HOMEOWNER Hubert de Givenchy

"I only like things that have the power to move me, to stimulate my emotions," Givenchy explained of his approach to decorating his homes. "I've never bought an object unless it had some kind of essential harmony in my eyes. I don't get lost in detail if I can help it; I just seek a kind of overall visual equilibrium. The same goes for couture." Paneled in rococo boiseries by carver Nicolas Pineau, the main salon also boasts a Louis XVI fire screen with a Saint-Louis blue-crystal panel, a pair of Louis XV fauteuils by Cresson, and a Louis XV Savonnerie carpet.

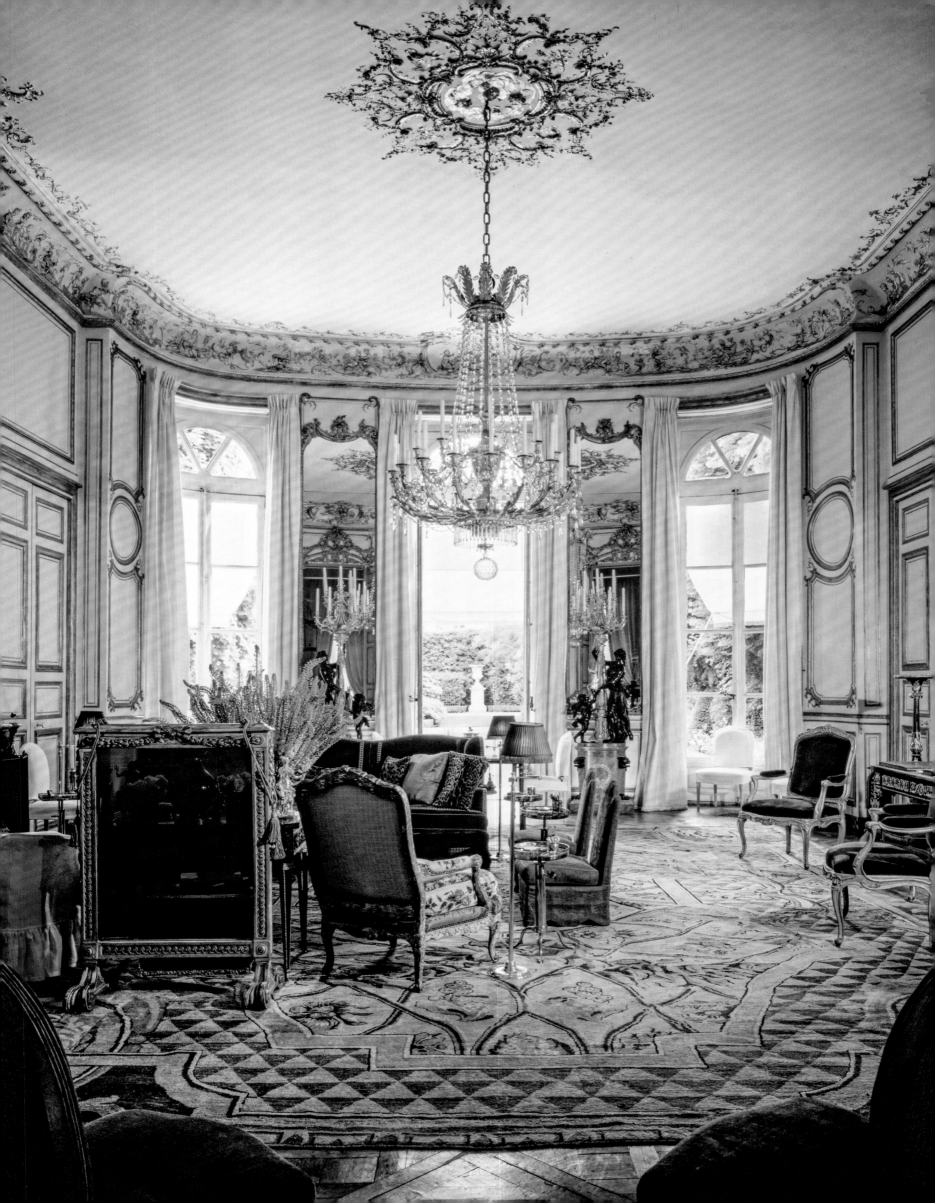

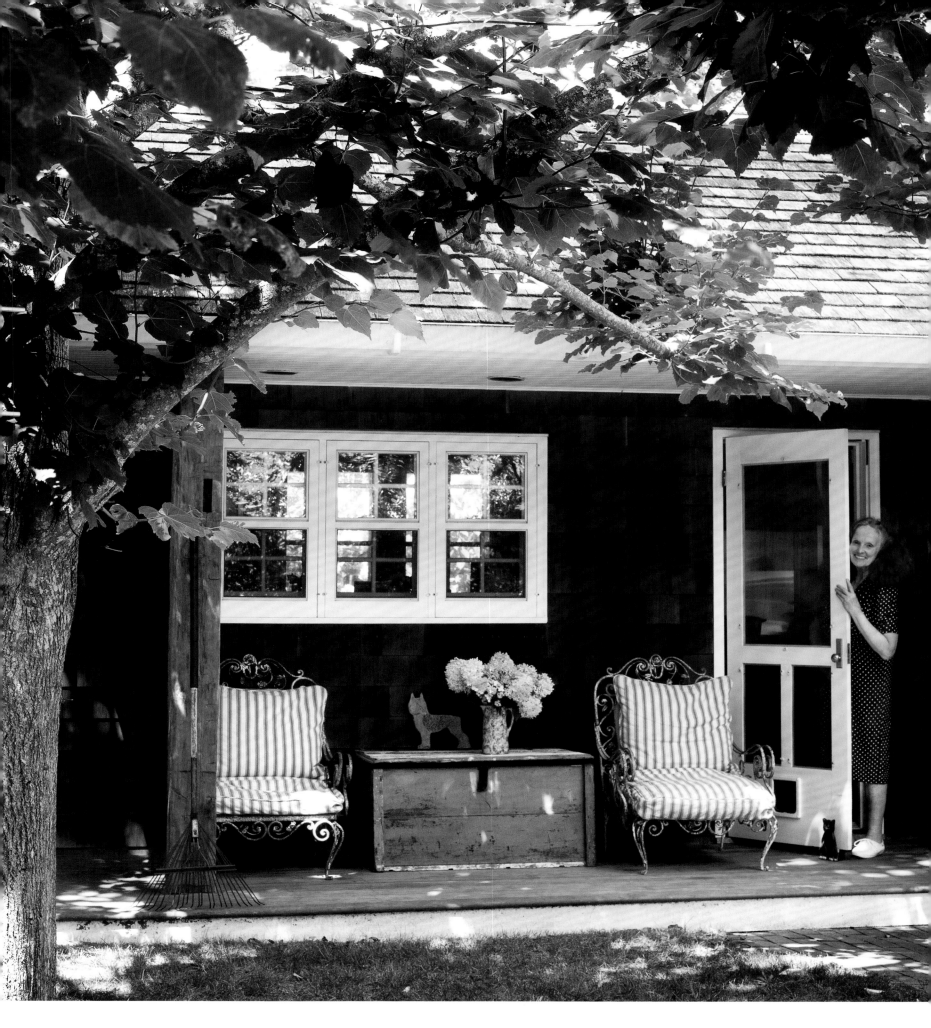

September 2018 | East Hampton, New York

HOMEOWNERS *Grace Coddington & Didier Malige*

"It's not very proper; it's just very comfortable," the longtime *Vogue* editor said of her charmingly laid-back Wainscott cottage, which she and her hairstylist partner share. "It's just a place where you can come in and throw yourself on the sofa and put your feet up." A sense of Coddington is felt throughout, evident in all the photos, books, and curiosities on display. "This home isn't actually designed," she said. "It's just full of stuff because my life is full of stuff—I can't help myself."

September 2017 | Manhattan

HOMEOWNER Alexander Wang

The fashion designer—with his miniature pinscher, Uni—perches on an Eric Schmidt table in front of a photograph by Steven Klein. Wang described the edgy, sophisticated space, which was designed by his longtime friend and collaborator Ryan Korban, as "50 shades of black."

April 1987 | Manhattan

HOMEOWNERS Carolina & Reinaldo Herrera

The Herreras had a rather unconventional request for designer Robert Metzger with regard to their Upper East Side townhouse. The tented dressing room, swathed in toile de Jouy, does double duty as a dining room for small dinner parties.

September 2017 | London

HOMEOWNER Kate Moss

The supermodel proved her sense of style extends beyond clothes when she opened the doors for *AD* to her London home, designed in collaboration with Katie Grove. "Picture a summer night when it goes silvery-blue from the light of the moon. I wanted that kind of film noir feel in here," she said of her master bath, which features curtains made of saris. To capture the mood of a "solarized Man Ray picture," Moss created a bespoke silver-tinted "Anemones in Light" dusk wallpaper with de Gournay, coupling it with a daybreak version to dress the hall where she is pictured.

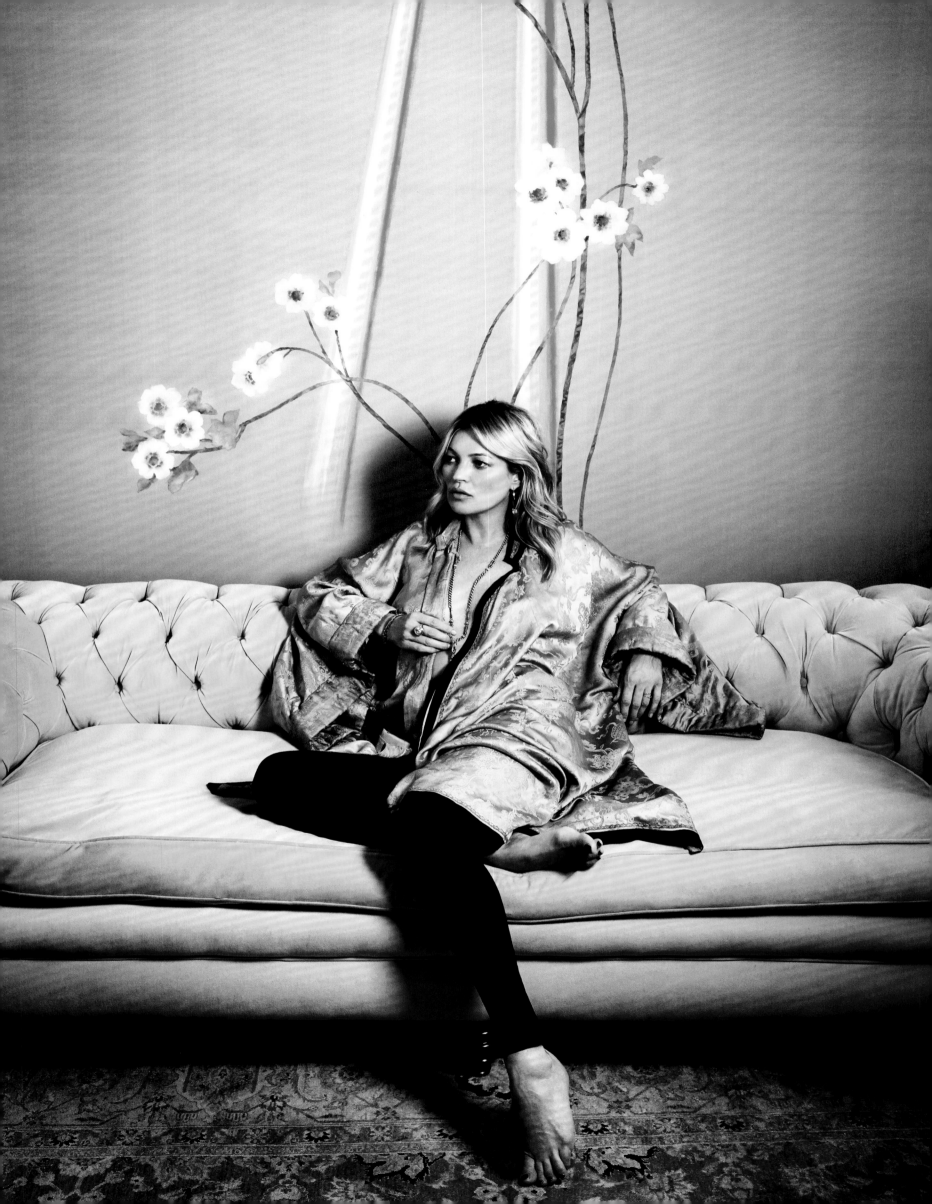

March 2013 | Manhattan

HOMEOWNER Diane von Furstenberg

Atop the six-story, 35,000-square-foot Meatpacking District building that comprises the designer's studio and flagship store sits the penthouse she calls home. Designed by WORKac, the residence doubles as a work space—the salon's Émile-Jacques Ruhlmann table is both desk and dining table—and is crowned by a glass-enclosed master suite. "When I was young, I lived like an old woman," she said. "And when I got old, I had to live like a young person."

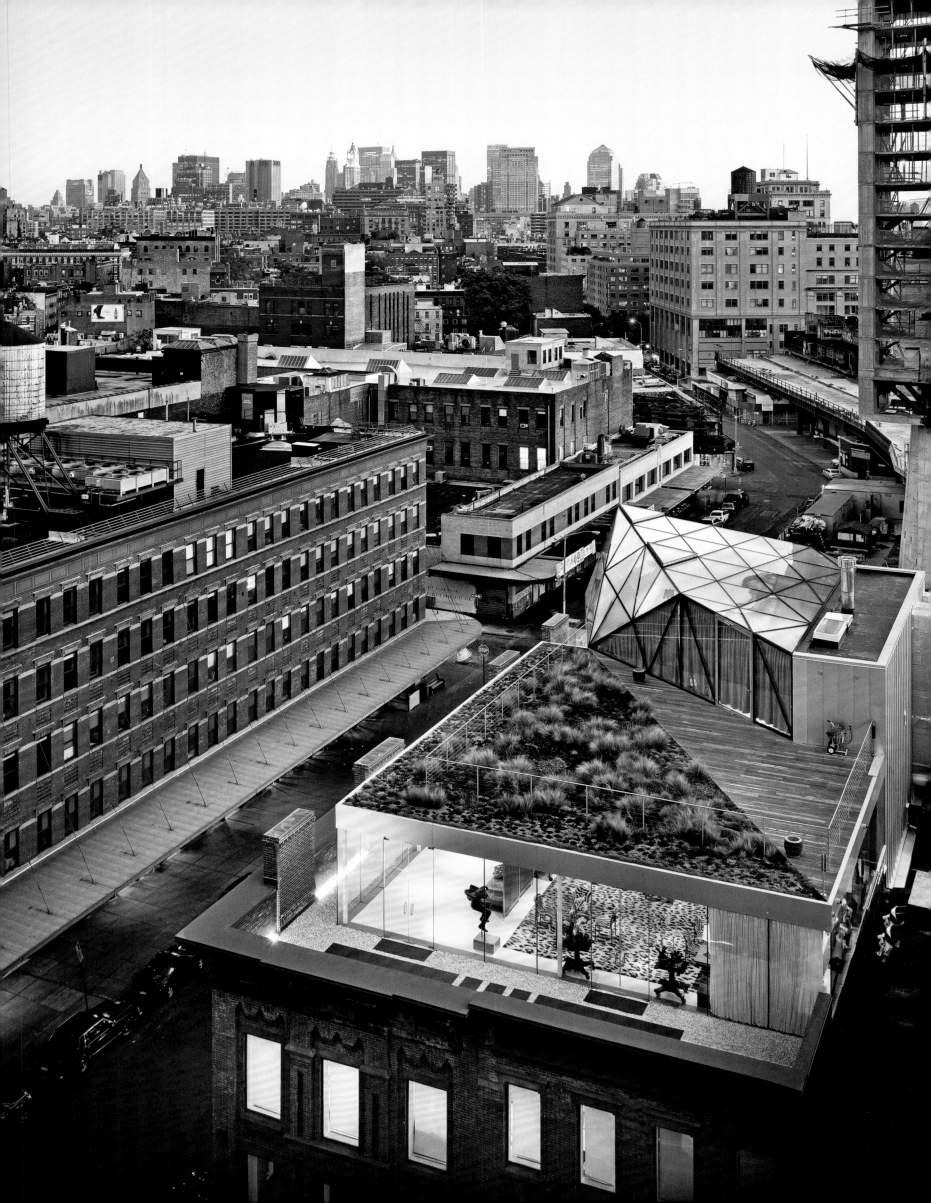

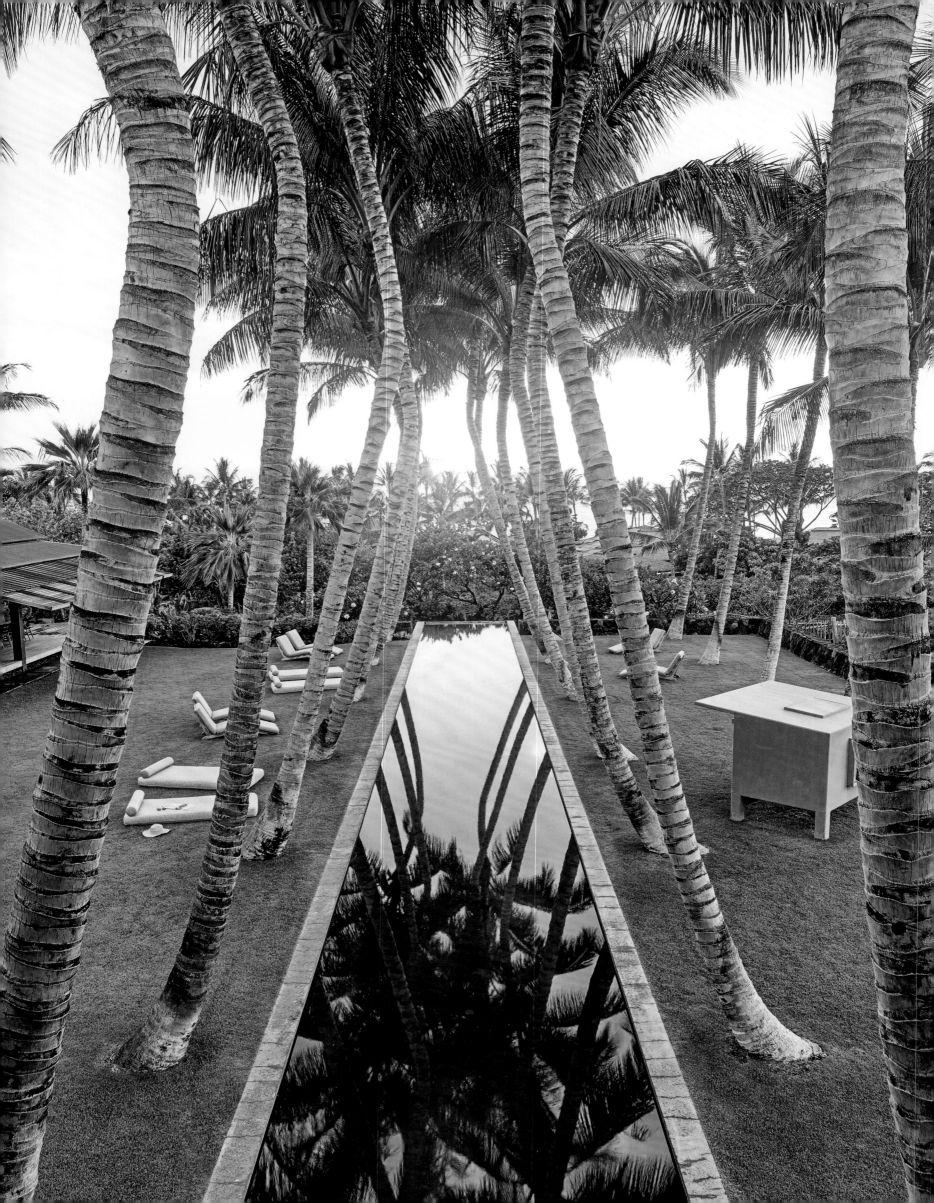

Olson Kundig
Rodman Primack
Legorreta
Ken Fulk
Jacobsen Architecture
Anderson Cooper
Jacques Grange
Michelle & Jason Rubell
François de Menil
Gwathmey Siegel & Associates
Isabel López-Quesada
Lyor Cohen & Xin Li
Leroy Street Studio
Jansen
Aerin Lauder
Truman Capote
Christoff:Finio

Coast

George Lindemann Jr.
Frank de Biasi
Foster + Partners
Valentine & Patrick Perrin
Robert A.M. Stern
Coco & Arie L. Kopelman
Ryan Murphy & David Miller
David Cafiero
Thomas Phifer
Marina & Björn Borg
Norman Jaffe
Merle Oberon & Bruno Pagliai
Joanne de Guardiola
Delphine & Reed Krakoff
Craig Robins & Jackie Soffer
Victoria Hagan

PREVIOUS SPREAD
For a house by
Olson Kundig and
RP Miller in Kona,
Hawaii, landscape
architect David
Tamura lined the
swimming pool with
naturally curving
palm trees (*AD*
January 2018; see
page 448).

GIVEN *ARCHITECTURAL DIGEST'S* days as Southern California's arbiter of design excellence and inspiration, it's no wonder that the magazine and its readers remain captivated by seaside housekeeping. The indoor-outdoor lifestyle that *AD*'s early articles celebrated—whether the house was a Georgian Revival mansion rising on a beach or a modernist glass box overlooking the sea—is a dream shared by many. Some imagine communing with the primeval, such as the majesty of a sun-spangled horizon or the clockwork rhythm of the tides. Others are more attracted to the relaxing of rules that coastal living suggests, like shrugging when upholstery comes into close contact with children clad in damp swimsuits.

Whether one's aesthetic desire is a shingled cottage, a hip bungalow, or a palatial villa, the natural world tends to rule when it comes to coastal decor. As a client of decorator *Markham Roberts* said of her fresh-faced Nantucket cottage—its rooms sprinkled with carved marsh birds, regional basketry, and artful allusions to the island's China Trade history—"Location matters; it matters a lot."

That being said, littoral acreage inevitably inspires fantasies of the far and away, giving homeowners a chance to build daydreams to live in, at least for periods of downtime. Hollywood actress *Merle Oberon* hired architect *Juan Sordo Madaleno* to construct a Moorish-modern pleasure dome on the Bay of Acapulco. *Anderson Cooper*, of journalism fame, decamps to a virtual tree house when he heads down to Trancoso,

Brazil, courtesy of designer *Wilbert Das*. Out on Long Island, *Peter Marino* assembled a well-traveled client's collections into a cottagey retreat where the doors open to reveal interiors with global vision, in which the daydreams of the Middle East meet the era of the maharajas. *Countess di Misurata's* idea was a Greek temple overlooking a desolate Italian beach—and that's precisely the staggeringly beautiful magnum opus that architect *Tomaso Buzzi* delivered.

Villa Fiorentina, one of the French Riviera's legendary estates, has been shaped by multiple talents since its 1914 inception, including architects *Gaston Messiah* and *Henri Delmotte* and landscape gurus *Harold Peto, Ferdinand Bac,* and *Russell Page. AD* visited the property in 1999, shortly before it was sold, recording the iconic decor that *Billy Baldwin* had created nearly 30 years earlier for the American power couple *Mary Wells Lawrence* and *Harding Lawrence.*

One of the most cutting-edge coastal fantasies that *AD* has captured of late is arts patron *George Lindemann Jr.'s* shocking-pink getaway in Miami Beach. It's an eye-popping (and life-enhancing) wonderland that he and designer *Frank de Biasi* outfitted with sinuous, colorful, and cartoonish furnishings by *Mattia Bonetti, Wendell Castle,* and many more of the world's design provocateurs. Small wonder it fills the owner's young children with glee—and it's likely sui generis, too. Said Lindemann with a smile, "I think we created our own new style." ▲D

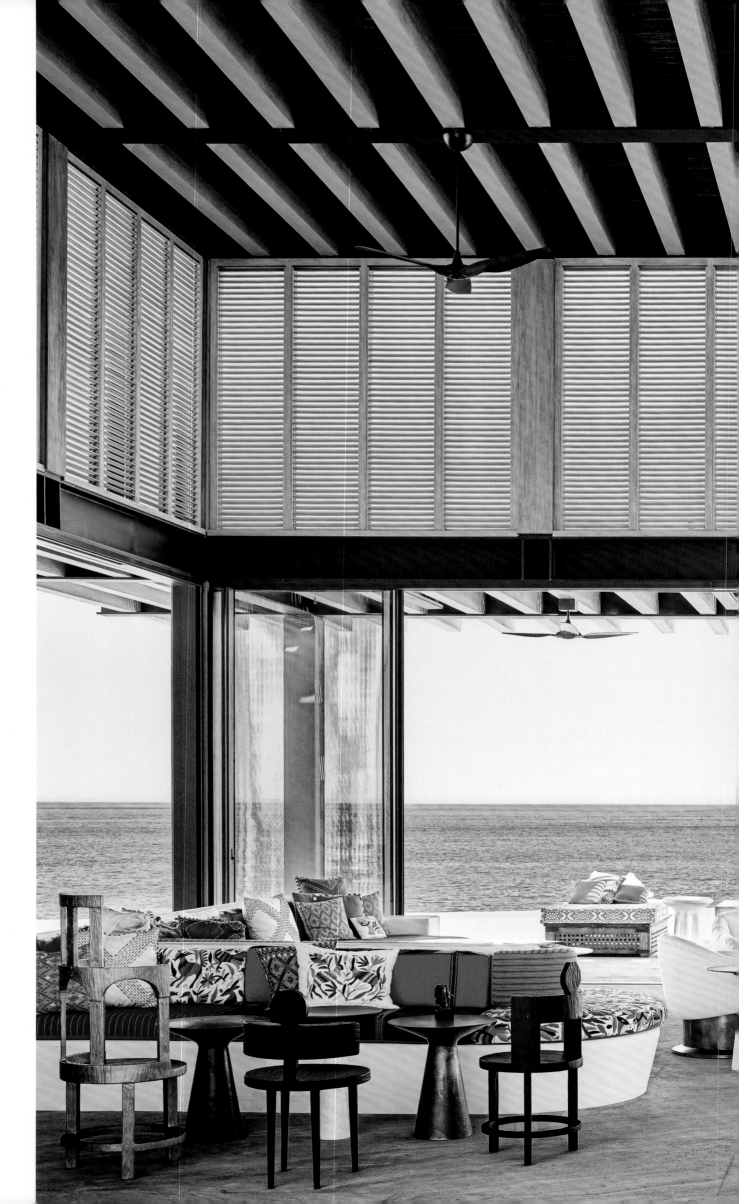

November 2018
Cabo San Lucas, Mexico

ARCHITECT
Legorreta
DESIGNER
Ken Fulk Inc.

"Ultimately, it was about more than simply building a beautiful house," said Fulk, who collaborated with Victor Legorreta on the project. "It was about setting the stage for experiences." The double-height living room, shielded from direct sunlight by shutters, opens to a terrace where the infinity pool has been painstakingly tinted to match the blue waters of the Sea of Cortez.

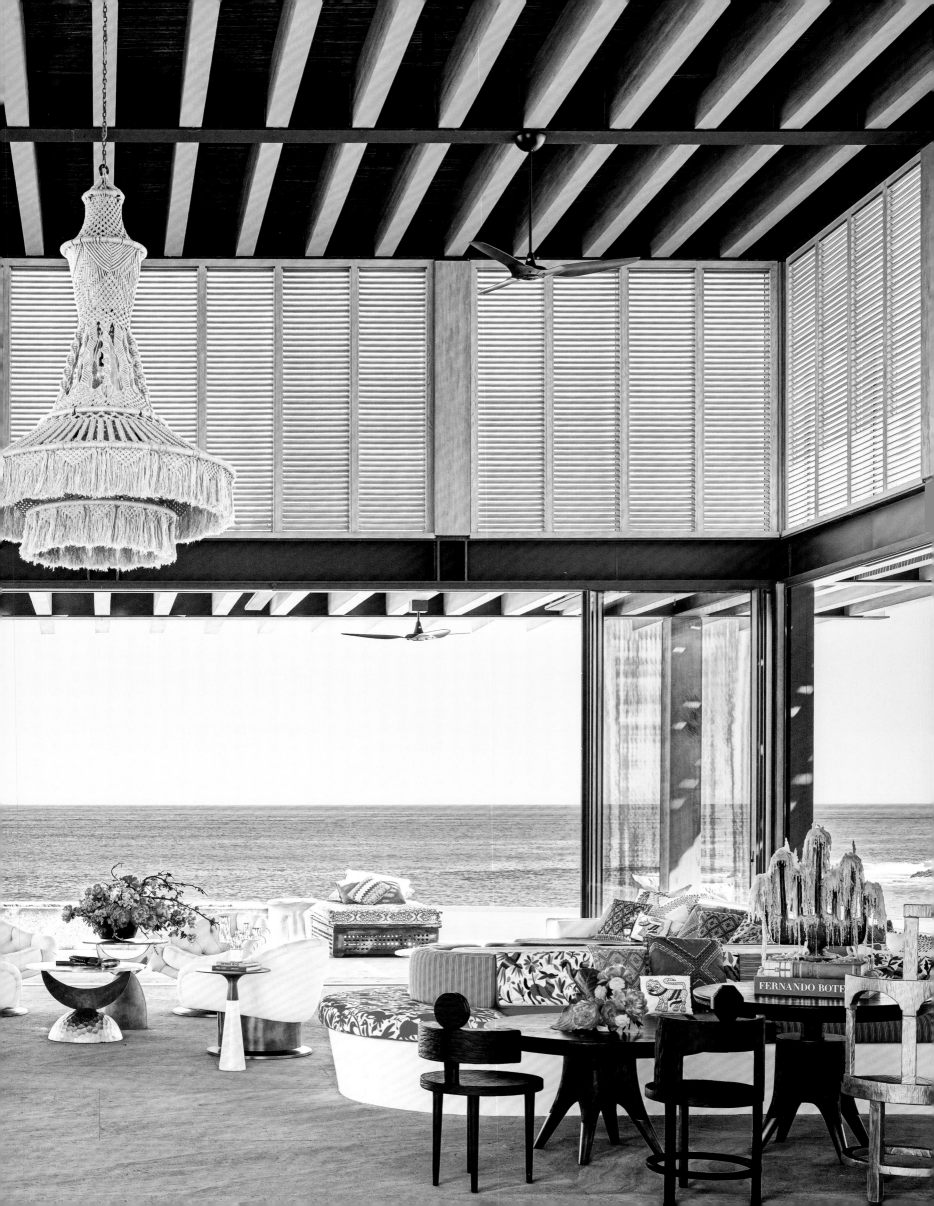

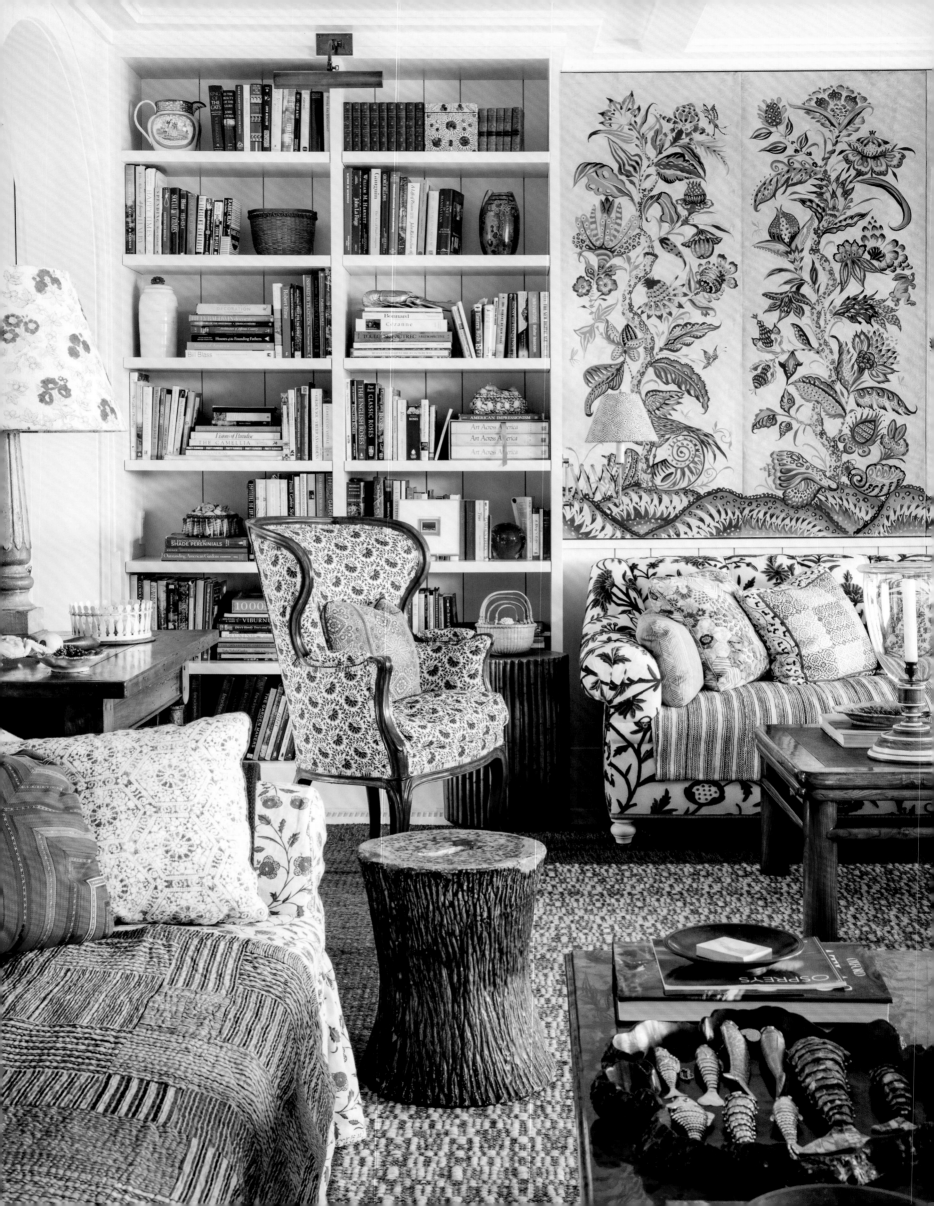

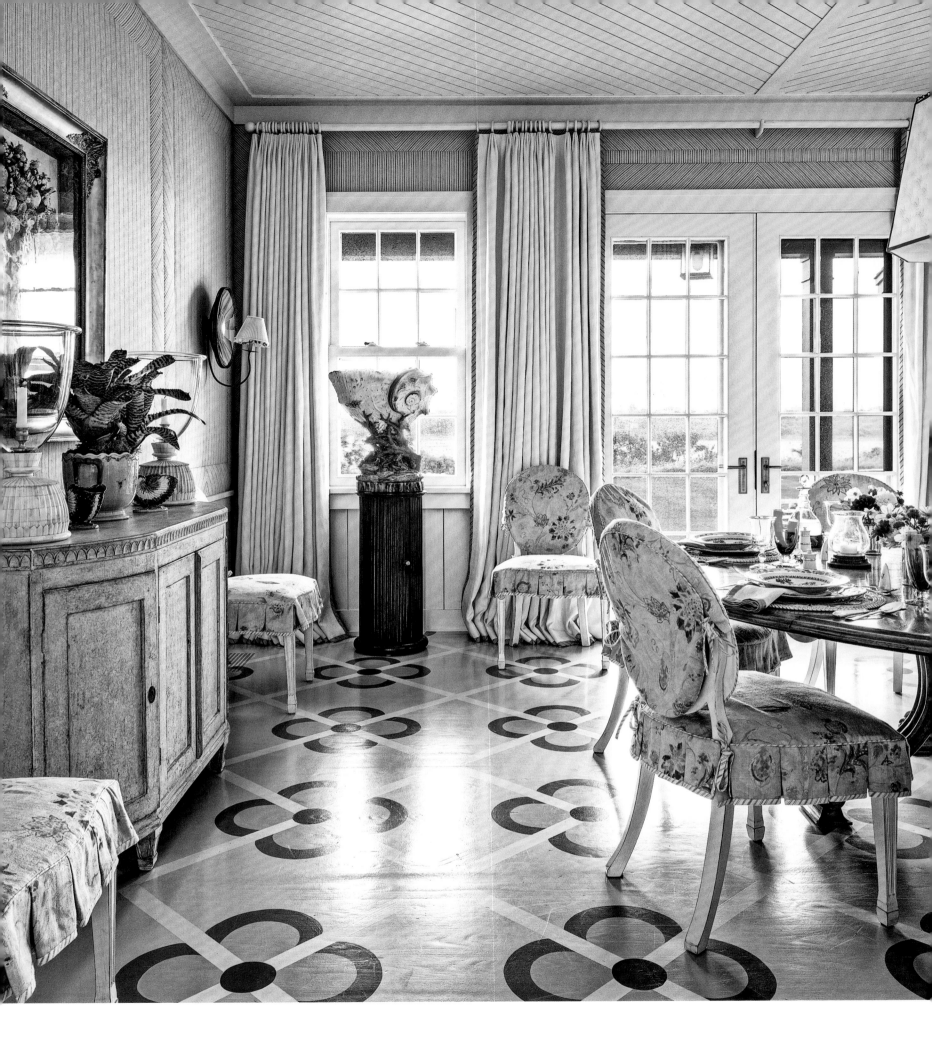

June 2018 | Nantucket, Massachusetts

DESIGNER Markham Roberts

"I wanted old, I wanted detail, I wanted this place to feel like my grandmother's house," the homeowner said of her rooms, where flowers—stenciled, printed, embroidered—run riot, notably in the living room's hand-painted wall panels and the giant daisy-like quatrefoils (also painted) on the dining-room floor. It's like living in an herbaceous border, right down to the artful evocations of nature, from a stump stool to a nautilus sculpture.

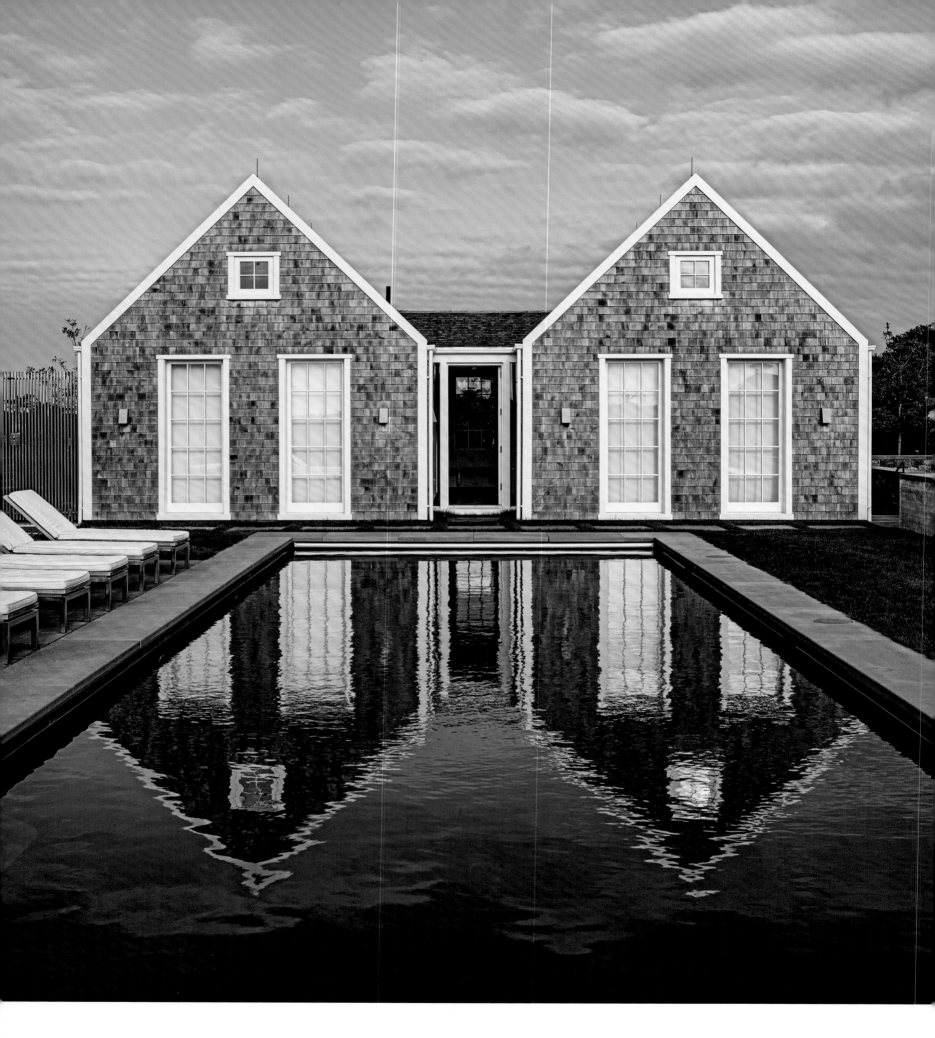

June 2014 | Nantucket, Massachusetts

ARCHITECT Jacobsen Architecture

"By code, buildings can basically be one of three shapes: gable, saltbox, or barn," said Simon Jacobsen, who took those local limitations as a challenge when creating a house for entrepreneur Donald Burns. Thus, a hamlet of small structures that are all vernacular charm on the outside and crisply modern within.

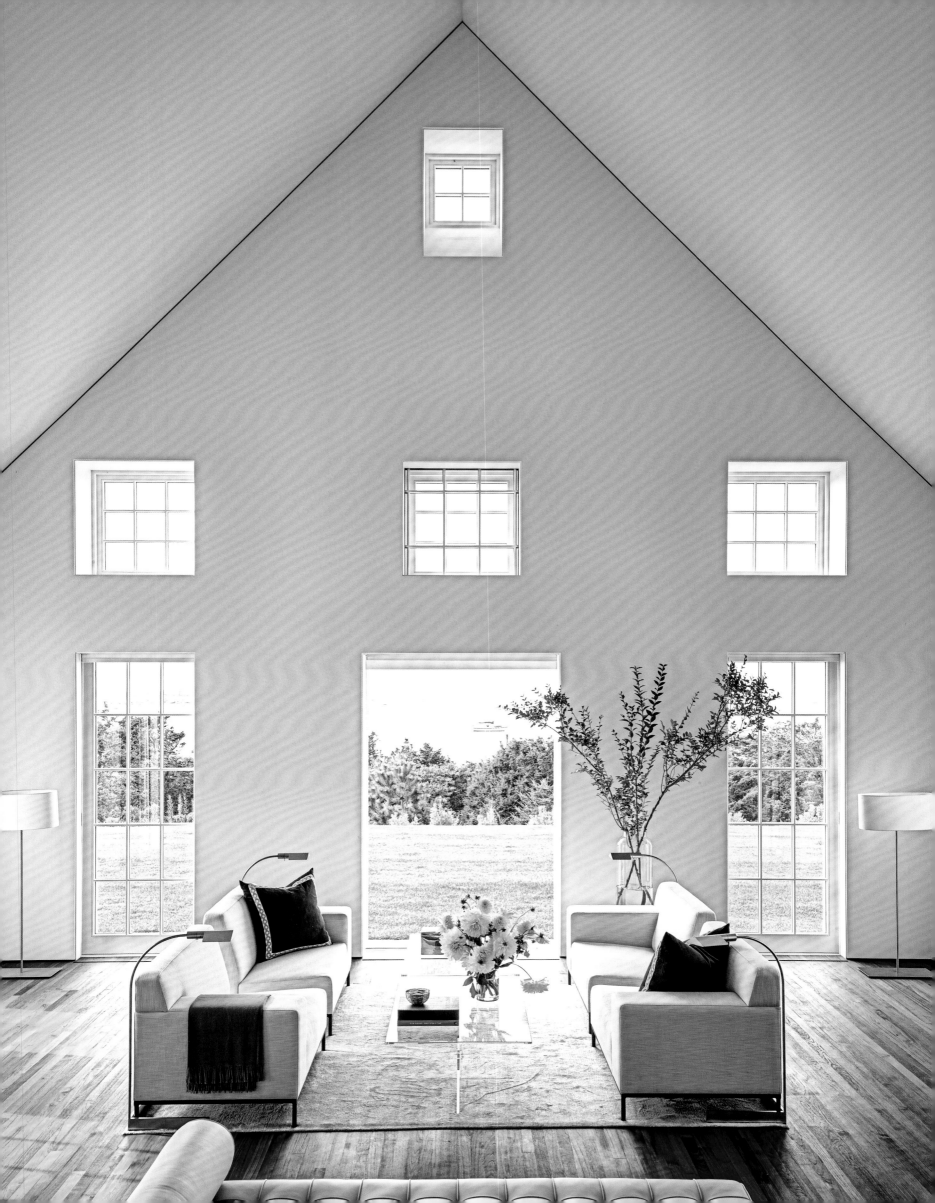

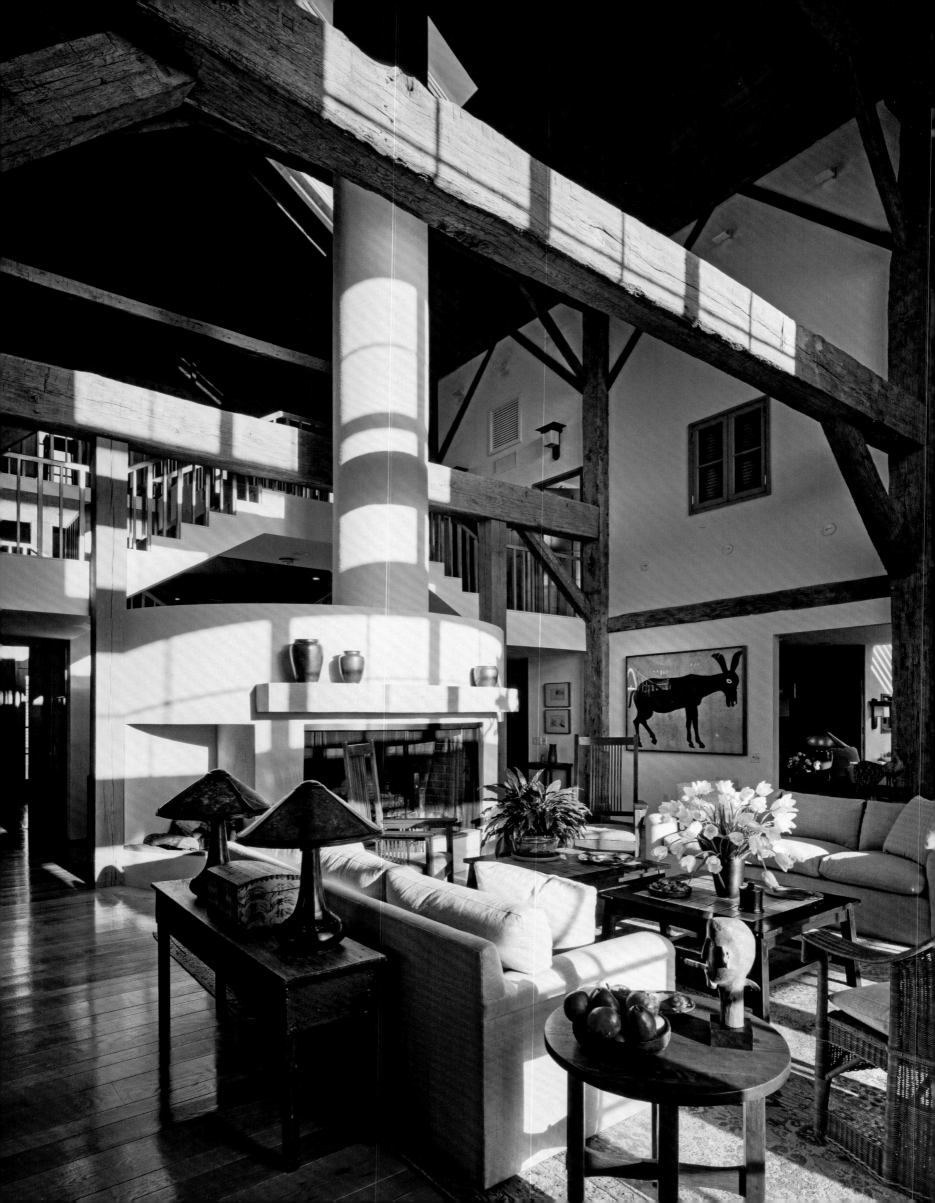

May 1988 | East Hampton, New York

HOMEOWNERS Steven Spielberg & Amy Irving

"The fireplace creates a sculptural object in the living room, where the existing structural frame and roof remain visible," said architect Charles Gwathmey of the warmly rustic residence that he conjured for the director and actress out of a 1790s Pennsylvania barn ("a found object," he called it). Decorator Courtney Sale Ross filled the lofty living room with Arts and Crafts treasures by august names such as Stickley, Vollmer, and Dirk Van Erp.

August 2016 | Trancoso, Brazil

HOMEOWNER Anderson Cooper

"I didn't want the place to look fancier than the other buildings in town," the journalist said of his wattle-and-daub vacation home in Trancoso, a town some 600 miles up the coast from Rio de Janeiro in the state of Bahia. (The door-to-door journey from his Manhattan home base is 14 hours.) Created by designer Wilbert Das, the house is embowered in a jungle landscape by Juliana Favarato.

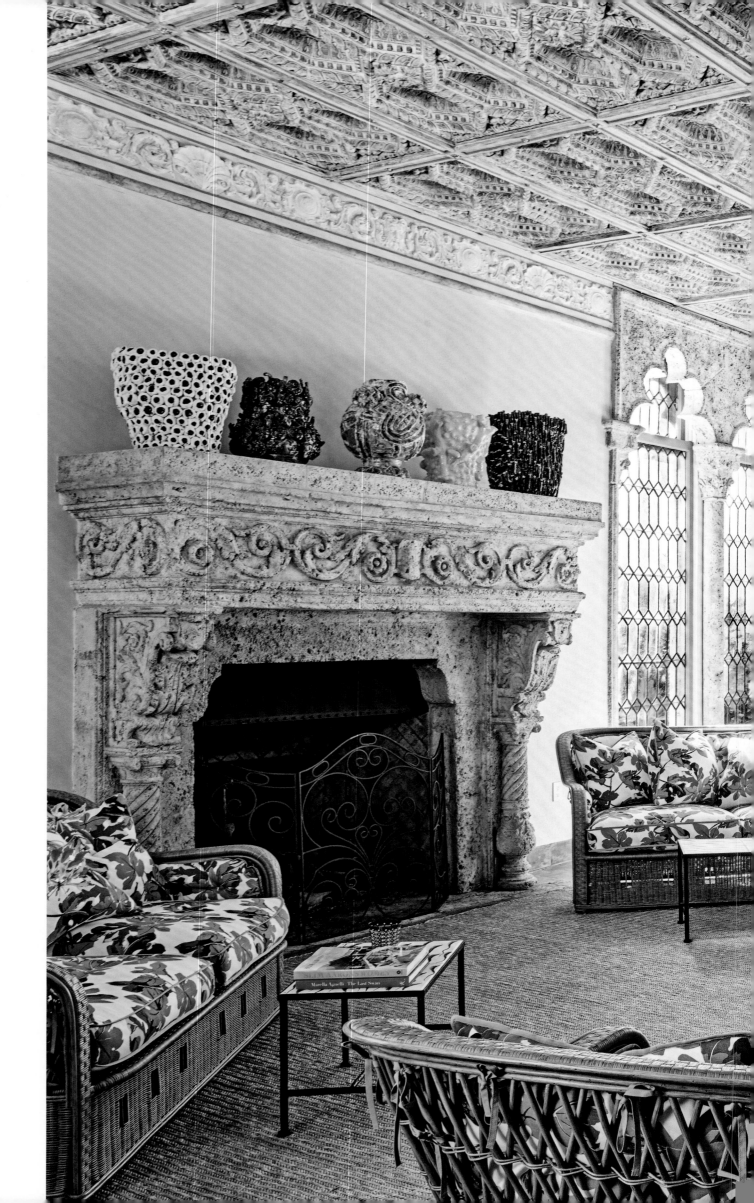

May 2018
Palm Beach, Florida

ARCHITECT
John L. Volk &
Gustav Maass

DESIGNER
Jacques Grange

"The decor doesn't feel important," Grange said of his interiors for a 1930 Hispano-Moorish mansion by Volk and Maass. "It feels dégagé— relaxed and easy." The walled garden, a Nievera Williams project, inspired a living room that is enriched with foliage prints that seem to creep indoors like errant vines and blues that echo the water and ceramic features outside.

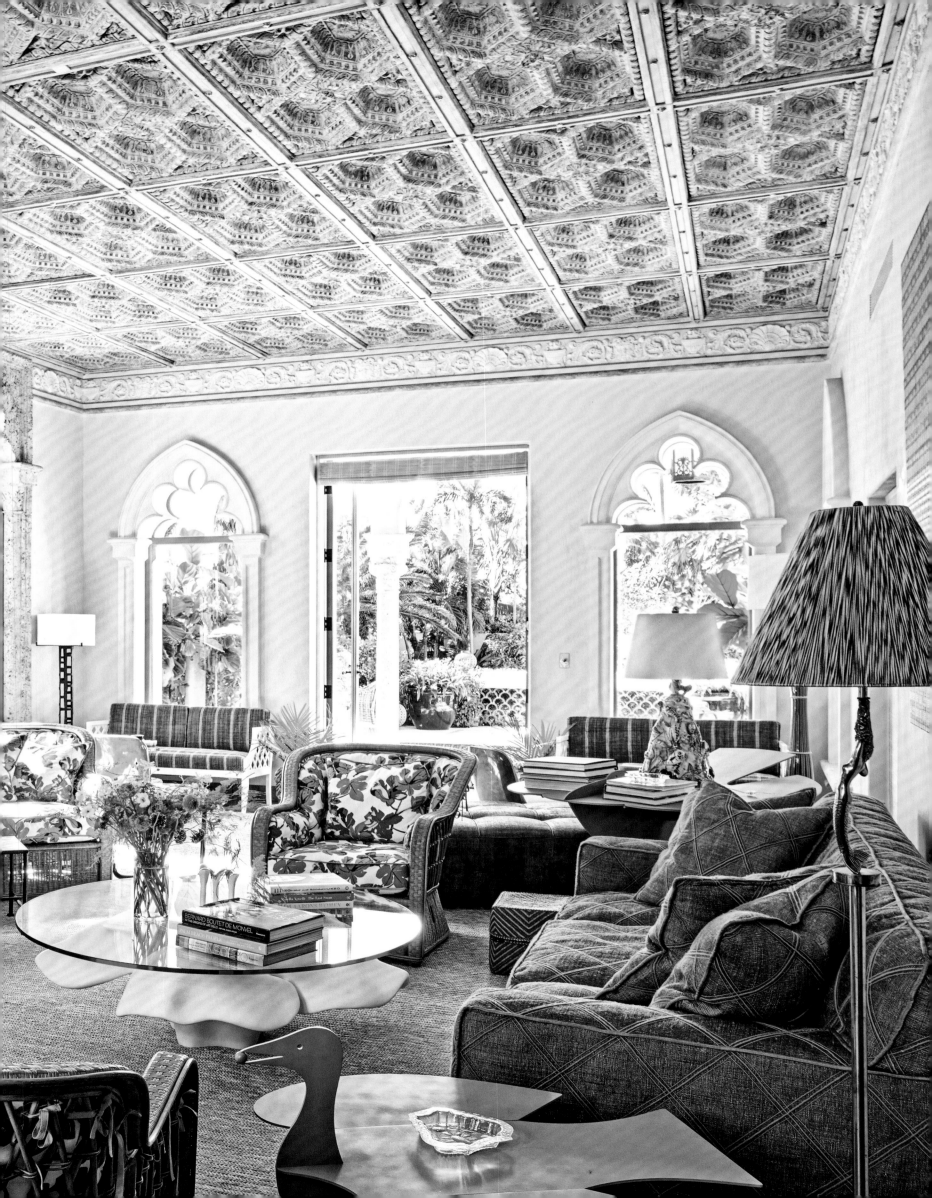

August 2017
Miami Beach

HOMEOWNERS
Michelle & Jason Rubell

The collectors' mod, board-formed concrete residence—which replaced their longtime Mediterranean Revival house on the same site—is "a celebration of the art and the family," said architect Francisco Llado Neuffer of Domo Architecture + Design, which conceived the house in collaboration with interior designer Austin Harrelson. Son Samuel Rubell sits in the open-air living room among sculptures by Guyton\Walker, Henry Taylor, and Aaron Curry; the painting is by Neo Rauch.

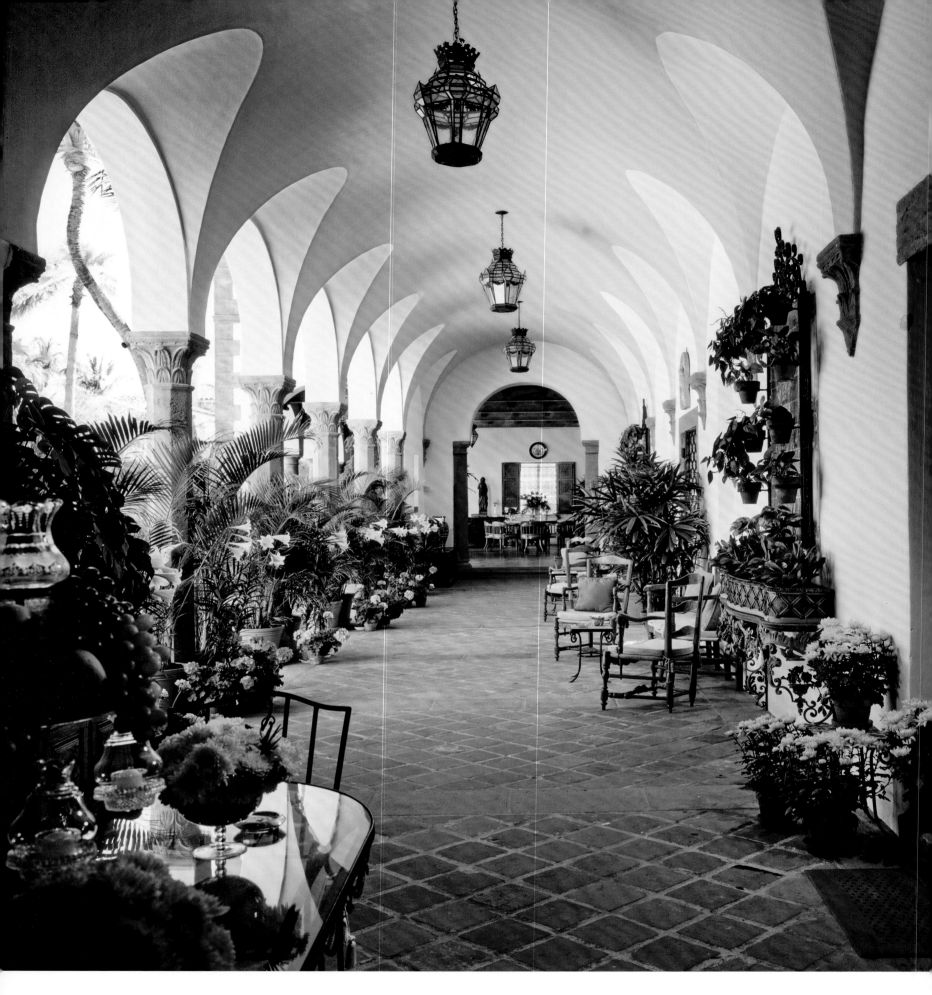

Fall 1968 | Palm Beach, Florida

Woolmar

HOMEOWNERS Mary Hartline & Woolworth Donahue

ARCHITECT Maurice Fatio

Antique French Provincial furniture and tropical plants live together beneath a dramatically vaulted loggia of Woolmar, the 1920s residence of the Woolworth heir and his wife, a former television star.

December 1983 | East Hampton, New York

HOMEOWNER François de Menil

ARCHITECT Gwathmey Siegel & Associates

The house for the art scion blends shipshape style with silvered wood and metal. Interior and exterior spaces are layered and interwoven—the terrace of the master bedroom functions as an outside room of sorts, and below it the screen doors of the first floor open the breakfast room to the outdoors.

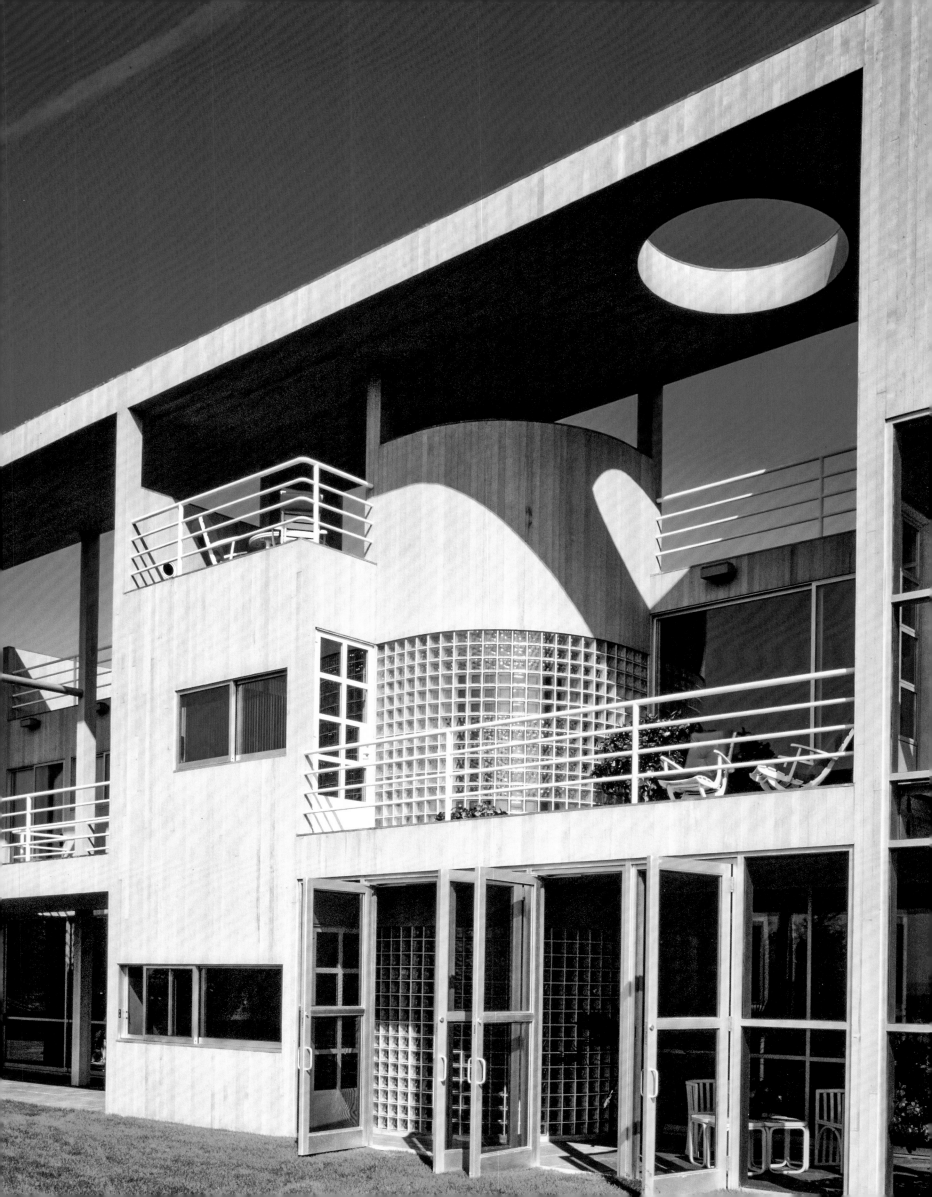

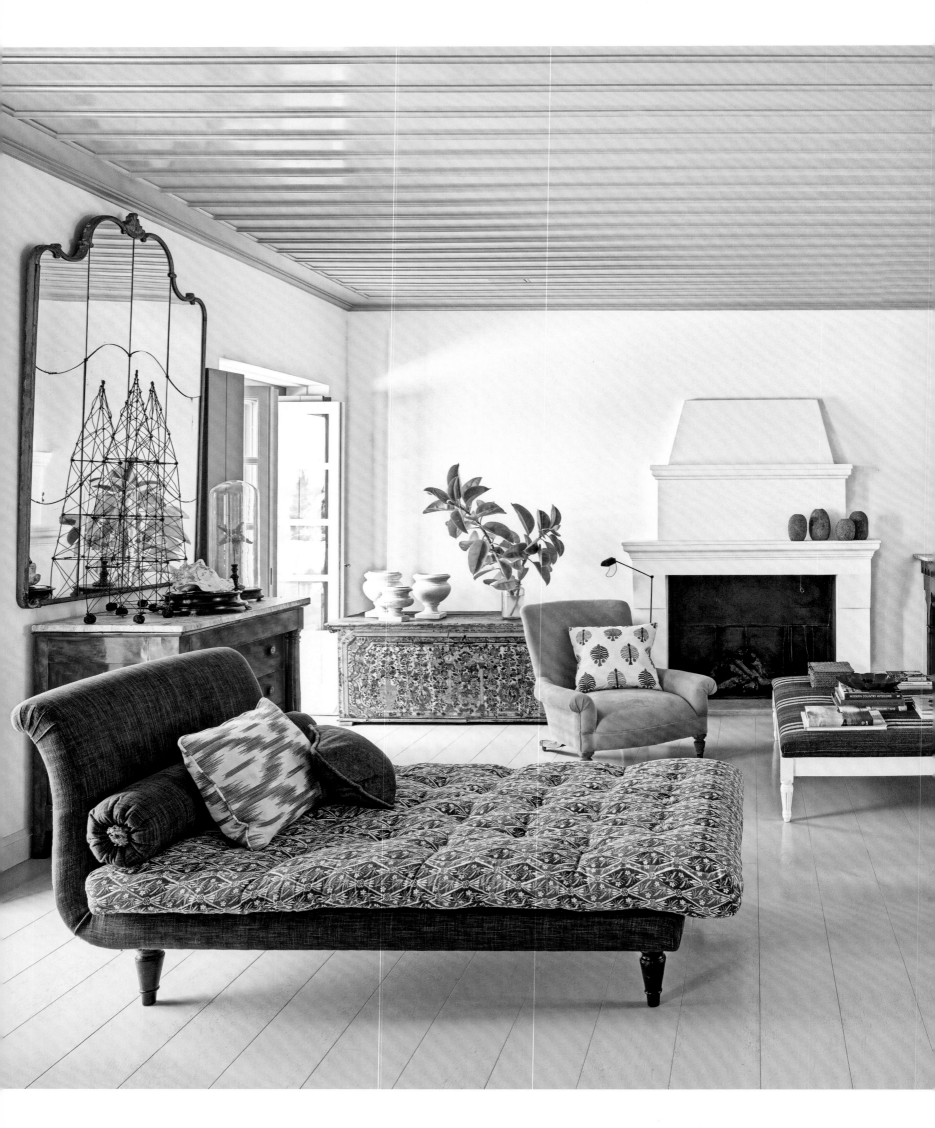

May 2016 | Spetses, Greece

ARCHITECT
Moustroufis Architects
DESIGNER
Isabel López-Quesada

In a family's rambling residence, López-Quesada deploys a Spanish Empire commode topped with a massive, frilly 1950s English mirror that brings to mind a London couture salon, along with a Greek painted chest and a funky captain's chair that would look at home on a Viking ship. The ceiling and floor are palest blue, as if they are extensions of the cloudless sky and the endless Aegean Sea.

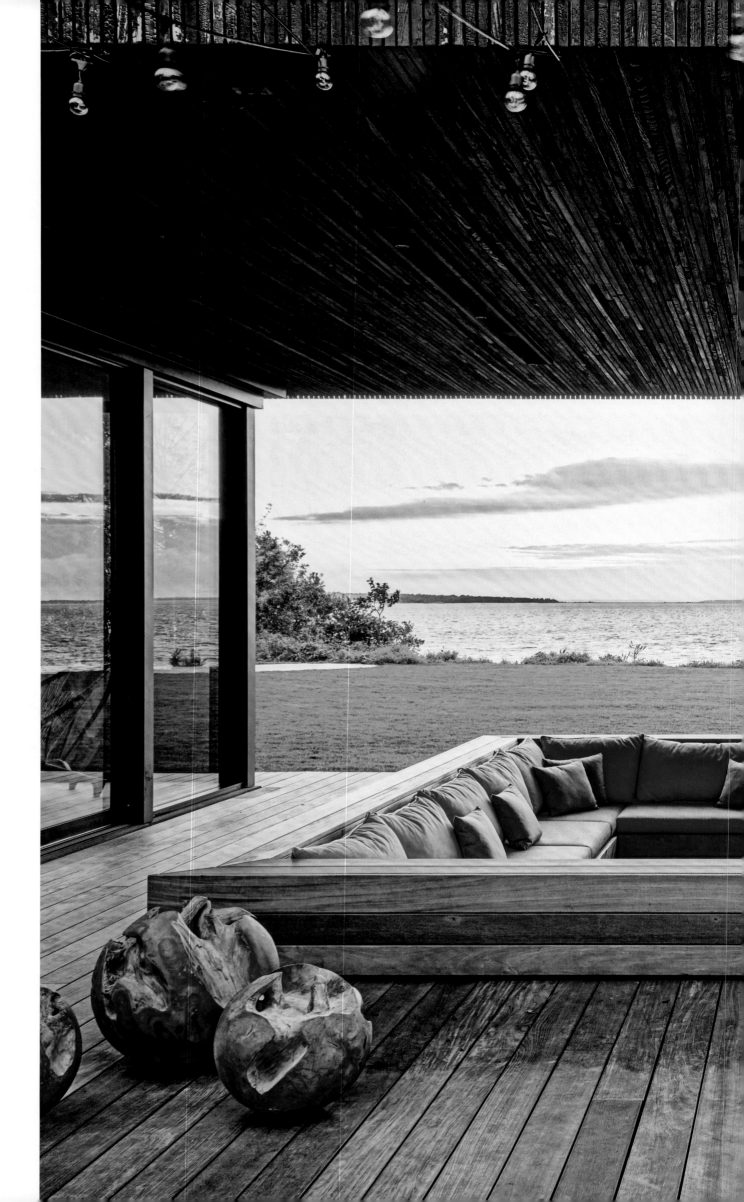

February 2017
North Haven, New York

HOMEOWNERS
Lyor Cohen & Xin Li

ARCHITECT
Leroy Street Studio

"We honor the sunset every day here. The terrace is like a stage on which we wait for its performance," said Cohen, a music mogul who married Li, deputy chairman of Christie's Asia, in the garden beyond. The low, lean modernist Long Island house is clad in cypress that has been charred in a Japanese technique known as *shou-sugi-ban.* "Burning is a natural sealant," Cohen explained, "and black is the most unobtrusive color in nature. We wanted the house to kind of disappear into the landscape."

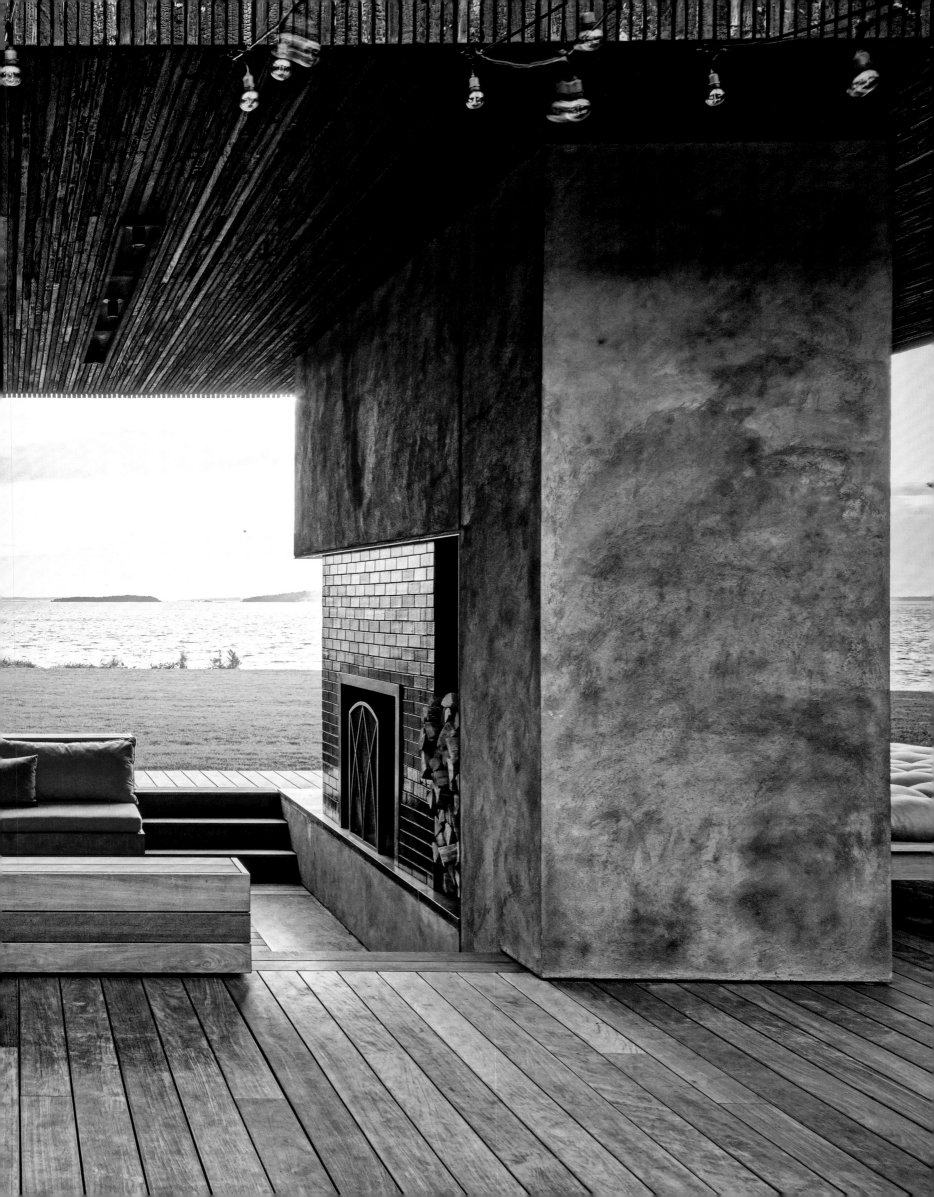

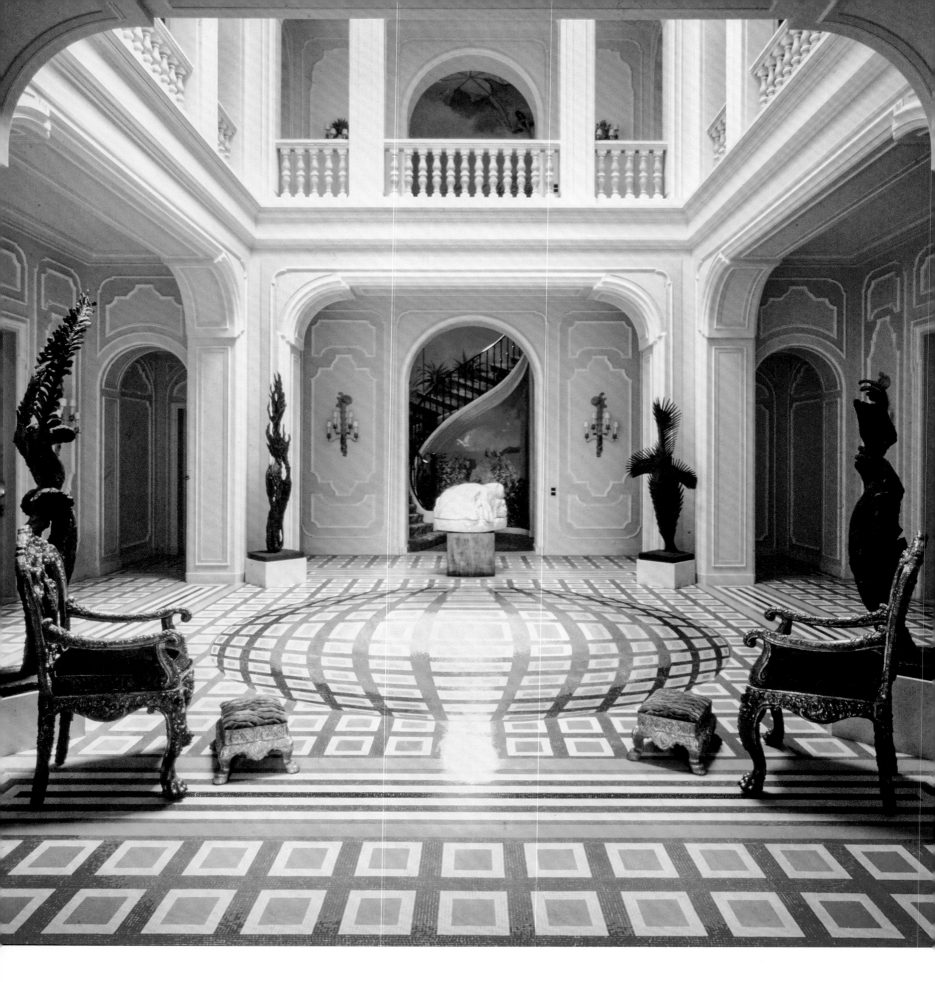

December 1980 | Majorca, Spain

Sa Torre Cega HOMEOWNERS María & Bartolomé March Servera DESIGNER Jansen

In the 1960s, the banker-collector and his wife put a modern spin on his Florentine palazzo–style birthplace by enlisting the Paris decorating firm, which established a blue-and-white color scheme in many rooms. A particularly trippy improvement is the entrance hall's optical-illusion floor, which Jansen associate Carlos Ortiz-Cabrera modeled after the paintings of Victor Vasarely. Sculptures by Apel les Fenosa stand in the corners.

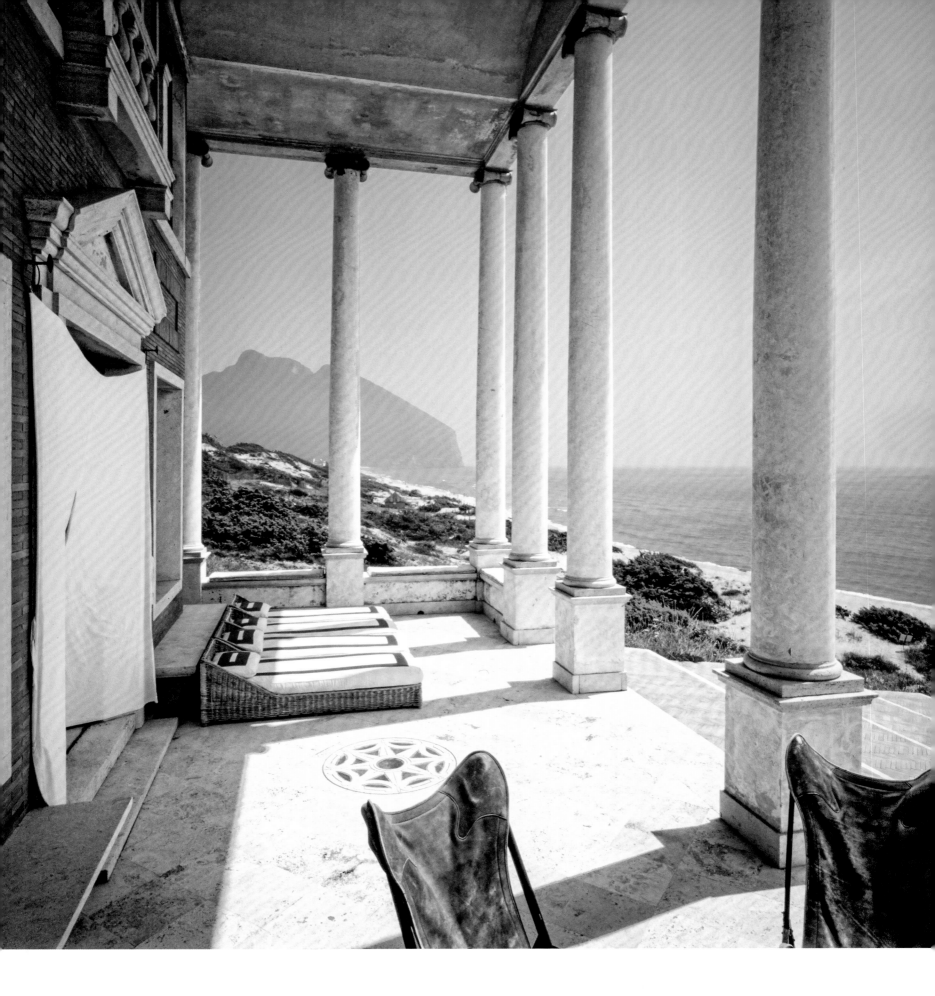

January 1987 | Sabaudia, Italy

Villa Rocca nel Circeo HOMEOWNER Nathalie Volpi ARCHITECT/DESIGNER Tomaso Buzzi

Volpi, the Countess di Misurata, originally had her heart set on acquiring a villa near Florence. But when a friend induced her to visit stark Sabaudia, on the coast of the Tyrrhenian Sea, the Algerian beauty immediately fell in love and set about building something new that would evoke the distant past. She enlisted Buzzi in the late 1950s, then left on a trip to the United States, "When I got back," the countess recalled, "my dream of ancient Greece was already taking shape." The terrace of her imposing temple looks across sand dunes to the horizon beyond.

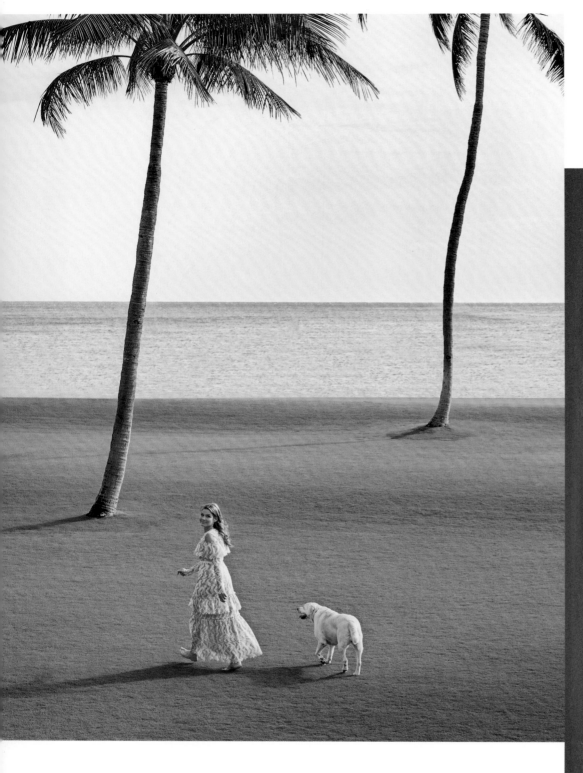

May 2017 | Palm Beach, Florida

HOMEOWNERS
The Lauder Family

"Estée loved white houses with pillars," said Aerin Lauder, who worked with designer Jacques Grange and B Five Studio's Victoria Borus on the 1920s Marion Sims Wyeth mansion that had belonged to her cosmetics-legend grandmother. (It is now used by the extended Lauder clan.) "For her, that was the definition of success, beauty, and style." Teak chaise longues beckon beside the pool, which is surrounded by a hedge of pink bougainvilleas.

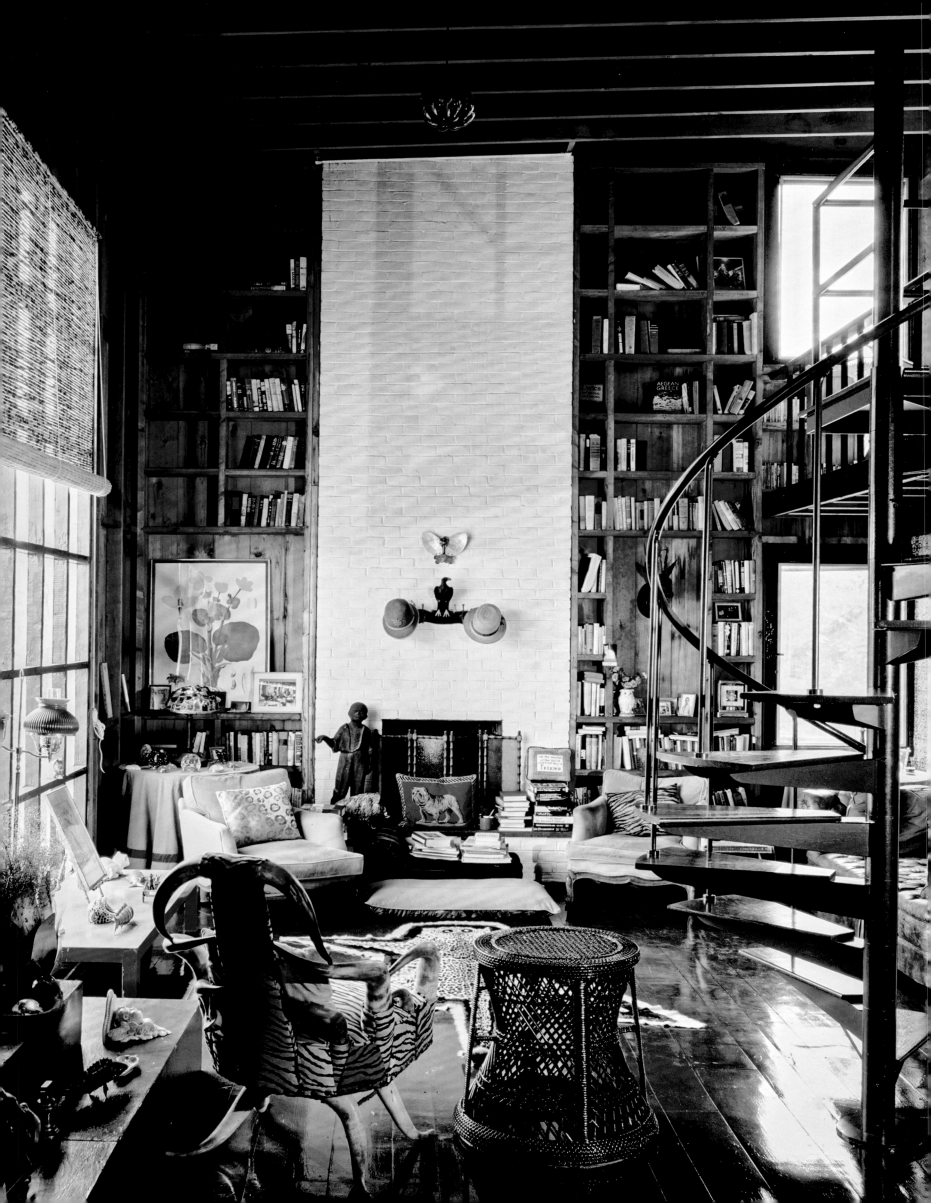

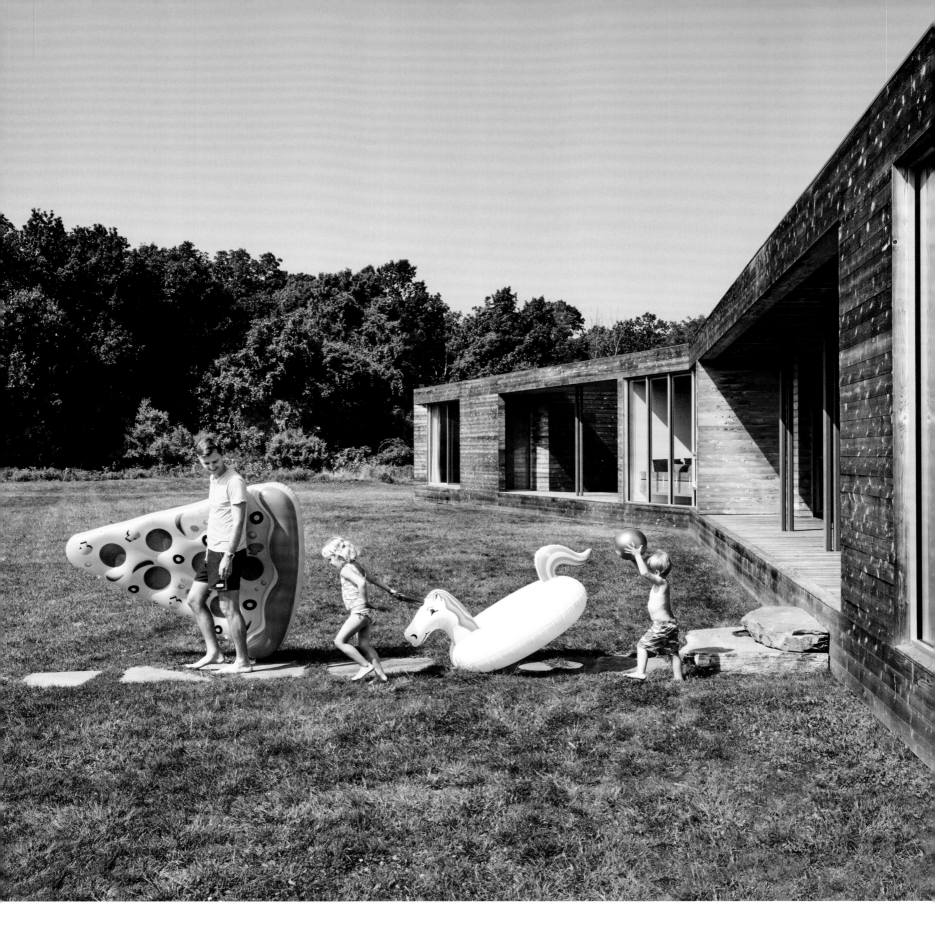

January/February 1976 | Sagaponack, New York

HOMEOWNER Truman Capote

"It's been designed to look unfinished," said the writer of his six-acre getaway. "I call it 'run-down comfort.' I like the effect of texture in rooms—the rawness of the wood." Highly personalized objects, books, and memorabilia were placed casually among the simplified furnishings of the double-height living room. "I'm not out here to entertain. I'm here to work. I come here a lot in the autumn and winter, and I see almost no one."

July 2018 | Shelter Island, New York

ARCHITECT Christoff:Finio

"A smallish home [that] presents itself as much bigger" is how Taryn Christoff described the house she and Martin Finio designed for *Vogue* executive editor Taylor Antrim, his wife Liz Twitchell, and their two kids. A single roof spans the house— actually three pavilions—as well as its exterior spaces. Added Christoff, "We created a gathering area for people to meet plus private zones for visitors and family."

January 2017
Miami Beach

HOMEOWNER
George Lindemann Jr.

DESIGNER
Frank de Biasi Interiors

"I think we created our own new style," the collector, environmentalist, and father of four (pictured at far right) said of the bold pink house that he devised with architect Allan T. Shulman and de Biasi. A Keith Haring painting is displayed on a mirrored divider that separates the sitting and living areas. Both spaces feature furniture by Mattia Bonetti and Wendell Castle; the free-form Doug & Gene Meyer carpets turn the floor into an archipelago.

May 1981 | St. James, Barbados

Mango Bay ARCHITECT **Oliver Messel**

Set designer Messel segued into an architectural career later in life, specializing in Caribbean villas for clients such as his nephew Lord Snowdon's wife, Princess Margaret. Completed in 1969 and snapped up by the boldface American couple Pamela and W. Averell Harriman, this coral-stone house known as Mango Bay emphasized Messel's preference for indoor-outdoor living. A loggia, paved with terrazzo and marble, is furnished for dining as well as relaxing. The palm-tree-motif fabric brings the landscape closer, as do étagères holding pots of orchids; a monkey chandelier adds a witty note.

March 2008 | Kawana, Japan

Kawana House ARCHITECT/DESIGNER **Foster + Partners**

"Traditional Japanese architecture is very humane," said David Nelson of Foster + Partners, "with the light subtly diffused through rice-paper screens and the interiors seamlessly linked to the nature outside." A floating deck, incorporating an aged cherry tree, surrounds the pool of a modernist guesthouse at the Foster-designed home of longtime clients; a trio of Japanese stone statues emerges from a field of lava rock.

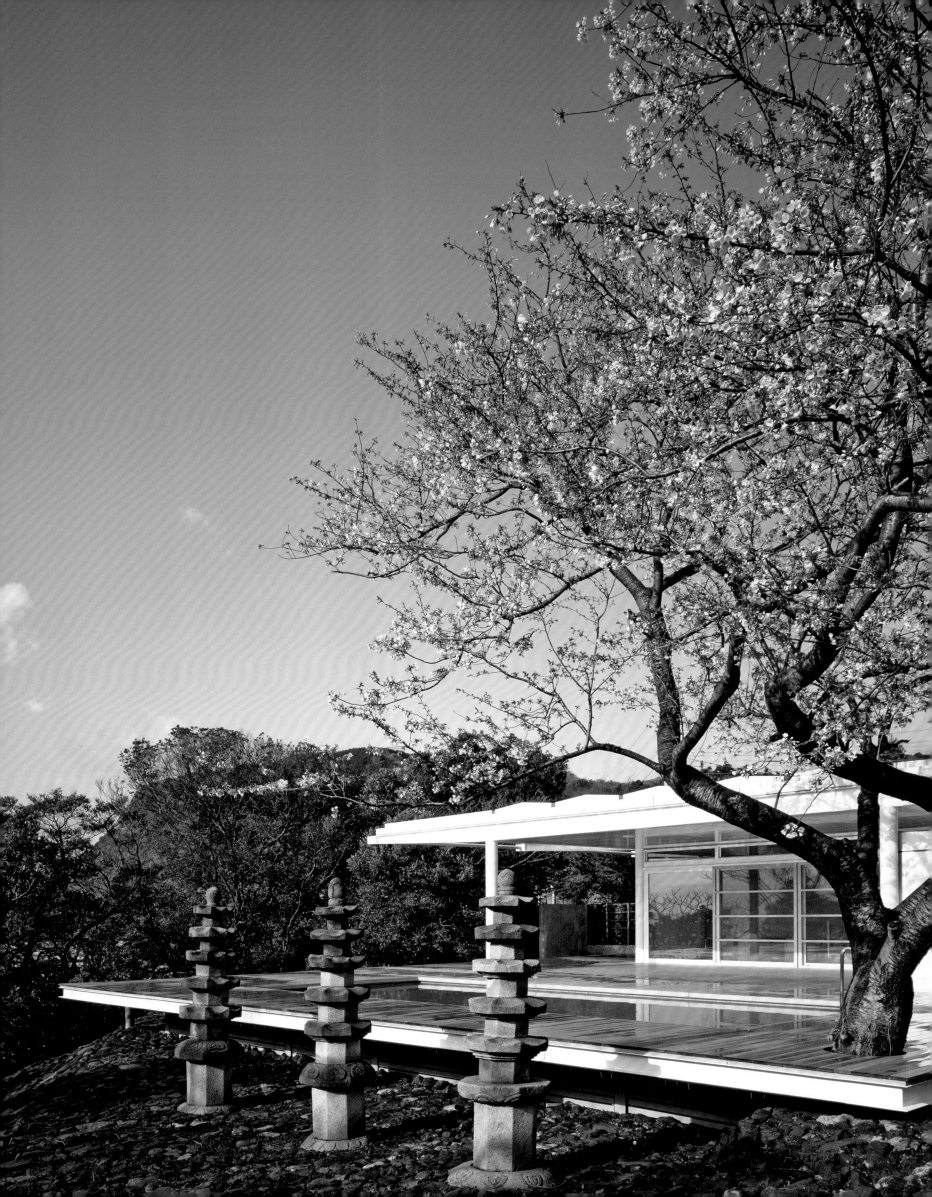

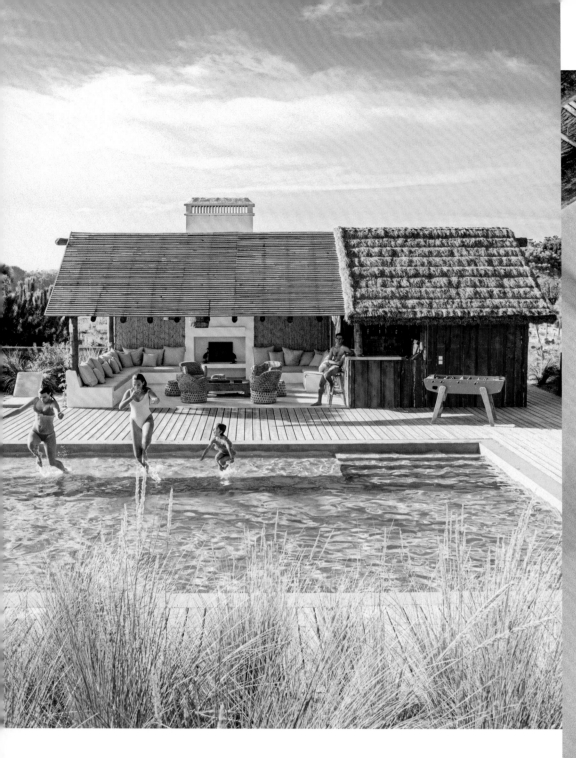

May 2018 | Comporta, Portugal

HOMEOWNERS Valentine & Patrick Perrin
DESIGNER Suduca & Mérillou

"I fell madly in love with the rugged landscape here—the sun, the sand, the endless beach," said Paris art dealer Patrick Perrin, who ultimately built a house for his wife and children. Refined textures complement that rough-and-ready air, such as earth-tone rattan, wicker, rope, and wool. "It's chic, but the holiday version," averred designer Thierry Mérillou.

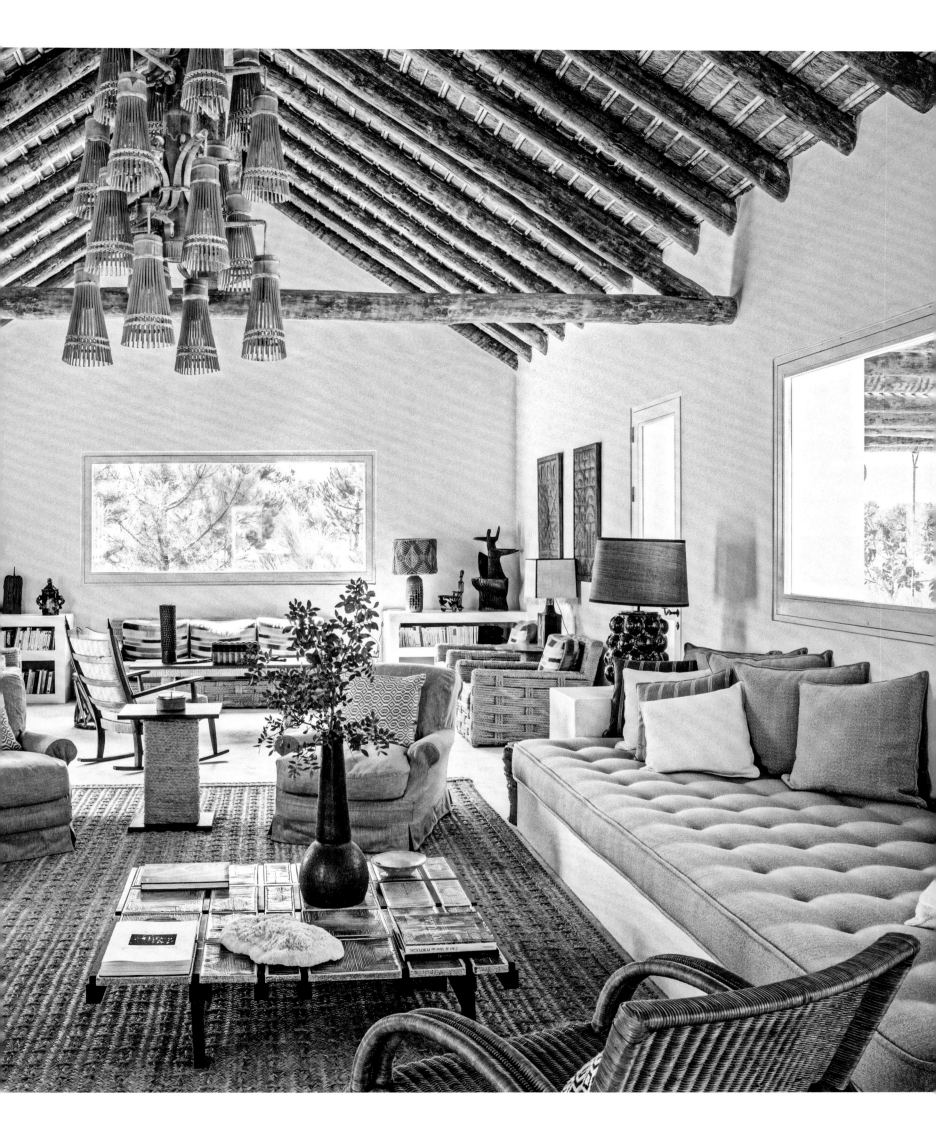

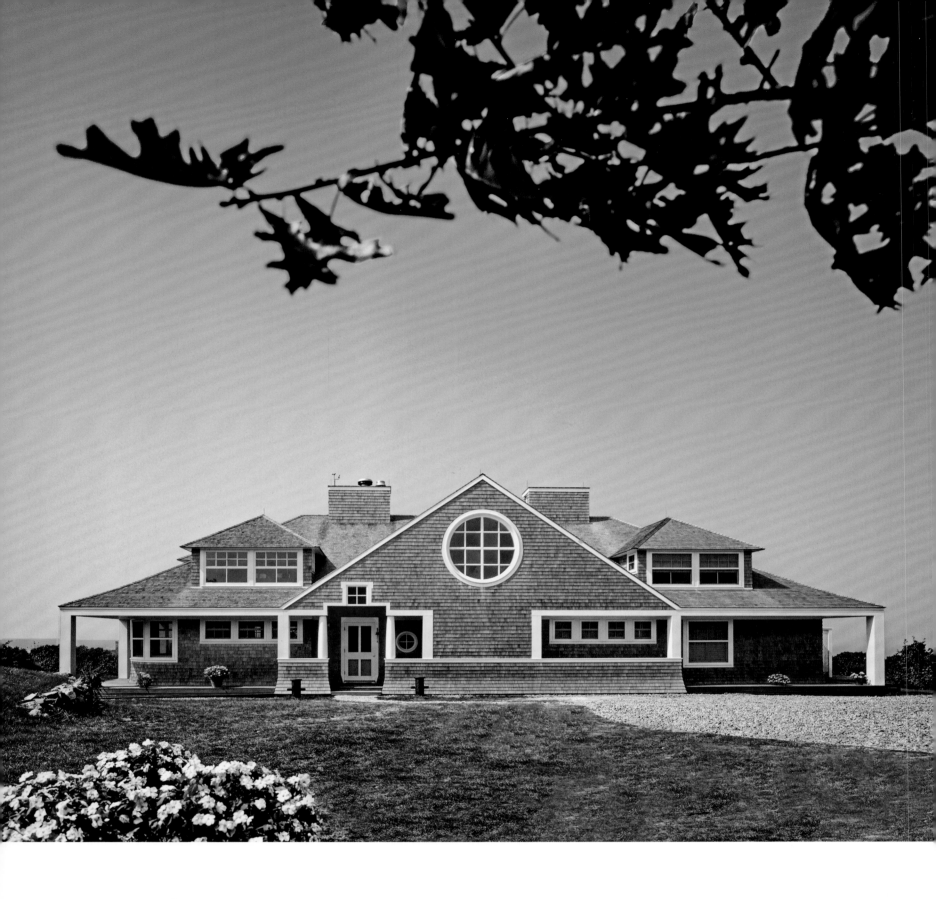

June 1984 | Martha's Vineyard, Massachusetts

ARCHITECT Robert A.M. Stern Architects

Inventively drawing on such Shingle Style precedents as McKim, Mead & White's 1887 Low House and A. C. Schweinfurth's 1898 First Unitarian Church—with a bit of Sir Edwin Lutyens tossed into the mix, too—this island retreat, *AD* observed, "is in every way the strongest new house to be seen in some time."

July 2017 | East Hampton, New York

DESIGNER Peter Marino Architect

"The couple travels everywhere in the world and has a wonderful sense of the exotic," Marino observed of the homeowners. "It was important to reflect that, while also maintaining the casual atmosphere of a beachfront cottage." The master bedroom exudes global vision with an Indian flowered fabric applied to the walls and the ceiling, which gives the space a tented effect. An ottoman blooms like a water lily on the blossomed carpet.

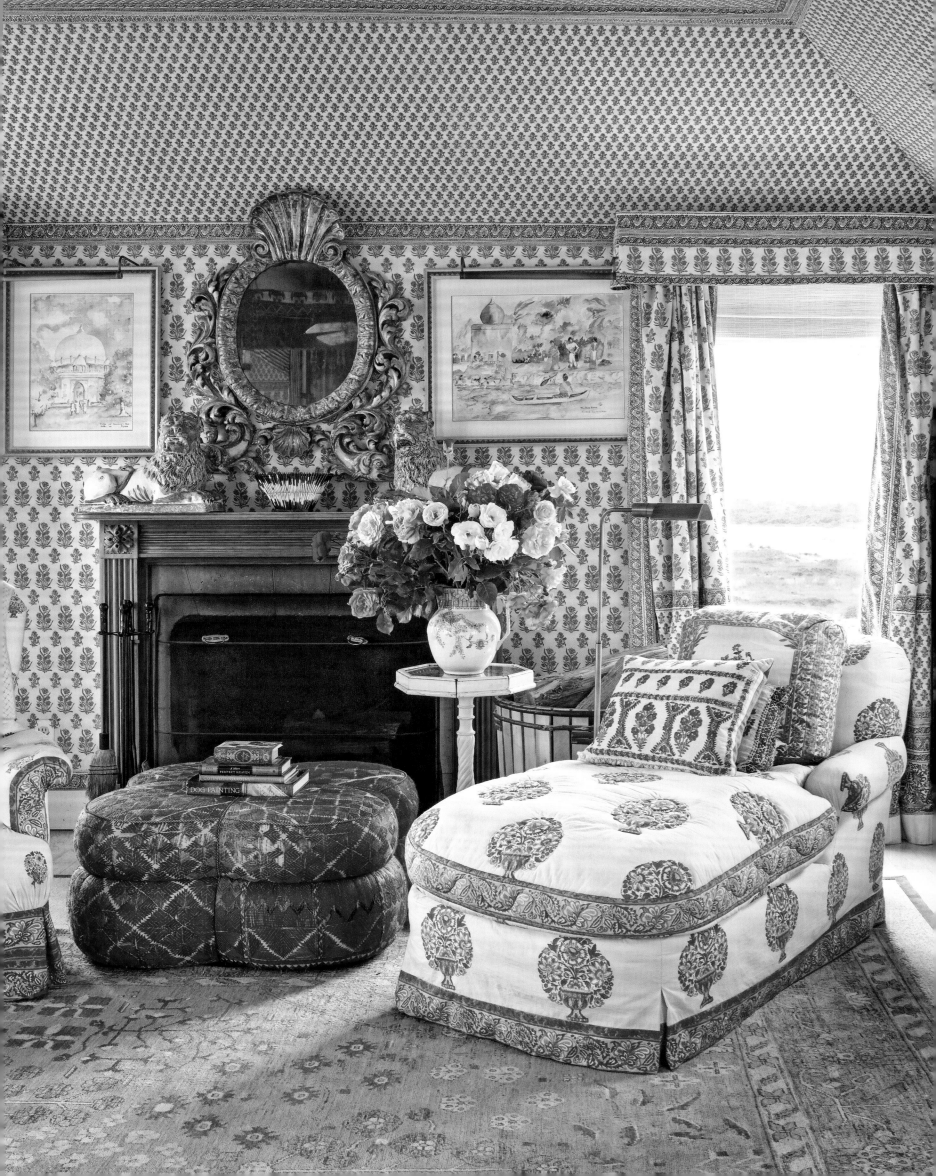

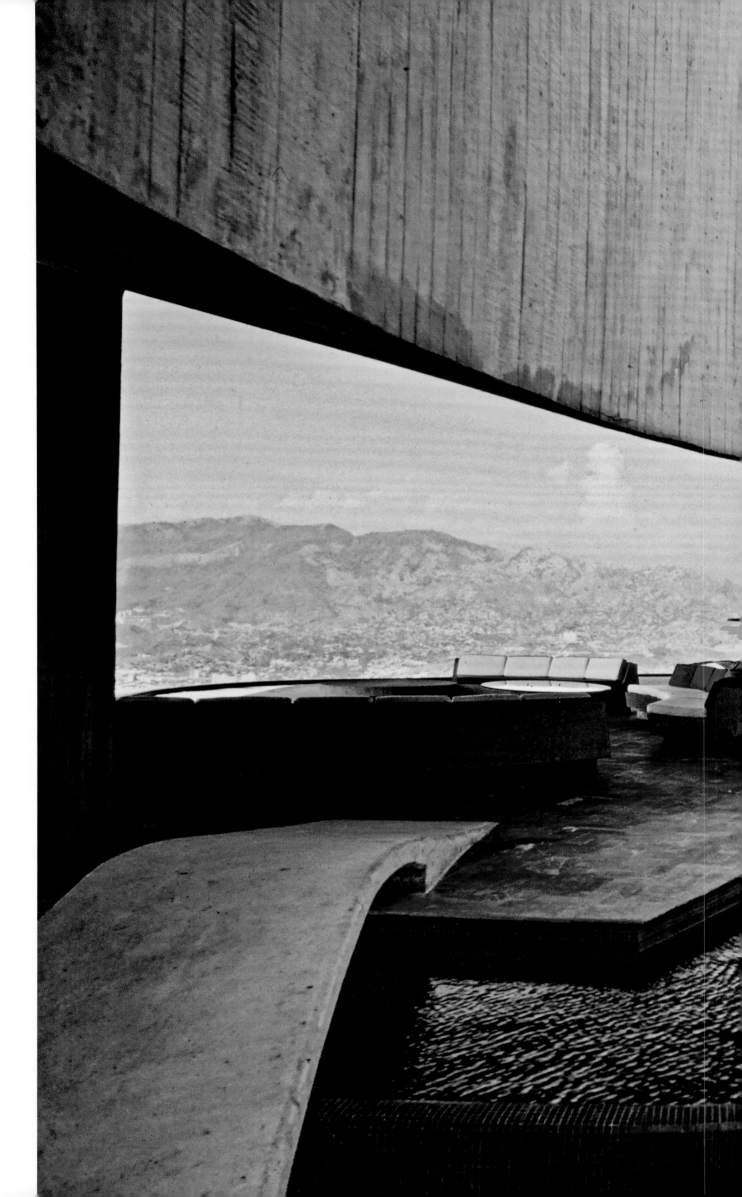

May 1978
Acapulco, Mexico

Marbrisa

ARCHITECT

John Lautner

Though sometimes described as an earthbound spaceship, Lautner's Mexican masterpiece for supermarket magnate and arts patron Jerónimo Arango Jr. takes its curvaceous cues from the coastline below. "I have never designed a plain box that you can understand in an instant—static and without surprises," said the architect, who partnered on the project with associate Helena Arahuete. One of the home's delights is a moat that courses around the terrace and is used for swimming instead of a conventional pool.

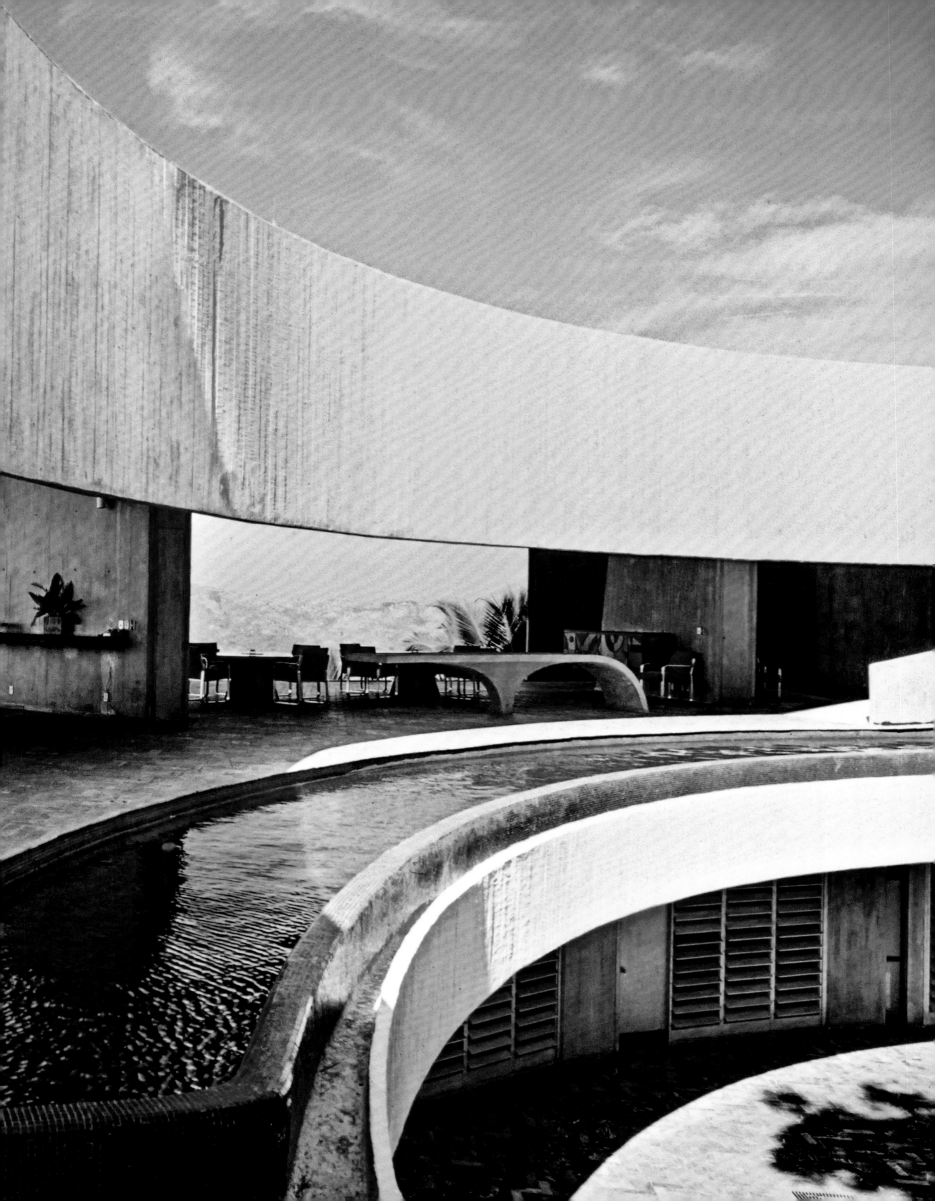

July 2012
Nantucket,
Massachusetts

HOMEOWNERS
Coco &
Arie L.
Kopelman

American antiques make
a sculptural statement
in a snow-white bedroom
at the former Chanel Inc.
president's home away
from home, a circa-1800
Federal Style residence
that he and his wife reno-
vated with Botticelli & Pohl
Architects. "Rooms can
have a clean, fresh, modern
sensibility," Kopelman
explained, "but still have
traditional elements that
let your mind wander
through history."

December 2019
Provincetown,
Massachusetts

HOMEOWNERS
Ryan Murphy &
David Miller
DESIGNER
Cafiero Select

"The room is its own work of art," said TV producer Murphy of the living room of his guesthouse, which was formerly the studio of Abstract Expressionist painter Hans Hofmann. Designer David Cafiero refreshed the interiors, bringing iconic furnishings by Fritz Hansen and cousins Pierre Jeanneret and Le Corbusier into the soaring, chapel-like space.

October 2010
Fishers Island, New York

HOMEOWNERS
Bunty &
Thomas
Armstrong

ARCHITECT
Thomas Phifer
and Partners

When the art collectors'
1920s clapboard house
burned to the ground,
Phifer replaced it with a
six-room glass box so,
Thomas Armstrong said,
"I could witness the land-
scape as I viewed the art."
Ringed by slender steel
columns, it is a modern
echo of ancient Greek
peristyles, reduced to
mere essence. As Phifer
explained, "I whittle
away until it barely stands
up. That's when I stop."

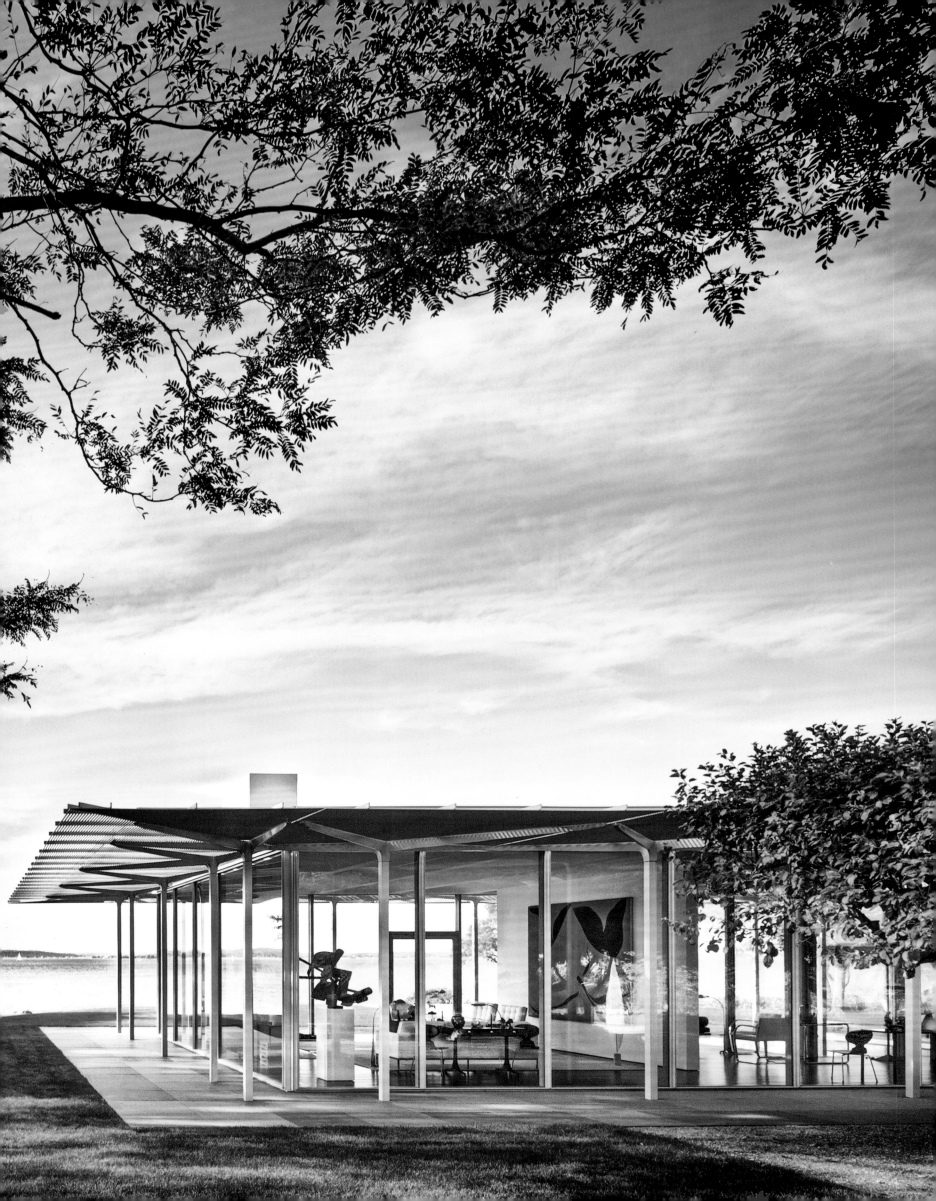

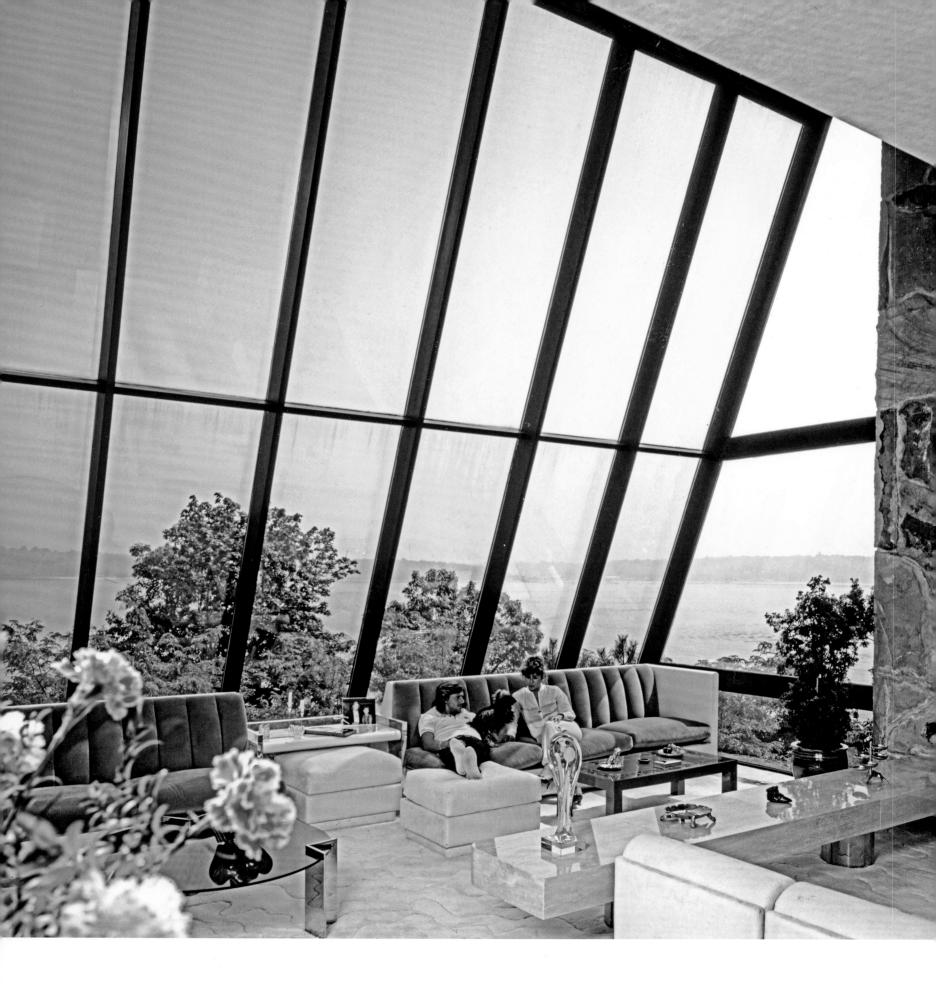

August 1984 | Sands Point, New York

HOMEOWNERS Mariana & Björn Borg ARCHITECT Norman Jaffe DESIGNER Michael DeSantis Inc.

"We were always dreaming about a certain kind of house. We like very modern things," the onetime best tennis player in the world said of the Jaffe home that he and his wife purchased in 1981. The couple furnished the place with DeSantis, and the contemporary decor was like being surrounded by velvety sculptures that also happened to be perfect for lounging amid the blue of Hempstead Harbor.

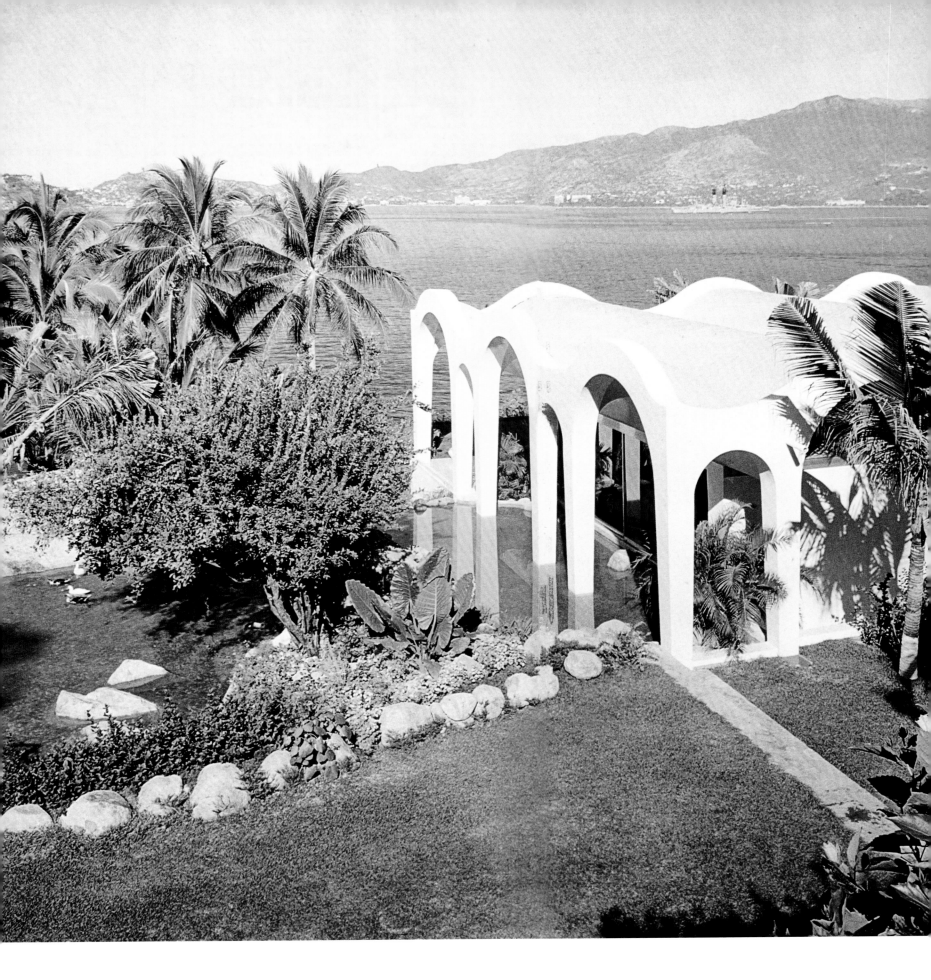

Summer 1966 | Acapulco, Mexico

Ghalál HOMEOWNERS Merle Oberon & Bruno Pagliai ARCHITECT Juan Sordo Madaleno

"Can you imagine a more beautiful place to spend the rest of your life?" asked Oberon, an Oscar-nominated Hollywood actress, of the villa that Sordo Madaleno designed for her, her industrialist husband, and their two children. Islamic-inspired arches of white plaster wrap the house—its name, Ghalál, said to be derived from the Tzotzil Mayan word for love—and shade a white marble terrace that overlooks the Bay of Acapulco.

July 2014

Highlander

HOMEOWNER/DESIGNER

Joanne de Guardiola

"*Highlander* didn't really suit a family's needs—it was built for corporate entertaining," designer de Guardiola maintained of the 1985 Jon Bannenberg yacht that she and her husband, Roberto, purchased from the estate of Malcolm Forbes. Her 18-month makeover made everything brighter, bolder, and inviting. A Frank Stella painting dominates the sky lounge, which is paved with sapphire-blue Brazilian onyx and can serve as a disco where the LEDs change colors. "Everything is contemporary and clean," she added, "to play up the boat's lines."

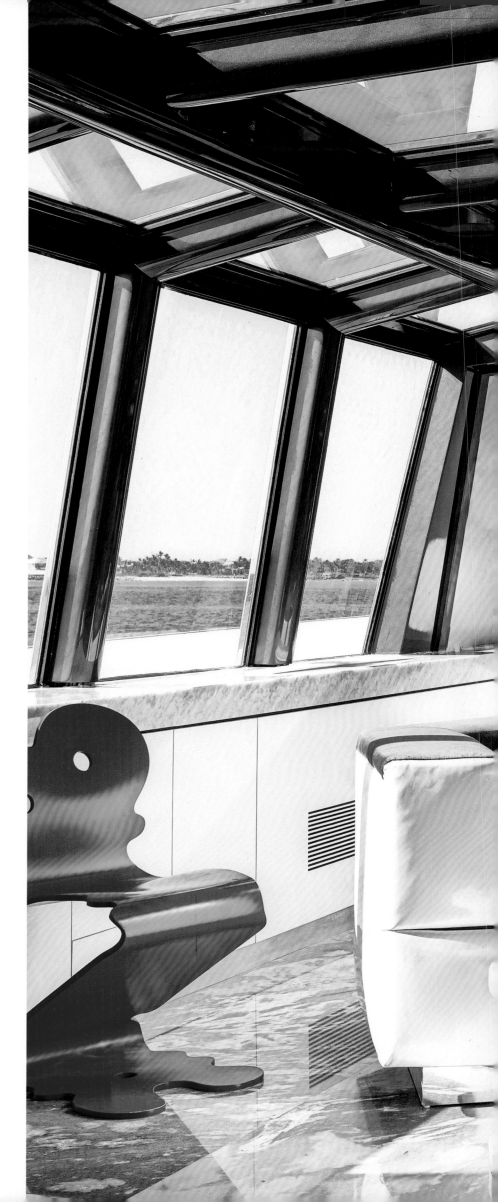

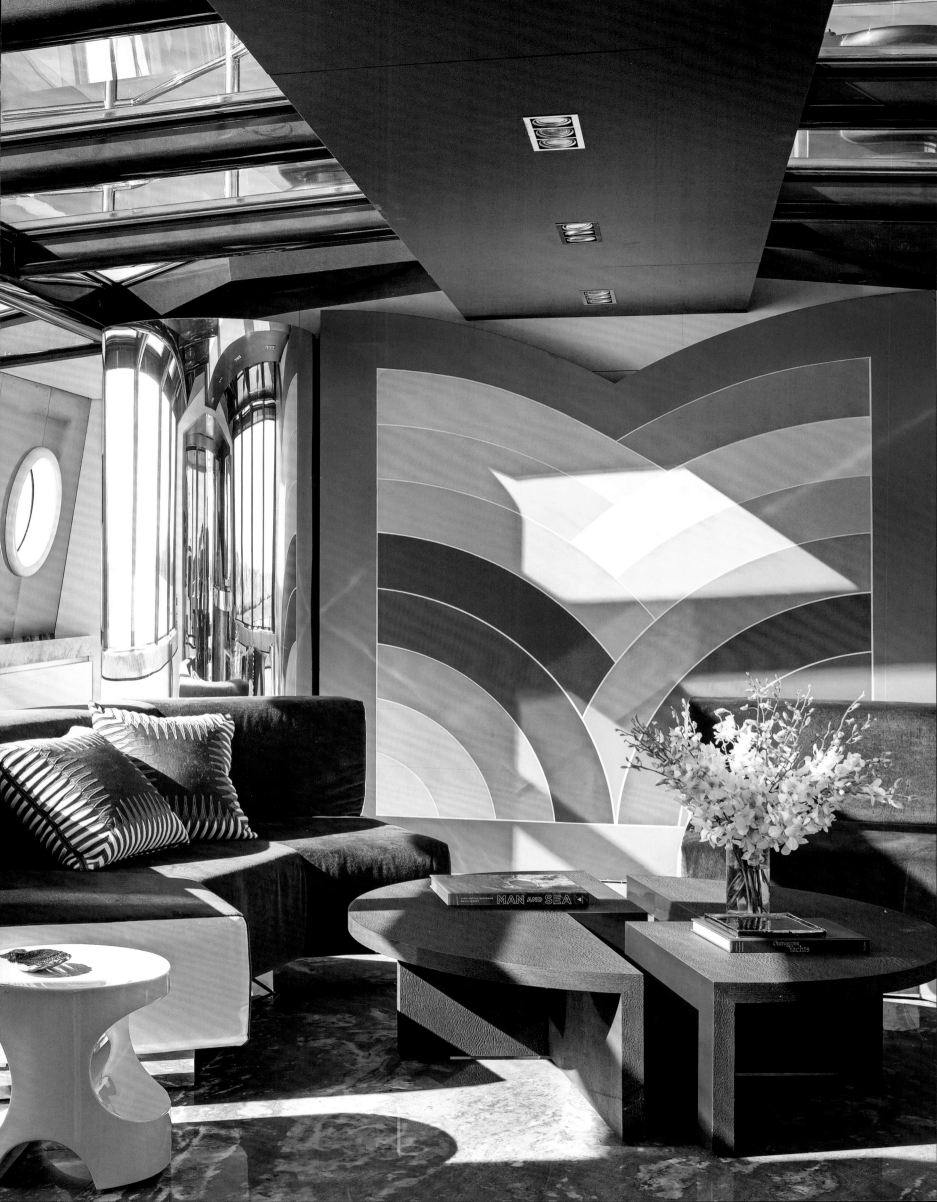

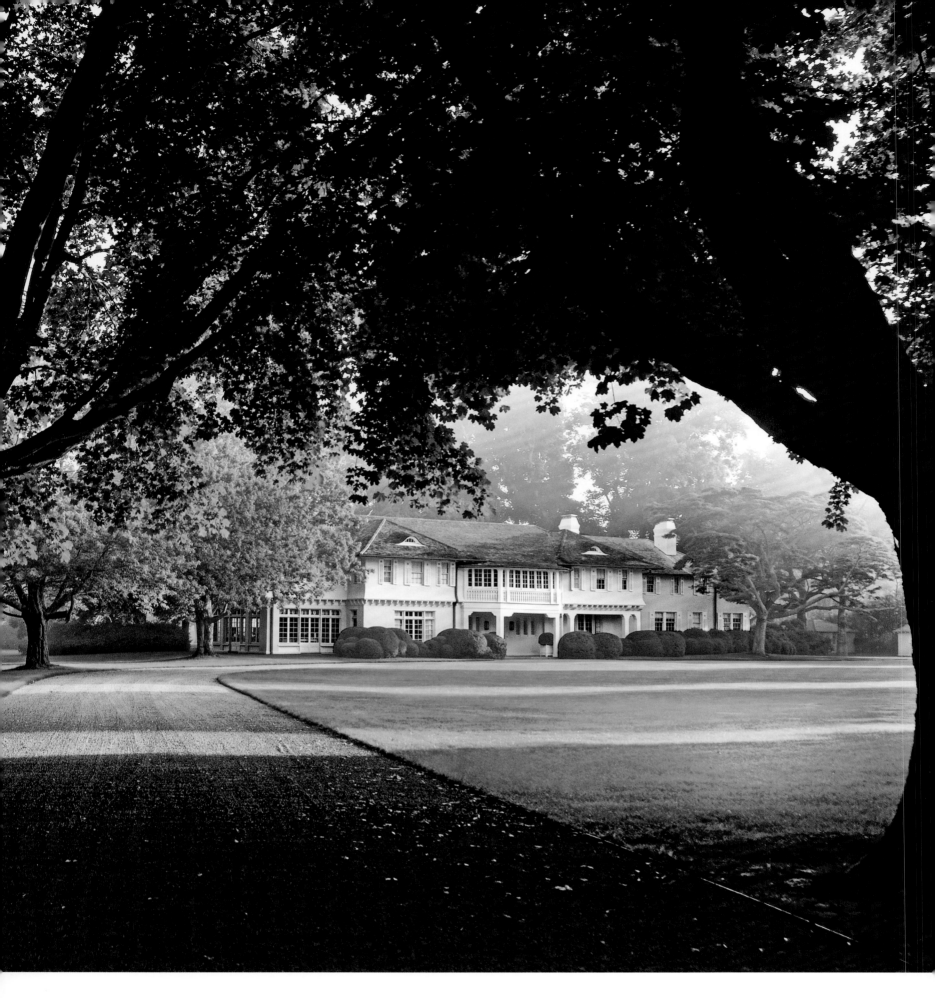

April 2016 | East Hampton, New York

Lasata HOMEOWNERS/DESIGNERS Delphine & Reed Krakoff

"We enjoy the process of bringing a house back to what it was more than the end product itself," said Delphine—founder of Pamplemousse Design—describing the property that she and her husband, chief artistic director of Tiffany & Co., rejuvenated with architect Mark Ferguson and landscape architect Perry Guillot. The Arts and Crafts residence, designed by Arthur C. Jackson in 1917, is famous as the childhood summer home of Jacqueline Kennedy Onassis. "One of the best moments was when Martha Stewart walked through the finished house and asked if we'd done anything," Delphine added. "That was the highest compliment." In the trelliswork-lined poolhouse, the couple paired a vintage Billy Baldwin sofa with woven-rush seating by Audoux Minet.

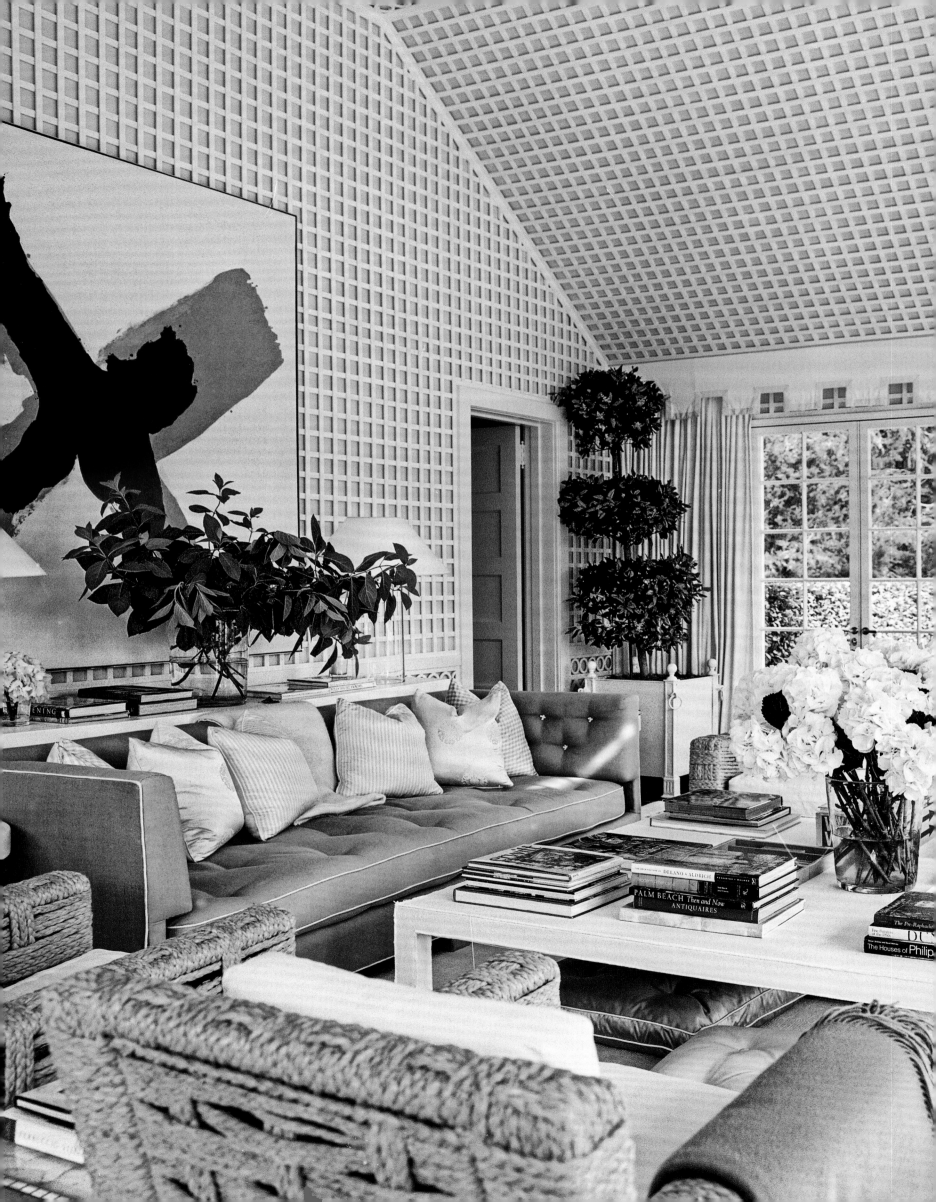

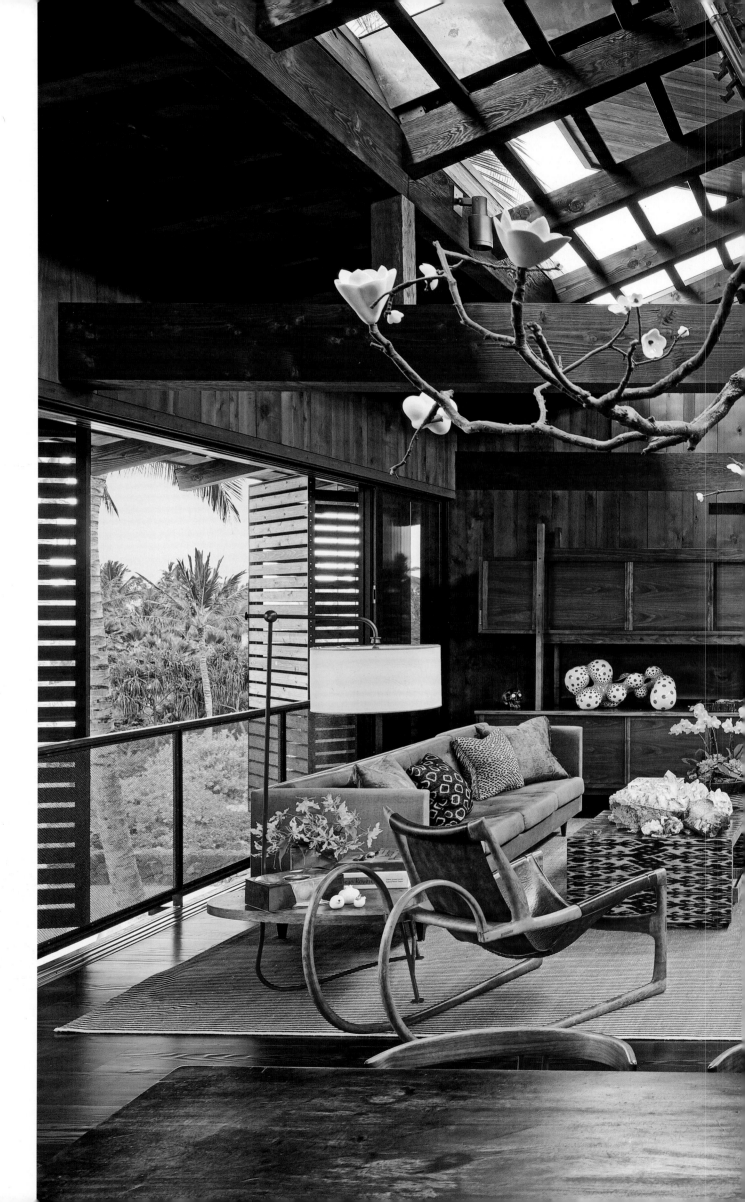

January 2018
Kona, Hawaii

ARCHITECT
Olson Kundig
DESIGNER
RP Miller

"In no way is the structure meant to be hermetic," RP Miller's Rodman Primack declared of a woody family house on which he and Tom Kundig collaborated. The entire roof can be opened so that trade winds cool the building, and shutters fold back to turn the interiors, among them the main sitting room, into virtual pavilions. Despite the impressive art (that's a painting by Yoshitomo Nara) and made-to-order furnishings (such as the David Wiseman flowered chandelier), Primack said, "at its heart, it's a beach house."

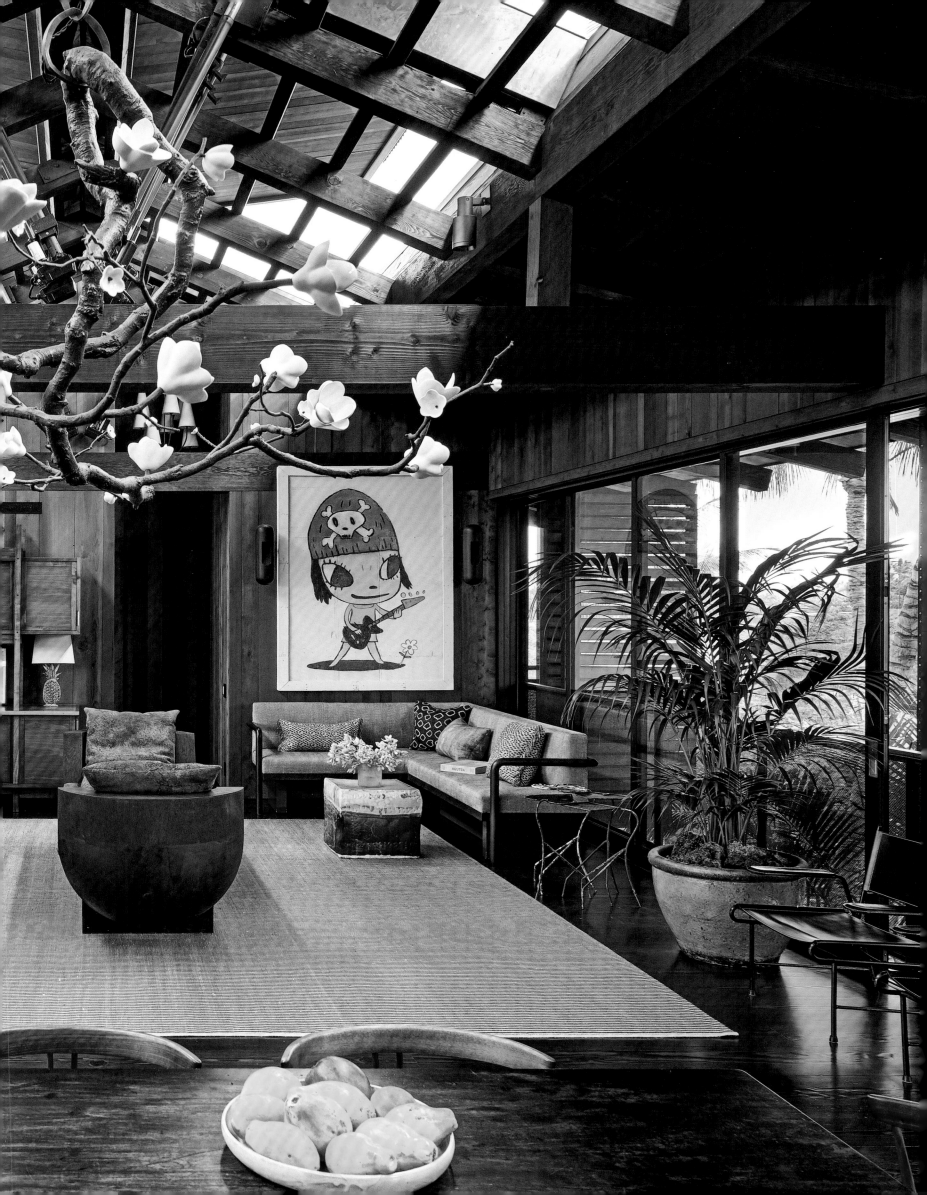

September 2017 | Miami Beach

HOMEOWNERS Craig Robins & Jackie Soffer

Guests at the many parties hosted by Robins, developer and impresario of Miami's Design District, have been known to gather in the master bath fashioned by Zaha Hadid. "I once walked in on Martha Stewart doing an impromptu shoot with photographer Todd Eberle," Robins recounted of the sculptural room, one of many showstopping moments at the house, which was updated by architect Walter Chatham and interior designer Julie Hillman. David Adjaye's pavilion for the 2011 edition of Design Miami stands in the garden.

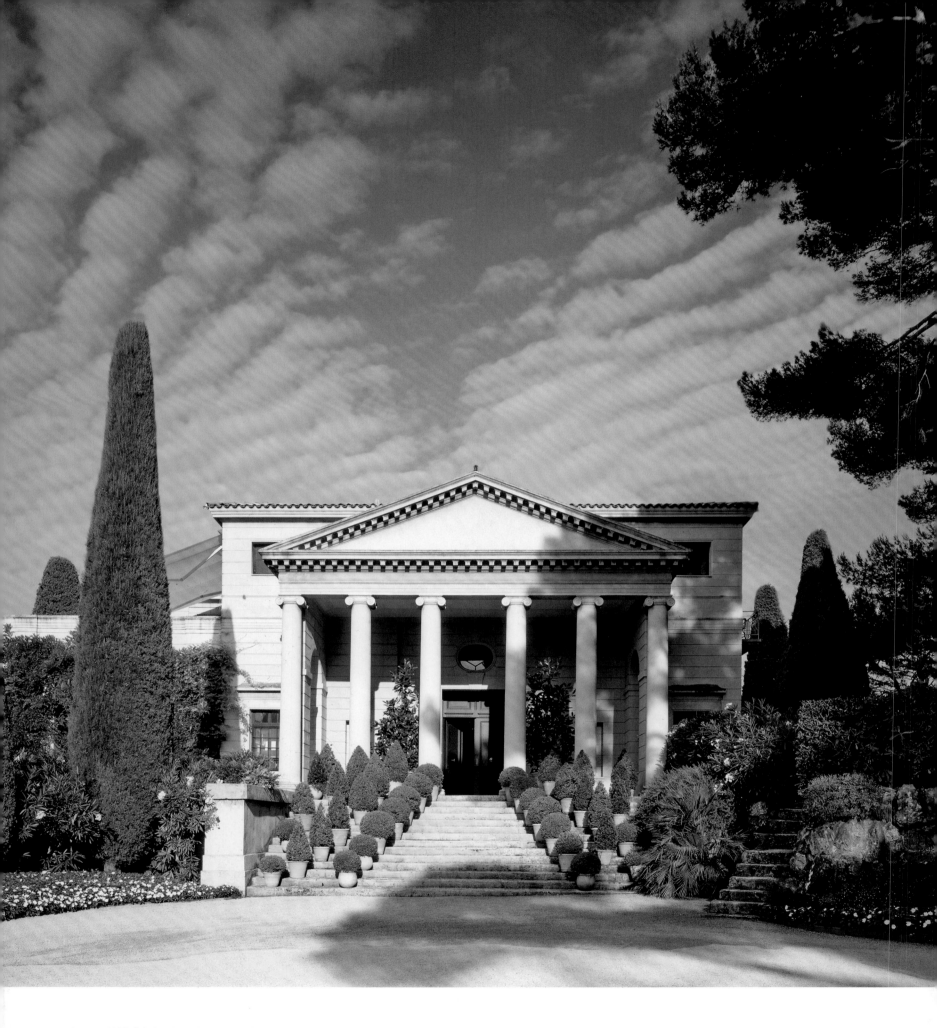

January 1999 | Saint-Jean-Cap-Ferrat, France

Villa Fiorentina

Built by one countess in 1914 and Palladianized after World War II by the tastemaking son of another—Rory Cameron, scion of Lady Kenmare—La Fiorentina was bought in the late 1960s by Mary Wells Lawrence and Harding Lawrence, powerhouses of the advertising and airline business worlds. They enlisted Billy Baldwin to personalize the interiors. Grass stairs installed around 1917 lead to what is reputedly the Riviera's first infinity pool, Cameron's addition.

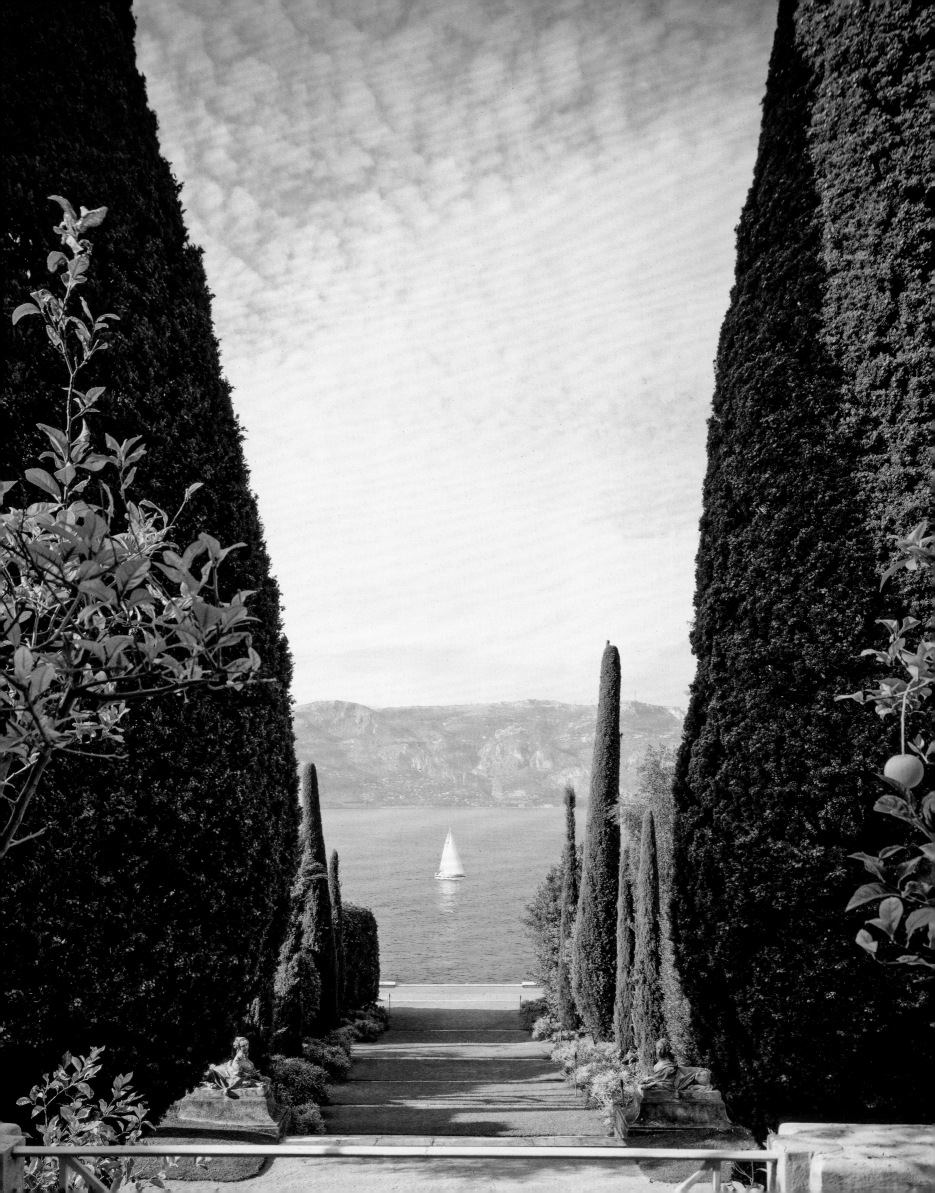

July 2015
Nantucket,
Massachusetts

HOMEOWNER/DESIGNER
Victoria Hagan

"This is a beach house, and I wanted it to feel that way," Hagan said of the island retreat she conceived for her family. A three-acre parcel of land on the eastern shore, the property embraces both manicured crispness and wild beauty, a style perhaps best evinced in the hedge-enclosed swimming pool.

Acknowledgments

This book has been, quite literally, 100 years in the making: Generations of editors, designers, photographers, stylists, writers, copy editors, researchers, and more have all been integral in helping *Architectural Digest* reach this milestone. For today's *AD* staff, creating the book you now hold in your hands has been a true labor of love—a once-in-a-lifetime opportunity.

SPECIAL THANKS TO: Interiors director *Alison Levasseur*, creative director *David Sebbah*, design director *Natalie Do*, visuals director *Michael Shome*, features director *Sam Cochran*, editorial operations manager *Nick Traverse*, researcher *Susan Sedman*, and assistant editor *Elizabeth Fazzare*, who all poured themselves into this project to give it the life it deserves; *Maureen Songco, Isaac Lobel*, and *Gabrielle Pilotti Langdon* for tracking down each and every photograph and envisioning the final volume; *Nobi Kashiwagi*, who designed the font (Saggio) used throughout this book; *AD* editors *Shax Riegler, Mitchell Owens, Mayer Rus, Jane Keltner de Valle, Hannah Martin*, and *Carly Olson* for combing through more than 600 of our back issues to uncover the magic in each home featured; *Diane Dragan, David Byars, Jason Roe, Joyce Rubin, Adriana Bürgi, Katherine Raymond, Christine Penberthy, Gabriela Ulloa*, and *Annie Ballaine* for managing operations, copyediting, researching, and, ultimately, making sure the production ran on schedule; *Erin Kaplan* for her publicity and promotion talents; those at Condé Nast's archives and library, especially *Ivan Shaw, Marianne Brown*, and *Cynthia Cathcart*; and *Rebecca Kaplan* and the team at Abrams for being such excellent publishing partners. We'd also like to extend our deepest appreciation to *Anna Wintour, Raúl Martinez, Christiane Mack*, and everyone at Condé Nast for their continued support of *AD*; our dear friends *Michael Reynolds, Gay Gassmann, Carolina Irving, Howard Christian, Lawren Howell, Mieke ten Have*, and *Robert Rufino*; and former *AD* stewards *Paige Rense* and *Margaret Russell*. Finally, our profound gratitude goes to the many people who have opened their doors to *AD* over the past century, and to all of the creative geniuses who conceived these unforgettable spaces.

EDITOR'S NOTE: Architecture, interior design, and landscape firm names are presented as they were at the time of original publication.

Credits

Artwork

Arthur Aeschbacher: 175; © 2019 Artists Rights Society (ARS), New York/ADAGP, Paris.

Jean Arp: 135, 196; © 2019 Artists Rights Society (ARS), New York/VG Bild-Kunst, Bonn.

Francis Bacon: 68–69; © The Estate of Francis Bacon. All rights reserved/DACS, London/ARS, NY 2019.

Jean-Michel Basquiat: 116; © The Estate of Jean-Michel Basquiat/ADAGP, Paris/ARS, New York 2019.

Larry Bell: 85; © 2019 Larry Bell/Artists Rights Society (ARS), New York.

Louise Bourgeois: 288–89; © 2019 The Easton Foundation/Licensed by VAGA at Artists Rights Society (ARS), NY.

Marc Chagall: 257; © 2019 Artists Rights Society (ARS), New York/ADAGP, Paris.

Jean Cocteau: 309; © ADAGP/Comité Cocteau, Paris 2019, Artists Rights Society (ARS), New York/ADAGP, Paris 2019.

George Condo: 246; © 2019 George Condo/Artists Rights Society (ARS), New York.

Willem de Kooning: 252–53; © 2019 The Willem de Kooning Foundation/Artists Rights Society (ARS), New York.

Niki de Saint Phalle: 260; © 2019 Niki Charitable Art Foundation. All rights reserved/ARS, NY/ADAGP, Paris.

Apel les Fenosa: 420; © 2019 Artists Rights Society (ARS), New York/ADAGP, Paris.

Sam Francis: 58; © 2019 Sam Francis Foundation, California/Artists Rights Society (ARS), NY.

Isa Genzken: 52; © 2019 Artists Rights Society (ARS), New York/VG Bild-Kunst, Bonn.

Katharina Grosse: 290–91; © 2019 Artists Rights Society (ARS), New York/VG Bild-Kunst, Bonn.

Keith Haring: 92, 426–27; © Keith Haring Foundation.

Al Held: 264; © 2019 Al Held Foundation, Inc./Licensed by Artists Rights Society (ARS), New York.

Charles Hinman: 305; © 2019 Charles B. Hinman/Artists Rights Society (ARS), New York.

Philippe Hiquily: 189; © 2019 Artists Rights Society (ARS), New York/ADAGP, Paris.

Damien Hirst: 190; © Damien Hirst and Science Ltd. All rights reserved/DACS, London/ARS, NY 2019.

Robert Indiana: 248, 249; © 2019 Morgan Art Foundation Ltd./Artists Rights Society (ARS), NY.

Jean Ipoustéguy: 420; © 2019 Artists Rights Society (ARS), New York/ADAGP, Paris.

Jasper Johns: 26; © 2019 Jasper Johns/Licensed by VAGA at Artists Rights Society (ARS), NY.

Alex Katz: 266–67; © 2019 Alex Katz/Licensed by VAGA at Artists Rights Society (ARS), NY.

Jeff Koons: 191, 230, 277; © Jeff Koons.

Claude & François-Xavier Lalanne: 265; © 2019 Artists Rights Society (ARS), New York/ADAGP, Paris.

Roy Lichtenstein: 242, 268–69; © Estate of Roy Lichtenstein.

Morris Louis: 305; © 2019 Maryland Institute College of Art (MICA), Rights Administered by Artist Rights Society (ARS), New York, All Rights Reserved.

Joan Miró: 272–73, 396; © Successió Miró/Artists Rights Society (ARS), New York/ADAGP, Paris 2019.

Henry Moore: 27, 276; Reproduced by permission of the Henry Moore Foundation.

Georgia O'Keeffe: 271; © 2019 Georgia O'Keeffe Museum/Artists Rights Society (ARS), New York.

Neo Rauch: 413; © 2019 Courtesy Galerie EIGEN + ART, Leipzig/Berlin/Artists Rights Society (ARS), New York.

Robert Rauschenberg: 27; © 2019 Robert Rauschenberg Foundation/Licensed by VAGA at Artists Rights Society (ARS), NY.

Mark Rothko: 204; © 1998 Kate Rothko Prizel & Christopher Rothko/Artists Rights Society (ARS), New York.

David Salle: 236, 282; © 2019 David Salle/VAGA at Artists Rights Society (ARS), NY, Courtesy of Skarstedt, NY.

Frank Stella: 241, 284–85, 445; © 2019 Frank Stella/Artists Rights Society (ARS), New York.

Victor Vasarely: 305; © 2019 Artists Rights Society (ARS), New York/ADAGP, Paris.

Jef Verheyen: 164; © 2019 Artists Rights Society (ARS), New York/SABAM, Brussels.

Andy Warhol: 77, 93, 221, 304; © 2019 The Andy Warhol Foundation for the Visual Arts, Inc./Licensed by Artists Rights Society (ARS), New York.

Jean-Michel Basquiat & Andy Warhol: 80–81; © 2019 The Andy Warhol Foundation for the Visual Arts, Inc./Licensed by Artists Rights Society (ARS), New York. © The Estate of Jean-Michel Basquiat/ADAGP, Paris/ARS, New York 2019.

Tim Noble & Sue Webster: 22; © Tim Noble and Sue Webster. All Rights Reserved, DACS, London/ARS, NY 2019.

Tom Wesselmann: 226; © 2019 Estate of Tom Wesselmann/Artists Rights Society (ARS), NY.

Frank Lloyd Wright: 56, 57, 180–81; © 2019 Frank Lloyd Wright Foundation. All Rights Reserved. Licensed by Artist Rights Society.

Photography

Index

Editor: Rebecca Kaplan
Creative Director: David Sebbah
Design Director: Natalie Do
Production Manager: Anet Sirna-Bruder

Library of Congress Control Number: 2018958264

ISBN: 978-1-4197-3333-8
eISBN: 978-1-68335-647-9

Text copyright © 2019 Condé Nast

Cover © 2019 Abrams

Printed and bound in Italy
12

Abrams books are available at special discounts when
purchased in quantity for premiums and promotions as
well as fundraising or educational use.
Special editions can also be created to specification.
For details, contact specialsales@abramsbooks.com or
the address below.

Abrams® is a registered trademark
of Harry N. Abrams, Inc.

ABRAMS The Art of Books
195 Broadway, New York, NY 10007
abramsbooks.com